# RELIGION AND CONTEMPORARY ART

D0145700

*Religion and Contemporary Art* sets the theoretical frameworks and interpretive strategies for exploring the re-emergence of religion in the making, exhibiting, and discussion of contemporary art. Featuring essays from both established and emerging scholars, critics, and artists, the book reflects on what might be termed an "accord" between contemporary art and religion.

It explores the common strategies contemporary artists employ in the interface between religion and contemporary art practice. It also includes case studies to provide more in-depth treatments of specific artists grappling with themes such as ritual, abstraction, mythology, the body, popular culture, science, liturgy, and social justice, among other themes.

It is a must-read resource for working artists, critics, and scholars in this field, and an invitation to new voices "curious" about its promises and possibilities.

**Ronald R. Bernier** is Professor of Humanities at Wentworth Institute of Technology in Boston, MA. His books include *The Unspeakable Art of Bill Viola* (2014), *Beyond Belief* (2010), and *Monument, Moment, and Memory: Monet's Cathedral in Fin-de-Siècle France* (2007). His research interests are modern and contemporary art and religious studies.

**Rachel Hostetter Smith** is Gilkison Distinguished Professor of Art History at Taylor University. She publishes widely on aspects of religion and the arts, including two edited volumes of *Religion and the Arts* and several exhibition catalogues, and has developed numerous international, intercultural art projects and traveling exhibitions, most recently *Matter + Spirit: A Chinese/American Exhibition*.

# RELIGION AND CONTEMPORARY ART

## A Curious Accord

*Edited by Ronald R. Bernier and*
*Rachel Hostetter Smith*

Routledge
Taylor & Francis Group

LONDON AND NEW YORK

Cover image: Wolfgang Laib *Passageway*, 2013 7 brass ships, rice 18 ×
128 × 102 inches (46 × 352.1 × 259.1 cm) overall © 2022 Wolfgang
Laib, Courtesy Sperone Westwater, New York

First published 2023
by Routledge
4 Park Square, Milton Park, Abingdon, Oxon OX14 4RN

and by Routledge
605 Third Avenue, New York, NY 10158

*Routledge is an imprint of the Taylor & Francis Group, an Informa business*

*British Library Cataloguing-in-Publication Data*
A catalogue record for this book is available from the British Library

*Library of Congress Cataloging-in-Publication Data*
Names: Bernier, Ronald R., editor. | Smith, Rachel Hostetter, editor.
Title: Religion and contemporary art : a curious accord / edited by
Ronald R. Bernier and Rachel Hostetter Smith.
Description: Abingdon, Oxon ; New York : Routledge, 2023. | Includes
bibliographical references and index. |
Identifiers: LCCN 2022052485 | ISBN 9781032354187 (hbk) | ISBN
9781032354170 (pbk) | ISBN 9781003326809 (ebk)
Subjects: LCSH: Art and religion. | Art, Modern—21st century—
Themes, motives.
Classification: LCC N72.R4 R445 2023 | DDC 201/.67—dc23/eng/20221121
LC record available at https://lccn.loc.gov/2022052485

ISBN: 978-1-032-35418-7 (hbk)
ISBN: 978-1-032-35417-0 (pbk)
ISBN: 978-1-003-32680-9 (ebk)

DOI: 10.4324/9781003326809

Typeset in Bembo
by codeMantra

# CONTENTS

# ACKNOWLEDGMENTS

This project is the result of myriad iterations and reconsiderations over many years. It began with a symposium, sponsored by the Association of Scholars of Christianity in the History of Art (ASCHA) in 2017, entitled "A Strange Place Still? Religion in Contemporary Art," where our ambition was to bring together scholars, critics, artists, and other arts professionals to explore the rich place of the sacred in contemporary visual culture. Along the way, it has benefitted from input and advice from innumerable individuals and organizations that gave generously of their time, guidance, expertise, and editorial acumen. We, the editors, take this opportunity to acknowledge some of them here.

First, we would like to thank the Board members and friends of ASCHA for their encouragement and steady support since the 2017 symposium when we had the idea that the topic called for a book. And, for this finished product, we are indebted to the editorial team at Routledge, to our editor, Ceri McLardy, who recognized the significance of this project from the outset, and to our intrepid editorial assistant, Iman Hakimi, who answered our many questions month after month with patience and professional consideration. Their stewardship of this project, from initial proposal to draft manuscript to publication, made our job as editors much easier and efficient. We would also like to thank the anonymous readers of our proposal whose comments and suggestions encouraged us to expand it further, particularly with respect to the diversity of voices and topics seen here. The generous support of the Council for Christian Colleges and Universities (CCCU), in the form of a Networking Initiative Grant, made possible the inclusion of the many stunning color images found within these pages. Similarly, we wish to acknowledge the artists who allowed us to include reproductions of their work.

Finally, and perhaps most importantly, we wish to thank our chapter contributors who gave their time, expertise, enthusiasm, and patience over the many months of its shaping and refining. They, along with the contributors to our Afterword colloquy, made this project the significant contribution to the field we believe it to be.

# INTRODUCTION

*Ronald R. Bernier and Rachel Hostetter Smith*

Nearly two decades have passed since James Elkins' trenchant study *On the Strange Place of Religion in Contemporary Art* (2004) first appeared, the Introduction to which aptly and succinctly described a sense of professional unease in pursuing the topic signaled by the volume's title: "For people in my profession of art history," Elkins confessed, "the very fact that I have written this book may be enough to cast me into a dubious category of fallen and marginal historians who somehow don't get modernism or postmodernism" (Elkins xi).

And, indeed, the estrangement of art from religion is one of the many unhappy legacies of modernism. The art world, Elkins maintained,

> can accept a wide range of "religious" art by people who hate religion, by people who are deeply uncertain about it, by the disgruntled and the disaffected and the skeptical, but there is no place for artists who express straightforward, ordinary religious faith.[1]

There is, the critic argued, a general tendency within the art world to see art that invokes religion in any but a critical or derisive way as retrograde and reactionary; that is to say, religion could not be treated in the academic world unless couched in recrimination, ironic distance, or scandal. In 2004, this was a shot across the bow of academic art history, a challenge to the profession – a profession that prides itself on its openness to diversity and inclusion – to answer for its apparent aversion to one of the most significant dimensions of human experience: faith and religious expression. In fact, similar ground had already been staked out as early as 1991 by author, artist, and art critic Suzi Gablik, in her appeal for a "reenchantment of art," where she called for "stepping beyond the modern traditions of mechanism, positivism, empiricism, rationalism, materialism, secularism, and scientism – the whole objectifying consciousness of the Enlightenment

DOI: 10.4324/9781003326809-1

and the materialistic disbelief in interiority – in a way that allows for a return of the soul," where "soul" may be taken to mean that which transcends isolated individuality and connects us with other people and communities – art as a way of rehumanizing us (Gablik 11).

Meanwhile, and quite to the contrary, some, such as contemporary theorist Thierry de Duve, argued for a continued faith in the Enlightenment project that others have generally agreed has failed us; de Duve's hope, expressed in his 2001 exhibition text, *Look: 100 Years of Contemporary Art*, is that artists *not* engage lingering interests in spirituality, maintaining that "the best modern art has endeavored to redefine the essentially *religious* terms of humanism on *belief*-less bases" (de Duve 14). "Belief" here, it seems, is understood as the modern notion of intellectual assent, with onto-theological implications – absent, we suggest, from an understanding of belief as faith and faith as trust. Indeed, "beyond belief" in dogma to faith as the substance of things hoped for. Postmodern religion scholar Mark C. Taylor goes further, identifying what he calls a *theoaesthetic* "in which art and religion join to lead individuals and society from fragmentation and opposition to integration and unification" (Taylor 1992, 46). "Art and faith," argues William Dyrness in his contribution to volume 7 of Elkins' and David Morgan's Art Seminar series, appropriately titled *Re-Enchantment* (2009), "both strain at the boundaries in which they are placed. They slip out of our grasp because they both deal in wonder. Maybe our conversation," he continues, "ought at least to remember this fact, and acknowledge that both are, ultimately, not within our control. That would be a start. All sides, it would seem, have much to gain from such humility" (Elkins and Morgan 229).

Much has changed since 2004 when Elkins issued his remarks. Artists, art historians, critics, and curators have vigorously challenged the assumed secularism of institutional art history, and a generation of scholarship and exhibition has developed that resists the skepticism that can still come when religion is a topic of discussion in the academy. This book explores the possible reemergence of a theological dimension to contemporary artmaking and art writing. Yet, the aim is not to propose a resurgence of traditional religious subject matter and iconography, but rather to give voice to long-suppressed – often maligned, mischaracterized, and at times professionally risky – positions informed by and resonant with themes of the sacred. It began, in 2017, as a one-day symposium of scholars, artists, and critics, sponsored by the Association of Scholars of Christianity in the History of Art (ASCHA), preceding the annual College Art Association conference. There, we, the symposium's organizers and this book's editors, posed the question, drawing from Elkins, of whether it is even achievable "to adjust the existing discourse enough to make it possible to address both secular theorists and religionists who would normally consider themselves outside the artworld" (Elkins xi).[2] And, as if framing the topic of the ASCHA symposium, a January 2017 edition of the *Los Angeles Review of Books,* in a lead article by S. Brent Plate, a contributor here in our Afterword, declared: "Reports of the Death of Religious Art Have Been Greatly Exaggerated."[3]

Elkins was not a lone voice in the wilderness in 2004, however. That year also saw the publication of Ena Heller's *Reluctant Partners: Art and Religion in Dialogue* and Eleanor Heartney's *Postmodern Heretics: The Catholic Imagination in Contemporary Art*. At the same time, the museum world saw the groundbreaking international exhibition "100 Artists See God" (2004), curated by artists Meg Cranston and John Baldessari. Just four years later, in 2008, the Centre Pompidou in Paris mounted "Traces du Sacré," and the aforementioned volume 7 of Elkins and Morgan's Art Seminar series, *Re-Enchantment,* and Daniel Siedell's *God in the Gallery*, were published; the following year saw the edited volume, *The Return of Religion and Other Myths: A Critical Reader in Contemporary Art*. That same year, the New York Guggenheim's "The Third Mind: American Artists Contemplate Asia" exhibition explored modern and contemporary art's religious themes. Even as early as 1996, the Museum of Contemporary Art in Chicago staged its massive exhibition, "Negotiating Rapture." Outside the scope of a purely Christian framework, in 1997 there was Wijdan Ali's art historical study, *Modern Islamic Art: Development and Continuity*; in 2013, *Visual Cultures in the Modern Middle East*, edited by Christian Gruber and Sune Haugbolle; and in 2015, LACMA's major exhibition "Islamic Art Now."

In 2006, the organizers of Singapore's first international biennale for the visual arts selected "Belief" as the theme for the invitational, which attracted artists from around the world including American notables Jenny Holzer and Barbara Kruger. The explanation for this choice of theme was described as follows:

> If today's world has painfully called into question many certainties governing society, history and humankind, can it also be described as an era of uncertainty in which the very subject of belief is in question? In the context of this so-called crisis of values, what do we individually and collectively believe in? Do we act on our beliefs or is belief simply a mindless act? Are the religious beliefs communicated by the great faiths more relevant than the secular beliefs in science, progress, democracy and politics that succeeded them? Or has the conflict between the two spawned such states of violent and ethical extremism in the service of religious and economic power that belief in anything appears incomprehensible? Are we beyond belief or at the threshold of its revival?[4]

Just two years later in 2008, Chinese artist Cai Guo-Qiang's exhibition at the Guggenheim, New York, titled "I Want to Believe," presented yet another example of the persistence of the ontological questions that confront all human beings regardless of their faith commitment, whether it is the nature of the cosmological order or a need to make sense of our mortality. These are the so-called "big questions" that every age must address.

Our contribution to this clearly vibrant and ongoing discussion aims to challenge the assumed secularism of institutional art history – what Sally M. Promey described in her seminal *Art Bulletin* essay in 2003, "The 'Return' of Religion

in the Scholarship of American Art," as the "secularization theory of modernity," which contends that "modernism necessarily leads to religion's decline, and the secular and the religious will not coexist in the modern world" (Promey 48), and what Hans Belting in his *Art History after Modernism* (2003) labels the predominant "paradigm of art history" (Belting vii). Beyond the field of art history (yet echoing Gablik), cultural anthropologist Talal Asad, in his study of secularism as ideology, *Formations of the Secular: Christianity, Islam, Modernity* (2003), argues that secularism entails "…an entire secular discourse of 'being human," central to which are ideals of individualism, "detachment from passionate belief," objectivity, skepticism, autonomy, and a "utilitarian calculus of pleasure and pain" in which there is "no way of engaging suffering but to minimize it" (Asad 124, 109). Asad's inquiry, and its relevance to the present study, was made salient at the 2017 symposium sponsored by the Center for Christianity, Culture, and the Arts (CCCA) hosted at Biola University in Los Angeles entitled "Art in a Postsecular Age," the sessions of which included the following: "What is Postsecularity?"; "Art History in a Postsecular Age"; "Art Making in a Postsecular Age"; and "Art in a Postsecular Age." Its participants included Sally Promey, James Elkins, and other prominent scholars working in the field, including Jeffrey Kosky, Matthew Milliner, Taylor Worley, and Lori Branch, among others.[5] The conference's theme, as indicated by its title, was a critique of the dominant narratives of modern and contemporary art history – the "malaise of disenchantment," they called it, as well as the critical theories used to interpret the artworks featured in those narratives, as shaped by modern secularization theory – the notion that modernization necessarily entails the decline of religious thought and practices in a society. In calling into question secularization theory, the conference participants reconsidered the ways that contemporary artmaking and art writing have been and continue to be shaped by religious contexts and theological concerns.

A much welcome 2013 publication, *ReVisioning: Critical Methods of Seeing Christianity in the History of Art*, edited by art historians James Romaine and Linda Stratford, both contributors to this volume, brought together more than a dozen essays by both emerging and established scholars, which collectively sought to expand the discourse on Christianity in the history of art, in part by challenging the equation of modernism with secularism as a methodological approach to the writing of art history. Romaine writes in the book's Introduction:

> The prevailing narrative of art history is one that charts a movement from the sacred to the secular, progressing out of past historical periods in which works of art were produced to reveal, embrace, and glorify the divine and toward a modern conception of art as materialist and a more recent emphasis on social context. In fact, for many art historians this secularization of art is not only a narrative within the history of art; it has been the narrative of art history as an academic field. Some interpretations of twentieth and twenty-first century art not only insist on equating modernism with

secularism but also describe the erasure of all mention of spiritual presence from the scholarly discourse as a triumph for the field of art history.

*(Romaine and Stratford 5)*

Perhaps most unpredictably, Thomas Crow, in his recent study *No Idols: The Missing Theology of Art* (2017), has argued: "Religious behavior and belief, along with theological meaning, appear as cultural artefacts to be dissected and decoded with clinical detachment, next to nothing presumably at stake for the interpreter beyond demonstration of scholarly acumen" (Crow 6). Even more surprisingly, Crow's study includes consideration of contemporary artists who reflect aspects of sincere and authentic religious faith and takes that faith and their work seriously, a real turn-about from when Elkins was writing *On the Strange Place of Religion in Contemporary Art* in 2004, where he concluded that there really is no such place for "authentic religious faith" in contemporary art – or contemporary art criticism, for that matter. As Brent Plate put it in 2017, "religion and art co-exist just fine, as long as it's a nebulous, personal 'spirituality' that the artists are trying to express – nothing too public, political, or potentially threatening to anyone who looks at it" (Plate para.2). But, he also prophesied:

> …there is an advocacy for a kind of reenchantment of the art world and, by extension, a reenchantment of the secular world as a whole (something Suzi Gablik was already calling for in her 1991 book *The Reenchantment of Art*). What is distinctive, however, are the ways these authors do not try to slip religion in through the backdoor by resorting to a foggy notion of "spirituality." Instead they find what is deeply religious – bodily performance, symbolic gestures, narratives on the cusp of the truth, immersive and interactive spaces – in the midst of the seemingly secular, unembarrassed to use religion and art in the same sentence. They do not assume religion can be captured through "beliefs," or art through a disinterested knowledge. Rather, if there is a connecting point between religion and art, it is to be found in the aesthetic, sense-based experiences and affects of the body.
>
>
>
> *(para.24–25)*

And he concluded:

> Perhaps now, with religious literacy an increasing necessity for civic life in an age of globalization, voluntary and involuntary immigration, and new instances of diversity, the arts might help find the ways renewed connections can be made. And, perhaps ultimately, critics will start paying more attention.
>
> *(para. 16)*

The present study aims to do something similar, to resist a pervasive skepticism when it comes to religion as a topic of discussion in the academy, to move beyond

our contemporary and unhelpful models of secular left and religious right and come to terms with faith as an irreducible part of the fabric of the social. We seek to contest that lingering narrative and contribute to an emerging field that still lacks the methodological framework by which to address, honestly and meaningfully, art's (re)engagement with theology. It will carefully interrogate Elkins' original argument and concerns and also look at some of the recent major publications and exhibitions that have begun, as the examples already mentioned above show, to tell a different story. To cite two additional major examples: Aaron Rosen's *Art and Religion in the 21st Century* (2015) looks at themes of creation, memory, embodiment, ritual, and mourning (among others) in contemporary art, and wonders: "despite this rich history of mutual engagement, religion and modern art continue to be typecast as mortal enemies. Misperceptions," he continues, "are particularly rampant when it comes to contemporary art" (Rosen 2015, 9). Notably, Rosen's more recent book, *Brushes with Faith: Reflections and Conversations on Contemporary Art* (2019), presents case studies and interviews with twenty-four artists reflecting on aspects of origins, materials, conflict, death, bodies and senses, communities, destruction, and transformation that demonstrate the global and multi-religious scope of this phenomenon for contemporary artists.

The Kunstsammlung-NRW's exhibition *The Problem of God* (2016), in dealing with Christian imagery in the work of internationally recognized contemporary artists, critically examined some of the most profound and sensitive commentary on religion occurring in art today. Also of note here is Donald Preziosi's *Art, Religion, Amnesia: The Enchantments of Credulity* (2013), which sought to dissolve the religion–art binary. Art and religion, he writes, "are variant yet mutually defining and co-determined answers or approaches to the same questions of the ethics of the practice of self" (Preziosi 79). Engaging with specific artists, Mark C. Taylor's *Refiguring the Spiritual* and Jeffrey Kosky's *Arts of Wonder*, both published in 2012, offer theological interpretations of concrete works of art. While Taylor considers artists like Joseph Beuys, Matthew Barney, James Turrell, and Andy Goldsworthy, Kosky (a contributor to this volume) invokes notions of the sublime, or "wonder," to reevaluate the work of Walter De Maria, Goldsworthy, and even the design firm Diller Scofidio + Renfro.

Yet another distinct counterpoint to the narrative that had prevailed for much of the previous century was the 2018 landmark exhibition "Encountering the Spiritual in Contemporary Art" at the Nelson-Atkins Museum of Art in Kansas City, Missouri. What set this exhibition apart was its affirmation of the affective role of contemporary art and the arts' capacity not merely to invoke the spiritual but, instead, to be a vehicle of transcendent experience. The viewer – and the viewer's *experience* – is given primacy of place, reflecting the growth of interest in reception theory in recent years. In the book of the same name published in conjunction with the exhibition – a substantial volume with a series of probing essays by a diverse group of rising and established scholars and critics including Ladan Akbarnia, Stephen Gilcrist, Eleanor Heartney (a contributor to this volume),

and Mary Jane Jacob – curator Leesa K. Fanning testifies to her own experience of encountering the spiritual through art, and contemporary art in particular, and her growing awareness of the persistent presence of spiritual and religious dimensions in much of the art being produced worldwide. But it was her growing mystification and dismay at the way it was still largely ignored by many – or most? – art professionals that compelled Fanning to pursue this particular project. So perhaps not as much has changed, in the perceptions of many in the art world that Elkins described in 2004 at least, as one might hope. Significantly, Fanning expressly stated that her book "omits art that mocks or parodies organized religion" (43), a counter to Elkins' earlier assessment that the only place of religion in contemporary art was that marked by irony, skepticism, or even ridicule. Fanning appears to suggest that it is instead a matter of which contemporary art scholars and critics choose to champion – and for what reasons – rather than some objective notion of what constitutes creditable contemporary art.

In a section titled "The Spiritual in Art and its Near Absence in Scholarship and Criticism," Fanning writes, "The spiritual is everywhere evident in contemporary global art….Yet the presence of the spiritual in contemporary art has not been the focus of most art-world professionals." She continues, "The purpose of this publication is to bring this topic forward to be a voice among a few others in the art world" (36). Quoting Christine Macel, curator of *Viva Arte Viva*, at the 2017 Venice Biennale, Fanning champions a role for contemporary art that nourishes and sustains without being naïve or otherwise superficial:

> Today, in a world full of conflicts and shocks, art bears witness to the most precious part of what makes us human….[It] elevates us to spiritual dimension[,]…builds us up and edifies us. At a time of global disorder, art embraces life.
>
> *(qted. on p. 37)*

At the close of her introduction to the volume *Encountering the Spiritual in Art*, Fanning proclaims:

> This contemporary spiritual art has an effect in the world. It changes minds, broadens understanding, and transforms lives. It is the embodiment of the artists' spiritual experience, and it means to evoke the same in us. Such works are dynamic agents of the spiritual: they provide a sense of plenitude, a healing place of respite, allow us to see anew as if for the first time, and celebrate our uniqueness and difference as well as our common humanity. The possibilities are endless.
>
> *(63)*

Even more recently, the 2022 Venice Biennale provides another example of how religion and spirituality are currently operating in contemporary art.[6]

The main exhibition – "The Milk of Dreams," curated by Cecilia Alemani, which spanned the vast spaces of both the Giardini and the Arsenale – featured numerous works engaging religious and spiritual themes and histories. Some-times this was made explicit in the curatorial framing, as, for example, in the capsule exhibits within the larger exhibition – including "Corps Orbite," which featured twenty women artists who all explore visionary spiritualities (e.g., Sister Gertrude Morgan, Minnie Evans, and Georgiana Houghton), or "The Witch's Cradle," investigating various forms of esoteric spiritualism (Leonora Carrington, Ida Kar, Augusta Savage, and more than thirty others). In other instances, religious contexts appeared in didactic wall labels throughout the main exhibition, where we learned, for example, of Ficre Ghebreyesus's Coptic Christian upbringing and of the ways Portia Zvavahera's Apostolic Pentecos-talism informs her large, exuberant (and quite haunting) paintings. And, of course, religion and spirituality appeared not only in the textual framing of the works but in the works themselves. In the main entrance to the Arsenale, Belkis Ayón's Abakuá-inspired works encircled Simone Leigh's *Brick House* (2019), a monumental eyeless, "goddess-like" bronze woman that generates "a site of sanctuary." Similarly, numerous other artworks engaged various interfacings of Christianity, Shona cosmology, Ancient Egyptian and Jewish mythologies, Haitian Vodou, Buddhism, and so on. Several of the national pavilions touched on similar concerns, including the United States' exhibition of Simone Leigh's "Sovereignty," Poland's exhibition of Malgorzata Mirga-Tas's "Re-Enchanting the World," Hungary's exhibition of Zsófia Keresztes's "After Dreams: I Dare to Defy the Damage," Romania's exhibition of Adina Pintille's "You Are Another Me – A Cathedral of the Body," and Egypt's "Eden Like Garden: Preserved for the Chosen Ones." There is an extraordinary diversity of emphases, influences, and depth of investment in religious thinking represented here, but clearly reli-gion and spirituality are now circulating through the discourse of contemporary art in significant ways.[7]

Beyond the Biennale itself, many of the exhibitions throughout the city of Venice were overtly and evocatively engaged with religious themes and histo-ries. Anish Kapoor's interventions in the Gallerie dell'Accademia made brilliant conversation with the permanent collection of medieval Christian icons, as did Anselm Kiefer's installation of gigantic paintings in the Palazzo Ducale.[8] The "Secrets of Faith" exhibition at Victoria Miro Gallery featured Paula Rego's several paintings and watercolor studies from her 2002 series on the life of Mary – including *Agony in the Garden* and *Descent from the Cross* – which were commissioned for the chapel of the Palacio de Belém in Lisbon. Meanwhile, the Peggy Guggenheim Collection presented the blockbuster exhibition, "Surreal-ism and Magic: Enchanted Modernity," exploring the various ways the history of surrealism was enmeshed with occultist ideas and practices.

★★★

Regarding structure, this book is divided into three distinct sections (in addition to this Introduction and the Afterword colloquy). Part I features essays by established scholars and critics on the evolving discourse of art and religion in our contemporary era. Part II treats themes and strategies employed by contemporary artists whose work reflects some kind of interface or mutual engagement of art and religious expression. And Part III features generally shorter essays treating specific artists and ideas that draw on and test the implications of the theoretical positions staked out in Part I and the strategies described in Part II. Finally, an Afterword closes out the volume; it is structured as a conversation among four scholars, including Elkins, working from different disciplinary frameworks, that takes stock of the current state of and future trajectories for the relationship between "religion" and contemporary art in art practice and scholarly/critical discourse.

Part I, Theoretical and Interpretive Frameworks, sets the theological parameters and interpretive strategies for exploring the reemergence of religion in the making, exhibition, and discussion of contemporary art. It opens with artist and art critic Jonathan Anderson's reassessment of James Elkins' book; here, Anderson refocuses Elkins' 2004 concern as not so much with the absence of religious *content* in contemporary art, as with the fact that this content "does not have a place in *talk* about contemporary art." And indeed, as Anderson points out, since the publication of Elkins' book, many recent essays, exhibition catalogues, conferences, and books have been devoted precisely to this kind of talk, fueled, as he puts it, "by broader debates about postsecularity and postcriticality in academia at large." We have mentioned but a few of these above. Religion, Anderson notes, "has not only become more visible in contemporary art, it has also become more discussable," as the CCCA conference also referenced above clearly showed. Indeed, Anderson maps out four general interpretive "horizons," as he calls them – anthropological, political, spiritual, and theological – which, he argues, currently organize and orient various of these discourses on art and religion.

Meanwhile, art historian Linda Stratford takes a broader, more historical and theoretical perspective on interpretive frameworks, reviewing, with optimism, the recent work of art historians and critics that suggests a rich and growing field of interest in the intersections of art and religion. Stratford worries, however, that the range of methodologies represented in these recent efforts has not been sufficiently critiqued. Her essay aims to propose a better understanding among art historians of the *theological dimensions of the aesthetic object*, and, among theologians, of the *aesthetic dimensions of theology.* One of the inherent risks to such interdisciplinary work, however, as Stratford cautions, is the insufficient knowledge in either camp – art and theology or religious studies – of the other's discipline. Her review of methods employed by art historians in the past two decades is intended to guide further work in the arena of art and religion and to invite continued professional critique and review.

Lieke Wijnia takes up this invitation to cross-disciplinary dialogue in a post-secular environment by introducing the notion of mutual "translation" from one realm – the pluriform character of contemporary art – to another – religious narrative, symbols, and heritage. "Explorations of the diversity in artistic translations of religion, and their appreciation found in exhibitions in public institutions like museums," she writes, "sheds light on the dynamic place of religion in secularizing contexts." Jeffrey Kosky, in his essay "The Question of Criticism: What to Do with Our Revelations," examines in turn how we might imagine a critical or scholarly writing that learns from religion, even in contemporary secular environments like museums, and allows for the possibility of the experience of "grace," "transcendence," or "revelation" without suspicion or qualm. Elissa Yukiko Weichbrodt's contribution provides just that; in an essay that probes the racial context of Carrie Mae Weems' photo installation, *From Here I Saw What Happened and I Cried*, and the range of responses we can have within our "archive" of possible socio-culturally delimited understandings, Weichbrodt offers a new, theologically informed way (the "Golden Rule") of grappling with difficult, traumatic subject matter in a loving and transformative way.

The final two chapters in Part I deal with the construction of collective and individual encounters with the sacred. Daniel Siedell focuses on the intentionally curated exhibition of works of art in *mutual reciprocity* with each other, wherein "questions of belief, doubt, knowledge, experience, and affect are posed in relation to each other," in ways that often far exceed curatorial intention. Siedell, as critic-curator, scholar, and student of theology, examines his own circuitous professional and personal engagement with art and theology to argue for a more complicated and multivalent understanding of faith than Elkins' 2004 essay presumes, and he introduces the idea of the "curatorial" as dynamic dialogue as a way to "exhibit" this complex, entangled, and ever-changing relationship between art and religion, and between art theory and theology. Similarly, Aaron Rosen's essay is about a shifting and wandering *pilgrimage* of art and faith, and an aesthetic of embodied looking. He takes as example his own international, multi-site public arts project, *Stations of the Cross*, to prompt reflection, dialogue, and action in response to challenges of/to social justice. Rosen considers how an exhibition explicitly inspired by Christian history and practice can galvanize Christian observance while providing ways for deep but non-confessional engagement by non-Christians. "Conceiving of an exhibition qua pilgrimage, and vice versa" he writes, "reveals important strategies for interfaith dialogue."

This question of contemporary art and exhibition as pilgrimage is interrogated more directly in the essay by Katherine Barush in Part II of this volume, Artistic Strategies. The eight chapters gathered here aim to build on the theoretical groundwork laid by Part I, featuring essays treating specific themes and strategies employed by contemporary artists whose work offers some kind of engagement, however subtle or explicit, with faith and religious experience. Barush's essay on the London-based contemporary artist and filmmaker Chiara Ambrosio considers the artist's ongoing episodic zine project, *As Far As The Eye*

*Can Travel*, as a site of, and occasion for, pilgrimage, a sequential process of art-making and art viewing as a sacred journey.

Katie Kresser uses the genre of portraiture, descendant of the Early Christian icon and its positing of spiritual existence and identity in the created object, as a model for a contemporary portraiture that similarly seeks to reveal a sacred, "transcendent Personhood that bursts the bonds of time and space and pulses with sacred meaning." Kresser addresses examples of portrait "installations" that reinforce ancient ideas about the dignity of Personhood. Meanwhile, Cynthia Hahn similarly reclaims an ancient religious trope, that of the "relic" – a strategy that makes use of material stuff and its containment to enshrine something to be recognized as valuable and worthy of our attention. Here, she examines the work of selected contemporary artists who employ a strategy of "relic-ing" and the focus that brings to otherwise mundane material, which in turn demands our attentiveness to the human mysteries they enshrine. Often, those mysteries or contradictions in the world prompt a response of "sacred discontent," which is the topic of Wayne Roosa's "Walking Naked and Barefoot: When Ancient Jewish Prophets Meet Avant-Garde Performance Artists." Roosa, invoking the ancient biblical tradition of prophetic action, draws connections between the "outrageous" actions of Old Testament Jewish prophets designed to draw attention to the political and religious hypocrisies of the time, and contemporary performance artists whose frequently transgressive symbolic performative actions are intended to speak "truth to power" and to shock their publics into wakefulness. Rachel Hostetter Smith's chapter on "Rogue Priests" takes a similar direction in thinking about artists whose work may be described as akin to that of a priest, healer, or truth-teller. She examines the ways contemporary artists such as Damien Hirst, Teresa Margolles, Doris Salcedo, and Wolfgang Laib employ physical actions and material agents that imbue their work with transcendent implications and transformative potential, such that the artist functions in the manner of a priest or intercessor between the human and some higher power.

Karen Gonzalez Rice's contribution, like Roosa's, similarly focuses on performance art, and, in particular, Shamanism. She interrogates Thomas McEvilley's influential 1983 *Artforum* essay, "Art in the Dark," wherein the late critic posited performance art's origins, function, and significance in terms of religion, arguing that performance artists act as shamans, a community's designated transgressors of traditional boundaries. Gonzalez Rice revisits McEvilley's influential essay to locate his universalizing claims within the real conditions of 1960s and 1970s counterculture.

Part II on Artistic Strategies closes with two essays that share an interest in contemporary video and projection art. Jorge Sebastián Lozano examines the intersection between contemporary art and Christian faith through the lens of projected light and sound, dematerialization of medium, and multimedia installation art. These creations, he argues, have succeeded in pushing the boundaries of the art world and are reaching other fields, like the spectacular video projections within and outside historical ecclesiastical structures that are becoming a

staple feature of religious festivals and large-scale public art events. He traces some of the theological issues inherent in such uses of light, space, and their interaction with modern immersive video technologies. One such artist he cites as actively pursuing themes that resonate with religious traditions and who serves as a model for some of the younger multimedia artists he reviews later in his essay is Bill Viola, whose continuing use of polyptychs comprised of high-definition video screens is a fully conscious reference to a centuries-long tradition of altar-piece painting, the main loci for Christian imagery within sacred spaces. Viola is given exclusive treatment in the chapter that closes this section by Ronald R. Bernier. Bernier locates Viola's art within postmodern notions of the "unrep-resentable," theologically invoking the idea of *apophasis* – the experience and description of the Divine as an abstract experience, not conceptually definable in terms of space and location, nor confinable to conventions of time – God as transcendent Being – and echoing St. Paul's description of the "Unknown God."

Part III of this volume, Case Studies of Artists and Artworks, is comprised of essays that more closely examine specific examples, with topical essays that pro-vide in-depth treatments of individual artists, those grappling with themes such as ritual, abstraction, mythology, the body, popular culture, science, liturgy, and social justice, among others. Art historian James Romaine, for instance, addresses the "place" of religion in contemporary art through the lens of art as a means of social resistance and moral demonstration, posing the question of whether art that visualizes the sacred can bridge cultural divides. He does this through a close reading of the art of Tim Rollins and K.O.S., one of the most successful artist collaborations of the last quarter century, whose work tests art's capacity to achieve more than symbolic action. Can contemporary art, Romaine asks, by making the spiritual materially present, initiate concrete change in our increas-ingly cynical culture?

Religious studies scholar, Stephen Bush, revisits the famously ambiguous work of Andy Warhol, in particular his paintings and prints that have overtly religious content, intermingling the sacred and profane, prompting the viewer to wonder whether to regard the art as blasphemous or as a sincere, albeit peculiar, form of piety. Bush discusses Warhol's religious art in light of recent methodological developments in academic religious studies, in particular what is referred to as "lived religion" – the way that religious practices are immersed in the activities of everyday life and popular culture. In his chapter on "Cities of Light," Matthew Milliner picks up the theme of mysticism, light metaphysics, negative theology (apophaticism), and the sublime, introduced by Bernier in Part II, here to estab-lish the California Light & Space Movement, and artist Phillip K. Smith III's Los Angeles 2019 exhibition, *10 Columns* at Bridge Projects, as a contemporary continuation of ancient mysticism and theologies of light. And Ben Schachter, drawing on the Dada tradition of "ready-mades" – and the transubstantiation of the ordinary and mundane into objects of reverence (Art) – considers (not with-out humor) the "found objects" of contemporary artists Anshie Kagan and David Shrigley and their transformation into artworks with eschatological resonance,

highly informed by (in these cases Jewish and Christian) religious belief that is expectant of a distant, or perhaps very near, future.

The theme of Endtimes resurfaces in art critic Eleanor Heartney's contribution, "Back to the Garden." In the *Book of Revelation*, Heartney tells us, "the terror of the Endtimes is followed by the balm of the New Jerusalem, that state of grace that is the reward of the just." However, this promise of Heavenly Paradise, she argues, has become entangled with earthly politics. Heartney cites American Exceptionalism and Manifest Destiny, the utopian movements of the 19th century, the purifications of National Socialism, and millenarian convictions on both sides of the so-called clash of civilizations as all "bear[ing] the imprint of the New Jerusalem's assurance of human perfectibility. Through the work of Jim Shaw, Liza Lou, Shirin Neshat, and Shoja Azari and the shared theme of Utopia and Paradise, Heartney examines how these artists have drawn on their own religious backgrounds to create works that explore, in different ways, "the equivocal messages inherent in the concept of Paradise."

At the other end of the contemporary art spectrum, Julie Hamilton considers the performance work of Lia Chavez, particularly her *Light Body* (2016). In this performance, Chavez employs ascetic disciplines, meditation techniques, and neurological training in hyperconsciousness alongside religious practices from Tibetan Buddhism and Christian mysticism. By drawing upon Western and Eastern traditions of ancient wisdom, argues Hamilton, Chavez demonstrates that the body is a studio within which one *acts* in order to *know*. Having discovered the body's aura through fasting, contemplative practice, and extended periods of silence, Chavez narrates her body through performance, disciplining her flesh through dramatized actions. This practice, according to Hamilton's reading, places the artist squarely in the historical lineage of monastics and saints' lives, which might themselves be read as early forms of performance art. Art historian, Isabelle Loring Wallace, similarly investigates performance art through Christian Jankowski's multimedia project, *The Holy Artwork*, which explores the unexpected conjunction of televangelism and contemporary art, at once a live performance, worship service, video, and television show.

Also addressing a performance of sorts, Donato Loia considers the abundance of religious references in Theaster Gates' *oeuvre*, focusing in particular on a procession-like performance organized by the artist for the opening of the 2010 Milwaukee Art Museum exhibition, *To Speculate Darkly*. Gates' religious upbringing and cultural milieu, Loia posits, inform his creative motivations and reveal an implicit critique of the museum space and art historical traditions expressed by this performance.

Meanwhile, Cecilia González-Andrieu examines the more formally conventional work of John August Swanson and his images of the poor and the vulnerable and the way his unconventional background growing up in Los Angeles as the son of a Mexican immigrant mother and dissolute Swedish father who was largely absent from his life, informed both his art and spirit in surprising and profound ways. González-Andrieu thoughtfully explores the inherent link between

the aesthetic and the ethical and suggests that Swanson's work embodies art's exceptional ability to be attentive to the world's suffering. By paying attention to the aesthetically embodied insights of the wounded, vulnerable, marginalized, and excluded, the author argues, Swanson functions as artist, spiritual seeker, and social justice activist, moving the viewer to respond with compassion.

Yohana Agra Junker's chapter expands our view of the intersections of religion and contemporary art in the Americas. In her examination of several Indigenous and Afro-Atlantic artists from Chile, Alaska, and Brazil, Junker traces how the importance of place and encounters with the land arising from their respective indigenous religious traditions provide models for what she calls a "poetics of resistance" to cultivate the capacity to thrive in their present circumstances, despite historic or contemporary disadvantage and marginalization, weaving historical, pictorial, geophysical, and cosmological structures together in profound ways.

Contributions by Karen von Veh and Sascha Crasnow both reflect artists responding to social ills and discrimination against marginalized people in their societies. Von Veh's chapter takes us to South Africa and the artist Diane Victor who has spent her life putting the spotlight on the violence and hypocrisy pervading much of South African society by drawing on religious imagery and allusion to create pointed and undeniably poignant critiques of both historic and, especially, contemporary South African realities. In this case study, von Veh examines the 2018 processional installation titled *Stations of the Cross* that includes projections of portraits of the victims of femicide in South Africa using Victor's signature smoke drawings on glass to create an "iconography of mourning" as a form of redress on behalf of those who have been discarded by contemporary society.

Crasnow, on the other hand, examines the phenomenon of SWANA (South West Asia and North Africa) Muslim artists' use of the figure of *al Buraq*, the winged hybrid creature who carries the prophet Muhammad on his night journey in Islamic mythology, to investigate the liminality of queer and trans identity and experience, as persons who live betwixt and between competing realms of existence that blur the distinction between fact and fiction, to champion a recognition of their full humanity within their Muslim communities.

Part III also includes two chapters on contemporary Chinese art. The first, by Patricia Eichenbaum Karetzky, surveys the appearance of religious themes and allusions drawn from Daoism, Buddhism, and Christianity by a great diversity of artists including global notables such as Wenda Gu, Xu Bing, Zhang Huan, and the Gao Brothers, which reflects the revival of interest in religion that has occurred in Chinese society since its opening in the 1980s after Mao's death. Significantly, the rush to develop and prosper after the devastation of Maoist rule and the Cultural Revolution in particular, resulted in a "spiritual void" in Chinese society that these artists seek to expose or address, including Chinese Christian artists who seek to create a distinctly Chinese art that is both contemporary *and* Christian. In contrast with Karetzky's overview of the appearance of

religion in contemporary Chinese art, Changping Zha's chapter examines two recent monumental paintings in-depth by a single Chinese artist, Meng Yan, who borrows from Western Christian sources for his critique of contemporary Chinese society. The first references Leonardo Da Vinci's *Last Supper*, which also inspired Andy Warhol decades earlier as discussed in the first case study in Part III on the lived religion of Andy Warhol by Stephen Bush. In the second painting, Meng Yan draws on Dante's *Divine Comedy* for motifs to present the ills that plague contemporary Chinese society in an exposé of greed, license, and all manner of moral corruption, in a style that melds traditional Chinese ink painting with hints of the emotionalism of abstract expressionism.

Finally, Haema Sivanesan's contribution in Part III bridges the cultural and religious traditions of the East and West in her case study of two artists who employ the mandala in their work: Chrysanne Stathacos, a Canadian artist who embraced Buddhism later in life as the result of tragedy and loss, and Charwei Tsai, a Taiwanese artist who became a follower of Tibetan Buddhism as a student in New York. Through her examination of works based on the mandala, Sivanesan demonstrates how both artists draw on Buddhist beliefs and practices as a contemplative method of inquiry to inform and guide their art practice so that the distinction between religious and artistic practice virtually disappears, a return to how art and religion have been inextricably intertwined for most of human history around the globe.

Without any claim to comprehensiveness, the case studies in Part III, in combination with the theoretical and interpretive frameworks presented in Part I and the common artistic strategies described in Part II, nevertheless reflect something of the breadth and depth of scholarship currently being produced at the intersections of religion and contemporary art and how much the field has developed in recent years.

★★★

We close this volume with a conversation among four scholars working from different disciplinary frameworks who have made leading contributions to the discourse on the relationship between religion and contemporary art: James Elkins (art history and criticism), Diane Apostolos-Cappadona and S. Brent Rodriguez-Plate (religion and visual culture), and Ben Quash (theology and the arts).

Collectively, their reflections take stock of the current state of artistic practice and its scholarly and critical discourse around the question of contemporary art's relation to something called "religion," first looking back in art's history to trace some of the significant critical and methodological developments that have paved the way for the diverse work being done today – in both artmaking and art writing. They then look ahead to speculate on the promise of today's work for future trajectories of art production and critical discourse in dialogue with religion.

One theme that arose for each of our discussants is the need to be more clear and transparent about what is meant when scholars and critics use terms like

"religion;" they worry about the current vogue for more imprecise terms like "spirituality," which connotes something less distinct and more elusive – a reference to personal, individual "feeling" or "sentiment" or "inner sense." They urge us to be more aware of and attentive to how such "spirituality," however private we may wish it to be, necessarily intersects with the social and political constructions of gender, race, sexuality, language, etc. *Religion*, they insist, conveys and lives in a more public realm than the privacies of "interiority," and commits to something that extends well beyond intellectual assent to, and confessional identity with, doctrinal orthodoxy and truth claims. It invokes more of the "lived reality" and "engagement" with the ideas and values religion claims to be about – humility, generosity, hope, community, communication, and the conditions for human flourishing.

Another theme shared by the participants in our closing colloquy is an equally urgent need to be clear about what we mean by "art," the other anchor of this book's topic. The term has shifted and morphed, they argue, particularly in the age we call postmodern, into something more encompassing like "material culture," "popular culture," and "visual culture." And, along with the societal shifts that have occurred at least since the 1960s and 1970s, it necessarily embraces the concerns for racial justice, ethnic identity, redefinitions of sexuality, and environmental causes. And all of this has implications for how "art" is (re)defined by its practitioners, critics, historians, and institutions (such as museums, exhibitions, and the academy).

With respect to future trajectories of scholarship and other engagements at the nexus of art and religion, our commentators call for a refocusing of our "talk" about art, away from its traditional concerns about art's production and onto its reception, the "affects" and responses that art invokes. "A primary aesthetic question for understanding the religion-art relation," argues one of our respondents, "could become: What happens to bodies, and what do they do, when they encounter a work of art?" The issue becomes one of our corporal engagement with art, as beholders, and *as* religious experience, behavior, and expression – the community that art, and its scholarship, serves.

<center>★★★</center>

What the essays and interventions in this volume share is a commitment to an emerging discourse, a coming to terms with faith as part of the fabric of human experience, and more specifically, they speculate on the place of the sacred in contemporary visual culture. Collectively, the authors approach these issues from a number of different and sometimes diverging perspectives, ranging from curatorial practice to theoretical speculation on theological aesthetics, to contemporary artmaking in painting, sculpture, installation, film, and performance. Our ultimate purpose was to invite more voices into this discussion. We eventually return to the question with which we began, prompted as it was by James Elkins' modest but rich interrogation of the "strange place of religion in contemporary

art." Is it still so strange? Or is it possible, thinking past the mutual mistrust of art and religion, to reread and reengage spiritual themes within postmodern culture? The scholars, critics, and artists gathered here propose an alternative perspective on the human condition, one that speculates on the place of the numinous and the life of faith in contemporary art, and opens up the field of art historical-critical and museological inquiry to include appreciation of the affective nuances of lived encounter. At the close of his seminal study, Elkins issued an eloquent charge, writing: "It is impossible to talk sensibly about religion and at the same time address art in an informed and intelligent manner: but it is also irresponsible not to keep trying" (Elkins 2004, 17). As this book hopefully demonstrates, in the nearly two decades since he penned those provocative words, scholars, critics, and curators alike have not just been trying, but have found fruitful and varied ways of dealing effectively with the breadth of art being made by contemporary artists and being talked about by art historians and writers that address this essential aspect of human being and the social.

## Notes

1  Elkins, 47. Segments of this review first appeared in Bernier, *Beyond Belief: Theoaesthetics or Just Old-Time Religion*, Wipf & Stock, 2010, 1–3.
2  See https://www.scholarschristianityhistoryart.org.
3  Plate, S. Brent. *Los Angeles Review of Books* (January 24, 2017).
4  2006 Singapore Biennale Press Release still found at https://charweitsai.com/projects/exhibition/singapore-biennale-2006.
5  See http://ccca.biola.edu/conference/2017-conference/.
6  The editors are indebted to Jonathan Anderson, a contributor to this volume, for his insightful review of the 2022 Venice Biennale found in the following paragraphs.
7  https://www.labiennale.org/en.
8  For an excellent review of these two exhibitions, see Matthew J. Milliner, "Venice Undone: Kapoor and Kiefer at the 59th Venice Biennale," *Comment* (July 28, 2022). https://comment.org/venice-undone/.

## Bibliography

Elkins, James. *On the Strange Place of Religion in Contemporary Art*. Routledge, 2004.
Elkins, James and David Morgan, eds. *Re-Enchantment*. Routledge, 2009.
Fanning, Leesa K. *Encountering the Spiritual in Contemporary Art*. The Nelson-Atkins Museum of Art and Yale University Press, 2018.
Gablik, Suzi. *The Reenchantment of Art*. Thames & Hudson, 1991.
Kosky, Jeffrey. *Arts of Wonder: Enchanting Secularity – Walter De Maria, Diller + Scofidio, James Turrell, Andy Goldsworthy*. University of Chicago Press, 2016.
Plate, S. Brent. "The Reports of the Death of Religious Art Have Been Greatly Exaggerated," *Los Angeles Review of Books*, January 24, 2017.
Preziosi, Donald. *Art, Religion, Amnesia: The Enchantments of Credulity*. Routledge, 2013.
Promey, Sally. "The 'Return' of Religion in the Scholarship of American Art," *The Art Bulletin*, Vol. 85, No. 3 (September 2003), 581–603.
Romaine, James, and Linda Stratford, eds. *ReVisioning: Critical Methods of Seeing: Christianity in the History of Art*. Cascade, 2014.

Rosen, Aaron. *Art & Religion in the 21st Century.* Thames & Hudson, 2015.
——. *Brushes with Faith: Reflections and Conversations on Contemporary Art.* Cascade Books, 2019.
Taylor, Mark C. *Disfiguring: Art, Architecture and Religion.* University of Chicago Press, 1992.
——. *Refiguring the Spiritual: Beuys, Barney, Turrell, Goldsworthy.* Columbia University Press, 2012.

**PART I**

# Theoretical and Interpretative Frameworks

# 1

# THE NEW VISIBILITY OF RELIGION IN CONTEMPORARY ART

## Four Interpretive Horizons

*Jonathan A. Anderson*

When James Elkins' meditation *On the Strange Place of Religion in Contemporary Art* appeared in 2004, it accomplished at least two things at once.[1] On the one hand, it opened the discipline of art history to broader debates growing since the 1990s concerning a "religious turn" in the humanities (Blond, de Vries, Janicaud et al.) – a turn that has been slower and more convoluted in the academic art world than in adjacent disciplines. Elkins pressed his colleagues to reconsider the ways religion had (or conspicuously had not) been operating in 20th-century art and in the dominant discourses surrounding and supporting it. On the other hand, his book also openly identified the disciplinary dynamics that generally preclude religion from serious study in the scholarship of 20th-century art. Indeed, his book pushes toward the conclusion that "It is impossible to talk sensibly about religion and at the same time address art in an informed and intelligent manner: but it is also irresponsible not to keep trying" (116).

Much has happened since the publication of Elkins' book. For starters, religion has become more *visible* in contemporary art. Numerous prominent artists today are directly engaging religious imageries, objects, and milieus from a range of perspectives – Kris Martin, Andrea Büttner, Danh Vo, Genesis Tramaine, Francis Alÿs, Arthur Jafa, Subodh Gupta, Hossein Valamanesh, and others explored in the following chapters. Many artists have been placing major works (temporarily or permanently) in churches, synagogues, and other religious sites, including Sol LeWitt, Sean Scully, Shirazeh Houshiary, Gerhard Richter, Sophie Calle, James Turrell, Anish Kapoor, and others. And in recent years, curators have organized major museum exhibitions addressing religion, spirituality, and related topics, including *100 Artists See God* at the Contemporary Jewish Museum in San Francisco and five subsequent museums (2004); *Belief* at nineteen locations in the first Singapore Biennale (2006); *Holy Inspiration* at the Stedelijk Museum in De Nieuwe Kerk, Amsterdam (2008); *Byzantine Things in the World* at The Menil

DOI: 10.4324/9781003326809-3

Collection in Houston (2013); *Ecce Homo* at nine sites in Antwerp (2017); and many others mentioned below.

This is not to suggest that religious belief and practice are simply reappearing in traditional forms. Artists and scholars are turning to the topic of religion, or to religious topics, but the forms of religion now in view are not in any straightforward sense a "return" to what has come before. Indeed, there are significant discontinuities here. There is a "new visibility" of religion but one comprising unprecedented variations, including both historical traditions and those not encountered before (Ward and Hoelzl 2). Zygmunt Bauman famously argued that the progressivist logics of modernization that were once "heavy" – "melting the solids" of traditional social orders for the sake of establishing new ones – have increasingly produced lighter, faster, perpetually "liquid" modes of relation. In the fast currents of "liquid modernity," religion is not disappearing; rather, it too becomes more lightweight, unaffiliated, and fluid. Or, switching to Charles Taylor's mixed metaphors, contemporary religion seems like "a spiritual supernova, a kind of galloping pluralism on the spiritual plane" (300).

All these developments are important as interconnected phenomena, and all are relevant to understanding contemporary artmaking. However, I want to focus on the ways religion has become more *discussible* in contemporary art. This, after all, is at the heart of Elkins' thesis. His book is less concerned with the absence of religious content in contemporary art than with the fact that such content "does not have a place in *talk* about contemporary art" (115). To distill his argument, the "strange place of religion in contemporary art" is that religious concerns and conceptualities are frequently in play, but the critical methods, theories, and narratives that have structured "the grain of the history of modernism" have rendered these concerns and conceptualities largely invisible and uninterpretable (20, 48). In other words, Elkins believes that the strangeness of religion in art has less to do with contemporary artmaking than with contemporary art *discourse*. This, too, is changing since the publication of Elkins' book, as many new books, articles, and exhibition catalogs are conducting precisely this kind of talk about religion in relation to contemporary art (and the modernisms from which it grew). Yet, many problems and confusions persist – including that when scholars speak of "religion," they are often referring to different phenomena understood through different interpretive frameworks.[2]

The task of taking up Elkins' call "to keep trying" to talk sensibly and intelligently about religion in contemporary art thus requires careful attention to the ways we *have been* talking and writing about this topic. That is the aim of this chapter: to offer a provisional mapping of this renewed talk, surveying the ways that art historians, critics, and curators have been writing about religion since the publication of Elkins' book. What are the primary questions, concerns, and assumptions organizing how religion appears in this writing? What kinds of intelligibility is this writing trying to identify or produce?

I propose that there are four general interpretive horizons within which religion is becoming visible, intelligible, and consequential in the scholarship of

contemporary art: (1) an anthropological horizon, (2) a political horizon, (3) a spiritual horizon, and (4) a theological horizon. This fourfold taxonomy is intentionally simple and heuristic – there are of course numerous possibilities within and between these. As a heuristic device, however, this identifies and distinguishes four prominent, fundamentally different concerns currently organizing and orienting various "art and religion" discourses. My naming of these horizons vaguely associates them with other academic disciplines, but there is no necessary correlation. Generally speaking, the "home" discipline here is art history, and these four horizons identify the major ways religion has become salient in the study of contemporary art. Agile, well-trained scholars can switch between these horizons and combine insights from each, but in almost every case, they consider one of these most fundamental. We will briefly survey each, highlighting examples of prominent books and exhibitions and clarifying their respective emphases and limits.[3]

## Art and Religion within an *Anthropological* Horizon

A renewed study of religion in modern and contemporary art has been especially concentrated among scholars working between art history and religious studies, who are tracing the entwining of art and religion in the formations and functions of material culture, social imagination, and cultural identity. When seen primarily within the hermeneutical space of an *anthropological* horizon, the most salient aspect of this entwining is what it reveals about how a collective human lifeworld (*Lebenswelt*) is constituted and sustained. In this view, the domains of art and religion are co-emergent and co-operative systems through which social groups organize how people imagine and relate to each other and to their surroundings.

Drawing from a range of influences, from Émile Durkheim and Mircea Eliade to Walter Benjamin and Aby Warburg, several prominent scholars (Promey, Morgan, Plate, Apostolos-Cappadona, Heartney) are tracing the profound influences of religious culture in the social contexts in which artworks are produced and interpreted. T.J. Clark famously argued that social histories of art analyze "the complex relation of the artist to the total historical situation, and in particular to the traditions of representation available to him [*sic*]" (*Image* 12). Why then, these scholars are asking, have we generally excluded religious traditions from our accounts of the "total historical situation" of modern and contemporary art? Correcting this blind spot requires deeper inquiries into how "the religio-cultural constructions of perception" operate even in the seemingly secular domains of modern and contemporary art (Plate 3). Such scholarship can move in both directions, allowing the study of visual and material culture to elucidate how religions "work" while also allowing the study of religion to elucidate how visual and material cultures (including artworks) "work." In North Atlantic contexts, this includes wide-ranging explorations of the ways contemporary art is shaped by and tacitly relies on Christianity, but a growing literature is similarly focused on other traditions, including Buddhism (Baas and Jacob, Brauen and

Jacob), Islam (Bruckstein Çoruh and Budde, Kamaroff), and Judaism (Baigell, Baskind and Silver, Olin, Washton Long et al., Soltes).

The writing surrounding the large 2015 exhibition *The Problem of God* in Düsseldorf provides a concrete example. According to Isabelle Malz, the exhibition's curator, the aim was to explore "how forms and symbols, derived from a Christian visual language and now part of our collective memory of images and texts, are found in the works of contemporary artists, albeit with a new complexity and ambiguity" (311). Taking Warburg's *Mnemosyne Atlas* as her model, Malz conceived this exhibition as "an open-ended, flexible archive" of the "afterlife" (*Nachleben*) of a Christian imagination, which still circulates through Western visual culture generally and contemporary art specifically, despite the common presumption of an otherwise comprehensive secularization (312). Her aim was to understand "the legacy of Christian imagery and cultural practices, which – detached from its religious context – has flowed into secular life, [and] proves to be as enduring, complex, and paradoxical a reference system in art as it ever was" (322). Featuring the work of thirty-three prominent contemporary artists, the exhibition thus highlighted Christian motifs and concepts that have "continued to develop independently of [their] original frame of reference" into new social contexts (311).

The tangle of questions driving this exploration of "the problem of God" includes profoundly spiritual and theological questions, which obliquely present themselves throughout the exhibition. The exhibition catalog, however, addresses this *Problem* almost entirely in its anthropological or sociological dimensions. Whereas Malz traces vestiges of a Christian "reference system," Morgan's essay seeks "a compelling description of the sociology of art and religion as visual enterprises focused on the management of aura [in Walter Benjamin's sense of the term]" (335). He sees aura as intimately linked to *the sacred*, but only "defined anthropologically" as whatever gets "set off from the world around it as special" (334). This setting apart is, in his view, a thoroughly social process "distributed across a network of interacting agencies," such that "producing the sacred is an ongoing cultural work that consists of interweaving different kinds of artifacts into webs of relations that stabilize their sacrality" (335). He distinguishes between how aura (or sacrality) functions in art contexts versus religious contexts, but he regards both art and religion as forms of "visual technology" that are "devoted to the production and maintenance of sacred objects" (337).

The sacred is thus visible in the writing of *The Problem of God* primarily in terms of how it is socially produced, stabilized, and transmuted. The writing ventures somewhat into political implications and vaguely into the spiritual. But mainly, the problem is posed and addressed anthropologically, leaving the theological questions integral to *The Problem of God* in contemporary art open but unexplored. Several other exhibitions take a similar approach, including *NeoHooDoo: Art for a Forgotten Faith* (2008) (Sirmans); *The Third Mind: American Artists Contemplate Asia, 1860–1989* (2009) (Munroe); and *Icons: Worship and Adoration* (2019) (Grunenberg and Fischer-Hausdorf).

There are clear limits to the scope of these investigations, often delineated by the scholars themselves. As curator Harry Philbrick notes, "When religion is broached, it is within some other critical context: heaven as a sociological construct; Mary as a gender symbol; Jewishness as a cultural condition" (15). In this way, religious practices and commitments are taken seriously as sociocultural forces shaping contemporary artworks, but not as practices or commitments one would inhabit as a scholar of those artworks. Interpretation thus proceeds "with the detachment of the observer rather than the attachment of the adherent" (Graham 53).

In many ways, these limits are productive. Religions certainly *are* complex sociohistorical systems, always embedded in the same "piled-up structures of inference and implication" within which artworks are produced, perceived, and interpreted (Geertz 7; cf. 87–125). And bringing religion into the study of contemporary art within an anthropological horizon enables "thick" descriptions of art and religion as interconnected practices shaping and shaped by larger sociocultural worlds. However, this also produces other kinds of interpretive thinness that restrict recognition of other dimensions of religion's implications for the study of art.

## Art and Religion within a *Political* Horizon

A number of prominent art historians, critics, and philosophers utilize similar anthropological categories but understand them principally within a *political* hermeneutical horizon. Here, the most salient questions of art and religion concern the organization and operation of power in a society. Drawing from the work of Theodor Adorno, Michel Foucault, Julia Kristeva, and Jacques Rancière, scholars working in this horizon argue that the most potent forms of power are not clearly visible but are those that determine "the distribution of the sensible" in the first place, organizing the conditions of visibility and spatiality in a society (Rancière 18–19). In this respect, all the splashy controversies between contemporary art and religion are mostly superficial, obscuring their deeper interdependency in the subtle organization of imagination, value, and behavior.

For many of these scholars, the "return" of religion in contemporary art has nothing to do with faith or belief but only with a need for new critical resources within larger political struggles. In the "Best of 2007" issue of *Artforum*, Benjamin Buchloh focused on a single work that puzzled him: Gerhard Richter's huge stained-glass window for Cologne Cathedral installed in August of that year. What could it mean for an artist like Richter to produce permanent "church decorations" for an overtly liturgical space (306)? Buchloh sees the situation in tactical terms:

> Under present circumstances it could only be expected that serious professional artists, progressive or conservative, would become increasingly desperate to find alternative institutional and discursive spaces to shelter

their work from the violent impact of three forces that have dramatically altered every facet and fraction of artistic practice in the past ten years: [1] digital electronic technology, [2] the globalization of capital, and [3] the monolithic power of an industrialized art market that aspires to a fast and final merger with the fashion and music industries.

*(306)*

Thus what seems to be an artistic turn toward religion – or "institutional and discursive spaces" associated with religion – might instead be a shrewd means of finding "shelter" from capitalism's technologized capacity to subsume anything. Buchloh regards this tactic as intensely problematic, but it's at least intelligible in "desperate" circumstances.

Other scholars see deeper entanglements here. T.J. Clark and Sven Lütticken, for example, see the persistence of religious themes and concepts in modern and contemporary art – eschatologies, iconomachy, and so on – as loci for political questions of suffering, tragedy, spectacle, and hope. For others, religion provides focal points for postcolonial analysis and critique, as exemplified in the widely traveled exhibitions *Animism* (2010) (Franke) and *The Divine Comedy: Heaven, Purgatory and Hell Revisited by Contemporary African Artists* (2014) (Njami). In a related way, some argue that art and religion must be understood (and critiqued) together as mediums of ideological formation, as in the exhibitions *God & Goods: Spirituality and Mass Confusion* (2008) (Bonami and Cosulich Canarutto) and · *Medium Religion: Faith, Geopolitics, Art* (2008) (Weibel and Groys).

In their 2012 book *Art Is Not What You Think It Is*, Donald Preziosi and Claire Farago further develop this idea that art and religion are mutually constituting mediums that organize "our relationship to things" (2; cf. 133). The two are "each other's shadow" in the sense that art(ifice) requires an implicitly religious metaphysics to underwrite signification and religion needs art(ifice) to mediate sacred realities (137–138, 161). Thus, they contend that modern, secular under-standings of art, artistic agency, and aesthetic response are "ultimately grounded in the ontological framework of Christianity, the unthought ground of the mod-ern idea of art as 'free' and 'secular'" (122). The bargain of secularization, they argue, was to actively unthink this grounding in order to fashion "Art" and "Religion" into seemingly autonomous cultural domains in public life, enabling modern Art to deny its reliance on religious ontology and modern Religion to deny its reliance on artistry (xiii). This argument is anthropological in rede-scribing the cultural underpinnings of modernism, but its governing horizon is deeply political, aimed at a coordinated critique of the ideological power in the cooperation of art and religion. Preziosi presses this further in *Art, Religion, Amnesia* (2014), where he argues for the need to recognize the entire "modernist parallax that is artistry-and-religiosity" as an enchanting representational logic that governs "the ethics of the practice of the self; of how self–other relations are to be coordinated and controlled or disciplined [...] in the service of the modern nation-state" (79, 81).

The renewed visibility of art and religion within a political horizon is productive and insightful. Both contemporary art and religion *are* deeply involved in the social powers that structure self–other relations, and their interrelations provide opportunities for perceiving and critiquing the ways these powers shape visuality and value. Once again, however, this interpretive horizon produces other kinds of distortion. For many scholars mentioned here, the political horizon is fundamental to all other orders of meaning, such that all questions of meaning in art and religion – and anything else involving language, images, or bodies – are ultimately reducible to questions of power as the basic organizing principle of human relations. This (almost reflexive) reduction can yield highly insightful critique, but it also often relies on caricatures or superficial understandings of theological traditions, producing accounts of "religion" that tend to be rather religiously "unmusical."[4]

## Art and Religion within a *Spiritual* Horizon

When studied within the hermeneutical space of a *spiritual* horizon, the most salient features of art and religion (and the relations between them) are their potential to foster social, ecological, and spiritual awakening, connectedness, or reenchantment amidst the disconnective and disenchanting conditions of secular modernity. Political concerns are often incorporated here, but they are seen as grounded in deeper spiritual crises that cannot be addressed through political struggle or critique without more comprehensive spiritual enlightenment and transformation. Within this horizon, the primary virtue of (and hope for) contemporary art resides in its capacity to catalyze these kinds of transformation, taking over roles in secular society that religions traditionally played but without traditional orthodoxies, institutions, or norms.

Drawing from earlier work by Sixten Ringbom, Roger Lipsey, Suzi Gablik, and others, several scholars are working to recover "a mythic, transpersonal ground of meaning" (Gablik 30) both in how art is made and experienced and in how it is written and spoken about (and considered worth writing and speaking about). A wide range of approaches is possible within this horizon (e.g., Yoon, Arya, Paglia, Witzgall), but common to most of them is a belief that "a central thread woven into the fabric of modern art is the reformulation of theological questions in secular terms" (Gamwell 10). "The spiritual" is usually the key term here, providing a general terminology and praxis for achieving this reformulation in a way that is simultaneously more universal (recovering a "transpersonal ground of meaning") and more individual (detached from "organized" religious and theological traditions).

In her survey of *The Spiritual Dynamic in Modern Art* (2014), Charlene Spretnak identifies the spiritual with "a sense of our embeddedness in the larger context: the exquisitely dynamic interrelatedness of existence" (14). She presents a whistle-stop tour of two centuries of modern art vis-à-vis this kind of spirituality. Leesa Fanning's *Encountering the Spiritual in Contemporary Art* (2018) continues

this line of thinking, surveying artistic embodiments of spiritualities that explicitly are "not about organized religion, institutionalized beliefs, doctrines, or creeds" but are instead pursuing "the idea of transcending the 'I' or ego" (33). For her, "the spiritual" has "a positive, unifying function that serves to bridge differences and bring people together in beneficial ways," which she juxtaposes to the "exclusivity" and "divisive fundamental doctrines" of traditional religions (33). Of course, prioritizing of inclusivity and "works that seek to exert a positive force in the world" inevitably requires its own forms of exclusivity, as she concedes (43).

"Positive" and "unifying" are, however, not the only terms correlated to the spiritual. In 2017, the exhibition *As Above, So Below: Portals, Visions, Spirits, and Mystics* opened at the Irish Museum of Modern Art in Dublin, featuring forty artists working between 1909 and 2017. According to curators Rachel Thomas and Sam Thorne, the exhibition originated as "an open-ended meditation on the reinvention of spirituality" (13), bolstered by an intuition that the "recent recuperation of the spiritual is surely a symptom of a more deeply rooted frustration with the modernist myths of ineluctable progress" (16). They organized the exhibition into four thematic groupings: *Portals*, which "concerns entrances into other worlds or systems of thought"; *Below* "takes us into the shadows, into netherworlds and fiery depths" and "the domain of, among other things, the occult"; *Above* was "concerned with healing, animism and transcendence"; and *Beyond* focused on "endings, death and alternative options" (17). Here, the spiritual had rather less to do with positivity and unity than with radical disjunction, defying modernist progress with willfully eclectic, esoteric, and "regressive" practices in an exhibition that was "rangy and associative, gathering together astral journeys and surrealism, tarot cards and shamanism, hallucinogens and demons" (15). A number of other major exhibitions operate similarly, including *Traces du sacré* (2008) (Alizart); *Not Without My Ghosts: The Artist As Medium* (2020) (Grant and Larsen); and *Supernatural America: The Paranormal in American Art* (Cozzolino) (2021).

In general, this scholarship helpfully critiques reductive theories of secularization, materialism, and disenchantment, while often emphasizing life-affirming wonder, gratitude, empathy, care, and social and ecological justice. On the other hand, its methods are often riddled with anachronism and equivocation. While eschewing "organized" religion, discussions of the spiritual in art range across assorted forms of (both Western and Eastern) mysticism, archaic mythologies, shamanism, occultism, animism, necromancy, and/or magic with superficial commitments to the historical coherency or philosophical integrity of these various traditions. The general umbrella of "the spiritual" allows these to be sampled, adapted, and remixed in ways that are intentionally unmoored from and unaccountable to any particular religious community or tradition of theological reasoning, even as it appropriates their languages and histories. The discursive openness of this horizon allows valuable space for rethinking the histories of modern and contemporary art, but as an approach to art history and criticism,

it has tended to lack historical rigor and sustained critical analysis of particular artworks. Scholars in the social sciences (e.g., Josephson Storm) are developing cultural histories and critical models that will enrich this kind of study as they make their way into the scholarship of modern and contemporary art. Yet "the spiritual" in art likely will remain conceptually underdeveloped until it more rigorously examines the theological genealogies and implications of its own traditions.

## Art and Religion within a *Theological* Horizon

Elkins ends his 2004 book by saying that "in a manner that is difficult to determine, the name *God* is still a part of the language of art even though the name has been set aside" (116). A growing number of scholars are pressing further into this observation, exploring the ways that questions of God, and histories of talking about God in relation (or nonrelation) to world, are indeed part of the histories of modern and contemporary art, even if rarely named as such. These scholars generally affirm the anthropological, political, and spiritual dimensions of these histories, but they argue that the interrelations between art and religion are not adequately accounted for without attending to the implicit theologics in play throughout those histories—in ways that are of course not reducible to artists' conscious beliefs or intentions. These inquiries do not necessarily have any creedal or doctrinal alignments, but they are attentive to how artworks are engaging theological ontologies, anthropologies, ethics, eschatologies, and so on.

From one disciplinary direction, many theologians and philosophers have been writing about modern and contemporary art from a wide variety of positions. Some see in contemporary art a radically apophatic mode of theology after "the death of God," with varying emphases on "God after God," "enchanting secularity," or new materialism (Kearney, M.C. Taylor, Kosky, Carlsson Redell). Other theologians see modern and contemporary art in highly constructive dialogue with extended theological traditions, especially Christian and Jewish, in ways that demonstrate greater continuity and reciprocity (Quash, Rosen, Raphael, Worley, Pattison, Thiessen).

From another direction, several scholars argue that more rigorous engagements with theological inquiry can aid us in perceiving and addressing significant aspects of the history of modern and contemporary art. For several art historians (Lewer, Herbert, Pinder, Rauchenberger, Romaine and Wolfskill, Masheck), the necessity for such engagements can arise within the social history of art, insofar as the social worlds in which artworks are made and received require attention to the enduring relevance of theological histories, reasonings, and conceptualities in the structuring of those worlds.

In his 2017 book *No Idols: The Missing Theology of Art*, Thomas Crow argues that a general refusal of theology in academic art history has created "a blind spot" that obscures key aspects of modernist history and deprives the discipline of vital hermeneutical tools (5). He identifies several instances in which sociohistorical

investigation requires "a parallel theological reflection of our own, a pursuit distinct from parsing parochial issues of period religious observance" (12). His interest is not in religious art but in how "the strength of religious outlooks and convictions should be assessed by the pressure they exert on ostensibly secular subjects" (6–7), which "need not follow pious channels of obvious devotion" nor involve religious iconographies (87, 35). The main theological "pressure" Crow sees cutting across modernism's "ostensibly secular subjects" is that issuing from "the concept of idolatry and its critique" (7), which he traces through a handful of artists working in the 1940s–1970s. His inquiry remains noncreedal even as it is deeply theological, aimed at clarifying the dialectics of idolatry and idoloclasm in the history of modernism. This draws historical theology into dialogue with the history of art but without being merely historical, insofar as the questions involved here inevitably "touch what is fundamental in life" (143).

For other scholars, the theological rethinking of modern and contemporary art arises from not only historical but also critical pressures, pertaining to what particular artworks *do* in particular contexts. Here, theology is less an object of study or a facet of social history than an orienting series of concerns, histories, and grammars within one's critical method. From a variety of perspectives (Pickstone, Bernier, Schachter), several critics are writing with sensitivities to the theological implications of how particular artworks function. For Dan Siedell, criticism unfolds in the difficulty of generating "words and sentences, not to explain [...] but to expand the experiential space that allows the painting to address the viewer" (xvii). He argues that the phenomenological "space" in which this reciprocal address occurs is "profoundly theological" insofar as it exposes one's inherent "ontological passivity, what [Martin] Luther called the *vita passiva*, in which I stand [...] in the 'dative case,' that is, in the case of 'being given'" (xviii, 33). For Siedell, the work of art history and criticism is thus always open to, and provoking, theological lines of questioning, because artworks only function in the ontologically and ethically charged distance of an *address* – "that theological reality in which you and I stand before the face of another, whether it is our neighbor, ourselves, or God" (11). In this sense, art criticism opens into theology not in order to tidy things up or to doctrinally regulate experience. On the contrary, theology "often makes the world more impenetrable, mysterious, and frustrating to me, creating discontinuities and sharp edges that confuse and anger me" (10).

Several recent exhibitions approach religion in contemporary art in ways that involve a theological horizon, including *Soul: Bezielde kunst* (2005) (Van den Bussche and Torfs); *Gott sehen: Das Überirdische als Thema der zeitgenössischen Kunst* (2005) (Messmer); *Fragments of a Crucifixion* (2019) (Praepipatmongkol); and *Here After* (2022) (Lewis et al.). The catalogs for each of these exhibitions feature essays that include (without reducing everything down to) a theological horizon. And perhaps more to the point, many of the exhibitions already mentioned in the preceding pages can sustain significant theological investigation, even if this

aspect is downplayed or avoided in the curatorial framing. *The Problem of God*, for example, is unavoidably a theological problem, as are the questions central to exhibitions such as *Medium Religion, God & Goods,* and *Traces du Sacré.*

This scholarship is opening significant avenues for further exploration, but it tends to be methodologically underdeveloped, either from the art-historical side or from the theological side (or both). This creates a propensity toward accounts that are either interpretively overdetermined (producing interpretations that feel foisted upon artworks) or overly generic (withdrawing from the works themselves into rehearsals of general theological or art-historical formulae). Of the four horizons surveyed here, the theological one is currently least developed *as art history*, but given the scope of the histories and questions involved, it also holds massive potential.

## Conclusion

Religion has become increasingly visible in contemporary art in recent years, but what this means is hardly uniform or univocal. I have identified at least four hermeneutical horizons within which this visibility is currently understood and discussed. Each of these categories can be framed in discrete kinds of questions – anthropological questions, political questions, and so on – but they are more fundamental and encompassing than that. Each designates a distinct hermeneutical *horizon* within which aspects of the world – in this case, the interrelations between art and religion – show up as intelligible and in some way important for human life. These "horizons" are not simply research questions or disciplinary frameworks; they have more to do with which questions are worth asking in the first place, with what appears most salient and vital for seeing and understanding the world.

There is a "family resemblance" between the first two horizons and between the second two – a similar structure of value and attention shared between the anthropological and political, on the one hand, and between the spiritual and theological, on the other. Yet as one delves into the literature, deep divergences emerge between these, demanding (at least) a fourfold distinction. And of course an extraordinary array of further divergences and variations emerge within each of these four. There are innumerable ways, for example, to productively think about the relations between art and religion within a political horizon or within a theological horizon, generating irreconcilable disagreements and polarities within each. Yet, there is some fundamental orienting set of questions within each of these general horizons – namely, the questions of *polis* (power as a structuring context of self–other relations) or the questions of *theos* (God as a structuring context of self–other relations).

These four horizons are not mutually exclusive. Insofar as the complexities of human life are simultaneously social, political, spiritual, and theological, so too are artworks potentially meaningful in all these ways. Each of these horizons is

exceedingly complex and highly demanding, but, in theory, careful scholarship can keep multiple horizons in view, or switch between them, allowing insights from each to challenge, adjust, and/or strengthen insights from the others. In Gadamer's terms, a "fusion of horizons" is always possible to some degree, not only between an interpreter and a hermeneutical tradition but also between different interpreters and between different hermeneutical traditions (305–306, 370–371). In practice, however, scholars usually (perhaps must) prioritize one of these as more pertinent, more encompassing, and more fundamental to the structure of human life. And thus, these horizons vie with each other, sometimes to the extent that scholars working in one horizon caricature, misunderstand, or simply ignore those working in another.

The aim of sketching these interpretive horizons here is to provide some heuristic means for making sense of the various ways the academic art world has been writing and talking about (and at) the nexuses of contemporary art and religion. All four horizons warrant further investigation and development, as do the interactions between them. Of the four, the last two – the spiritual and, especially, the theological horizon – are currently least developed in the scholarship of modern and contemporary art, but they are also the horizons most vitally in question in Elkins' 2004 book. Ultimately, what has been most "impossible to talk sensibly" about in contemporary art is not really "religion" in its various anthropological or political dimensions – these require further study, but scholars have long had the tools for, even if aversion to, analyzing them in detail. Rather, the problematics of (non)sensible talk about religion in contemporary art are, for Elkins, concentrated around the uninterpretability of "religious meaning" (12, 21–27, 29, 47, 74, 88–90, 105, 115–116), which presumably pertains to the spiritual or theological valences of an artwork. As historically extended modes of understanding, numerous theologics have been vitally in play and at stake throughout the history of modern and contemporary art, but art historians are still working out how to write about (or within) these effectively and profoundly – and do so in relation to the other horizons in view here. There are still formidable (yet crumbling) paradigms in place that preclude the ways "religious meaning" might be relevant to the study of modern and contemporary art. But with continued development and experimentation in and between these four horizons, the strange place(s) of religion in contemporary art will become more visible and more intelligible.

## Notes

1 An early version of this chapter, originally titled "Postsecularity and the Return of Religion in Contemporary Art Criticism," was first presented in 2017 as the keynote lecture for the Association of Scholars of Christianity in the History of Art symposium, *A Strange Place Still? Religion in Contemporary Art*, Union League Club, New York.

2 For further development of this paragraph, see Anderson, "(In)visibility" 53–63; Anderson and Dyrness 17–47; Anderson, "Modern Art"; Elkins and Anderson.

3 The remainder of this chapter borrows its basic structure and some of its wording from the last section of Anderson, "Modern Art."
4 In a personal letter, Max Weber wrote: "It is true that I am absolutely unmusical religiously [...] But a thorough self-examination has told me that I am neither anti-religious *nor irreligious*" (Weber 324; emphasis original). For a rereading of Weber on this point, see Josephson Storm 269–301.

## Bibliography

Alizart, Mark, editor. *Traces du sacré.* Exhibition catalog. Centre Pompidou, 2008.

Anderson, Jonathan A. "The (In)visibility of Theology in Contemporary Art Criticism." *Christian Scholarship in the Twenty-First Century: Prospects and Perils*, edited by Thomas M. Crisp, Steve L. Porter, and Gregg Ten Elshof. Eerdmans, 2014, pp. 53–79.

——. "Modern Art." *The Oxford Research Encyclopedia of Religion*. Oxford University Press, 2021, https://www.doi.org/10.1093/acrefore/9780199340378.013.800.

Anderson, Jonathan A., and William A. Dyrness. *Modern Art and the Life of a Culture: The Religious Impulses of Modernism.* InterVarsity Press, 2016.

Arya, Rina, editor. *Contemplations of the Spiritual in Art.* Peter Lang, 2013.

Baas, Jacquelynn, and Mary Jane Jacob, editors. *Buddha Mind in Contemporary Art.* University of California Press, 2004.

Baigell, Matthew. *Jewish Art in America: An Introduction.* Rowman & Littlefield, 2007.

——. *Jewish Identity in American Art: A Golden Age since the 1970s.* Syracuse University Press, 2020.

Baskind, Samantha. *Jewish Artists and the Bible in Twentieth-Century America.* Penn State University Press, 2014.

Baskind, Samantha, and Larry Silver. *Jewish Art: A Modern History.* Reaktion Books, 2011.

Bauman, Zygmunt. *Liquid Modernity.* Polity Press, 2000.

Bax, Marty, editor. *Holy Inspiration: Religion and Spirituality in Modern Art.* Exhibition catalog. Museumshop De Nieuwe Kerk, 2008.

Bernier, Ronald R. *The Unspeakable Art of Bill Viola: A Visual Theology.* Pickwick, 2014.

Blond, Phillip, editor. *Post-Secular Philosophy: Between Philosophy and Theology.* Routledge, 1998.

Bonami, Francesco, and Sarah Cosulich Canarutto, editors. *God & Goods: Spirituality and Mass Confusion.* Exhibition catalog. Azienda Speciale Villa Manin, 2008.

Brauen, Martin, and Mary Jane Jacob, editors. *Grain of Emptiness: Buddhism-Inspired Contemporary Art.* Exhibition catalog. Rubin Museum of Art, 2010.

Bruckstein Çoruh, Almút Sh., and Hendrik Budde, editors. *Taswir: Pictorial Mappings of Islam and Modernity.* Exhibition catalog. Nicolai Verlag, 2009.

Buchloh, Benjamin H.D. "Gerhard Richter, Cologne Cathedral." *Artforum*, vol. 46, no. 4, 2007, pp. 306–309, 376.

Carlsson Redell, Petra. *Avantgarde Art and Radical Material Theology: A Manifesto.* Routledge, 2021.

Clark, T.J. *Image of the People: Gustave Courbet and the 1848 Revolution* (1973). Revised edition. Thames & Hudson, 1982.

——. *Heaven on Earth: Painting and the Life to Come.* Thames & Hudson, 2018.

Cozzolino, Robert, editor. *Supernatural America: The Paranormal in American Art.* Exhibition catalog. Minneapolis Institute of Art; University of Chicago Press, 2021.

Crow, Thomas. *No Idols: The Missing Theology of Art.* Power Publications, 2017.

de Vries, Hent. *Philosophy and the Turn to Religion*. Johns Hopkins University Press, 1999.

Elkins, James. *On the Strange Place of Religion in Contemporary Art*. Routledge, 2004.

Elkins, James, and Jonathan A. Anderson. "The Strange Persistence of Religion in Contemporary Art." *Image*, no. 110, 2021, pp. 48–62.

Fanning, Leesa K., editor. *Encountering the Spiritual in Contemporary Art*. Nelson-Atkins Museum of Art, 2018.

Franke, Anselm, editor. *Animism: Volume I*. Exhibition catalog. Sternberg Press, 2010.

Gablik, Suzi. *The Reenchantment of Art*. Thames & Hudson, 1991.

Gadamer, Hans-Georg. *Truth and Method* (1960). Translated by Joel Weinsheimer and Donald G. Marshall. 2nd revised edition. Continuum, 2004.

Gamwell, Lynn. *Exploring the Invisible: Art, Science, and the Spiritual*. Princeton University Press, 2002.

Geertz, Clifford. *The Interpretation of Cultures: Selected Essays*. Basic Books, 1973.

Graham, Gordon. *The Re-Enchantment of the World: Art versus Religion*. Oxford University Press, 2007.

Grant, Simon, and Lars Bang Larsen, editors. *Not Without My Ghosts: The Artist as Medium*. Exhibition catalog. Hayward Gallery, 2020.

Groys, Boris, and Peter Weibel, editors. *Medium Religion: Faith, Geopolitics, Art*. Exhibition catalog. Walther König, 2011.

Grunenberg, Christoph, and Eva Fischer-Hausdorf, editors. *Icons: Worship and Adoration*. Exhibition catalog. Kunsthalle Bremen; Hirmer Verlag, 2019.

Heartney, Eleanor. *Postmodern Heretics: The Catholic Imagination in Contemporary Art*. Midmarch Arts Press, 2004.

Herbert, James D. *Our Distance from God: Studies of the Divine and the Mundane in Western Art and Music*. University of California Press, 2008.

Janicaud, Dominique, Jean-François Courtine, Jean-Louis Chrétien, Michel Henry, Jean-Luc Marion, and Paul Ricoeur, *Phenomenology and the "Theological Turn": The French Debate*. Fordham University Press, 2000.

Josephson Storm, Jason Ā. *The Myth of Disenchantment: Magic, Modernity, and the Birth of the Human Sciences*. University of Chicago Press, 2017.

Kamaroff, Linda, editor. *Islamic Art Now: Contemporary Art of the Middle East*. Exhibition catalog. Los Angeles County Museum of Art, 2015.

Kearney, Richard. "God After God: An Anatheist Attempt to Reimagine God." *Reimagining the Sacred: Richard Kearney Debates God*, edited by Richard Kearney and Jens Zimmerman. Columbia University Press, 2016.

Kearney, Richard, and Matthew Clemente, editors. *The Art of Anatheism*. Rowman & Littlefield, 2018.

Kosky, Jeffrey L. *Arts of Wonder: Enchanting Secularity – Walter De Maria, Diller + Scofidio, James Turrell, Andy Goldsworthy*. University of Chicago Press, 2013.

Lewer, Deborah. "'The Uncorrupt Image': Hugo Ball, Zurich Dada and the Aesthetics, Politics, and Metaphysics of Asceticism." *Virgin Microbe: Essays on Dada*, edited by David Hopkins and Michael White. Northwestern University Press, 2014, pp. 91–116.

Lewis, Cara Megan, Linnéa Spransy Neuss, Vicki Phung Smith, and Meaghan Ritchey, editors. *Here After*. Exhibition catalog. Bridge Projects, 2022.

Lütticken, Sven. *Idols of the Market: Modern Iconoclasm and the Fundamentalist Spectacle*. Sternberg Press, 2009.

Malz, Isabelle, editor. *The Problem of God*. Exhibition catalog. Kunstsammlung Nordrhein-Westfalen, 2015.

Masheck, Joseph. *Texts On (Texts On) Art*. Rail Editions, 2011.

———. *Classic Mondrian in Neo-Calvinist View*. National Galleries of Scotland, 2018.

Messmer, Dorothee, and Markus Landert, editors. *Gott sehen: Das Überirdische als Thema der zeitgenössischen Kunst* [*Seeing God: The Supernal in Contemporary Art*]. Exhibition catalog. Niggli, 2005.

Morgan, David. *The Sacred Gaze: Religious Visual Culture in Theory and Practice*. University of California Press, 2005.

———. "Art and the Devotional Image: Visual Cultures of the Sacred." *The Problem of God*, edited by Isabelle Malz. Exhibition catalog. Kunstsammlung Nordrhein-Westfalen, 2015, pp. 331–337.

Munroe, Alexandra, editor. *The Third Mind: American Artists Contemplate Asia, 1860–1989*. Exhibition catalog. Guggenheim, 2009.

Njami, Simon, editor. *The Divine Comedy: Heaven, Purgatory and Hell Revisited by Contemporary African Artists*. Exhibition catalog. Kerber, 2014.

Olin, Margaret. *The Nation without Art: Examining Modern Discourses on Jewish Art*. University of Nebraska Press, 2007.

———. "The Eruv: From the Talmud to Contemporary Art." *Jewish Religious Architecture: From Biblical Israel to Modern Judaism*, edited by Steven Fine. Brill, 2020, pp. 369–378.

Paglia, Camille. "Religion and the Arts in America." *Arion*, vol. 15, no. 1, Spring/Summer 2007, pp. 1–20.

Pattison, George. *Art, Modernity and Faith: Restoring the Image* (1991). 2nd edition. SCM Press, 1998.

———. *Crucifixions and Resurrections of the Image: Christian Reflections on Art and Modernity*. SCM Press, 2009.

Philbrick, Harry. "Creating Faith." *Faith: The Impact of Judeo-Christian Religion on Art at the Millennium*, edited by Christian Eckart, Harry Philbrick, and Osvaldo Romberg. Exhibition catalog. Aldrich Museum of Contemporary Art, 2000, pp. 14–20.

Pickstone, Charles. "A Theology of Abstraction: Wassily Kandinsky's *Concerning the Spiritual in Art*." *Theology*, vol. 114, no. 1, January 2011, 32–41.

———. "Joan Miró: The *Constellations* Series." *Critical Quarterly*, vol. 55, no. 3, October 2013, pp. 59–71.

Pinder, Kymberly N. *Painting the Gospel: Black Public Art and Religion in Chicago*. University of Illinois Press, 2016.

Plate, S. Brent, editor. *Walter Benjamin, Religion, and Aesthetics: Rethinking Religion through the Arts*. Routledge, 2005.

Praepipatmongkol, Chanon Kenji, editor. *Fragments of a Crucifixion*. Exhibition catalog. Museum of Contemporary Art Chicago, 2019, http://www.mcachicago.org/Publications/Websites/Fragments-Of-A-Crucifixion.

Preziosi, Donald. *Art, Religion, Amnesia: The Enchantments of Credulity*. Routledge, 2014.

Preziosi, Donald, and Claire Farago. *Art Is Not What You Think It Is*. Wiley-Blackwell, 2012.

Promey, Sally M. "The 'Return' of Religion in the Scholarship of American Art." *The Art Bulletin*, vol. 85, no. 3, September 2003, pp. 581–603.

Quash, Ben. *Found Theology: History, Imagination and the Holy Spirit*. Bloomsbury, 2013.

———. "Religion, Ritual and Myth." *A Cultural History of Tragedy in the Modern Age*, vol. 6, *1920 to the Present*, edited by Jennifer Wallace. Bloomsbury, 2019, pp. 93–108.

Quash, Ben, Aaron Rosen, and Chloë Reddaway, editors. *Visualising a Sacred City: London, Art and Religion*. I.B. Tauris, 2017.

Rancière, Jacques. *The Politics of Aesthetics: The Distribution of the Sensible* (2000). Translated by Gabriel Rockhill. Continuum, 2004.

Raphael, Melissa. *Judaism and the Visual Image: A Jewish Theology of Art*. Continuum, 2009.

Rauchenberger, Johannes. *Gott hat kein Museum, No Museum Has God: Religion in Art in the Early 21st Century*, 3 vols. Ferdinand Schöningh, 2015.

Romaine, James, and Phoebe Wolfskill, editors. *Beholding Christ and Christianity in African American Art*. Penn State University Press, 2018.

Rosen, Aaron. *Imagining Jewish Art: Encounters with the Masters in Chagall, Guston, and Kitaj*. Legenda, 2009.

———. *Art & Religion in the 21st Century*. Thames & Hudson, 2015.

Schachter, Ben. *Image, Action, and Idea in Contemporary Jewish Art*. Penn State University Press, 2017.

Siedell, Daniel A. *Who's Afraid of Modern Art?: Essays on Modern Art and Theology in Conversation*. Cascade, 2015.

Sirmans, Franklin, editor. *NeoHooDoo: Art for a Forgotten Faith*. Exhibition catalog. The Menil Collection, 2008.

Soltes, Ori Z. "Modern Jewish Art: Definitions, Problems, and Opportunities." *Brill Research Perspectives in Religion and the Arts*, vol. 2, no. 2, 2018, pp. 1–107.

Spretnak, Charlene. *The Spiritual Dynamic in Modern Art: Art History Reconsidered, 1800 to the Present*. Palgrave Macmillan, 2014.

Taylor, Charles. *A Secular Age*. Belknap/Harvard University Press, 2007.

Taylor, Mark C. *Disfiguring: Art, Architecture, Religion*. University of Chicago Press, 1992.

———. *Seeing Silence*. University of Chicago Press, 2020.

Thiessen, Gesa Elsbeth. *Theology and Modern Irish Art*. Columba Press, 1999.

Thomas, Rachael, and Sam Thorne, editors. *As Above, So Below: Portals, Visions, Spirits, and Mystics*. Exhibition catalog. Irish Museum of Modern Art, 2017.

Van den Bussche, Willy, and Rik Torfs, editors. *Soul: Inspired Art*. Exhibition catalog. Stichting Kunstboek, 2005.

Ward, Graham, and Michael Hoelzl, editors. *The New Visibility of Religion: Studies in Religion and Cultural Hermeneutics*. Continuum, 2008.

Washton Long, Rose-Carol, Matthew Baigell, and Milly Heyd, editors. *Jewish Dimensions in Modern Visual Culture: Antisemitism, Assimilation, Affirmation*. Brandeis University Press, 2010.

Weber, Marianne. *Max Weber: A Biography* (1926). Translated and edited by Harry Zohn. Transaction, 1988.

Witzgall, Susanne, editor. *Real Magic*. Diaphanes, 2018.

Worley, Taylor. *Memento Mori in Contemporary Art: Theologies of Lament and Hope*. Routledge, 2020.

Yoon, Jungu. *Spirituality in Contemporary Art: The Idea of the Numinous*. Zidane, 2010.

# 2

# EXPLORING THEOLOGICAL DIMENSIONS OF THE WORK OF ART

*Linda Stratford*

In the year 2000, no less prolific an art historian than Debora Silverman claimed that religious concerns could now be treated "with the nuance and historical complexity" with which academics treated other topics such as class and gender (13). Scholars in the professions of art history and criticism continue to bring evidence of that assertion. Built on methodological strengths gained over the course of the 20th century, scholarship particularly to Christianity and the visual arts has continued to build methodological muscle gained from precedents. Furthering the "nuance and historical complexity" cited by Silverman through the present century will require that the range of available frameworks be (1) sufficiently recognized; (2) critically assessed; and (3) wedded to contemporary training made available to emerging critics and art historians. To that end, this chapter examines opportunities employed by scholars seeking to explore the intersection of Christianity and art, recognizing avenues that have enabled fruitful investigation of the ways in which works of art address themes and content particular to Christianity with the promise of progressive approaches yet to come (Stratford, "Methodological Issues" 27).

In the field of art history over the course of the prior century, competing ideological notions of aesthetic autonomy versus aesthetic contingency gave rise, respectively, to disciplinary oscillation between object-oriented and contextual methodologies. As is stated in Donald Preziosi's *The Art of Art History*, these approaches in turn engendered various art historical "schools" [e.g. the historical or contextual schools (Ernst Gombrich, Meyer Schapiro) versus ahistorical and formalist schools (Heinrich Wölfflin, Henri Focillon, Erwin Panofsky)]. As methodology admitted iconographical analysis, for example, based on the pioneering work of Panofsky, approaches to understanding the ways in which works of art addressed themes and content particular to Christianity allowed for rich engagement not only through directly legible, symbolic associations in

DOI: 10.4324/9781003326809-4

religious art but also through more deeply embedded cultural signifiers, which could as well be treated as "subject matter." The particular contribution of Meyer Schapiro's methodology over the first half of the 20th century serves as one early illustration of deeply embedded signifiers. Schapiro interpreted the sudden, distinct display of fantasy creatures and forms in Romanesque sculpture as expressive of an "underground," urban, secular spirit emerging from within Christian expression *per se*. What Meyer Schapiro and others to follow in the 20th century would demonstrate was that a thick reading of works of art with Christian content promised unexpected returns in historical understanding.

Several decades following Schapiro's breakthrough art historical methodology in the context of studying Romanesque art, art historian Leo Steinberg continued the trajectory of critical pictorial thinking in his study of Leonardo da Vinci's *Last Supper*. In order to achieve rich investigation of the ways in which Leonardo's *Last Supper* addressed themes and content particular to Christianity, Steinberg deployed both highly trained visual acumen and, at the same time, a theologically meaningful repertoire of thought. Steinberg brought attention, for example, to Christ's open left hand in the fresco, which follows the orthogonal direction of the ceiling beams. In this design scheme, Christ gestures openly to the site of the monastic cemetery outside the entry door where *The Last Supper* is located. To a person passing through the door, this formal arrangement serves as a visual token of salvation assurance to both the living and the dead, with Christ beckoning both to those entering the room and to those outside buried in the graveyard.

Steinberg's methodology embraced the site-specific nature of the painting as this example illustrates, emphasizing its spatial engagement with the monastic complex; at the same time, it connected that arrangement with theological import. In so doing, Steinberg was able to model thickly nuanced art historical methodology circumventing competing trajectories of extrinsic (theological) versus intrinsic (formal) sources of revelation. As in the case of Meyer Schapiro's study of Romanesque imagery, Steinberg's study of Leonardo's *Last Supper* revealed an unexpected historical return in investment: when Steinberg first published his work on Leonardo's *Last Supper* in a series of articles in *Art Quarterly* in 1973, he reflected on the ways in which what he called a "dominant secularism in the academy" had diminished understanding of the spiritual content of the fresco. He described his work on *The Last Supper* as resistance to "triumphant secularism" (qtd. in Apostolos-Cappadona 40). Given hundreds of years of Christian content in important works of art in the West, one would not imagine that the fields of art history and criticism might ever become dismissive or hostile to religious content. Yet, Steinberg uncovered this particular distortion in practice – that of projecting contemporary secularism onto work holding sacred content – and intervened with a theologically nuanced framework of interpretation (Apostolos-Cappadona 40).

It is significant for the purposes of this study that in order to achieve productive investigation of the ways in which Leonardo's *Last Supper* addressed themes and content particular to Christianity, it was necessary first and foremost that

Steinberg deploy highly trained *visual* acumen. Steinberg explained after investigating the theological import of the *Last Supper*, "It is the wonder of great art to be so richly dowered that it satisfies even under restricting assumptions" (qtd. in Apostolos-Cappadona 40). Working from the concrete nature and physical placement of da Vinci's fresco, Steinberg employed both two- and three-dimensional analysis. That analysis was essentially "haptic," concerned with the full space of the monastic complex, emphasizing the centrality of *sensate presence as a starting point* (Dillenberger and Apostolos-Cappadona). Theological analysis as a starting point would not have rendered a comparable impact. As Steinberg himself stated of his work on *The Last Supper*, to do any less "de-emphasizes Leonardo's pictorial thinking" (qtd. in Apostolos-Cappadona 57).

Works of art evoke and require, by nature, pictorial thinking; it is trained pictorial thinking that promises progressive approaches in scholarship particular to Christianity and the visual arts. It will be most profitable for those seeking to explore the intersection of Christianity and art, rather than decry "dominant secularism," to continue to foster scholarly and critical understanding of the means by which meaning (theological and otherwise) may be disclosed expressly via imagistic and material forms. While religious content in works may have missed past disclosure, no permanent harm has been done. Art remains stubbornly present. It is possible to become blind to the claims of religion; it is impossible to "unsee" works of art (Steinberg 57).

Coming to works of art with a theologically meaningful repertoire of thought and art historical and critical training will allow scholars to avoid future blind spots. One such blind spot occurred in the treatment of Barnett Newman's *Stations of the Cross* series. When the series was first exhibited in 1966 at the Guggenheim, the full title of Christ's cry from the cross was prominently displayed. *Lema sabachthani* ("My God, Why Have You Forsaken Me?") followed the spectator throughout the installation. Critic Lucy Lippard offered a positive review of the series but acknowledged its stated subject matter might strike artworld insiders as "retardataire" (Temkin 64), and indeed, art historical and critical treatment has under-emphasized the series' religious weight. This occurred despite the series' title and despite the fact that Newman himself stated the series emphatically concerned the cry of Jesus on the cross (Temkin 64). In a statement that accompanied the 1966 display, Newman wrote, "This question is the unanswerable question of human suffering" (9). Admittedly, the radically abstract work lies, imagistically speaking, outside of Christian tradition, offering minimalist vertical bands of black paint on raw canvas. One might imagine indifference or even antagonism to the Christian story, left without depictive references to be read narratively. Yet, Newman explained this radical pictorial approach to Christ's cry from the cross in the following manner: "Can the Passion be expressed by a series of anecdotes, by fourteen sentimental illustrations?" (9).

Numbering fourteen works, the series makes a clear allusion to the Christian tradition of picturing fourteen Stations of the Cross. The tradition of fourteen stations provides Christian worshippers with individual depictions of the events

of Christ's Passion, beginning with his condemnation before Pontius Pilate, and moving to particular moments of suffering, crucifixion, death, and burial. At the same time, Newman was working at once both *inside* and *outside* the tradition of Christian art, moving beyond Christian tradition to broader empathic association with Christ's suffering. Reference to Christ's cry throughout the series has been considered by some as referencing the historically recent martyrdom of millions in the Holocaust. As Newman himself explained to those puzzled by his radically minimalist abstraction:

> The events of WW II, the Holocaust, and the atomic bomb had converted the human condition of terror – consciousness of the unknown and the unknowable – into actual tragedy. "When Hitler was ravaging Europe [could we] express ourselves by having a beautiful girl lying naked on a divan?"
>
> *(Shiff 81)*

Newman explained in a 1970 interview with Emile de Antonio, "I felt the issue in those years was – what can a painter do?" (qtd. in Shiff 5). Some have considered the *Stations'* cry to be autobiographical on Newman's part (Temkin 65). By 1969, Harold Rosenberg had framed Newman's work (along with that of other abstract expressionists) as "an arena in which to act," emphasizing through minimalist voice, the existential state. It is also possible to consider the *Stations* cry that of martyred 20th-century avant-garde art (given, in particular, Nazi treatment of outlawed avant-garde art often literally set aflame) (Shiff and O'Neill). Douglas Davis offered a phenomenological interpretation, less interested in the artist's presence than how visual and bodily encounter with Newman's work impacted the viewer (Shiff 86). Davis' approach offered much in regard to the *religious* tenor of the series. As Richard Serra put it in a 1992 interview, "When you reflect upon a Newman, you recall your experience, you don't recall the picture" (Shiff 86). In defense of the seriousness and gravity of his concerns in his abstract work, Newman utilized the term "sublime" for a time to circumvent a formalist reading of his work (Shiff 83), and in so doing affirmed experience such as Serra described.

In *Stations of the Cross*, suffering was given ultimately sobering material form. Yet, art historical and critical treatment has under-emphasized the series' religious referents. As a result, the religious gravitas of *Stations of the Cross* has been largely missed. Perhaps a portion of blame rests with the lingering "Newman effect" associated with decades of quips about his "zip paintings." As Shiff recounts,

> … the gravity of his work was sometimes missed by those over-doing the "zip" reference, the "one-liner" quip such as made by Andy Warhol of him, "The only way I knew Barney was I think Barney went to more parties than I did…Maybe he didn't have to work a lot if he just painted one line, so he had time for parties"
>
> *(Shiff 78)*

Lack of illustrative character (in this case, minimalist abstraction) can make religious meaning difficult to access. However, with sufficiently widened methodology, this does not have to be true. Methodological approaches working from the *limits* of material encounter as a starting point have for some time fueled studies of art as sublime encounter, many working from the example of Robert Rosenblum, whose *Modern Painting the Northern Romantic Tradition Friedrich to Rothko* (1975) provided an alternate reading of modernism in order to affirm the importance of religious and spiritual dimensions (Tuchmen, Polcari, and Bernier). One thinks of Simon Schama's close to a segment on Mark Rothko in Schama's 2006 series *The Power of Art*. In deft analysis of Rothko's work, Schama asks viewers to consider that what is visible in Rothko's canvases "... is visible only when, and because, the *invisible* is allowed to emerge" (Brown 17). Such treatment of Rothko's color field paintings allows their transcendent content proper critical attention. Schama goes on to describe the works as "gates that open onto the thresholds of eternity..." (Brown 17). Mark Rothko never created his color fields as merely formal designs. However, in the hands of certain critics, they have been taken as such (Brown 16). Again, one does not need artwork with a conventional religious subject to allow religious nuance. However, what *is* often required is religiously inflected art historical and critical engagement to allow for discussion of religious disclosure.

Practitioners of visual culture, a field emerging in the mid-1990s, contributed to the intersection of art and Christianity with a significantly different methodology. "Art," with its hierarchical connotations, was replaced by "visual culture" or "material culture," allowing for a wider and thus more participatory frame by which to discuss objects that suggest religious sensibilities. As a result of working in this methodology (as opposed to traditional art history), David Morgan's study *The Art of Warner Sallman* (1996), for example, countered the mistaken assumption that Protestantism lacked significant visual practice. Morgan demonstrated the ways in which religion happens "materially" and how the act of looking, widely understood, contributes to religious formation. Morgan's study explained how popular reception of Sallman's *Head of Christ* provided an iconographically distinctive image that was deployed widely in Protestant communities. The portrait ended up in bookmarks, calendars, prayer cards, tracts, Bibles, lamps, clocks, plates, buttons, stickers, stationery, and illustrated Sunday School materials (Stratford, "Methodological Issues" 39). Practitioners of visual and material culture provide an example of the unexpected returns in historical understanding that will be made possible by thick readings of works with Christian content.

The art historical and critical lens of the 20th and early 21st centuries eventually widened enough that works without *overt* Christian content were recognized as having such. It is not insignificant that it took someone working outside a dedicated art historical arena to initially reveal, for example, that Andy Warhol came to his art practice informed by a deeply religious upbringing. Art historian Jane Dillenberger, whose teaching career was spent entirely in *theological seminaries*, practiced this "spiritual detective work" as she called it, to reveal religious nuance in Warhol. Dillenberger – trained as an art historian – credited her

particular teaching setting, that is, a theological school, with facilitating ground-breaking work on Warhol that continues today.

My own work on Jackson Pollock is another case where what is most "religious" about a work of art is not its nominal subject (Stratford, "Spiritual Charged Visual Strategy" 239). I have argued that the visual language with which Pollock constructed his drip paintings (understood in the context of the artist's own religious quest) gives representation to what can only be described as religious experience. Contemporaries described Pollock's turn to action painting in religious terms, describing Pollock's breakthrough in works such as *Autumn Rhythm* as a personal, salvific event. Art historians such as John Golding, Elizabeth Langhorne, and others today recognize that as Langhorne has observed, "The very forms that so fascinated Greenberg in Pollock's work were in fact the products of a spiritual quest of just the sort Greenberg dismissed" (48).

As stated above, while religious content in works may have missed past disclosure, art remains stubbornly present. The "stubborn" presence of art often carries with it a cultural capital with power to expose social practices and beliefs. Writing on "The Conditions of Artistic Creation" in an essay of that title in 1974, T.J. Clark opened up the field of New Art History, asking, "…why should art history's problems matter? On what grounds could I ask anyone else to take them seriously?" (249). In answering this question, the present study has argued that a thick reading of works of art with Christian content promises unexpected returns in historical understanding. One such recent example appears in a study of the divergent paths represented by the work of African American artists addressing Christian subjects and themes.

*Beholding Christ and Christianity in African American Art* (2017) edited by James Romaine and Phoebe Wolfskill highlights the diversity and complexity of African American identity and expression in a collection of 14 chapters focusing on African American art. Mary Edmonia Lewis (1845–1907) and Henry Ossawa Tanner (1859–1937) worked from within Western Christian art traditions in terms of subjects and treatments. Aaron Douglas (1899–1979) radically *transformed* Christian art tradition in concert with the Harlem Renaissance, reimagining biblical characters by Africanizing and situating those figures in modern American settings, complete with trombones suggesting the blare of jazz tunes. Allan Rohan Crite (1910–2007) countered unitary notions of black Christianity by appropriating Byzantine and Renaissance treatments. Crite explained:

> … the concept of blacks was usually of somebody up in Harlem, or the sharecropper from the deep south, of what you might call the jazz Negro… But the ordinary person—you might say middle-class—you just didn't hear about them.
>
> *(qtd. in Romaine and Wolfskill 111)*

The historiographic contribution of this collection is to demonstrate the *complexity* of African American artistic expression in Christian art, thereby challenging

essentialized conceptions of black identity. *Beholding* and other studies of African American Christian expression exemplify the wide potential of the critical study of Christianity and art, including its capacity to further questions of artistic autonomy versus contingency, and its capacity to draw attention to art's transforming social vision.

The study of Christianity in the history of art as a vehicle for *innovation rather than anachronism* is also the focus of Cordula Grewe's 2009 and 2015 investigative studies of the Nazarene movement. Grewe's redress of this religiously inspired 19th-century German secession from academic art uncovers challenging turns by which the commitments of the Nazarenes signaled iconographical experiments as striking as those of today's most challenging conceptual artists. Because the movement's revivalist artists set out to convey meaningful religious truth by means of traditional Christian narratives and iconography (e.g. the Adoration, the Crucifixion, the Resurrection, and the Ascension), Nazarene art has often been rejected as a spent movement employing overly simplified mimetic illusionism. Yet in Grewe's analysis, Nazarene art must not be taken as a matter of simple Bible illustration. Rather, from the highly allegorical (Overbeck's *Seven Sacraments*) to the more literal (Schnorr's *Bible in Pictures*), reflective symbolism consistently holds sway, with meaning rising beyond that which is replicated.

A small but poignant example taken up in *Painting the Sacred in the Age of Romanticism* serves as illustration. Overbeck's 1845 work *Lamentation* counters a pale rendition of the dead Christ with a fully alive, pondering Lazarus standing aside the mourning women. Grewe suggests that by inserting Lazarus' corporality into the death scene, the artist invites the possibility of renewed life, first adding complexity to what otherwise would function as a traditional *pietà* narrative. Such interventions, Grewe contends, are central to Nazarene art: its imagery exemplifies the Latin Christian model of *figuration as a transfiguration* (*The Nazarenes* 13). Beneath what appear to be the easily accessible surfaces of figuration lie deeper levels of meaning demanding slow, multi-layered perception moving beyond a simple object-correspondence read. Secondly, the figure of Lazarus in Overbeck's *Lamentation* for Grewe serves as a stand-in for the state of profound spiritual inwardness that the Nazarene art aims to incite in the spectator. Lazarus embodies the experience of "a disembodied state of pure spirituality" (*Painting the Sacred* 316).

This chapter has examined opportunities employed by scholars seeking to explore the intersection of Christianity and art, exploring avenues that have enabled fruitful investigation of the ways in which works of art address themes and content particularly to Christianity. Art historians and critics discussed above, as well as other scholars, including those associated with The Association of Scholars of Christianity in the History of Art (ASCHA) continue to utilize ever-widening art historical methodology, allowing for a range of theological and other ideological presuppositions to be revealed in important works. Reuniting the (non-identical) twins of art and theology to their rightful relationship requires engagement with (extra-pictorial) content (content social and

theological) along with the ability to recognize material form *as* content. One of the biggest challenges today is the lack of institutions within which art historians and critics can train and practice in interdisciplinary methodologies that allow art history and criticism to meet religion on its *own* terms. The risk of failing to acknowledge theological inflections in works of art is real. At the same time, the risk endemic to interdisciplinary study – that of insufficient knowledge or overinflating of one discipline over the other – is also real. Where and how art historians and critics will receive further encouragement for such training and practice remains to be seen.

## Bibliography

"ABOUT." *Association of Scholars of Christianity in the History of Art*, http://www.scholarschristianityhistoryart.org/engage. Accessed 29 September 2021.

Apostolos-Cappadona, Diane, ed. *Art, Creativity, and the Sacred*. 1st ed. Continuum International Publishing Group, 1995.

Bernier, Ronald. *Beyond Belief: Theoaesthetics or Just Old-Time Religion?* Wipf and Stock, 2010.

Brown, Frank Burch. *The Oxford Handbook of Religion and the Arts*. Oxford University Press, 2014, pp. 16–17.

Clark, T.J. "The Conditions of Artistic Creation." *Art History and Its Methods*, edited by Eric Fernie, 1st ed. Phaidon Press, 1999, p. 249.

Dillenberger, Jane. *Image and Spirit in Sacred and Secular Art*. Edited by Diane Apostolos-Cappadona, 1st ed. New York: Crossroad Pub Co, 1990, p. ix.

Grewe, Cordula. *Painting the Sacred in the Age of Romanticism*. Routledge, 2009.

———. *The Nazarenes. Romantic Avant-Garde and the Art of the Concept*. Pennsylvania State University Press, 2015.

Langhorne, Elizabeth. "The Magus and the Alchemist: John Graham and Jackson Pollock." *American Art* vol. 12, 1998. 10.1086/424328.

Newman, Barnett. Exhibition statement. Stations of the Cross, Solomon R. Guggenheim Museum. New York, 1966.

Panofsky, Erwin. *Studies in Iconology: Humanistic Themes in the Art of the Renaissance*. 1st ed. Oxford University Press, 1939.

Polcari, Stephen. *Abstract Expressionism and the Modern Experience*. Cambridge University Press, 1991.

Preziosi, Donald. *The Art of Art History*. Oxford University Press, 2009.

Romaine, James and Phoebe Wolfskill, eds. *Beholding Christ and Christianity in African American Art*. Pennsylvania State University Press, 2017.

Rosenberg, Harold. "The American Action Painters." *ARTnews* vol. 51, no. 8, 1952, p. 22.

Shiff, Richard, John O'Neill, et al. *Barnett Newman: Selected Writings and Interviews*. University of California Press, 1992.

Shiff, Richard, et al. "Whiteout: The Not-Influence Newman Effect." *Barnett Newman*, 1st ed., Philadelphia Museum of Art, 2002, pp. 5–81.

Silverman, Debora. "Introduction." *Van Gogh and Gauguin: The Search for Sacred Art*, 1st ed., Farrar, Straus and Giroux, 2000, p. 13.

Steinberg, Leo. "The Seven Functions of the Hands of Christ: Aspects of Leonardo's *Last Supper*." *Leonardo's Last Supper, Art Quarterly*, vol. 36, 1973, pp. 297-410.

Stratford, Linda. "Spiritual Charged Visual Strategy: Jackson Pollock's *Autumn Rhythm*." *Art as Spiritual Perception*, edited by James Romaine, 1st ed. Crossway, 2012, p. 239.

——. "Methodological Issues from the Fields of Art History, Visual Culture, and Theology." *ReVisioning: Critical Methods of Seeing Christianity in the History of Art*, edited by James Romaine and Linda Stratford. Wipf and Stock, 2014, p. 27.

Temkin, Ann, et al. "Introduction." *Barnett Newman*, 1st ed., Philadelphia Museum of Art, 2002, pp. 64–65.

Tuchman, Maurice, et al. *The Spiritual in Art: Abstract Painting 1890–1985*. Los Angeles County Museum of Art, 1986.

# 3

# TRANSLATING RELIGION

## Contemporary Art through a Postsecular Lens

*Lieke Wijnia*

## Introduction

Toward the end of the collection presentation in Museum Catharijneconvent, the national museum for Christian art and heritage in The Netherlands, the sculpture *Blue Madonna* (1965) by Jacques Frenken (1929–2022) is on display. Within a rectangular shape, four Madonna sculptures are placed in a Droste effect (Figure 3.1). In order to achieve this echoing effect, Frenken sawed the Madonna sculptures in four parts, except for the smallest one at the heart of the sculpture. He painted the entire object in an evoking Marian blue. During the 1960s, Frenken's artistic path ran parallel to dramatic changes in Dutch Catholic churches. Following the Second Vatican Council, the desire for modernization resulted in the large-scale removal of neo-gothic sculptures from church interiors.[1] This new wave of iconoclasm led to the question of what should happen with these removed sculptures. Although no longer embedded in places of worship, the sculptures were deemed too sacred to be thrown out with the trash.[2] Notably, artists bought or rescued these sculptures, often with the intention to integrate these into their own artistic practices – a development that is still prevalent today.[3] When Frenken created his sculptures in the 1960s, his art was met with shock and dismay. His works explored boundaries, but were also meant as a new form of religious art. Yet for many of his contemporaries, Frenken's reuse of sacred sculpture was a bridge too far. His artworks mostly ended up in museums and private collections. Today, *Blue Madonna* has become a museum audience favorite. That initially experienced shock has worn off over time, or rather, younger generations can no longer relate to the experienced shock of the late 1960s.

In studies of the treatment of Christian images and objects in secularizing societies, the notion of *recycling* tends to be invoked (Alexandrova; Malz; Meyer).[4] Artworks like *Blue Madonna*, indeed, constitute a literal sense of recycling. Sacred sculptures were taken out of their original context and turned into waste. The artist took this waste material, processed it, and reused it for new purposes. The new

DOI: 10.4324/9781003326809-5

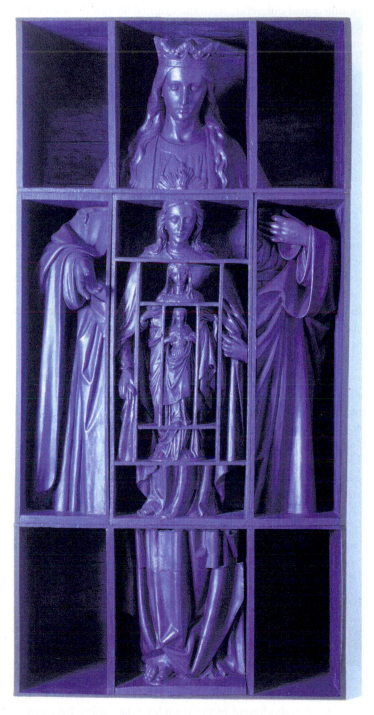

**FIGURE 3.1**   Jacques Frenken, *Blue Madonna*, 1965. Gypsum, wood, paint. 151 × 74 ×
39 cm (59.45 × 29.13 × 15.35 in). Museum Catharijneconvent, Utrecht.
RMCC b119. Used with permission.

artwork functioned differently from the original liturgical context. However, the notion of recycling does not necessarily seem the most adequate when discussing artworks featuring Christian narratives, figures, and symbols that did not become waste first. Artists invoke a particular image and its narrative tradition, within the context of their artistic practices. Such invoking is part and parcel of the tradition of how Christian imagery and narratives have always been dealt with – constituting a dynamic tradition of interpretation, appropriation, and association.

In this chapter, I argue for the relevance of the notion of *translation* to understand this dynamic taking form in postsecular societies like The Netherlands.[5] Translation, a fundamental concept in the theoretical framework of the postsecular, allows for a lens on processes of transformation from one realm to another, while simultaneously reinforcing a sense of continuity. It is reminiscent of sociologist Danièle Hervieu-Léger's conception of religion as a chain of memory (Hervieu-Léger) – a chain in which art and heritage play an important role. And it resonates with the more recently coined notion of the religious heritage complex (Isnart and Cerezales). This concept considers the many stakeholders involved in the conservation and formation of religious heritage, reflecting the dynamic societal contexts in which religious objects and sites, as well as narratives and symbols, are preserved and presented for new audiences and future generations. Precisely, the dual aspect of continuity and transformation is relevant to understanding religion's dynamic presence in contemporary art, especially in the context of The Netherlands, a country in which Christianity was long a dominant socio-cultural force, but which has now gained a simultaneously secularized and religiously pluriform character.[6]

First, this chapter explores several ways of how religion in contemporary art has been a topic of academic scrutiny. A distinction between religious iconography on the one hand and the functioning of artworks on the other is maintained here. Second, translation is introduced as elemental concept in the place of religion in contemporary art. I argue for an open and dynamic approach to translation by looking at the concept from the perspective of translation strategies. And, finally, different translation strategies are discussed by means of art projects by three artists who had exhibitions in Dutch art museums in 2018.[7] Their artistic work, seen through the lens of translation, fosters a continued, albeit transformed, presence of religion in secularizing societies.

## On the Place of Religion in Contemporary Art

As Diane Apostolos-Cappadona, theologian and art historian, has demonstrated, the ways to look at the relationship between religion and art are legion and dependent on the aspect within this relationship deemed most pressing (2–4). To arrive at concrete analytical categories to work with, theologian Frank Bosman distinguished six perspectives from which art "could be interpreted as 'religious', as an embodiment of the complex relationship between art and religion" (3). Bosman identified material, contextual, referential, reflexive, ritual, and existential perspectives. These range from "the more or less objective to the

more subjective, and as such from artist-intended to viewer/listener-perceived" dimensions in art (6). Before anything, the resulting perspectives underscore the necessity for researchers to emphasize their objective. The six perspectives can be grouped under two overall dimensions that are recurrent features in the growing body of literature on art and religion: artistic use of religious motifs (relating to the material, contextual, or referential) and the functioning and experience of artworks (addressing the reflexive, ritual, or existential).

Both are relevant to the analysis of contemporary art through a postsecular lens. Iconography usually is a more easily identifiable way into religion in art. If motifs have some resemblance to or openly draw from religious narratives, symbolism, or rituals, art is easily regarded as religious, or at least as dealing with religion. Art theorist James Elkins observed how non-religious contemporary artists have become more successful and critically appreciated for their use of religious iconography than religious artists have been. Via conversations with young artists, Elkins looked at how they discuss religion in their work, and how art historical scholarship integrates religion in its analytical frameworks. It resulted in a paradox:

> [T]he artworld can accept a wide range of 'religious' art by people who hate religion, by people who are deeply uncertain about it, by the disgruntled and the disaffected and the skeptical, but there is no place for artists who express straightforward, ordinarily religious faith.
>
> *(33)*

Art theorist Alena Alexandrova studied artists operating in the secular realm of art who all, one way or other, tap into the domain of religious iconography. Alexandrova identified artistic reuse of religious motifs as a form of recycling (6). The used motifs originated in religious contexts and are transferred and transformed in artworks without any religious purpose. Artists make use of narrative and symbolic traditions in their communicative efforts to viewers, but do not reinforce these traditions' spiritual convictions. These dynamics are certainly relevant to understanding the place of religion in contemporary art, yet I will propose a replacement for the term recycling.

Beyond iconography, religion in art can also relate to how people engage with artworks. Art historian Hans Belting has written an influential study on the transformed functioning of religious art objects.[8] Until the late Middle Ages, sacred images (Belting notably studied portraits) served the purpose of worship and veneration. Holy images functioned within liturgical and devotional contexts. These demanded prescribed behavior, and access to the images was strictly regulated.

> When the image was venerated, a ritual memory exercise was (...) performed. Often, access to an image was permitted only when there was an official occasion to honor it. It could not be contemplated at will, but was acclaimed only in an act of solidarity with the community according to a prescribed program on an appointed day.
>
> *(13)*

Belting characterized such practices with images as *cult*. Images were accompanied by narratives and legends, embodying their truthfulness and the power of the depicted person. Such holy images contained power not because they re-presented a saint or god, but because they channeled the depicted person's presence and significance.

Such power was lost, Belting argued, during the Reformation period, when "art took on a different meaning and became acknowledged for its own sake – art as invented by a famous artist and defined by a proper theory" (xxi). Images lost their revelatory power, their potential for presence. "Into its place steps *art*. (…) Art becomes the sphere of the artist, who assumes control of the image as proof of his or her art" (16). In *art*, religious motifs are experienced differently. Viewers

> seize power over the image and seek through art to apply their metaphoric concept of the world. The image, henceforth produced according to the rules of art and deciphered in terms of them, presents itself to the beholder as an object of reflection.
>
> *(16)*

Presence has an uncontrolled and unmediated character, which might be experienced through ritualized engagement with artworks. Instead, reflection gives control to the person engaging with the art object, either artist or viewer.[9] "Form and content renounce their unmediated meaning in favor of the mediated meaning of aesthetic experience and concealed argumentation" (16). Belting called the religious dimensions in the cultic image *presence,* where the art image bears religion's representation, its *likeness.* While the use of the religious motif significantly changed overtime, from presence to likeness, the reasons why people engage with art nowadays still very much resemble the framework of presence.

Rina Arya, visual culture scholar, explored spirituality's location in artworks (76–93). Arya studied three artworks of different time periods, materiality, figuration and abstraction, and intentions of production. She looked at a Byzantine Icon, a painting by Mark Rothko, and a video piece by Bill Viola. Each of these artworks is rooted in different artistic and spiritual practices, but all made with the purpose to incite devotional, transcendent, or existential experiences. Part of Arya's method is her own engagement to the artworks.[10] "In most cases understanding [form and content] leads to an engagement with [spiritual meaning] – an understanding of the visual code deepens our awareness of the spiritual aspects of it" (78). Through this, the spiritual dimension is located in the responses evoked by the artworks. The icon, rooted in a particular religious tradition, incited rule-governed ritual behavior. In that behavior, the sacred character of the icon is reinforced and spirituality is evoked within the person performing this behavior (prayer, reflection). The works of Rothko and Viola also demand a particular type of response; they invite us to take time and explore existential feelings or questions. The Rothko painting appeals to the sensory realm by means of abstract color fields, while Viola used figurative symbolism and human interaction as the dominant means of evoking a response. Arya identified two preconditions for a response to be evoked: *receptivity,* one has to be open to let the

artwork in in a multisensory way,[11] and *context*, which must allow for an in-depth engagement to the work of art.

With his notion of slow art, art and literature scholar Arden Reed reinforced that visual art is regarded as an effective instrument for creating an attentive attitude, evoking a mindful presence. Reed departed from major societal transformations of modern life, where acceleration of daily life resulted in an increased desire for quietness and opportunities for reflection. However, secularization also diminished the previous presence of such (religious) opportunities in daily life structures. This coinciding of two contradictory processes meant that

> [s]low art came to supplement older sacred practices by creating social spaces for getting off the train. (…) [A]s cultures sped up and sacred aesthetic practices waned, slow art came to satisfy our need for downtime by producing works that require sustained attention in order to experience them.
>
> *(11)*

Slow art, then, can be any form of art that invites intense engagement from viewers, all at once or through repeated engagements over time. Where Arya selected distinct artworks dealing with existential and transcendent subject matter, Reed's theory significantly expands the potential realm of the transcendent by solely focusing on engagement. Receptivity and context remain relevant to both.

In artistic practices over the last decades, relationships themselves have moved to the heart of artistic content and intention. Art curator and theorist Nicholas Bourriaud theorized the nature of artistic practices in the 1990s as *relational aesthetics*. This concept reinforced how art does not solely represent or show a likeness to, for instance, societal, political, or religious structures. Instead, artists create projects to actively engage within these structures, bring people together, and establish relationships among them. Art viewers become art participants. Museum or gallery visitors become a prerequisite for the art's existence. Relational art invests in the generative potential of the artistic practices, resulting in relationships that ideally have impact beyond the scope or duration of the artwork.[12] This characterization does not limit itself to the art of the 1990s, but still seems applicable today – especially where it concerns socially and politically engaged art projects. Relational intentions lay not only with the maker but also with the viewers – or rather participants.

What do such participants want or get from engaging with art? Theologian Nicholas Buxton observed,

> As with participation in religion, so experiencing art may bring about transformation, if not salvation, in the one who experiences it. Indeed, at least one of the purposes of art is to change the way we look at things, the world, or each other.
>
> *(55–56)*

Both Buxton and Reed related engagement with art to religious practices: Buxton as parallel, and Reed as replacement. Each approach emphasizes the continued

relevance of the notion of *presence* in engagement with artworks. People can visit a museum with the hope of finding a relational experience, an experience of impactful nature, which lasts beyond their time within the museum walls. Belting aptly analyzed the transformed appearance of religion in artistic images from presence to likeness. Yet, this does not mean that a longing for the experience of presence has disappeared altogether. It can be seen as one of the primary reasons for engagement with art and how art has a potentially generative function in contemporary lives. This generative potential not only includes but also transcends the boundaries of religious iconography or subject matter. It is a transformed function of religious iconography in contemporary art, moving beyond the notion of likeness and connecting it once again to presence – albeit in a different form.

## Translation Dynamics and Strategies

The concept of the postsecular directs attention to how religion and the secular relate to one another in contemporary secularizing societies. For historian of religion Arie Molendijk, the postsecular "stands for the attempt to understand the position and role of religion in late modernity in a way that overcomes the idea that 'religion' is basically a premodern phenomenon which will disappear in the long run" (101). The postsecular invites a further understanding of contemporary phenomena, which have "the intertwinement of the secular and religious" at their heart (Molendijk 110). The arts are exemplary for such phenomena. Rather than seeing religious motifs or topics disappearing from the religious realm (of liturgy, private devotion, churches, and monasteries) and moving into the secular realm (of arts, museums, and galleries), this relationship consists of a dynamic exchange.

To study this intertwined nature, the notion of translation holds relevance. As a fundamental concept in the theoretical framework of the postsecular, translation reinforces both transformation and continuity. Sociologist Jürgen Habermas argued for the importance of the continuity and relevance of religion in secularizing societies. Crucial for such continuity is translation. In secularizing societies, religious literacy is declining and religious language is no longer self-evidently understood. However, its semantic potential remains unchanged according to Habermas. The translation of religious language into the secular public sphere, and with that a form of conservation of religion, is important (17–29). Religious language no longer has a place in public institutions such as parliaments or courts of law, yet it represents a body of values, morals, and ethics relevant to secular and non-religious public actors. As a source of existential meaning-making, religion should not be ignored. In order for non-religious actors to recognize their frames of reference in originally religious concepts, a translation process from the religious to the secular domain is in order, which might lead to a fruitful conversation. By means of transformation, continuity and reflexivity become possible (De Roest 226). Habermas predominantly focused on language. However, artistic expression functions similarly as a source for continuous reflection, as well as a means of continuity through transformation.

Translation reflects the reason why the postsecular has emerged in the first place, in response to the widespread observations that entangled formations of religion and the secular continue to exist and to emerge. The arts are an example of entangled formations *par excellence*. At first sight, translation might indicate a one-dimensional trajectory. It implies that religious terminology is translated into secular language, transmitted from one party to the other – in order to facilitate a two-way conversation. However, the translation process itself is as fluid as it might be transmitted to, and gain response from, a variety of audiences. Religious motifs in artworks are not the result of a one-directional translation process, but these constitute a mutual dynamic. Such complexities can be explored through *translation strategies*. Such strategies reflect translation's enduring, active, and context-specific nature, while also indicating the variety of forms translation may result in. As such, it reinforces a process of negotiations back and forth, performed by individual and collective actors in the public sphere. Translation can only take place in a context of mutuality and of open receptivity.

By means of three bodies of artistic work, three translation strategies are explored next. These strategies reinforce the variety of roles religion can play in artistic practices, as well as the various manifestations of the continued presence of religion in secularizing contexts. *Reformulation* is "the finding of new vocabularies that build further on existing religious heritage." *Ludification* is "the creation of playful combinations of religious imagery and vocabulary." *Representation* is "the reframing of existing, historically, and traditionally rooted religious art and heritage" (Wijnia, "Beyond the Return" 35–43).

## *Reformulation*

With reformulation, artists depart from motifs, narratives, or symbolism from traditional religious contexts. They use such motifs in their art production, in which their contemporary visual vocabularies provide new forms for traditional stories. This art can, for instance, be produced on the invitation of a religious institution that wants to engage with art or from the interest of an artist in the context of their oeuvre. Reformulation is at the heart of the work of Dutch painter Helen Verhoeven (1974). She is known for large-scale group paintings, part and parcel to the project *Oh God!* in the Maastricht *Bonnefanten* Museum. For this project, she created new work in response to the museum collection. In addition to its contemporary collections, *Bonnefanten* has a significant medieval sculpture and painting department. Verhoeven created a series of nine monumental paintings relating to nine historic collection pieces. She visually reformulated biblical and religious scenes like the adulterous woman brought before Jesus, the descent from the cross, and the lamentation of Christ. In her distinct figurative style, the visual vocabulary embodied long-existing religious narratives. These are events regarding grief, lust, or friendship. They convey moralistic lessons about, for example, sin, revenge, or guilt. Verhoeven brings these events or lessons back to their core of human relationships, while also including her own memories or thoughts these narratives evoke.

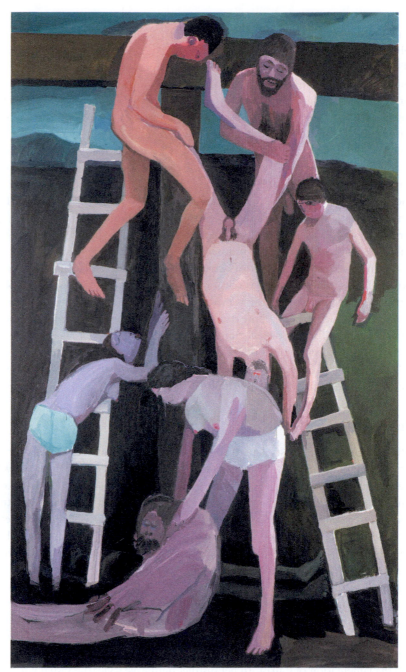

**FIGURE 3.2** Helen Verhoeven, *Descent from the Cross*, 2017. Acrylic on canvas. 280.5 × 165 × 5 cm (110.43 × 64.96 × 1.97 in). Centraal Museum, Utrecht, acquired with support by the Mondriaan Fonds. Inv. 34862.

In the painting *The Adulterous Woman brought before Christ* (2017), all the depicted people are naked, except for the adulterous woman, who is wearing underwear bottoms. It makes her stand out among the crowd, but not in the shameful or embarrassing way which she is supposedly made to feel by the people in the story. From the left, a child is entering the pictorial space with two round stones in hand; in the middle, the central figure holds the arm of the woman accused of adultery. Because all except the woman look the same, at first glance it is not immediately clear which man is Christ. He is naked, like the rest of the men. Does this make them each other's' equals? Or does this make him connect to the others better, in teaching on how they should treat this woman? Christ's full nudity – as an adult – is not something often displayed in art. Yet, Verhoeven treats him like the other men in the scene. This paradoxically makes him stand out because this is unusual within the Christian iconographic tradition.

Verhoeven explores human relationships in the biblical events by means of their nudity and clothing. This is also apparent in *Descent from the Cross* (2017), in which the women helpers are the ones wearing underwear but Christ is not, neither are the men taking his body of the cross (Figure 3.2). What does this say about the status of these women in relation to the men? And in relation to Christ? Verhoeven does not provide direct answers to such questions. Yet, making the viewer wonder about such questions, is the very purpose of these paintings. This dynamic of questioning and confusion is taken a step further in *Lamentation of Christ* (2017). A group of two women and a man lament over the gray-colored dead body of Christ, all naked, against a landscape of blue and green tones. While the other two look up in agony, the kneeled woman puts her hand on Christ's penis. Somehow Verhoeven succeeds in painting this gesture as a caring act, devoid of sexuality. It makes the viewer wonder and look twice – or perhaps look away – while this gesture can also incite a sense of care or closeness.

These paintings show human relationships in their most essential forms. The contemporary, raw visual vocabularies express sacred imaginaries in transformed, secularized realities. Yet, Verhoeven's paintings are undoing the narratives of a traditionally sacralized status, while reinforcing the humanity of the characters in the narratives. Perhaps it can even be said that she reorients the sacrality into the depicted relationships. As such, she directly appeals to the viewer's frame of reference. It turns the paintings into visual reformulations of traditional narratives for contemporary audiences.

## Ludification

The strategy of ludification consists of playful citations and transformations of religious imagery, a type of playful appropriation. Scholars across disciplines have observed a ludification of contemporary culture (Frissen). For anthropologist Andre Droogers, play is an essential human faculty, a way in which people deal with their realities. Play has to do with trying and experimenting, not only with humor but also with the potential of failure and moving forward. In the context of religion, individuals might try on features of religious identities, explore what fits

them, even mix, and match aspects drawing from various traditions (Taves 138–161). There is a connection to playfulness because it includes breaking down barriers or moving across thresholds of tradition. When it comes to the arts, artists have the power and freedom to place narratives, figures, or sites in new contexts. Such appropriations might question long-established meanings and attribute other situated or diversified meanings to narratives and their image traditions. In order to do so, a sense of playfulness is often welcome, allowing for a breath of air in semantic negotiations. Such negotiations have an inherent paradox. Playful recontextualization of religious imagery is often deemed necessary because in secularizing contexts traditional iconography becomes less meaningful for younger generations. At the same time, appropriations of traditional iconography are thought to communicate authority and power, a sense of universal appeal (Kruse 17–58).

Ludification is found with American photographer David LaChapelle (1963), who creates work for both commercial and fine art purposes. LaChapelle connects art photography with features from pop culture, consumerism, and religion. The resulting photographs are spectacularly colorful, often stage the surreal, and are borderline kitsch. In 2018, LaChapelle had a monographic exhibition in the *Groninger Museum* titled *Good News for Modern Man*. Ten of his photo series were displayed, among others: *Jesus is my Homeboy* (2003), *After the Deluge* (2005–2009), and *Paradise* (2009–2014). Religious iconography, narratives, and symbolism from a variety of traditions are recurrent features in LaChapelle's work. Also, the series and photo titles allude to religion. For example, *After the Deluge: Museum* (2007) shows two museum spaces with paintings on the walls flooded and devoid of visitors or guards. While no immediate religious visual references are incorporated in the image, the title brings to mind the biblical flood.

One of the featured series in the Groningen exhibition was *Jesus is my Homeboy* (2003). Consisting of six photographs, LaChapelle visualized scenes from the life of Christ on earth. He placed these scenes in the streets of urban America. In them, Christ interacts with socially marginalized people, with the police, and with his group of disciples. Every aspect is highly scripted and contemporary, except for Christ. He is the stereotypical long-haired, white man wearing a white toga with a blue sash. It makes him a timeless, eternal figure against the contemporaneity of every other aspect in the photographs. In *Loafs and Fishes* (2003), Jesus holds a fish unwrapped from a red plastic bag. He shows it to three disciples, of which one kneels before him and two stand next to him. One of them, Mary Magdalene, looks in wonder; her head shifted away from the scene as if she is looking for others to witness this moment. The photograph title refers to the miraculous multiplication of fish and bread; however, here just one fish is visible. The scene is staged against the backdrop of a supermarket, or perhaps a market stall, where bread to the left and fish to right are prepped for another day of sales. Notably, Mary Magdalene is presented as one of the disciples. This is also the case in *Sermon* (2003), in which Jesus stands surrounded by twelve track-suit-wearing, ethnically diverse male disciples, and one high-heeled pumps-wearing Mary Magdalene. She is placed on Christ's left side, making her both part of the disciple group and being the one standing closest to Christ.

An elemental feature of the ludification strategy is the use of celebrity. While in *Jesus is my Homeboy* no celebrities were used as models, in other work of LaChapelle it is a recurring aspect. For example, Tyra Banks, the Kardashian family, and Michael Jackson have modeled for his photographs. In *American Jesus: Hold me, carry me boldly* (2009), a pieta scene is recreated. Instead of Mary holding her deceased son, here Christ holds Michael Jackson on his lap. The popstar is presented as martyr, as a Messiah of the new millennium, despite that by then Jackson had become a highly disputed figure. In a more recent series, LaChapelle portrayed reality star Kim Kardashian in *Mary Magdalene* (2018). In a set of two photos, she is shown repenting and receiving the holy spirit. The use of celebrity in the representation of traditionally rooted religious scenes has a dual effect. It potentially appeals to contemporary viewers who might not feel connected to the particular religious tradition it draws from, but who do recognize the celebrity model and relate to them. Also, it tends to elicit strong responses, either positive or negative, because of the association between the celebrity and the religious symbolism. If the celebrity is surrounded by controversy, or for instance considered not religiously devout enough, should they be allowed to take on the guise of a religious role model? But at the same time, exactly because they do so, religion is turned into the topic of a public discussion in the first place.

## Re-presentation

The strategy of re-presentation sheds new light on religion or religious heritage. It is rooted in the understanding that a continuously changing society needs transformed ways of seeing existing heritage. Re-presentation entails creating new points of entry, often found in artistic practices. Churches are increasingly organizing exhibitions or inviting artists to create work in response to their liturgical spaces. Sometimes, such exhibitions are also part of the survival strategy for a church building or community. Exemplary is the *Oude Kerk* in Amsterdam. The oldest remaining building of the city, dating back to 1306, stands in the city's historic heart. In 1587, the building transformed from a Catholic house of worship into a Protestant church. Iconoclasm caused the removal and destruction of many visual elements. In 1951, the building was transferred from the Protestant church into a foundation. Since then, this foundation is in charge of the building and its use. The Protestant congregation continues to make use of the church for their services, choral practices, and other activities. In 2016, the church building officially received museum status. It is not only a museum due to its heritage status, but also through contemporary art exhibitions. Jacqueline Grandjean, *Oude Kerk* director until 2021, set up a program in which she invited artists to create new site-specific work in relation to the building, its history, or its surroundings.

For his project *Anastasis* (2018), Giorgio Andreotta Calò (1979) covered all church windows with red foil, alluding to the once richly decorated church (Figure 3.3). The images that were once there are no longer present – yet, in memory they still exist. By coloring the light fall into the church red, the church became a photography dark room, where images are also in limbo. Through the

**FIGURE 3.3**   Giorgio Andreotta Calò, *Anastasis*, 2018. Light Installation. Installation View. Oude Kerk, Amsterdam.

developing process, images will emerge, but they do not exist just yet. Calò made visitors view and experience the church and its history from a new perspective.[13] While some of the art projects take up physical space and impact the performance of the liturgy, Calò's project could be undone during service times with a simple switching on the lights.

A project that impacted the liturgical use of the space was *Poems for Earthlings* (2019–2020) by Adrián Villar Rojas (1980). He created a desolate, apocalyptic scenery in the church with stacks of sandbags, blacked-out windows, and scarce candlelight. A soundscape consisted of historical sounds from the archive, as well as contemporary sounds from the church's neighborhood. The installation connected to past times during which the church building faced threat, such as wars or iconoclasm, while it simultaneously evoked the potential of a dystopian future. Like *Anastasis*, *Poems for Earthlings* created a fully embodied, multisensory perspective on the church, its history, and heritage. Due to the installation's physical presence, the congregation was required to use different walking routes and an alternative space for services.

Re-presentation incites the question for whom this representation takes place, whose perspective is reoriented, and what the consequences might be.

The artworks in the *Oude Kerk* never function independently, like they might in a museum setting. Rather, they are intentionally made to interact with the church building and precisely for the users and visitor of the site to become part of this interaction.

## Conclusion

From a postsecular perspective, religion has a pluriform presence in contemporary art. This chapter explored this pluriformity in the use of religious iconography and the evocation of presence. Instead of approaching the use of religious motifs in terms of recycling for the purposes of secular artistic practices, I argued for a dynamic perspective on the intertwinements of religion and the secular in which the notion of presence also receives a place. It reflects why people often engage with art in secularized societies, to get a sense of potentially generative presence in the context of their own lives. To achieve an analytical perspective taking these dynamics into account, the notion of translation is elemental. Taking this concept from the theoretical framework of the postsecular into the realm of visual arts, dynamic intertwinements come to the fore. While recycling implies a gradual decline with each step along the chain, translation evokes a sense of circularity and continued existence. Explorations of the diversity in artistic translations of religion, and their appreciation found in exhibitions in public institutions like museums, shed light on the dynamic place of religion in secularizing contexts. As such, art is regarded as a relevant aspect to study the chain of memory by means of which religion has been characterized, allowing room for its continued albeit transformed presence in a pluriform society like The Netherlands.

## Notes

1 In 1853, the Diocesan Hierarchy was officially restored by the Vatican for The Netherlands. Only after that, it became possible for Catholics to officially practice their faith in public again, in a country largely dominated by Protestantism. This decision resulted in a Catholic reorientation in visual culture and saw an increase in newly designed and built church buildings with lavish interiors in the then fashionable neo-gothic style. Architect Pierre Cuypers (1827–1921) was an important proponent in this development. Cuypers also designed the buildings of the Rijksmuseum and Amsterdam Central Station, which display similar interests in the neo-gothic visual language.
2 This phenomenon has been theorized by Daan Beekers (2016) as a "sacred residue" that remains with sites or objects, also when they have been removed from official religious use.
3 Contemporary prevalence of such practices can be found in, for instance, the work of Wout Herfkens (1962), Jan Tregot (1970), and Moniek Westerman (1960). About the reuse of sacred sculptures in contemporary Dutch art, see Joost de Wal and Wout Herfkens (2017). The exhibition title was translated into English as *Recycling Jesus. Reusing Christian Images in Contemporary Dutch Sculpture*.
4 This was, for instance, the case in the influential 2015–2016 exhibition *The Problem of God* in K21, Düsseldorf, Germany.

5 This chapter is based on, and further develops, research first published in L. Wijnia 2018; 2022.
6 Between 2012 and 2017, religious affiliation steadily declined. By 2017, more than half of the Dutch population self-identified as non-religious: 51 percent of the population did not affiliate itself with a religious institution or a spiritual movement. Within the 49 percent that self-identified as religious, Catholics took up 24 percent, Protestants 15 percent, and Muslims four percent. The remaining 5 percent consisted of people who identified with other types of religious or spiritual movements. See Hans Schmeets 2018.
7 Although these artists had exhibitions in Dutch museums, their artistic practices are representative for the functioning of the international art world.
8 The description of Belting's work that follows is based on Wijnia, "Resonating Sacralities" 65–67.
9 Reflection and the change of focus from an outer force to an inner control reflect what Charles Taylor has called the transformation from transcendence to immanence. See Chapter 15 on the immanent frame, in Charles Taylor 2007.
10 Arya described her methodology as follows. "Contemplating the works enables me to understand, interpret, and engage with it. This happens on a number of different levels: deciphering the formal properties of the work and its accompanying content, and then engaging with the spiritual meaning" (78).
11 An attitude which anthropologist Timothy Ingold has called *attentionality* (9–27).
12 The focus on relationality moves beyond the confining frameworks of artistic disciplines. The original French publication of Bourriaud's relational aesthetics appeared in 1998. In that same year, musicologist Christopher Small published his theory on the relationality of musical practices, in which he most importantly turned the notion of music into a verb: *musicking*. In this practice, all parties are involved (performers, audience, managers, roadies, technicians – all who make a performance happen) in establishing an experience of actual and ideal or desired relationships through the performance of music (50).
13 As remnant of this temporary exhibition, the *Oude Kerk* installed a red-colored window in one of the side chapels. The transparent glass was changed for red glass. This resulted in a heated public debate. Although the city council provided a permit for this installation, an Amsterdam heritage organization sued the Oude Kerk because this window impacted the exterior of the building in a semi-permanent manner. Eventually, it was ruled that the Oude Kerk operated within regulations, because the installation of the window glass is reversible. It is the intention this window remains in place for a period of ten years.

## Bibliography

Alexandrova, Alena. *Breaking Resemblance. The Role of Religious Motifs in Contemporary Art.* Fordham University Press, 2017.

Apostolos-Cappadona, Diane. "*Religion and the Arts: History and Method.*" Brill Research Perspectives in Religion and the Arts, 1, 1, 2017.

Arya, Rina. "Contemplations of the Spiritual in Visual Art." *Journal for the Study of Spirituality,* 1, 1, 2011, pp. 76–93. DOI: 10.1558/jss.v1i1.76

Beekers, Daan. "Sacred Residue." *The Urban Sacred: How Religion Makes and Takes Place in Amsterdam, Berlin and London.* Susanne Lanwerd, ed. Metropol, 2016, pp. 39–41.

Belting, Hans. *Likeness and Presence. A History of the Image before the Era of Art.* Edmund Jephcott, trans. The University of Chicago Press, 1994.

Bosman, Frank. "When Art is Religion, and Vice Versa. Six Perspectives on the Relationship between Art and Religion." *Perichoresis,* special issue *In the Footsteps of*

*Divine Artists: On the Religious and Spiritual Dimension in Art.* Wessel Stoker and Frank Bosman, eds., 18, 3, 2020, pp. 3–20. DOI: 10.2478/perc-2020-0013

Bourriaud, Nicolas. *Relational Aesthetics.* Simon Pleasance et al., trans. Les Presses du Réel, 2002.

Buxton, Nicholas. "Creating the Sacred: Artist as Priest, Priest as Artist." *Contemplations of the Spiritual in Art.* Rina Arya, ed. Peter Lang, 2013, pp. 49–68.

Droogers, Andre. *Play and Power in Religion: Collected Essays.* De Gruyter, 2012.

Elkins, James. *On the Strange Place of Religion in Contemporary Art.* Routledge, 2004.

Frissen, Valerie, et al., eds. *Playful Identities: The Ludification of Digital Media Culture.* Amsterdam University Press, 2015.

Habermas, Jürgen. "Notes on Post-Secular Society." *New Perspectives Quarterly*, Fall 2008, pp. 17–29. DOI: 10.1111/j.1540–5842.2008.01017.x

Hervieu-Léger, Danièle. *Religion as a Chain of Memory.* Simon Lee, trans. Polity Press, 2000.

Ingold, Timothy. "On Human Correspondence." *Journal of the Royal Anthropological Institute*, 23, 1, 2007, pp. 9–27. DOI: 10.1111/1467–9655.12541

Isnart, Cyril, and Nathalie Cerezales, eds. *The Religious Heritage Complex. Legacy, Conservation, and Christianity.* Bloomsbury, 2020.

Kruse, Christiane. "Offending Pictures. What makes Images Powerful." *Taking Offense. Religion, Art, and Visual Culture in Plural Configurations.* Christiane Kruse et al., eds. Wilhelm Fink, 2018, pp. 17–58.

Malz, Isabelle. *The Problem of God.* Kerber, 2015.

Meyer, Birgit. "Recycling the Christian Past. The Heritagization of Christianity and National Identity in the Netherlands." *Cultures, Citizenship and Human Rights.* Rosemarie Buikema, Antoine Buys, and Ton Robben, eds. Routledge, 2019, pp. 64–88.

Molendijk, Arie L. "In Pursuit of the Postsecular." *International Journal of Philosophy and Theology*, 76, 2, 2011, pp. 100–115. DOI: 10.1080/21692327.2015.1053403.

Reed, Arden. *Slow Art: The Experience of Looking, Sacred Images to James Turrell.* University of California Press, 2017.

Roest, Henk de. "Lessen van Religies: Jürgen Habermas en de onmisbaarheid van Religieuze Gemeenschappen." *Nuchtere Betogen over Religie: Waarheid en Verdichting over de Publieke Rol van Godsdiensten.* Govert Buijs and Marcel ten Hooven, eds. Damon, 2015, pp. 217–227.

Schmeets, Hans. *Wie is religieus, en wie niet? CBS Statistische Trends.* Centraal Bureau voor de Statistiek, 2018.

Small, Christopher. *Musicking. The Meanings of Performing and Listening.* Wesleyan University Press, 1998.

Taves, Ann. "Building Blocks of Sacralities. A New Basis for Comparison Across Cultures and Religions." *Handbook of Psychology of Religion and Spirituality.* Raymond F. Paloutzian and Crystal Park, eds. Guilford Press, 2013, pp. 138–161.

Taylor, Charles. *A Secular Age.* Harvard University Press, 2007.

Wal, Joost de and Wout Herfkens. *Verspijkerd en Verzaagd. Hergebruik in de Nederlandse Beeldhouwkunst.* Noordbrabants Museum and WBooks, 2017.

Wijnia, Lieke. "Beyond the Return of Religion: Art and the Postsecular." *Brill Research Perspectives in Religion and the Arts*, 2, 3, 2018.

——. *Resonating Sacralities. Dynamics between Religion and the Arts in Postsecular Netherlands.* De Gruyter, 2022.

# 4

# THE QUESTION OF CRITICISM

## What to Do with Our Revelations?

*Jeffrey L. Kosky*

Several years ago, while visiting Los Angeles to deliver a lecture at a conference on art and post-secularity hosted by a Christian university, I had the good fortune to visit the Los Angeles County Museum of Art (LACMA) with newly made friends. They were artists and writers about art, each of whom greatly enriched my experience of what I saw at the museum. One of the works we encountered was an untitled work (Figure 4.1) by Y.Z. Kami (1956–). It was exhibited as part of the show "Endless Prayers," which first appeared at the Parasol unit in London, from November 2008 to February 2009. When I saw it at LACMA, the exhibition was smaller but bore the same name.

Warmth radiates from the picture, and surfaces are soft, like skin. The figure shimmers and flickers in a slightly out-of-focus blur. It even appears to tremble, and a tremor, the artist reminds us, is "the internal movement of an immobile figure," signal of fragility. It is a symptom of life. "The figures still appear to be breathing," the artist Bill Viola says (qtd. in Mahlouji 32). I think of this one as possessed by the tremor of a heart that beats hidden within. It's magnificent.

My new friends explained that the blur that came over me was an effect of the fact that many problems of the painting are unresolved, making it feel not finished. There are, they said, open issues regarding the definition of line, smudges of paint that are not blended in, the surface has brush marks, fibers, and so on. The effect of the unresolved surface, what it means or does to me, is to make it appear in such a way that it has no definitive outer shell: I imagine my gaze touches it as if it were skin that yields and gives to gentleness but breaks if you push too hard. It feels intimate this way.

And yet, for all the intimacy, I still can't reach him. That is the magnificence of the work. The face where we would look for an expression that might indicate his intentions or what's on his mind is blank. His eyes are not windows to the soul. They are closed, shut and shuttered, yet intimate an interiority, an inner recess

DOI: 10.4324/9781003326809-6

**FIGURE 4.1** Y.Z. Kami, *Untitled*, 2009–2012. Oil on linen, 284.5 × 190.5 cm (112 × 75 in), unframed.

that comes to the surface of the work without losing its depth. The picture feels possessed of a deep, vibrant, indeed pulsing interiority that makes it intimate yet inaccessible, magnificently present. Speaking of his own aim in making the work, the artist says "the sense of immobility and the sense of the interiorized focus magnifies the presence of the figure" (Mahlouji 32). I sense the magnification he speaks of: the presence of the figure grows as a reserve withdraws, and that interiority, the withdrawn reserve, is what comes forward in the presence that looms over me. That is indeed magnificent. I want to praise it as such.

But it is not easy to receive moments when we come across something like this, and words can be hard to find. What's on his mind? What does he see behind those closed eyes? What is he thinking, what is he feeling? Those are clearly questions raised by the picture, but it does not give much help answering them. Left with unanswered questions, one struggles to know what to say, what to do, and is tempted to go one's way.

Not so my friends and I. We lingered a while, wondering together, asking the very questions I just raised. "He's gone," one of them finally said. "Yes," said another, "and I'd like to go with him." Much of the ensuing conversation concerned where he might be, how to get there, and what sort of practices or assistance might help along the way. It was a spirited discussion. While nobody spoke directly of "a state of grace" as I would later find Robert Storr do (21), the magnificence of the sitter's withdrawn reserve was clearly attractive to my friends, the intimated interiority obviously alluring. There was little doubt among them as to the picture's depiction of a desirable place to be. Even if I, less committed, less believing, was not so sure about going there wherever it was, I did want to stay with the picture a little longer. That remains the case even now, many years later, as I write, diligently write. Why? What am I thinking that I want to stay, abide in the shadow (or is it the light?) of this enigmatic presence? And perhaps more importantly, how? How do I prolong my encounter with what comes over me when I am given a moment like this?

<div align="center">★★★</div>

We look to critics and art historians for help with such questions, at least I do. Being inexpert and still a novice, I turn to their writing – sometimes as a model, sometimes as a source of language or concept, sometimes for inspiration, and sometimes for all of the above to help me linger longer with the works I encounter. The ones I like best are the ones whose descriptions bring to mind what is there but not seen until they say it. Their interpretations are, in this way, revelations of the work, and their revelations, in fact, in which the work reveals itself. Good interpretations, the kinds I want to have, are therefore, I would say, revealing responses: revelations of what comes over the writer when she is encountering the work. I confess, therefore, that I like critics whose descriptions put themselves in the picture; they admit their subjectivity – by which I mean the singularity of their first-person experience being there with the work that has revealed itself in that encounter; and by which I do not mean a subject that speaks authoritatively and unimpeachably of feelings or

experiences one has had or should have given who one has already identified one-self as being. When the work is good and the critic particularly gifted, something happens, and that event takes form in the revealing response of the critic who tries to figure out what has come over her with the revelation of the work, tries, that is, to figure out some revelation that strikes while lingering with the work.

I say "revelation," for it is one. What we call a revelation strikes from out of the blue, without knowing what has dawned on us until after the fact. Our interpretations are efforts to figure out what; in other words, they are responses that provide a figure for what they don't know, a revelation. I have them when encountering certain works of art, the paintings exhibited at "Endless Prayers," for instance. The friends who were with me did, too. When we say we have had a revelation, we mean also that a thought comes over us that changes our world, sometimes slightly, sometimes greatly, adding to our world what it had not included before, and sometimes going so far as to modify how everything else in it appears. A revelation, then, is not just a matter of knowing something, not just a matter of information. When I have a revelation, the idea also affects me, touches on me, my first-person person. That my world has changed with a revelation means that the possibilities for my being have altered or enlarged.[1]

This was the case for my believing friend at LACMA. He was not just enter-taining ideas. His revealing response made that clear: his world now included there wherever it was that man was ("he's gone") and, more significantly, the possibility of his, my friend's, being there ("*I want to go, too*"), a possibility that appeared therefore in desire, not knowledge ("I *want to* go, too"). This is also the case, I believe, for good critics. Revealing responses can be found in their writ-ing, too. In that of the most gifted, it is plain that her interpretation is her way of trying to manage – to figure and figure out something that struck her, something puzzling that struck her, and some puzzling thing to which she remains faithful in writing that is confident enough in its revelation to stick with it by responding in a way that offers a figure for what it does not know.

The work of managing revelations is always difficult for professional schol-ars and critics, but it can be particularly difficult when the revelation concerns thoughts and ideas of transcendent and mysterious states – like those that came over me and my friends at LACMA. The show was titled "Endless Prayers." It included images of the man lost to us in contemplation of who knows what, a state of grace and contemplative bliss that could only be imagined. It also included images of praying hands, disembodied and unidentifiable hands clasped together against an empty black background, praying in the dark for who-knows-what to whom-one-knows-not. And it ended with dizzying images of concentric rings made of brick-like tiles through which I, or at least my friend, would ascend to who knows where, uplifted into the transcendent state of that enigmatic man. When the ideas that dawn on us concern mysterious matters such as these, the journey that follows our revelations can be particularly difficult to manage.

★★★

**FIGURE 4.2** Y.Z. Kami, *Untitled (Hands) I*, 2013. Oil on linen, 274.3 × 182.9 cm (108 × 72 in), unframed.

In the case of the paintings I encountered at LACMA, one of the best efforts I found to manage a revelation is the essay by Robert Storr I already mentioned, "Every Time I Feel the Spirit...," in a volume published on the occasion of an exhibition of Kami's work at the Gagosian Gallery in New York.[2] The title of Storr's essay is provocative, the ellipsis even more so. It raises the question of just what we do with the revelations had in the presence of a work of art when we "feel the spirit," especially when the work hangs in a gallery or museum where it is presented as object of the artworld's gaze.

Storr responds quite eloquently to the spirit he feels, revealing what comes over him far more candidly and revealingly, as it were, than anything else I read:

> A tender wonderment emanates from the soft-focus, fine-grained brush-work of Kami's pictures, as if the artist – and, vicariously the viewer – were exploring the surface with his fingertips.... Two renditions of what appears to be a monkish man with a shaven head meditating demonstrate the extremes of that sense of wonder, with the smallest offering a porcelain-fragile embodiment of his arresting self-possession, while the larger one presents a looming, potentially all-enveloping evocation of that same state of grace, as though the spectator stood in the path of a light-suffused fog bank.
>
> *(Storr 21)*

The state of grace and wonder revealed in Storr's response appears in the man's face, a face that has no purpose in mind, no place else it intends to go, and nothing it wants to say about itself or the world it inhabits. Neither anxious nor glee-fully absorbed in fun, he is just sitting, being in place, peacefully and serenely. Effortless and without apparent regard for the laws of nature or the world, this is, as Storr says, the embodiment of grace. My friend surely sensed that, too.

When we saw the painting at LACMA, another picture accompanied it (Figure 4.2).

We had to pass it in order to reach the blissful place of that man in a state of grace. Hands clasped in the darkness. They could be clapping and applauding, but the title of the show, "Endless Prayers," suggests otherwise: they have come together in prayer. Storr sees this image too as a longing for that state of grace and unidentifiable bliss:

> When the heel, palm, and fingers of one hand palpably mirror those of the other hand, a person... centers his or her being and consciousness with respect to everything that might diminish them or distract.... With or without creed, it constitutes an existential Sabbath, or, as a mystically inclined rabbi once termed it a 'cathedral in time,' in the context of which upraised hands become the corporeal arches of a temporal hiatus.
>
> *(Storr 23, 26)*

To continue the revelation Storr helped me manage, I would add: one enters that cathedral when the lids droop, eyes shut, and darkness closes round. Then, the

gathering darkness truly gathers, it collects and envelops you in a collectedness that penetrates the person who says 'yes,' 'amen,' 'so be it,' to standing in its midst. That gesture of assent, the affirmation of being collected by the gathering darkness, is seen in these hands that let themselves be collected, brought together by it. Such collectedness or composure in giving oneself over to the gathering darkness is witnessed in the look of the man with lowered gaze and drooping lids, who lets the darkness gather in and into peace and serenity, contemplative bliss.

My friend at LACMA was clearly touched by what he saw and took it personally. Believing his revelation, he didn't just want to get the picture, he wanted to get into the picture, to be there where that man was, wherever it was. "He's gone." "Yes, and I want to go with him." I don't know that what was gathering my friend into its draft was the darkness. He was not as revealing in his response as Storr is in his. In his enthusiasm, his revelation took form in a desire that I could only partially understand, in both senses: he did not give me to see what he had seen (his response fell short of the ideal of clarity and distinctness, the supposed objectivity equally accessible to all, that are virtues expected of our scholarly works and criticism), and I could not entirely sympathize with his desire.

What was clear, however, was that the picture had revealed feelings that my believing friend followed eagerly. This is not the case for Robert Storr. He admits his hesitation at the thoughts and feelings being revealed in him.

> [It] makes me twitch as I write these sentences – I expect they will also make a fair number of my readers cringe – but the calm assurance of Kami's pictures force me to do so despite inner resistance…. The allusive powers of painting have prompted thoughts I would rather avoid, awareness I would rather suppress, and, yes, yearnings I would prefer to disavow. Usually, these reactions are triggered by images that trouble the waters of my subconscious or shock and horrify my conscious emotions and logical predisposition. In this case, however, they are the result of images that summon the prospect of unimaginable transcendence, of a peace beyond understanding.
>
> *(Storr 26)*

Storr is clearly embarrassed to speak about states of grace, longings for serenity, and a transcendent peace or bliss. Such thoughts having been revealed in him, he thinks twice, gets hold of himself, and wants to disavow them, stating his revelations only by denying them. That twitch and cringe at words that seem to have arisen unbidden and to have given such beautiful form to these spiritual feelings – his recoil before the revelation – is that what the ellipsis in the title of his essay is meant to convey? It is as if he were saying, "Every time I feel the spirit… No, no, I can't go on, I can't go on with it anymore," and then faints; the revelation is not one he can manage any longer. But while his spirit lacks the capacity to hold on, at least he did manage to stay with it for a little while. I am the beneficiary of that.

Interestingly enough, Storr notes having had similar reactions to thoughts and ideas that are less positive – ones that he says "trouble the waters of my subconscious or shock and horrify my conscious emotions." These troubling or horrifying

revelations include thoughts that outrage our sense of our humanity, our sense of justice or kindness, and images that appear frequently in the media storm that surrounds us but also in an art community that has become activist and engaged. It's easy to understand Storr's disavowal in those cases, his saying no to negatives, denying revelations of something negative, or turning away from negative emotions. What is happening, though, when a seemingly positive image, in this case, a revelation of bliss, peace, or serenity, is admitted only in the resistance it arouses? Why are we so reluctant to receive ways to be that seem to come with such grace? I don't have an answer or explanation so much as more description of the phenomenon.

Interrogating his resistance to that revelation, Storr observes that it is quite common in the art community, especially among the critics.

> The difficulty confronting a fan of [Kami's] work is the discomfort the contemporary art community – and in particular professionally critical members of that community – has with the presence of affirmative images. For as a group we seem to have lost the capacity – or perhaps it is the confidence required – to address art that speaks to longings for serenity… [for] such a state of sweet well-being.
>
> *(Storr 12)*

This was not the case with my believing friend. He was not uncomfortable with these images, and a lack of confidence did not seem an issue for him. In fact, he believed, confidently believed, the revelations of "serenity" and "sweet well-being" that came over him so gracefully, and believing the picture before him, wanted to get into it. Storr, in contrast, admits he is "an inveterate doubter" and as such "finds it awkward" to believe someone might be genuine or sincere in "evoking a 'higher consciousness'" and states of bliss. Letting himself be moved by these images, admitting prayerful longings for such graceful states, Storr fears he might be letting himself be deceived. This is likely what "the professionally critical members" of the art community would have said about my believing friend when he declared his desire to go to the state of grace presented by the picture: rather than getting it, he had been gotten by the picture; naïve and amateurish, he was falling prey to "self-serving charlatans and deft but opportunistic aesthetes" who appeal to longings for transcendence and serenity in order to "use and abuse them," leading on people like my friend who will waste time and money on work that serves these hidden holders of power, another case of the culture industry taking advantage of an unenlightened consciousness.

We, as members of the "contemporary art community, and in particular professionally critical members of that community," are more guarded than my friend, our confidence less assured. We keep our critical faculties intact and on alert, suspecting any pictures that would promise such states of grace as appealing to a faith that could only be "bad faith" (Storr 12, 14, 14). Storr concludes that we thereby "have lost the capacity… to address them." Incapacitated by the vigilance of our critical spirit, we cannot manage the revelations. We "lack the confidence required," Storr says, to believe them, or to love them, without self-consciousness

holding us back. Trained instead to find manipulative powers operating everywhere, inclined to be suspicious, we are not well-equipped to talk about bliss and serenity, phenomena we should like, even desire. For, what would a true happiness be that is not desired, a real state of bliss that is not loved? And if images of such states of grace and bliss are revealed in an assured love or ardent desire, no wonder they are not revealed in the writing of our critical scholars and scholarly critics. We are more comfortable with images that themselves arise from a spirit of critique, ones that would show such bliss only to mock it or expose the powers operating in it. Those are images we recognize and can talk about, for they come from the same spirit that dominates most of our professional work. The critical faculties stumble on sincere happiness and don't know what to say.

My friend at LACMA didn't say much either, far less than Robert Storr, but he wasn't stumbling. He was running confidently in the direction of some mysterious bliss. The picture had not invited critique but devotion to an enigmatic promise of some state of grace. It had not called on him to know what it was truly made of, either formally or historically and sociologically, but to pursue its

**FIGURE 4.3** Y.Z. Kami, *White Dome IV*, 2013. Acrylic on linen, 137.2 × 149.9 cm (54 × 59 in), unframed.

mysterious allure. He clearly loved it. It was attractive to him, and he wanted to follow the attraction.

<p style="text-align:center">★★★</p>

The man my friend followed so willingly and gladly was "gone," and nobody really knew where. Where had his prayers taken him? Where was he? Data for a response were provided by paintings like "*White Dome IV*, 2013" (Figure 4.3), a painting that hung in the gallery at LACMA along with the praying hands and untitled man in a state of grace.

If I were to say where he went, after looking at this picture, I would say "Up." Maybe "down" if it was a bad day, for what looks like a dome also looks like a bowl, what was bringing him up might also be bringing him down. My believing friend did not see it this way. He made that clear in a revealing response of his own: he saw it only up; "Endless Prayers" could only be leading up in his mind. There is a big difference between his world and mine. Wondering together in these differences is how we were managing our revelations.

When I learned about contemplative paths and introspective turns as an undergraduate student, the pattern I was taught was "one goes in to go up." It is the path my friend was confident about following. I first heard that phrase in the context of reading the Christian saint Augustine, his *Confessions* in particular, but I have since learned it is common in Platonic and Neo-Platonic contemplation, as well as in the many religious traditions influenced by them. The inward turn, introspection, discovers the transcendent way, the path up and out of world and self. Darkening the world, shutting it out by turning inward, lets the darkness gather, and in that gathering darkness, one sees an inner light, which is seen in truth to be light (illumination) shined by a light (source) above.

Contemplative traditions differ as to whether the transcendent light above is one I reach at the end of my journey or one I am always reaching for on an endless journey. Is the "up," in other words, someplace I am or a direction I am going? Is transcendence revealed in having or wanting, knowledge that possesses it or desire that moves toward it, infinitely, endlessly? My friend expected an end, some Light, some transcendent light there at the end that this man had already reached or would one day, or some day beyond days, reach but even now had in hope and knowledge. My take was the latter: "Endless Prayers" is the title after all, and *White Dome* looks to me like an opening to that endlessness more than an arrival at an end.

Regardless of these differences, the pattern remains: the contemplative mind experiences itself in the light shined by a transcendent light outside it so that turning inward I am led upward to that light, which illuminates my interiority. That journey is what "Endless Prayers" was about.

<p style="text-align:center">★★★</p>

Much of the scholarship and criticism we are trained to be expert at does not let us go on it.

When our professionally critical and scholarly faculties are presented with these pictures of prayer and bliss, they founder. Images of praying hands and blissful states of grace strike at the heart of our identity as scholars and critics. We identify ourselves by our suspicion and unbelief, our doubt and skepticism, and our critical self-awareness maintaining self-possessed thoughts. These images, bordering on the sentimental, appeal to something opposed to that; if they are "good" works, something other than critique and critical self-awareness must be "good." We critics and scholars know better than that and knowing better suspect sentimental images are evidence of something going on outside and around them, something that calls for explanation. We are too knowing about the ways of power and the manipulations that make for images to believe our revelations of graced states and the enigmatic presence of bliss. We see work more circumspectly, in other words, and as such, we explain it, sometimes formally but these days most often by referring it to something other than it, namely, historical and social circumstances. Our circumspect approaches to the work of art look at it in order to see through it, in other words, through it to see something else such as economic, social, and political forces, conflicts, and divisions that account for its fabrication and constitute its true meaning. Looking that way, our scholarship and criticism see the work only to be done being there with its revelation.

"Endless Prayers" frustrates this approach. It is clearly work of the highest artistic skill, yet its subject matter borders on the naïve or sentimental. It is not kitsch, but the material it treats, and even some of the imagery, is most often found in work scholars and critics would probably consider so – those praying hands, for instance. Storr notes this. Our critical faculties are confounded by the confident sincerity in apparently sentimental matters, and the pictures offer little that refers us to historical or sociological circumstances. The sitting man is unidentifiable, the hands are disembodied, and the concentric circle of rings is detached from recognizable locations. There is a presence, but it is heightened by the absence of identifiable individuals. Nothing specific is communicated about this person's history or about the world they inhabit. We don't know where he comes from, if he has a job, his sexuality, family situation, or anything else that might confer a recognizable or meaningful individuality. We don't know how he got here – migration, indigenous, or otherwise. We don't even know where he is. The paintings frustrate efforts to interpret them socially or politically, and historically or biographically, by suspending the worldly context that might determine their truth. They are lit by their own light, as it were – you can see it glowing in the picture.

What remains, what we are left with when these contexts have been reduced to nothing, is just the withdrawn presence of a person sitting, hands clasped together in the dark, an ascent into untold mysteries. What does this man stand for? Does he stand for anything? What do these hands ask for? What desire moves their longing? Where will it take him, and should we follow? Responding to these questions, wondering about them together, is how my friends and I managed the revelations of the pictures before us. One friend proved particularly willing, particularly glad to venture that response when he interpreted it as

calling on him, in person, on his desire, that is, to follow: "I want to go there, too." The more circumspect my gaze, the more hesitant I am to risk the adventurous response "Endless Prayers" calls for.

<div align="center">★★★</div>

To bring some conclusions to this essay... Robert Storr, I have said, is a critic who admits some revelations. His critical appreciation, "love" might be too much to say, of Kami's painting manages those revelations in writing that tries to disavow them. Like Storr, I have tried at certain moments of this essay to respond to Kami's paintings in ways that manage the revelation of the work that came over me when I saw it at LACMA.

Storr alludes to another type of criticism, which manages no revelation at all. It is dominated by the spirit of critique we in the university know well. When he listens to the voice of that spirit, Storr cuts off the revelation of prayerful states of bliss and well-being and disavows what has come over him.

My friend, believing wholeheartedly, didn't seem to hear that voice at all. What did he hear? What was the revelation that struck him? I know less about it because his response was less developed than Storr's as he ran off into the gathering darkness – or was it perhaps blinding light? I need gifted writers like Storr for revelations to be had more revealingly, more revealing than both my enthusiastic friend, on the one hand, and the circumspect scholars, on the other, who see the work only to see right through it.

And yet, Storr's gifts take him only so far on the journey opened by his revelation of "Endless Prayers," and he recoils. He attributes his recoil to an unspecified secularism: "A deep-seated secularism makes me twitch as I write these sentences," he says (Storr 26).

I have tried to say that what Storr calls his "secularism" is the spirit of critical scholarship and scholarly criticism, and indeed a critical spirit of a certain kind, one I would call disenchanted, the disenchanted spirit of critique. Calling it "secularism" risks saying that secularity has no interest in such states of grace. This seems an open question at best, and probably not the case.[3]

I also tried not to say that the difficulty we have encountering such works is with religious thoughts or feelings, religious longings or claims, provoked by works of art. I wanted to say instead that the difficulty concerns thoughts and ideas, feelings, or longings, that are traditionally managed by religions or that have for a long time and still are also managed by traditional religions. It might be the case that this fact – that the feelings and ideas have historically been located in religion – labels and classifies them in a way that renders them immediately suspect or off-limits to our critical spirit.

The distinction in how we state the difficulty is important, for it suggests that the problem that concerns me is not how secular scholarship and criticism treats religions or addresses the ideas and experiences promoted and discussed in particular religions – that is a problem, but it is not mine here. The problem that interests me is how criticism and scholarship treat certain ideas that dawn on us,

often surprisingly and unbidden, in the presence of a work of art, at least some of us some of the time, whether we identify as religious or not. Many of the feelings and moods, states of mind and world, longings and desires, that prove problematic are ones that have traditionally been addressed by religion and religious traditions. These ideas could be our revelations, but very often scholarly criticism and critical scholarship do not help manage them in ways that let them appear. Religions and religious traditions have some history of doing so.

Implied in my discussion, then, is the thesis that we scholars and critics could learn something from religion and the religions. I have tried at certain moments of this essay to perform that. I have tried to draw from my own study of religion and religions to suggest how we might manage our revelations in the presence of works of art. I have also tried to include examples of the sorts of conversations had when we do manage some. What was particularly striking to me about these conversations at LACMA was that the meanings and ideas that had come over my friends in the presence of these works mattered and mattered deeply to them. That is probably not surprising to most people, but to a scholar, it is. My friends were speaking about matters in their mattering, more than about the position of these works within the many histories where they might belong, including, too, the history of art. My friends were also speaking about works they appreciated, loved even. They put their concerns into their responses, and while not objective in this sense, their assured first-person responses prolonged the journey that was the revealing response to those pictures. They put themselves into it, a journey in to go up, "Endless Prayers."

## Notes

1 In the case of very powerful, transformative revelations, I can spend a lifetime trying to figure it out, even making my entire life into the figuring out of it. This is not usually the case for the revelations we have when we encounter works of art, but it is often the case that in their presence, something new dawns on us unexpectedly from out of the blue and our world changes, sometimes slightly but sometimes even radically.

2 In addition to his work as a professional critic, Storr is formerly Senior Curator at MOMA, retired Dean of the Yale School of Art, and Director of the 52nd Venice Biennale (2007). He is also a painter himself.

3 I have tried to show elsewhere how disenchantment might be separated from secularity. See *Arts of Wonder: Enchanting Secularity* (University of Chicago Press, 2013). Though that book does not consider disenchantment explicitly in light of the spirit of critique, it could be read as part of this discussion. I have begun to do so as I think about the issues it addresses together with works by Rita Felski: *The Limits of Critique* (University of Chicago Press, 2015) and *Hooked: Art and Attachment* (University of Chicago Press, 2020).

## Bibliography

Barthes, Roland. *Camera Lucida: Reflections on Photography*. Translated by Richard Howard. Farrar, Straus and Giroux, 1981.

Elkins, James. *Our Beautiful Dry and Distant Texts: Art History as Writing.* Routledge, 2000.
——. *Pictures and Tears: A History of People Who Have Cried in Front of Paintings.* Routledge, 2004.
Felski, Rita. *The Limits of Critique.* The University of Chicago Press, 2015.
——. *Hooked: Art and Attachment.* The University of Chicago Press, 2020.
Kosky, Jeffrey L. *Arts of Wonder: Enchanting Secularity.* The University of Chicago Press, 2013.
Madoff, Steven Henry. "Y.Z. Kami and the Fact of Mere Being." *Y.Z. Kami.* Gagosian Gallery, 2008.
Mahlouji, Vali. "Memories, Dreams, Obsessions: Sketching a Portrait of Y.Z. Kami." *Y.Z. Kami: Beyond Silence.* National Museum of Contemporary Art, Athens, Greece, 2009.
Marion, Jean-Luc. *Being Given: Toward a Phenomenology of Givenness.* Jeffrey L. Kosky, trans. Stanford University Press, 2002.
——. *D'ailleurs, La Révélation.* Grasset, 2020.
Storr, Robert. "Every Time I Feel the Spirit…" *Y.Z. Kami: Paintings.* Gagosian Gallery, 2014.
*Y.Z. Kami.* Gagosian Gallery, 2008.
*Y.Z. Kami: Endless Prayers.* Parasol unit foundation for contemporary art and Koenig Books, 2008.
*Y.Z. Kami: Beyond Silence.* National Museum of Contemporary Art, Athens, Greece, 2009.
*Y.Z. Kami: Paintings.* Gagosian Gallery, 2014.

# 5

# CURATING FAITH

## Art, Religion, and the Curatorial

*Daniel A. Siedell*

James Elkins' little book, *On the Strange Place of Religion in Contemporary Art*, has provoked strong responses from religious believers on the relationships between artistic practice and Christian faith in contemporary culture since it appeared in 2004. Based in part on his personal interactions with art students at the School of the Art Institute of Chicago, Elkins concluded that the art world:

> ...can accept a wide range of 'religious' art by people who hate religion, by people who are deeply uncertain about it, by the disgruntled and the disaffected and the skeptical, but there is no place for artists who express straight-forward, ordinary religious faith.

*(115)*

The response from artists and art writers of religious faith to Elkins' claim that there is "no place" in the contemporary art world mainstream for artists of "straight-forward, ordinary religious faith" was swift and vociferous. And, as this collection of essays reveals, there continues to generate responses nearly twenty years later.

But Elkins makes a crucial assumption that has gone largely overlooked among those artists and art writers who profess Christian faith. That assumption, which seems to be shared by his interlocutors, is that there exists something called "*straight-forward, ordinary religious faith.*"[1] But eighteen years later, as religious fundamentalism and extremism have become an increasingly urgent problem in the public sphere, from racial justice to planetary catastrophe, Elkins' presumption about faith needs revisiting. But moreover, my religious faith as a lived practice has evolved considerably since the publication of his book. This paper charts this course, a course itself that not only pushes against Elkins' thesis but its critical reception among artists and critics of faith. It also offers a different way to explore

DOI: 10.4324/9781003326809-7

this complex relationship between art and religion, and between artistic practice and religious belief, through the concept of the curatorial.

When Elkins' book appeared, I was already beginning to develop my thoughts that would lead to the publication of *God in the Gallery: A Christian Embrace of Modern Art* (Baker Academic, 2008). I am trained as a historian of modern art, theory, and criticism, studying European avant-garde and American neo-avant-garde activism in the 20th century. At the time, I was serving as Chief Curator of a university art museum, where I organized dozens of exhibitions per year and collaborated with numerous contemporary artists on publishing and exhibition projects. I attempted to reflect on my participation in the art world through the lens of my Christian faith. Several years later, I returned to this subject with a collection of short essays, reflections, and meditations that explored my relationships with modern artistic practices through a different set of theological concepts, which reflected not only my evolving understanding of modern and contemporary artistic practice but an evolving Christian faith that represented as many turns as my professional life.[2]

I discovered two things during the process of writing these books, and my experience of teaching modern art history at both public and private, faith-based institutions, collaborating with contemporary artists on exhibitions and practicing my religious faith through multiple church traditions. First, my personal religious faith has been shaped by and expressed through my experience with art. They simply could not be separated, and when I did try to pull them apart, often by relating through this or that theological discourse or cluster of concepts, what was lost was precisely what *gave life* to both my religious faith and my involvement with art. In addition, both art and religion generated and required similar gestures of faith, although it became increasingly clear that there was really only *one* practice of faith that found expression through two practices. This inseparability – even indistinguishability – challenged the limits of my theological resources. How could I think theologically about the fact that it was easier for me to think of religion and art, God and the aesthetic *together*, in relationship not necessarily as a stable totality, but as an unruly and unpredictable *assemblage of multiples* and in constant motion? In his book on the sculptor Auguste Rodin, with whom he had worked closely as his secretary, the poet Rainer Maria Rilke reports that the sculptor once told him:

> I learnt sculpture and I knew very well that it was something great. I remember now that in the *Imitation of Christ*, particularly in the third book, I once put sculpture everywhere in place of God, and it was right and gave the right meaning.

*(60)*

Rodin's substitution in this famous mystical text of Thomas à Kempis gave voice to my experience of contemporary art and my religious faith. When it came to my faith, it was often difficult, if not impossible, to distinguish whether its object was art or God, and whether I was practicing art theory or theology.

Second, given this hybrid faith, the indistinguishable continuity of art and religion in my practice of faith, which coursed through my professional and personal life, it became increasingly evident that I needed to find new theoretical-theological concepts, discourses, and ideas from and through which to understand and express it. Ecotheorist Timothy Morton's recent writing on art and ecology offered a way to rethink this relationship by rethinking what art does and how it reveals the uncanniness and strangeness of the earth and its inhabitants. For Morton art operates in the subjunctive mood, revealing that "things aren't directly, constantly present" and that "being isn't presence," that reality is something that we "feel," revealing itself to us only in slivers because there is a gap between "being" and "appearing," because things are never exactly as they appear. Therefore, truth is itself a feeling, a subjunctive mood, something that he calls "truthfeel," which art has the potential to disclose. The uncanniness of the world, in which there is not "true or false," but *kind of* true, *slightly* false, *almost* right, nevertheless opens up space for considerations of the spiritual. For Morton, then, art and religion are thus not so easily distinguished given their common aesthetic nature. In a description of his experience of the Rothko Chapel in Houston, Morton concludes,

> Religion is turned into something like appreciating art; appreciating art is turned into something like spiritual contemplation. And those two transformations don't neatly map on to one another.
>
> *(83)*

Both art and religion seep into one another. They relate but can't be mapped – that is, their points of relation isolated, demarcated, *stabilized*. This, I think, is why partisans on either side of the conjunction "and" ("religion" or "art") often work so hard to keep them apart, from one infecting the other. In fact, such hygienic gestures are evident in attempts to *relate them* by religious artists and critics. Such relations only work in particular ways, ways that maintain the authority of a religious tradition. However, such clarity and cleanliness ultimately became impossible for me – both art and religion, aesthetic appreciation and spiritual contemplation, operate in the realm of this truthiness, truthfeel, even the "slightly false." In fact, Morton goes so far as to suggest that to recognize and enjoy beauty, art, and the experience of wonder and enchantment (and I would add, the divine), *we must open ourselves to the possibility of being deceived.* (Was that *merely* a dream or was it a vision? Who can be sure?) But the fear of being deceived by the likes of Duchamp, Beuys, or Warhol has motivated modernist art theory to produce a rationalized discourse that can protect art from such deceptions, including its involvement with faith, of any kind. Morton argues,

> Art theory in modernity tends to want to distinguish art from conning or selling or ripping off, and from the dreaded status of "object"; and this results in art's confinement to a tiny experiential region…
>
> *(85)*

As art, so too religion. Critics of religious faith as well as its defenders do battle over precisely this notion of being deceived, conned, or otherwise ripped off. Adherents of religious faith, especially its theorists – whom we call theologians – defend its reasonableness and justifiability.[3] So, following Morton, whether it is Duchamp's *Fountain* (1917) or the theological concept of the Resurrection, deception and doubt are an inherent part of *both* contemporary art and religion. *Both* require faith to practice them, as well as living with the feeling of their (potential) ridiculousness and irrelevance. It is the work of faith, believing though not seeing, or at least seeing through a glass darkly, that is crucial for both art and religion to work, that is, to generate enchantment, wonder, and allow the spirit to move.

My faith in art as a vulnerable and fragile – even absurd – practice, in constant need of justification, had manifest this incomplete – shimmering "slightly false" but perhaps "kind of true" – throughout my career as an art historian and curator. The opening sentence of T.W. Adorno's *Aesthetic Theory* (1970) sums up my experience of modern and contemporary art's fragility and vulnerability.

> It is self-evident that nothing concerning art is self-evident anymore, not its inner life, not its relation to the world, not even its right to exist.
>
> *(1)*

But while my professional practice as an art historian, art critic, and curator worked with and embraced the lack of self-evidence and the vulnerability and fragility of faith, this seemed not the case with the theological discourse I brought to the aesthetic experience. In other words, I sought to ground, to anchor this fragility in theological discourse. So, I sought from theology a way to justify artistic practice, to pin it down, or, at least, to stabilize it, which is why my access to theology was firmly within creedal and ecclesial orthodox traditions, whether evangelical, Reformed, Lutheran, or Eastern Orthodox. Theology thus served as an *anchoring* discourse, something around which I could stabilize the flickers of aesthetic and religious experience. It also served as a hygienic discourse, one that could clean up, clarify, and scrub away the seepages and leakages, and cleanse the brackish mess that discomforted the vagaries of both my involvement with art and religious practice. So, theological discourses were means by which I could find ways to clarify and sort, stabilize, and anchor my shifting, undulating, flickering faith in both art *and* religion. However, these theological discourses often overwhelmed or even suffocated the delicate and fragile and ever-changing experiences of art and religion.

What has only gradually and at times uncomfortably become apparent is that my deployment of theological discourse had dulled the intensity of both my practice of and experience with art and religion. What I began to search for, then, was a theological discourse that didn't have the first and last word, a discourse that could be as vulnerable, fragile, unjustifiable, and unexplainable as my experience with art. Indeed, I needed to find a theological discourse that itself shimmered, that was as intense, potentially deceptive as my lived experience of religious faith, which could not be purified of my experience with art. I needed

to find theological tools and materials that might help construct a more useful contraption that could actually account for how I experience religious faith, not *how I thought it should be*. I needed a discourse that was not afraid of truthfeel, truthiness, seepage, leakage, doubt, and even the threat of self-deception. My desire for such a discourse led me to study theology with Catherine Keller at Drew Theological School, a theologian whose work was shaped by process philosophy, deconstruction, feminism, ecological justice, and theopoetics.

What I discovered is what John Caputo calls "radical theology, a discourse of "disturbances" at the edges of confessional theology, a discourse that reflects on the texts, practices, discourses, and concepts of confessional communities "without *normative authority*" (5). Crucial for Caputo is what he calls the "theopoetic reduction," in which the "logos of theology" are weakened, "without falling into the illogical and irrational." Theological discourse becomes a "poetics," a creative iteration of the implications of God, or, in Caputo's language, the event or what is going on in or harbored by the name, "God." Unhooked from the tether of orthodox or traditional theology, this "theopoetics" creatively deployed traditional (as well as heterodox) theological concepts without the pressure of either origins or teleology – Beginnings and Endings – that characterizes the traditional theological discourses and practices with which I was familiar.

This so-called radical theological practice dwells in murkiness and opacity, what Caputo calls "weak" theology, a theology that is entangled with how God appears in the world of experience, how we might think or practice in light of what occurs under what we might call "God," an entity that doesn't "exist" but "insists," and a God that needs "doing" as Catherine Keller puts it. I am reminded of Gilles Deleuze's provocative claim that theology is the "science of non-existing entities" (Deleuze 1999, 281). This is a God that mathematician-turned-philosopher A.N. Whitehead called the "eros of the universe," a God who is in all things, a God of endless and boundless creativity within the cosmos, who is "the poet of the world," and who is also not transcendently omniscient and omnipotent but impossible to untangle or extricate from the world. As Whitehead claims, "It is as true to say that God creates the World, as the World creates God" (348). Perhaps this is the God that Deleuze was referring to when, in his reversal of the (Kantian) argument against atheism (without God all is permitted) in the context of El Greco's painting, Deleuze exclaims, "For with God, everything is permitted" (Deleuze 2003, 10). It is also the God of the poet Rainer Maria Rilke, who wrote in his Tuscan diary, "God is the most ancient work of art" (Baer 2006, 169). That same year, in a short article on art, Rilke observes, "And when the devout say: 'He exists,' and the sad feel: 'He once did exist,' the artist smiles: 'He will exist'" (Baer 2006, 180). His belief is thus a creative constructive practice; for he, himself is helping to build this God *through his belief*. Following Rilke and Deleuze, theology is a *creative* practice of belief, of a belief in this world. This God weaves through experience, a God to come, a God that is hidden, immanent, creative, and "weak," eschewing sovereignty and transcendence, whose attempt is, as Whitehead claims, to express "tender care"

and to "save all that can be saved" (346). Rilke's God cannot be constrained by or reduced to the creeds and confessions of "orthodoxy" – or even to heresy and heterodoxy. It is also Rilke's God that German playwright and theorist Bertolt Brecht called "totally gay" (*absolut schwul*) (Baer 2014, 61).

I began to experience this hidden, immanent, heterodox, creative, "weak" and "totally gay" God can be found lingering on the margins, where mysticism predominates and where the careful and stable distinctions of the orthodoxy, heterodoxy, and heresy cannot be maintained. And perhaps where the distinctions between "belief" and "unbelief" cannot be determined. In addition to the crucial role that Whitehead, Deleuze, and Rilke have played in my emerging work as a theologian that deploys a process-oriented, theopoetic, and brackish theology, other religious and artistic figures found their way to co-exist in my emergent constellation of belief. Such religious figures as Nicholas of Cusa, J.G. Hamann, Gerhard Ebeling, Thomas J.J. Altizer, Marcella Althaus-Reid; philosophers like Ernst Bloch, Walter Benjamin, Hegel, and Lacan; and artists and writers like Octavia Butler, Nick Cave, Marcel Duchamp, Kurt Schwitters, Enrique Martínez Celaya; as well as my teachers Catherine Keller and Stockholm-based theologian Petra Carlsson Redell.

But to return to Elkins' little book. Re-reading it for this discussion, *"straight-forward, ordinary religious faith"* simply does not describe my practice of religious faith. It presupposes a static, one-size-fits-all kind of faith that does not grow, emerge, recede, lay fallow, and re-emerge in new guises – which reflect a living process that is responsive to life.[4] In my case, my involvement with art, not just as an art professional, one who studies the visual arts, but as one whose experience of the world (and of God) has been shaped through relationships with works of art, is anything but straightforward and ordinary. According to Morton's approach to art and experience, *nothing* is straightforward and ordinary. It's all a bit weird, even a bit queer.

So how do I propose to think these murky, brackish waters of art theory and theology, experience and confession, faith and doubt, God and world, and art and religion – where we're not sure what we're seeing or experiencing or talking about to describe such experiences seem inadequate or deceptive, even delusional, and if the object of our study, observation, and experience keeps eluding our grasp, receding from us.

If "God" doesn't so much *exist* as *insists* (Caputo), if "God" can be interchangeable with "Art" (Rodin), is inseparable from the world (Whitehead) and seems to appear under several guises, whether under the event "God" or the event "Art," and if we make or do God (Rilke and Keller), how does theology account for this entity or experience that seems incapable of remaining still an entity that shapeshifts, not unlike the electron in quantum mechanics, which can appear either as a "wave" or as a "particle?" How do we think theologically about what we're not sure we're experiencing, certain only of its glowing intensity? *They need to be curated.*

In quantum theory, the electron behaves like a wave or a particle *depending on how it is measured*. The electron appears as a wave or particle *only through such*

*measuring apparatus.* But how can this shifty, shadowy experience of art and religion be measured? What is the apparatus? My experience of art and religion — their relationship, their inextricable contamination, their constantly flickering slippage and movement — was negotiated *in and through my curatorial practice.* I therefore negotiated my experience of and faith in art and religion not primarily through art history, art theory, or theology, *but through the curatorial.* I suggest that the concept of the curatorial and curatorial practice might offer a more productive way to think about how art (and the art world Elkins seems to have in mind) and religious faith relate, which faith is anything but straightforward. Elkins' cosmos is a mechanical and Newtonian one of objects and empty spaces, in which there exist things like "straight-forward religious faith." As Morton observed about this quantum cosmos, "No God could be omniscient in such a world…" (91). What is needed is a quantum theory of art and religious faith that is comfortable with energies, intensities, flickering, and indeterminacy. Art and religious faith need to be *curated.* (And for the faithful, who live and breathe and have their being in and through art, I suggest that is what they are *already doing.*)

## But What Is the Curatorial? What Is a Curator?

It is no secret that the concept of the curatorial has migrated from art museums into the broader cultural domain. As a *New York Times* article suggested in 2020, "everyone's a curator now, from social media feeds and playlists to meals and vacations (Stoppard). But curatorial practice is much more than merely the collection or consumption of preferences and I think reflecting on the curatorial might offer other ways to think about the relationship between contemporary artistic practice and contemporary religious practice.

The figure of the curator developed from the *"cura"* tradition in ancient Roman literature and in the bureaucracy of the Roman Empire as "caretakers" of aqueducts and public supplies. It connotes, on the one hand, being weighted down with anxieties and troubles, and on the other, it is an expression of concern for the welfare of another, conscientiousness, and devotedness.[5]

The most complete expression of this ancient Roman and Latin tradition is a fable by the Roman poet Gaius Julius Hyginus about a mysterious quasi-goddess figure named Cura, who, after crossing a river, fashions a human from the mud she finds on the other side. It owes its notoriety in philosophical thought to Martin Heidegger, who quotes it in full in *Being and Time* and devotes considerable time discussing it in relation to *Da-sein* as "care" (184–186).

The curator cares for works of art, through their preservation, presentation, and interpretation. But the curator expresses care not only for isolated objects and artifacts but also for these objects and artifacts *in relationship.* The curator works with multiples, assembling works in relation to others. Moreover, the curator cares not only for the artifacts but also for other human beings, with whom she *shares* these cared-for works through *exhibitions,* that is, a relational assemblage. It is this public, social, and relational dimension of the curatorial that is most crucial for my

negotiation of art and religion, in which questions of belief, doubt, knowledge, experience, and affect are posed in relation to each other. As Swiss curator Hans Ulrich Obrist observes, "to curate, in this sense, is to refuse static arrangements and permanent alignments and instead to enable conversations and relations" (Obrist 2013). The exhibition, the result of curatorial practice, is an assemblage of artifacts, images, concepts, and ideas *in relation*. Importantly, this assemblage is always *temporary*. Obrist continues, "Curating, after all, produces ephemeral constellations that disappear" (Obrist 2007). Exhibitions last for only a few weeks and then are dismantled, the objects are returned to their lenders, to their place on the rack in storage, or they find their way into other exhibitions, in other new assemblages.

The curated exhibition is always more than merely the sum of its parts – individual works of art, particular images hung or projected on walls or displayed on pedestals. It generates particular relationships that are, however, *always changing* because visitors to the exhibition move through the spaces, galleries, and rooms in different ways and different directions. The exhibition galleries are not linear and so offer multiple ways of moving through them as the "junctions" or juxtapositions of works of art, and generate connections, conversations, and relationships that would not have emerged otherwise. Moreover, despite the curator's agency in selecting and installing the work, the relationships that emerge cannot be reduced to curatorial intention. On many occasions, visitors, students, or docents pointed out relationships between works that they presumed I had intended but had not. What was revealed, then, in the exhibition, exceeded the intentions of the curator. Curatorial theorist Elena Filipovic suggests that this reality makes the exhibition a particularly powerful means for generating new experiences, critique, and activism – even new forms of knowledge and understanding. Filipovic observes,

> At their best, exhibitions venture out on a limb, allowing all of the strange and wondrous incommensurability of the artwork to provoke its own terms of engagement. Such an endeavor could only be subjective in the extreme, and, as a result, fallible, inexhaustive, potentially contradictory, and provisional...
>
> (76)

For Filipovic, it is its fragmentary, ephemerality, and even "potentially contradictory" nature that characterizes the potential power of the exhibition, that is distinctive artifact of curatorial practice. Theorist of the curatorial Jean-Paul Martinon describes it this way:

> As our bodies move in space, the curatorial proceeds by inventive steps or missteps from space to space. As such, the curatorial is a disruptive generosity...that can never be properly translated into language and always gives the slip to the economy of received and exchanged knowledge.
>
> (29)

For Martinon, as well as other theorists, the exhibition is just one dimension of the curatorial, which he defines as a "disruptive generosity" of thought and practice that cannot be reduced to language and exchange. Both Filipovic and Martinon affirm the partial, contingent, and ephemeral nature of curatorial practice, whether or not it results in "exhibitions." It is no coincidence, then, that their concepts of the exhibition and the curatorial resemble radical theology, a "weak" theology that subverts and disturbs stable and sovereign concepts of God and the theology discourse in general.[6]

Filipovic and Martinon draw attention to the reality that to experience art in art museums is not a solitary merely static and contemplative experience. The art museum is a bustling public space buzzing with multiplicities: bodies, discourses, sounds, experiences, and competing interests that represent the hive of energies that can only be loosely and temporarily assembled, marshaled, and guided by the decisions of a curator or a team of curators. Not all works of art appear equally at any one time. We get glimpses or overlook them completely – until they emerge out of nowhere on a return visit when we least expect it. The curatorial dimension of the art museum encourages experiences that are non-linear, imaginative, and creative. It generates the potential for ideas, concepts, artifacts, and images to be put in temporary relation that provoke effects, feelings, emotions, memories, experiences, and concepts that defy "logic" and resist prediction (and mere repetition), description, and explanation. Through the exhibition, as one of the artifacts of the curatorial, the curatorial demonstrates that there is no "pure" experience of art.

In an essay on Robert Rauschenberg's white paintings of 1951, the composer John Cage suggests, "'Art is the imitation of nature in her manner of operation.' Or a net" (100). The curatorial functions something like Cage's net – attracting, collecting not only works of art on view in a room but *all* that occurs therein, notwithstanding our own thoughts, feelings, memories and the bodies, the sounds, and the movement within which our experience of the works of art takes place. The curatorial casts a net, yet that net is neither constricting nor constant – what it yields is always changing and surprising as we negotiate the galleries, moving through and experiencing works of art in always new ways, with new assemblages.

So, how might this concept of the curatorial allow us to revisit the relationship between contemporary art and religious faith that circumvents Elkins' flat binary opposition between "first-rate" art and "straight-forward religious faith" that many of us have been locked into since 2004?

The curatorial as a "measuring apparatus" and as a "net" rejects the hygienic binary opposition between modern and contemporary art and religious faith and accounts for the diversity and complexity of the experience of art and the experience of religious faith that cannot be separated, at least in my case. Instead of trying to separate and clean up the mess, the curatorial works in and through such unhygienic messes, to generate temporary and ephemeral relationships and juxtapositions. Religious faith, like artistic practice, cannot be predicted, pinned

down, stabilized, and categorized. The curatorial is to my mind a methodological concept that might help rethink these relationships between artistic and religious practices, God and art, theory and theology, and the role of faith in both practices that can more appropriately give voice to the joys of life guided and shaped by art and religion.

But there is also something else about the curatorial that is crucial for this rethinking. The exhibition is never "permanent." The exhibition is only a temporary apparatus, a temporary net, perhaps for a week or a few months. And then, the installation is dismantled and new artifacts and ideas are brought into the space to be unpacked and installed. Therefore, the concept of curating art and religion means that it is never static, which will be dismantled in order to make way for new exhibitions and new presentations of this art-religion assemblage. It has been this pace of installation, de-installation, and re-installation that more accurately represents my experience of a life devoted to the practice of faith – in art and in God – as it manifests itself in and through diverse iterations in the classroom, museum space, church service, and every place in between.

The curatorial, however, is not "representational" but is creative; that is, it does not describe but construct. For example, as Hans Ulrich Obrist writes:

> ...an exhibition is not an illustration. That is, it does not, ideally, represent the thing it purports to be "about".... Exhibitions, I believe, can and should go beyond simple illustration or representation. They can produce reality themselves.
>
> *(Obrist 2014, 167–168)*

To curate faith (in God, in art) is to *create* it in the process. The curatorial is a theopoetic activity. Again, for Rilke (and Caputo), God is a God who will be, a God to come. Rilke writes:

> He will be and those who are lonely and extract themselves from time, build him with their heart, head, and hands the way lonely individuals are creative and build art-works (that is: things of the future), build him, begin him, the one who will at some point be when time will be filled with eternity.
>
> *(Baer 2006, 180)*

The challenge for those of us who practice a religious faith and whose lives have been shaped by and through artistic practice in whatever form it takes (makers, curators, critics, et al) is to continue to curate ever more expansive, imaginative, even radical exhibitions of art and faith and somehow and in some way live them out. The curatorial is a way to theorize *and practice* this murky, messy, complex, yet life-giving relationship that most of us have already been practicing.

## Notes

1 This chapter will not explore another arguable assumption that Elkins and many of his interlocutors make, that religious faith presumes that the art that will be generated will be "religious art," and that such religious faith will naturally find expression in religious content, an assumption I reject.
2 See my *Who's Afraid of Modern Art? Essays on Modern Art and Theology in Conversation* (Cascade, 2015).
3 See, for example, Graham Ward, *Unbelievable: Why We Believe and Why We Don't* (I.B. Tauris, 2014).
4 For approaches to religious language in relation to belief and unbelief, see Christian Wiman, *My Bright Abyss: Meditation of a Modern Believer* (Farrar, Giroux & Strauss, 2013) and Bruno Latour, *Rejoicing: Or the Torments of Religious Speech*, trans. Julie Rose (Polity, 2013).
5 See Stefan Novotny, "The Curator Crosses the River: A Fabulation," in Jean-Paul Martinon, ed. *The Curatorial: A Philosophy of Curating* (Bloomsbury, 2013). See also Maria Puig de la Bellacasa, *Matters of Care: Speculative Ethics in More Than Human Worlds* (Minnesota, 2017). John T. Hamilton, "Homo Curans," in *Security: Politics, Humanity, and the Philology of Care* (Princeton, 2013). Hans Blumenberg explores Heidegger's use of the fable of Hyginus (64 BCE–17 CE) in *Care Crosses the River*, trans. Paul Fleming (Stanford, 2010).
6 This essay is the result of my doctoral research for a dissertation entitled, "Exhibiting God: The Curatorial as Theological 'Practice'," at Drew Theological School.

## Bibliography

Adorno, T.W. *Aesthetic Theory*, intro. and trans. Robert Hullot-Kentor. 1970; University of Minnesota Press, 1997.

Baer, Ulrich. *The Rilke Alphabet*. Fordham University Press, 2014.

———, ed. and trans. *Rainer Maria Rilke: Letters on Life*. Modern Library, 2006.

Cage, John. "On Robert Rauschenberg, Artist, and His Work." *Silence: Lectures and Writings*. Wesleyan, 1961.

Caputo, John. *In Search of Radical Theology*. Fordham University Press, 2021.

Deleuze, Gilles. *Francis Bacon: The Logic of Sensation*, trans. Daniel W. Smith. University of Minnesota Press, 2003.

———. *The Logic of Sense*, trans. Mark Lester with Charles Stivale, ed. Constantin V. Boundas. Columbia University Press, 1999.

Elkins, James. *On the Strange Place of Religion in Contemporary Art*. Routledge, 2004.

Filipovic, Elena. "What is an Exhibition?" In *Ten Fundamental Questions of Curating*, ed. Jens Hoffmann. Mousse Publishing, 2013.

Heidegger, Martin. *Being and Time*, trans. Joan Stambaugh, foreword. Dennis J. Schmidt, 1953; SUNY Press, 2010.

Martinon, Jean-Paul, ed. *The Curatorial: A Philosophy of Curating*. Bloomsbury, 2013.

Morton, Timothy. *All Art Is Ecological*. Penguin, 2021.

Obrist, Hans Ulrich. *Everything You Always Wanted to Know About Curating*. Sternberg Press, 2007.

———. *Sharp Tongues, Loose Lips, Open Eyes, Ears to the Ground*. Sternberg Press, 2013.

———. *Ways of Curating*. Faber and Faber, 2014.

Rilke, Rainer Maria. *Auguste Rodin*. 1907; Dover Press, 1967.

Stoppard, Lou. "Everyone's a Curator Now." *New York Times*, March 3, 2020.

Whitehead, Alfred North. *Process and Reality*, ed. David Ray Griffin and Donald W. Sherburne. The Free Press, 1978.

# 6

# A LOVING REGARD

## Contemporary Art and Expanding the Archive

*Elissa Yukiko Weichbrodt*

We are standing in a gallery, looking at Carrie Mae Weems' installation *From Here I Saw What Happened And I Cried* (1995–1996). A syncopated row of thirty-three framed photographs lines the wall. But rather than displaying photographs she herself has made, Weems gathers and repurposes existing photographs of Black bodies.

She begins and ends the series with an early 20th century photograph of a Mangbetu woman, photographed in profile, her chin jutting out to balance the elaborate crown of braids on her head, and her bare breasts silhouetted against the blurry landscape. But Weems also alters the historical image. Instead of a sepia tone or gray-scale print, the photograph is a cool blue; the woman's skin becomes a rich navy in the shadows, with pale gray-blue highlights. Text – written in an all–caps, serif font – is etched into the protective glass and floats just above the image. The words begin, "FROM HERE I SAW WHAT HAPPENED."

The text continues across the next thirty-one images, but these are tinted a brilliant crimson and framed by circular black mats. As we walk down the row of photographs, the hovering words weave a poetic narrative of Black marginalization and suffering, as well as resistance, complicity, and struggle. We reach the end. The final image is a mirror of the first; the Mangbetu woman now faces to the left, gazing back over the blood-red images in between. Over the darkness of her shadowed shoulder, we read, "AND I CRIED."[1]

It may initially seem strange to include this artwork in a volume on the relationship between religion and contemporary art. Its gritty imagery does not invoke transcendence or spur the viewer to spiritual contemplation. We could, perhaps, explore Weems' references to Yoruba, Caribbean, and Christian practices that have shaped Black endurance and resistance in American history. That is, we could consider the role of religion in the *production* of a contemporary artwork.

DOI: 10.4324/9781003326809-8

But my primary interest here is found in another question. How might religious commitments provide a framework for the *reception* of an artwork? In this chapter, I argue that the Golden Rule – the injunction found in almost all historical and contemporary religions to love others as oneself – can also apply to an engagement with visual art. While acknowledging the broad application of this ethic of reciprocity, this chapter also seeks to identify how Christian religious commitments in particular might shape a viewer's response. I begin with the notion of the Archive, identified and critiqued by poststructuralist and postcolonial scholars, to describe the way that artworks and images coalesce to shape our cultural understanding of who and what we honor, admire, objectify, or deride. That is, the Archive impacts who we consider worthy of our care. To follow the Golden Rule, then, necessitates that we recognize the Archive's limitations and counter the ways it might limit our view of "others."

Throughout the chapter, I explore how Weems' installation *From Here I Saw What Happened and I Cried* does just that. Weems utilizes and critiques the Archive, but she also offers an alternative path; she expands the Archive so that it more fully encompasses the diverse texture of humanity *and* acknowledges our human limitations. Finally, her artwork proposes a response anchored in love for the other. The concluding "AND I CRIED" resonates with the Judeo-Christian practice of lament. Weems thus offers a case study of how art itself can make evident the limitations of our literal and figurative archives while modeling an empathetic, loving regard for one's "neighbor."

## The Archive

An archive is a repository, a collection of artifacts and documents held by an institution or organization as a historical record. In the simplest sense of the word, Weems presents us with a photographic archive in *From Here I Saw What Happened*. She offers us a collection of historical images, literally excavated from institutional collections. The ethnographic photographs that bracket the installation are George Specht's *Nobosodru: Femme Mangbetu*, taken in 1925 while on an expedition to central Africa. The first four red-tinted images are daguerreotypes taken by the South Carolina photographer J.T. Zealy at the behest of Swiss anthropologist Louis Agassiz and now under contested ownership by the Peabody Museum at Harvard University. We see the well-known abolitionist carte-de-visite *The Scourged Back*, distributed by the McPherson & Oliver Studio, Garry Winogrand's infamous 1967 photograph *Central Park Zoo*, and a collection of studio portrait photographs of African Americans that hail from the late 19th century. In a sense, as Weems seeks out, rephotographs, and reorganizes existing photographs, she functions more like an archivist than a high art photographer.

But an archive is not merely a receptacle of history. As a number of critics have demonstrated, it is also a means of interpreting the past and thus constructing the limits and possibilities of our present. To distinguish this more expansive use of the term as a conceptual frame, I choose to capitalize it: the Archive.

In *The Archeology of Knowledge*, Michel Foucault argues that the Archive is not "the library of libraries" but instead "the system of discursivity" (*The Archaeology of Knowledge* 128–129). That is, the Archive is a means of constituting knowledge and determining the rules for what can and cannot be said within that structure of power relations. Foucault explains,

> By the archive, I mean first of all the mass of things spoken in a culture, pre-served, valorized, re-used, repeated and transformed. In brief, this whole verbal mass that has been produced by men, invested in their techniques and in their institutions, and woven into their existence and their history
>
> *(Foucault Live 66)*

But these rules – this discourse – are not permanent or fixed. Knowledge is not a preexisting object floating about in culture that needs to be captured and pre-served. The construction of taxonomies, the process of acquisition, the division of disciplines, the gatekeepers to collections, and the practice of citations may all seem unquestionably natural to some, but they operate within and reinforce a particular notion of knowledge. The Archive is how we produce knowledge, not simply preserve it.

## The Archive and Art History

Artworks, likewise, make meaning within what Foucault would call a discursive field. Art objects themselves do not contain "meaning" like a discrete, hidden treasure. As viewers, we assign significance to them, and though the process seems natural, it is governed by cultural conventions. We treat artworks as signs and as objects that point to meaning outside themselves. These signs, in turn, make sense because of our past experience. Alex Potts uses the example of Leon-ardo da Vinci's *Mona Lisa* to demonstrate this (20–34). When we treat the work as a "painting of something and not just paint on canvas" we are interpreting it, recognizing it "as a particular type of visual image designed to evoke an object in the real world" (Potts 23). Museum-goers' apparent "impulse" to identify the meaning of an abstract painting is, likewise, the result of conventions. We engage with artworks not as objective viewers in a sterile environment but as subjects within a cultural discourse.

Certainly, there has been robust debate within the field of art history over what precisely happens when we interpret an image or cultural object. Should artworks be considered autonomous objects, disconnected from the surrounding world and creating meaning exclusively through formal means (Fried)? Or are artworks products of cultural environments, in which case we must take into account not only their subject matter but also their historical context (Panofsky)? Is it even possible to recontextualize an artwork given our own subjectivity (Bal and Bryson)? Is the meaning of an artwork, a sign, ever secure, and singular or is it always polysemous and shifting? What is the interpretive relationship

between traditional "high" art and visual culture? And yet even this debate operates within a discursive field, an Archive, "a practice which has its rules, its conditions, its functioning, and its effects" (Foucault, *Foucault Live* 66).

A full exploration of this debate is beyond the scope of this chapter. Yet on a practical, descriptive level, I find the imagery of the Archive helpful for describing the process of making sense of cultural objects I encounter. We may not be able to precisely name or identify the other images in our Archive, but they nonetheless play a powerful role in how we sort and understand new things that we see.

Of course, we know that artists are often very purposeful in referencing an assumed Archive, connecting their work to others that came before them. Most viewers of the *Lansdowne Portrait*, the iconic image of George Washington painted by Gilbert Stuart in 1796, for example, would confidently categorize the subject as someone who has authority. This interpretation develops not from some universal visual code of leadership, but because the viewer's Archive is populated with figures in a similar pose and setting. Washington's erect, three-quarter pose, slightly lifted gaze, and outstretched arm echo the regal carriage of the *Augustus of Primaporta* and Grand Manner portraits of kings like Hyacinthe Rigaud's *King Louis XIV* (1704). When we learn more about the particular historical context of Stuart's portrait, we can better understand the implications of specific choices, such as the emphasis on Washington's civilian status and the inclusion of symbols borrowed from the Roman Republic such as the eagle and the fasces. Still, it is the Archive that provides the initial, seemingly intuitive category of interpretation.

Artists have also achieved their ends by purposefully *diverging* from the expectations set by the Archive. Francisco Goya applied the pose of a Christian martyr to a political prisoner in *Third of May 1808*. Edouard Manet upset visitors to the French Salon in 1865 when he painted *Olympia,* a reclining female nude, as a contemporary prostitute rather than an idealized goddess. And contemporary artist Julie Mehretu has made monumental paintings that remind us of maps but that complicate rather than clarifying our understanding of space and place.

Weems, of course, makes her use of the Archive explicit in *From Here I Saw What Happened and I Cried.* By appropriating photographs, Weems pushes our largely unconscious or invisible interpretive processes to the surface. She asks us to pay attention to the images already in our heads. However, Weems does not simply replicate a historical archive. Instead, like other cultural critics, she calls attention to the power – and the dangerous limitations – of our collective Archive.

## Critiquing the Archive

Like Foucault, Jacques Derrida interrogates this expansive notion of the Archive in his lecture and subsequent essay *Archive Fever*. Derrida is particularly concerned with what he calls "archivization," the technical methods that shape and limit what can be preserved (17). If Sigmund Freud had access to email,

to fax machines, and to the telephone, Derrida argues, the entire history of psychoanalysis would be rewritten. This is because different kinds of records shape what kind of knowledge can be produced (16). The Archive is thus conditional rather than transcendent, shaped by technological, political, and cultural forces (Manoff 12).

When we ignore these contingencies, however, and assume that the Archive is an objective, naturally occurring phenomenon, we miss the ways that the Archive can be purposefully used to surveil, control, or erase certain communities. Theorist Gayatri Spivak, first in her influential essay "Can the Subaltern Speak?" (1988) and then in *A Critique of Postcolonial Reason* (1999), argues that western scholars have – inadvertently or not – reimposed a western hegemonic structure on their study of the "other" that fundamentally denies their agency as full human subjects. The subaltern appears in the literal colonial archive only under circumstances that serve the colonizers' interests. Other events, artifacts, and "texts" in the most expansive sense can be ignored as irrelevant. This institutionalized way of producing knowledge, what we're referring to as the Archive, can present the illusion of comprehensiveness even as it actively excludes.

These same limitations are present in the visual Archive and are especially evident in the realm of photography, Weems' chosen medium. As such, we will focus on photographic images for much of this chapter. Photography's claim to indexicality is central to its function as an archival tool. In his 1986 essay "The Body and the Archive," Allan Sekula links the invention of photography in the 19th century with the simultaneous development of literal and metaphorical archives in Europe and the United States.

According to Sekula, photography's presumed truthfulness gave the medium extraordinary social power. Photographs could function both "honorifically" and "repressively" to create a seemingly natural social hierarchy. We see the honorific usage in the proliferation of photographs that applied the visual conventions of bourgeois portraiture to middle- and working-class individuals (Sekula 6). On the contrary, police and medical photography created a visual vocabulary for the "deviant" body. Sekula writes,

> The general, all-inclusive archive necessarily contains both the traces of the visible bodies of heroes, leaders, moral exemplars, celebrities, and those of the poor, the diseased, the insane, the criminal, the nonwhite, the female, and all other embodiments of the unworthy
>
> *(10)*

It operates through contrast, teaching us who to look up to and emulate, and who we can look down upon.

As the photographic archive grew, it also shaped the representation of bodies in art and broader visual culture. For example, illustrators for *Harper's Weekly*, a popular magazine in 19th century America, frequently translated photographs into woodcuts that could be more easily reproduced by the mass publication.

Woodcuts of presidents and celebrities and mugshots of criminals simplified and sometimes exaggerated elements from photographs, recirculating and reinforcing social categories that seemed natural and unquestionable.

## Exposing the Archive

*From Here I Saw What Happened and I Cried* raises similar concerns about the ways we naturalize the images we repeatedly see. Indeed, the work actually began in response to an uncritical embrace of a literal photographic archive. In 1995, Getty Villa in Malibu, California, departed from its usual emphasis on classical and European art and hosted an exhibition of mid- and late-19th century photographs of African Americans. The show, entitled *Hidden Witness*, was one of the very first major museum exhibitions to focus exclusively on historical images of Black Americans. It was guest-curated by an avid collector, Jackie Napoleon Wilson, who also owned many of the images. The collection included photographs of enslaved people, such as Black women with the white children they cared for, but it also contained portraits of beautifully dressed Black women, Black soldiers and firefighters in uniform, and Black family units. The photographs of free antebellum Blacks, in particular, offered a startling alternative to more widely reproduced images of Black suffering. Displayed in a dimly lit room in their original, velvet-lined cases, the photographs were offered as honored relics, portals to a forgotten past. Indeed, in his wall texts for the exhibition, Wilson tended to treat all photographs as transparent sources of information, providing direct access to the photographic subjects. As art critic David Pagel noted, Wilson "freely speculated about the attitudes, feelings and personalities of the mostly anonymous sitters."

For example, an 1862 photograph by Henry Moore depicts a large group of Black men, women, and children sitting and standing in front of small, wooden structures while a white Union officer stands in the foreground. The image is titled "Slaves of General Thomas F. Drayton" and was taken on the occasion of the Union occupation of the general's property. In the exhibition text, Wilson provides this scant historical information, then goes on to confidently interpret the body language of the various figures (17). "One woman stands defiantly," he writes, "The tallest man, the Negro in the center, gestures with his hands. As a slave-driver, he was probably as hated as the former master and would have been ostracized by these still-enslaved Americans" (Wilson 17). As art critic Susan Kandel observes, in this caption and others Wilson suggests that the photographs offer unmediated access to the past.

The Getty invited Weems to make an exhibition of her own in response to *Hidden Witness*. Although initially skeptical, Weems eventually agreed and crafted an installation intended to "implode the show, add[ing] a different level of experience and issues of race and gender" (qtd. in Muchnic). To Weems, the weakness of *Hidden Witness* lay in its assumption that the photographs told a clear story of Black success or resistance under dire circumstances. The show

uncritically added to the literal archive without acknowledging the history, limitations, and stakes of the cultural Archive. In *From Here I Saw What Happened and I Cried*, Weems rephotographed a number of the images included in *Hidden Witness*, but she also set out to push the apparatus of the Archive to the surface and engage it both critically and generatively.

Weems accomplishes this in several ways. First, she disrupts our conventional ways of looking at historical images. With the exception of the two book-ending photographs, all of Weems' rephotographed images are tinted blood red. The cool objectivity or sweet nostalgia of black-and-white photographs thus becomes charged with a deeply emotional color. It feels as if we are looking at the image through a pool of blood. Weems also presents all of the photographs in circular mats, creating a telescopic effect. We are implicitly distanced from the images and made aware that our access is anything but direct. A final way that Weems upends our expectations is by her use of language. The text refused to stay confined below the image, like a traditional caption would. Instead, her words – literally cut into the protective glass – hover over the image. We cannot see the image without seeing the text, and we cannot read the text without seeing the image. Often, the text and the image seem disconnected or even at odds with each other. These artistic strategies are not merely aesthetic. Rather, Weems provides us with the opportunity to recognize and question the ways that we have been taught to interact with photographs.

Second, Weems makes the Archive's absences and erasures evident. That is, she alerts us to the fact that the Archive is a construction, not an objective, descriptive collection. We see this in another passage of the installation that classifies subjects according to their presumed jobs, flattening complex individuals into single words. In front of a photograph of an old, bearded man, we read: DESCENDING THE THRONE YOU BECAME FOOT SOLDIER & COOK. Then, we encounter a grouping of four images of Black women, each with a single word etched across their glass: HOUSE, YARD, FIELD, and KITCHEN. And yet, the women in each photograph do not neatly align with the labels they bear. The woman in the YARD photograph, for example, depicts a young, neatly dressed woman in a collared jacket and jaunty straw hat casting a seemingly casual glance over her shoulder at the viewer. Similarly, the woman in the KITCHEN photograph has sleek, coiffed hair, large earrings, a beaded necklace, and a fashionable dress. Weems creates dissonance between the images and the text. The single words are both inadequate and inaccurate descriptions of the subjects in the photographs. Indeed, even the vast negative space around each lone scrap of text suggests just how much knowledge we are missing.

The Archive, Weems implies, may present itself as accessible and objective, but in actuality, it is riddled with gaps and misnomers. The exhibition *Hidden Witness* attempted to add to the cultural Archive, but it did so without questioning or even acknowledging the power of that discursive field. *From Here I Saw What Happened and I Cried*, on the contrary, alerts us not only to the Archive's presence but to its limitations.

## The Stakes

These limitations are not mere inconveniences to historical study. The stakes are far, far higher. Other scholars add an additional, crucial layer to Sekula's notion of the visual archive and implicit hierarchy. According to artist and critic Coco Fusco, the photographic archive also constructs a *racial* hierarchy. She writes, "Rather than recording the existence of race, photography *produced* race as a visualizable fact" (60). The 19th century anthropologists and naturalists, in particular, created a set of visual tropes that codified racial difference. By emphasizing certain physical characteristics, posing bodies in particular ways, and framing the image with text, photographs offered "proof" of racial difference.

To this, Shawn Smith adds her own argument. In the 19th century United States, visual culture played a significant role in the "racialized formation" of American identities and personal, institutional, and public archives functioned as sites where "national belonging and exclusion [were] produced" (5). Even objects like family photo albums offered opportunities to link oneself to a certain social group through props, poses, and dress. But the presumed democracy of this national visual Archive was an illusion: one's gender, race, and class largely determined ability to access and alter prevailing visual categories. Smith's work demonstrates the looping effect of the Archive. Visual culture – and artworks, too – does not merely reflect cultural attitudes. They fundamentally shape how viewers understand themselves and others around them in terms of personal and social worth.

Weems, likewise, is acutely aware of the Archive's power to create and maintain racialized and gendered hierarchies. We can see this in several different ways in *From Here I Saw What Happened*. First, Weems calls upon images that have been historically used to literally dehumanize Black bodies. In the first grouping of red-tinted photographs, Weems demonstrates how presumed scientific discourse denied the humanity of enslaved Black Americans. As mentioned earlier, Weems rephotographs four daguerreotypes taken by the South Carolina photographer J.T. Zealy at the behest of the Swiss naturalist Louis Agassiz during his time at Harvard University. The first appropriated image is of the enslaved woman Delia. Stripped to the waist, she stands in profile, eyes downcast and mouth set. Hovering above her body, etched into the glass, float the words, YOU BECAME A SCIENTIFIC PROFILE. The following three images – of Renty, Jack, and Drana – continue the sentence: A NEGROID TYPE, AN ANTHROPOLOG-ICAL DEBATE, A PHOTOGRAPHIC SUBJECT.[2] Each of these three figures faces the viewer squarely, staring back unblinking as light rakes across their form, throwing facial features, muscles, and breasts into shadowed relief.

Here, the text describes the original use of the photograph. Agassiz, along with many other scientists in the mid-19th century, held to the notion of polygenesis: the belief in multiple, separate creations for each race. Hoping to build a photographic archive that demonstrated clear, quantifiable differences between races, Agassiz visited a plantation in South Carolina and selected various slaves

to be photographed (Barbash et al.). With their clear lighting, calm faces, blank backgrounds, and direct poses, the images asserted cool, scientific objectivity. For Agassiz, the photographs allowed for the sustained and detached scrutiny of Black bodies, akin to studying a pinned insect under a microscope in order to detail its particular features. But crucially, Agassiz was not just looking to catalog differences; he located those differences within a racialized hierarchy, where Black people occupied a position above an orangutan and below a classical ideal (Wallis 175). These photographs served as visual proof of Black people's fundamental inferiority to whites. Thus, Delia – photographed in profile – is quite literally imaged this way in order to become a "scientific profile," a specimen of sorts. By directly addressing the photographic subjects – "YOU BECAME" – Weems highlights the way that the Archive sought to erase the humanity of certain subjects (Murray).

A second way that Weems acknowledges the Archive's powerful reach is by connecting these racialized images to lived experiences. She makes it clear that the construction of ranked social categories is not an abstract philosophical problem. Instead, her poetic text evokes the implications of the Archive for Black men and women who were called slurs, relegated to low-wage jobs, and otherwise exploited. SOME SAID YOU WERE THE SPITTING IMAGE OF EVIL floats above the portrait of an elegantly dressed, dark-skinned woman. OTHERS SAID "ONLY THING A N----- COULD DO WAS SHINE MY SHOES" is juxtaposed with a photograph of an older Black woman holding a white baby. Weems demonstrates the inconsistent but still-insistent ordering of our world according to a racialized hierarchy constructed and sustained through the circulation of images.

## A Loving Regard

If we accept this claim that our Archive forms our attitudes toward those we encounter, we should also recognize its necessary tension with the ethic of the Golden Rule. By creating implicit categories of those we should honor and those we can disregard with impunity, the Archive delimits who the "other" is that we must love as ourselves. Fidelity to the ethic of reciprocity demands that we work against the Archive's often truncated view of humanity.

For the Christian viewer of art specifically, Christ's command in Mark 10:31 to love one's neighbor as oneself means that looking at artworks or visual culture is not simply a matter of personal taste or aesthetic appreciation. It is instead an essential, formative component of one's ability to regard others with love. The importance and even obligation of this loving look develop from other Christian beliefs about the nature of humanity and the nature of knowledge.

A theological anthropology begins with the belief that every human has inherent dignity and worth because we all bear the *imago Dei*, the image and likeness of God (Gen. 1:26–27). In his book *Imagining the Kingdom: How Worship Works*, philosopher and theologian James K. A. Smith further argues that part of

this image-bearing is our relational nature. We are fundamentally loving creatures who are in turn formed by what and how we love. Repetitive practices that may seem innocuous – like playing video games or eating out to celebrate an achievement or looking repeatedly at certain kinds of images – orient us. They tell us stories about who we are and where we belong. Thus, for the Christian viewer, the visual Archive is not a neutral collection of past images. Instead, looking at art and visual culture becomes a kind of liturgy. What we see shapes what and who we desire and, in turn, how we act in the world (Smith, *You Are What You Love* 2).

Furthermore, artworks and images are not logical propositions that we rationally assess and then accept or reject. In fact, a Christian epistemology might argue that this is not how knowing operates at all. Esther Meek, in her book *Loving to Know: A Covenant Epistemology,* argues that knowing is an interpersonal, covenantal, and transformative encounter that develops into relationship. To put it another way, knowing "is not information so much as it is *transformation*" (63). "This makes sense," she continues, "if knowing Christ the Truth – having been known *by* Christ the truth – is central epistemically. It isn't about mere information, but about being transformatively *known*" (63). Rather than knowledge being deductive and linear, Meek claims that all acts of coming to know are integrative, meaning they become part of us. All knowing, she says, is akin to knowing God: it is transformative and relational (70). And so, she ultimately argues, Christians do not know in order to love, but they love in order to know. A covenant epistemology demands that Christians look upon others with love, giving themselves for the sake of the other. This is knowledge as an act of covenantal care.

The story of Hagar in the Christian Scriptures links together these aspects of loving, knowing, and seeing. In Genesis 16, we find the enslaved Egyptian woman, Hagar, desperately running through the wilderness. Sexually exploited and pregnant with her master Abram's child, she would rather die from thirst and exposure in the desert than continue suffering abuse at the hands of her mistress, Sarai. But then, the angel of the Lord, thought by many commentators to be the preincarnate Christ, appears to her. He tells her to name her unborn son Ishmael, "God hears," and bestows God's blessing on the child and his offspring (Gen. 16:11).

Then Hagar, a woman without social standing or capital, becomes the first person in Scripture to name God. She calls him *El-roi*, "God sees me." Amazed, she wonders aloud, "In this place, have I actually seen the one who sees me?" (Gen. 16:13) Hagar can hardly believe that the all-powerful God of the universe would *see* her and provide from his abundant grace. She is not invisible. She is known through a loving look. God's gaze dignifies Hagar. He locates her in the desert, notices and names her distress, and reminds her of her inherent worth.

This is a loving regard.

Viewers who claim Christianity thus have a responsibility to love their neighbors by knowing them rightly and *seeing* them rightly, addressing the ways that

their Archives might limit or deform their understanding of the world. How can this be done? How might we acknowledge and counteract the violence that has and continues to be perpetuated against the *imago Dei* through the Archive? Again, Weems' *From Here I Saw What Happened And I Cried* suggests a way forward.

As we have already seen from Weems' questioning of the *Hidden Witness* exhibition, simply adding more images to a flawed structure does not address the Archive's fundamental inequities. However, enacting the ethic of the Golden Rule, we can expand our Archive in ways that more fully honor the rich complexity and fundamental dignity of our neighbors' humanity. I want to pull three strategies from Weems' work, specifically focusing on how Christian viewers might find resonance between these approaches and their theological commitments.

## Expanding Our Archive: Absences

First, Weems models an approach that can initially seem counterintuitive: making space in the Archive for absence. When initially creating *From Here I Saw What Happened*, Weems noted that most of the photographs in *Hidden Witness* were made by and of people who could afford to pay for them. She, however, wanted to acknowledge the existence of the people and the moments who were *not* photographed. It is such absences that serve as the driving force of her artistic practice. In a 2009 interview, Weems stated, "This invisibility – this erasure out of the complex history of our life and time – is the greatest source of my longing" (Bey 63). In *From Here I Saw What Happened*, Weems thus set out not only to interrogate the invisibility of African Americans in dominant visual culture but also to highlight and mourn the *absence* of a record of Black interior lives. We cannot know the private thoughts, for example, of enslaved women who cared for white children because there was no space, no category, in the Archive for them.

We have already seen how Weems uses formal choices to create distance between us and the depicted subjects. The sky blue and blood red photographs, the circular mats, and the friction between image and text all keep us from seeing the images as windows or conduits to an accessible past. Instead, they call attention to the constructed nature of the Archive. The text also describes what has been done to the subjects and what they themselves have done, but the narrator never presumes to know what the subjects were thinking or feeling. Weems carves out a space and leaves it purposefully blank.

But the gap between the viewer and subject need not be seen as an impediment or a barrier to breach. Christian viewers might instead be reminded of their own, God-given finitude. We are limited creatures, living in particular times and places in particular bodies (Kapic). We should not – we cannot – claim to know the inner workings of another image bearer's mind. Honoring the *imago Dei* in fact means honoring the mystery of others.

## Expanding Our Archive: Agency

Another way that Weems encourages us to expand our Archive is by insist-
ing on the agency of the Black figures in these historical images. Rather than
building a neat, monolithic story of victimization, she allows for complex,
even contradictory, attitudes and actions. For example, just after the four Zealy
daguerreotypes, Weems includes a photograph of a stern, middle-aged Black
woman in a white headwrap, standing with her hands on her hips. Across her
image, we read: YOU BECAME MAMMIE, MAMA, MOTHER & THEN,
YES, CONFIDANT – HA.[3] Although we might initially interpret the woman
as the stereotypically maternal, desexualized mammy figure, the text – par-
ticularly that interjection "HA" at the end – gives pause. There is more to this
woman than the loyal and carefree persona the Archive has taught us to expect.

The particular history of the photograph that Weems appropriates further
supports this double reading. The image was made in 1932 by the African Amer-
ican photographer P.H. Polk as part of his "Old Characters" series. Rather than
titling the photograph "Mammy" after the common trope, Polk instead called it
"Boss." He later described the woman thusly: "She is not cloaked in victimiza-
tion. She is not pitiful; therefore, she is not portrayed in pitiful surroundings. She
is not helpless, and she is not cute" (qtd. in Willis 72). Weems inserts this Black
self-fashioning into a series of images taken by white photographers and labeled
according to the logic of white supremacy. Following the erasure of humanity
in the preceding daguerreotypes, this photograph and text remind us that Black
women's agency can and does persist in such dehumanizing circumstances.

But Weems also challenges a singular narrative of Black victimhood or
resistance. Further into her photographic series, viewers – regardless of their
own identity – find themselves complicit in a woman's objectification, peering
between the splayed legs of a reclining nude while reading: YOU BECAME
PLAYMATE TO THE PATRIARCH. But other photographic subjects are also
accused of unholy compromise. We see a 1957 photograph of Josephine Baker,
heavily made up with lightened skin, sitting alone on a chair with her eyes down
and hands clasped in her lap. YOU BECAME AN ACCOMPLICE, the text
reads. In isolation, the combination of text and image might sound accusatory
or even self-righteous. But in the context of the work as a whole, we hesitate.
How might we begin to understand the complex psychological realities that
these women inherited, the choices they made for their seeming survival? This is
not a simple history of moral triumph over white supremacy. Through the jux-
taposition of historical images and poetic, personal text, Weems insists that we
see these figures as complicated, fallible, individuals instead of simplified icons.

Again, Christian viewers' theological commitments should compel them to
see others in this way. It is easier, of course, to set up uncompromised heroes for
worship and total villains to despise. But the Scriptures do not present humans
in such binary terms. Instead, we learn about David's faithful obedience to God
while he is on the run from Saul, but we also bear witness to his adultery, his
murderous conspiracy, and his complicity in the sexual abuse of his daughter at

the hands of his son. We learn about Ruth, a poor Moabite woman with no legal standing in Israel who nonetheless advocates for herself and her mother-in-law. We learn about Martha, who wonders if Jesus sees her labor yet is confident that He has power over death. These biblical figures are flawed and faithful, operating within the particularities of their culture. To look faithfully upon our neighbors is to see them in this way, whether represented in art and visual culture or encountered in our lived experience.

## Expanding Our Archive: Lament

Finally, Weems expands our Archive by modeling lament as an appropriate response to the history of violence, exploitation, and degradation. Toward the end of the installation, the text shifts to describing the actions of the photographic subjects themselves. Instead of "becoming" different things, her subjects act. The final two crimson images read, "RESTLESS AFTER THE LONGEST WINTER YOU MARCHED & MARCHED & MARCHED" and "IN YOUR SING SONG PRAYER YOU ASKED DIDN'T MY LORD DELIVER DANIEL?" With that question hanging in the air, we move to the final panel of the installation, a mirror image of the first, blue-tinted photograph of the Mangbetu woman. She offers a response to all that we have seen: AND I CRIED.

Weeping may seem like a strange or even anti-intellectual response to art and historical narrative. Yet, the Christian Scriptures do offer a model of righteous outcry in response to the kinds of injustices described by Weems in her work: lament. Scholar Claus Westermann has argued for the primacy of lament in the Old Testament as a means of giving voice to oppression, anxiety, pain, and peril and appealing to God's compassion (24–25). We see lament offered throughout the Old Testament as a means of the people of Israel, corporately and individually, expressing outrage and sorrow over affliction past and present (Westermann 25). Lament in the Judeo-Christian context is also a declaration of relationship (Bruggemann 100–101). When the people of Israel publicly mourn the violence they've experienced, their grief is an expression of faith in a God who promises to be with them. They know their sorrow will be carried. They know that restoration will eventually come to pass, even if they might not understand precisely what form that will take.

Old Testament scholar Walter Brueggemann has further asserted that lament should continue to play a crucial role in the life of the Christian today (108). According to Brueggemann, the assertions that things are not as they ought to be, that the situation can be changed, and that God can and will bring about justice and restoration are Christian imperatives. Without lament, Brueggemann argues, the Christian misunderstands her relationship with God and allows unjust systems of the status quo to remain unchallenged (111). He concludes this reflection: "The new resolve in heaven and the new possibility on earth depend on the initiation of protest [through lament]" (111).

From this perspective, Weems' "AND I CRIED" can function as a prompt to lament. A weeping recognition of the Archive's deleterious effects on neighbors

past and present need not be mere sentiment or a passive complaint. It can, instead, be a call that initiates action.

## Conclusion

Throughout this chapter, I have used Carrie Mae Weems' *From Here I Saw What Happened And I Cried* as an example and model of identifying, critiquing, and expanding the cultural Archive. I specifically emphasized how Christian theological commitments provide the framework for a loving regard that informs engagement with contemporary artworks, particularly those that grapple with histories of trauma and cultural oppression. A Christian viewer can bring patterns of truth-telling, complexity, and lament found in Scripture to an artwork like *From Here I Saw What Happened*, and the encounter can be personally transformative.

Though I've focused on a Christian application here, the reciprocity of the Golden Rule, found in almost all religions, can more broadly reshape our reception of contemporary art. With this injunction in mind, we must consider the implications of what we see and how we look. An unattended, unconsidered Archive deforms our view of the "others" whom we are to treat as we wish to be treated. In order to counter this distortion, we may need to examine our Archives critically, recognizing who we have been taught to honor, disregard, desire, or diminish. Then, we must also be generative, working to expand our Archives by acknowledging the gaps and erasures, remembering the complexity and agency of our fellow humans, and actively mourning unjust events and systems. To "*do* unto others" means we must also work to *see* others with a loving regard.

## Notes

1 Installation shots of this artwork, along with images of the individual photograph-and-text works can be viewed at https://www.moma.org/calendar/exhibitions/5255/installation_images/46401. Accessed 14 September 2022.
2 The dehumanizing effects of objects in our Archive thrown into sharp relief today by ongoing legal battles over the photographs of Renty, one of the enslaved men in the daguerreotypes commissioned by Agassiz. Renty's descendant, Tamara Lanier, cites the ongoing trauma of seeing her great-great-grandfather's face and body recirculated as an object of consumption, the cover of an anthropology textbook, for example, or the featured image on a flier for a conference. See Ariella Azoulay, "Free Renty! Reparations, Photography, and the Imperial Premise of Scholarship" *Hyperallergic*, 2 March 2020, https://hyperallergic.com/545667/free-renty/. Accessed 20 June 2022.
3 This specific image can be viewed at https://www.moma.org/collection/works/91842?sov_referrer=theme&theme_id=5255. Accessed 14 September 2022.

## Bibliography

Azoulay, Ariella. "Free Renty! Reparations, Photography, and the Imperial Premise of Scholarship." *Hyperallergic*, 2 March 2020, https://hyperallergic.com/545667/free-renty/. Accessed 20 June 2022.

Bal, Mieke and Norman Bryson. "Semiotics and Art History." *The Art Bulletin,* vol. 73, no. 2, 1991, pp. 174–208. Taylor & Francis Online, doi: 10.1080/00043079.1991.10786750

Barbash, Ilisa, et al. *To Make Their Own Way in the World: The Enduring Legacy of the Zealy Daguerreotypes.* Aperture, 2020.

Bey, Dawoud and Carrie Mae Weems. "Carrie Mae Weems." *Bomb* 108, 1 July 2009, pp. 60–67, https://bombmagazine.org/articles/carrie-mae-weems/. Accessed 20 June 2022.

Brueggemann, Walter. "The Costly Loss of Lament." *The Psalms and the Life of Faith,* edited by Patrick D. Miller. Fortress, 1995, pp. 98–111.

Derrida, Jacques. *Archive Fever: A Freudian Impression.* Translated by Eric Prenowitz. University of Chicago Press, 1995.

Foucault, Michel. *The Archaeology of Knowledge and The Discourse of Language.* Translated by A. M. Sheridan Smith. Pantheon Books, 1972.

——. *Foucault Live: Collected Interviews, 1961–1984,* edited by Sylvère Lotringer. Semiotexte, 1996.

Fried, Michael. "Art and Objecthood." *Art and Objecthood: Essays and Reviews.* University of Chicago Press, 1998, pp. 148–172.

Fusco, Coco. "Racial Times, Racial Marks, Racial Metaphors." *Only Skin Deep: Changing Visions of the American Self,* edited by Coco Fusco and Brian Wallis. International Center of Photography and Harry N. Abrams, 2003, pp. 13–48.

Kandel, Susan. "Art: 'Witness' at the Getty: Black Lives Considered." *Los Angeles Times,* 6 March 1995, http://articles.latimes.com/1995-03-06/entertainment/ca-39327_1_hidden-witness. Accessed 20 June 2022.

Kapic, Kelly. *You're Only Human: How Your Limits Reflect God's Design and Why That's Good News.* Brazos Books, 2022.

Manoff, Marlene. "Theories of the Archive from Across the Disciplines." *Libraries and the Academy,* vol. 4, no. 1, 2004, pp. 9–25. Johns Hopkins University Press, doi: 10.1353/pla.2004.0015.

Meek, Esther. *Loving to Know: A Covenant Epistemology.* Cascade Books, 2011.

Murray, Yxta Maya, "From Here I Saw What Happened and I Cried: Carrie Mae Weems' Challenge to the Harvard Archive." *Unbound: Harvard Journal of the Legal Left,* vol. 8, no. 1, 2013, pp. 2–78, https://papers.ssrn.com/sol3/papers.cfm?abstract_id=2324363. Accessed 20 June 2022.

Pagel, David. "Hidden Witness: African Americans in Early Photography, Carrie Mae Weems Reacts to Hidden Witnesses." *Frieze,* 9 August 1995, https://frieze.com/article/hidden-witness-african-americans-early-photography-carrie-mae-weems-reactshidden-witnesses. Accessed 20 June 2022.

Panofsky, Erwin. *Studies in Iconology: Humanistic Themes in the Art of the Renaissance.* 1939. Harper & Row, 1972.

Potts, Alex. "Sign." *Critical Terms for Art History,* edited by Robert S. Nelson and Richard Schiff. University of Chicago Press, 2003, pp. 20–34.

Sekula, Allan. "The Body and the Archive" *October,* vol. 39, 1986, pp. 3–64, doi: 10.2307/778312.

Smith, James K.A. *Imagining the Kingdom: How Worship Works.* Baker Academic Press, 2013.

——. *You Are What You Love: The Spiritual Power of Habit.* Brazos Press, 2016.

Smith, Shawn. *American Archives: Gender, Race, and Class in Visual Cultures.* Princeton University Press, 1999.

Spivak, Gayatri. "Can the Subaltern Speak?" *Colonial Discourse and Postcolonial Theory: A Reader,* edited by Patrick Williams and Laura Chrisman. Columbia University Press, 1994, pp. 66–111.

——. *A Critique of Postcolonial Reason.* Harvard University Press, 1999.

Wallis, Brian. "Black Bodies, White Science: Louis Agassiz's Slave Daguerreotypes." *Only Skin Deep: Changing Visions of the American Self,* edited by Coco Fusco and Brian Wallis. Harry N. Abrams, 2003, pp. 163–81.

Westermann, Claus. "The Role of the Lament in the Theology of the Old Testament." *Interpretation: A Journal of Bible and Theology,* vol. 28, no. 1, 1974, pp. 20–38, doi: 10.1177/002096437402800102.

Willis, Deborah. *Reflections in Black.* WM Norton and Company, 2000.

Wilson, Jackie Napoleon. "African Americans in Early Photography." *The Historian,* vol. 57, no. 4, 1995, pp. 713–720, doi: 10.1111/j.1540–6563.1995.tb01362.x.

# 7

# EXHIBITION AS PILGRIMAGE

## Visual Strategies for Interfaith Dialogue[1]

*Aaron Rosen*

Pilgrimages are goldmines for scholars of religious studies, replete with rich lodes of beliefs and practices. When it comes to interreligious studies, however, the same sites are not so easy to quarry. The anthropologists Victor and Edith Turner got to the crux of the problem in their exploration of Christian pilgrimage in 1978, writing:

> With rare and interesting exceptions, the pilgrims of the different historical religions do not visit one another's shrines, and certainly do not find salvation *extra ecclesia*...[Instead, pilgrimages] intensify the pilgrim's attachment to his own religion, often in fanatical opposition to other religions. That is why some pilgrimages have become crusades and jihads. (6)

The Turners' skepticism is warranted. In recent times alone, we might recite a tragic litany of pilgrimage sites that have been the subject of attack. The Harmandir Sahib, the Sikh Golden Temple in Amritsar, India, has been attacked numerous times throughout its history, most infamously in 1984. The Cave of the Patriarchs in Hebron, Palestine – said to be the burial place of Abraham and Sarah and their descendants, and even Adam and Eve according to some traditions – has been a site of exclusion and violence over centuries, including a massacre of Muslim worshippers in 1994. In 2014, the tomb and mosque of the Prophet Jonah in Nineveh, Iraq, was blown up by militants of the so-called Islamic State as part of their devastating campaign against Muslim, Christian, and Yazidi holy sites in the region.

Still, this lachrymose trail is not the only story one might tell. Indeed, the past decade has witnessed a flowering of pilgrimages devoted to interfaith worship, dialogue, and action. Some have taken the form of global summits, such as the

DOI: 10.4324/9781003326809-9

pilgrimage convened by Pope Benedict XVI in Assisi in 2011, commemorating the twenty-fifth anniversary of the World Day of Prayer for Peace organized by his predecessor. Other pilgrimages have sought to shift popular perceptions about religion, especially in the wake of the "War on Terror," including a 2015 procession in London aimed at countering religious extremism and Islamophobia.[2] In 2020, the murder of George Floyd, Breonna Taylor, and other African Americans by police unleashed a moral outcry for racial justice. Some pilgrimage sites formed spontaneously, sacralized almost overnight by the anguish and righteous indignation of protestors. The massive statue of Robert E. Lee in Richmond, Virginia – the former capital of the Confederacy – became a veritable shrine to Black Lives Matter, plastered with expressions of resistance and illuminated at night by a projection of Taylor, with candles and other objects left at its base like *ex-votos*.[3] Formal pilgrimages took place as well, including "Walk the Walk: A Faith Pilgrimage of Racial Reckoning, Resolve, and Love," from Charlottesville, Virginia, to Washington, DC.[4] Building upon long-standing efforts at the grassroots level, such endeavors signal a growing trend in which pilgrimages help symbolize, mobilize, and consolidate networks of religious activists working to effect social change.[5]

These events, situated at the intersection of pilgrimage and protest, provide ample avenues for interfaith dialogue and interreligious studies. As a scholar of religion and visual culture, I am particularly interested in the role that art, broadly conceived, might play in shaping participants' experiences of pilgrimage, especially in ways that motivate interfaith dialogue and action. In this chapter, I want to focus on a single case study: *Stations of the Cross*,[6] an international, multisite public arts project I co-founded, whose mission is "to use the story of the Passion to prompt reflection and action in response to challenges of social justice" ("About"). My stake and vantage point in this inquiry is hardly neutral and is informed by my perspectives as both a scholar and a curator, attuned to practical and theoretical concerns. Moreover, I write as a practicing Jew, married to an Episcopal priest, with whom I am raising our son Jewish. I also teach a denominationally, culturally, and ethnically diverse cohort of students preparing for ministry as the director of the Henry Luce III Center for the Arts & Religion at Wesley Theological Seminary, a Methodist institution in Washington, DC. At multiple levels, both personal and professional, I am thus vested in the flourishing of interfaith dialogue and interreligious studies.

## Concept and History

*Stations of the Cross* began as an exhibition in London in 2016. I then co-founded it as an annual project with the Anglican priest and theologian Catriona Laing, who became a key partner in developing the project, both practically and conceptually, in a way that made it adaptable across multiple countries and cultural contexts. While the project has evolved in scope and ambition, its guiding concept remains the same. The exhibition draws upon the devotional practice many

Christians follow during Lent, in which they retrace the final fourteen episodes (stations) of Jesus' journey through Jerusalem, from condemnation to crucifixion and entombment. In each city that hosts the project, curators design a bespoke, fourteen-stop route, marked by both existing and specially commissioned works of art. The journey – envisioned as a form of contemporary pilgrimage – weaves through both sacred and secular sites, and indeed often perforates the perceived boundaries between these categories. At every station, participants are invited to deepen their reflection by listening on their smartphones to specially recorded reflections by leading artists, thinkers, and activists. While rooted in Christian practice, *Stations* is designed to engage people of all faiths and none, with participating artists, podcasters, and institutions running the religious and cultural gamut.

One of the great learning experiences of this project has been the amount of negotiation it has required at every level, from the needs and concerns of artists to those of participating museums, churches, and other institutions, as well as religious, academic, and cultural funding organizations, each with their own remit. I have engaged in this delicate planning process – sometimes itself a form of interfaith dialogue – firsthand as a curator for the project in London in 2016, Washington, DC in 2017, and New York City in 2018. Subsequently, I have had the opportunity to witness these engagements in a consulting capacity as *Stations* co-director, supporting local curators responsible for designing and implementing the exhibition. Artway director Marleen Hengelaar-Rookmaaker and independent curator and researcher Anikó Ouweneel-Tóth led *Stations* in Amsterdam in 2019, while Ouweneel-Tóth served as co-curator with artist Arent Weevers in another Dutch city, Deventer, in 2020. In 2021, when the pandemic made indoor gatherings risky, I co-curated an online, global edition of *Stations* with Catriona Laing. In 2022, the exhibition resumed in Toronto, led by John Franklin. While I will focus on my experience as a curator in this chapter, I will also include insights I owe to my colleagues, who have brought their own creative vision to the project in fruitful, sometimes unexpected ways.

Since this project is inspired by the Stations of the Cross as a religious practice, it is worth taking a moment here to survey how this tradition evolved. The Stations have their roots in the middle ages, when interest in embodied devotion and reenactment of Jesus' suffering blossomed. The Crusades nourished – and were themselves fed by – a fascination with the specific locations associated with the Passion. Over the centuries, veneration crystallized around certain key locations and moments in Jesus' final steps, moored less in scripture or history than evolving popular tradition. Indeed, following the surrender of the Kingdom of Jerusalem to Muslim rule in the late 12th century, the geographic Jerusalem began to pale in significance to the imagined Holy City, as creatively reconstructed in pilgrimage sites across Europe, from Italy to Ireland (Turner and Turner 6). Christian pilgrims who did travel to Jerusalem in the ensuing centuries went looking for a city that had, in a sense, been invented in their own backyard. In turn, they superimposed this vision of Jerusalem onto the actual

stones beneath their feet. Depending on whom one asked during the early modern period, the true *Via Crucis* could crisscross the streets of the Old City in any number of directions. And not only did believers wildly disagree on the number of stops to commemorate, it was also even common for a period to retrace Jesus' steps backward, starting with Golgotha, the site of his Crucifixion.

The convention of reciting prayers at fourteen specific stations along the Way of the Cross in Jerusalem itself, or virtually at plaques erected inside churches elsewhere, was only formally established by the Catholic Church in 1731 by Pope Clement XII, with Franciscans playing a leading role in devotions. Even after this imprimatur was granted, innovation continued. In 1991, Pope John Paul II began celebrating an alternative fourteen-station "Scriptural Way of the Cross," linked more closely to the Gospels, which for years he celebrated by walking around the Colosseum in Rome on Good Friday. While the Stations are most visible within Catholic practice and spaces, Anglicans and members of other Protestant denominations often follow their own iterations of the Stations, sometimes reducing the number to eight, for example, or highlighting episodes that resonate strongly with aspects specific to their theology or liturgy. In addition to denominational differences, diverse cultural settings – from the Philippines to Latin America – have also contributed to the ongoing development of the Stations of the Cross, sometimes incorporating practices from indigenous traditions. As a curator, these intersecting elements of ritual, history, and symbolism represent a rich but challenging – even risky – seam to mine. In the ensuing sections, I will consider how an exhibition explicitly inspired by Christian history and practice can enrich Christian observance while simultaneously providing avenues for deep but non-confessional engagement by non-Christians. I will focus on two deceptively simple modes of engagement in which *Stations* fosters interfaith encounters and opens areas of inquiry for interreligious studies: looking and walking.

## Looking

At its most basic level, the practice of praying the Stations involves devoting significant time and mental energy to engaging with specific, physical images. This is a far cry from how most people engage with works of art in museums. Indeed, studies routinely show that visitors tend to spend mere seconds in front of even the most celebrated masterpieces. Alain de Botton highlights the dilemma facing curators in order to keep museums relevant and responsive to the emotional life of contemporary society. "[A]rt museums," he opines,

> often abdicate much of their potential to function as new churches (places of consolation, meaning, sanctuary, redemption) through the way they handle the collections entrusted to them. While exposing us to objects of genuine importance, they nevertheless seem unable to frame them in a way that links them powerfully to our inner needs.

The solution to de Botton's dilemma seems to stare him in the face, in his own framing of the problem. Yet rather than looking afresh at the myriad modes of religious viewing shaped and contoured over centuries, like the Stations, de Botton hopes to reconstitute such experiences through popular psychology. In 2014, he and John Armstrong selected and captioned more than a hundred works on display throughout the Rijksmuseum in Amsterdam, a repository of some of the world's finest religious treasures, including several biblically themed masterpieces by Rembrandt. For the title of this exhibition, de Botton and Armstrong boiled their thinking down to a single aphorism: *Art is Therapy.*[7] This syrupy formula seems intended to apply to everyone in the curators' blasé vision of a pluralistic society, regardless of viewers' religious or cultural identities. And yet for an actual multifaith, multicultural, multiracial society jostling its way through the chaos and conflict of contemporary life, this "therapy" feels like weak medicine.

We are better served, I think, by studying the complex, textured practices of "visual piety," which David Morgan defines as "the visual formation and practice of religious belief" (1). While earlier generations of curators expressly sought to avoid invoking such modes of looking, in the 21st century curators have begun – albeit tentatively in most cases – to embrace such connections. In a few cases, often as part of a strategy to engage specific local communities, museums have actually welcomed religious ceremonies in their galleries. For more than a decade, the Birmingham Museum and Art Gallery has hosted *Wesak* (Buddha Day) in its galleries, with devotions performed by Buddhist monks before the great copper *Sultanganj Buddha* (500–700 CE) (Paine 38). For its part, Brighton Museum and Art Gallery has invited members of the local Gujarati community to perform *puja* at its historical Hindu shrine (Paine 39).[8] Wary of being construed as evangelizing, museums have pushed the boat out more cautiously when it comes to engaging the Christian liturgical context of many Western masterpieces. Neil MacGregor has been a pioneer in this field, overseeing the blockbuster exhibition *Seeing Salvation* at the National Gallery in London, staged in 2000 to coincide with the second millennium since Jesus' birth.[9] The show's design conjured an ecclesial ambiance through dimmed lights, dark walls, and liturgical music playing in the background. Yet despite such purposeful, palpable nods to Christian history and practice, the Gallery delicately danced around the words "religious" and "spiritual" when describing its aims. The catalog tellingly "expresses the view that modern secular audiences can engage with the masterpieces of Christian art at an *emotional* as well as purely aesthetic or historical level" (*The Image of Christ* back cover, emphasis added).

Roughly a decade later, the British Museum – notably with MacGregor at its helm – staged a series of exhibitions delving into ancient Egyptian, medieval Christian, and modern Islamic religious practices. Rather than sheltering under the shibboleth of the "emotional," these shows sought to tackle devotion more phenomenologically, as part of a richly textured, lived religious reality. *Hajj: Journey to the Heart of Islam* (2012), curated by Venetia Porter, marked the culmination of this exploration. Viewers examined precious objects – including one

of the world's earliest Qur'ans – alongside contemporary videos, soundscapes, and art representing the experience of Hajj today. The exhibition unfurled along a spiral path through the museum's iconic domed reading room, evoking the centripetal procession of Muslims around the *Ka'ba* in Mecca. The exhibition was immensely popular across an audience that was 47% Muslim, compared to only 3% in a survey of general visitors the previous year (Parker 266). A study commissioned by the museum found that a significant number of both Muslims and non-Muslims who attended *Hajj* reported not only increased knowledge about Islamic history and culture but also "high levels of emotional and spiritual outcomes," with many citing the diversity of the crowds themselves as contributing factors (Parker 265–266). Running against the grain of much received museological wisdom, these findings suggest that it is possible to deliver satisfying pedagogical and devotional experiences simultaneously and, indeed, that a complex interplay between them might be mutually beneficial. For an outsider, observing someone else's devotional engagement might be both educational and spiritually moving, while for an insider, watching an outsider thoughtfully delve into one's own tradition might prove both educational and uplifting. Where de Botton might rhapsodize about the potential for museums to become cathedrals, MacGregor's exhibitions remind us that if we want to *find religion* in museums, the answer may be confoundingly obvious: we must do religious things there. And we must – just as importantly – do them together.

These lessons lingered with me as I planned *Stations of the Cross*, especially in its first iteration in London. From its inception, *Stations* was conceived as an opportunity not only to commission new works of art, but also to reframe creatively how we discuss, experience, and interact with existing works of art. When working with contemporary artists, I have found that interpretive frameworks often evolve organically, alongside the creation and installation of their works. The non-Christian artists I have collaborated with on *Stations*, for instance, have displayed a remarkable openness to grappling not only with Christian themes and iconography, but also with Christian reception, including prayer. I think in particular about how Muslim artists Güler Ates and Dua Abbas, and Jewish artists Leni Dothan and Siona Benjamin,[10] embraced the challenge of presenting their work within explicitly Christian contexts, from the medieval Temple Church in London to the Cathedral of St. John Divine in New York City. In contradistinction, constructing a discursive framework around existing works has proven much more challenging, both rhetorically and bureaucratically. While artists may thrive in the uncertain territory of interreligious encounter, museums can – with good reasons – be squeamish about acknowledging religious and cultural difference, even, sometimes especially, when the religious (usually Christian) content of their collections stares one right in the face.

In her pioneering work *Civilizing Rituals*, Carol Duncan makes the case that public art museums in Europe and North America are "environments structured around specific ritual scenarios," which serve to inculcate and naturalize the ideologies of bourgeois nation-states (2). While these rituals have shifted over time

across different regional and cultural contexts, there remains a remarkable consistency in the rhetoric mustered to support them. "Advocates of art museums," Duncan notes, "almost always argue one of two ideals: the educational museum or the aesthetic museum," the first stressing the formation of informed citizens, and the second emphasizing the uplifting value of contemplation (4). Despite their apparent differences, the former owing more to Enlightenment models of detached examination, and the latter to Romantic fantasies of sublime encounter, "[b]oth ideals are advanced as *socially* valuable" (4). One key function – though Duncan does not dwell on it – is to underscore the beneficent religious tolerance of the state. The educational model brackets religion as a matter of mere historical interest. The aesthetic model, meanwhile, marginalizes it as merely personal reverie, disassociated from any particular creed (save that of *l'art pour l'art*).

Ironically, the "ritual scenarios" of the art museum thus seek to secure it a place outside the province of any definable, observable religious praxis, in service of an enervated – and many would argue, outdated – model of religious pluralism. For public museums, dependent in large part on public funding, adherence to this model is of vital, even existential importance. And so it is that even a modest curatorial intervention like *Stations of the Cross* can in fact be controversial, simply by seeking to open space for devotional responses to art made for explicitly devotional purposes! In practical terms, this has meant delicate negotiations with senior museum staff about even seemingly tiny matters. At the National Gallery in London, for example, the museum's director eventually had to sign off on placing a *Stations* wall text (with accompanying QR code) next to Jacopo Bassano's *The Way to Calvary* (c. 1544–5), linking it to the *Stations* podcast by New Testament scholar Joan Taylor. In the end, the National Gallery set aside its concerns that offering such a conceptual framework might compromise its duty as a national institution to speak to viewers of diverse religious backgrounds. My clinching argument, made with the help of some theologically savvy curators, came full circle. *Stations*, I suggested, was simply extrapolating upon the logic of the National Gallery's own groundbreaking exhibition, *Seeing Salvation*. As that exhibition suggested, opening the door to one faith is sometimes the best, and most honest, way to invite discussions with others.

## Walking

It is not easy, as we have seen, to create an atmosphere, conceptual framework, or even physical space conducive to religious looking in public institutions, especially museums. Even if this can be accomplished, however, much more is required to make a meaningful pilgrimage. After all, a pilgrimage is defined as much by its route – the spaces in between and along the way – as its destination. We began this chapter with an admonition from Victor and Edith Turner about the challenges that pilgrimages, invariably geared toward in-group objectives, pose to out-group relations. It is telling, then, that as they describe the "liminoid" experience of pilgrimage (35) and the profound feelings of interrelatedness

it can engender – what they term *communitas* – they wonder whether such feelings might swell beyond the boundaries of particular faiths:

> [A Pilgrimage's] posing of unity and homogeneity (even among the most diverse cultural groups) against the disunity and heterogeneity of ethnicities, cultures, classes, and professions in the mundane sphere—serves not so much to maintain society's status quo as to recollect, and even to presage, an alternative mode of social being, a world where *communitas*, rather than a bureaucratic social structure, is preeminent. Thus, out of the mixing and mingling of ideas from many traditions, a respect may grow for the pilgrimages of others. These may be seen as providing live metaphors for human and transhuman truths and salvific ways which all men share and always have shared, had they but known it. Pilgrimages may become ecumenical. (39)

At the heart of this reflection lies a crucial insight, not only for the study of pilgrimage but interreligious studies more generally: dialogue and camaraderie thrive on shared experience as much or more than shared theology. "Those who journey to pray together," the Turners add, "also play together in the secular interludes between religious activities," (37) including a whole host of excursions off the religiously beaten track. The bonds that develop between pilgrims may, on the surface at least, have little to do with religion; an insight that dates at least as far back as the travelers in Chaucer's *Canterbury Tales*, swapping bawdy stories on their way to the shrine of Thomas Becket.

So how exactly does one go about planning a pilgrimage that walks this fine line between structure and liminality, between sacred and profane? As our exhibition has taken shape in each host city, my collaborators and I have focused first and foremost on assembling a coherent and compelling series of stations. At the same time, though, we have learned – sometimes the hard way – that the project is most successful when it also values the interstices, drawing visitors along routes that are not only logical, feasible, and safe, but also evocative in their own right. We felt it was important from a practical perspective that stations connect in ways that would not require any particular navigational genius and could be visited in geographical clusters in case participants only had limited time or energy. Where possible, we considered areas congenial to multiple forms of transport, including bicycles, cars, and public transport.[11] But while our logo was inspired by the King's Cross train station, and participating artists have often explored the multiple meanings of "stations," walking has constituted an archetypal experience in the concept and design of the project. This is not without problems, and I am ashamed to admit that the ableism which this presumes entered my thinking later than it should have; not only because of the medical (and thus moral) importance of accessibility generally but also because the history of pilgrimage itself has so often been entwined with theologies of healing and wholeness. What has nonetheless kept walking, in one form or another, at the forefront of the project is a conviction that there is a powerful correlation between the pace of pilgrimage and its affectivity. At the

most fundamental level, walking (or its aided equivalent) forces us to take things slow(er) and, in a deep sense, *to look where we are going.* In Turnerian terms, it promotes liminality and the spiritual openness and attentiveness that comes with it.

As *Stations* has developed over the years, we have got better at conjuring the conditions for such experiences, whether by organizing walking tours or supporting partner organizations who do so. Sometimes, these groups are specifically designed to promote interfaith engagement, like the walk I led with the Anglican Bishop of London, Richard Chartres, and the Catholic Archbishop of Westminster, Cardinal Vincent Nichols, for *Stations of the Cross* in 2016. At other times, ecumenical encounters spring up organically, when groups discover that they are traveling the same route, or pausing before the same work of art. What is especially interesting, though, is the experience of solitary visitors who discover a sense of *communitas* along the way, with people they do not know, and may not even interact with directly. During *Stations'* first iteration in London, Brent Plate, a fellow contributor to this volume, asked insightfully:

> When people have to walk from one artwork to the next, how do you think their perceptions change? What's going on in that urban negotiation of crossing streets, and bumping against other people in between the more or less stationary contemplation of art?
>
> *("Stations of the Cross Exhibition..." Interview 255)*

Still gathering data – and in fact still processing what the project was becoming – I responded rather speculatively:

> I like to imagine that at various points in the day, amidst otherwise indistinguishable crowds, there are people walking nearby – perhaps unaware of each other – taking this journey. And even if they aren't, I think it's a powerful idea to imagine that everyone we see walking anonymously alongside us might be a pilgrim, whether following these Stations of the Cross, or undertaking their own completely different journey.
>
> *("Stations of the Cross Exhibition..." Interview 256)*

As it turned out, feedback via online surveys revealed that many visitors did feel an unexpected sense of togetherness during their experience. And this was especially noted by those who indicated that they had visited the *Stations* alone. "It felt like a pilgrimage and heightened my awareness to people around the walk, especially the homeless and disenfranchised in London and across the World," one respondent noted. "As a whole experience," wrote another visitor, "the walking through the city felt important; the seeking out being a necessary part of the task." One commented, "It was a remarkable experience...to reflect and to pray, all in the midst of the noise and frenzy of the city" before adding, "I wonder if worship spaces from other faith traditions might be incorporated as well?" Having self-conceived as pilgrims or seekers for the purpose of visiting

*Stations*, it was clear that these participants began to see the city itself – and its extraordinarily diverse population – through the same lens. To them, it seemed, passersby were part of their pilgrimage, whether those individuals knew it or not.

*Photo by Güler Ates. Courtesy of the Artist © Güler Ates*

**FIGURE 7.1**   Güler Ates, *Sea of Colour*, 2016. Salvation Army International Headquarters, London, UK.

My own moment of *communitas* came not while contemplating a piece of art, or walking between stations, but walking *with* a work of art. For the tenth station, in which Jesus is stripped of his garments, I commissioned the Turkish artist Güler Ates to create an installation for the Salvation Army International Headquarters' glazed lobby, visible from the street. Ates is best known for her photographs of mysterious figures in shimmering, diaphanous veils, drifting through opulent spaces. In *Sea of Colour* (2016), fabric took a different form, drawn from donated and discarded children's and baby clothes, too worn or damaged to be used for charity (see Figure 7.1). Working with a diverse assembly of volunteers including a local network of female refugees, as well as members of the Salvation Army, workers in the City of London financial district, and students of mine from King's College London, Ates stitched the castoff clothes into a massive tapestry dedicated to the millions dying and fleeing from the Syrian Civil War. Some items, emblazoned with animals, sports insignias, and holiday designs, stood in mute testimony to stolen innocence, while others bore messages of raw pain, inscribed by refugees. "Why did my son have to die?" read a plain white onesie, scrawled with a red pen.

Ates marked the completion of the piece with a choreographed procession, evoking Catholic and Orthodox rituals with icons and relics, including the Mandylion and the Veil of Veronica (see Figure 7.2). The procession for *Sea of Colour* began outside the Salvation Army, crossed the nearby Millennium Bridge, turned around at the Tate Modern art museum, then retraced its steps back to the Salvation Army, with the iconic dome of St. Paul's Cathedral rising behind.

*Photo by Cilin Deng. Courtesy of the Artist © Güler Ates*

**FIGURE 7.2** Güler Ates, *Sea of Colour*, 2016. Performance on February 2, 2016. Millennium Bridge, London, UK.

In effect, the route traversed the symbolic distance between the realms of art and religion. The event began with a sinewy performance artist hoisting the massive tapestry over her head. As she trudged forward, her shoulders hunched to bear its weight, the other volunteers and I held the edges of the tapestry, like attendants lifting a bridal train. As we marched, a few people in suits gruffly brushed past us. Some tourists stopped and took photographs. But a surprising number of people seemed to sense we were doing something important, however mysterious. A few asked questions, then joined in as they grasped the concept, while others helped silently for a bit without asking, then continued on their way. It was a bright, chilly, cloudless day, but as we crossed the groaning suspension bridge, the wind stiffened, catching the fabric. The tapestry began to ripple, then violently crest and snap like ocean waves in a gale. The wind effortlessly tore a half-dozen pieces of clothing from the surface, sending them flying hundreds of feet downwind, into the river. It took the efforts of everyone, including those recruited just moments before, to keep the entire piece from taking flight. As Ates later reflected, "The journey we took across the Millennium Bridge was a very small reflection of the experience of modern-day refugees, who take extraordinary risks to reach a safer home" (Rosen 2019, 129). In a poignant episode of interreligious geometry, I found myself, a Jew, participating in a performance led by an Alevi-Sufi-inspired artist, commemorating both the ancient suffering of Jesus and the present pain of Middle Eastern refugees. Rather than occupying the distanced position of a curator or scholar, in this liminal moment I had – almost without recognizing it – become a pilgrim.

## Conclusion

"[F]undamental to every pilgrimage," writes David Freedberg, "is the element of hope" (100). Freedberg has in mind the soteriology of medieval Christians, seeking deliverance from misfortunes and maladies through the agency of icons and relics. Yet, Freedberg's insight, I think, finds new relevance in the kinds of contemporary pilgrimages we have been discussing in this chapter, including *Stations of the Cross*. I imagine few if any visitors to *Stations* have gone looking at the art on display for palliative purposes, at least not physically. Nonetheless, visitor testimonials and survey responses from each of our host cities, in the United Kingdom, the United States, and the Netherlands, have indeed registered an "element of hope" in other ways, most notably in their encounters with others. Rather than preceding and animating pilgrimage, hope has itself become an outcome. This might not seem so miraculous – though I think we do well not to underestimate how remarkable it can be to find and sustain hope – but it has the advantage of being open and applicable to people across faith traditions, or even none. The acts of embodied looking and attentive walking that we have engaged with in this chapter are not the privileged holdings of particular faiths, however deeply individual traditions have explored their potential. For all their ostensible simplicity, such practices constitute a still under-utilized, under-studied

resource for interreligious engagement as we march toward a more equitable future. Pilgrimages plotted and undertaken on these grounds may not save souls or heal bodies, but they may well repair communities.

## Notes

1 An earlier version of this chapter appeared as "Curating an Interfaith Pilgrimage: Visual Strategies for Interreligious Studies," in *The Georgetown Companion to Interreligious Studies*, ed. Lucinda Mosher (Georgetown University Press, 2022), and I gratefully acknowledge the permission of Georgetown to reprint that text, as well as the insightful input of the editor Lucinda Mosher on that earlier text.
2 See, for example, "The Coexist Pilgrimage – People of Faith Walk as People of Peace."
3 Another powerful example is Lafayette Square near the White House, forcibly cleared of peaceful protestors for racial justice by order of Donald Trump on June 1, 2020. Visiting the site to interview protestors and collect signage and other materials for The National Museum of African American History and Culture, curator Aaron Bryant recalls, "I was surprised by how Lafayette Square had become a pilgrimage site of sorts" ("Curator's Corner," *Image Journal*, Issue 106, Fall, 2020.
4 See https://walkthewalk2020.us/.
5 Beyond self-defined pilgrimages, one might also expand this field of inquiry to include a range of mass political protests, stimulated in many cases by the election of President Donald Trump in 2016. To pick only examples from the left wing of the political spectrum – right-wing protests have been larded with religious language and imagery, but very rarely with an eye toward productive interfaith engagement – one might include: the Poor People's Campaign, the Women's March, the March for Science, March for Our Lives against gun violence, and the Climate Strike, which have all had signature events in the US capital, as well as iterations across the country. While the formal agendas and demands of these protests have not usually been religious, they have – in different ways – constituted ritualized performances of identity, with significant implications for interreligious studies.
6 See www.luceartsandreligion.org/stations-of-the-cross.
7 The exhibition coincided with the launch of de Botton and Armstrong's book *Art as Therapy* in 2013.
8 As Paine reminds us, in addition to such museums "encouraging people to do religious things in their galleries," possibly more common "must be instances of people who pray, leave offerings, kiss icons or the like," which are not sanctioned or even recorded (40).
9 Subsequent shows at the National Gallery have built on this legacy, including *The Sacred Made Real* (2009–2010) and *Devotion by Design* (2011).
10 See interviews and essays about Ates, Benjamin, and Dothan in Aaron Rosen, *Brushes with Faith: Reflections and Conversations on Contemporary Art*.
11 There has been an interesting uptick in pilgrimages by bicycle, whether following traditional routes like El Camino in Spain, or developing new routes, such as Buddhist pilgrimages in California organized by DharmaWheels (https://dharmawheels.org/). There is also a growing literature about the psychological and phenomenological dimensions of cycling, for example, Jon Day, *Cyclogeography: Journeys of a London Bicycle Courier.*

## Bibliography

Armstrong, John and Alain de Botton. *Art as Therapy*. Phaidon, 2013.
Bryant, Aaron and Aaron Rosen. "Curator's Corner," *Image Journal*, Issue 106, Fall, 2020.

Day, Jon. *Cyclogeography: Journeys of a London Bicycle Courier.* Notting Hill Editions, 2016.

De Botton, Alain. "Should Art Really Be For Its Own Sake Alone?" *The Guardian,* January 20, 2012. http://www.theguardian.com. Accessed 1 October 2020.

Duncan, Carol. *Civilizing Rituals: Inside Public Art Museums.* Routledge, 1995.

Freedberg, David. *The Power of Images: Studies in the History and Theory of Response.* University of Chicago, 1989.

*The Image of Christ: The Catalogue of the Exhibition Seeing Salvation.* Edited by Susanna Avery-Quash and Gabriele Finaldi. National Gallery (London), 2000.

Morgan, David. *Visual Piety.* University of California, 1998.

Paine, Crispin. *Religious Objects in Museums: Private Lives and Public Duties.* Bloomsbury, 2013.

Parker, Rosalind. "The Museum Space as a Mediator of Religious Experience: Sacred Journeys at the British Museum." In *Visualising a Sacred City: London, Art and Religion.* Edited by Ben Quash, Chloe Reddaway, and Aaron Rosen. I.B. Tauris, 2016.

Rosen, Aaron. *Brushes with Faith: Reflections and Conversations on Contemporary Art.* Cascade, 2019.

———. "Curating Pilgrimage: Visual Strategies for Interreligious Studies." In *Georgetown Companion to Interreligious Studies.* Edited by Lucinda Mosher. Georgetown University Press, 2022.

"Stations of the Cross Exhibition in London: S. Brent Plate interviews Aaron Rosen," *Material Religion: The Journal of Objects, Art and Belief,* Issue 12.2, June 2016.

Turner, Edith and Victor Turner. *Image and Pilgrimage in Christian Culture.* Columbia University Press, 1978.

**Websites**

"About," *Stations of the Cross,* Henry Luce III Center for the Arts & Religion. http://www.luceartsandreligion.org/about-stations. Accessed October 1, 2020.

"The Coexist Pilgrimage – People of Faith Walk as People of Peace" https://www.interfaith.cam.ac.uk/events/coexistpilgrimage. Accessed November 8, 2020.

DharmaWheels. https://dharmawheels.org/. Accessed November 13, 2020.

"Faith over Fear: Choosing Unity over Extremism." https://cathedral.org/wp-content/uploads/2016/04/20151220FaithoverFear.pdf. Accessed November 8, 2020.

"Walk the Walk." https://walkthewalk2020.us/. Accessed November 8, 2020.

## PART II

# Artistic Strategies

# 8

# ICONIC

## Contemporary Portraiture and Sacred Personhood

*Katie Kresser*

### Identity Discourse and Portraiture

In 2016, Pulitzer Prize winner Jerry Salz, art critic for *New York* magazine, published an essay with the journalist Rachel Corbett titled "How Identity Politics Conquered the Art World." Still available on the website www.vulture.com, a subsidiary of *New York* magazine, the essay covers more than thirty years of contemporary art history and features interactive timelines and gorgeous illustrations. It is a widely used resource among people wishing to understand contemporary art.

The essay begins with a consideration of the groundbreaking 1993 Whitney Biennial, which galvanized audiences through its focus on race, gender, and sexuality. Hosted every two years by the Whitney Museum of American Art in New York, the Whitney Biennial is America's most prestigious exhibition venue for emerging artists. Artworks featured at the 1993 Biennial, including buttons reading "I CAN'T IMAGINE EVER WANTING TO BE WHITE" and an installation showing a Latino figure slain by police would feel at home on the protest scene of the early 2020s. Other works from the 1993 Biennial, including pieces by Alison Saar (celebrating Black identity) and Nan Goldin (photographically documenting LGBTQIA+ subjects), have arguably become classics of contemporary art history.

Throughout the essay, Salz and Corbett ably demonstrate how issues of identity have continued to grow in art world importance in the new millennium, to the point of launching a "take over." And indeed, a look at the most recent Whitney Biennial, held in 2019, indicates that "identity politics" – or, at least, the exploration of social identity and its consequences – continues to inform the work of major contemporary artists. Kota Ezawa's *National Anthem*, for example, showed American football players kneeling during the "Star-Spangled Banner,"

DOI: 10.4324/9781003326809-11

protesting police violence against Blacks. And Jeffrey Gibson's *People Like Us*, a multi-media reimagining of traditional Native American costume, celebrated Gibson's intersectional identity: Native American, colonized, and queer (*Whitney Biennial 2019*).

In its concern with identity, portraiture has long been the artistic genre *par excellence*. And the 2019 Biennial, certainly, was not devoid of portraiture. (John Edmonds's sensitive photographs, for example, walked the line between portraiture and art-historical appropriation, ultimately embracing both.) In fact, even realistic portraiture, rendered using "old-fashioned" techniques, has made a huge comeback in recent years, often at the hands of artists demographically excluded from the heyday of Western portraiture during the 1400s–1700s. The painted portraits of Lynette Yiadom-Boakye, for example, display Black sitters in a style that recalls the work of Diego Velasquez and John Singer Sargent. Meanwhile, the portrait sculptures of Rigoberto Torres, often featuring Torres's neighbors in the Bronx, remind viewers of the marble portrait busts of the Italian Quattrocento.

## Religion as a "Third Rail"

It is both notable and ironic, however, that religious affiliation is often excluded in contemporary visual expressions of identity. In fact, religion often functions as a dangerous "third rail" in art world discourse today and can be studiously avoided. (One portrait artist considered for inclusion in this chapter, in fact, asked to be omitted on the grounds that the discussion would be "religious.") When religion *is* referenced in contemporary portraiture, the implications have frequently been critical or subversive. Francis Bacon's stunning "papal portraits," for example, show historical pontiffs screaming in ghostly, hellish agony. More recently, Maurizio Cattelan echoed Bacon (somewhat humorously) with his resin "portrait" of John Paul II being struck by a meteor.

To be sure, some contemporary portraits do approach religion in nuanced ways, though they are exceptions that prove the rule. The photographs of Shirin Neshat, for example, are notable for their direct, fraught engagement with Islam; they wrestle with the implications of Islamic law for Neshat's pious female sitters. Similar issues are explored in the striking work of Moroccan artist Lalla Essaydi. More often, however, the earnest incorporation of religious symbolism – when it occurs – is placed in service to a bespoke, personal spirituality. In the portraits of Nadia Waheed, for example, elements from Buddhism, Christianity, and Islam are combined to form personal expressions of female empowerment.

It could be argued, however, that our 21st century's preoccupation with "identity politics," and portraiture specifically, is *itself* fundamentally religious. Indeed, though the phenomenon of "identity politics" is often linked to Marxist ideas that originally denied a spiritual dimension, it actually reveals deep assumptions about individuals' cosmic dignity – assumptions rooted in an incarnational, Christian worldview. For many of us, regardless of our religious affiliation,

*Personhood* approaches a divine condition, anchored in something that transcends age and health and gender and skin. This conviction is a legacy of the Christian paradigm.

## The Christian Origins of Portraiture

The genre of portraiture has long been central to the so-called "Western tradition." Indeed, some of the most important surviving artworks from the world's earliest large civilizations are effigies of specific people. (Consider the gleaming statues of Egypt's early, pyramid-building pharaohs, or the regal bronze heads of Akkadian kings.) In these ancient images, one questions, admittedly, whether an individual's essence is truly being captured; the individual instead seems to be absorbed into an archetype. By the early-century BCE, however, individual qualities are assuredly being honored (as in the so-called "Capitoline Brutus" of the 4th-c. BCE, or the many portraits of Alexander the Great). Here, finally, a kind of transcendent dignity is linked to incisive observation.

The sculpted portraits of the ancient world, however, weren't portraiture completely – *tout court*. In their massiveness, three-dimensionality, and politico-cultic function, they had one (marble) foot in the world of the idol. They were both representations and *presences* to be worshipped and obeyed (or, in the case of explicitly funerary sculpture, to be maintained and served by pious descendants on behalf of the departed soul). They were extensions of beliefs about the divinity of emperors and about idols' capacity to "hold" actual spirits. Their analogues, today, are the massive statues of Abraham Lincoln and Thomas Jefferson in Washington, DC, or even the giant mountainside Buddhas of East Asia. For the ancients, sculpture was a container for spirit, and the sculpted portrait was a true effigy that in some ways held its prototype's place.

It fell to Christianity, with its radical spiritual egalitarianism and its assertion of divine over family ties, to conceive of the individual independent of both social role and tribal obligation. For Christians, every individual was precious in the eyes of God and endowed with a mysterious and unique divine destiny. (Thus, the Apostle Paul could envision the church as a cosmic "body... made up of many parts" (1 Cor 12:12) and the evangelist John could write of the "new name" (Rev 2:17) each Christian would earn in heaven.) In the ancient world, scattered geniuses could be regarded as precious individuals whose souls should be captured in portraits (the philosopher Plotinus is a famous example), but only Christianity extended transcendent dignity to every person. In Galatians 3:27–28, the Apostle Paul famously wrote, "For all of you who were baptized into Christ have clothed yourselves with Christ. There is neither Jew nor Greek, slave nor free, male nor female, for you are all one in Christ Jesus." Every demographic, according to Paul, had an equal claim to becoming a memorable and dignified divine likeness.

At the same time that Christianity extended portrait-worthy significance to everyone, it elevated a second-class artform to first-class status. Its preference for

pictures was sharply at odds with the ancients' more three-dimensional sensibil-ity. In the ancient Middle East and Mediterranean, of course, sculpture was vastly preferable to painting – no doubt due to its simultaneous permanence and ability to conjure a presence. Indeed, among the ancient Mesopotamians and Egyptians the sculpted form, because it could be coterminous with the human body (hav-ing physical parts that extended into space), was the only acceptable resting place for the soul. With their three-dimensional reach, sculptures alone could afford a sufficient range of power in the afterlife.

The Early Christians, however, preferred the two-dimensional picture to memorialize the departed, including figures such as Jesus Christ and the Virgin Mary. These *icons*, as they came to be called – flat, rectangular, and partial in their focus on the head and chest – are the predecessors of our rectangular por-traits, hanging in galleries, lobbies, and living rooms. They cast a remote glow over the unveiling of each new Presidential portrait, and they inform the most glamorous Instagram selfies, with their rectangular formats and diffused light. On picture day at school, framed and centered before backdrops of blue, my own children are made "iconic."

The Early Christians' choice of the two-dimensional form was convenient for its evasion of "idolatrous" prototypes, and it also had the benefit of economy. (Pigments and wood were no doubt cheaper than blocks of stone.) But at a deeper level, the Christian icon asserted the *separateness* of its heaven-dwelling subjects. The Christian God was transcendent, and his kingdom was "not of this world" (John 18:36). Sanctified souls could not be fully contained in earthly vessels. The sensory, the perceivable, and the spatio-temporal became a mere window – and a small one, at that – onto a vaster realm of spirit. Under such a paradigm, the light, sketchy, fragmentary, and insubstantial quality of the icon could seem more appropriate to reality – more solidly *true*.

Typical Early Christian icons, such as the 6th-century *Christ Pantocrator* from the Monastery of St. Catherine at Mt. Sinai, have a few notable characteristics (Figure 8.1).

First, they are rather small. (The Sinai Christ is about two- and three-quarters feet tall: sizable but a far cry from monumental.) Second, they have beautiful but rather indeterminate backgrounds; these would later be understood as evocations of a timeless heaven. Third, their figures have a composite or vibratory quality, as if they are shifting from one position to another or transitioning from state to state; this makes them ageless and suggests their subjects' activity in eternity.

All of these complementary qualities work together to make a tantalizing window onto something separate – something *living*. Throughout the develop-ment of the icon form, in fact, artists have employed different strategies to suggest the flickering life in their subjects – a spiritual life that pictures are insufficient to capture. Some of these strategies include mysterious shadowing, the incorpo-ration of glittering gold, unnatural angles, partial views, and deliberate asym-metries. The Christian icon, above all, is *suggestive* – neither coterminous with its subject nor rhetorically "complete."

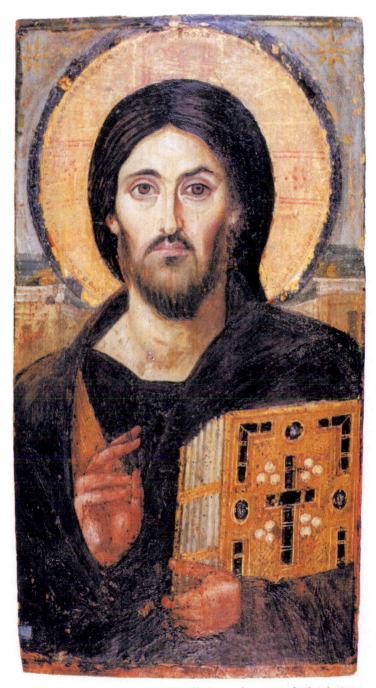

**FIGURE 8.1**    Christ *Pantocrator* icon, 6th c. Encaustic on wood, 84 × 45.7 cm (33 × 18 in). Monastery of St. Catherine on Mt. Sinai.

In his defense of icons against the iconoclasts (image destroyers), the 8th-century monk and polymath John of Damascus outlined the theology undergirding the icon-makers' compositional strategies. In his *Treatise on the Divine Images*, the sainted monk wrote:

> Of old, God the incorporeal and uncircumscribed was never depicted. Now, however, when God is seen clothed in flesh, and conversing with men, I make an image of the God whom I see. I do not worship matter, I worship the God of matter, who became matter for my sake, and deigned to inhabit matter, who worked out my salvation through matter. I will not cease from honouring that matter which works my salvation.
>
> *(John of Damascus, sourcebooks.fordham.edu)*

In John's writing, the material world, which the iconoclasts deemed hopelessly and even blasphemously insufficient for evoking the divine, is given two distinct honors. First, it is shown to have been inhabited by God, and therefore deemed by God himself to be a fitting vessel for divinity. And second, matter is found to participate in the ongoing work of "salvation." (Later, John would spell out how this happened through objects such as Christ's cross and burial clothes, and through places such as Gethsemane and Golgotha.) Though insufficient to capture the divine, matter is nevertheless connected to, and ennobled by, divine grace.

John would never argue, of course, that an icon could manifest God as completely as Christ himself did. The icon could, however, evoke Christ's factual, optical, material presence for the senses. And just like Christ's cross and shroud, icons could participate in God's saving action by inspiring the faithful to meditation, empathy, and gratitude for God's work in the world. They could perform their own, humble role in the unfolding of God's redemptive plan.

In this respect, icons doubly manifested a kind of *transcendent particularity*, or particular transcendence. They could participate, irreplaceably and irrevocably, in God's divine plan in a way tailored exactly for their moment in history. This transcendent particularity – rooted in the providence of God and adapted very specifically to a point in space-time – was a quality shared both by the icon itself and by the saint pictured within its borders. Both, in their own way, provided some of the inspiration necessary to move specific souls toward holiness. In fact, the cult of the saints, with its never-ending cast of eccentric characters (sitting cross-legged on columns, hiding under stairways, fishing youths from pickle barrels), was a natural extension of the Early Christians' enchanted worldview. For early believers like John of Damascus, all matter could potentially reflect the earthy, idiosyncratic unfurling of God's rich salvation story.

## From Icon to Portrait

In Early Christian and medieval times, only saints and royalty merited the portrait treatment, as a general rule. By the early Renaissance, however, thanks to

factors such as increased economic prosperity, the invention of new devotional practices, and the outworking of latent theological principles, the portrait as we know it began to emerge. Burgeoning trade networks, urbanization, and a more efficient division of labor extended middling prosperity to a far greater percentage of the European populace. More leisure time granted more space for private devotion and self-discovery. And religious geniuses like Saint Francis of Assisi and St. Bonaventure had birthed a new spirituality that extended divine dignity to ever further reaches of the material world. (Consider St. Francis's sermon to the birds.)

Thus, in short order, the portrait was everywhere. That flat, small, portable, rectangular image of the human face – whether man or woman, noble or common – became ubiquitous, boldly capturing evanescent character with the flick of a brush. The famous Flemish artist Jan van Eyck, perhaps best known today for the recently restored Ghent Altarpiece, was an early portrait master, and his own (probable) self-portrait is inscribed with words of high ambition: "Als ich kann" – "all I can." In some ways, for van Eyck, the self-portrait became the highest expression of the painter's art: the summoning-forth of a transcendent particularity that the painter both knew best (as his very self) and could offer up most completely toward the achievement of God's providence. Another Flemish artist, Rogier van der Weyden, made this message even more explicit when he painted himself as the main character in his famous image of *St. Luke Drawing the Virgin*. Here, van der Weyden's identity as an artist is united with the identity of St. Luke, the Gospel writer, suggesting that both men, in the exercise of their crafts, had contributed in their own way to salvation history.

In its form, the Renaissance portrait was very much like the old Early Christian or Byzantine icon. And some portraits even had formal qualities that emulated early icons obviously and directly. During the High Renaissance, for example, Raphael Sanzio combined the flickering light, monochromatic backgrounds, and shifting views of the icon to captivating effect in both portraits of living sitters like Baldassare Castiglione and devotional "portraits" like his famous Madonna del Granduca. Though Leonardo da Vinci's elaborate backgrounds depart from the golden fields of the icon prototype, his smoky *sfumato*, closely emulating the patina and natural coolness of many classic icons, elevates portraits like the *Mona Lisa* to a kind of iconic status. The German painter Albrecht Dürer, meanwhile, is well known today for his own self-portrait that closely emulated the typical *Christ Pantocrator* type (Figure 8.2). With his long, brown hair parted down the middle and his hand raised in almost blessing, Dürer clearly channels Christ as the Creator-of-creators. The effect is sealed by the small inscriptions on either side of Dürer's head, obviously emulating the alpha and omega flanking Christ's visage in so many iconic prototypes.

After the Renaissance set the template, later artists dutifully followed suit. The Baroque-era portraits of Rembrandt van Rijn, with their surfaces that seem to throb and glow, radiate a deep spirituality of unrivaled and unmistakable power. Similar qualities are present in some portraits by the Spanish artists Diego Velásquez and Francisco de Zurburán. Even during the Revolutionary period, portrait artists like John Singleton Copley in the United States and Jacques-Louis

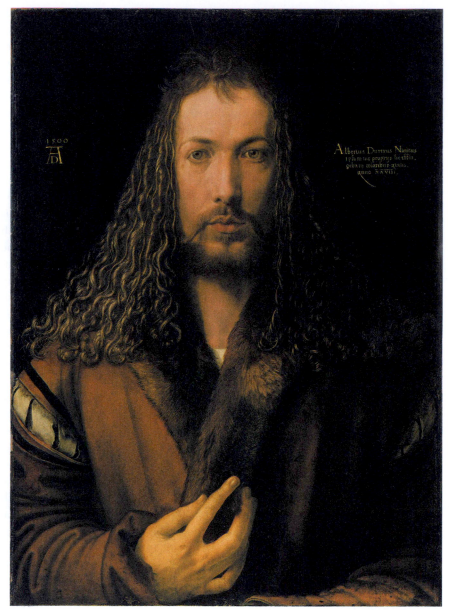

**FIGURE 8.2** Albrecht Dürer, *Self-portrait*, 1500. Oil on panel, 66 × 50.8 cm (approx. 26 × 20 in). Alte Pinakothek, Munich, Germany.

David in France did the same for their sitters – though the atheist David's motivations, at least, were far from explicitly spiritual.

Nor did the best high modern art fail to draw on the icon prototype when developing images of concentrated, immediate power. Thus, we feel that the portraits of the maverick Pablo Picasso, hailing from all phases of his career, have

an iconic gravity. In fact, the artist's Cubist formulations, whether purposely or not, recall the flattened space and strategic asymmetries of the earliest icon painters. Though Picasso's portraits, with their loss of character, seem like dissolutions of the portrait form, they in some ways return, through mystery and ambiguity, to their earliest icon prototypes. Here, through the fragmentation of his sitters, Picasso conjures a mind-boggling, unsearchable particularity that seems to extend to the molecular level.

## Contemporary Iconic Portraiture

Indeed, the formula discovered by the earliest Christian iconographers is so fruitful that it has supported prolific experimentation by a range of contemporary artists. This chapter has already touched on contemporary portrait-makers like John Edmonds and Lynette Yiadom-Boakye. Both Edmonds and Yiadom-Boakye, it has been noted, are Black artists who appropriate traditional forms in the elevation of new subjects. They are joined in this effort by figures like Kehinde Wiley and Amy Sherald, famous today for their portraits of President and Michelle Obama. Wiley, now a global superstar, combines the heavenly space of the icon with the luxury of aristocratic portraiture – to spectacular effect.

While some contemporary artists have appropriated the icon type subtly and implicitly, others have launched explicit dialogue with the ancient form and its spiritual connotations. Andy Warhol, for example, made obvious reference to devotional forms in ironic "portraits" like his famous *Marilyn Diptych*. Here, Warhol invites us to compare – for better or worse – modern celebrities with ancient saints. In her own series of works on Marilyn Monroe, the feminist artist Audrey Flack combined iconic vignettes of the doomed *femme fatale* with still-life objects ranging from lipsticks to devotional candles. Flack's images are funerary altars, *memento mori*, and feminist critiques all at once. Together, Warhol and Flack seem to suggest that the modern cult of celebrity kills – and it kills specifically by rejecting the humble and lovable *particular*. Messy individuality is rejected in favor of old, quasi-pagan archetypes (think Aphrodite or Helen of Troy) that level and flatten and judge.

Because the "iconic" portrait form has often been associated with specific, religious definitions of virtue (indeed, its earliest subjects usually wore haloes), some contemporary artists have appropriated it in a questioning and revisionist spirit. The lesbian photographer Catherine Opie, for example, has made numerous portraits of gender-non-conforming individuals, each of them resonant with the "icon" form in their simplicity, their "spacelessness" (often thanks to richly monochromatic backdrops), and their meditative qualities. Some of these portraits are titled with slurs such as "Pervert" and "Dyke." Here, Opie challenges viewers to grant full humanity – a precious, transcendent Personhood – to individuals whose lifestyles are in conflict with traditional religion. The photographs of the gender non-binary South African artist Zanele Muholi employ similar strategies, though with an aesthetic that incorporates African design motifs. Some of Muholi's self-portraits, in particular, seem to interpret the halo in entirely novel ways.

By fragmenting his three-dimensional sitters and reconfiguring them on a flat plane, the Cubist-era Pablo Picasso evoked the strange perspectives of Early Christian icons; this approach could suggest essences that existed outside of time and space. Without being strictly "Cubist," other contemporary portrait-makers have embraced this same tension between the deep and the flat – the spatially distant and the immediately present – to a similar "timeless" effect. The painterly portraits of Alice Neel, for example, walk a satisfying line between solid flesh and ephemeral spirit. With their intense eyes and wavering, tapering faces, they also recall very early icons like the *Christ Pantocrator* at Mt. Sinai. The early portraits of the celebrated Chuck Close have a similar melting, pulsing intensity and a similar focus on the eyes, "the windows to the soul." Meanwhile, Close's late portraits are actually mosaics of sorts, combining smaller, tessellated forms into singular, larger ones in a manner clearly reminiscent of Byzantine mosaic icons like the great Deësis at the former church (now mosque) of the Hagia Sophia in Istanbul.

Another artist who combines a serviceable realism (his sitters are clearly recognizable) with a spatial tension that lifts one out of the present is the British painter Lucien Freud. In Freud's portraits, a sliding, galvanic asymmetry and tremulous alertness combine to lift the eye up and away from the torments of the flesh. And for Freud, the flesh is assuredly a realm of torment. Few artists have rendered the depredations of age and ill health more unsparingly. In Freud's portraits, therefore, we seem to watch as the flesh melts away to reveal the soul. In the work of Jenny Saville, also British, the dissolution of the flesh is even more literal – pieces are missing! – showing existential pain that reveals something enduring underneath. Much of Saville's work concerns women's embodied experience – in sex, motherhood, childrearing, and sometimes physical abuse.

When it comes to exploring the full implications of the icon prototype, however, it is not surprising that artists working in Christian contexts have gone the furthest. The neo-realist painter John Nava is today best known for his series of huge tapestries in LA's Cathedral of Our Lady of the Angels. Here, 136 saints and blesseds (or saints-in-the-making), hailing from many different times and places, are rendered, against faintly golden grounds, with a high degree of photorealism. This is "transcendent particularity" at its most assertive. Dwelling beatifically in heaven, these saints nevertheless retain the minutest flaws and eccentricities, suggesting the absolute, providential necessity of even their smallest quirks. One is reminded, here, of a famous quote attributed to St. Catherine of Siena: "What is it you want to change? Your hair, your face, your body? Why? For God is in love with all those things and he might weep when they are gone" (Ladinsky 203).[1] In Nava's tapestries, all care is taken to erase nothing, lest God be forced to weep for the lack.

In the portraits of Massachusetts painter Bruce Herman, meanwhile, the icon prototype is flaunted and celebrated, in a reverent attempt to find the holiness in everyone. Herman's *Ordinary Saints* series depicts the artist's friends and family

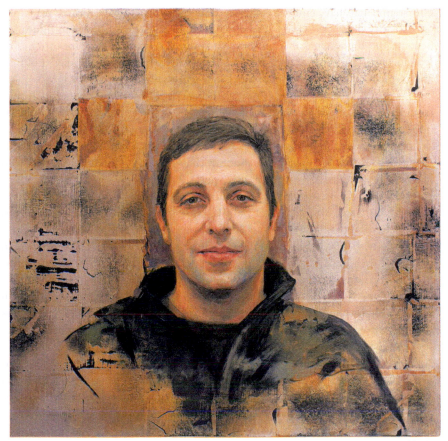

**FIGURE 8.3**   Bruce Herman, *Ben,* 2014. Oil and alkyd with silver leaf on wood 76.2 × 76.2 cm (30 × 30 in).

against luminous backgrounds sometimes obviously reminiscent of early icons' heavenly spaces. This is especially clear in the portraits *Ben*, with its silver tiles (Figure 8.3), and *Malcolm Guite*, radiant with gold leaf. For Herman, the use of the icon prototype can help us both rediscover the earliest Christians' experience of Spirit-bathed immanence and newly appreciate the value of the souls we live among today.

## Contemporary Portraits beyond the Pale

These appropriations of the icon form – to varying degrees and by artists with a diversity of belief systems – show our enduring acceptance of the idea of Personhood as conceived by Early Christianity. The human individual is precious, unique, and somehow transcendent, with a core identity that cannot be violated by age, illness, repression, or persecution. Even artists antipathetic to

Christian beliefs have embraced this central, and I think incarnational, principle. Christianity holds that God became man; because of this, the human figure has become the highest possible sensory expression of transcendent meaning. The icon form still helps us capture this compelling idea, regardless of today's political and ideological challenges to the Christian worldview.

As a result, even when contemporary portraiture has moved away – far away – from the traditional icon form, it has continued to assert a transcendent Personhood that bursts the bonds of time and space and pulses with a sacred meaning. In the conclusion of this chapter, I will consider three examples of portrait "installations" that reinforce ancient ideas about the dignity of Personhood – albeit in playfully or challengingly unorthodox ways.

In *Project for a Memorial*, the Columbian artist Oscar Muñoz filmed himself painting, in water, the visages of slain Columbians on surfaces of stone. Just as each recognizable image begins to emerge, the water of which it consists begins to evaporate so that the image fades away like a fleeing ghost. The fragility and brevity of each life taken is thus underscored. But at the same time, the Columbian martyrs are given a sort of delicate immortality. This is because Muñoz's film, of course, can be played over and over again, all over the world. Such repeated evocation and loss can remind viewers of the dreadful toll Columbia's drug wars have taken and can above all honor the transcendent particularity of souls whose beings cannot, even by violence, be erased.

The artist Candice Breitz has adopted a very different angle on the precious particular and its endurance in the face of broader social phenomena. In *King (A Portrait of Michael Jackson)*, Breitz juxtaposes, on a horizontal array of small screens, a diverse group of individuals all privately singing Michael Jackson's *Thriller*. The result is humorous and cacophonous and playful. And it reveals something about human particularities that naturally transcend – and *distend* – mass-culture leveling effects. Though Michael Jackson's *Thriller* was an enormously popular single that inspired youth everywhere to dress and move in emulation of the pop star, the song also became an anthem for fans to own – and make their own. In *King*, Breitz's sixteen subjects show the individuality they bring to a shared song, suggesting that even the most popular and leveling phenomena cannot erase individual idiosyncrasy. Even Michael Jackson himself recedes behind the displays of eccentric exuberance, becoming a humble facilitator and not an untouchable "star."

Finally, the Seattle-based artist Barbara Earl Thomas has attempted a fresh kind of installation portraiture in her 2020 piece, *The Geography of Innocence* (Figure 8.4). Here, an entire gallery room is backlit with draped, cream-colored paper, perforated to look like the finest lace. The resulting effect is one of almost heavenly gentleness, delicacy, and luminosity; viewers entering the room emit a quiet gasp of awe. Situated in niches hollowed from within the graceful, draped patterns are warmly backlit images of Black children, themselves cut from black paper. These dark faces glow with happy smiles; their presence rendered spellbinding by the sharp, black/white contrast of the portraits and their surroundings.

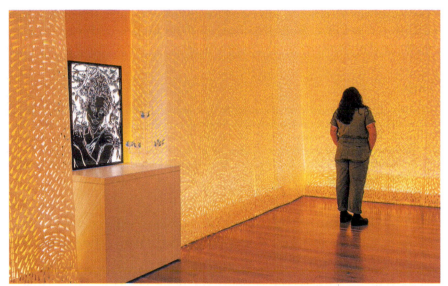

*Photo: Spike Mafford*

**FIGURE 8.4**  Barbara Earl Thomas, *The Geography of Innocence,* 2020. Installation view. Permission Seattle Art Museum.

Thomas, who often makes reference to her Christian heritage in her work, asks us to consider how we define "innocence." Why is the color white associated with sacredness and purity while the color black is associated with villains and shadows? How can we reconcile these unquestioned connotations with the innocent Black faces looking out at us with wide and trusting eyes? In its explanation of Thomas's installation, the Seattle Art Museum notes that "the biblical stories of the New Testament underscore that the value of each human life is part of the myth we say that we believe" (Seattle Art Museum). In her secular "sanctuary" installed in the Seattle Art Museum, Thomas wants each visitor to experience her young Black sitters as full of value, radiant with innocence – precious, inviolable, and in some way eternal. Perhaps, through works like Thomas's *Geography of Innocence*, we can finally accept that "the value of each human life" is not a "myth" at all, but a truth foundational to all the best practices, the best expressions, the best impulses, our world has to offer.

In his essay *The Weight of Glory*, the literary scholar and Christian apologist C.S. Lewis wrote, "I believe in Christianity as I believe that the sun has risen: not only because I see it, but because by it I see everything else" (Lewis 92). I think that in a way anterior to creeds and alliances and dogmas, many of us – regardless of belief system – can say something similar. We believe in inviolable Personhood – the transcendent, lovable, particular – because by it we "see" everything else. By it, we see the way to decency, generosity, acceptance, compassion, and admiration. By it, we see the way to hearty lament, and to commitments to rescue and serve. By it, we see the way to conceive of humanity as a loving family.

The incarnational spirit of Christianity has given us this light, this probing sight, and artists today, of all faiths and none, are showcasing its challenges, its implications, and its beauty.

## Note

1 This quote is popularly attributed to St. Catherine of Siena, but it likely originated from the volume *Love Poems from God: Twelve Sacred Voices from the East and West* (New York: Penguin Compass, 2002), by Daniel Ladinsky, p. 203. Ladinsky freely and poetically adapted words from Catherine of Siena and other ancient saints. Thanks to Seattle Pacific University librarian Steve Perisho for discovering the real origin of this popular quote.

## Bibliography

Antonova, Clemena. *Space, Time and Presence in the Icon: Seeing the World with the Eyes of God*. Routledge, 2010.
*The Holy Bible*, New International Version. Zondervan and HarperCollins, 2011.
John of Damascus. Mary H. Allies, translator. *On Holy Images*. Thomas Baker, 1898.
Kresser, Katie. *Bezalel's Body: The Death of God and the Birth of Art*. Cascade, 2019.
Ladinsky, Daniel. *Love Poems from God: Twelve Sacred Voices from the East and West*. Penguin Compass, 2002.
Lewis, C.S. Walter Hooper, editor. *The Weight of Glory*. Macmillan, 1980.
Porphyry. S. MacKenna and B.S. Page, translators. *The Life of Plotinus*, in *The Enneads of Plotinus*, 4th ed. London, 1969.
Salz, Jerry and Rachel Corbett. "How Identity Politics Conquered the Art World." *New York Magazine*, April 21, 2016.
Seattle Art Museum. "Barbara Earl Thomas: The Geography of Innocence." https://thomas.site.seattleartmuseum.org/.
*Whitney Biennial 2019*. https://www.whitney.org/exhibitions/2019-Biennial.

# 9

# RELIC-ING NOW

## Reliquary Strategies of Materiality and Memory in Contemporary Art

*Cynthia Hahn*

Relics are material objects used in the mediation of the sacred in many religions – Christianity, Buddhism, African ancestor cults, and many others. Often consisting of bits of bone or other abject matter, relics enter the world of art through their presentation in "reliquaries," that is, containers that range from boxes, to chapels, or stupas, and which are often created through the combination or nesting of types of containers, from the mundane to the precious to the architectural.

Through their essentially "indexical" or pointing nature, religious relics have the possibility to seize the imagination and direct it elsewhere, to there and then from here and now. Moreover, they instantiate memory in important ways. But, as stubbornly material objects, how do they do these things? Without doubt, it is the reliquary that plays an essential role in the work of relocation and refocusing. The reliquary and its creation of the "reliquary effect" establishes value and captures attention through a *re-presentation* of the abject/object itself – indeed, the reliquary substantively replaces the relic – establishing the holy matter in a new context, through the primary move of enshrinement (Hahn 2017, Chaganti).

As we will see in this discussion, this same approach can be used in contemporary art. If the "reliquary effect" can be best defined as a set of moves or strategies that continuously asserts the value of the material object or remains, while simultaneously pointing beyond the material thing to a transcendent significance, it is not an approach confined to religious art. Let us look more closely at these various operations.

Aspects of the reliquary effect that prove essential to the efficacious encapsulation of a relic include a series of paradoxical assertions, all the more powerful for their self-contradiction. For example, typically the "reliquary" object is both intrinsically associated with death and forcefully asserts an after-*life*. Additionally, the assertion of specific materiality and specificity of place is almost always combined with an open-ended possibility of re-making. That is, at the same

DOI: 10.4324/9781003326809-12

time the reliquary asserts age and antiquity or even timelessness, in order to maintain a perennial freshness of reception, the object can change and relocate. Finally, there is frequently a claim to beauty (often through the use of beautiful materials), despite the recognition of a concomitant repulsion of the usual stuff of relics – bones, dust, or old scraps of cloth. Such contradictions and their power may be characteristic of response endemic to human nature – for example,

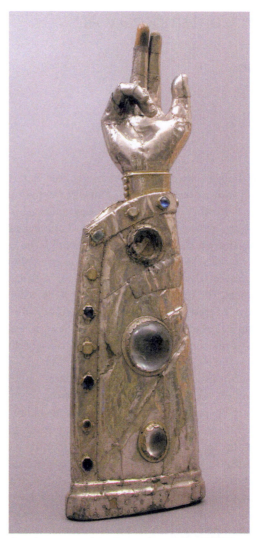

*Photo: Metropolitan Museum of Art, Creative Commons Zero (CC0) license*

**FIGURE 9.1**   *Arm Reliquary,* French, 13th-c. with 15th-c. additions. Silver, silver-gilt, glass, and rock crystal cabochons over wood core, 51.6 × 15.8 × 7.4 cm (20 5/16 × 6 1/4 × 2 15/16 in). Metropolitan Museum of Art Collection, 17.190.353. Gift of J. Pierpont Morgan, 1917.

both beauty and disgust are thought to be components of attraction (NYTimes, 12.27.21).

A medieval arm reliquary in the Metropolitan Museum of Art (13th and 15th centuries, 17.190.353; Figure 9.1), a type of reliquary that is very common, may serve us as an example. The reliquary may or may not have once contained a relic of an arm (some examples contained other bones or even scraps of cloth), but as realized, the arm conceptualizes the relic as the resplendent silver right arm of a saint resident-in-heaven, therefore, as the power of such a saint. The implicated powers specific to such an arm could range from healing through touch (note the wear on the silver fingers), to blessing during religious liturgies (note the fingers that make the gesture used in the customary blessing effected through the movement through the air in a cross-shape), to the certification of speech acts such as acts of baptism or even sermons of conversion as an extension of the priest's arm (Hahn 1997). The Gospels frequently make use of a metaphor of the body in which Christ is the "head" of the Church but utilizes the "arms" of the saints to accomplish his work.

We should note that although the fragment that makes up the saint's relic inside the reliquary may have been imported from elsewhere in a relic exchange, the act of enshrinement in this arm reliquary establishes a particular Church treasury as home to that relic.[1] Through its residence, the relic loaned its specific location a power, which was ultimately, however, also bi-local – both fixed in the community of the faithful and empowered by the saint's residence in heaven. Moreover, although emphatically local, the reliquary might grow in power through movement. It could move about in the church for use in the liturgy, but it could also venture outside the walls for work in the community – both processions and ceremonies of healing. It could even travel further abroad to raise funds or "speak" a truth on behalf of its congregation (Hahn 2019).

Finally, reliquaries are not art work as modern viewers tend to imagine such things. They were subject to reworking as the community saw fit. On this reliquary arm, the large cabochon glass was probably added to simulate a powerful crystal gem that would have revealed a relic to the sight of the faithful. In making this change, the older opaque reliquary cedes its power of mystery to a new trend that preferred visible relics.

If we concede that these multiple strategies of containing and making are essential to the reliquary's presentation of the relic as powerful, eternal, and a link to the divine, we begin to understand the work of a "reliquary effect." At the same time, however, while the reliquary performs these functions of presentation, it efficiently disappears in the viewer's awareness. Instead, the "presence" of the relic that it has "made" comes to the fore.

But perhaps we move too fast – pressing questions remain. How does physical material become imbued with such sacred significance that it seems to shine forth in this manner? How does it first become a relic?

Another culture may give us some insight. Relics are just as important in Buddhism as in Christianity. In both religions, enshrinement can be likened to

"relic-making." In an account of the practices of one 17th-century Japanese nun, we learn that she made use of bodily sheddings to manufacture Buddhist relic objects. Using the nail parings and hair of her father, a great and pious emperor, which she deployed in both calligraphy and images, the nun was able to "facilitate interaction between this world and the next" (Fister 222). Ultimately, the nun aspired to make her father one with the Buddha by incorporating his body parts into a temple. Such practices may have had an origin in votive offerings, but they actively sought to unify the worshipper with the divine, both literally and through acts of making. In the case of the emperor and other venerable men, portraits also took on sainted status. Similarly, the Buddhist practice of writing sutras with one's own blood joins body with devotion even more directly. The result of such manipulation of materials is that a holy person becomes a "saint" and a devotee elevates abject materials through a kind of devotional "artistic practice."

Above all, relics and reliquaries assert themselves through human practice and by that I do not refer only to practices of making; we must also consider other actions. These include the telling of legends (referenced by inscriptions on objects), use in ritual, and even a more passive use of reliquaries as objects of attention and devotion. Although these practices could be considered universal, at the same time they posit particular relics as *unique* and *authentic*, and for its part, the reliquary also makes this assertion. Reliquary materiality, for example, asserts the antiquity of the relic through the most basic comparison with its own "newness." It then further is able to imply the "double condition" of an old material thing, that is, that it stands both for the present (presence) and for the past (Nagel/Wood 298). As above, Christian reliquaries further assert the presence of the saint both "here" and in heaven. The reliquary has all these strategies at its disposal to assert the value and temporal/spatial significance of the relic.

But we should return again to the very first step in order to fully understand the spatial consequences of the reliquary, that is, the act of enclosure. Through this action, the reliquary locates the sacred in a specific space. As a frame, it might be as subtle as a sacred precinct, or it might be as assertive and impenetrable as a strong locked box. In any case, the framing reliquary not only announces the value of the relic but also activates both the enclosed space (the contents) and the space around it. Moreover, in contrast to its enclosure, the relic is set in a larger environment, perhaps a series of successively defined spaces, or even incommensurable space. The "space" of the relic is ultimately redefined as numinous, perhaps even the space of salvation. Thus, rather than a small fragment – possibly just a tiny piece of bone – the relic is amplified and situated in a complex field of relations and space. As Helen Hills expands upon this notion:

> … in relations that not only hold and protect, hide and reveal, but displace one substance with another … the relics are never housed and never contained; instead they are always excessive, overflowing, spilling out.
>
> *(Hills)*

The relic is never truly enclosed, for indeed while it is enclosed, its power escapes enclosure.

The ability of the relic to "escape" thus creates yet another paradox. The reliquary, while certainly framing the relic and creating an interior, simultaneously *destroys* any clear sense of interior and exterior; contained and containing. One response to this quality of the relic as "escape artist" seeks a multiple-containment strategy – a sort of funhouse sequence of iterations of enclosure, a veritable, physical *mise-en-abîme* of containment. But despite the multiplication of frames that attempts to fix the relic in place – in examples from early Christian churches to Buddhist temples to Neapolitan Baroque chapels – the result demonstrates that the power of the relic is never housed, never contained, and always excessive. The relic works, as many have noted, through a sort of contagion that cannot be quarantined by physical confines, but that wonderfully, that is, miraculously, spreads its divine qualities through touch, through sight, and even through the air.

The impossibility of containment may be the reason for the reliquary's teasing game of hide and seek. Many reliquaries do not allow visual access to their relics (and devotees were also rarely allowed to touch the relic or reliquary). The reliquary arm discussed above tried both strategies – it both hid and then exposed relics in different iterations of its presentation. Some reliquaries manage an exchange in which the power of the relic is transferred to another substance (cloths that touch the outer surface), or power moves from the relic material to a sacred image, for example, a saint's portrait. Ultimately, as Cesare Poppi argues in discussing African sacral remains, if the secret is to be effective, it has to be known that there is a secret, and the constitution of the secret is far more important than the secret itself. Its production, but also its obscurity, allows levels of access, and hierarchies of competency in interpretation that regulate the power of the sacred (Poppi 201).

Finally, if the reliquary is the intersection of the abject and the beautiful, and the precious and the valueless, these values also continually change place – because as so many Fathers of the church inform us, the dust contained within the reliquary is more valuable than any gem (Hahn 2017, 19–23).

In sum, relics do not have intrinsic worth but require ritual, story, and social actors to find their place in religious meaning. In religious vision, the beauty of the relics is linked to their authenticity, but this authenticity is created socially rather than being intrinsic to the nature of the object, and much of the work of authentication is done by actions of choice, collection, and enshrinement – what we might, by putting the emphasis on action rather than object, call relic-ing[2] – the making of relics.

★★★

Encouraged by art students I have taught, I have argued that relic strategies are relevant to modern artistic practice. Of importance perhaps to the resonance and

origins of their practice, it must be noted that every artist I will mention below is either Catholic or was raised in a devout community. These creators emerge from societies perhaps still steeped in relic use, and work with or against these ideas to think through their art making. Christian forms and practices are familiar and seem to hold their power. However, as we will see, for these artists, relic strategies are used to elucidate the "problem" of the body, and effectively express memories of pain and degradation – a need to materialize but not to objectify horror – as well as to instantiate and remember issues of personal and national history. The "rhetoric" of reliquaries proves to be a powerful tool in socially engaged discourses. We will see that artists consistently use art to create memory pieces that enshrine and explore material and its possibilities.

In *The Reliquary Effect*, I investigated at length the work of three contemporary artists and their interaction with reliquary strategies. Joseph Beuys is perhaps the least specific in his references to relics, but remains a touchstone for artists of the 20th century in his concentration on materials and for his part in the emergence of German art from what Theodor Adorno characterized as its inability to make "poetry," as well as its post-WWII wholesale rejection of institutional Christianity (Ray 68, citing Adorno). His "student" Anselm Kiefer is more literal in his references to religion but, using the Kabbalah, envisions much of the mystique of objects from Judaic perspectives and issues around Nazism and the Holocaust. A third primary proponent of reliquary strategies – the American Paul Thek – worked to some degree in the same environment as the two Germans, living as an expatriate and creating some of his most influential work for German galleries. He labels some of his sculptures "reliquaries," but such a title begs the question of their contents. All three artists were raised in the Catholic Church, and Thek pursued an interaction with the Church, at least sporadically, throughout his life.

Here, I would like to investigate the work of more recent artists, not all Catholic – Nari Ward, but also Dario Robleto and José Leonilson, as well as Bettye Saar – to explore the persistent strategies of bringing power to objects that in turn are memorials that address racism, sexism, and other violence, inequities, and mysteries of the contemporary world.

Nari Ward, although born in Jamaica, now identifies his community as Harlem, in New York City.[3] I will focus on three pieces in which he treats the engagement of the viewer and the representation of the individual in a community: *We the People (Black Version) 2015* at Crystal Bridges and Museum of Contemporary Art, Chicago; *Sugar Hill Smiles,* a community performance piece of 2014; and *Homeland, Sweet Homeland*, 2012.[4]

*We the People* forces us to simultaneously rethink both the words of the Constitution and the art work's material: shoelaces (Figure 9.2). In the iteration at Crystal Bridges, the piece is presented on a black wall, and most often viewed by white bodies, the realization in Chicago perhaps has a somewhat different audience. The shoelaces, inserted into the wall itself, makes each piece site-specific, in effect immovable and irreversibly part of its place (white versions exist

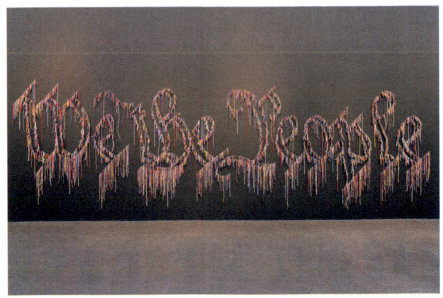

**FIGURE 9.2**  Nari Ward, *We the People (Black version)*, 2015 Shoelaces 96 × 324 inches (243.8 × 823 cm) In collaboration with The Fabric Workshop and Museum, Philadelphia Installation view, *The Freedom Principle: Experiments in Art and Music, 1965 to Now*, MCA Chicago, July 11–November 22, 2015.

elsewhere). The presentation is both abstract and inclusive, and indeed, as the artist notes, the viewer perceives it differently depending on his or her distance.

This lived experience, especially that of black persons, quite literally "talks back" to the original intent of the US constitution. "We the people" as a declamation in that founding document may, in effect, deny the divine right of kings, but originally, the phrase empowered only white landowners. The shoelaces used in the piece, according to Ward, are a kind of "inoculation." As the material of the art work, they are an entry point to true diversity, including viewers and multiple identities through things that, in effect, cross economic boundaries. The shoelaces, Ward argues, relate to any-body, and given that we all learned to tie shoes at a very young age may represent one of our first engagements with "craft." The effect of the shoelaces on the wall with their random drapings, multiple textures, and many colors is therefore both abstract but also immediate and personal. The laces provide an alternate sense of dangling movement versus the historic lean and swagger of the pen lines of the Constitutional quote.

Titles are important to Ward, allowing a level of access to which he is committed; as he says, the title "starts the experience." *We the People*, in fact, grabs us and makes us perform a speech act. Enunciating the title leads us to assert that we are "the people." In discussing a different early work, Ward argues that its title, *Hunger Cradle*, implicates both need and care and that concern for need and

care resonates with much of his work. As with that early work, Ward asserts that although he is known as a sculptor of found materials, his works are not made of "garbage" but remnants – objects that still have "hope." Transformed to things that are positioned as art and beauty, materials start an alternate although also parallel journey and live on in their community. Ward often salvages material locally and thus brings attention to materials, and things (and thus ideas), that would otherwise be ignored or discarded.

It might be tendentious to belabor the similarities of *We the People* to relics – but we cannot ignore elements of Ward's artistic practice that bring an empowerment of earthly residue – remnants [Latin= *reliquiae*] – and secure a dynamism with the end result. This practice creates not only conditions of reception of things by both the individual and the community with a site-specific nature but also an ability to reach beyond the confines of material and place.

Moreover, when Ward asserts his interest in an "imagination of expectation," he tells us he asks, "Site?, what in a site is contentious or inspiring?" He asks, can he bring such questions into a "layered experience?" As an example of his exploration of such ideas, the video *Sugar Hill Smiles*, 2014, exemplifies a quite literal activation of materials (Figure 9.3).

For the piece, which was realized in a joy-filled performance in his community, Ward supplied himself with a Jamaican-style cart, a supply of empty cans with mirrored interiors and a device to seal the cans. He trundled the cart through the city, engaged with viewers, asking them for a smile, which they supplied by looking into the cans. He then promised to "keep them fresh" and

**FIGURE 9.3** Nari Ward, *Sugar Hill Smiles*, 2014, performance, cans, and video, for *No Longer Empty: If You Build It*, exhibition June 25–August 10, 2014 in Broadway Housing Communities' Sugar Hill Building, NYC Video still, courtesy of the artist. Full video available on Vimeo: https://vimeo.com/104024881.

sealed the smile in with a lid. He sold the cans for $10, but forbade customers from buying their own, making the case that these were "no longer empty presents" and that he was making a case for social justice.[5] In this instance, the container became a true reliquary of an abstract but powerful experiential content. Unlike an earlier example in which another artist canned his own excrement and sold it as art work, Ward refocuses this disdainful and ironic move into a strategy that encapsulates joy and community and both the sharing and dispersal of meaning (Nagel 215 discussing Piero Manzoni).

A last piece I would like to mention allies Ward to other artists working with materials as memorial and introduces the use of both handwork and fabric entanglements, a deeply meaningful aspect of textiles. Ward described a moment when he wanted to give out business cards, but finding the practice unusual among artists, he sought to make the gesture meaningful. He adapted an idea from his brother, a lawyer, and distributed cards with "citizen's rights" imprinted on the front (and his details on the reverse). However, he realized that in handing out such cards, it was as if he was implying the recipients were criminals, that he was creating an "incriminating moment." Subsequent to these first actions, he created a single large piece: *Homeland, Sweet Homeland* (2012). On this object, made of cloth, plastic, megaphones, razor wire, feathers, chains, and silver spoons, an embroidered eagle spreads its wings over the declarations of the citizen's rights creating a kind of plaque that is reminiscent of a woman's sampler (Pérez Art Museum Miami), but is labeled: "A Notice to Police Officers and Prosecutors."

Such use of handwork and meticulously recorded materials is strikingly similar to pieces from artists concerned with materials as diverse as the Texan Dario Robleto and Brazilian José Leonilson.

Robleto, who calls himself a "materialist poet," combines unlikely materials into objects that look like samplers or women's shadow boxes or work baskets. His labels also include meticulous material lists that even detail some of the processes of making: *No One Has a Monopoly Over Sorrow* (2005, men's wedding ring finger bones coated in melted bullet lead from various American wars, men's wedding bands excavated from American battlefields, melted shrapnel, wax-dipped preserved bridal bouquets of roses and white calla lilies from various eras, dried chrysanthemums, male hair flowers braided by a Civil War widow, fragments from a mourning dress, cold cast brass, bronze, zinc, silver, rust, mahogany, glass).[6] As with the last work by Ward, there is a deliberate confusion of object type – women's work made by men. One sees the work as a "sampler" of emotions and memory that may through assemblage lead to thought and even activism.

José Leonilson, *Ninguém* (1992), also reverses categories of gender-associated materials and techniques to create a piece that confuses boundaries and ultimately seeks to provoke activism, but is ultimately far more personal than those of Ward or Robleto. In fact, in it, Leonilson asserts his queer status and precarious health by embroidering an awkward childlike signature on the intimate found/constructed object that originally was suspended from its uppermost corners: a

tiny pink embroidered pillow with a striking sense of texture and assertive mate-riality.[7] As Irene Small writes:

> Made in 1992, a year after … [he] learned he was HIV-positive, and a year before his death at the age of thirty-six, …the small pillow, its case hand-sewn from fabric remnants…[ is] too small for bed, it seems intended for succor rather than sleep: something to clutch in the darkness, rest one's head on during the day.

In contradiction to its title: *Ninguém/Nobody*, the piece very much indicates a specific some-body, and furthermore speaks to that body's suffering: it is "replete with Christian iconography [in its embroidery and marks]: stigmata, scars, bleed-ing hearts, crosses, crowns, swooning and supine bodies, miraculous touches that bridge worlds apart" (Small).

Small characterizes the piece as a political "denouncement" of AIDS policy, and in its current place in the art world continues to serve equally to condemn "hypocrisy social, violence and greed." In all of these three last pieces, textile entanglements speak forcibly to communities, emotions, and social inequity.

I end with a piece that turns decisively away from these powerful but "fem-inine forms" and domestic techniques. Made by a woman long before the work of the male artists discussed above, Betye Saar created what has become a femi-nist icon, using reliquary and materialist strategies to make overtly political and activist work. The exhibition *Black Heroes* at the Rainbow Sign Cultural Center, Berkeley, CA (1972), was organized as a community response to the death of Martin Luther King Jr. Saar's contribution,

> …caused a sensation. The depiction of Aunt Jemima as a liberator and revolutionary resonated with the growing Black Power and feminist move-ments. Years later, civil rights activist Angela Davis said that *The Liberation of Aunt Jemima* was the starting point of the black women's movement. [8]

This meager description seems to imply that the work was a kind of poster made in the moment to promote a political cause. Although this is said to be Saar's first political piece, a piece in which she forcefully inserted black women into the liberation movements of feminism and black power, her process of creation was based on her longstanding practice and has proven to have staying power in its intrinsic force.

Saar, again, began with a group of "found objects" and called attention to them by putting them in a frame or what is better described as a box. Such a shadow box, familiar to the art world from the work of Joseph Cornell (who she recognizes as an inspiration) and similar to Robleto's work of a later date, encour-ages the viewer to peer into a doll-like world of a created environment. What the viewer sees in this instance is a *mise-en-abîme* of nested images of "Mammy,"

not as a beloved domestic servant or perhaps slave, but as a powerful figure of potential acts of liberation.

Saar centers her composition on a small plastic figurine of Aunt Jemima, the "mammy" of the kitchen still known for her pancakes. Saar repainted the original object depicting Aunt Jemima with a very Black skin contrasted with bright bulging eyes, a red-checked kerchief and flowered dress, and a wide red smile with white teeth. The figurine once carried a broom in one hand and a pencil in the other with a "serviceable" notepad across her stomach. Saar reconfigured the image replacing the pencil with a rifle, another toy readymade. In place of the notepad, she inserted a postcard showing the second image of a mammy, this one with a squalling white infant tucked under her arm. Superimposed over the laundry strung on the fence in the postcard, Saar painted an image of a woman's black fist rising from a ribbon with the colors of the Pan-African flag. Saar's interventions transform both images of the obedient servant into a doubled set of threatening figures, now grimacing with what must be seen as unsettling smiles. The *mise-en-abîme* of transformed exultant Jemima is completed with the repeated figure taken from advertisements for Aunt Jemima pancakes, which now papers the back of the box surface. The cotton at the feet of the figurine not only refers to the labor of picking cotton but also creates a kind of cloud of apotheosis (perhaps a parallel to martyrs who were victorious over their torture).

The strategies of multiple "enshrinements," of elevating base materials, of using bright colors and attractive shiny surfaces, of implicating the involvement and emotion of the viewer, and of asserting contradictions such as both history and presentness, all are important aspects of the way that this piece makes its declaration of defiance.

★★★

Although ultimately these thoughts about an arbitrary selection of powerful but diverse works by contemporary artists do not by any means sufficiently tell their history, "explain," or interpret them, I have tried to make the case that reliquary strategies and the enshrinement of materials can be a powerful force in the practices of contemporary artists. This perspective can, above all, supply a useful toolbox of questions for the art historian or critic. Perhaps best exemplified by medieval reliquaries and their uncanny powers, "the reliquary effect" can be said to live on as a force in the present artistic moment, especially among artists with a strong faith and community focus. Strategies of relic-ing persist and enable a focus on objects and materials that in turn are empowered to address racism, sexism, and other violence and mysteries of the modern world.

## Notes

1 Later disruptions of churches and monasteries have led to reliquaries being sold on the art market, but the long memory of a relic's home can lead to disputes (*ArtForum*).

2 Suzanne Preston Blier coined this active term at "Matter for Debate: A Workshop on Relics and Related Devotional Objects," at the Institute for Advanced Study Princeton, July 2010.
3 Full disclosure, Nari Ward is my colleague at Hunter College and received his BA from Hunter.
4 Early work of a religious nature included *Vertical Hold 1996*, created at a Shaker farm in a program for contemporary artists – a quilt-like hanging of recovered bottles – and manifested as a circle, *Hunger Cradle 1997* uses recovered textiles. Ward uses the BaKongo Cosmogram and the Christian cross in works. See videos: *Nari Ward*.
5 For an example, see https://www.albrightknox.org/artworks/20187-sugar-hill-smiles.
6 In a conversation with the author, Robleto asserted that the listing of materials was literally accurate. For images, see: https://americanart.si.edu/blog/eye-level/2013/12/635/civil-war-and-american-art-six-questions-materialist-poet-dario-robleto; and http://www.dariorobleto.com/works/146.
7 For an image, see: https://www.artforum.com/print/202102/irene-v-small-on-leonilson-s-ninguem-1992–85003.
8 The Rainbow Sign was a Black community center in Oakland, California. Oakland was the birthplace of the Black Panthers and a focal point of the politically motivated Black Arts Movement (BAM). *Nittle*. For an image and details, see: https://smarthistory.org/betye-saar-liberation-aunt-jemima/.

## Bibliography

*Artforum*, "French Village Urges Metropolitan Museum to Return Religious Bust" January 19, 2018. https://www.artforum.com/news/-73648.

Chaganti, Seeta. *The Medieval Poetics of the Reliquary: Enshrinement, Inscription, Performance*. Palgrave Macmillan, 2008.

Fister, Patricia. "Creating Devotional Art with Body Fragments: The Buddhist Nun Bunchi and Her Father, Emperor Gomizuno-o," *Japanese Journal of Religious Studies*, XXVII (2000), 213–238.

Hahn, Cynthia. "The Voices of the Saints: Speaking Reliquaries," *Gesta*, 36 (1997): 20–31.

——. *The Reliquary Effect: Enshrining the Sacred Object*. Reaktion, 2017.

——. "Theatricality, Materiality, Relics: Reliquary Forms and the Sensational in Mosan Art," *Sensory Reflections: Traces of Experience in Medieval Artifacts*, edited by Fiona Griffiths and Kathryn Starkey. De Gruyter, 2019, 142–162.

Hills, Helen. "Beyond Mere Containment: The Neapolitan Treasury Chapel of San Gennaro and the Matter of Materials," *California Italian Studies*, III (2012): http://escholarship.org/uc/item/7d49p517.

Metropolitan Museum of New York, Collection, 17.190.353. https://www.metmuseum.org/art/collection/search/464334.

Nagel, Alexander. "The Afterlife of the Reliquary," *Treasures of Heaven*, edited by Martina Bagnoli et al. New Haven, 2012, 215.

Nagel, Alexander and Christopher S. Wood. *Anachronic Renaissance*. New York, 2010.

Nittle, Nadra. "Betye Saar: The Brilliant Artist Who Reversed and Radicalised Racist Stereotypes," *The Guardian* (September 23, 2021). https://wams.nyhistory.org/growth-and-turmoil/feminism-and-the-backlash/empowerment-through-art/. Accessed September 23, 2021.

Poppi, Cesare. "Sigma! The Pilgrims Progress and the Logic of Secrecy," *Secrecy: African Art That Conceals and Reveals*, edited by M. H. Nooter. New York, 1993, 197–203.

Ray, Gene, ed. *Joseph Beuys: Mapping the Legacy*. New York, 2001.

Sanyal, Sunanda K. "Betye Saar, Liberation of Aunt Jemima," *Smarthistory*, January 3, 2022. https://smarthistory.org/betye-saar-liberation-aunt-jemima/. Accessed June 30, 2022.

Small, Irene V. *Close-Up: Negative Capability, Irene V. Small on Leonilson's Ninguém, 1992, Artforum*, 59 (March 2021) https://www.artforum.com/print/202102/irene-v-small-on-leonilson-s-ninguem-1992-85003.

Young, Molly. "How Disgust Explains Everything," *New York Times*, December 27, 2021. https://www.nytimes.com/2021/12/27/magazine/disgust-science.html.

Ward, Nari videos cited:

*Nari Ward, We the People*. Smarthistory. https://www.youtube.com/watch?v=Ba8Jsja1dEM.

*Southern Symbols: Nari Ward*. Speed Art Museum. https://www.youtube.com/watch?v=WiMZ-z6dr_o.

*Talk | Nari Ward*. Contemporary Arts Museum Houston. https://www.youtube.com/watch?v=jxjVENHrXWg.

# 10

# CONTEMPORARY ART AS PILGRIMAGE AND SITE

Ambrosio's *As Far As The Eye Can Travel* Zine Project

*Kathryn R. Barush*

About once a month, a little envelope arrives in the mail, stamped with an eye where a wax seal might have been in an earlier century. Tucked inside, I know that I will find a tiny zine – in size only – as it will contain multitudes. A zine is usually understood to be a small-circulation, self-published artist's book, often including an assemblage of materials, sometimes original and sometimes appropriated (including text, quotations, and images).[1] In this case, each one is a portal to another place and time. One issue transports the viewer to the Gardens of Bomarzo in Central Italy as the eye traverses a precarious staircase leading into the great, open Orcus mouth. The inscription on its lips – ALL THOUGHTS FLY – could pertain just as well to the contents of the zine. Another issue invites the viewer into an orchard in Granada, which is now a space of solace and resistance with the trees planted in a ravine just 10km away from a mass grave where victims of the Spanish Civil War are interred, and where the poet-activist Federico García Lorca was murdered. Another month, readers were ushered into an obscure, vernacular beach chapel in Calabria, built by shipwrecked Neapolitans in thanksgiving for the intercession of the Madonna di Piedigrotta, who had come to their aid. The zines are hand-held, requiring attention and – like a film – time: time to tear the envelope, to turn the pages, to bring the zine close to the eye to take in the minute details. In No. 55 "Portals," for example (July 2020), there is even a space for a cinematic intermission, as a glowing sign invites. The zine subscription project, entitled *As Far As The Eye Can Travel*, is the ongoing initiative of London-based artist and filmmaker Chiara Ambrosio (Figure 10.1). The objects are interactive, thematic, and cinematic – one page a panoramic landscape, the next an intimate portrait; vicariously carrying the viewer from Coney Island to Palermo and beyond.

This chapter brings *AFATECT* into dialogue with some of its historic precedents in order to argue that art can engender an embodied experience of

DOI: 10.4324/9781003326809-13

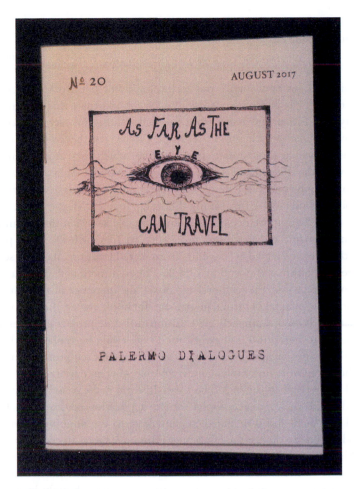

FIGURE 10.1   Chiara Ambrosio, *As Far As The Eye Can Travel*, No. 20, Palermo Dialogues (August 2017). Hand-held printed paper zine, 6 × 8.5 cm (2.36 × 3.35 in). Photo: Chiara Ambrosio. Used with permission.

pilgrimage, with the artist functioning as a pilgrim-guide. It takes a *longue durée* approach in order to show the continuation, rather than rupture, of this tradition and conceptual framework, in this case achieved through the collecting and assemblage of photographic images of places and objects perceived to have a sacred significance:

> The material world is extremely charged for me, and objects, surfaces, landscapes – to say it with [Czech neo-Surrealist filmmaker] Švankmajer – carry layers of history that have gathered within them through space and time, and that await our touch to be released. With regards to *As Far As The Eye Can Travel*, the zines are handmade talismans, amulets and portals

inside which the captured images are given to the paper, transformed into charged objects [...].

<div align="right"><em>(Ambrosio 2019)</em></div>

Ambrosio engages new media and technology, but her work participates in a long-extant artistic and religious impulse. We could trace this back to Classical antiquity (see Elsner and Rutherford's edited volume on sacred travel in from Greek and Roman polytheism, for example), but given the form and function of the zines, as well as the cultural contexts from which they arose, it makes sense to start with the illuminated manuscripts of the Middle Ages as sites of mental, or stationary pilgrimage for those who could not travel for a variety of reasons (Connolly 1; Rudy 494–515). Taking this a step further, Megan Foster-Campbell has described the importance of the agency of objects *within* these manuscripts – and their talismanic and apotropaic properties, such as the lead and tin pilgrimage badges that were collected as souvenirs from sacred locations and later sewn on to the pages of illuminated devotional books. These functioned as an "aid for personal devotion beyond the temporal and physical experience of a pilgrimage journey – facilitated mental or virtual pilgrimage for book owner, through memory or imagination" (Foster-Campbell 229). Ambrosio's zine project provides a focused case study, but the critical framework used here could be applied to the work of many other artists engaging in the use of assemblage (in sculpture, in installations, or in photographs) in order to engender an embodied experience of entering into a sacred space (Barush *passim*).[2] The socio-historic context and spiritual impetus that undergirds these projects allows for the application of this kind of methodological approach, and is intended to contribute to the ongoing development of a critical lexicon to discuss the efficacy of religious objects in contemporary art.

In his book, *On The Strange Place of Religion in Contemporary Art*, to which the current volume is offered in response, James Elkins delineates contemporary art as "whatever is exhibited in galleries in major cities, bought by museums of contemporary art, shown in biennales and the Documenta, and written about in periodicals such as *Artforum, October, Flash Art, Parkett*, or *Tema Celeste*" (Elkins 1). Ambrosio's art is a compelling case study because she straddles both the mainstream art world and the underground; she has undertaken a major commission from the Victoria & Albert Museum, collaborated with the composer Michael Nyman, curates a film salon at the Horse Hospital in London, hosts a radio show, RAFT, on RESONANCE 104.4fm, and has exhibited at the Whitechapel Gallery in London and Anthology Film Archives in NYC. She was also the recent recipient of a major UK Arts and Humanities Research Council award for her second feature film. In an endorsement for the Arts Council grant, NYU English professor Sukhdev Sandhu highlighted this, writing,

> In the films that she makes, the artist books that she creates and publishes, the music that she composes, as well as her tireless cultural advocacy, she is a topographer of effaced and imperiled spaces, a social sculptor who

assembles and shines a spotlight on a diverse range of shamefully neglected figures, a haptic artist who draws attention to the material and often sensuous traces of wounded environments.

*(Sandhu)*

Ambrosio told me in a recent interview that the "paper Wunderkammer" of *AFATECT*:

> ...offer a way to challenge mainstream narratives, suggesting that meaningful and transformative events happen often unnoticed, and that through the act of paying attention to what is seemingly marginal, real change and revelation can occur. They are an act of commitment to the mystery of presence, a search for continuity within the cracks and the margins.

*(Ambrosio 2019)*

All of her work takes seriously this spiritual (or spirit-aware) impetus and unironically seeks to prompt an experience of pilgrimage through the incorporation of religious objects, tactility, text, and (in the case of her films) soundscapes.

As one of her long-time collaborators has emphasized, Ambrosio "never 'captures' a moment, instead, she sets it free from falling away into non-existence" – an act of rewilding (Kirkpatrick 2021). Rewilding can be understood both as returning a cultivated environment to its natural state and, more broadly, as a returning to ancestral ways through remembrance and a return to the senses. Her first feature film, *La Frequenza Fantasma* (*The Ghost Frequency*), which was screened at the Whitechapel Gallery in London in 2015

> tells the story of a place suspended in time and space, where the memory of a mythical past and the present are inextricably intertwined. It is an investigation into the nature of collective and personal history, into the origin and preservation of memory.[3]

Although Ambrosio emphasizes the collective subconscious at work in what she sees as a universal re-enchantment of artistic production, she admits that her love of "charged architectures and spaces of ritual" recalls her childhood in her *own* ancestral spaces of Calabria and Rome. Catholics there and everywhere are "haunted" (as Andrew Greeley put it) by a sense that objects, events, and persons of daily life are revelations of grace and that "the artist (musician, storyteller, poet) is a 'sacrament maker,' a person who calls out of his materials insights and images into the meaning that lurks beneath them" (Greeley np). In *AFATECT*, but also her films, Ambrosio engages not only canonical Catholicism, but also the richness of syncretism: the folk beliefs and magic that have long subverted the hierarchical structures of the church in Southern Italy. The title of one of the zines is a nod to Ernesto De Martino's *Magic: A Theory from the South*, an

anthropological study that has detailed descriptions of practices that combine ritual and prayer (for example, tying a red ribbon around a child's head for thirteen days and reciting a spell followed by an Our Father and Ave Maria to encourage healing of a condition called *seretedda*). De Martino acknowledges the choice between "magic" and "rationality" that runs from Greek thought to the natural magic of the Renaissance to the "Protestant polemic against Catholic ritual" (xi). In relation to the particularities of "tattered relics and forms of magical-religious life," De Martino speaks of the "structural and functional features of the magical moment – albeit one that has been refined and sublimated – that we find also in Catholicism, especially in its Southern [Italian] specificities and nuances" (xiv–xv).

Although the inculturation of folk traditions has been attempted (not just in Southern Italy but all over the Catholic world), De Martino's book shows the robustness of their survival as "Southern Italian cultural life" participates in, and – simultaneously – resists the "option" of modernity (xi-xv). Ambrosio's work emerges from, and straddles, these worlds: the ancient, the modern, the folkloric. She harnesses contemporary techniques and media to resist the disenchantment that Weber warns of. As poet, essayist, and travel writer Marius Kociejowski put it, Ambrosio "has not only Calabria but Naples going through her veins":

> Compared to the north [the south of Italy] is another world, one in which Christianity and Paganism seem to be of the same material and it is this which feeds [Ambrosio's] imagination. It is not something you can learn… I wouldn't say Chiara is religious in the ways we usually think of, but it is fascinating to observe her dedication to Giuseppe Moscati, a doctor who treated the poor in Naples and who was later beatified. Chiara always goes to his shrine at the church of Gesù Nuovo in Naples and she shares with other southern Italians an almost casual relationship with their saints, almost as if they are family members.
>
> *(June 30, 2021)*

Still, attention to the medieval-modern belief in the transfer of "spirit" from object to representation and the theological impetus behind acts of popular piety such as creating third-class relics all provide useful critical frameworks to think about *AFATECT* zines as generating an embodied experience.

Ambrosio acts as a pilgrim-guide in the case of the zines (as well as her films), ushering the viewer into a space that she herself has documented and recorded. In this way, we connect with her (as an artist and a mediator) and with the site that is portrayed within the zines. In a symposium as part of the *turn the page Artist's Book Fair* on June 26, 2021, Ambrosio described the photography of *AFATECT* as a time-based medium of "epiphanic moments," stating that each photograph was taken quickly, but that they take time to unravel (2021). Issue no. 26, "Napoli 18" begins with an augury into the landscape as we follow a figure's gaze out the window. Turning the page, we find ourselves on the street looking

at a pile of debris, which juxtaposes plywood cupboards with an empty sculptural niche. Day turns to night as Ambrosio presents to the beholder a view up to the rooftops and then down onto a roadside Marian shrine. An icon of Maria Della Strada, Our Lady of the Way, is affixed to the wall and underneath is an altarcito of photographs and flower offerings including red roses for Mary (Figure 10.2).

The anthropologists Edith and Victor Turner's notion of *communitas* developed in the now-classic book *Image and Pilgrimage in Christian Culture* can be applied here, but with an emphasis on its proposed "existence outside of structured time" (1974: 238–239 and 2011: XIII).[4] Rather than the focus on the community enacted within a group of pilgrims, which has been the focus of many anthropologists when marshaling the idea of *communitas*, I am more interested in an artwork as a site of extratemporal *communitas* in and of itself. That is to say, as a "symbol vehicle" (*pace* Turner and Turner) and site of community where, through the act of viewing, the beholder connects to those who have seen the object, person, or image in the past and those who will see it in the future. It is a connection that transcends temporal boundaries (Barush 5-6). For example, when I squint into the mouth of that cave at Bomarzo, I can imagine – and perhaps even feel the presence – of the pilgrims who have entered it or who will in the future.

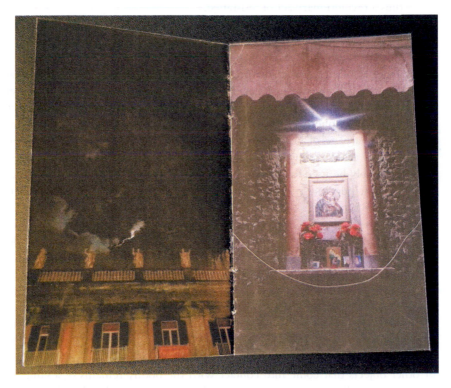

**FIGURE 10.2**  Chiara Ambrosio, *As Far As The Eye Can Travel*, No. 26, Napoli 18 (August 2016). Printed paper 'zine, 4 × 8.5 cm (2.16 × 3.65 cm). Photo by the author. Used with permission of the artist.

The title of the zine project itself – *As Far As The Eye Can Travel* – invokes the medieval idea of surrogate pilgrimage *through* objects like manuscripts, maps, and labyrinths. It also echoes theories of vision as put forth by, for example, the mystic theologian Hugh of St. Victor in which the eye becomes the site of an expansive cycle of vision. In his writings on the use of visual aids as a way to facilitate a mystic experience, the act of seeing takes on a tactile dimension – the eye can "touch" and travel (Camille 17; Chase 79–81; Kemp 83; Weststeijn *passim*). Ambrosio's work can be contextualized within the medieval tradition of pilgrimage-in-place, or vicarious (yet embodied) pilgrimages of the eye through the space of books or the built environment. In *AFATECT*, this takes on urgency as again we find ourselves sheltering-in-place in a time of plague and pandemic – the same reasons that spurred our medieval ancestors toward vicarious pilgrimage practices:

> Photography and the printed matter together can make us see and touch the world again, dispelling our feelings of loss and loneliness at the thought of a distant, removed and alienating reality. Watch it all bloom again, from seed into vigorous tree- an image, a single seed that yields endless stories, and invites you to contribute to the never-ending journey. *Seeing* becomes thus a revolutionary act of resistance.
>
> *(Ambrosio 2019)*

In this way, it is almost radical in its rootedness. The tiny zines are reminiscent of the tactility of medieval miniatures and hand-held devotional books. Instead of sewn-in or painted trompe-l'oeil pilgrimage badges that Foster-Campbell speaks of as spurring a multi-dimensional experience of viewing, the objects in *AFATECT* are photographed and curated into serial images. No. 8, "Napoli 16" contains a page of head ex-votos commonly used in Italy and elsewhere as a token of thanksgiving for the intercession of a saint (Figure 10.3). These would probably be used for head complaints – headaches, dizziness, migraines. Although not pilgrimage badges, they recall visually the souvenirs affixed to pages of manuscripts.

Medievalists have also emphasized, through an historic lens, the integral relationship between "place, proximity, sight, and touch," which is tied to attitudes toward relics of the saints but also "intrinsic to the spread of pilgrimage and to the power associated with 'primary' holy places and the secondary network of sites which developed through belief in 'transferable holiness'" (Dyas 1; Hahn, *passim*).[5] *AFATECT* can also be seen as a modern recapitulation of this medieval idea of the perceived transfer of spirit from object to representation, especially as exemplified through the making of third-class or "contact" relics. This is the still-popular belief that prayer cards, bits of cloth, souvenirs, pilgrimage badges, or other objects that come into contact with the bodily remains of a saint (no matter how small), or items worn or owned by a saint, are imbued with a trace of the sacredness of that person.[6] Again, it is an example of continuity of religious tradition and devotional praxis rather than rupture.

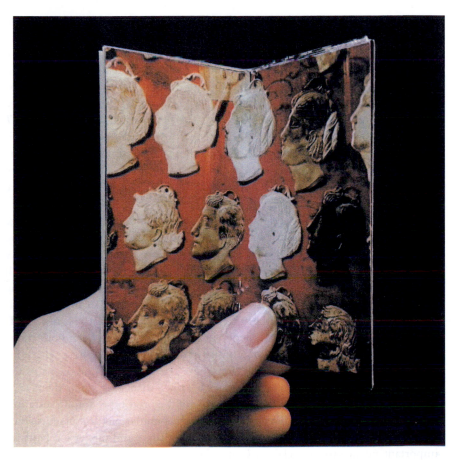

**FIGURE 10.3** Chiara Ambrosio, *As Far As The Eye Can Travel*, No. 8: Napoli 16 (August 2016), hand-held, printed paper zine, 4 × 8.5 cm (1.57 × 3.35 in). Photo: Chiara Ambrosio. Used with permission.

With a bit of imagination, a parallel can be made here with the phenomenological capacity of light and shadow; perhaps a trace of a person remains embedded in a photographic image – after all, they were touched by the light of the flash with the image passing through the aperture, transferred (or translated) to film, both still and moving, and fixed with silver nitrate. There is a relationship here to the Catechism of Trent, which discusses the efficacy of the "shadows of the Saints" as channels to the divine (367). Photography is, in its very essence, a medium of light and shadow, which captures objects and transfers them onto film, then paper. Every step of the way is mediated by touch – from the flash of light to the silver nitrate process, which fixes the image. This notion was secularized starting around the Reformation and then probably entered critical discourse through Walter Benjamin's influential theorizations of the loss of the "aura" through mechanical reproduction in which an important caveat is often

left out. Benjamin actually states that "in permitting the reproduction to meet the beholder or listener in his own particular situation, it reactivates the object reproduced" (qtd. in Garnett and Rosser 195). As Jane Garnett and Gervase Rosser posit in their book on the "enduring Western belief" in the supernatural power of images in the northwest of Italy and beyond, "there is clearly a reciprocal relationship between copy and prototype, of which the history of image cults can show many examples." (195) What Ambrosio is doing in *AFATECT* is intentionally exploring this idea of presence through the photography that is embedded in these hand-held books. There is also a relationship between illuminated psalters and pilgrimage badges in their size, scale, and portability; like the devotional books, they invite both artist and viewer into a shared experience of *communitas*.

As a young Italian growing up in Rome with an unsympathetic village priest, Ambrosio did not understand the need to mediate an experience of the divine. Moving to London brought a sense of freedom where she saw "sacrality manifesting itself in so many ways" (Ambrosio 2017). In art history, there is a rich bibliography proposing the agency of works of art – this sense of things being "charged" that Ambrosio describes – from the middle ages to today, including contributions by Hans Belting, David Freedberg, Bruno Latour, and W.J.T. Mitchell. Alfred Gell's art nexus theory in *Art and Agency* has been both influential and criticized. There are some limits to his lack of engagement with contextual theology; for example, Gell describes "the index" of holy icons of the Virgin Mary, which cure those who touch rather than look upon them (32). Although Gell does not exclude fully the role of the prototype, a more sustained look at church teachings in conjunction with the popular pietistic practices that arose from them, in terms of devotion but also critique and subversion, adds an important nuance to such claims. Canon law officially forbids the sale of bodily relics, but it is possible to buy prayer cards on Amazon.com and eBay with notes of certification stating that they have been touched to the relics of various saints. In a comprehensive essay on the origin of third-class relics and modern and medieval understandings of their use, Julia M.H. Smith has noted that the classification is "a mid-twentieth-century variant on the categories prescribed in post-Tridentine canon law" and highlights a key point, which is the "tension between spontaneous and officialized veneration" (Smith 42). A connection can be drawn between medieval and modern sensibilities; in the distant past, and still today (as shown through this research) relics are objects that "derive their meaning from the subjective understanding of those who…cherished them"(Smith 60).[7] Colleen McDannell, too, has asserted that

> [w]hile religious authorities can easily say that an object has no power, I want to argue that Christians have not always heeded church authorities. Protestants, as well as Catholics, cherish religious images to the point that their devotions fuse the sign with the referent.
>
> (26)[8]

While official teachings have discouraged such thinking, the focus here is on personal belief, expressions of those beliefs (which often draw from various sources), and how they are received.

The popular Catholic religious culture of Southern Italy is one of the tactility and expression. Ambrosio's 2014 feature-length film, *La Frequenza Fantasma* (*The Ghost Frequency*), which I invoked earlier in relation to the concept of "rewilding," explores a forgotten village in the mountains in the south of Italy – catacombs, embodied devotional practice, and the presence of the dead; an exploration of communitas through filmic space. It is a religious culture saturated with incorrupt bodies visited for blessings; it is quite normal for a devotee to press a prayer card to the glass tomb of a saint to create a third-class relic that carries a trace of the blessing of the holy body – itself a channel to the divine. Musician Mikey Kirkpatrick, who created the soundtrack for the film, said of the project:

> [Ambrosio] had discovered a mountain village in Calabria…that had been almost completely abandoned for a newer village that had been built around it. The footage she showed me was of a cat that appeared to be sleeping, its body of paper, lifeless but for the wind lifting its weightless body as it passed through the doorless and windowless thresholds, old jars of preserves still on the shelves, a dusty shrine, bleached newspapers from more than 40 years ago, skeletons of bed frames and chairs. I don't think she was conscious at the time of the reasons why she was so drawn to that place[.]. Later, on our frequent visits together to that village, we found people who had known her grandfather (a highly respected orthopedic doctor), and we got to know the scents, the heat, the sounds, the labyrinthine twists and turns, the inhabitants and their wine cellars, the mayor with his pink house, libraries and home-made myrtle liquor. [Ambrosio] would say something like 'I don't know why I'm here, or what I'm looking for.' Everyone welcomed her in and filled her arms with what little they had, like a daughter who had returned home after a long journey away. Every time we returned Chiara would peel away a new, invisible layer. The man who uncovers roots while farming and gives them eyes. The man who followed her for a day to apologize for not having returned her morning greeting. The photographs taken of her taking photographs. The night processions, the flower-carpeted streets. Click. Breath. Words. Melody. Drawing. John Cage said that 'Art Is Life.' I always associate that idea with [Ambrosio].
>
> *(July 4, 2021)*

Ambrosio describes the impetus of her art – films and *AFATECT* zines alike – as a "commitment to the shaping of matter, an investing the matter with faith, a shared experience that eventually is presented before witnesses." Her art is

> a way to talk about transcendence, to translate the mystifying and often unspeakable revelations that occur in those fleeting moments of deep

connection with a place, a person or an object, what holds onto you and hurtles you towards a much wider history than your own singular one.

*(January 6, 2019)*

It is an invitation to a journey through time and into these spaces of encounter, and many will find something resonant there.

Although I have been focusing on Catholic medieval theological constructs and their vestiges in popular piety today, the idea of *communitas* across time and space also crosses denominational boundaries. For example, Ambrosio's 2009 animated short *Charon* resonates with the 18th-century mystic and theologian Emmanuel Swedenborg's idea of inner states, of which space and time are categories. Charon is the ferryman of Hades in Greek mythology who appears, also, in Dante Alighieri's *Inferno*. The 12-minute film follows Charon's journey over the river Styx on a pilgrimage to regain his mortality. The film was awarded Best Animation at the Swedenborg Film Festival in 2010, and Stephen McNeilly, the Executive Director of the Swedenborg Society in Bloomsbury, London, commented on the extratemporal nature of the film and its relationship to Swedenborg's theology, writing, "the figures we encounter in mythology, and fables, are emblematic of mental or emotional processes. Ambrosio, in her short animation *Charon*, employs this principle to great effect":

> Drawing on the image of death as a transition or a movement between inner states, time and desire become foregrounded in the mythological figure of Charon, whose duty it is to ferry the deceased across the Rivers Styx and Acheron. In Ambrosio's narrative however, it is the Ferryman himself who becomes subject to the process of desire and longing, and in so doing breaks the cycle of death by returning to his childhood home, a correspondential representation of innocence and rebirth.
>
> *(McNeilly)*

The film, like the zines, is an immersive experience as the beholder is drawn into Michael Nyman's haunting soundtrack and the inky expanse of churning sea. Vivian Sobchack has elaborated on the embodied experience of the cinematic viewer, acknowledging and emphasizing the perception of a film as "sensible" and immersive; "the film experience is a system of communication based on bodily perception as a vehicle of conscious expression" (9). In this case, we find ourselves not *watching* Charon, but *on pilgrimage* with him. Ambrosio leads us as Dante leads Virgil through the *Divine Comedy*.

It seems almost instinctive for reviewers to talk about *entering into* Ambrosio's work as a pilgrim would enter a sacred space. Kirkpatrick has underscored this idea of Ambrosio as a pilgrim-guide into the space of these works: "when you turn the pages of an *AFATECT* zine, or you fall into her film and animation work…she is calling on you to make contact, the way she does, to find a barrier or blockade and step over it" (2021). Brian Catling, artist and Honorary

Professor of Fine Art at the University of Oxford's Ruskin School of Art, has spoken of *La Frequenza Fantasma* (*The Ghost Frequency*), as a "haunting epic poem of shadows and echoes" that "whispers the ages *under your approach*." Catling's description resonates with what I am describing as extratemporal *communitas* – a certain presence that is perceived during an encounter with a sacred object or space. In his review of the film, Joel Schlemowitz, filmmaker and faculty at the New School, describes "an elderly man" who "moves with halting step through the landscape, *guiding us* through the narrow streets" (22). Ambrosio follows the man, and we follow with her – right into the filmic space. Tanya Peixoto, owner of the Bookartbookshop in London where the *AFATECT* zines are sold, speaks to their tactility and expansiveness:

> Why so small? A child's world? Not at all. Hers is a skilled and experienced eye, ravished by the world she experiences as miraculous. These tiny visual narratives find their shape according to their subject matter. Each zine is a blink not an immersion – but we are immersed in the moment not the

**FIGURE 10.4**  Chiara Ambrosio, *As Far As The Eye Can Travel*, No. 3, Justo Botanica (December 2014). Hand–held printed paper zine, 5 × 7 cm (1.97 × 2.76 in). Photo by the author. Used with permission of the artist.

blink. I always open the glass-paper envelope with care and then sit the zine in the palm of my left hand to turn its pages with my right. Sometimes the zines have a calm simplicity that is almost austere. Others are rich and complicated like a banquet of nourishing decay – I'm thinking of Betanzos in Spain... They open an *intimate communication between Chiara and me but it's my job to find the secret, hers to provide the clues.*

*(Peixoto)*

The intimacy inspires close-looking as the objects are drawn toward the eye, and as the eye enters these curated sacred spaces.

In issue 3, *Justo Botanica*, Ambrosio explores a botánica, or religious goods shop in East Harlem, NY where candles, statues of saints, luck potions, and herbal remedies are sold. The idea for *Justo Botanica* was the result of a chance encounter with the owner, Jorge Vargas, a spiritual healer in his community (Figure 10.4).

Jorge died before she had a chance to share the finished zine, but she was able to show his wife and daughter, who propped the centerfold photo of Jorge on the counter on which he was depicted. The zine became a portable altarcito – a site of communitas and sacred space where the spirit of Jorge was made present. That sacramentality of the objects and sacred spaces we encounter through the senses, through sight, touch, smell, and sound – the idea of the "holy lurking" through all of these experiences – is expressed in and through the *AFATECT* zines.

## Notes

1 The *Oxford English Dictionary* (Oxford University Press, 2022) defines a zine as "a magazine, *esp.* a fanzine or other magazine produced non-professionally for a relatively small audience." See also "What is a Zine?" from the University of Texas Libraries LibGuides, https://guides.lib.utexas.edu/zines.

2 Case studies in my book Imaging Pilgrimage (Bloomsbury 2021), of which this current essay is a sort of extension, include the work of Allan Kaprow, Gisela Insuaste, Sri BhaktiyiMa, the British Pilgrimage Trust, and contemporary documentary filmmaking.

3 Whitechapel Gallery, London events page, January 8, 2015. https://www.whitechapelgallery.org/events/chiara-ambrosio-ghost-frequency/.

4 As Jerry Moore emphasizes in *Visions of Culture: An Introduction to Anthropological Theories and Theorists* (Rowan & Littlefield, 2004) "that one element of communitas is its existence outside of structured time – is, as far as I know, Turner's unique insight," 248), which is central to the theory of extratemporal communitas, posited here. It allows for communitas to be seen as penetrating beyond the pilgrim group to a feeling of the tangible presence of those who have visited a site in the past, and those who will come in the future.

5 I am grateful to Cynthia Hahn for moderating our 2019 College Art Association panel, which, in part, considered the afterlife of relics in contemporary art including the work of Chiara Ambrosio and Gisela Insuaste.

6 Joseph Braun, SJ described such objects as "retaining something of [the holy person's] sacred character." Braun, *Reliquaire*, 3 in J.M.H. Smith, "Relics: An Evolving Tradition in Latin Christianity," 44.

7 See also *ibid* p. 53:

Medieval discourses about relics were the product of the educated, clerical, and monastic elite. Participation in the cult of relics was far more widespread,

however, and we can establish what a large circle of people regarded as relics by interrogating the evidence of what they collected and treasured.

8 In other words, and with recourse to Walter Benjamin's famous essay "The work of art in the age of mechanical reproduction," Jane Garnett and Gervase Rosser have pointed to the "reciprocal relationship between copy and prototype" that can be observed throughout the history of sacred images (195).

## Bibliography

Ambrosio's zine project can be found at https://asfarastheeyecantravel.com.

Ambrosio, Chiara, interviews conducted by K. Barush: June 2017; January 6, 2019; January 9, 2019; September 1, 2019.

——, turn the page Symposium (hosted by Rosie Sherwood), June 26, 2021.

Barush, K.B. *Imaging Pilgrimage: Art as Embodied Experience*. Bloomsbury 2021.

Benjamin, Walter, "The Work of Art in the Age of Mechanical Reproduction" [1936] in *Illuminations*, edited by Hannah Arendt and translated by Harry Zorn, London, 1999.

Camille, Michael. *Gothic Art*. Weidenfeld and Nicholson, 1996.

*The Catechism of the Council of Trent*, trans. T.A. Buckley (London: 1852), 'Question XV: The Virtue of Reliquaries and their Great Power and Efficacy proved', 367.

Catling, Brian. Endorsement for *The Ghost Frequency* North American Premier, Instituto Italiano di Cultura, New York, June 24, 2015. https://iicnewyork.esteri.it/iic_newyork/en/gli_eventi/calendario/la-frequanza-fantasma-prima-americana.html

Chase, S. *Contemplation and Compassion: The Victorine Tradition*. Orbis, 2003.

Connolly, D.K. *Imagined Pilgrimages in Gothic Art: Maps, Manuscripts, and Labyrinths*. University of Chicago, Ph.D. thesis, 1981.

De Martino, Ernesto, trans. Dorothy Louise Zinn. *Magic: A Theory from the South*. Hau Books, 2015.

Dyas, D. "To Be a Pilgrim: Tactile Piety, Virtual Pilgrimage and the Experience of Place in Christian Pilgrimage." *Matter of Faith: An Interdisciplinary Study of Relics and Relic Veneration in the Medieval Period,* edited by J. Robinson, L. DeBeer, and A. Harnden. British Museum (London), 2014.

Elkins, James. *On the Strange Place of Religion in Contemporary Art*. Routledge, 2004.

Elsner, Jaś and Ian Rutherford. *Pilgrimage in Graeco-Roman and Early Christian Antiquity: Seeing the Gods*. Oxford, 2008.

Foster-Campbell, M. "Pilgrims' Badges in Late Medieval Devotional Manuscripts." *Push Me, Pull You: Imaginative and Emotional Interaction in Late Medieval and Renaissance Art,* edited by S. Blick and L.D. Gelfand, Leiden: Brill, 2011, Vol. I, 229.

Garnett, Jane and Gervase Rosser, *Spectacular Miracles: Transforming Images in Italy from the Renaissance to the Present*. Reaktion, 2013.

Gell, A. *Art and Agency: An Anthropological Theory*. Oxford, 1998.

Greeley, Andrew. *American Catholics Since the Council: An Unauthorized Report*. Thomas Moore Press, 1985.

Hahn, Cynthia. *The Reliquary Effect: Enshrining the Sacred Object*. Reaktion, 2017.

Harries, Richard. "Modern Art is Not the Enemy of Religious Art, It's Revived It." *Apollo*, 18 April, 2014

Kemp, Martin. *The Science of Art: Optical Themes in Western Art from Brunelleschi to Seurat*. Yale University Press, 1990.

Kirkpatrick, Mikey in an interview conducted by K. Barush, July 4, 2021.

Kociejowski, Marius, personal interview via correspondence with K. Barush, June 30, 2021.

Layton, R. "Art and Agency, a Reassessment," *The Journal of the Royal Anthropological Institute*, Vol. 9, No. 3 (September, 2003), 447–464.

McDannell, Colleen. *Material Christianity*. Yale University Press, 1998.

McNeilly, Stephen, in a correspondence with the author via email, July 23, 2021.

Moore, Jerry. *Visions of Culture: An Introduction to Anthropological Theories and Theorists*. Rowan & Littlefield, 2004.

Morphy, H. "Art as a Mode of Action: Some Problems with Gell's *Art and Agency*," *Journal of Material Culture*, Vol. 14, No. 1 (2009), 5–27.

Peixoto, Tanya, in a correspondence with the author via email, July 29, 2021.

Rudy, K.M. "A Guide to Mental Pilgrimage: Paris, Bibliotheque de L'Arsenal Ms. 212." *Zeitschrift für Kunstgeschichte*, 63 Bd., H. 4 (2000), 494–515.

Sandhu, Sukhdev. Endorsement for an Arts Council England grant, November 2020.

Schlemowitz, Joel. Review of *La Frequenza Fantasma*, *Millennium Film Journal* (Spring–Fall 2020).

Smith, J.M.H. "Relics: An Evolving Tradition in Latin Christianity." *Saints and Sacred Matter: The Cult of Relics in Byzantium and Beyond,* edited by C. Hahn and H.A. Klein. Harvard University Press, 2015.

Sobchack, Vivian, *The Address of the Eye: A Phenomenology of Film Experience*. Princeton University Press, 1992.

Tanner, J. and R. Osborne. *Art's Agency and Art History*. Oxford, 2007.

Turner, Edith and Victor. *Image and Pilgrimage in Christian Culture: Anthropological Perspectives*. Columbia University Press, 2011.

Turner, Victor, *Dramas, Fields, and Metaphors: Symbolic Action in Human Society*. Cornell University Press, 1974.

Weststeijn, T. "Seeing and the Transfer of Spirits in Early Modern Art Theory." *Renaissance Theories of Vision,* edited by J. S. Hendrix and C.H. Carman. Ashgate, 2010.

# 11

# ROGUE PRIESTS

## Ritual, Sacrament, and Witness in Contemporary Art

*Rachel Hostetter Smith*

In the year 2007, bad-boy British artist Damien Hirst sold his work titled *For the Love of God* for the asking price of 100 million dollars.[1] The work consists of a diamond-encrusted platinum skull, cast from the remains of a 35-year-old 18th-century European man, but retaining the original teeth. It is covered with 8,601 diamonds, including a 52-carat pink pear-shaped diamond in the center of its forehead. With a well-established reputation for sensationalism, crude antics, and the use of profuse foul language, critics – and the public – had a field day claiming this to be yet another case of the emperor having no clothes and a Hirst publicity stunt. It didn't help when the artist identified the source of the title as his mother who purportedly exclaimed on learning about the work, "For the love of God, what are you going to do next?" (Shaw).

Just two years later, in June 2009, the art world was a-buzz with reaction to the opening of the Mexican pavilion of the Venice Biennale where artist Teresa Margolles created what British art critic Waldemar Januszczak described, reporting on site at the time, as "one of the most powerful and dark pieces" of the entire exhibition (Januszczak). It was aptly named *What Else Could We Talk About?* The work dealt with the people killed in the Mexican drug wars. Outside the Venetian Renaissance palazzo in which it was installed, fluttering in the breeze, hung a flag soaked in the blood of the victims, sopped up at the sites of the murders by their family members at Margolles' behest. Inside the palazzo hung more blood-soaked cloths embroidered in gold with the mottos called "narco-mensajes," commonly found with bodies at the sites of gang-ordered executions as a warning to those who remain. The gold thread clashes with the words they render in Spanish, which translate to English as "Until all your sons have fallen," "This is the way rats end," and "So that they learn to respect." But perhaps the most provocative – and poignant – aspect of the installation was the ritual "cleansing" that took place daily throughout the months of the Biennale, where

DOI: 10.4324/9781003326809-14

those relatives of the dead mopped the floors with a solution of water mixed with the blood of their loved ones.[2]

So, one might ask, what does Hirst's diamond-encrusted sculpture have to do with Margolles' blood-soaked installation? The obvious connection would be that both have to do with death, with each artist presenting it in an extraordinarily graphic way that could variously be described as macabre (Hirst) or morbid (Margolles). But there is something more fundamental that undergirds and animates the work of these two provocative and very different artists.

Since the inception of modern art and the writings of Wassily Kandinsky[3] at the beginning of the 20th century, artists responding to their contemporary world and its distinct realities and tensions from Joseph Beuys[4] to Wolfgang Laib have described the work that they do as intercessory – on behalf of humanity, and akin to that of a priest, healer, or erstwhile holy man. In his book *God in the Gallery*, published in 2008, Daniel A. Siedell offers a theological explanation for this perceived calling, stating: "The vocation of humanity is not only as prophets who proclaim God's love and as kings who rule as God's royal representatives but also as priests who mediate between creation and Creator," and asserts that, "Much modern and contemporary artistic practice manifests this priestly function, this yearning for a liturgical reality that reveals the world as gift and offering" (34). Siedell grounds his claim in these words of Orthodox priest and theologian Alexander Schmemann, from his book *For the Life of the World: Sacraments and Orthodoxy*:

> The first, the basic definition of man is that he is the priest. He stands in the center of the world and unifies it to his act of blessing God, of both receiving the world from God and offering it to God – and by filling the world with his eucharist, he transforms his life, the one that he receives from the world, into life in God, into communion with Him. The world was created as the "matter," the material of one all-embracing eucharist, and man was created as the priest of this cosmic sacrament.[5]
>
> *(qtd. in Siedell 34 and 139)*

Even more to the point of Siedell's interest in the relationship between many aspects of contemporary art and the ritual and liturgy of religious practice is Schmemann's assertion that,

> All that exists is God's gift to man, and it all exists to make God known to man, to make man's life communion with God. It is divine love made food, made life for man, God blesses everything He creates, and, in biblical language, this means that He makes all creation the sign and means of His presence and wisdom, love, and revelation.[6]
>
> *(qtd. in Siedell 139)*

In other words, all that exists is fundamentally sacramental, where the *material* manifests "the holy," as described by Norwegian theologian Espen Dahl in his

book *In Between: The Holy Beyond Modern Dichotomies* (2011), and where "the world" – and all that is in it – to use Siedell's phrasing, is "both gift and offering."

The artists treated in this chapter make no claim of adherence to any clear or specific religious faith. Nevertheless, they adopt stances and employ physical actions, material agents, and other means widely used in contemporary art, which infuse their work with transcendent implications and a transformative potential that is sacramental in nature, creating a bridge to some essential truth or "higher" reality.

## Damien Hirst

Damien Hirst first made his reputation on works like *The Physical Impossibility of Death in the Mind of the Living* (1991), which took a form typically seen in biology laboratories or Natural History museums where they provide a means to understanding life processes, in this case, presenting a tiger shark suspended in a formaldehyde tank. By changing the context, placing these creatures preserved in formaldehyde tanks in an art museum, their purpose changes from providing knowledge to posing questions about the significance of life itself and its meaning. His titles often signal ways of thinking about the thing presented. *Away from the Flock* (1994) suggests both vulnerability and a wayward spirit. By bisecting the animals, Hirst puts the intricacy of their inner workings, which give and preserve life, on bold display, for visitors to inspect and contemplate, making manifest both the miracle of life and the inevitability of death. In this way, they are in line with the *vanitas* and *memento mori* traditions in art while the tanks call up images of the relics of saints whose whole bodies are placed on display in glass cases beneath altars in churches across Europe.

In the monumental work titled *Hymn* (1999), a six-meter-tall painted bronze replica of Humbrol Limited's Young Scientist Anatomy Set, Hirst turns his interest to human beings and the mysteries of the inner workings of the body that give us life. The pun on the masculine pronoun in the title is typical of Hirst's tendency to produce works that allow for conflicting and multivalent readings. His work *The Void* (2000) presents a plethora of different types of pills meticulously laid out in a display cabinet. It reflects the ontological realities of human existence and the way so many people, including Hirst himself, seek all manner of substitutions, like these pharmaceutical ones, to avoid dealing with the perennial questions of life, its meaning, and purpose. Situated within the rest of his work and seen through the lens of the *vanitas* and reliquary traditions of Western Christianity, *For the Love of God* becomes a *memento mori*, a reminder that although death comes to us all, a human being is precious, of immeasurable and, perhaps even, eternal value. A platinum skull covered in diamonds that puts on display the original teeth simply highlights the tension in the dual reality of the fragile – and fleeting – nature of our physical existence and our incomprehensible (and inextinguishable) worth.[7] Significantly, Hirst chose to leave a gap in the teeth resulting from a lost tooth that serves to emphasize further the disparity

between that which may not last and what endures. In Hirst's works, the material always matters and is a primary, irrepressible bearer of meaning. Still, Hirst has frequently said, "I try to say something and deny it at the same time" (Shani 7), choosing to leave it to viewers to resolve the tensions introduced for themselves.

## Teresa Margolles

In contrast to the broadly universal and timeless concepts that Hirst typically addresses, Teresa Margolles grounds her practice in concrete, specific, and immediate events and social/political realities (Figure 11.1). *What Else Could We Talk About?* is centered around the fate of the people killed in the Mexican drug wars, which was reported by the press as numbering well over 5000 in 2008 and more than an additional 3000 by early June in 2009 when the work was being installed at the Venice Biennale. Housed in a classic Renaissance Venetian palace built in the 16th century, close to San Marco square, the project has been described as "a single and continuous intervention" (e-flux). The blood-soaked flags and embroidered tapestries were provocative enough but it was the mopping of the

© *Teresa Margolles*

**FIGURE 11.1**  Teresa Margolles, *Limpieza (Cleaning)*, 2009. Performance: exhibition floors were cleaned with a mixture of water and blood from people murdered in Mexico. The action took place at least once daily for the duration of the 2009 Venice Biennale. Performance view: *What Else Could We Talk About?*, curated by Cuauhtémoc Medina, 53rd Biennale di Venezia, 53rd Biennale de Venezia, Italy, June–November 2009. Courtesy of the artist and James Cohan, New York.

floors by the relatives of the deceased with a solution of their blood and water that had the greatest impact.

This action created over time what Margolles called growing "strata" of their remains in the gradual build-up on the floor that was largely imperceptible apart from a slightly sticky haze beneath the feet of the visitors to the site (Medina). In this instance, the ritual of cleaning was wholly insufficient to cleanse the stain, and altogether more poignant because of the inherent futility of the act. *What Else Could We Talk About?* indeed.

It was not, however, just the graphic portrayal of the violence that pervaded Mexican life in recent years that was disturbing, but that the medium used was actual human blood – and the blood of the victims, no less.[8] The very real presence of those dead, some innocent of involvement in the drug trade and others not, made avoidance of the real consequences of such violence impossible. Yet as Raul Martinez recounted in *Art in America*, this was nothing new for Margolles *or* for Mexico:

> Since the beginning of her artistic career in the early 1990s with the collective SEMEFO (Servicio Medico Forense – Forensic Medical Services), Margolles has gained international recognition for using human body parts, fluids and residues collected in the morgue as well [sic] objects trouvés at crime scenes in her sculptures, murals, installations and urban interventions. Interested in the "political life" of dead bodies, Margolles strives to dignify the indigents – in many cases, exploited alive, immediately forgotten as they die – found in the morgue and nameless victims of Mexico's disturbingly quotidian violence while questioning the social and economic conditions that render them invisible (and their deaths, tolerable).[9]

Significantly, fundamental to the impact of Margolles' work is the language of ritual and sacrament it employs, mirroring religious practice. Encountering the work, there is no doubt that Margolles grasps that there is something sacred in human life and that the presentation of that holy blood spilt in unholy acts not only serves to indict those who perpetrate them but also makes all who encounter it complicit in their guilt. Significantly, Margolles has a long history of also employing the water used to wash corpses in her work, where it becomes a "privileged material," in the words of Pascal Beausse in his consideration of her work in the section titled "Bodies that Matter" in the volume *Materiality: Documents of Contemporary Art*. "The water that has been in contact with corpses is distilled, vaporized, turned into mist solidified and mixed with cement, and takes as many forms as possible in an attempt to reintroduce death in the cycle of life," Beausse explains (137). Understandably, visitors who are brought unawares into contact with these substances in the exhibition context, such as *En el Aire* ("In the Air," 2003) where they enter a fog-filled room only to discover the mist consists of vaporized water used to wash corpses in the morgue or find their shoes sticking to the floor only to learn that they have been mopped with a solution of water

and the blood of human beings in *What Else Could We Talk About?*, are unsettled if not utterly horrified. Water and Blood. What more sacramental substances could an artist use? Presenting what remains of these dead for such immediate and tangible "communion," the work conjures connections to the Church's veneration of the saints and martyrs of whom Jesus Christ is the supreme example, to bear witness to the sacrilege of their execution.[10]

## Doris Salcedo

Colombian artist Doris Salcedo has also taken up the violence of her own country as the subject of much of her work. She describes herself as a "secondary witness," who comes on the scene only after some catastrophic, typically violent, event has occurred in order to document its effects, particularly on those who survive. Her work is painstakingly researched and methodical, meticulously planned and laboriously executed, requiring a dedicated and skilled team to produce works that commonly involve strange juxtapositions of objects and materials employing disparate methods such as cutting, casting, drilling, and stitching, sometimes in a single work. The results are often deliberately disjointed and disquieting.

To produce the work *Unland* (1995–1998), itself an invented word representing the displacement of children who witnessed the murder of their parents in Colombia's civil war (a conflict that has continued to ravage the country since its start in 1948), Salcedo and her assistants drilled thousands of tiny holes into the surfaces of tables before a team of volunteers laboriously threaded a combination of human hair collected from a local hairdresser and silk through the holes covering the wood with what looks like the cobwebs enshrouding objects long lost or discarded. The tables themselves were re-made by sawing off the legs at one end and fitting the legless ends of two different tables together. Salcedo describes the act of "embroidering" with human hair into wood as "an insane gesture, an absurd gesture." One of her long-time studio assistants has recounted how the task of drilling tiny holes suddenly made existential sense to him as he was working to the sound of gunshots outside the studio in Bogotá one day during yet another outbreak of the resurgent conflict (Salcedo, "Compassion"). When faced with what appears to be a hopeless situation where one is rendered helpless, the only thing left, it is often said, is to pray. The repetitive action of drilling countless holes is like the desperate pleading of a priest interceding with God on behalf of a world gone hopelessly astray. On its face, it is a response devoid of practical effect but the only real hope when confronted with a circumstance that exceeds the limit of our capacity to help. "The word that defines my work is impotence," Salcedo says. "I am responsible for everything that happens, and I simply arrive too late…I cannot give anybody back their father or their son. I cannot fix anything…It's from that perspective of one who lacks power that I look at the powerful ones and at their deeds" (Salcedo, "Compassion").

In *Atrabiliarios* (1992–2004), commonly translated as the "Defiant Ones," Salcedo took shoes belonging to women who disappeared in one of Colombia's

many political purges since the period known as "The Violence" began in 1948, which she acquired from their families and placed them in small shoe-box-sized niches cut directly into the gallery wall. The apertures were covered with cow's bladder, a translucent, obviously organic material, ghostly white, stretched taut, and firmly sutured — using the type of stitch surgeons use to repair a wound, directly to the wall — they appear as a veritable columbarium of sacred remains. She explains that "every time we see a shoe in the street we wonder what happened there...it's the wrong place for a shoe to be" (Salcedo, "Compassion"). More to the point, shoes are made for human beings, just as chairs have no reason to exist without people to sit on them. The shoes here serve as a visual synecdoche, an abbreviated yet powerful stand-in for each of those persons who disappeared in these purges. They are indexical signs, to use the Peircean term, where the signifier is directly connected to the signified and anything but arbitrary.[11] Stretched and scuffed, they carry the literal imprint of the feet of the women who wore them, to create the palpable presence of their absence in a way little else might do. Like Margolles' use of blood in *What Else Could We Talk About?*, these shoes constitute a direct line of connection to her missing subjects, palpably present in their absence. The profound weight of her particular calling as a "secondary witness," "impotent" yet "implicated," to use her own phrasing, is immediately evident when Salcedo describes the subjects she takes up and what compels her to do so. It is personally costly, requiring her to take on the pain and sorrow of these others, to weep with those who weep, as Christian scripture enjoins that we do (Romans 12:15).

In a conversation with critic Carlos Basualdo, she explained the importance of materials to her work: "The way that an artwork brings materials together is incredibly powerful. Sculpture is its materiality. I work with materials that are already charged with significance, with meaning they have required in the practice of everyday life...then, I work to the point where it becomes something else, where metamorphosis is reached."[12] As with Hirst and Margolles, the materials used to provide a bridge to a higher truth or transcendent reality. In another interview with art historian Charles Merewether, Salcedo expanded on this notion of the metamorphosis: "The silent contemplation of each viewer permits the life seen in the work to reappear. Change takes place, as if the experience of the victim were reaching out...The sculpture presents the experience as something present — a reality that resounds within the silence of each human being that gazes upon it."[13] The viewer is an essential "partner" in Salcedo's practice, completing it, as practitioners of reception theory might say.[14] By adopting a posture of openness and willing engagement, they allow for the possibility of being "changed." As Dan Siedell argues, art "is not merely a form of communication but requires contemplation and *communion* [my emphasis] — an active, experiential relationship with the artifact" (50). Salcedo's work prompts just such communion.

*Plegaria Muda* (2008–2010), typically translated as "Silent Prayer," presents a room full of double-stacked tables, up-ended on top of each other, with legs

pointing to the ceiling, giving the appearance of a restaurant after hours in the dead of night, empty, silent, and seemingly devoid of life, like the tombs they are intended to represent. But on closer examination, one catches glimpses of thin strands of bright green sprouting from the undersides of the upside-down tables, blades of grass sprouting from earth trapped between the tabletops, wriggling their way between cracks and crevices in the wood planks. These signs of life, persistent, fragile, and new, assert Salcedo's stated hope that "life might prevail" (Salcedo, 2011). While her work is most often discussed in social/political terms, it is the language of sacrament and ritualistic practice employed, which convinces and convicts, bearing witness to unbearable truths and transcendent realities. Moreover, it grants the work a gravitas commensurate with the supreme worth of these persons, their lives, and our responsibilities to them.

## Wolfgang Laib

Perhaps there is no other contemporary artist whose practice partakes of ritual and sacrament so fully and fundamentally as does that of Wolfgang Laib. While Hirst, Margolles, and Salcedo deal with death, Laib focuses entirely on the mystery and magnitude of life and the affirmation of its goodness. While his work is most often discussed in relation to nature because of his use of natural materials like pollen, milk, rice, and beeswax, the religious aspect of his practice has long been acknowledged by Laib and critics alike, where Laib has even expressed frustration and dismay with those who respond to his work in only aesthetic terms.[15] This is most obvious in the ritualistic discipline involved in the methodical collecting of pollen from fields nearby his home in Germany, which he does himself as a solitary, meditative activity, and the daily replacement of milk on the milkstones that he instructs others to do for the duration of their installation at a site. He traces the evident influence of Eastern mysticism, and Buddhism and Hinduism specifically, to his parents who took him to live with them in India for a time when he was a child and where he continues to live and work part of each year even today. After studying medicine to be a doctor, Laib abruptly decided to pursue his desire to be an artist, producing his first work in 1972, a large black egg-shaped sculpture carved from a large boulder, which he called *Brahmanda*, which means "cosmic egg" in Sanskrit. From his start, Laib has moved against the current of the art world as well, pursuing an art that was arresting in its beauty and affirming of life when both the practitioners and gatekeepers of contemporary art rejected such qualities in favor of edgy, transgressive work that they deemed "socially and politically relevant." As he has said,

> I am not afraid of beauty, unlike most artists today. The pollen, the milk, the beeswax, they have a beauty that is incredible, that is beyond the imagination, something which you cannot believe is a reality – and it is the most real. I could not make it myself, I could not create it myself, but I can

participate in it. Trying to create it yourself is only a tragedy, participating in it is a big chance.

<div align="right">*(qtd. in Farrow, 18)*</div>

There is a humility in Laib's choice of medium and method, recognizing that an artist does not create *ex nihilo*, "out of nothing," to use the theological term for that which only God can do, but merely re-forms that which has been already made and provided for our flourishing. His signature motifs of miniature mountains of rice and pollen, where each individual and tiny grain carries in it tremendous potentiality, represent an abundant provision. Moreover, the sacramental nature of his materials of choice needs little explication as they represent sources of new life, nurture, and sustenance – in abundance – in their very substance. And the simple elemental forms he employs of mountains, boats, and ziggurats hold in them concepts of ascendance, journey, and communion. *The Rice Meals* (1992), composed of a single line of shallow brass bowls filled with rice, calls to mind the "begging bowls" used by some Buddhist sects where the monks go door-to-door each day asking for an apportionment of rice, dependent on others for their daily sustenance. This is not just an act of humility on the part of the monks, for by so doing they impart the opportunity for spiritual progress for those who see their need and respond. It is a reciprocal act of generosity and care. His beeswax ziggurats are inspired by ancient Mesopotamian stepped temples one would ascend to make offerings to the gods on whom life itself depended. His installations of flotillas of miniature brass boats perched atop mounds of rice recall the barques of ancient Egypt and suggest the journey and safe passage through this life and into the next. And the beeswax rooms he has been creating for decades, like *The Passageway,* produced very early in 1988, are like the "womb chambers" in Hindu temples where worshippers commune with their god. Laib's works are multi-sensory with a palpable presence involving sight, sound, touch, and smell, exhibiting what philosopher Paul Crowther refers to as "body-hold," which "brings rational and sensuous material into an inseparable and mutually enhancing relation" (qtd. in Siedell, 27).

That religion informs his work was never more obvious than when Laib brought thirty-three Brahman priests from India to offer sacrifices at morning and evening over a seven-day period at thirty-three altars specifically constructed as part of his exhibition at the Fondazione Merz in Turin in June 2009. As Guy Tossato asserts in his catalogue essay for this exhibition, it is because of their natural elements and ritualistic dimensions that,

> [Laib's] works are as close as may be to the sacred sphere. Far from constituting just simple formal combinations, or the expression of the artist's subjectivity, they re-establish the bond with a primary function of art: expressing the inexpressible, revealing the invisible. In doing this, they strongly stimulate the involvement of the spectator who, to see or rather

**FIGURE 11.2**   Installation view. Wolfgang Laib, *Crossing the River with Pollen Mountain*. Hazelnut pollen and rice. Bündner Kunstmuseum Chur, 2022. Curated by Damian Jurt. © 2022 Wolfgang Laib. Permission of the artist.

> live them, has to accept their intrinsic nature as objects of meditation, or events leading to revelation, to an awakening.
>
> *(17)*

For Laib, art and life are one where there is a sacral character to both that transcends the limits of time and place in their pursuit of timelessness and universality (Jurt, et al., 57).

In the 2022 exhibition titled *Crossing the River* at the Bündner Kunstmuseum Chur, Switzerland, curated by Damian Jurt,[16] Laib created yet another field of miniature mountains of rice with a team of helpers who spent several days together quietly focused, seated on the floor, methodically pouring little mounds of rice that stretched from wall to wall in a gently undulating pattern of intersecting lines (Figures 11.2 and 11.3). At two ends of the space, facing each other, he installed two white rectangular pedestals with the height and size of an altar. On one, he installed a single small mountain of brilliant yellow pollen. Opposite it, he placed a small gold-covered Eucharistic casket from the 8th century from Chur Cathedral, which he came across "quite by chance" when he was looking through an old book of his father's when he was invited to do the exhibition (Jurt, et al., 58). He was immediately entranced with the small house-shaped box with a carnelian gemstone embedded on one side surrounded by a raised interlace

**FIGURE 11.3**    Installation view. Wolfgang Laib, *Crossing the River with Early Carolin-gian Eucharist Casket*, 8th century. Gold-plated copper sheet on wood casket, 1 carnelian, 1 glass flux, 2 crystals, 16.5 × 20 × 6.5 cm (6.5 × 7.87 × 2.56 in), Chur Cathedral Treasure Museum (Inv. No. VS.IV.2) and rice.

pattern in the gilding. Laib had long seen a connection between the house forms he made and Medieval Christian reliquaries. In a conversation with Paola Igliori, published in 1992, he said: "The first larger pieces I made were houses with very thin metal on the outside and wood on the inside, and rice inside. They refer somehow to the reliquaries of the Middle Ages, but then instead of the bones of the saints I had the real food…" At Chur, Laib very directly relates Eastern and Western religious traditions, to fully realize the link between the promise of life intrinsic in pollen and the Christian sacrament of the Eucharist, where the priest instructs the faithful, using the words of Jesus Christ at the Last Supper, to "Take. Eat. This is my body, which is given for you" (1 Corinthians 11:24, New Living Translation). In this work, symbols of physical and spiritual regener-ation meet, juxtaposing brilliant yellow and antique gold, nature and the divine, the temporal, and that which never changes, presiding together over a vast rice field, where that sustaining provision extends to the farthest corners of the space, indiscriminate and available to all. The term "Eucharist," which comes from the Greek for "thanksgiving," seems especially applicable here, where the work hovers between "gift" and "offering," exuding grace *and* gratitude in reciprocal and near equal measure.

When asked why he decided to become an artist, Laib says, "I felt [art] is the essence of life...something that holds the world together...this is what I searched for in medicine and somehow I did not find it in medical science. I feel I never changed my profession. I did with these things what I wanted to do as a doctor" (Laib, "Legacy"). In other words, he sees himself as a healer, offering healing to an ailing and wounded world. While Laib adheres to no particular religion or spiritual practice, both his life and art are clearly deeply informed by them. As Heidi Zuckerman Jacobson has written, "In Laib's work, art assumes an ancient function, that of constituting a privileged access to the sacred" (n.p.). There could be no more priestly a role, where sacrament and ritual are the vehicles for bringing others into relationship with a higher reality.

## Grace "from the work performed"

The *Catechism of the Catholic Church* describes the sacraments as "efficacious signs of grace...by which divine life is dispensed to us. The *visible rites* by which the sacraments are celebrated signify and *make present the graces* [my emphasis] proper to each sacrament" (paragraph 1131). Significantly, the sacraments typically involve a physical action or material as the agent of grace; water in Baptism, bread and wine in the Eucharist, and the exchange of rings and bodily consummation in marriage. In Catholic doctrine, the belief, intention, or "holiness" of the one administering the sacraments – the priest – is irrelevant to their effectiveness. Grace arises *ex opere operato*, literally "from the work performed," not the person performing it. Even more significantly, the *Catechism* continues, stating that the sacraments "bear fruit in those who receive them with the required disposition" (paragraph 1131).[17] In sum, it is the "disposition" of the recipient that determines the result, not that of the one who administers it. This comports with reception theory, which places vital importance on the viewer in determining the "meaning" of a work of art.

In Protestant, and particularly in Reformed Calvinist theology, the doctrine of Common Grace – that God lavishes his goodness on believers and unbelievers alike – is based on the understanding that all human beings are made in the image of God. As such, they have the capacity to know and manifest aspects of truth and goodness regardless of belief in him, to nurture and sustain the world.

By extension, the artists discussed here may be seen as rogue priests who offer up profoundly moving, reverential works that have the capacity to bring those who engage them into a profoundly affective encounter with the sacred and transcendent truths. Acting on their own instead of some other clearly identifiable higher authority, they move against the expectations of not only institutional religion but also the secular intellectual elite that eschews religious sensibilities, displaying a significant degree of independence to create work that moves outside of standard practices. Nevertheless, the work carries in it an undeniable and moral authority, extending grace to those who are ready to receive it.

Their artistic practice exhibits what philosopher Andrew Chignell characterizes as a "liturgical attitude." A specialist in the ethics of belief and

liturgical philosophy, Chignell is particularly interested in those persons who despite their unbelief participate in religious practice because they recognize something fundamentally valuable that they desire – something they might even deem an expression of their full humanity – that is manifest in that practice. This represents a "teleological insincerity" as Chignell has put it. It may, however, be better characterized as an "a-sincerity" because their actions do not lack authenticity, goodwill, or personal investment. It is instead the response of "acceptors" who recognize that there is something of real value in their participation absent the full embrace of belief.[18] Such persons are not unlike the man who comes to Jesus to cast a demon out of his son who exclaims, "I believe; help my unbelief" (Mark 9:24).

In his 900-page tome, *A Secular Age*, published in 2007, Charles Taylor traces how we arrived at the place where unbelief is the expected default position and belief persists only against an onslaught of doubt and opposition, internal and external, after most of human history where belief in the divine was assumed and nearly universal and to believe otherwise almost unthinkable. One of the most notable, and relevant, take-aways from *A Secular Age* is Taylor's observation and analysis of what one might call a malaise that is a condition of secularism, where "the atmosphere of immanence will intensify a sense of living in a 'waste land,'" (770) wanting life to have "meaning" but unable to find solid ground on which to found it.[19]

Damien Hirst might best represent this tension between belief and unbelief, as one who has embraced the profane with an insistence and gusto only occasionally seen while producing work with undeniable and ever-increasing beauty and transcendence. The titles of exhibitions (and individual works) certainly have an undeniably religious cast: *Relics, Mandala, The Psalms.*

Over the last two decades, Hirst has produced an astonishing body of work based on the motif of the butterfly, an age-old symbol of transformation and the soul,[20] typically large-scale pieces using real butterfly wings, detached from their bodies, and arranged in kaleidoscopic patterns with household gloss paint on a canvas ground (Figure 11.4). In *The Explosion Exalted* (2006), a title suggesting cosmic generative power, Hirst arranges those butterfly wings in the circular form evoking a mandala, a cosmic map, or Gothic rose window that signifies the wholeness of divine love and sovereign power. But in true Hirstian fashion, he seems to flip between "belief" and "unbelief" the following year with the exhibition *Superstition* (2007) where each butterfly work, taking the shape of rose or pointed Gothic stained-glass windows, is given two different titles that leave the viewer wondering just what they really "mean." Yet, he persisted in making works with titles like *The Kingdom of the Father* (2007), *Bring Forth the Fruits of Righteousness from Darkness* (2008), *and Contemplating the Infinite Power and the Glory of God* (2008) and large series of smaller works such as the Psalm paintings (2008), one hundred and fifty individual pieces inspired by a different Old Testament Psalm. The inspiration of the Psalms is particularly apt as they cover the full range of human experience and emotion; moving from abject despair at feeling

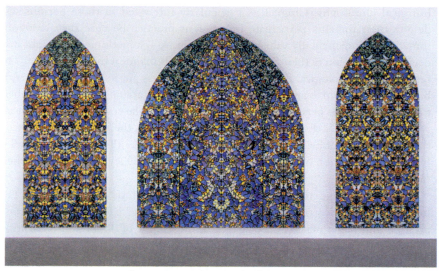

**FIGURE 11.4**  Damien Hirst, *The Kingdom of the Father,* 2007. Butterflies and household gloss on three canvas panels, 294.31 × 482.6 cm (115 7/8 × 190 in). The Broad Art Foundation. Image used with permission.

abandoned, railing at God for his apparent failure to act as he should, to humble recognition of his goodness and praise for his glory and everything in between. They constitute a catalogue of existential experience.

In the Paul Stolper Gallery formal introduction to Hirst's *The Souls*, a series of foil-block prints of individual butterflies that are intended to be installed to cover the gallery walls from top to bottom, first released in 2010, Hirst is described as "a great religious artist." Moreover, that statement informs our understanding of his work more generally offering a compelling reading:

> More than that of any contemporary artist, and in a modern lineage that includes the work of Andy Warhol and Francis Bacon, the art of Damien Hirst confronts the balances between life and death, vanity and transience, value and worth, faith and existential alienation with a visceral and terrifying immediacy. Hirst's choices of media, his innovations within them and the sheer scale on which he works, are integral to the philosophical depth and empathetic charge of his art... Vibrant with hue, the finished effect of each print is that of a resonant tension between the stillness of death and the trembling, iridescent life that the individual butterflies convey.... Hirst's fascination with butterflies derives in large part from the way in which these beautiful insects embody both the beauty and the impermanence of life, becoming symbols of faith and mortality. Like Warhol and Bacon, Hirst is in many ways, primarily, a great religious artist. His

work – as further evidenced by 'The Souls' – deals directly with the time-less and endlessly renewing predicament of faith and belief in the face of mortality. In this, 'The Souls' can also be seen to connect directly to the allegories of mortality to be found throughout the history of art. As the butterfly itself is a traditional symbol of the soul, and of the soul's residence on Earth prior to transmigration to an Afterlife, so 'The Souls' surrounds the viewer – chapel-like – with an art which is as meditational and con-templative as it is aesthetically forceful.

*(Paul Stolper)*

Some may challenge the designation of Hirst as a "religious artist." But Hirst himself exclaimed in an interview with Gordon Burn in 1999, "It comes down to f---ing God. I always think that art, God, and love are really connected. I've already said I don't believe in God. At all. I don't want to believe in God. But I suddenly realized that my belief in art is really f---ing similar to believing in God. And I'm having difficulties believing in art without believing in God" (Hirst and Burn 86–88).

In a 2011 interview with Nicholas Serota, Hirst identified the title of the work *The True Artist Helps the World by Revealing Mystic Truths,* by Bruce Nau-man, as his favorite (28). This work was one of Nauman's first neons, produced in 1967, and has long been considered a founding work in his career. The full title of that work is actually *The True Artist Helps the World by Revealing Mystic Truths (Window or Wall Sign)*, which introduces an ambiguity about the true intent of the work *or* its maker. This is classic Nauman, where tensions and possible contradictions abound between medium and "message," context and expectations, and form and content so that the "meaning" resides somewhere at the convergence of a complex of interactions and their implications. It also reflects Nauman's life-long interest in the role and, perhaps more importantly, the *responsibilities* of the artist.

Like Nauman, the artists examined in this chapter takes their responsibil-ities *as artists* very seriously, driven by some inner compulsion to bear witness to the infinite value and goodness of life itself and human being. Whether that conviction is manifest by addressing our mortality through exposing the great-est atrocities enacted by human beings against their fellows (Margolles) and the immeasurable sorrow that obtains (Salcedo) or by revealing the wondrous gift that is life itself in all of its complex workings (Hirst) and interdependent, sus-taining forces (Laib), their work exhibits a profound reverence for humanity. That reverence carries in it a moral authority that requires a response from those who engage their work. It is not surprising that the language that most power-fully captures the state of the contemporary world – where prosperity and want, hope and despair, the predator and those preyed upon so often collide – draws on religion, marked by strains of ritual practices, sacramental references, and the compulsion to bear witness to higher truths or moral obligations. As such, the practice of artists like Teresa Margolles, Doris Salcedo, Wolfgang Laib, and even

Damien Hirst may be described as priestly where they employ physical actions, methods of making, or material agents that are sacramental in nature, such that their work constitutes a bridge between the immanent experience of life in this world and the transcendent reality of its significance and ultimate worth.

## Notes

1 See Blanché, 147, for information regarding some of the questions surrounding the purchase and whether that price should be considered an accurate reflection of its perceived value on the art market.
2 See Medina, Cuauhtémoc, editor, *Teresa Margolles: What Else Could We Talk About?* RM Verlag, S.L., 2009, published in conjunction with the exhibition, for more information on this work.
3 Most famously, Kandinsky's treatise *Concerning the Spiritual in Art,* first published in 1912, where he describes the artist as a "priest of beauty."
4 See Friedhelm Mennekes, *Beuys on Christ,* Verlag Katholisches Bibelwerk, 1989, for an in-depth consideration of how Beuys and his work are informed by religious and specifically Christian theology and concepts.
5 See Alexander Schmemann, *For the Life of the World: Sacraments and Orthodoxy* (St. Vladimir's Seminary Press, 2000), 15, for additional context.
6 Ibid., 14.
7 See Blanché, 144–170, for an extensive discussion of *For the Love of God.* See *For Heaven's Sake – Damien Hirst* (Gagosian Gallery and Other Criteria, 2011) for a provocative account of the "origins" of that later skull work of the same title as the publication.
8 Significantly, many contemporary artists have worked with blood, including Hermann Nitsch, Ana Medieta, Damien Hirst, Marc Quinn, Ron Athey, and Andres Serrano. Jordan Eagles is only one of the most recent who has made blood the essential subject and medium of his practice. See Jane Szita's interview with Eagles titled "New Blood" in *One Artist: One Material: Fifty-five Makers on their Medium,* Frame Publishers, 2018, pp. 114–119, where Eagles explains that his works "propose philosophical questions about mortality, spirituality and creation. The works become relics of that which was once living, embodying transformation, regeneration and an allegory of death to life (117)." See also the feature on Eagles in the journal *Image* No. 105 (Summer 2020) where he states,

> I am not religious. I believe in a universal energy that is part of everything that exists, and I consider most of my work to be spiritual. I was raised in a household with art and texts from many cultures and religions. I also find spirituality in science. I am amazed that cellular details seen through a microscope can often look like telescopic images of the cosmos. The connections between body, spirit, energy, and regeneration are fundamental to my work.
>
> (83)

9 For more on Margolles, see Julia Banwell, *Teresa Margolles and the Aesthetics of Death.*
10 See Caroline Walker Bynum's book *Wonderful Blood* (University of Pennsylvania Press, 2007) for information on the theology and practices of the European cult of the blood of Christ, as but one example of the depth and extent of this veneration.
11 In Peirce's taxonomy of signs, "the signifier is not arbitrary but is directly connected in some way (physically or causally) to the signified in a way that can be observed or inferred," in the Index, Michael W. Cothren and Anne D'Alleva's *Methods and Theories of Art History,* Third edition. Laurence King, 2021, 56. Cothren and D'Alleva go on to quote Rosalind Krauss's 1977 essay "Notes on the Index: Seventies Art in America," in *October* 3 (Spring 1977), 68–81, where she describes Dennis Oppenheim's transfer of his thumbprint in his work *Identity Stretch* (1975) as "focused on the pure

installation of *presence* [my emphasis] by means of the index." For more on Peircean semiotics, see *Peirce on Signs: Writings on Semiotics by Charles Sanders Peirce,* edited by James Hooper. University of North Carolina Press, 1991.

12 Interview with Carlos Basualdo in Princenthal et al., 21.

13 Interview with Charles Merewether in Princenthal et al., 137.

14 Reception theory has done a great deal to heighten awareness of the significance of the viewer to works of art and the creation of "meaning." See especially Wolfgang Kemp's work and David Freedberg's *The Power of Images: Studies in the History and Theory of Response* (University of Chicago Press, 1991) for more on reception theory.

15 See Carol Diehl's article "Transcendent Offerings" for confirmation of Laib's response.

16 The exhibition title comes from a poem by the Chinese Buddhist monk Yishan Yining written in the early 14th century inscribed on a painting of *Bodhidharma Crossing the Yangzi River on a Reed* by artist Li Yaofu. A translation of the poem reads, "Crossing rivers and deserts he came. Facing the emperor he confessed, 'I don't know'; Unsuccessful, he moved on, His feet treading the water." According to Damian Jurt, the poem references the story of Bodhidharma, who brought Chan (Zen) Buddhism to China (Jurt et al., 44, 65–66).

17 See also paragraph 1123 of the *Catechism,* which expands on the purpose and disposition of the recipient.

18 This summary is based on my notes from Andrew Chignell's talk on liturgical philosophy at the Abraham Kuyper Conference at Princeton Theological Seminary on April 11, 2014. The distinction between "insincerity" and "a-sincerity" was introduced in a question from an unidentified member of the audience at that meeting. Chignell is one of the directors of the New Princeton Project on Philosophy and Religion for the University Center for Human Values at Princeton University. Chignell, with Andrew Dole, edited *God and the Ethics of Belief: New Essays in Philosophy of Religion* (Festschrift for Nicholas Wolterstorff), Cambridge University Press, 2005.

19 See James K.A. Smith's book *How (Not) to be Secular* (Eerdmans Publishing, 2014) for a good overview of key points in Taylor's *A Secular Age.*

20 See Mengham, 4, for more on the symbolic origins of the butterfly.

## Bibliography

Banwell, Julia. *Teresa Margolles and the Aesthetics of Death.* University of Wales Press, 2015.

Beausse, Pascal. "Teresa Margolles: Primordial Substances 2005." *Materiality: Documents of Contemporary Art.* Petra Lange-Berndt, editor. Whitechapel Gallery and The MI Press, 2015, 136–139.

Blanché, Ulrich. *Damien Hirst: Gallery Art in a Material World.* Rebekah Jonas and Blanché, Ulrich, translators. Baden-Baden: Tectum Verlag, 2018.

*Catechism of the Catholic Church,* Second Edition. Libreria Editrice Vaticana, 2019.

Dahl, Espen. *In Between: The Holy Beyond Modern Dichotomies.* Vandenhoeck & Ruprecht, 2011.

Diehl, Carol. "Transcendent Offerings." *Art in America,* March 2001, 88–95.

e-flux. "Mexican Pavilion." May 17, 2009. http://www.e-flux.com/shows/view/6773.

Farrow, Claire. *Wolfgang Laib: A Journey.* Edition Cantz, 1996.

Hirst, Damien. *The Souls I, II, III & IV.* Other Criteria & Paul Stolper, 2010.

——. Interview with Nicholas Serota, 14 July 2011. *Damien Hirst: Relics.* Skira, 2013, 23–35.

——. *Damien Hirst: The Complete Psalm Paintings.* Other Criteria, 2014.

Hirst, Damien and Gordon Burn. Interview on August 30, 1999, published in *On the Way to Work.* Universe, 2002.

Igliori, Paola. *Entrails, Heads & Tails: Photographic Essays and Conversations on the Everyday.* Rizzoli, 1992.

Jacobson, Heidi Zuckerman. "Wolfgang Laib/MATRIX 188: Pollen from Pine." October 14, 2000–December 17, 2000. BAMPFA, University of California. https://bampfa.org/program/wolfgang-laib-matrix-188.

Januszczak, Waldemar, with Teresa Margolles. "Venice Biennale 2009: Mexican Pavillion." *YouTube,* June 2009. https://www.youtube.com/watch?v=BtLcedTTIBc.

Jurt, Damian, Stephan Kunz, and Bündner Kunstmuseum Chur, editors. *Wolfgang Laib: Crossing the River.* Lars Müller Publishers, 2022.

Laib, Wolfgang. "Legacy." *Art21,* Season 7, November 7, 2014. https://art21.org/watch/art-in-the-twenty-first-century/s7/wolfgang-laib-in-legacy-segment/.

Martinez, Raul. "What Else Could We Speak About Teresa Margolles at the Mexican Pavilion." *Art in America,* June 9, 2009. https://www.artnews.com/art-in-america/features/what-else-could-we-speak-about-teresa-margolles-at-the-mexican-pavilion-57746/.

Medina, Cuauhtémoc, editor. *Teresa Margolles: What Else Could We Talk About?* RM Verlag, S.L., 2009.

Mengham, Rod. "Butterfly Affect." *Damien Hirst: Mandalas.* White Cube, 2019, 4–8.

Paul Stolper Gallery Press Release for *Damien Hirst – The Souls,* October 7–November 13, 2010. https://www.paulstolper.com/usr/documents/exhibitions/press_release_url/78/damien-hirst-the-souls-press-release.pdf.

Princenthal, Nancy, Carlos Basualdo, and Andreas Huyssen. *Doris Salcedo.* Phaidon, 1997.

Salcedo, Doris. "Compassion." *Art21,* Season 5, October 7, 2009. https://art21.org/watch/art-in-the-twenty-first-century/s5/doris-salcedo-in-compassion-segment/.

———. *Doris Salcedo: Plegaria Muda.* Moderna Museet Malmö (Sweden), Fundação Calouste Gulbenkian, and Prestel, 2011.

Shani, Annushka. "Between Fact and Wonder – Damien Hirst's New Religious Works." *Damien Hirst – Romance in the Age of Uncertainty.* Jay Jopling/White Cube, 2003, 7–11.

Shaw, William. "The Iceman Cometh." *The New York Times Magazine,* June 3, 2007. https://www.nytimes.com/2007/06/03/magazine/03Style-skull-t.html.

Siedell, Daniel. *God in the Gallery.* Baker, 2008.

Taylor, Charles. *A Secular Age.* Harvard University Press, 2007.

Tosatto, Guy. "Elsewhere, the Fire." *Wolfgang Laib.* Fondazione Merz, 2009.

Widholm, Julie Rodrigues and Madeleine Grynsztejn, editors. *Doris Salcedo.* Museum of Contemporary Art Chicago and The University of Chicago Press, 2015.

# 12

# WALKING NAKED AND BAREFOOT

## When Ancient Jewish Prophets Meet Avant-Garde Performance Artists

*Wayne L. Roosa*

In his magisterial study, *Sacred Discontent, The Bible and Western Tradition,* Herbert Schneidau argues that an irreconcilable ambivalence between our highest values and our social institutions runs through the very DNA of Western culture. This ambivalence produces a perennial discontent, or, as Schneidau calls it, a *Sacred Discontent*.[1] A discontent manifest as an alternating "love and hate of our culture." The anatomy of *Sacred Discontent* is this: if our highest spiritual values are our "truths," then the institutions intended to embody them are our "myths." And the inevitable failure of a culture's myths to fulfill its truths; the inevitable slippage of institutions from the purity of abstract spiritual values into the pragmatism of politics and economics, which exploit spiritual values (often in the very name of God), is a betrayal of those values for the sake of power, security, or gain, producing idols. Such idols, when they arise, require exposure through criticism, protest, and reform. And reform works. At least until the next slippage into corruption brings the next betrayal and its idol.

Such is the rhythm of our *Sacred Discontent,* our "love and hate of our culture." Schneidau further argues that this rhythm, and the ambivalence in it, is structurally inherent in the very nature of the radical monotheism that formed the Judeo–Christian heritage. Repeatedly, ancient Israel, and later the Church, failed to live up to the impossible purity of the mysterious YHWH or the selfless love of the Gospel, finding it easier and more profitable to drift into self-serving myths using religion to justify its institutions, power, wealth, nationalism, exceptionalism, and racism. But also repeatedly, a fierce prophet arose with a radical critique, calling society back to its deeper values. The same rhythm continues today in the secular terms of the modern era, as bourgeois social values clash with the utopian avant-garde's *épater les bourgeoise*. Clement Greenberg's claim that the "superior consciousness" of avant-garde culture was "a new kind of criticism," was not, in fact, new (3–4). Structurally, it bore the same ambivalence and

DOI: 10.4324/9781003326809-15

pattern of protest as ancient Israel's sacred discontent, except that now the "superior consciousness" of YHWH and his prophets is understood as fully immanent with secular culture, ideals, and betrayals. The ancient prophets' protests arose from their belief in transcendence; today's prophets tend to arise from a place of this world's politics.

Schneidau's book was published in 1976, but the pattern he identifies has continued in postmodernism's critique of modernism. The avant-garde, having been absorbed into bourgeois culture as "style," now required the next "higher consciousness" of deconstructionism to undercut its myth. Postmodernism's critique of modernism's failure to fulfill its utopianism set out to be the ultimate prophetic sacred discontent, attempting to undercut all metanarratives as myth. Until, of course, deconstruction itself has become a new metanarrative, a myth that is only now being undercut by the reinstating of what for practice purposes stand as a new kind of "absolute" truths and justice through the metanarrative of feminism, postcolonialism, pluralism, race theory, and relational aesthetics, as these seek to purge the entire history of the West from corruption and usher in once again a purity of abstract values that brings justice to the subjugated.

Schneidau's study of sacred discontent as a subliminal motor force of Western culture is deeply compelling. Its insights are revelatory even for those who do not have his regard for the spiritual. Because I am an art historian, I like abstract truths, myths, spirituality, and critiques firmly grounded in the embodied terms of art objects and events. And so, I wondered, is this rhythm of truth/ mythologizing corruption/sacred protest evident in the history of Western art? After all, art is one of the most fertile realms in which abstract spiritual truths, aspirations of purity and freedom, the corrupting influence of wealth and power, patronage and institutions, and culture myths intersect and collide.

Was there, I wondered, a lineage of sacred discontent running through the arts? For example, contemporary performance artists are renowned for their "prophetic" symbolic actions that oppose the status quo. As I reread the texts of those ancient Jewish prophets, I discovered that their work was not merely preaching. Very often, it involved their use of quite strange symbolic actions. One might say "performances." Was this a rich through-line of sacred discontent that had not yet been connected? Were those prophets and today's performance artists kindred spirits and unexpected fellow travelers in a deep current of moral, spiritual, political, and cultural concerns?

I did not have to wait long to find out. Indeed, my next art history seminar class on contemporary performance art set it into motion. We were examining the early performance work of Yayoi Kusama. With Schneidau's scholarship now in the back of my mind, a connection – an echo or resonance – suddenly sparked. It went like this:

On July 14, 1968, Yayoi Kusama, an avant-garde performance artist, directed four artists to violate U.S. law and offend the decorum of American manners by dancing naked on the steps of the New York Stock Exchange. As they gyrated to

the rhythm of bongo drums, Kusama spray-painted their bodies with blue polka dots, creating a full-on "Be-in," until police closed the event down. Kusama's naked performance, *The Anatomic Explosion*, was accompanied by her explanatory text. For the event, she sent out manifestos as press releases. They still ring with urgency and transgression:

> STOCK IS A FRAUD! /STOCK MEANS NOTHING TO THE WORKING MAN/ STOCK IS A LOT OF CAPITALIST BULLSHIT./ We want to stop this game. The money made with this stock is enabling the war to continue...Wall Street men must become farmers and fishermen. /...OBLITERATE WALL STREET MEN WITH POLKA DOTS ON THEIR NAKED BODIES...

Supplementing this press release was an open letter to President Nixon that read, in part:

> Our earth is like one little polka-dot, among millions of other celestial bodies, one orb full of hatred and strife amid the peaceful, silent spheres. Let's forget ourselves, dearest Richard, and become one with the Absolute, all together in the altogether....and finally discover the naked truth: You can't eradicate violence by using more violence.
>
> *(Kusama 106–107)*

In the immediate context of now thinking about sacred discontent, I felt a resonance between Kusama's work and the work of one of those ancient Jewish prophets, namely, Isaiah. In 711 BCE., Yahweh, God of Ancient Israel, commanded the prophet Isaiah to violate Mosaic Law and offend the decorum of Jewish manners by ordering him to walk naked in public for three years while preaching oracles against Israel for its corrupt political alliance with Egypt and Cush. The text still rings with eloquence, urgency, and transgression:

> At that time Yahweh had spoken through Isaiah son of Amoz, saying, "Go and loose the sackcloth from your loins and take off your sandals from your feet," and he done so, walking naked and barefoot. Yahweh then said, "As my servant Isaiah has walked naked and barefoot for three years as a sign and portent for Egypt and Ethiopia, so shall the king of Assyria lead the Egyptians captives and the Ethiopians exiles, both the young and the old, naked and barefoot, with buttocks uncovered, to the shame of Egypt.
>
> *(Is 20:2–6)*

Isaiah's performative critique of his nation's political strategies was no less radical than Kusama's dance troupe, though perhaps his poetic genius is more eloquent. Although there were no photographers to document it, its visual imagery still flashes from the page for readers who have eyes.

I have set these two examples of transgressive, symbolic protest side by side as if they are equivalents and legitimately parallel. The juxtaposition is both provocative and problematic. I hasten to say that my interest in this essay is not in the specific partisan politics involved or in one's beliefs about the matters of policy, religion, or values – liberal or conservative – raised by these events. Rather, my interest is in the transgressive phenomenon of public performance art and symbolic prophetic gestures, both contemporary and ancient. More significantly, my interest is in the idea that there exists a deep structure of sacred discontent within the Western psyche regarding how to confront contradictions between abstract idealism and real-world pragmatism. Ultimately, my interest is in the role that *performative images* play as the culturally embodied mechanism that undercuts our myths when they morph into idolatry and seeks to reestablish our sacred values. This much Isaiah and Kusama share.

Of course, from the point of view of valid historiography and method, my comparison could be considered problematic. How can we legitimately compare two symbolic actions separated by vastly different times (8th-century BCE versus 20th-century CE), cultures (Ancient Near Eastern versus Modern American), continents (Asia versus North America), social structures (theocracy versus democracy), and notions of "art" (Ancient Israel's aniconism versus America's glut of eroticized consumer images)? If we insist on traditional art historical methods, should we not find direct influences, knowing appropriations? Did Kusama read Isaiah? While those methods are useful tools, recent approaches to art history such as David Freedberg's *The Power of Images,* Hans Beltings's *Likeness and Presence,* James Elkins' *Pictures and Tears,* or Mieke Bal's *In Praise of Anachronism* are more helpful. Using response theory, Freedberg speaks for these alternate methods saying, "This book is not about the history of art. It is about the relations between images and people in history" (xix). In that spirit, Bal embraces a "willful anachronism" for discovering multiple nuances of *meaning.*

The dilemma is whether merely to note this pairing as an interesting echo or to claim this as a provocative example of an unstable territory wanting further exploration. Whether Kusama had read Isaiah is interesting, and unknown. But my idea, in keeping with Schneidau's insight, is that the common ground between these two performances is *meaning,* not direct art historical influence. One "myth" of art history as a discipline is that it demands concrete, archival connections for validity. But working artists know full well that the human imagination is itself a rich source of connection in terms of *meaning and expression.* Both artist and prophet recognized corruption when they saw it and instinctively knew that diplomatic words were not enough. Both favored a powerful and transgressive *gesture.* So, my near equating of Kusama and Isaiah is not based on the history of style or influence. Who after-all would equate the poetic eloquence and genius of Isaiah with the vernacular hippie slang of Kusama? And yet we might equate their moral insight. What makes this juxtaposition of Isaiah and Kusama compelling is not equivalence of *aesthetic quality* or proof of influence, but rather *connection* of human *significance* through instinctive *resonances* that

*exist in humans* across centuries, continents, cultures, and philosophies. In other words, perhaps there *are* abstract spiritual values that transcend specific historical conditions.

While *resonances* may still seem too soft for some, there are two other connections here that suggest a hard continuity. First is a shared symbolic instinct grounded in all human experience; namely, both performances involve pitting the vulnerability of naked individuals against the impersonal power of mass cultural institutions. Second, despite their vast differences, the unique contexts of corruption in Isaiah's Israel and Kusama's America turn out not to be so different on the structural level. And, in fact, both Ancient Israel and Modern America were (still are) profoundly linked by the mechanisms of radical monotheism and the convictions of divine substantiation of their nationalism.

They share the terrible dilemma involved with radical monotheism. Monotheism demands radical allegiance to abstract spiritual ideals, but to survive, nations need pragmatic compromises with worldly powers in the face of real politics. Isaiah's criticism of Israel was that it had established corrupt political treaties with its enemies and abandoned its trust in Yahweh. To be fair, Israel faced dangerous times. To the east, Assyria had amassed an empire and was aggressively taking up arms against the kingdom of Egypt to the south. Both realms were hostile to the small kingdom of Israel existing precariously between the jaws of these world powers. To protect itself, Israel sought political alliance with Ethiopia, thus obligating Israel to Egypt, its ancient slave master and theological foe. Opposing such treaties was Yahweh, whose position was that Israel should "trust in God" rather than forge political alliances with Israel's enemies. But here is the impossible rub of radical monotheism. The nation's trust in God was only as good as the nation's political living up to God's abstract spiritual values, namely, "to loose the bonds of wickedness,...to let the oppressed go free,... to share your bread with the hungry,...and bring the homeless poor into your house" (Is 58:6–7). Since there was no chance that the nation's institutions would embrace such just and merciful policies, a treaty with one's enemies seemed more reasonable. In opposition to the reasonableness of compromise, Yahweh caused Isaiah to strip off his sackcloth and sandals and walk about naked, "his buttocks exposed as a sign of shame," indicating just how vulnerable Israel was, not only before its enemies, but before its God.

Structurally, the American situation protested by Kusama was not very different. Kusama delivered her indictment of the United States' conflict with North Vietnam. To be fair, the United States faced dangerous times. To the east, the Soviet Union had amassed an empire and was aggressively developing nuclear arms, while to the west Communist, China was building its arsenal. Both realms were hostile to the U.S. existing between the jaws of these world powers. To protect itself, the United States sought political alliance with small, third world countries around the globe; a strategy matched by Russia and China seeking counterinfluence. To keep the Cold War "cold," these nuclear superpowers avoided open war by leveraging themselves with military conflicts through those

small nations as their surrogates. Justifying these moves against "godless communist states" was America's religious faith. The "Judeo–Christian ethic," a term coined by Eisenhower in 1952, was dubbed as inherent to American civil religion and made official by the congressional vote to make "In God We Trust" the legal national motto, which was then added to the dollar bill; the very bills traded in the New York Stock Exchange and used to fund the war.

The United States had long sought a work-around of Israel's dilemma between faithfulness to radical monotheism versus political expediency through compromised institutions. This is the problem with being a theocracy. The United States had invented "civil religion" as the permeable membrane separating church and state. As a democracy only latent with theocracy, the nation could claim to maintain the abstract spiritual ideals of monotheism by embracing God *spiritually* within private religion, while still pursuing military and political policy *pragmatically* in the real world of politics. This allowed its citizens to sustain their conviction of trust in God while yet being confident that it was Yahweh himself who had founded the national identity and protected the country. Of course, like ancient Israel, God's protection would depend on the nation "living righteously, not oppressing the poor, not craving undue material gain and always doing justice in their dealings."

Artists such as Kusama found in all this a sleight of hand. What she protested was the alliance of American religious faith with Wall Street wealth and the industrial-military complex. She objected to how the symbiotic engines of religion, capitalism, and militarism were unified within a democracy claiming its national legitimacy through its origins in radical monotheism. While the sagging naked buttocks of old Isaiah walking may have hung in contrast to the firm nude buttocks of Kusama's lithe young dancers cavorting, their collective nakedness was aimed at symbolically exposing what she believed to be the culture's contradiction and violence. Using art as a prophetic form, she undercut the national myth, accusing the nation of contradiction even as it reaped substantial profit and protected national security in the name of God.

At this point, the question arises: Is this relation between Kusama and Isaiah merely a one-off, albeit fascinating, connection? Or are there many such resonances that substantiate a broader notion of sacred discontent? It turns out there are many. And as one examines these, a second question arises because many of these performative, prophetic actions are quite extreme. Indeed, in observing the consequences of performative protests, both ancient and modern, there is a serious question as to what extreme can prophetic performances – whether religious or artistic – go to make their point? In the ancient world, these sometimes brought death to the prophet. In our world, they sometimes bring self-maiming or abject actions to the artist.

The reason for extremity, of course, is that in both ancient and contemporary times, prophets and artists needed to alienate the culture for protest to succeed. To quote Schneidau, they often "sought alienation induced by self-maiming, drugs, etc., [in hopes of] leading back to social reintegration" (18). Here another

tension arose: Does the creative voice's commitment to abstract spiritual ideals justify a real-world transgression of danger and pain? Other cases soon emerged.

For example, performance artist Mona Hatoum's *Variations on Discord and Division* evoked the prophet Jeremiah's symbolic uses of his poetic books. In this example, we might find an artist who is aware of the biblical texts given that Hatoum is Palestinian-born and originates from a background where scripture texts are better known in the general culture. In *Variations*, she performed several vignettes in a space where the walls and floors were covered with newspapers. Newspapers are the texts of the world tasked with reporting the 'truth,' thereby stimulating dialog and freedom through open information. Yet, as everyone knows, what each newspaper presents, given government censorship and journalistic perspective, is an interpretation from a point of view. The depths of discord and division are not easily resolved by the media's reportage, even though we look to it for clarity. Surrounded by these texts of information is Hatoum, dressed in overalls and a black stocking mask covering her eyes, ears, and mouth, cutting her off from the world while obscuring her identity, whether as hooded victim or masked terrorist. In one vignette, she is on hands and knees attempting to scrub the newspaper-lined floor clean. But she ends up only smearing it with blood-colored water. At another point, she takes a knife and slits the mask at mouth, eyes, and ears in the effort to see, hear, and give voice even though remaining masked.

At least one level of this piece is the expression of frustration and futility implicit in the contradictions between what really happens in the world versus the nationalistic rhetoric, ideological values, and claims of truth for the individuals who try to act and change that world. It captures the sense that we are blind, deaf, and mute, even as we take actions to clean up or resolve problems; actions that may even result in more bloodshed. It points to the ambiguous role of texts – both as truth-telling and as rhetorical weapon – as we vie for justice or dominance. And it suggests the difficulty of understanding through the hooded isolations of our positions of discord and division.

Hatoum and Jeremiah, like Kusama and Isaiah, are not rare or sole examples. Indeed, Jeremiah's texts and his political-religious context were so rich that other contemporary performance works resonate. The radical accusations of Jeremiah's texts got him into trouble with the political and religious authorities, to the extent that he was accused of what we call sedition. He was imprisoned for disloyalty (lack of patriotism) to Israel because his writings criticized the King and national attitudes, "not seeking the welfare of Israel."[2] To put Jeremiah in his place, the King had his secretary, Elishama, read Jeremiah's texts out loud. Every three or four columns, the King cut off that part with a knife and burned it while mocking the prophet, who had been beaten, imprisoned, and threatened with death. Ultimately, Jeremiah's predictions proved reliable, and per his warnings, Israel was taken into captivity in Babylon, at which point Yahweh instructed him to write another text and give it to Seriah as they went into captivity. The second text was one of hope in the face of despair in exile. Seriah was told to read

it aloud to the people once in exile, and then tie a stone to it and sink it in the Euphrates River as a sign against Babylon and proof that God would not abandon the nation during their captivity.

Once again, while there is no direct influence or exact similarity between Hatoum and Jeremiah, an authentic resonance, that intense sacred discontent, can be felt between them. Their common ground is in the function of texts to confront power. It is in how texts mediate and give elegy to the tragedies of violence, bloodshed, and loss. And it is in how a prophetic sense of "artist" – Jeremiah as a poet and Hatoum as an agent of symbolic action – operates.

No less resonant – or poignant – was Ann Hamilton's haunting performance, *Malediction* (Figure 12.1), when placed in relation to the prophet Ezekiel's troubling enactments of Jerusalem under siege while eating bread baked on human dung. Hamilton's performance involved two rooms: an anteroom with rags soaked with red wine and wrung with water littering the floor, and an inner room with the artist eating bread. In the anteroom, viewers stepped on the wine-soaked rags as they passed into the inner room where Hamilton sat on a tall stool at a refectory table. On the table was a large bowl filled with balls of raw bread dough. She placed these in her mouth, bit down to form an impression or

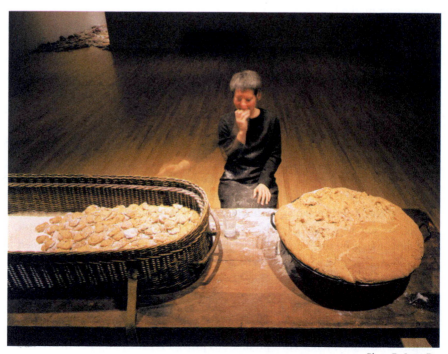

*Photo: D. James Dee*

**FIGURE 12.1** Ann Hamilton. *Malediction,* 1992. Performance, Louver Gallery, New York. Courtesy of Ann Hamilton Studio.

"cast" of her mouth's hollow interior, then put each impression in a 19th-century wicker basket used by undertakers to transport dead bodies to the morgue. A voice playing on a speaker read from Whitman's *Song of Myself* and *The Body Electric* (Ann Hamilton Studio).

This installation performance occurred in the same neighborhood where, in the early 20th century, poor immigrant women worked in sweatshops with no labor laws and no legal voice to protect them. The *cause célèbre* of that neighborhood was the Triangle Shirtwaist Fire of 1911, where 146 women died in a fire. The owners had locked the back doors to prevent them from talking with labor union radicals during their rest breaks, thus silencing voices.

What is powerful is how this work connects to specific historical meanings through simple yet universal symbolic elements and actions. Class struggle, labor laws, gender, economics, and justice are expressed by symbolic reference to working, eating, clothing, bread, and wine. It is a prophetic, socio-economic piece, even as it is equally an allusive, poetic piece. And in the gap between pragmatic politics and abstract poetic allusion, Hamilton's chosen elements and actions bridge from historical specifics to universal values. It is her use of certain elements that are common to every culture in every time – wine, bread, labor, power, subjugation, and seeking a voice to gain freedom – that links a particular moment in modern history to a universal poetic elegy about our human contradictions. This is modern and ancient.

If we allow the idea that powerfully felt resonances indicate a reality – and continuity – in human meaning across societies, eras, and contexts, then Hamilton's work enriches our understanding of another ancient prophet. It is illuminating to bring her performance alongside the symbolic actions of Ezekiel. The point is not a "where's Waldo" hunt to prove the validity of "resonance," but rather to unearth a similar moral urgency made manifest by using symbolic objects and repetitive daily actions to reveal human conditions, both historically and poetically. Once again, it was *resonance* through shared symbols that makes the connection.

In the book of Ezekiel, the prophet is commanded to bake a strange and offensive bread, which he must eat publicly in front of his neighbors after performing bizarre enactments foretelling the military siege and destruction of Jerusalem. Having been told to take a brick, draw a picture of Jerusalem on it, then heap up dirt around it as the symbolic earthworks of a siege, Ezekiel was tied up in cords and ordered to lay on his left side for three hundred and ninety days, then on his right side for forty days, these numbers symbolizing the years of impending exile once the city is destroyed.

The sheer endurance of physical pain and discomfort is shocking. Performance artists such as Marina Abramovic have made much of the idea that artists must have extreme endurance and tolerance for pain if they are to be genuine (Brockes). Ezekiel's four hundred and thirty days of lying in bondage beside a clay depiction of beloved Jerusalem must have challenged him while severely testing the patience of his audience, whose demise he was predicting.

But he was not done. These strange labors were only the anteroom to his full prophetic actions. To this torturing mock siege and bondage as social criticism, Yahweh added the eating of bread that involved defilement in the eyes of Mosaic Law. Ezekiel's eating of defiled bread would stand as portent of how the society's moral defilement would bring conquest and exile to the nation. Yahweh instructed Ezekiel:

> You shall take wheat and barley, beans and lentils, millet and spelt, and put them into a single vessel, and make bread of them. During the number of days that you lie on your side…you shall eat it…And you shall eat it as a barley cake, baking it in their sight on human dung. And the Lord said, "Thus shall the people of Israel eat their bread unclean, among the nations whither I will drive them.
>
> *(Ez 4:9–13)*

To this last element, Ezekiel himself protested: "Then I said, 'Ah Lord God! Behold, I have never defiled myself; from my youth up till now I have never eaten what died of itself or was torn by beasts, nor has foul flesh come into my mouth" (Ez 4:14). This raises a significant issue for both prophet and performance artist. To what lengths must one go to fulfill the moral mandate and make the point? Is it necessary and is it ethically permissible – even when the command to perform is attributable to God – for the performative prophet/artist to compromise and endanger him or herself literally?

Here, the provocation and discomfort of bringing ancient religious prophets alongside contemporary performance artists become more anxious. Are socially transgressive and literally dangerous actions required for an authentic prophesy or performance? Is not a metaphoric action adequate? Every reasonable person would say yes, and indeed as a teacher and mentor to young artists I would agree. And yet, examples from both religious and art-world actions have crossed these lines. Chris Burden literally had himself shot with a rifle and crucified on a Volkswagen. Marina Abramovic almost suffocated when a ring of fire deprived her of oxygen. Abramovic and Catherine Opie carved words and symbols into their own skin with knives during their performances, bleeding in pain and risking infection. And these are hardly the most grotesque examples.

The public – and ironically, especially the conservative religious public – is repelled by this. And yet the biblical text offers no less strange moments. Isaiah goes naked in public, Ezekiel endangers his health with bread baked on dung, and Jeremiah so alienates his government that they arrest, beat, imprison, and threaten to kill him. And yet all of these are less transgressive than the prophet Hosea, whom God commanded to marry and conceive children with a known prostitute named Gomer as a symbol of Israel's state of spiritual infidelity. And when Gomer grew restless and returned to the city square to resume her trade, Yahweh told Hosea to publicly retrieve her, despite the shame this brought to the prophet (Hs 1). How was his public supposed to understand such extreme actions?

Hosea's example is particularly agitating to any of us who define marriage through idealized and sacred concepts. Theologians salve the shock by telling us that Hosea was not only prophesying a negative message to Israel; he was also signifying that Yahweh still loved his people and would redeem them, and even remain their lover despite their spiritual and cultural wantonness. Given the sacredness of marriage and the severity of Deuteronomic prohibitions against illicit sex punishable by stoning, is it not outrageous that Yahweh would order such a marriage, endorse sex, and condone the real conception of their first child *as a metaphor* to reconcile the contradiction between abstract spiritual ideals and social corruption? (I am skirting questions of literalness in biblical interpretation, partly because the hermeneutical problems are large, but partly because in my experience, the audiences who most protest avant-garde performance art are conservative religious audiences whose view of the Bible is explicitly literal.)

The story of Hosea inevitably provokes comparison with performance artist Andrea Fraser. In *Untitled,* Fraser, working within the framework of "institutional critique," sold a performance work to an unnamed male art collector consisting of her having unsimulated sex with him for one hour in a hotel room (Lescaze). The performance was video-recorded and exhibited later in a Chelsea Gallery. To accusations from an established art critic that Fraser "is a whore," *Village Voice* art critic, Jerry Saltz replied that Fraser's *Untitled* occurred within the contexts of "women taking control, Baudelaire's idea of the artist as prostitute [and] art as institutional critique that risks being vulnerable" (Lescaze). Anyone who follows the art world knows that world's double binds of aesthetic/marketable, socially critical/necessarily collectible, spiritually rewarding/economically profitable, and beauty/investment. In this context, the working artist is like that small nation operating between the jaws of the large and wealthy realms: art institutions and Wall Street hedge funds collectors (replete with auction house alliances that drive up prices and ask artists to compromise to succeed in the system). The contradictions are rife between "sacred" notions of art as abstract ideal and the pragmatic alliances of art as status and investment. Here, the truth of sex as sacred versus getting screwed by the system is enacted. Metaphor collapses into reality, and the buffering protection of symbol evaporates. And crucially, these dynamics are not solely metaphorical. Their conditions guarantee strange, compromised, and certainly unsimulated bedfellows.

Whether this justifies a female artist having stranger sex with a collector becomes a serious question. Saltz suggests that without actual risk, the work lacks a force equivalent to the "unsimulated system" of compromise between art-as-money and art-as-keeping faith. And yet, when it comes to gestures that are meant symbolically but involve concrete actions that go to the core of one's person, perhaps the giving of one's intimate personhood under the auspices of aesthetic detachment involves too much? After all, even Yahweh relented when Ezekiel protested to eating bread baked on human dung – "Ah Lord God! Behold, I have never defiled myself" – and allowed him to substitute animal dung. One wants – I want – to leave Fraser's *Untitled* out of this essay or find in Ezekiel's substitution the bottom line to the question of "how far?" Does the artist literally have to screw to prove she has been screwed?

These symbolically transgressive and literally dangerous actions go to considerable lengths, raising ethical and safety questions about the line between necessary realism versus adequate symbolism that only feigns danger. There are, of course, self-indulgent and narcissistic performance artists just as there were

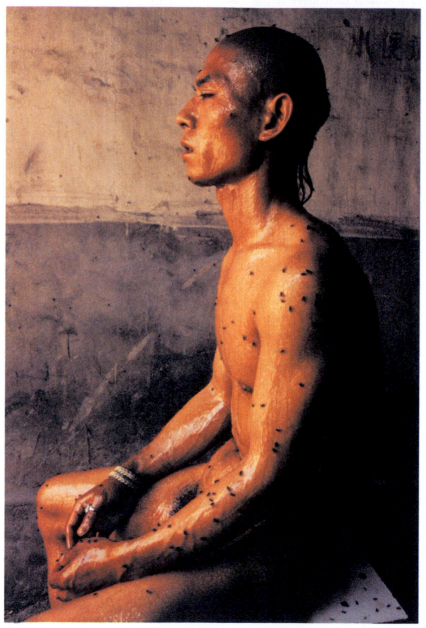

**FIGURE 12.2**   Zhang Huan. *12m² (Twelve Meters Squared)*, 1994. Performance. Beijing, China.

false and pandering ancient prophets. There is not space here to sort out these complexities.

Inherent in this complexity is the level of risk between an "aesthetic" versus "activist" performance. This is evident in Zhang Huan's *Twelve Meters Squared*, performed in Beijing, East Village, China, in 1994 (Figure 12.2). This piece was in protest against the deplorable sanitation conditions of public toilets in the poor neighborhood of Beijing's East Village (www.artsy). The toilets did not work, flies swarmed, and the filthy stench of human dung reeked everywhere. Complaints to the government got no notice. So, Zhang Huan brought attention to the situation by lathering his naked body with honey and fish oil and sitting on a rough-hewn latrine in the public toilets until hordes of flies covered him. In this way, he shamed the authorities into cleaning up the toilets. The courage required to transgress public decorum, sanitation, and the Chinese government, in a generation of young Chinese artists that the government often jailed as unpatriotic for protesting human rights violations, is quite extraordinary. But it also put the artist in bodily and legal jeopardy.

Though there is no direct influence, Zhang Huan's risk bears *resonance* with that of Ezekiel. In fact, Ezekiel's public soon became hostile to his symbolic actions and demanded to know what he was doing. Not unlike the Chinese government's accusation against Zhang Huan, Ezekiel's public accused him of being unpatriotic for thus criticizing his people. To which Yahweh provided instructions for Ezekiel's self-defense:

> In the morning, the word of the Lord came to me: "Son of man, has not the house of Israel, the rebellious house, said to you, 'What are you doing?' Say to them, 'Thus says the Lord God: This oracle concerns the prince in Jerusalem and all the house of Israel who are in it.' Say, 'I am a sign for you: as I have done, so shall it be done to them'.
>
> *(Ez 12:8–10)*

Undoubtedly, each prophet and artist must decide for themselves what constitutes valid symbolic action and what is defilement. And undoubtedly, each audience will have to do the same. But for my money, this last passage offers a way of thinking that provides helpful criteria. Yahweh's answer to the public's question, "What are you doing?" is answered by the phrase, "Say, 'I am a sign for you'." This is an act of separating one's social, personal self from one's prophetic, performative self. Schneidau argues in his chapter, "In Praise of Alienation," that the prophet must create a self-alienation from society in order to act prophetically. To say, "I am a sign for you," is to enter into a "set-apart" status. Whether in an ancient theocracy or a modern democracy and whether as a religious prophet or a contemporary performance artist, a set-apart status becomes an "office," an agency under the auspices of which the person-as-sign may depart (transcend?) from decorum of the person-as-citizen in order to expose contradictions between spiritual/ethical values and political corruptions undertaken in the name of spiritual values.

This idea of making oneself into a sign also assists in the question of whether a finding of resonances across centuries, across diverse cultures, across theocracies and democracies, and across disciplines from theology to art exists as a valid territory. This idea serves as a valid bridge across those chasms of context. Israel had no context of "Art," and yet, it had a creative context of expression. For Israel, "prophet" was the counterpart of what "Artist" is for contemporary society.

This also felt substantiated by another element that felt universal, namely, the use of symbolic objects. Despite a lack of common narratives or direct influence between these cultures, there is a common use of symbols and elements that transcend "ancient" and "modern." These are symbols of human dignity (bread, oil, wine, labor) and human processes (eating, sex, cleanliness, excrement, death).

Most significantly, what encourages comparison is the resonance of a similar or shared strategy by both prophet and artist, that is, the use of such elements to symbolically inflict upon themselves the present conditions of their culture and the sufferings, punishments, or humilities resulting from the culture's policies and practices. These are borne in their own persons first, and in that strategy of proclamation-cum-scapegoat, they simultaneously bear and impute responsibility for their culture's corruptions and judgment onto viewers who now find it more difficult to remain passive onlookers. The moral force of the performance is to imply that we, the viewers, have the power to alter social direction, ethical and spiritual contradictions, and political policy. The final reality, however, is that neither life nor art is ultimately safe, and the perennial roiling of sacred discontent runs deep in our beings.

## Notes

1 An earlier version of this essay was previously published as: "The Avant-Garde and Sacred Discontent: When Contemporary Performance Artists Meet Jewish Prophets," *Image, A Journal of the Arts and Religion*, Issue #83 (December 2014), 23-32. I want to thank *Image* for permission to publish this revised version with Routledge Press.
2 See *Jeremiah*, especially chapters 18, 20, 36–52, for the complex narrative of Jeremiah's interaction with political power through prophetic text and a series of symbolic actions.

## Bibliography

Ann Hamilton Studio. https://www.annhamiltonstudio.com>malediction and https://www.annhamiltonstudio.com/projects/malediction.html.

Bal, Mieke. "Temporal Turbulence, in Praise of Anachronism." *The Persistence of Melancholia in Arts and Culture.* Routledge, 2019.

Belting, Hans. *Likeness and Presence, A History of the Image Before the Era of Art.* University of Chicago Press, 1994.

*The Bible*, Revised Standard Translation.

Brockes, Emma. An Interview with Marina Abramovic on the personal costs of making performance art. https://www.theguardian.com/artanddesign/2014/may/12/marina-abramovic-ready-to-die-serpentine-gallery-512-hours.

Elkins, James. *Pictures and Tears*, Routledge, 2001.

Freedberg, David. *The Power of Images, Studies in the History and Theory of Response*. University of Chicago Press, 1989.

Greenberg, Clement. "Avant-Garde and Kitsch." *Art and Culture*. Beacon Press, 1961, 3–21.

Hoptman, Laura, Akira Tatehata, and Udo Kulturemann, editors. *Yayoi Kusama*. Phaidon Press Ldt., 2000 (reprinted 2001).

Kuspit, Donald. *Chris Burden: Beyond the Limits*. Cantz, 1996.

Lescaze, Zoë. "Have We Finally Caught Up with Andrea Fraser?" *New York Times Style Magazine*, December 3, 2019; Updated December 4, 2019. https://www.nytimes.com/2019/12/03/t-magazine/andrea-fraser.html.

Opie, Catherine. *Self-Portrait/Cutting* (1993). https://whitney.org/collection/works/8990.

Schneidau, Herbert N. *Sacred Discontent, The Bible and Western Tradition*. University of California Press, 1976.

Zhang Huan. https://www.artsy.net/artwork/zhang-huan-12-square-meters.

# 13

# REVISITING "ART IN THE DARK"

## Thomas McEvilley, Performance Art, and the End(s) of Shamanism

*Karen Gonzalez Rice*

In 1983, Thomas McEvilley's essay "Art in the Dark" appeared in *Artforum* as the first theory of performance art to explore the medium's origins, function, and significance in terms of religion (62–71).[1] In this wide-ranging consideration of the state of performance art, he examined the relationships among performance actions and myriad religious rituals, including Buddhism and mindfulness, Roman sacrificial acts such as *taurobolium*, Transubstantiation in the Catholic tradition, and the focus of my analysis, shamanism. McEvilley argued that performance artists act as shamans, communities' designated transgressors of traditional boundaries. He wrote,

> Both art and religion, through the bracketing of their activities in the half-light of ritual appropriationism, provide zones where deliberate inversions of social custom can transpire; acts repressed in the public morality may surface there, simultaneously set loose for their power to balance and complete the sense of life, and held safely in check by the shadow reality of the arena they occur in.
>
> *(McEvilley, "Art in the Dark" 67)*

From Günter Brus to Kim Jones, McEvilley examined the relationships among performance actions and shamanistic practices, such as calling on "power animals," ritualized behavior he called "female imitation," and more. By identifying these and other performance practices as shamanic, McEvilley resisted sensationalizing these difficult artworks. Instead, in this essay, he advocated for the significance of performance art within the canon of art history, and insisted that it demands thoughtful and sympathetic audiences and that it exists within a larger context of cultural history, specifically the history of religions: "In order to understand the wellsprings of such works, in order to approach them with a

DOI: 10.4324/9781003326809-16

degree of sympathy and clarity, it is necessary to frame them somewhat in cultural history, where in fact they have a clear context" ("Art in the Dark," 66). This framework for understanding performance art as shamanism contributed to several pervasive ideas about performance art to art world discourses and demonstrated one powerful approach to contemporary art and religion.

This chapter revisits this influential essay to acknowledge McEvilley's innovative, important work and simultaneously to call for the end of shamanism and other generalized religious references within performance art discourses. The concept of shamanism has a long and complicated history within scholarly discourse, and McEvilley rooted his work in the work of a key figure, Mircea Eliade, whose universalizing theory of shamanism has been criticized for its etic approach and deliberate decontextualization of non-Western religious practices. In this chapter, I situate McEvilley's theory of performance as shamanism within the context of American intellectual history and religious history in the 1970s and early 1980s. I trace McEvilley's mobilization of Eliade's brand of shamanism in this essay and in his scholarly publications in philosophy, his use of images in the essay as a supplementary narrative, and the changing landscape of shamanism in scholarship and mainstream American culture in the 1970s and 1980s.

McEvilley's art criticism took shape alongside and intertwined with his scholarly writings in the early 1980s. Although now best known for his art criticism, McEvilley was a scholar of philology and philosophy (Cotter). He earned his PhD in classical philology through the study of Greek, Latin, and Sanskrit, as well as the philosophy of ancient Greece and India. As a lecturer at Rice University from 1969 to his retirement in 2008, he taught courses on Greek and Indian philosophy and the history of religions while commuting between New York and Houston. In the early 1980s, McEvilley began writing art criticism as a contributing editor of *Artforum* while also actively publishing in his scholarly area of expertise. McEvilley was particularly active between 1980 and 1982, when he produced a series of scholarly articles comparing the classical philosophies of India and Greece, including "Plotinus and Vijñānavāda Buddhism" (181–193), "Early Greek Philosophy and Mādhyamika" (141–164), and "Pyrrhonism and Mādhyamika" (3–35), as well as "An Archaeology of Yoga" (44–77), which focused on shamanic lineages of yoga in India. During this same period in *Artforum*, McEvilley wrote on subjects including James Lee Byars, Eric Orr, and Yves Klein, as well as a piece on the classical Greek figure Diogenes of Sinope in the context of contemporary artistic practices. In these early *Artforum* texts, he was developing his signature, wide-ranging approach to writing about art, and practicing bringing together his knowledge of philosophies and philology, his methodological approach to the history of religions, and his familiarity with contemporary art. Reading McEvilley's early writings on art in the context of his work on Greek and Indian philosophy reveals significant parallels, overlaps, and borrowings.

"Art in the Dark," which appeared in 1983, made these foundations of his critical style particularly visible. For art audiences, McEvilley's ideas and footnotes

appeared eclectic and surprising. However, this essay was built on, referenced, and even directly quoted his own scholarly research. His art criticism directly incorporated methodologies and examples from philology, the history of religions, and the comparison of Indo-European philosophies. All of these disciplines played a role in "Art in the Dark," which can be divided into four sections. Throughout the essay, McEvilley engaged concepts from the history of religions and examples of diverse religious practices. In the first section, McEvilley offered an extensive linguistic examination, drawing from his background in philology, of how conceptual and performance art universalized the term "art" ("Art in the Dark" 62–65). He then used examples from Greek and Indian religion to interpret the Nietzschean binary between Apollonian and Dionysian in performance art ("Art in the Dark" 65). In the third section of the essay, he focused on interpreting difficult or shocking performances in terms of shamanism ("Art in the Dark" 65–69). The final pages of "Art in the Dark" explored discipline and decision-making in endurance art (67–70). These last two perspectives on performance art – the framework of shamanism and the discussion of discipline – were the most novel of his ideas about performance and continue to appear in discourses about performance art into the present. In this chapter, I focus on McEvilley's use of shamanism as an organizing structure for understanding performance art.[2]

In "Art and the Dark," McEvilley argued that the performance actions that audiences found most challenging could be understood in terms of the primary forms and functions of shamanism. Shamans, he argued,

> …were the individuals who went out on the razor's edge and, protected in part by the brackets of religious performance, publicly breached the taboos of their times. Today the exhibitionistic breaching of age and gender taboos, as well as other forays into the darkness of the disallowed within the brackets of the art performance, replicates this ancient custom, sometimes with the same cathartic intention.
>
> (65)[3]

In doing so, he insisted on the seriousness of these forms of art:

> It is the work based on the shamanic ordeal that the art audience has found most difficult and repellent. Clearly that is part of the intention of the work, and in fact a part of its proper content. But it is important to make clear that these artists have an earnest desire to communicate, rather than simply shock. Seen in an adequate context, their work is not aggression but expression.
>
> ("Art in the Dark" 65–66)

For McEvilley, the transgressive actions of the Viennese Aktion artists served as exemplars of this serious, challenging work. He highlighted three elements of

what he called "Paleolithic" shamanism in the works of Günter Brus, Rudolf
Schwartzkogler, and Hermann Nitsch: taboo actions including self-injury, what
he called "female imitation," and the public performance of transgressive acts.
He described the taboo actions of the Viennese Aktion artists:

> Brus, during his performing period (1964–1970), would appear in the per-
> formance space dressed in a woman's black stockings, brassiere, and garter
> belt, slash himself with scissors till he ran with blood, and perform various
> acts ordinarily taboo in public settings, such as shitting, eating his own
> shit, vomiting, and so on. Schwarzkogler's pieces presented young males
> as mutilated sacrificial victims, often wounded in the genitals, lying fetally
> contracted and partially mummy-wrapped as if comatose, in the midst of
> paraphernalia of violent death such as bullet cartridges and electrical wires.
> Not only the individual elements of these works, but their patterns of com-
> bination – specifically the combination of female imitation, self-injury,
> and the seeking of dishonor through the performance of taboo acts – find
> striking homologies in shamanic activities.
>
> *("Art in the Dark" 66)*

McEvilley's emphasis on these artists was reiterated visually: three images of
Brus performances appeared on the second page of the article, taking up one of
the three columns on the page, and one full page is devoted to an illustration
of a Schwartzkogler action.[4] For McEvilley, these artists embodied the shaman-
istic trend that he also located in American performance art of the 1970s, par-
ticularly in the work of Paul McCarthy. The perspectives on shamanism that
McEvilley advanced in "Art in the Dark" were deeply rooted historian of reli-
gion Mircea Eliade's theory of shamanism and influenced by the proliferation of
new approaches to shamanism in the 1970s and early 1980s.

Western scholars have been enchanted by their invention of the concept of
shamanism since the 18th century.[5] While approaches to studying shamanism
have changed over the centuries, the essential discourse relies on encounters
among Westerners and practitioners of nature religions from communities in
Siberia to Tibet to North America, which produced regional "evidence" of
behaviors and beliefs that seemed bizarre, primitive, spectacular, and possibly
insane. For scholars in history, anthropology, archeology, literature, and later
psychology and the history of religions, shamanism has served as both an Other
against which Westerners differentiated themselves and an opportunity to appro-
priate and play with a titillating identity.[6]

McEvilley based much of his scholarly work and his art criticism in the early
1980s on Mircea Eliade's *Shamanism: Techniques of Ecstasy* published in 1964. As
a scholar of the history of religions, Eliade in this text sought to decontextu-
alize shamanic practices from their historical and cultural contexts in order to
identify a set of universal characteristics of shamanism. He brought together the
accounts of nineteenth- and early 20th-century Western travelers, ethnologists,

and anthropologists who encountered the practice of nature religions in diverse areas including Siberia, Australia, South America, Africa, Indonesia, and more. He organized these Western observations on non-Western nature religions thematically, discussing cross-cultural cosmology, for example, and the symbolism of clothing, without regard for the particularities of place, economics, history, or emic interpretations or experiences. Instead, he was interested in mining present-day "archaic societies" for ancient religious ideas and practices that had survived from the Paleolithic period. He noted, "It is almost certain that at least a part of prelithic humanity's magico-religious beliefs were preserved in later religious conceptions and mythologies," while also acknowledging that these remnants do not represent unchanged, "pure" aspects of Paleolithic religion (11).

Eliade's conflation of a temporal designation ("archaic") with geographical communities of people in his own present (Siberians, for example) was rooted in colonialism and has been criticized and rejected by many scholars (e.g., Kehoe 377–392). Despite this disconnect with disciplinary trends since the 1990s, Eliade's phenomenological approach has remained influential into the 21st century; "it has been the popular success of Eliade's book that has gradually imposed it as a reference on anyone who writes on shamanism" (Hamayon 145). Scholars continue to study shamanism as a globalized, decontextualized phenomenon, while also continuing to explore and reference his endnotes, which compiled hundreds of details about disparate shamanic practices from around the world. In particular, his set of universal shamanic characteristics remains central to the study of shamanism for scholarly and mainstream audiences. These include ecstasy, or an altered state of consciousness, which he understood as a direct connection with the sacred; shamanic ascent or flight; and symbolism for the *axis mundi* or center of the world, such as a tree or drum; and many more.

In the early 1980s, McEvilley's writings were steeped in shamanism as theorized by Eliade. Both McEvilley's scholarly articles "An Archaeology of Yoga," which argued that yoga emerged from shamanic practices, and "Art in the Dark" in *Artforum*, which identified performance artists as contemporary shamans, relied on Eliade's approach. While both texts do reference *Shamanism* in footnotes, the extent of Eliade's influence on McEvilley (and indeed, on most scholars of shamanism) may not necessarily be obvious to readers outside of religious studies. McEvilley's interest in the transgressive aspects of shamans may obscure these references. Further complicating matters, McEvilley drew directly on his article "An Archaeology of Yoga" in drafting "Art in the Dark," so the two texts are related, sharing citations and sections of text. In other words, during this period the theoretical and methodological foundations of McEvilley's scholarly work, including its grounding in Eliade, migrated into his art criticism to a startling degree. To clarify the relationships among McEvilley's two articles and Eliade, here I detail a few examples of the basic tenets of Eliade's shamanism that appeared in both texts.

At a foundational level, in both texts, McEvilley assumed Eliade's definition of shamanism as a universal concept and mimicked his cross-cultural methodology.

Both texts compared evidence from disparate geographic regions, cultures, and times, often based on references to 18th- and 19th-century primary sources from the notes in Eliade's *Shamanism*.[7] McEvilley also followed Eliade in defining multiple cultural roles and social functions of the shaman. Eliade wrote that "of course, the shaman is...a magician and a medicine man...he is a psychopomp, and he may also be priest, mystic, and poet" (4). McEvilley echoed this language: "The poets, mythographers, visual artists, musicians, medical doctors, psychotherapists, scientists, sorcerers, undertakers, psychopomps, and priests of their tribal groups, they have been one-person cultural establishments" ("Art in the Dark" 66). In both pieces, McEvilley referred to flight, which in Eliade's view was a foundational activity of the shaman. "An Archaeology of Yoga" directly cited Eliade on shamanic ascent, including flight and climbing ladders, while "Art in the Dark" presented the idea of ascent in performance art through images only (McEvilley, "An Archeology of Yoga" 68, 70). The last three images of the essay depicted photographs of performances viewed from below: Piero Manzoni standing on a high pedestal, Bill Harding on a tall stool, and Kim Jones climbing a telephone pole. Together, these images were allotted the equivalent of one full page across the last two pages of the essay, with two images extending over one column and one more filling two columns.[8] The importance of Eliade to McEvilley's thought cannot be overestimated.

However, McEvilley's work on shamanism differed from Eliade's in foregrounding transgressive actions, particularly taboos of gender and sexuality, and violence. These themes do appear in Eliade, especially in the extensive footnotes, but McEvilley stressed the dangerous, obscure, and confrontational aspects of shamans' activities. He marked this shift of attention in the first paragraph of "Art in the Dark" when he wrote that performance art "flowed into the darkness beyond its traditional boundaries" (2). In addition, all three of the key characteristics of "Paleolithic" shamanism that McEvilley identified in performance art – "self-mutilation, female imitation, and the performance of taboo acts" – pivoted on transgression ("Art in the Dark" 66). In "An Archaeology of Yoga," too, he was concerned with transgression, excavating ancient yogic sexual practices "buried...beneath a veil of celibate ethics" (65). This preoccupation with edgy content revealed the ways in which McEvilley's work was influenced by his own intellectual milieu, particularly psychoanalysis and the counterculture, which shaped academic and mainstream ideas about shamanism in the 1970s and early 1980s.

Most psychoanalytic perspectives on shamanism in the early and mid-20th century were fixed on the psychopathology of shamans (Boekhoven 173–178). Against Eliade, who from his earliest work on shamanism in the 1950s, deliberately rejected pathologizing shamans, anthropologist Claude Lévi-Strauss interpreted shamanism as a collective "fabulation" shared by shamans and their communities (Boekhoven 91–92). He compared the function and significance of shamanism to psychoanalysis and also theorized that shamans themselves displayed various pathologies (Throop and Dornan 213). Lévi-Strauss's view of shamanism

and mental instability was adopted by art critic Jack Burnham. Inspired by artist Joseph Beuys, who discussed shamanism in interviews throughout the 1970s, Burnham published a series of pieces in *Arts Magazine* in the early 1970s about contemporary art, shamanism, and ritual, including a review of Dennis Oppenheim's sculptural, conceptual, and performance work entitled "Artist as Shaman" (42–44). Historian of shamanism Grace Flaherty has noted that the 1970s saw an increase in articles about shamanism within the arts and that "among the most fashionable, yet least informed were those by Jack Burnham" (521n5). Collected in the volume *Great Western Salt Works: Essays on the Meaning of Post-Formalist Art*, Burnham's musings connected shamanism with "psychoneurosis," compulsion, obsessiveness, "mental instabilities," and (in a strange turn) "physical deformities" ("Artist as Shaman" 42). In this, Burnham followed Lévi-Strauss and Andreas Lommel, whose book *Shamanism: The Beginnings of Art* (cited in Burnham "Artist as Shaman," 44), as described by art historian Robert J. Wallis, "introduced a new trope of the shaman into the interpretation of cave art and the artist-shaman more broadly, that of the psychotic, mentally ill shaman or suffering visionary artist" ("Art and Shamanism" 13). This approach may explain why Oppenheim, when confronted with this interpretation when interviewed by Burnham, expressed "considerable uneasiness in discussing some works" (Burnham, "Artist as Shaman" 43). Burnham's views seem to have reverberated through the art world. McEvilley took on aspects of Burnham's approach in "Art in the Dark" when he noted that shamans were considered "independent, uncontrollable, and eccentric power figures whose careers have often originated in psychotic episodes – what anthropologists call the 'sickness vocation'" (66). Even feminist art critic Lucy Lippard relied heavily on ideas from Burnham's *Great Western Salt Works* in her own book, *Overlay: Contemporary Art and the Art of Prehistory*, published in 1983, the same year as "Art in the Dark."[9] McEvilley's analysis of shamanistic performance art in terms of transgression corresponded directly to this intellectual context.

In both "An Archaeology of Yoga" and "Art in the Dark," McEvilley brought these 1970s psychoanalytic perspectives together with foundational observational data compiled by Eliade in *Shamanism*. In "Art in the Dark," McEvilley directly addressed self-harming performance actions and advocated for taking these artworks seriously by linking them to shamanism: "Perhaps the most shocking element in the various performance works mentioned here is the practice of self-injury and self-mutilation. This has, however, been a standard feature of shamanic performances and primitive initiation rites around the world" (66). He then described examples of cutting behaviors from Siberia and Tibet, citing sources listed in the footnotes of Eliade's *Shamanism*, and compared these actions to performances in which artists including Chris Burden, Dennis Oppenheim, Linda Montano, and Stelarc were sliced or pierced with glass, rocks, needles, or hooks. When Eliade did address violence in shamanhood – as evinced by the practices cited by McEvilley – his work focused on the role of injury and spiritual surgery in shamanic initiation rather than self-directed harm. For example:

"Dream, sickness, or initiation ceremony, the central element is always the same: death and symbolic resurrection of the neophyte, involving a cutting up of the body performed in various ways (dismemberment, gashing, opening the abdomen, etc.)" (56). McEvilley also mobilized psychoanalytic perspectives to make sense of another aspect of performance art, which he called "female imitation," and described in "Art in the Dark" as "a standard shamanic and initiatory motif, involving sympathetic magic. Male shamans and priests around the world, as well as tribal boys at their puberty initiations, adopt female dress to incorporate the female and her powers" (66). McEvilley offered performance examples including the Viennese Aktion artists, Paul McCarthy, and Kim Jones ("Art in the Dark" 66).[10] This aspect of McEvilley's performance theory does not hold up to 21st-century audiences, who may cringe at the pathologizing of non-binary gender identities (rooted in psychoanalytic interpretations) and the assumption of male shamanhood expressed here.

McEvilley first developed his ideas about female imitation in "An Archaeology of Yoga" (71–72nn197–199), later importing paraphrased sections into "Art in the Dark" (66nn22–24) including the similar wording and exact citations in both articles. In this instance, McEvilley's research directly informed his art criticism. The argument advanced in "An Archaeology of Yoga" pivoted on identifying the gender of a possibly yogic figure on an Indus Valley seal based on visual markers of anatomy and clothing. Eliade had addressed the concept of "shamanic transvestitism" in *Shamanism* (257–258n132), and McEvilley included several citations of Eliade's original sources on this topic, including descriptions of Chukchee practices in Siberia ("An Archaeology of Yoga" 71n198; reiterated in "Art in the Dark" 71n23). However, his analysis was driven by *The Mothers*, published in 1952 by surgeon/social anthropologist Robert Briffault: he observed, "Briffault has demonstrated with a huge collection of instances that 'the adoption of female dress by male shamans and priests is a worldwide phenomenon'" ("An Archaeology of Yoga" 71; "Art in the Dark" 71n22). McEvilley went on to offer several decontextualized examples, including indigenous Australian practices ("An Archaeology of Yoga" 64n140; "Art in the Dark" 67, 71n27). All of these references also appear in "Art in the Dark," with the addition of the psychoanalytic work of Bruce Bettleheim, whose research with "disturbed children" informed McEvilley's analysis of performance actions that combined "female imitation and self-mutilation" ("Art in the Dark" 71n17, 71n25). This use of psychoanalysis to explain disturbing aspects of 1970s performance art overlooked the influence of feminist performance strategies and discounted the role of historical trauma such as the Vietnam War and trauma within artist biographies (see Gonzalez Rice; Stiles).

Overlapping with psychoanalytic approaches and the foundation of Eliade's *Shamanism*, "Art in the Dark" reflected anti-establishment sentiments, psychedelic experimentation, and a DIY approach to practicing shamanism, all corresponded to prevailing concepts of shamanism in the early 1980s. The counterculture of the 1960s and 1970s had drastically reshaped the academic study

of shamanism and its communication to a mainstream audience. The distrust of authority that characterized the 1960s made the shaman an appealing figure set against mainstream religious organizations. For counterculture historian Theodore Roszak, writing in his influential book *The Making of a Counterculture* (1969), shamanism represented a challenge to the oppressive structures of mainstream religion (Boekhoven 166–167). At the same time, many academics, skeptical of traditions and institutions, began to experiment with new methodologies. Influenced by the psychedelic counterculture and an academic interest in drugs as a means of achieving altered states of consciousness, anthropologists such as Carlos Castaneda and Michael Harner used methods of experiential anthropology to personally explore hallucinogenic shamanism (Boekhoven 203–223). McEvilley addressed both of these anti-institutional perspectives in "Art in the Dark." He wrote,

> Religious structures in our society allow no setting open enough or free enough to equate with that of ancient Greek religion…[P]lacing such contents within the art realm allows…free access that the category of religion, with its weight of institutionalized beliefs, does not allow… That this was the age of psychedelic drugs, and that psychedelic drugs were widely presumed to do the same thing, is not unimportant.
>
> *(65)*[11]

McEvilley's basic premise in "Art in the Dark" – the exploration of contemporary artists as shamans – resonated with the practical shamanism of anthropologist-turned-shaman Michael Harner. In the 1970s, Harner developed an approach to shamanistic practice that he called "core shamanism," and presented and elaborated in the popular book *The Way of the Shaman*. Like Eliade, Harner emphasized the similarities in shamanistic practices across cultures, removing the specifics of history, culture, and context to reveal a set of common or "core" practices.[12] Since the 1970s, his courses and workshops trained (mostly White) shamans all over the world, and his work contributed to the rise of the New Age movement in the 1980s and 1990s.[13] Scholars in the 21st century use the term "Neo-Shamanism" to describe these and other current practices of shamanism to distinguish it as a contemporary phenomenon. McEvilley's conceit that performance artists took on shamanistic actions and significance followed Harner's instantiation of shamanism in the present. "Art in the Dark" also contained uncited references to Harner's ideas, as in the use of the term "power animal," for example. McEvilley wrote, "Shamans in general adopt the identities of their power animals, act out their movements, and duplicate their sounds….Echoes of the practice are, of course, common in the annals of performance art" including the art of Joseph Beuys, Linda Montano, Terry Fox, and others (69). Eliade discussed talking with animals as a shamanistic practice, and McEvilley refers to those 19th-century sources in his footnotes ("Art in the Dark" 71n33). But it was Harner who guided would-be shamans to choose a "power animal," devoting an entire chapter in *The Way of the Shaman* to a detailed

process of seeking one (57–72). This interest in the power animal is also related to the impact of environmentalism on shamanism in the 1970s. For many White environmentalists of the time, experimenting with the practice of shamanism nat urally resulted from participating in broad earth-based practices and philosophies including organic gardening, natural foods, and Earth Day celebrations, and from White curiosity about Native American nature-based spiritualities, which were considered countercultural in their emphasis on social values and spirituality. With the popularity of core shamanism and other guides to becoming a shaman, many Native Americans have challenged the adoption of indigenous religious practices by non-natives.[14]

In its association with the counterculture, during the 1970s the shaman became a mainstream symbol of wisdom and spiritual redemption. Mass media discussions increasingly applied the term "shaman" to figures in the arts who seemed to represent the most authentic, charismatic figures existing outside of mainstream social and cultural structures (Boekhoven 219, Znamenski 364–365). Boekhoven highlights this point by quoting Roszak: "Indeed, the shaman might properly lay claim to being the culture hero *par excellence*" (Boekhoven 166–167). By locating performance art within the shamanistic tradition, McEvilley extended this heroic identity to performance artists. "Art in the Dark" advocated for difficult performance art and for charismatic performance artists at a crucial moment in the history of the medium. By framing performance art in the context of shamanism, McEvilley sought to secure its place in art history, connect it to deep histories of culture and humanity, and insist on its capacity to move, change, and teach us. As a form of shamanism, he claimed, performance art demands that we look beyond our knee-jerk reactions to confrontation and taboo, that we look with sympathetic, open attention, and that we sustain engagement with the deep questions that it raises. This text was the first serious attempt to address performance art in terms of religion, and its dense, thoughtful array of references, performance descriptions, citations, and visuals calls on us, as readers and audiences, to respond to these human actions with empathetic curiosity and an awareness of deep connection. In addition, in "Art in the Dark," McEvilley observed a set of unique characteristics of performance art. He theorized a structure for identifying how disparate performance art actions could share similar forms, content, and strategies. He discussed performance content that continues to challenge audiences: transgressive sexuality, self-harm, taboo actions, transgender and non-binary explorations of gender, and more. Performance artists, performance scholars, and art critics continue to engage with all of these currents within performance art.

However, the essential tension in "Art in the Dark" is McEvilley's universalizing approach to shamanism, which strips practitioners of nature religions of their historical and cultural contexts, versus the extremely individual character of performance art. He wrote, "As the shoals of history break and flow and reassemble, to break and flow again, these and other primitive practices have resurfaced, in something like their original combination, in an altogether different context"

("Art in the Dark" 67). Rather than a metaphorical or comparative relationship with religions, the real conditions of religious history in the 1960s and 1970s – foundational decades in the development of performance art history – shaped artists' performance strategies and the critical reception of their performance artworks, including "Art in the Dark." As the art actions of intersectional, contradictory humans, performance art insists on specificity, biography, and historical context. McEvilley's adherence to shamanism as a universal concept obscured the specific historical conditions that focused his attention on particular artists and led to his emphasis on White, male artists. With his attention to psychoanalysis, he missed the role of traumatic historical contexts and personal histories directly relevant to the significance of art actions and overlooked the powerful role of feminism in the strategies he studied and skipped over the richness of contemporary histories in favor of the hazy philosophies of diverse ancients. Robert Wallis has written that "each new generation reinvents the shaman-artist for themselves" ("Art and Shamanism" 17). Perhaps, in the 21st century, it is time to retire the metaphorical figure of the shaman, to bring an end to this figure constructed of and for the Western imagination, and to root our research, instead, in the lived experiences, biographies, and micro-histories of our present contexts, in all of their inelegant, messy abundance and complexity.

## Notes

1  Also available in Warr and Jones (222–227).
2  I explore his analysis of endurance art and decision-making in a future article on performance, discipline, and monasticism.
3  For an analysis of shamanism as performance, see Flaherty (519–539).
4  These images included Günter Brus, *Head Painting* (1964), and two views of *Paint Action* (1964–5) and Rudolph Schwartzkogler, *Action 2* (1965).
5  See Flaherty (519–539), also Znamenski. Put succinctly, "shamans were a hot topic during the enlightenment" (Wallis "Art and Shamanism," 7).
6  For discussion of the latter, see Znamenski.
7  These early sources are collected in Narby and Huxley.
8  These images included Piero Manzoni, *Magic Base* (1961), and Bill Harding, *Three Stages to Stability* (1980) on p. 70 and Kim Jones, *Telephone Pole* (1978) on p. 71.
9  Art historian Jennie Klein has noted that West Coast feminists had access to the archaeologist and linguist Marija Gimbutas, who studied Neolithic religious traditions and provided a more nuanced perspective of gender in ancient societies (575–602).
10  McEvilley's perspective on "female imitation" overlooks the context of feminism in 1970s West Coast performance art. Both Paul McCarthy and John Duncan explored feminist performance strategies in their own art actions, including consciousness-raising and extreme enactments of the consequences of gender conditioning. On Duncan and feminism, see Gonzalez Rice. For McCarthy, see Stiles' interview with McCarthy in Stiles, et al.
11  McEvilley, or indeed any history of religion scholar studying shamanism during this time, appeared unaware of Pentecostalism and the charismatic turn in post-war American religion.
12  For more, see Bužeková (116–130).

13  For histories of Neo-Shamanism and perspectives on Whiteness in Neo-Shamanism, see "Shamans/Neo-Shamans" by Wallis.
14  For indigenous perspectives, see Kehoe (377–392) and Wallis "Altered States, Conflicting Cultures" (41–49).

## Bibliography

Boekhoven, Jeroen W. *Genealogies of Shamanism: Struggles for Power, Charisma and Authority.* Barkhuis, 2011.

Burnham, Jack. "Artist as Shaman." *Arts Magazine*, vol. 47, no. 9, May–June 1973, pp. 42–44.

———. *Great Western Salt Works: Essays on the Meaning of Post-Formalist Art.* Braziller, 1974.

Bužeková, Tatiana. "The Shaman's Journeys Between Emic and Etic." *Anthropological Journal of European Cultures*, vol. 19, no. 1, 2010, pp. 116–130.

Cotter, Holland. "Thomas McEvilley, Critic and Defender of Non-Western Art, Dies at 73" *The New York Times,* March 30, 2013. https://www.nytimes.com/2013/03/31/arts/thomas-mcevilley-critic-and-scholar-of-non-western-art-dies-at-73.html.

Eliade, Mircea. *Shamanism: Archaic Techniques of Ecstasy.* Princeton University Press, 1964.

Flaherty, Gloria. "The Performing Artist as the Shaman of Higher Civilization." *MLN*, vol. 103, no. 3, 1988, pp. 519–539.

Gonzalez Rice, Karen. *Long Suffering.* University of Michigan Press, 2016.

Hamayon, Robert. "History of the Study of Shamanism." *Shamanism: An Encyclopedia of World Beliefs, Practices, and Culture*, edited by Mariko Namba Walter and Eva Jane Neumann Friedman. Santa Barbara, CA, ABC-CLIO, 2004, p. 145.

Harner, Michael J. *The Way of the Shaman: A Guide to Power and Healing.* Harper & Row, 1980.

Kehoe, Alice B. "Eliade and Hultkrantz: The European Primitivism Tradition." *American Indian Quarterly*, vol. 20, no. 3/4, 1996, pp. 377–392. https://doi.org/10.2307/1185783.

Klein, Jennie. "Goddess: Feminist Art and Spirituality in the 1970s." *Feminist Studies,* vol. 35, no. 3, 2009, pp. 575–602.

Lévi-Strauss, Claude. *The Savage Mind.* University of Chicago Press, 1966.

Lippard, Lucy R. *Overlay: Contemporary Art and the Art of Prehistory.* Pantheon Books, 1983.

McEvilley, Thomas. "Plotinus and Vijnanavada Buddhism." *Philosophy East and West*, vol. 30, no. 2, April 1980, pp. 181–193. https://doi.org/10.2307/1398846.

———. "Early Greek Philosophy and Mādhyamika." *Philosophy East and West*, vol. 31, no. 2, April 1981, pp. 141–164.

———. "An Archaeology of Yoga." *Res: Anthropology and Aesthetics*, vol. 1, Spring 1981, pp. 44–77.

———. "Pyrrhonism and Mādhyamika." *Philosophy East and West*, vol. 32, no. 1, January 1982, pp. 3–35.

———. "Art in the Dark." *Artforum International,* vol. 21, no. 10, June 1, 1983, pp. 62–71.

Narby, Jeremy, and Francis Huxley. *Shamans through Time: 500 Years on the Path to Knowledge.* Thames & Hudson, 2001.

Roszak, Theodore. *The Making of a Counter Culture: Reflections on the Technocratic Society and Its Youthful Opposition.* Anchor Books, 1969.

Stiles, Kristine. *Concerning Consequences: Studies in Art, Destruction, and Trauma.* University of Chicago Press, 2016.

Stiles, Kristine, et al. *Paul McCarthy.* Phaidon Press, 2016.

Throop, Jason, C. and Jennifer L. Dornan. "Psychopathology and Shamanism." *Shamanism: An Encyclopedia of World Beliefs, Practices, and Culture*, edited by Mariko Namba Walter and Eva Jane Neumann Fridman, Santa Barbara, CA, ABC-CLIO, 2004, p. 213.

Wallis, Robert J. "Altered States, Conflicting Cultures: Shamans, Neo-Shamans and Academics." *Anthropology of Consciousness*, vol. 10, no. 2–3, 1999, pp. 41–49. https://doi.org/10.1525/ac.1999.10.2-3.41.

———. "Art and Shamanism: From Cave Painting to the White Cube." *Religions*, vol. 10, no. 1, 2019, p. 54. https://doi.org/10.3390/rel10010054.

———. *Shamans/Neo-Shamans: Ecstasy, Alternative Archaeologies and Contemporary Pagans.* Routledge, 2003.

Warr, Tracey, and Amelia Jones. *The Artist's Body.* Phaidon, 2000.

Znamenski, Andrei A. *The Beauty of the Primitive: Shamanism and the Western Imagination.* Oxford University Press, 2007.

# 14

# INFUSED WITH LIGHT

## Christian Traces in Multimedia Installation Art

*Jorge Sebastián Lozano[1]*

The fertile, but little acknowledged, intersection between contemporary art and Christian faith has light and multimedia installation art as one of its best examples. It might in fact be its best-known manifestation, thanks mostly to the extraordinary visibility reached by Bill Viola's dramatic yet subdued video installations that have received public applause over the last few decades. His case is by no means exceptional, as shown below in the heterogeneous but bold interrogations that many artists have been formulating in this regard. Interestingly enough, these creations have outgrown the rich but limited boundaries of the artworld and are reaching other fields, like the spectacular video mappings within and outside historical churches that are becoming a staple feature of religious festivals or large-scale public events. This chapter focuses on some aspects of this trend while acknowledging that they have been met with different degrees of institutional response and academic study.[2] It also tries to outline some of the theological issues inherent to wide-ranging concepts such as light or space, or to their interaction with modern immersive technologies.

In 1970, James Turrell, one of the most relevant artists in this regard, wrote:

> I sometimes feel I've found some things out, but they don't apply to anyone else unless they come to them in the same way… If either art or technology becomes a religion, maybe this stuff will start getting more exciting. There's got to be an Art and Technology Christ.
>
> *(qtd. in Crow 118)*

His statement incorporates the many tensions, ambiguities, and levels of meaning that are often found in these artists and their works. Disconcerting, peaceful, skeptical, strident, resolute, ironic, doubtful… the artistic approaches to

DOI: 10.4324/9781003326809-17

Christian faith or merely to spiritual beliefs are probably just as diverse as they usually are in contemporary society as a whole.

No claim to exhaustivity is made, of course. The selection of names and locations under study is very much determined by the author's own experience and circumstances, but there is little doubt that others could be added from other contexts. If these pages provide stimulus for further and better research, they will have accomplished their mission.

## Setting Up the Scene

The hopeless mission of trying to summarize Western notions about the relationships between art, light, and the Christian tradition must in any case begin with scriptural references. The equation between light and God is a recurring theme in the Old Testament, just like divine protection is usually indicated by the presence of light.[3] Jesus continues and deepens this tight relationship, presenting himself as the light of the world.[4] Among many other liturgical formulas, the Nicene Creed declares Christ to be Φῶς ἐκ Φωτός, *lumen de lúmine*, light from light.

Among Greek philosophers, Plotinus elaborated on what was going to be the most influential theory about the nature of light, linking it to God by way of emanation. The tension between light as a physical and a spiritual reality had already been present in Plato and Aristotle, but Plotinus, Pseudo-Dionysius, and the Neo-Platonists prevailed by interpreting light as both a substance and a quality or accident. The first is accessible only to the intellect, and the second only to the sense of sight. The image, its splendor, is therefore a reflection of the inner, substantial light, in typical Neo-Platonist fashion. These ideas, mixed with Judeo-Christian traditions, would later offer a basis for the medieval distinction between *lux* and *lumen*, as posited by many authors from Avicenna to Robert Grosseteste and beyond. The former was understood as the causal source of vision, singular and universal, while the latter was the physical, particular, multiple manifestation, its effect as seen by the eye. To these main two concepts, Saint Bonaventure added color and splendor, i.e., light as reflected by opaque bodies and as emitted by brilliant ones. Other authors, such as Grosseteste and Saint Thomas Aquinas, adopted a more metaphysical approach to light, thus following the path opened by Plotinus but moving away from it.[5] Thus, a mixture of sophisticated metaphysics, theology, and intuitive attempts at scientific observation characterizes the writings about light from this period. Its understanding as both a natural and supernatural presence lay always at the core of medieval aesthetics.[6]

Medieval art patrons and creators applied these ideas in countless contexts, seeing divine light substantiated in colorful stained glass, gleaming mosaics, shimmering gold vessels, and precious stones.[7] During these and the following centuries, the visual arts continued to explore many ways to convey divine interventions through enormously varying resources and light effects, both within

two-dimensional and three-dimensional settings: from Byzantine icons to van Eyck; from Titian to Bernini and Rembrandt. By the mid-18th century, however, this long tradition lost importance as light – *les lumières* – took on a new meaning, one that was exactly intended to oppose ideas about transcendence and spiritual realities, substituting God by Reason.[8]

In any case, as the examples below will show, light – understood as an appropriate bearer of Christian meaning – continues to be relevant for living artists. The use of video art and installations as a specific reference to materiality and its transcendental implications lends itself to suggestive speculations about their ultimate meaning, as sensuous signs of supersensible realities.[9] Most notably, immersive experiences are undergoing a chain of technological breakthroughs, based on cutting-edge digital media. The idea of all-encompassing environments, however, is millenniums old, and some of its best manifestations through the history of Western art correspond precisely to Christian temples. One needs only to think about the Baroque exaltation of the senses or the unified experience afforded by medieval liturgy, architecture, and music.

Light art has been another artistic language of choice for some of these artists. While this is by no means exceptional within the contemporary scene, such a choice adds a remarkably rich perspective to issues of form and content within their works. Again, visual or architectonic quotations from the past are hard to avoid, layering levels of historical reference within new works. The sacralization of space through light – be it natural or artificial – has offered stunning achievements in the form of domes, clerestories, stained glass windows, scenographic arrangements, and glittering coatings or trappings, among others.

Changes in the perception of space and the built environment are also highly relevant in this context. Since the early 2000s, indoor or outdoor video mappings have also become a common fixture in many festivals and artistic events. Multisensorial environments and immersive multimedia installations invite the participation of spectators. These elements attest to a strong interest in experiencing art in a more integral, bodily, and spiritual manner, akin to a mystical happening of self-oblivion. The spectators' engagement, their physical interaction with the work, makes the entire happening – not just any given set of objects – become the work of art. When such experiences happen within a public event, like a liturgical celebration or a music festival, they become an occasion of group communion, in addition to its other individual dimensions. Even the mystical can be a shared experience.

This move toward immersive experiences is made possible by the dissemination of audiovisual digital editing tools, and the increased availability of better projection technologies, too. Large-scale projections, often including a soundtrack, all too commonly lead to overpowering, spectacular setups, that blur even more the sometimes-fuzzy boundaries between art and entertainment. The global spread of the White Nights festivals is a clear example. Born in 1989–1990 in Helsinki and Nantes, the *Nuit Blanche* became a successful, worldwide model after Paris took up the idea in 2001. The concept itself – a night devoted to art

museums and galleries that remain open for late visitors, complemented by an outdoor art festival – easily lends itself to interventions that use light in creative and spectacular ways (Cianchetta 152–156). These are projected sometimes on the façades of existing buildings, in many cases interacting with historical environments, either religious or secular. It is also possible to find them within modern art exhibition spaces, where the white cube can serve as an aseptic container or as an adapted stage. The interior of historical churches, however, provides a most adequate environment, offering a dialogue on creativity and worldviews, both old and new.

Again, Paris provides a prime example. Its main center for contemporary culture, the Centre Pompidou in Beaubourg, sits right across Saint-Merri, an outstanding Gothic church that houses an active pastoral program involving music and contemporary visual arts. Not by chance, local clergy and community carry out a program featuring frequent artistic interventions. Since 2006, they invite international artists to participate in the *Nuit Blanche* with a site-specific installation in the church nave, as a part of the city's official program. Most of them have offered works based on video and light media, not a surprising choice for events that happen during the night.[10]

This field continues to develop and diversify in recent years, through events that cover the entire range from the experimental to the popular, from corporate sponsorship and advertising to grassroots movements, from the catechetical to the commercial. While the rest of this chapter deals with artists that work within the artworld scene – the one demarcated by art galleries and dealers, museums, academies, specialized criticism, journals, etc. – it is indeed a land of fuzzy borders, where technology and creativity become entangled through various channels and in unexpected ways. Religion adds further complexity, bringing into play art forms that approach spirituality through moving but ineffable ways. The awe-inspiring nature of some of these creations is not so distant from a Spanish 16th-century testimony about the room for the Eucharistic monstrance in El Escorial:

> On the inside, before the stained–glass window, one can draw silk veils, in different colors: green, blue, white, and red, in accordance with the liturgical feast. In the same way as sunlight passes through the glass and the veil, the entire room and the monstrance are bathed with that light, that produces an admirable effect of tremor and reverence, so that one shivers when, in the mornings, the red silk veil is hung, and everything looks like a ruby set alight.[11]

## Visibility and/or Understanding

As the following examples will show, allusions to religious and spiritual concerns are not at all absent from contemporary practice. In fact, some of the artists working around concepts of light, multimedia, and transcendence are hard to

miss in the contemporary scene. Bill Viola (b. 1951, New York) is treated else-where in this volume, but his public leading role in this context cannot be glossed over. Leaving aside the many references to a Christian narrative and visuality within his works, his knowledgeable exploration of video techniques and sup-ports is always an essential part of his practice. His continuing use of triptychs and polyptychs made up of high-definition video screens is a fully conscious reference to a centuries-long tradition of altarpiece paintings, the main loci for Christian — quite often, Catholic — imagery within churches. This is most suc-cessfully articulated in his pieces for Saint Paul's Cathedral in London, exploring classical themes in the history of that imagery — the Virgin Mary and the Christ child, or martyrdom — as seen through a palimpsest of other non–faith-specific references, like motherhood, or the four elements.[12] In this case, as in the case of Paris cited above, one can even find an urban dialogue between the temple and the museum: Saint Paul's and Tate Modern face each other from opposite sides of the Thames, as his interventions in the cathedral in 2004 and 2014 were accompanied by shows in the museum.

For many years, Viola has been quite exceptional in pursuing themes that strongly resonate with religious traditions: not only Christianity but also Zen Buddhism and Islamic Sufism. This has led to showing them predominantly in the ordinary scene of galleries and museums, but also in current places of worship and in former churches. His many temporary interventions range from the early pieces for Durham Cathedral (*The Messenger* and *The Crossing*) in 1996, to par-ticipation in the *Pause* event in Milan Cathedral (*Departing Angel* and *Emergence*, March and April 2004)[13], to his exhibition in Bern Cathedral in 2014, to a more recent retrospective in Cuenca (2018), where three pieces were shown within churches or former chapels, through a context-sensitive usage of screens or pro-jection devices. *Ocean without a shore*, his acclaimed participation in the 2007 Venice Biennale, was created as a site-specific work for the church of San Gallo. In the recesses behind three altars, plasma screens were installed, once more evoking altarpiece paintings. It is also typical of his layered, intricate approach to deep questions about the transcendent in human life: installed within a church, titled after verses from the Sufi mystic Ibn Arabi, intimating the inapprehensible connections to our dead ancestors through a stunning visual language of water curtains and cutting-edge technology. When dealing with larger spaces, pro-jection is the logical choice, one that also risks giving in to the spectacular for its own sake. A difficult balance is found, however, between the sheer natural elements so overwhelmingly displayed and the calm meditation that punctuates his entire oeuvre. Temporal and spatial dilation coexist in his works with high-end technology, turning a heightened sensory experience into a path toward transcendent realities.

Not an entirely different mindset is to be found within the work of Dan Flavin (1933–1996, New York). Its theological implications may have been ascer-tained through some overt yet ecliptic references in the titles for some of his pieces. It has been directly dealt with only in recent times, however, bringing

to light his continuing interest in overcoming the Catholic scholasticism of his early education (Louria-Hayon). Even by way of opposition, his early work was strongly grounded on theological categories, which led him to embrace a nominalist, radical immanence, yet still in search of the invisible. In his own words, "by making space and the on-looker visible, light, in a way, creates them."[14]

In this context, his scarce interest in placing his works within places of worship comes as no surprise. The only exception to that rule is worth noting, nonetheless.[15] In 1996, he was approached by an Italian priest, Giulio Greco, and invited to create a permanent fluorescent light installation as part of the renovation of the Santa Maria Annunciata in Chiesa Rossa church in Milan. Flavin prepared some sketches for the work but died shortly thereafter. Realized posthumously and opened the next year, it consists of a color gradation within the nave and transept, from green to blue, pink, golden, and ultraviolet light, echoing the natural "night-dawn-day" progression of light. While he rejected any symbolic or spiritual interpretation of his entire work (Govan), the seamless integration of fluorescent color lighting within the church space, the way in which it is always present yet made invisible, suggests a departure from his many other architectonic interventions. In many aspects, it anticipates the interventions from our next artist in a similar environment.

James Turrell (b. 1943, Los Angeles) deserves another important chapter within this narrative. Light occupies pride of place in his aesthetic thinking and his entire career, from the very early works in his first studio, the Mendota Hotel in Santa Monica (1966), to his four-decade involvement with a massive natural observatory in Roden Crater, Arizona. His "skyspaces" frame open skies within an architectural setting that, combined with artificial lighting, puts them into dialogue with the changing natural surroundings. With more than eighty commissioned for art galleries, private residences, or institutional environments, on a mere couple of occasions, he has installed them in new Quaker Meeting Houses. In fact, one of his first skyspaces was named "Meeting" (1986), just like Quaker gatherings.[16] Raised within this faith, he abandoned it for many years, but more recently has experienced a rekindled affinity toward it, described in loose terms that often mix personal memories and artistic interests. For instance, he often reminisces about going to a meeting for the first time, as a child, with his grandmother. Upon asking her about what they were going to do, her reply was "we are going inside to greet the light," something that provided the exact title for the second of those pieces, the one in Philadelphia (in Chestnut Hill Friends Meeting House, since 2013).[17]

Light does play an important role within Quaker spirituality, where it is usually seen as an inner light, one to be found with eyes shut, bent toward the inner soul. The tension between these theological tenets and the captivating visual experience created by his skyspaces is not easy to elucidate. Could an outward gaze become an invitation for an inner meditation? Can sensorial beauty be something deeper than an invitation for nonbelievers to join the quest for internal illumination? These questions touch upon some permanent issues in the

history of images and their spiritual role, and here as always, there are no easy answers. In the refurbished chapel of the Dorotheenstadt Lutheran Cemetery in Berlin (2015), he has pushed the expressive properties of changing artificial lighting to an entirely different degree, involving dramatic changes in color of the walls and the altar itself.[18]

At the same time, framing Turrell's creativity within a religious framework seems unjustified, whatever his past or current relationship to Quaker beliefs. While he makes no explicit denial or critique of such a theological background, his artistic intentions and interests are much more focused on human perception, within a clearly immanent approach. Talking about his skyscapes, he has often used the metaphor of "bringing the sky down" for the spectators, instead of the uplifting and transcendent perspectives that one could hope to find in his works.[19] His outright rejection of notions like symbolism and storytelling sets them in complete opposition to and distracting from the deepest meaning of light, understood as nothing more than a place for heightened human perception.[20] He explains:

> In looking at light that way, I have enjoyed the quality of truth in light. With this thought, I have come to make work that has no image, that has no object, that has no particular place of focus. So, without image, without object, without focus, what is there to look at? I think it's possible to look at your own looking, to see yourself see.
>
> *(James Turrell 62).*

Even more, his early mention of some hoped for "Art and Technology Christ" (quoted earlier in this chapter) is a fitting illustration of the ambivalence and difficulties that many contemporary artists find in connecting Christian faith and artistic practice. From that perspective, technology might come to be seen as an important means, but not enough to become transformative, while art could also fulfill a redeeming role. However, he seems to advocate a quasi-religious upgrading of art and technology, a savior that could spare both from their shortcomings and eventual futility. It is hard to determine exactly what to make of that comment, which might just as well signal sincere longing for transcendence or ironic detachment from it.

In any case, it is also hard to look at Turrell's scrutiny of light as merely immanent. Mysticism has always found resonance with interior and exterior contemplation. According to Jeffrey Kosky, the skyscapes parallel the movement often made by mystical theology. A light that is not directed toward something else but constitutes a revelation in itself becomes "a mysterious presence with an unnameable appeal that draws us into light without end" (Kosky 101). The fact that the artist explicitly disavows any theological connections does not make his works less contemplative, "just as the things we see as revelations in the mystical cosmos invite us to penetrate them more deeply as ways to unseeingly see the invisible" (Kosky 107).

The last and partly posthumous work from Ellsworth Kelly (1923–2015) provides an example of a relevant contemporary artist that resorts to Christian light symbolism, even if just as a historical framework for basic human needs. *Austin*, now a part of the Blanton Museum in Austin, Texas, was originally conceived in 1986 as a chapel for a collector's vineyard in California.[21] The artist abandoned the idea at that time since it was too important for him to be placed in a private property that could be sold and repurposed (Corbett).

Before his death, Kelly was able to develop for the Blanton and the University of Texas at Austin[22] the final project of the work, which was built and decorated during the next three years, according to the artist's detailed instructions (Figure 14.1). It is not a chapel, not even a non-denominational, one, but simply "a place of calm and light," somewhere to "go [...] and rest your eyes, rest your mind," in the artist's words ("Austin in Depth," chapter 1). Nevertheless, the resonance from French Romanesque architecture and stained glass windows is not just visually obvious, but also clearly proven by the many preparatory drawings Kelly made, and that now belongs to the Blanton Museum. During his extended stay in France during the 1940s and 1950s, he painted and drew from Romanesque churches and Eucharistic monstrances some of whose motifs directly fed into the designs for *Austin*'s three stained glass windows. The religious resonances

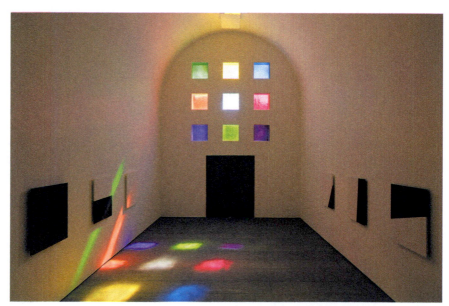

*Blanton Museum of Art, The University of Texas at Austin, photograph by Kate Russell ©Ellsworth Kelly Foundation, Courtesy Matthew Marks Gallery*

**FIGURE 14.1** Ellsworth Kelly, Austin, 2015. Artist-designed building with installation of colored glass windows, marble panels, and redwood totem, 18.3 × 22.25 × 8 m (60 × 73 × 26 ft 4 in).

of the building are further supported by an abstract set of the fourteen Stations of the Cross, made in black and white marble, again following his designs.

His determination in taking the project to completion, three decades after the original commission, speaks volumes about his attachment to it. However, he rejected offers from other institutional venues that were interested in him making an explicitly religious building, a chapel. The appeal of historical Catholic art for him seemed to be limited to its visual or technical aspects. He described himself as atheist or pantheist, believing only in nature, and always claimed that his abstract art is based on close attention to nature (Paltrow).

In this context, the interaction between light and color in its stained glass windows is *Austin*'s key element. Kelly laid great care in choosing the exact hues, having up to four sets of glasses sent to him from Munich, in order to ensure color consistency ("Austin in Depth," chapter 6). The changing direction and conditions of sunlight throughout the day and the year, and their impact on the interior of the building through the windows, play the leading role in the conception of the work, and the corresponding visitor's experience, making it such a successful work. Their geometric disposition takes up common themes of Kelly's previous oeuvre: color grids, and color spectrums, laid out in radial fashion – as in the rays flowing out from a monstrance – or in a circular shape, inspired, as he has stated, by the rose window on the North façade of the Cathedral of Notre-Dame de Chartres ("Austin in Depth," chapters 4 and 7).

The case of these major, global artists argues once and again for a spiritual, if not religious, reconsideration of their light and multimedia works, or at least an important part of them. However, hesitation and denial thereof – first of all, by the artists themselves – have averted articulate reflection and public commentary on this topic in contemporary art discourse (Elkins). Against this foundation, I turn to consider a diverse group of artists and artworks revolving around similar issues, within admittedly different environments and heterogeneous approaches.

## The Old and the New

The following cases demonstrate an unstable dialectic of contemporary artists with the powerful Christian spaces and images of bygone centuries, in this case, within the context of multimedia and light installations. Again, they attest to a continuing conversation with the past, with the question about creating art that is, in its own wavering way, heir to a great number of magnificent precedents. These artists' personal relationship to religions – specifically, to Christianity – varies broadly, as can be easily seen.

Rebecca Horn (b. 1944) works across a broad range of media and environments. Among her recent works, *Glowing Core* was installed in Palma de Mallorca in 2015 and in Berlin in 2018.[23] The precise location for the latter was Saint Hedwig's Cathedral, about to be closed for renovations. The work consisted of a complex interplay of large mirrors laying on the ground and golden cones

suspended from the ceiling, which created different perceptions when looking upward and downward from the center of the round building. In her own words,

> as an observer one is caught in this process of ascending and falling. The blue of the sky and the depth of the sea are suspended through the building. The vortices of water flow through golden funnels to the ceiling, but one finds oneself at the bottom of the fountain in a rotating universe.
>
> *("A Core for Art Glows in Berlin's St. Hedwig's Cathedral")*

In the Berlin version, it was to be visited only during night hours so that the lighting in the dome would increase the effect of a vortex of blue light.

The work fitted within Horn's long-running usage of mirrors and lenses, one that triggers an active viewing experience. No explicit religious resonances can be found in her works; as already mentioned, *Glowing Core* was first shown in an art exhibition hall in Palma, a Gothic commerce hall. However, for one of her main scholars, her "desire to fathom the nature of man, his powers of perception, his capacity for suffering and his ways of dealing with beauty, death and mourning" was shrouded in references to wandering souls, resurrection, and ascension:

> The intersection of vertical and horizontal lines, combined with the rotating mirrors in the centre and the revolving mirrors in front of the skulls, create a magical space of sacred beauty that captures the notion of salvation in a flitting yet beguilingly complex image.
>
> *(Sartorius)*

The artist herself had resorted to religious inspiration for another of her most renowned installations, *Spiriti di Madreperla*, evoking the catacombs of San Gaudioso in Naples (2002). This usage of Christian environments revealed a continuing interest in exploring deep questions about human existence, somehow connecting them to an intuitively spiritual experience.

In her *Night Sky: Mercury & Venus*, Angela Bulloch (b. 1966) adopted the same, explicitly not religious approach to this kind of works, even though it was housed in Basel's Cathedral. History, religion, and context seemed to weigh heavily on the artist's acceptance to install the work above the main altar:

> …it is not religious and neither am I. I don't believe in God. But the work reacts, of course, to the context of the cathedral. I've made the piece very much with the space in mind and it addresses fundamental questions such as 'where are you in the world?'
>
> *(Harris)*

In fact, *Night Sky* comprised an entire series of works that were mostly exhibited in commercial galleries, sharing the same basic traits: LED lightboxes that show algorithm-generated views of the universe from positions other than the Earth. It was installed in Basel between June 17 and 19, 2010, as part of the fair's Art

Parcours – again, a project where contemporary art is brought to the historical center of the city, including one night with live performances.

Other approaches to Christianity within multimedia art verge on the irreverent, or at least on the ironic and indifferent. Pipilotti Rist (b. 1962) took part in the 51st Venice Biennale (2005) with *Homo Sapiens Sapiens*, a large multimedia projection on the ceiling of the San Stae church.[24] An art-historical parallelism comes to mind very easily, recalling the expansive fresco decorations within so many Italian churches. This led a curator to speak of an "electronic Baroque" (Gioni). The message was not so clear, as the subsequent events demonstrated. The imaging combined her usual language of exuberant biological forms with two primeval Eve figures, naked and frolicking in the grass. Understandably, these dealings were deemed inappropriate for a church by the ecclesiastical authorities and some parishioners. The exhibition was closed after a few months, allegedly because of technical problems, an obvious sign of other kinds of problems.

Paul Chan (b. 1973) also resorted to art-historical foundations for his video installation series *The 7 Lights*, produced between 2005 and 2007.[25] The tension between light and darkness played a key role within the work, whose historical, philosophical, aesthetic, and theological references stood in contrast to its apparent formal simplicity. Through projections on floors, walls, and corners of the gallery space, the seven installations mixed the passage of time from dawn to dusk, the days of creation, the cycle of genesis, and contemporary apocalypses. In the 3rd Light, the architectural setting of Leonardo's *Last Supper* was eerily invoked as the stage for a playful elaboration on scriptural and contemporary motifs.

Other contemporary artists have investigated interactive, immersive video environments from positions much closer to institutional religious beliefs, or even for liturgical purposes. A very different reference to the Genesis prompted Studio Azzurro's installation for the Vatican pavilion at the 55th Venice Biennale in 2013, titled *In principio (e poi)*, i.e., "In the beginning – and afterwards." Commissioned by the Holy See, it consisted of a "sensitive environment," the usual name for this kind of interactive installations made by the Milanese art collective. Body movement by visitors triggered moving images of various characters talking not only about their family ancestors, but also about plants and animals, and other moments of the Genesis narrative.[26] These interactive, multimedia videos were projected on stoneware slabs placed on the walls and the ground, creating a chorus of storytellers.

References to light need not be always tied to image projection technologies. Older supports, such as TV monitors, continue to be relevant, even if on a smaller scale. Davide Coltro has become known for his exploration of video screens as "electronic panels" (*quadri elettronici*), often linked to his gaze toward the landscape. The artist separates his *quadri* from video art, since the images shown on the monitors are being remotely controlled by him, modified through algorithms so that they are never twice the same. He has applied these ideas to his media installation *Crux – per crucem ad lucem*, installed at the church of San Raffaello in Milan during the time of Lent, in 2013, and permanently, since April 2021, in the Galleria d'Arte Sacra dei Contemporanei Villa Clerici, also in Milan (Figure 14.2).

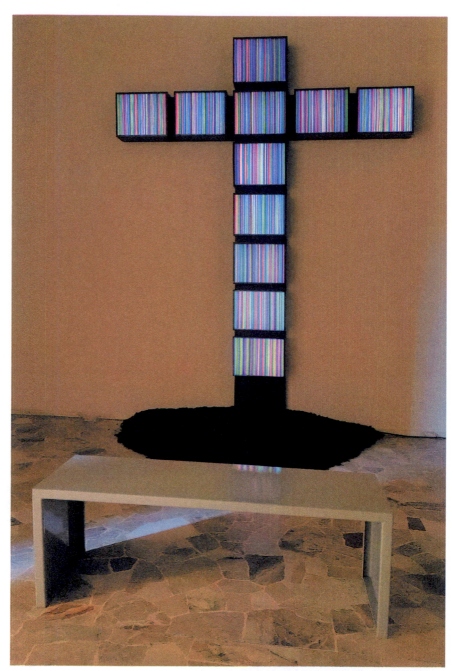

**FIGURE 14.2** Davide Maria Coltro, *CRUX – per crucem ad lucem*, 2013–2022. Installation of 11 media panels with digital icons transmitted remotely. Hardware and software designed by the artist.

In this work, eleven monitors form a cross that, in the original installation, showed images of the sky. The title's traditional Christian saying ("Through the cross to the light") alludes to light (thus, implicitly, to sky, heaven, and salvation[27]) that, within Christianity, is to be reached through Christ's death on the cross (*crux, crucem*). Coltro consciously chose two archetypes that can be understood not only within Christian traditions but also by many other cultures (Ferri 105). Light is a universal symbol for the divine; a cross-links the earthly and the heavenly, combining a stable shape with an upward thrust. The work is also intelligent in its re-elaboration of two by now classic works of video art, Yoko Ono's *Sky TV* and Gary Hill's *Crux*.[28]

In the second and current installation of *Crux*, the sets of images shown on the screens have been modified a few times, following the liturgical seasons of Lent, Pentecost, and Advent, or on specific feast days. This noteworthy variation adds a new field of exploration for a sacred visual art whose appearance is not static but can follow the changes in sacramental and prayer life throughout the year. Quite a different look toward liturgy lay at the heart of *Dwellings*, an unfinished series of video installations by David López Ribes (b. 1972).

As originally conceived in 2006, it comprised seven pieces where various characters would appear to take part in common tasks from family life: a woman reading on a couch, or a baby being bathed. Each of these tasks was linked to one of the seven Catholic sacraments: the Holy Orders and Baptism, in the examples

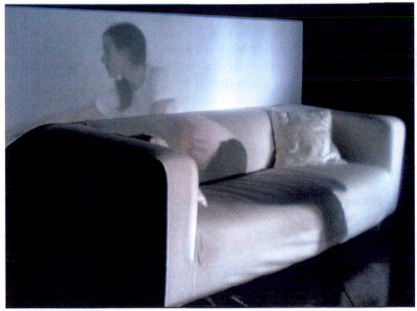

*Photograph courtesy of the artist*

**FIGURE 14.3**   David López Ribes, *Dwellings (Couch)*, 2006. Video installation.

just mentioned. The transcendent meaning of family "liturgies," "public services" in the original meaning of the Greek word, was conveyed through the video projection of the performers on the actual pieces of furniture. Thus, a translucent performance of family life is layered on humble housewares, as in the sacramental transformation of ordinary matter or words into signs of a sacred reality. Shown partially in different locations around Spain, between 2011 and 2012, it was not taken to completion at that time (Figure 14.3).[29]

For the artists studied here, such superpositions of images and meanings on preexisting material environments are a recurring strategy, but one that admits widely varying manifestations. As mentioned above, the interaction between historical sacred architecture and projected video mappings is a continuing field of development. As Nicola Evangelisti (b. 1972) puts it, the superposition of video projections is akin to not only a digital fresco, a skin for historical architecture, but also a passage (namely, a Passover, *pascha*) from the interior to the exterior.

> The use of artificial light within my work ideally symbolizes a reappropriation of Lux, aimed at an authentic, reborn and renewed spirituality, thus also recovering the meaning of Easter, understood as a passage and means for a new life. The work of art becomes the real counterpoint, the transfiguration of a spiritual dimension
>
> *(Ferri 115)*

For that goal, Grosseteste's metaphysics of light provides the artist with constant guidance. The second of his projections on historical religious buildings, *Lux Inaccesibilis* (January 25–26, 2013), took place within a White Night, just like the projections presented earlier.[30] Within a much larger body of light art works, sacred references and spaces have been a continuing line of research and production for him since the early 2000s (Barzel 201–203).

Sometimes, unusual environments and imposed limitations provide occasion for creative efforts that rise to the challenge of providing a new visual language for religious experience. The following case was produced as the setting for something as traditional as a 40-hour vigil of Eucharistic adoration. This was part of a larger program of events organized by the Catholic archdiocese of Madrid, within the weekend of December 30, 2012. City authorities gave event organizers permission to use a 360-degree hemispherical dome temporarily erected within a public square, intended for other institutional purposes. However, that provisional installation within it would have to be promptly installed and disassembled during that very weekend. Subsequently, the visual artist Javier Viver and the architect Eduardo Delgado Orusco coordinated the ideation, assembly, and installment of what they called "an audiovisual temple," one that combined the possibilities of that immersive space, the liturgical and devotional needs it had to serve, and the particularly demanding circumstances of the available space and timeframe (Figure 14.4).[31]

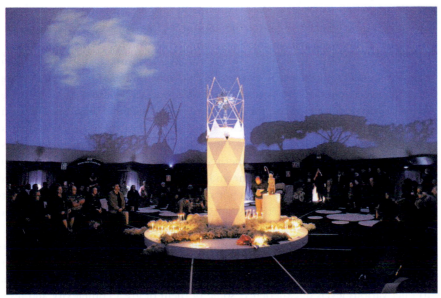

**FIGURE 14.4**    Javier Viver and Eduardo Delgado Orusco, ephemeral Eucharistic chapel in Madrid, 2012.

That covered space, over 22 meters in diameter, was transformed in a chapel, whose central element was a Eucharistic monstrance built specifically for the occasion. This visual and theological centerpiece was referred to as a "Eucharist lighthouse" (*Faro Eucaristía*), thus sharing in the same set of fundamental metaphors studied so far: the divinity – in this case, Christ in the Eucharistic bread – as the rising sun that illuminates the darkness with his brightness. Even more interestingly, the walls of the dome were transformed into a cosmic backdrop for the monstrance. This was done through the projection of the solar cycle, looping from dawn to twilight to a starry night, as in the cases of Flavin and Chan cited above but with a completely different mindset.

That immersive video projection had to contribute to the peaceful adoration and meditation taking place within the chapel. The gradual changes in light, color, and intensity were shown on a slow tempo, again returning to a millennia-old theme: a cupola as a celestial dome, as a shelter but also a site for contemplation. The appearance of the rising sun within the projection, and the space itself, were oriented toward the East, in yet another nod to biblical, liturgical, and art-historical references. In this regard, the entire installation participated in the same dialogue between the old and the new that all artworks briefly presented here have engaged into, offering a particularly rich and successful integration.

★ ★ ★

The works cited above show how multimedia installations and light-based art are providing a fertile ground for the continuing presence of Christian themes within contemporary artistic creativity. Their creators engage in image making that is based on deep theological, visual, aesthetic, and historical roots, even if in unsystematic and idiosyncratic ways. Many of them share an interest in alluding to the transcendent through basic elements of human experience: light, color, the cosmic cycle of day and night, the elements, and the spiritual meaning hidden in simple rituals of ordinary life. It seems a reasonable choice since the resource to those fundamental, universal traits is more suggestive for contemporary viewers, less attuned to the complexity of inherited Christian iconography. When certain knowledge about Christian doctrine and traditions cannot be taken for granted any longer and when neither artists nor spectators share a common set of beliefs and interpretative strategies, the use of very open-ended imagery comes as no surprise.

This does not preclude ironic or merely detached views about institutional religion. Sometimes, it does not prevent shallow approaches to Christian themes or settings, either. At the same time, however, some of those manifestations continue to offer various levels of experience, some of them of great complexity and resonance, just like in the past. The extraordinarily rich heritage of Christian belief, art, and architecture still provides stimulus and inspiration for artists coming from widely ranging personal positions toward religion, in Western societies that can be considered not only post-Christian but also post-secular. To what extent these explorations may open new avenues for the millennium-old accord between Christianity and visual arts is a question that deserves patience and attention.

## Notes

1  The author wishes to express his gratitude to the volume editors for their kind invitation to contribute to it, as well as for their unwavering support during the preparation of this chapter. Some of the ideas included here were first presented in ASCHA's 2017 Symposium, and later drafted in Sebastián Lozano, Jorge. "The Word's New Faces. Video Art and Christian Imagery." *11th European Symposium on Religious Art, Restoration & Conservation. Proceedings Book*, edited by María Luisa Vázquez de Ágredos-Pascual. Kermes, 2019.

2  A valuable and forward looking study on very much related topics, while devoted only to video art, can be found in Silvo Gonzalez, Daniel "El vídeo en el espacio del templo cristiano: el vídeo-arte como disciplina del arte sacro," Doctoral dissertation, Universidad Complutense de Madrid, 2011. http://danielsilvo.com/wp-content/uploads/2018/12/Daniel-Silvo-Tesis-2011.pdf, particularly in chapters 6 and 8.

3  See, respectively, Exodus 13:21; 1 Samuel 3:3; 2 Chronicles 4:7, 13:11; Isaiah 10:17, 60:19; Psalms 35:10; Wisdom of Solomon 7:26; and Numbers 6:25; Psalms 4:7, 26:1, 88:16; Job 22:28; Micah 7:8. Biblical references taken from the *Grove Dictionary of Art*, under term "Light," sec. 5, i.

4  See Luke 1:79, 2:32; Acts 26:23; 2 Corinthians 4:6; John 8:12, 9:5, 12:46.

5  For Grosseteste, light is the greatest of all proportions, and proportions are the key to beauty. Light is self-proportioned; it is always congruent and identical to itself. Aquinas sees light, *claritas*, as the manifestation of form, the proper structure of a

being according to its own essence. See Umberto Eco's *Arte y belleza en la estética medieval* Lumen (1997) for a brief presentation of these variations.

6  The classical study on medieval "aesthetics of light" is Edgar de Bruyne's "L'esthétique de la lumière" in Études d'esthétique médiévale, Vol. 2, Éditions Albin Michel, 1998, first published in 1947. For a recent, specific analysis of the continuity of Neo-Platonic ideas in later categorizations, see Yael Raizman-Kedar, "Plotinus's Conception of Unity and Multiplicity as the Root to the Medieval Distinction between Lux and Lumen," *Studies in history and philosophy of science. Part A*, Vol. 37, No. 3, 2006, 379–397, doi:10.1016/j.shpsa.2006.06.006.

7  As set forth in Erwin Panofsky's essay on Abbot Suger's Saint Denis, first published as introduction to *Abbot Suger on the Abbey Church of St. Denis and Its Art Treasures,* edited by Erwin Panofsky, Princeton University Press, 1946.

8  Andrea Pinotti has noted that modern art historical writing has paid much more attention to shadows than to light, thus ignoring Hans Sedlmayr's late calls to develop a history of light through its artistic manifestations; Pinotti, Andrea. "Presentazione." *Hans Sedlmayr, La Luce nelle sue manifestazioni artistiche,* Aesthetica edizioni, 2009, 7–23.

9  The art critic Jack Burnham had already theorized a paradoxical connection between TV art (in the 1970s terminology) and materiality; Burnham, Jack. "Sacrament and Television." *Video Art,* Institute of Contemporary Art, University of Pennsylvania, 1975, 91–96. He went so far as to link them with, in his own words, "sacramentality."

10  Among them, Jacotte Chollet and Hugo Verlinde, Guillaume Marmin, the Dutch collective Children of the Light, Cecilia Traslaviña and Juan Ramírez, Valérie Simonnet and Jean–Pierre Porcher, Serge de Laubier, Milène Guermont. See http://www.voir-et-dire.net/?-A-Saint-Merry- Other artists have also staged their installations in the church; for example, by Edouard Taufenbach. A particularly acclaimed one, "Polysémie," was carried out by Pascale Peyret in the church of Saint-Séverin, in 2012, also within the Nuit Blanche.

11  From Fray José de Sigüenza's *Fundación del monasterio de El Escorial* (1605), quoted in Nieto Alcaide, Víctor. *La luz, símbolo y sistema visual.* Cátedra, 1978. English translations by the author.

12  *Martyrs (Earth, Air, Fire, Water)* was permanently installed in 2014, and *Mary* in 2016, in Saint Paul's. Viola first explored the "polyptych" format within a religious setting in a permanent installation at Basilica di San Marco, Milan, in 2008 (*Study for The Path,* 2002).

13  The *Pause* events featured artistic multimedia interventions in the Milan Cathedral during Easter, in 2004, 2005 and 2006, including many elements in common with the aforementioned experiences in Paris' *Nuit Blanche*: http://www.artache.it/eng/project.html.

14  Louria-Hayon, Adi. "A Post-Metaphysical Turn: Contingency and Givenness in the Early Work of Dan Flavin (1959–1964)." *Religion and the Arts*, Vol. 17, 2013, 20–56. According to this reading of his life and work, he was motivated not just by the overhaul of formalist theories, as Minimalism at large. He was also adopting a phenomenological post-metaphysics that rejected Aristotelian-Thomist theology and philosophy, like many others in the cultural aftermath of World War II.

15  It could be argued that Dia Bridgehampton, where he installed nine works, was a Baptist church between 1924 and the 1970s, and a firehouse before that, but this fact does not seem to have had any bearing on his intervention. See https://www.diaart.org/visit/visit-our-locations-sites/dia-bridgehampton-bridgehampton-united-states.

16  https://www.moma.org/collection/works/204919.

17  The first one, titled *One Accord*, was created for the Live Oak Friends Meeting House in Houston, in 2000. See https://www.nytimes.com/2001/04/08/arts/art-architecture-using-the-sky-to-discover-an-inner-light.html.

18  http://www.nedelykov-moreira.com/de/projekte/kirchen-grabstaetten/
trauerkapelle-dorotheenstaedtischer/lichtkunst.
19  As stated by Turrell himself:

> I don't want you to experience the sky out there anymore, where it seems to be
> away from you toward the horizon. I want to bring it down into contact with the
> space you are in, so you feel it to be right on top of you.

*James Turrell.* edited by Ana María Torres, IVAM, Institut Valencià d'Art Modern,
2004.
20  Turrell explained,

> The highest state is without form, but if there were no form how could the form-
> less be approached? I thought, why not work without form, without image, with-
> out word. In particular, symbolism; I had this idea of getting away from that kind
> of content

ibid. "I don't want to lose light's power by putting a storyline over it. I want the light
itself" ibid.
21  The artwork's name is consistent with his occasional practice of using place names as
titles for his pieces.
22  The construction of artist's "chapels" within universities is an issue of its own,
obliquely related to our topic here. The evident starting reference for this typology is
the Rothko chapel (1964–1971), originally intended for University of Saint Thomas
in Houston but soon converted into an independent institution. A recent and highly
visible case, as referenced in the main text, is *Austin* (2012–2018) from Ellsworth
Kelly. Charles Ross (b. 1937) has created solar spectrum installations for two non-
denominational chapels: one for Harvard Business School (1992) and the Dwan Light
Sanctuary for United World College near Las Vegas (1996). These are not dealt with
in the main text, as they lack any kind of connection to Christian faith.
23  In La Llotja, March 28 to October 1, 2015; and in Saint Hedwig's, September 27 to
November 11, 2018.
24  For a box of associated leaflets and illustrations with short captions, see Rist, Pip-
pilotti. "Pepperminta : Homo Sapiens Sapiens : Boxa Ludens : Biennale Di Venezia
2005, Chiesa S. Staë" edited by Biennale di Venezia (51. 2005), Lars Müller, 2005.
The piece was also shown in Salamanca's MUSAC, within her "Pröblemäs büenös"
show (2005), though staged in a very different way.
25  While stating his ambivalent views on religion, for Gioni "through the use of spiritual
symbols and mystical thoughts, Chan defines a space in which religion acts as a force
of imagination, a tool to open up new ways of envisioning and describing our pres-
ent." Chan, Paul. *Paul Chan : The 7 Lights.* Verlag der Buchhandlung Walther König,
2007.
26  For an introduction, within the general context of their work, see Valdaliso Casa-
nova, Teresa. "Studio Azzurro: tres décadas de experimentación en la creación audio-
visual y los espacios sensoriales." Doctoral dissertation, Universidad Politécnica de
Valencia, 2016. doi:10.4995/Thesis/10251/62217. It is now permanently exhibited
within the Vatican museums: https://www.museivaticani.va/content/museivaticani/
es/collezioni/musei/collezione-d_arte-contemporanea/sala-12/studio-azzurro--in-
principio--e-poi--.html. See, for additional reference, https://www.studioazzurro.
com/opere/in-principio-e-poi-2/ and *In Principio. Padiglione della Santa Sede. 55.
Esposizione Internazionale d'Arte della Biennale di Venezia.* edited by Micol Forti and
Pasquale Iacobone, FMR, 2013.
27  It is worth reminding that, in Latin, "caelo" (and deriving words in Italian and other
Romance languages) means both "sky" and "heaven."
28  Ono's work was first exhibited in 1966. It is her only video work, but it has been
shown in many different installations afterward. It transmits live images of the sky

to a television monitor in the gallery. While the work itself is extremely open in its meaning, no specific reference to transcendence has ever been made by Ono, in relation to it. See https://www.getty.edu/news/why-yoko-ono-wants-you-to-look-at-the-sky-for-24-hours/ and https://www.moma.org/audio/playlist/15/377. Hill's *Crux* is a five–channel video/sound installation, produced between 1983 and 1987. It is one of his most exhibited works. See https://garyhill.com/work/mixed_media_installation/crux.html.

29 For a contemporaneous interview with the artist, see https://es.zenit.org/2012/11/27/el-artista-que-conocio-la-belleza-de-la-vida-cristiana-tiene-que-transmitirla/.

30 It took place in the cloister of the Basilica of San Domenico, as a part of Arte Fiera, Bologna's art fair. See an overview of his sacred contemporary oeuvre in Ferri, Michela Beatrice. *Sacro Contemporaneo. Dialoghi sull'arte*. Àncora, 2016, https://www.nicolaevangelisti.it/sacred-contemporary.

31 For a detailed presentation and photographic documentation of the entire project, see *El Faro/the Lighthouse. Arquitectura efímera e instalación audiovisual para la Fiesta de las Familias/Ephemeral Architecture and Audiovisual Installation for the Feast of the Families*. Edited by Javier Viver and Eduardo Delgado Orusco. VIA/RU Books, 2016.

## Bibliography

Please note that all URLs are valid as of August 1, 2022.

*Abbot Suger on the Abbey Church of St. Denis and Its Art Treasures*. Edited by Erwin Panofsky, Princeton University Press, 1946.

"A Core for Art Glows in Berlin's St. Hedwig's Cathedral." *DW.com*, 26.09.2018. https://www.dw.com/en/a-core-for-art-glows-in-berlins-st-hedwigs-cathedral/a-45643651.

"Austin in Depth." Blanton Museum of Art. https://blantonmuseum.org/chapter/introduction-13/.

Barzel, Amnon. *Lightart: Targetti Light Art Collection*. Skira, 2005.

Bruyne, Edgar de. "L'esthétique de la lumière." Études d'esthétique médiévale, Vol. 2, Éditions Albin Michel, 1998.

Burnham, Jack. "Sacrament and Television." *Video Art*, Institute of Contemporary Art, University of Pennsylvania, 1975, 91–96.

Chan, Paul. *Paul Chan: The 7 Lights*. Verlag der Buchhandlung Walther König, 2007.

Cianchetta, Alessandra "City by Night: The Illuminated City." *Nightscapes*, edited by Marc Armenguad, 2009, 107–166.

Corbett, Rachel. "Ellsworth Kelly, an Atheist, Has Built a Transcendent Church for Art in Texas." *artnet*, 2018. https://news.artnet.com/art-world/ellsworth-kelly-chapel-opens-texas-blanton-1227392.

Crow, Thomas. *No Idols: The Missing Theology of Art*. Power Publications, 2017.

Eco, Umberto. *Arte y belleza en la estética medieval*. Lumen, 1997.

*El Faro/the Lighthouse. Arquitectura efímera e instalación audiovisual para la Fiesta de las Familias/Ephemeral Architecture and Audiovisual Installation for the Feast of the Families*. Edited by Javier Viver and Eduardo Delgado Orusco, VIA/RU Books, 2016.

Elkins, James. *On the Strange Place of Religion in Contemporary Art*. Routledge, 2004.

Ferri, Michela Beatrice. *Sacro Contemporaneo. Dialoghi sull'arte*. Àncora, 2016.

Gioni, Massimiliano. "Pipilotti Rist: Desiring Machines." *Cura*, No. 32, 2019, https://curamagazine.com/digital/pipilotti-rist-desiring-machines/.

Govan, Michael; Bell, Tiffany. *Dan Flavin. The Complete Lights 1961–1996*. Dia Art Foundation, 2004.

Harris, Gareth. "Interview with Angela Bulloch: Shining a Light on the City." *The Art Newspaper*, 1 June 2010. https://www.theartnewspaper.com/2010/06/01/interview-with-angela-bulloch-shining-a-light-on-the-city.

*In Principio. Padiglione della Santa Sede. 55. Esposizione Internazionale d'Arte della Biennale di Venezia*. Edited by Micol Forti and Pasquale Iacobone, FMR, 2013.

*James Turrell*. Edited by Ana María Torres, IVAM, Institut Valencià d'Art Modern, 2004.

Kosky, Jeffrey L. *Arts of Wonder: Enchanting Secularity. Walter De Maria, Diller + Scofidio, James Turrell, Andy Goldsworthy*. University of Chicago Press, 2012.

Louria-Hayon, Adi. "A Post-Metaphysical Turn: Contingency and Givenness in the Early Work of Dan Flavin (1959–1964)." *Religion and the Arts*, Vol. 17, 2013, 20–56.

Nieto Alcaide, Víctor. *La luz, símbolo y sistema visual*. Cátedra, 1978.

Paltrow, Gwyneth. "Ellsworth Kelly." *Interview Magazine*, 2011, https://www.interviewmagazine.com/art/ellsworth-kelly.

Pinotti, Andrea. "Presentazione." *Hans Sedlmayr, La Luce nelle sue manifestazioni artistiche*, Aesthetica edizioni, 2009, 7–23.

Raizman-Kedar, Yael. "Plotinus's Conception of Unity and Multiplicity as the Root to the Medieval Distinction between Lux and Lumen." *Studies in history and philosophy of science. Part A*, Vol. 37, No. 3, 2006, 379–397, doi:10.1016/j.shpsa.2006.06.006.

Rist, Pippilotti. "Pepperminta : Homo Sapiens Sapiens : Boxa Ludens : Biennale Di Venezia 2005, Chiesa S. Staë" edited by Biennale di Venezia (51. 2005), Lars Müller, 2005.

Sartorius, Joachim "Measuring the Sky from the Depths of a Wall." http://rebecca-horn.de/pages-en/GlowingCore5.html.

Sebastián Lozano, Jorge. "The Word's New Faces. Video Art and Christian Imagery." *11th European Symposium on Religious Art, Restoration & Conservation. Proceedings Book*, edited by María Luisa Vázquez de Ágredos-Pascual, Kermes, 2019.

Silvo Gonzalez, Daniel "El vídeo en el espacio del templo cristiano: el vídeo-arte como disciplina del arte sacro." Doctoral dissertation, Universidad Complutense de Madrid, 2011. http://danielsilvo.com/wp-content/uploads/2018/12/Daniel-Silvo-Tesis-2011.pdf.

Valdaliso Casanova, Teresa. "Studio Azzurro: tres décadas de experimentación en la creación audiovisual y los espacios sensoriales." Doctoral dissertation, Universidad Politécnica de Valencia, 2016. doi:10.4995/Thesis/10251/62217.

# 15

# BILL VIOLA, THE ICON, AND THE APOPHATIC SUBLIME

*Ronald R. Bernier*

In February 2011, the Museum of Biblical Art (MoBIA) in New York opened the exhibition *Passion in Venice*, which featured more than 60 works of art – from painting and sculpture to prints and illuminated manuscripts – all exploring the rich and multivalent theme of "passion" within the Venetian artistic tradition. One theme in particular, central to the history of Christian art, Christ as Man of Sorrows, was the exhibition's central focus. "It is a figure," explained exhibition co-curator Dr. William Barcham, "whose name derives from the Book of Isaiah where a humble and suffering servant is foreseen as the savior of the Jewish people" (MoBIA). Featured in the exhibition was a small and unassuming video piece by American artist Bill Viola, entitled *Man of Sorrows*; it is with this image that I propose a possibility for contemporary art's return to the theological import of the *sublime*, and to an attendant aesthetic of ethics and *revelation*.[1]

> He was despised and rejected by others;
> a man of suffering and acquainted with infirmity;
> and as one from whom others hide their faces
> he was despised, and we held him no account.
> Surely he has borne our infirmities
> And carried our diseases;
> Yet we accounted him stricken,
> Struck down by God, and afflicted.
>
> (Isaiah 53:3–4)

Viola's modest work, measuring roughly 19″ × 15″, is part of a multipiece series of video installations collectively titled *The Passions*, a project first exhibited at the J. Paul Getty Museum in Los Angeles in 2003, and begun in 1998 when Viola was a participating scholar in a year-long study sponsored by the Getty

DOI: 10.4324/9781003326809-18

Research Institute devoted to the question of how to represent the power and complexity of human emotion (Figure 15.1).

*Man of Sorrows* is the portrait of an anonymous individual's encounter with deep sorrow, pain, and loss. Like the traditional devotional icons of the suffering Christ (traditionally referred to as the "Man of Sorrows"), here is an image of a man in tears,

*Photo: Kira Perov © Bill Viola Studio*

**FIGURE 15.1**  Bill Viola, *Man of Sorrows*, 2001. Color video on freestanding LCD flat panel, 49.2 × 38.1 × 15.2 cm (19 3/8 × 15 × 6 in). Performer: John Fleck. 16:00 minutes. Edition of five with one artist's proof.

framed in conventional portrait style and presented on a small, portable, table-top flat-panel screen. The artist himself describes the image as offering a painfully "privileged window into a private, intimate moment of extreme anguish." Throughout the slow-moving sequence (approximately eleven minutes), the man remains

> immersed in a world of sorrow. Waves of emotion open and unfold gradually and subtly across the man's face, his actions...further slowed and expanded in time during playback. With the image cycle continuously repeating and his suffering unrelenting, he remains in a state of perpetual tears and eternal sadness.
>
> *(Walsh 104)*

What is *our* response to such woundedness in a stranger? Fear, mistrust, hospitality? Do we engage – or look away? The viewer is caught in a moment of appeal to moral-ethical conscience; we are being summoned to see the holiness in the abject (Figure 15.2).

A related work within the same series is *Dolorosa* from 2000. Here, too, is an evocation of the universal human condition of suffering. Two figures now, a woman and a man, presented as photographic-style portraits on individual digital flat screens, framed and mounted together in a hinged diptych, like an open devotional book resting on a small table or pedestal. Joined but separate, framed together like a votive image, the two are seen, again as the artist describes, in the

*Photo: Kira Perov © Bill Viola Studio*

**FIGURE 15.2** Bill Viola, *Dolorosa*, 2000. Color video diptych on two freestanding hinged LCD flat panels, 40.6 × 62.2 × 14.6 cm (16 × 24 ½ × 5 ¾ in). Performers: Natasha Basley, Shishir Kurup. 11:00 minutes. Edition of five with one artist's proof.

throes of extreme sorrow, with tears streaming down their cheeks. Their
actions unfold in slow motion and the sequence is presented on a contin-
uously repeating loop, placing the individual's temporary state of crying
within the larger domain of perpetual tears and eternal sorrow.

*(Walsh 6)*

Much of the *Passions* series is indebted to the artist's studies in the 1990s of pre-
modern Western art, particularly Medieval and Renaissance devotional painting
and a return to the functions of such art as a liturgical path to spiritual growth.
In our examples here, Viola is aware of the widespread and powerful spiritual
practice of faithful meditation on icons of the suffering Christ (and Sorrowing
Virgin). He has studied late medieval images of this kind, such as Dieric Bouts's
*Christ as Salvator Mundi* (c.1450)[2] and his *Mater Dolrosa* (c.1470/1475).[3] Far more
than modern re-stagings of art history, though, Viola's deceptively spare video
installations go beyond representation to pursue the ancient theme of *revelation*
within the layers of human consciousness.

Viola's denim-shirted man of sorrows weeps without explanation; we do not
know the cause of his suffering. His head is inclined to one side, brow furrowed,
his pain seeming to intensify; he looks up in supplication, tears continue to stream
down his cheeks; his pain deepens, peaks, then subsides. But he never shrinks from
our view. Instead, like the Christ in the guise of Man of Sorrows, he holds himself
up to be contemplated, urging an ethical response. Here again is Isaiah:

He was oppressed, and he was afflicted,
Yet he did not open his mouth;
Like a lamb that is led to the slaughter,
And like a sheep that before its shearers is silent,
So he did not open his mouth.
By a perversion of justice he was taken away.
Who could have imagined his future?
For he was cut off from the land of the living,
Stricken for the transgression of my people.

(Isaiah 53:7–8)

The soliciting force of these images is further evidenced, even more abstractly,
in the work aptly named (for reasons that will become clear) *Unspoken* (*Silver
and Gold*) of 2001, recently on view at the exhibition *Bill Viola: Icons of Light*,
in Rome, Italy. Much like *Dolorosa*, here is a projected diptych in which the
emotional instability of two individuals is on view. A woman and a man are
projected onto two adjacent wood panels of silver and gold leaf respectively (Fig-
ure 15.3). "The two precious materials have special optical properties," claims
the exhibition catalogue, "and their highly textured surfaces reflect and color
the projected light, greatly altering the appearance of the image." The man and
woman are seen in close-up as grainy, indistinct images filmed under very low

**FIGURE 15.3**   Bill Viola, *Unspoken* (*Silver and Gold*) (2001). Black-and-white video projected diptych on one gold and one silver-leaf panel mounted on wall, 62.3 × 193 × 5.7 cm (24.53 × 75.98 × 2.24 in); 35:40 minutes. Performers: John Malpede, Weba Garretson.

light conditions. The viewer must work slowly, deliberately, and with patience, to attend to the shifting emotions of these sufferers.

> They each silently endure states of extreme anguish as waves of emotion continue to wash over them in unrelenting succession. Subtle changes in light and shadow continually push the visual image to the *threshold of visibility* while the two reach their emotional extremes, locked in a relationship of continual suffering with no apparent beginning or end.
>
> *(Arthemisia 40; my emphasis)*

In our following the illusion (it isn't quite a narrative) of these images – or attempting to – Viola explores how the limits of the image and its manipulations of space and time – speed, simultaneity, succession – force us to reevaluate what we have really seen (like an apparition or theophany); we are left positioned on the boundary between the visible and the invisible – at the threshold of visibility. And it is the technology of video that enables the artist, as David Jasper has argued, to "negotiate these sacramental moments in crossings of space and time, breathless moments of eternity in which our being is both slowed and quickened" (qtd. in Townsend 118). Video is an art of duration and absorption, through which the artist shows us "the hidden dimension to our lives," as Viola has often put it, and a return to interiority. Exploring the possibilities of electronic technology, Viola creates a disrupted embodiment of movement and time to explore a sense of the "unseen," and in dealing with the idea of representing the invisible, Bill Viola's art converges with notions of the Sublime. It is in the presence of the sublime that we experience the straining of the mind at the edges of itself and at the edges of rationality, prompting a mode of attendance to the ineffable. In that which is thus hidden, I wish to argue, the artist offers moments for a self-revealing divine.

## Toward a Theological Sublime

For arch-theorist of the Enlightenment, Immanuel Kant, the sublime was that experience which reveals to the mind Nature's power to suggest to the imagination, to intimate and embody, what is visually unrepresentable. In the presence of the sublime – denoted, as Kant had it, by vast and powerful objects and overwhelming spaces – we are reminded that Nature as boundless manifold is not ours to know completely; the imagination cannot grasp it in a single clarifying image, nor can understanding deal with it – a defect of or affront to human faculties, unacceptable under an *a priori* law of reason, which demands wholeness of comprehension.

In short, Kant construes the sublime as occasioned by powers that transcend the phenomenal self and prompt a mode of awe or reverence. The sublime is that which, through the suggestion of perceptually, imaginatively, or emotionally overwhelming properties, succeeds in rendering the scope (and limit) of some human capacity vivid to the senses and opens up a space for encounter with the *noumenon,* in an experience of what Paul Crowther has aptly called "existential vertigo" (Crowther 171). Moreover, for Kant that material limit to our perceptual and rational capacity serves as a kind of *analogue* of total understanding; that is to say, we can never *know* the Infinite, but we can imagine it, gesture toward it, think it as an idea, and thus experience the consolation that something transcends the limitations of our phenomenal (rational) being. Yet, that initial experience of the disproportion between the mind's ordering power and an ungraspable complexity may serve us as an analogue for another situation, one in which we attempt to comprehend something else beyond the scope of our understanding – when we find ourselves attempting, for instance, to grasp (to know and describe) ideas such as God and the Infinite. For Kant, we can never grasp the whole "beyond" this world, limited as we are in the human situation of being "in" the world; we don't have access to its ultimate Absoluteness. But, as with the sublime, our self-conscious awareness of perceptual and rational limitations is what allows for the reassuring intimation that *something* transcends finite being. Contemporary theorist Slavoj Žižek explains this paradox of the sublime: mindfulness of an unbridgeable gap between the world of sensuous reality and the realm of the supersensible, made available to reason *by the very failure of reason*:

> This is also why an object evoking in us the feeling of Sublimity gives us simultaneously pleasure and displeasure: it gives us displeasure because of its inadequacy to the Thing-Idea [the supersensible Idea], but precisely through this inadequacy it gives us pleasure by indicating the true, incomparable greatness of the Thing, surpassing every possible phenomenal, empirical experience.
>
> *(Žižek 229)*

Of course, the sublime as aesthetic category has its own considerable tradition, a tradition not lost on Viola. Seventeenth-century essayist and poet Joseph

Addison, for instance, described this freedom from perceptual confinement in our experiences of the sublime as that which resists the mind's call to order:

> Our imagination loves to…grasp at anything that is too big for its capacity. We are flung into a pleasing astonishment at such unbounded views, and feel a delightful…amazement in the soul at the apprehension of them. The mind of man naturally hates everything that looks like a restraint upon it, and is apt to fancy itself under a sort of confinement….
>
> *(Addison 387–398)*

Or, there is Edmund Burke in his 1756 treatise, *A Philosophical Inquiry into the Origin of Our Ideas of the Sublime and the Beautiful,* who situates the quality of fear and attraction in the sublime, in a psychological calculus of pleasure and pain, which relies on a strong empirical sense of bodily orientation and an experience that "pierces" us to "our inaccessible and inmost parts:"

> Whatever is fitted in any sort to excite the ideas of pain, and danger, that is to say, whatever is in any sort terrible, or is conversant about terrible objects, or operates in a manner analogous to terror, is a source of the Sublime; that is, it is productive of the strongest emotion which the mind is capable of feeling.
>
> *(Norton 33)*

That the sublime came to be thus characterized by the experience of transcendence and ineffability is observed by Rudolf Otto in his seminal 1913 study, *The Idea of the Holy,* in which he makes the association between the sublime and the numinous:

> While the element of 'dread' is gradually overborne, the connexion of 'the sublime' and 'the holy' becomes firmly established as a legitimate schematization and is carried on into the highest forms of religious consciousness – a proof that there exists a hidden kinship between the numinous and the sublime which is something more than accidental analogy, and to which Kant's *Critique of Judgement* bears distant witness.
>
> *(qtd. in Ward 126)*

For Otto that overpowering absolute before which we are sorely aware of our own creatureliness "may become the hushed, trembling, and speechless humility of the creature in the presence of – whom or what? In the presence of that which is a mystery inexpressible and above all creatures" (Otto 1–3).

## On Inexpressibility and the Apophatic Tradition

In a 1997 interview, Viola remarked on his study of the figures of Early Christianity and the 16th-century mystics (such as John of the Cross and his mentor

Teresa of Avila), as well as the earlier 14th-century Dominican German monk
Meister Eckhart and the anonymous author of the medieval text, *The Cloud of
Unknowing*, all within the Christian tradition of the *via negativa*:

> The *via negativa* in the West is connected to a shadowy fifth-century char-
> acter known as Pseudo-Dionysius the Aeropagite, who…described an
> immanent God…as opposed to the transcendent God of the more familiar
> *via positiva*, over and above all and outside the individual. The *via positiva*
> describes God as the ultimate expression of a series of attributes or qual-
> ities—good, all-seeing, all-knowing, etc.—of which human beings con-
> tain lesser, diminished versions…The *via negativa*, on the other hand, is the
> way of negation. God is wholly other and cannot be described or compre-
> hended. There are no attributes other than unknowability. When the mind
> faces the divine reality, it seizes up and enters a "cloud of unknowing," or
> to use St. John of the Cross' term, "a dark night of the soul." Here in the
> darkness, the only thing to go on is faith…
>
> *(Ross 144)*

Here, Viola draws a connection, as he understands it, between the 16th-century
saints and their medieval mystic forebears, tracing the history back even fur-
ther to Pseudo-Dionysius the Areopagite in the ancient theological fabric of
*apophaticism* – that is, a speaking of God only in terms of what may *not* be said
about God, a "negative theology," often allied with the intuitive and affective
approaches of mysticism.

Negative theology, as Ilse Bulhof and Laurens ten Kate (among others) have
shown, is an ancient tradition the sources for which are found in late antiquity
reaching as far back as Plato's *Parmenides* and the early Christian era with Gregory
of Nyssa (4th century), St. Augustine (4th–5th century), attaining its first signif-
icant high point in the Neoplatonic philosophy of the 3rd-century CE, with yet
more radical representations found among the mystics of the early-to-late Middle
Ages, from Johannes Scotus Eriugena (9th century) to Thomas Aquinas (13th
century).[4] Apophatic theology is a form of discourse that fundamentally consists of
language that negates itself in order to evoke that which is beyond words, beyond
the limits of saying altogether. "'Apophasis' reads etymologically," explains Wil-
liam Franke, "as 'away from speech' or 'saying away' (*apo*, 'from' or 'away from';
*phasis*, 'assertion,' from *phemi*, 'assert' or 'say'), and this points in the direction of
unsaying and ultimately of silence" (Franke 2). Apophasis is, paradoxically, a rich
genre of theological discourse that articulates the utter inefficacy of the Logos
to name ultimate reality. This tradition is fostered by a notion fundamentally
opposed to the central tenet of classical Greek philosophy of Being (or ontol-
ogy) and its claims for autonomous human reason; rather, says apophatics, what
human desire truly seeks – the divine – cannot be defined, pronounced, or known
because it is radically transcendent, incommensurably *Other*, beyond the (human)
subject and outside the limits of rationality and the hubris of classical metaphysics.

Negative theology's emphasis on the unknowableness and the unutterableness of the Divine informs the notion that "transcendence is best approached via denials, via what according to earthly concepts *is not*. Hence the name 'negative theology'" (Bulhof and ten Kate 5). Denying what is given and speaking in contradictions and obscurities is the very means for communicating transcendent or hidden realities. "The apophatic," argues theologian Denys Turner, "is the linguistic strategy of somehow showing by means of language that which lies beyond language" (Turner, 1995, 34). Put another way, rather than a *concept* of God, negative theology looks to an affirmative and intimate *experience* of God and theological insight into the ineffability of God. While ineffable, God *is* encountered.

In language, Turner further argues, this deliberate refusal of a materialist clarity is precisely what appeals in medieval mysticism to postmodern thought and to a contemporary apophatic revival, with its "messages of the decentering and fragmentation of knowledge, of the collapse of stable relations between cognitive subjects and the objects of their knowledge, of the destabilizations of fixed relations between signifier and signified" (Turner, 1998, 473). Apophatic or negative theology is a knowing that is, conceptually, inaccessible; a Divine beyond words, an abstract experience that can only be recognized or intuited; human beings cannot describe the essence of God, and therefore all descriptions, if attempted, will be by necessity false.

Neither existence nor nonexistence as we understand it applies to God; in this sense, God is beyond existing, or, as contemporary philosopher Jean-Luc Marion will have it, "God without Being." In other words, God, the divine, or to use the more secular terminology of the postmodern, the "Wholly Other," is not a creation, not conceptually definable in terms of space and location, and not conceptually confinable to assumptions of temporality.

Yet is it *not* nothing. Again, as William Franke has argued,

> this very nullity is itself something. We conceive of something which we cannot conceive …Our conceiving and saying relates itself to what cannot be conceived or said. The capacity for such relating (without concepts and language) can be verified as an existential fact by every individual who attempts, for example, to conceive of 'God'….
>
> *(Franke 17)*

There is still *something*, an encounter that defies talking about; but to talk about it we must still try. Such "Ultimate Reality," as Bulhof and ten Kate account for it, "is inaccessible to human thinking, inexpressible in human language, invisible to human eyes, unimaginable for the human mind" (Bulhof and ten Kate 6) – but at the same time, I would add, it is an experience there for the having, if one is willing to recognize it.

Much of Bill Viola's work is precisely about the cultivation of that experience of inexpressible divine reality as beyond the realm or limits of

ordinary perception. In an interview published in 1993, the artist sounds a familiar note:

> The basic tents of the *Via Negativa* are the unknowability of God: that God is wholly other, independent, complete; that God cannot be grasped by the human intellect, cannot be described in any way; that when the mind faces the divine reality, it becomes blank. It seizes up. It enters a cloud of unknowing. When the eyes cannot see, then the only thing to go on is faith, and the only true way to approach God is from within..
>
> *(qtd. in Townsend 131)*

Viola'a art probes our human condition as embodied beings and urges us toward the experience of vulnerability, longing but ill-equipped for transcendence and ultimate renunciation of self, and it does so via the ancient traditions of mysticism and, more specifically, via apophatic theology and the idea that God is best identified in terms of "hiddenness" and "revelation." This, ultimately, has resonance in contemporary notions of "negation" and "excess" (sublime) as developed in continental philosophy and in particular in postmodern deconstructive critiques of Enlightenment ideals.

## Lyotard and the Postmodern Sublime

For Jean-François Lyotard, the sublime (in art) is essential in our postmodern age, an age in which all legitimizing and stabilizing narratives have been shattered, as it keeps relevant metaphysical thinking (presenting the unpresentable) (Lyotard 1992a, 64–69).

> That which is not demonstrable is that which stems from Ideas...The universe is not demonstrable; neither is humanity, the end of history, the moment, the species, the good, the just, etc. – or, according to Kant, absolutes in general.
>
> *(68)*

According to Lyotard, contemporary art (abstract art in particular) can give new form to Kant's "negative presentation" of the unpresentable, and a new apophaticism; it can make "ungraspable allusions to the invisible within the visible" (Lyotard 1992a, 68). The incapacity of the imagination produces a negative presentation of what exceeds presentation, "a sign of the presence of the absolute." And Lyotard brings this to bear on modern art, which will, he argues, "present something though negatively; it will therefore avoid figuration or representation" (qtd. in Costelloe 118–131, 120). "The aesthetic of the sublime," Lyotard argues elsewhere, "is where modern art...finds its impetus...showing that there is something we can conceive of which we can neither see nor show" (Lyotard 1992b, 9–10). The "presence," which he identifies as "a kind of transcendental pre-logic

in which thought and sensation are complicit," is prior to an orientation by (Kant's) categories of the understanding that enable feeling to be thought. This "presence" does not correspond to the ontological order of things in themselves, the immediate apprehension of which was for Lyotard, as for Kant, impossible. The presentation of the sublime, then, is negative; it is, Lyotard argues, "compatible with the formless"; it exceeds the Kantian faculties of imagination – understanding and reason – and is thus freighted with negativity in words like "infinity," "unboundedness," "unconditioned," and "unseen"; and it is an awakening of the idea of the supersensible in the subjectivity of contemplation on the sublime. For Lyotard, it acknowledges the "desire for the unknown" in the postmodern:

> The postmodern would be that which, in the modern, puts forward the unpresentable in presentation itself; that which denies the solace of good forms…that which searches for new presentations, not in order to enjoy them, but in order to impart a stronger sense of the unpresentable.
>
> *(qtd. in Ward 137–138)*

In reckoning with the idea of representing the invisible, Bill Viola's art, I am suggesting, may be situated within postmodern notions of the "unrepresentable." Theologically, this invokes the idea of seeing God in "glimpses" or "traces," never knowing God completely, but only in part – or as St. Paul had it, "in a mirror dimly" (1 Corinthians 13:12). Moreover, the apophatic description of God as an abstract experience, not conceptually definable in terms of space and location, nor confinable to conventions of time – God as transcendent of essence – can be theorized within the context of "unknowability" and, I suggest, French phenomenologist and mystical theologian Jean-Luc Marion's "God without Being." This sense of the "unseen" is central to Bill Viola's work. Its appeal is, I wish to call it, a *poetics of hope* in the as-yet-unsatisfied desire for union and fellowship with the (divine) other, such that the divine – God – is present in being hidden. It is a God whose presence is felt – and revealed – indirectly; its givenness or grace rests upon our disinterestedness (in the Kantian sense of disinterest). It involves a *phenomenology of hope*, such that we remain receptively open to the overwhelming *promise* of the "appearance," of God, or to what Jean-Luc Marion theorizes as the "saturated phenomenon."

## Jean-Luc Marion and the Saturated Phenomenon as Theological Sublime

Central to Marion's thinking – and its pertinence to my argument – is his distinction between the *idol* and the *icon*, which, for him, refer to two different modes of divine appearance. Marion's **ICON** is a theory of the way the invisible (unseen) shows itself. Marion distinguishes the icon by contrasting it with the **IDOL**. A thing or being becomes an **idol** when the human gaze directed toward it allows itself to be filled (completed) by this visible thing or being. Thus, the 'idol' is essentially an image or confirming concept of God. The intention of

the human gaze is completely absorbed in the sight of the idol. This means that intention and gaze allow themselves to be fixed on a given visible shape. Our intention and gaze do not *see through* the visible; rather, they are enraptured *with* the visible. Thus, the idol is the image of God adjusted to human, finite standards. It is the "human experience of the divine," as Marion calls it; it refers to the structure of thought on God within human limits. As a result, the gaze creates the idol, and the onlooker is fully satisfied by what he sees. This way of seeing Marion calls **idolatry**. The idol is exactly there where the gaze stops, and as such, the idol is like a mirror; it is merely reflecting my desires – does not allow any "beyond" – it is our gaze obsessed with itself. I see nothing but my own gaze, my own intention. There is no Other there. The idol may be a "picture" of God, but cut to the size and limits of human imagination.

The **icon**, by contrast for Marion, represents a nonconceptual 'appearance' of God. The icon is not produced by the human gaze; rather, the icon *summons* a gaze. The theology of the icon, he claims, is found in Colossians 1:15: "He is the image of the invisible God…" The *icon* overcomes the mirror and the intentional gaze. The icon itself claims the gaze of the onlooker. In other words, the icon, the visible object, refers beyond itself to the invisible. "The icon does not make the invisible *tangibly* present. The icon makes the invisible *as invisible* present for the gaze. The icon can be seen and refers beyond itself" (Marion 2001, 158). Marion continues: "In the idol, the gaze of man is frozen in its mirror; in the icon, the gaze of man is lost in the invisible gaze that visibly engages him." I do not focus upon the icon; rather, the icon focuses on me. The icon is the intentional gaze of the Other in me. The icon approaches me, *gives* itself; it is a **soliciting** force (Figure 15.4).

## *Observance, 2002*

This is precisely what I think is occurring in works like *Observance* from 2002, which substitutes the traditional notion of a painting as a window through which the viewer gazes upon an image of the world, with the religious icon which *calls the viewer into the image*. In *Observance*, also part of the *Passions* series and also featured in the recent exhibition in Rome, "Icons of Light," a steady stream of people on multiple screens – of different ages, races, gender, and ethnicities – slowly moves forward toward us. One by one, they pause at the head of the queue, overcome with emotion. Their gazes are trained on an unknown object or unseen (by us) tragedy. In sorrow or despair or lamentation, they are witness to some tragedy or loss, just out of sight below the edge of the frame, mesmerized by some petitioning force operating within our space. Sometimes gently touching, overlapping, or occasionally exchanging brief glances between them as they pass, all are unified by their common desire to reach the front and make contact with what/whoever is there. The effect is a "crossing of gazes" as Marion would have it, two currents of consciousness pressing upon each other – recognizing separation and alienation while desiring to overcome it. There is a private intimacy

*Photo: Kira Perov © Bill Viola Studio*

**FIGURE 15.4**   Bill Viola, *Observance*, 2002. Color high-definition video on flat panel display mounted vertically on wall, 120.7 × 72.4 × 10.2 cm (47.52 × 28.5 × 4.01 in). 10:14 minutes. Performers: Alan Abelew, Sheryl Arenson, Frank Bruynbroek, Carol Cetrone, Cathy Chang, Ernie Charles, Alan Clark, JD Cullum, Michael Irby, Tanya Little, Susan Matus, Kate Noonan, Paul O'Connor, Valerie Spencer, Louis Stark, Richard Stobie, Michael Eric Strickland, Ellis Williams.

in their silence, yet they urge us somehow to participate in their emotions. Like Marion's icon, they preserve the divine's transcendence by refusing the mirroring function of the idol, such that the viewer finds himself *envisaged* by the other.

The philosopher Emmanuel Levinas called this the "address," the proffering to and petitioning force of the Other, seeing in the Other the inescapable ethical appeal that obligates me. He refers to this as the Face of the Other that speaks, not in a language of words or sounds, but as a *call*, a beckoning of our responsibility in relation to the Other. In this crossing of awarenesses, we recognize the other person facing us as a free and self-determining subject with an ethical claim upon me, rather than as an object at my disposal. The Face of the Other *is* the wordless discourse, the silent and unconditional ethical appeal that manifests pre-ontological intelligibility before language. Levinas' philosophy is one deeply indebted to the apophatic and mystical tradition. William Franke glosses the philosopher:

> Our being in relation to others, blindly and helplessly, without any conscious control or conceptual mastery, precedes all sense and intelligibility of objects that we are able to grasp and conceptualize…The ineffable transcendence discovered in the ethical relation to the Other cannot be comprehended and articulated, but rather dis-articulates me from my origin as self-conscious subject and freely chosen agent.
>
> *(Franke 27–28)*

## Concluding Remarks

In the model of the apophatic sublime as I have proposed it, the question arises: Is God/the divine Other *too* transcendent, without possibility for relationship? This is the critique Richard Kearney, author of *The God Who May Be: A Hermeneutics of Religion* (2001), puts to Marion. Kearney argues instead for a *revelation* of God that doesn't speculate about Being or ontology but rather remarks on the experience of plenitude (Marion's "excess" or "saturated phenomenon"), and therefore the idea of a God of possibility and promise, a more hopeful notion than that which he imputes to Marion as "a divinity so far beyond being that no hermeneutics of interpreting, imagining, symbolizing, or narrativizing is really acceptable," and where "God's alterity appears so utterly unnameable and apophatic that any attempt to throw hermeneutic drawbridges between it and our finite means of language is deemed a form of idolatry" (qtd. in Gschwandtner 78). Such negative or apophatic theology, Kearney claims, denies any possibility of narrative imagination, such that "the divine remains utterly unthinkable, unnameable, unrepresentable – that is, unmediatable" (qtd. in Gschwandtner 98).

While this notion of the absence (or unavailability) of God may very well be present in postmodernist reveling in the bankruptcy of representation, Marion, I think, is closer to the mark in arguing not simply about this inadequacy but, despite it, urging us – as flawed human beings – to imagine nevertheless, to trust in a revelation and to be open to overwhelming promise of grace. Yet, Kearney's critique is helpful to our purposes in articulating what is going on in Bill Viola's

construction of just such an aesthetic – and theological – posture of openness and attentiveness. Kearney insists on a need for what he calls a "narrative hermeneutics," according to which "religious language" – and I count Viola's efforts as such – "endeavor to say something…about the unsayable."

To return to where we began, in Viola's *Man of Sorrows* what occurs is the viewer's receptiveness to a world that, coming from the "other," resounds in him/her/us. We are open to being "caught upon" by the image, instead of having authority of visual *possession* over it (as in the modernist narrative); we are called into an aesthetic posture of *attentiveness*.

Like Marion's icon, Viola's work preserves transcendence by refusing the mirroring function of the idol, such that the viewer finds himself *envisaged* by the other. This phenomenology of the "saturated phenomenon" *is* the theological sublime, the idea that "there are phenomena of such overwhelming givenness or overflowing fulfillment that the intentional acts [such as conscious efforts at conceptualization] aimed at these phenomena are overrun, flooded – or saturated" (Caputo 164). It may be crushing and engulfing, but it is something we cannot resist. It can never be mastered or possessed, but the sublime's reintroduction of desire at least holds out the possibility of engagement. As one Marion scholar puts it – and I extend his remarks here to include Viola –

> Marion [Viola] will not show us God; he just makes sure there is room for God to show Himself! Thus, Marion [Viola] emphasizes the difference between appearance and perception. Something appearing does not a priori urge me to perceive it!
>
> *(Jonkers and Welten 206)*

Viola's work does just this, I think; it opens our eyes to a new way for things one would not otherwise see – an aesthetic, an ethics, a theology, and a technology of *revelation*.

## Notes

1  The material of this chapter is, in part, a distillation (and extension as well) of a much larger project on Viola I published in 2014 as *The Unspeakable Art of Bill Viola: A Visual Theology* (Wipf & Stock).
2  See Dieric Bouts, *Christ as Salvator Mundi*, c.1450. Museum Boijmans Van Beuningen, Rotterdam. https://rkd.nl/en/explore/images/27677.
3  See Workshop of Dieric Bouts, *Mater Dolorosa (Sorrowing Virgin)*, 1480/1500. https://www.artic.edu/artworks/110673/mater-dolorosa-sorrowing-virgin.
4  Bulhof and ten Kate, *Flight of the Gods*, 4–5. See also William Franke's two-volume edited study, *On What Cannot Be Said: Apophatic Discourses in Philosophy, Religion, Literature, and the Arts* (2007).

## Bibliography

Addison, Joseph. *Collected Works, III.* Edited by H. Bohn. London, 1890.
Arthemesia. *Bill Viola: Icons of Light.* Exhibition Catalogue: Palazzo Bonaparte: Rome, 2022.

Bulhof, Ilse N. and Laurens ten Kate, Eds. *Apophatic Bodies: Negative Theology, Incarnation, and Relationality*. Fordham University Press, 2000.

Burke, Edmund. *A Philosophical Inquiry into the Origin of Our Ideas of the Sublime and the Beautiful*. 1756.

Bychkov, Oleg V. and James Fodor, Eds. *Theological Aesthetics After Von Balthasar*. Ashgate, 2008.

Caputo, John. "Jean-Luc Marion. *The Erotic Phenomenon*. Translated by Stephen E. Lewis," *Ethics* 118:1 (2007).

Costelloe, Timothy M., Ed. *The Sublime: From Antiquity to the Present*. Cambridge University Press, 2012.

Crowther, Paul. *The Kantian Sublime: From Morality to Art*. Clarendon Press, 1989.

Davies, Oliver and Denys Turner, Eds. *Silence and the Word: Negative Theology and Incarnation*. Cambridge University Press, 2002.

Franke, William, Ed. *On What Cannot Be Said: Apophatic Discourses in Philosophy, Religion, Literature, and the Arts*. 2 vols. University of Notre Dame Press, 2007.

Gschwandtner, Christina. *Reading Jean-Luc Marion: Exceeding Metaphysics*. Indiana University Press, 2007.

Jonkers, Peter and Rudd Welten, Eds. *God in France: Eight Contemporary French Thinkers on God*. Peeters, 2005.

Kant, Immanuel. *The Critique of Judgement*. Trans. James Creed Meredith. Oxford, 1952.

Kearney, Richard. *Anatheism: Returning to God After God*. Columbia University Press, 2010.

Lyotard, Jean-François. "Presenting the Unpresentable: The Sublime," *Artforum*, 20, April 1992a.

———, *The Postmodern Explained: Correspondence 1982–1985*. Ed. Julian Perfanis and Morgan Thomas. University of Minnesota Press, 1992b.

Marion, Jean-Luc. *God Without Being*. Trans. T. Carlson. University of Chicago Press, 1991.

———. *The Idol and Distance: Five Studies*. Trans. T. Carlson. Fordham University Press, 2001.

———. *The Crossing of the Visible*. Trans. James K.A. Smith. Stanford University Press, 2004.

Museum of Biblical Art (MoBIA). Press release. http://mobia.org/exhibitions/passion-in-venice. Originally accessed December 8, 2012.

Norton, Charles Eliot, Ed. *Edmund Burke*. Harvard Classics. P.F. Collier & Son, 1937.

Otto, Rudolf. *The Idea of the Holy*. Trans. John W. Harvey. Oxford University Press, 1950.

Ross, David, Ed. *Bill Viola*. Whitney Museum of American Art, 1998.

Townsend, Chris, Ed. *The Art of Bill Viola*. Thames & Hudson, 2004.

Turner, Denys. "The Art of Unknowing: Negative Theology in Late Medieval Mysticism." *Modern Theology*, 14/4 (1998) 473–488.

Turner, Denys. *The Darkness of God: Negativity in Christian Mysticism*. Cambridge University Press, 1995.

Walsh, John, Ed. *Bill Viola: The Passions*. Getty, 2003.

Ward, Graham. *Theology and Contemporary Critical Theory*. St. Martin's, 2000.

Žižek, Slavoj. *The Sublime Object of Ideology*. Verso, 1989.

# Case Studies of Artists and Artworks

# 16

# THE LIVED RELIGION OF ANDY WARHOL

*Stephen S. Bush*

## The Last Supper for 59 Cents

We might well think that Andy Warhol's *The Last Supper (with Blue GE & 59¢/ Pink Dove)* (1986) (Figure 16.1) is sacrilegious, a desecration of two of the most esteemed figures in the pantheon of the Western tradition: Leonardo da Vinci and Jesus Christ. The source for Warhol's painting was an outline sketch of the fresco from a 19th-century art encyclopedia. Warhol paints the outline in a gestural manner with uneven, wavering lines that appear hasty. Drips appear on the canvas. Two giant logos (that of General Electric and Dove soap) overlay the scene of Jesus' final meal with his disciples. A massive, red price tag in the upper left-hand corner seemingly advertises that the whole mass of it all is worth 59¢. Other entries in Warhol's *Last Supper* series overlay Leonardo's image with a Wise potato chip logo, ketchup and cigarette logos, a camouflage pattern, and motorcycles. *60 Last Suppers* (1986) and *Christ 112 Times* (1986) multiply the silk-screened images over and over, depriving Christ's visage of uniqueness. An easy way to read these paintings is as the profanation of the sacred, the sacred of both Christianity and the Western artistic tradition. When Marcel Duchamp, with Dada sensibilities, wanted to reject all the standards of Western art, he too turned to Leonardo, defacing the cherished *Mona Lisa* (c. 1503–1506) with a moustache and an obscene title, *L.H.O.O.Q.* (1919) ("she has a hot ass").[1] Is not Warhol doing the same? He seems bound and determined to drag the artistic and religious sacred into the mud of the profane world of consumer capitalism. Is this not a mocking criticism of Christianity? Of that and consumer capitalism? Of those and the revered ideals of Western art?

These questions are closely tied to disagreements about how to understand Warhol's art more generally. His artistic depiction of the mundane objects of

DOI: 10.4324/9781003326809-20

**FIGURE 16.1**   Andy Warhol, *The Last Supper (with Blue GE & 59¢/Pink Dove)*, 1986. Synthetic polymer paint and silkscreen ink on canvas, 305 × 676 cm (120 × 266 in).

everyday consumption – soup cans, advertisements, scouring pads, celebrities, and soft drinks – has led to divergent interpretations. Some have thought that such imagery served as an ironic criticism of consumerism.[2] The point of artistic portrayals of supermarket emblems is to highlight the superficiality of American culture and to criticize the triumph of economic value over political, ethical, and aesthetic values. The exact opposite interpretation sees in Warhol's art the total capitulation of art to capitalism, a full-throated embrace of the values of mass production and mass consumption. In this account, Warhol's pop art is a symptom, not a judgment, of decadent superficiality. Frederic Jameson sees Warhol's depictions of merchandise goods as "obviously representations of commodity or consumer fetishism," seemingly devoid of any political or critical statement (158). A third take on Warhol sees his work as a sort of artistic populism. By populism here, I just mean an expression of the values of ordinary people over and against those of the elites, whether those of the business, politics, or the art world. (I don't mean to imply the xenophobia that frequently attends populist political movements.) Warhol showcases the paraphernalia of the everyday life of ordinary people, without portraying it as necessarily meaningless or condemnable. He challenges the distinction between high art and low art; indeed, he challenges the distinction between art and daily life. His *Brillo Boxes* are indistinguishable from the actual wares. In Arthur Danto's words, Warhol's "mandate was: *paint what we are*" (16). The artist's works show the things we care about and that occupy our attention, for good and for bad: the fare of our daily bread (soup and cola), our celebrity fascinations (Marilyn Monroe and Jacqueline Kennedy Onassis), and our fears and failures (suicides, executions, car wrecks, race riots, and nuclear explosions). Warhol's work invites us to reflect on what we value, desire, and abhor, without predetermining any singular assessment of how

we should assess such things. Where Jameson sees Coca-Cola as an emblem of multi-national capitalism, Warhol sees it as populist and democratic:

> The richest consumers buy essentially the same things as the poorest. You can be watching TV and see Coca-Cola, and you can know that the President drinks Coke, Liz Taylor drinks Coke, and just think, you can drink Coke, too. A Coke is a Coke and no amount of money can get you a better Coke … All the Cokes are the same and all the Cokes are good.
>
> *(100–101)*

This populist interpretation seems best to acknowledge the full range of Warhol's subject matter, and, unlike the first two, it does not render him – or American culture, for that matter – as simplistic or one-dimensional.

However, when it comes to his depiction of religion, it's not clear that things fit easily into the populist understanding of Warhol's art. To be sure, some of his religious themes can be interpreted in this way. For example, his *Crosses* (1981–1982) and *Eggs* (1982) prints depict religious symbols unmixed with secular images. However, many of his works, including most significantly his *Last Supper* series, mix religious with consumerist iconography and in doing so pose a particular interpretive challenge.

Any attempt to understand these works must take into account the fact that these paintings challenge one of the most significant distinctions in the Western artistic tradition: the sacred/profane distinction. Émile Durkheim (1858–1917) made this distinction the essential basis of religion. In his *Elementary Forms of Religious Life*, he writes of the sacred realm as categorically distinct from the profane realm, the former is "set apart" from the profane world, and these two realms are "heterogeneous and incompatible," posing a "radical duality" (41). Durkheim's text has had a massive influence in determining how scholars have thought about religion and the differentiation of the religious from the non-religious. And some distinction not too far off from Durkheim's has governed the production and interpretation of Western art. Religious art in the Western tradition is largely Christian art, and the earliest Christian art, alongside and through its aesthetic qualities, served devotional and pedagogical purposes. The depictions of Christ and the saints elicited pious attentions of prayer, worship, and communal ceremony. The portrayals of biblical stories were pedagogical resources to instruct the faithful in the Christian narrative. For art to serve these purposes, the religious content must be unambiguous and thoroughly distinct from non-religious art, and these origins ensured that as the Western tradition progressed, a more or less clearly demarcated distinction obtained between artworks that treated religious themes and those treating other themes (of course, there are exceptions). As the Medieval era gave way to the Renaissance and all the subsequent developments, religious iconography progressively lost its prominence, but still the distinction between the religious and the non-religious remained fast. Indeed, in the 20th century, the attitudes that were once characteristically evoked by religious

content (awe, reverence, spirituality, a sense of transcendence) became associated with art that had no explicit religious content (for example, the abstractions of Wassily Kandinsky, Mark Rothko, and Barnett Newman). Newman is explicit about modern art's displacement of overtly religious art. The former is now the appropriate seat of transcendent emotion:

> We are freeing ourselves of the impediments of memory, association, nostalgia, legend, myth, or what have you, that have been the devices of Western European painting. Instead of making cathedrals out of Christ, man, or "life," we are making it out of ourselves, out of our own feelings. The image we produce is the self-evident one of revelation, real and concrete, that can be understood by anyone who will look at it without the nostalgic glasses of history.
>
> *(173)*

The imagery changes, but the distinction between the profane world and the sacred "revelation" or "cathedrals" of modern art is still present; indeed, perhaps it has even deepened. One shudders with horror at the thought of one of Rothko's *Seagram* (1958) murals with a bright red 59¢ label painted into the upper left quadrant or the Camel cigarettes logo astride one of the zips in Newman's *Vir Heroicus Sublimis* (1951). Three of the most famous "blasphemous" artworks of the 20th century, Andres Serrano's *Piss Christ* (1987) (a crucifix doused in urine), Chris Ofili's *Holy Virgin Madonna* (1996) (Mary embellished by pornographic images and elephant shit), and David Wojnarowicz's "A Fire in My Belly" (1986–1987) (ants crawling across a crucifix) elicited more outrage and condemnation than Warhol's *Last Supper* paintings, due to their employment of the aesthetics of disgust. But in a certain light, their association of Christ or Mary with the organic materials of human or non-human animals is actually less shocking than Warhol's juxtaposition of Christ with the advertising insignia of profit-seeking corporations.[3]

Warhol's identity as a gay man in his time and era, his obsession with glamour and physical appearance, and his association with all manner of what many regarded as impious folk (trans people, queers, drug users, rock and roll stars, movie celebrities, and so on) would give weight to the sacrilegious interpretation of his art. However, over the last twenty or so years, scholars and critics have increasingly come to appreciate Warhol's own devout religiosity. Raised in a Byzantine Catholic household, Warhol remained connected to his faith over the course of his life, attending mass regularly and volunteering his time to church programs to feed unhoused and impoverished people. Few may have known about his religious convictions during his life, but this is now an established aspect of his legacy, explored in detail in Jane Daggett Dillenberger's *The Religious Art of Andy Warhol* and other scholarly works, as well as the "Andy Warhol: Revelation" exhibition at the Warhol Museum (2019–2020) and Brooklyn Museum (2021–2022). This knowledge has given reason to reject the

blasphemous interpretation. Thus, several significant recent interpretations of Warhol's religious art regard him as affirming the Christian symbolism, not cynically and ironically rejecting it.

These interpretations, however, do not adequately account for the way in which Warhol combines the imagery of the sacred and the profane. In order to convey an affirming attitude toward religiosity, they tend to construe the commercial symbols as referring to spiritual realities and to minimize the reference to consumer goods and the economic system in which they are produced, marketed, and sold. For Wessel Stoker, the owl logo in *Last Supper (Wise Potato Chips)* (1986) and *Last Supper (The Big C)* refers to wisdom (135). For Jane Dillenberger, the Dove soap logo in *Last Supper (Dove)* refers to the Holy Spirit, in keeping with the traditional Christian association with the Third Person of the Trinity, and perhaps also the cleanliness of moral purity (92–93). The General Electric logo refers to power and light, which is to say the spiritual power that Jesus possessed and the light of the revelation of God in Christ. The 59¢ is a reference to the betrayal of Christ by Judas, for which the disciple was paid in money (Stoker 154, 158). The "The Big C" wording in *The Last Supper (The Big C)*, originally a reference to cancer in the *New York Post* article that served as Warhol's source, is not so much a reference to the disease itself but to Christ (also a "big C") and his capacity as a healer to overcome the disease (Stoker 137). By reading these as symbols that have religious realities as their referents instead of daily life (consumer goods, economic exchange, and illness), the tension between the sacred and the profane is minimized or eliminated. As P.A.P.E. Kattenberg says, "The brand 'Dove' does not represent Cosmetics in *The Last Supper (Dove)*, but the Comforter [the Holy Spirit]" (131). Rather than seeing the painting as affirming both cosmetics and spirituality, we are to understand the profane elements as signifiers strictly of sacredness, and so the paintings' visual incongruities between commerce and piety are neatly resolved on the level of symbolic meaning.

To be sure, the Dove logo undoubtedly refers to the Holy Spirit and the GE logo to the spiritual power of Christ. The price tag is not as clear. Judas betrayed Jesus for thirty shekels, not fifty-nine, and Warhol uses price tags as a motif in other paintings than this one, not least in his *Dollar Sign* (1981) series. *The Last Supper (The Big C)* and *Raphael Madonna-$6.99* (1985) both prominently include a 6.99 price marker. The latter has no clear reference to betrayal, unlike the Last Supper, an event that, in the Gospel narratives, included Jesus's announcement that one of his disciples would betray him. Dillenberger sees the 6.99 in *The Last Supper (The Big C)* as operating critically, not in a populist way. "The large price tag … could suggest that money and material needs stand between the viewer and Christ" (92).[4] This is especially noteworthy because she seems to subscribe to the populist interpretation of Warhol's pop art when it doesn't involve religious content.[5] She reconciles the marketing with the religion by portraying the price tag as a negative reference to greed or to commerce as anti-religious. But could it be that Warhol was simultaneously affirming religion and commercial goods? Whether or not 59¢ or 6.99 references Judas's blood money, we should

also understand it as a reference to the experiences of reading ads, shopping, purchasing, and budgeting, as well as enjoying the goods that one has obtained. It strains credulity to think that the artist, whose entire mature career explored consumer goods and drew the art world's attention to the significance of super-market fare as an appropriate object of art, would incorporate such imagery only to condemn it or only to reference other, transcendent things. In this regard and in so many stylistic regards (the use of silkscreen and repeated images, for example), the *Last Supper* series is not radically discontinuous with Warhol's earlier work and themes. Sometimes, a can of soup is just a can of soup, or rather, if GE refers to religious revelation, it surely also refers to kitchen appliances.

Furthermore, practicing religion is a material practice, not just a matter of the mind and spirit. Bibles, other religious books, and devotional artifacts, including paintings, prints, and sculptures, all cost money. Warhol's *Christ, $9.98* (1985–1986) has for its source a newspaper advertisement for a Jesus Night Light ("Amazing Low Price ONLY $9.98" it proclaims) (Diaz and Lash 73). Whatever distaste for kitsch we might have should not predispose us to read Warhol's take on the ad as mockery or criticism.[6] Devotional objects, many of them kitschy, are at the heart of the life of many of the faithful, and they are, for all their religious significance, matters of consumerist production, marketing, and purchase.

In terms of "the Big C," as Jessica Beck points out, we must understand this as involving a reference not just to Christ and cancer, but to the HIV epidemic that was a profound crisis in Warhol's community at that time. People, including Warhol himself, commonly referred to AIDS as "the gay cancer." In his diaries, he expressed considerable anxiety about the disease. He lost a romantic interest, Jay Gould, to AIDS-related complications. Alexander Iolas, the gallerist who commissioned the *Last Supper* series for a 1987 exhibition in Milan, was suffering from AIDS at the time that the show opened, and died soon after (Beck). The reference here is very much to matters of this-worldly concern.

Beck and Dillenberger see a tension in Warhol's work, not between the sacred and the profane, but between the religious and the sexual. His eulogizer, John Richardson, spoke of Warhol's "secret piety" as a surprise to "those of you who knew him in circumstances that were the antithesis of spiritual," referring presumably to his homosexuality and his association with partiers, rock and roll stars, drug users, and queers (quoted in Dillenberger 13). Beck writes, "Warhol's *Last Supper* paintings are a confession of the conflict he felt between his faith and his sexuality." Whereas Dillenberger can read soap and appliance advertising as symbols of spiritual ideals, the motorcycles in *Last Supper (The Big C)* are too much.

> Warhol's juxtaposition here of the Christ of Leonardo with the motorcycle, our age's symbol of untrammeled freedom, power, and sexuality, results in a brash and commanding painting. Two sides of Warhol, his piety and his deep involvement in the aspects of the culture that are inimical to that piety, are here asserted and held in unresolved tension.

> *(Dillenberger 92)*

Citing this passage, Stoker too worries about the tension between "Warhol's piety and his use of logos from the culture in which he was so intensely involved." He thinks that the logos that have clear religious/transcendent referents in relation to the last supper (the "big C," the dove, the GE, and the price tag as betrayal) are reconcilable with his Catholicism, but not the ones that don't (the Camel cigarettes logo, the Heinz 57 logo, and the potato chips logo) (136).

Whatever might have been the case about Warhol's interior psychological dynamics in relation to his sexuality and his religion, we cannot equate the art with the interiority of the artist as though the former is some straightforward expression of the latter. His art resists the multifarious attempts to convey sex and God as oppositional. We see this, for example, in his *Last Supper/Be a Somebody With a Body* (1986) works (Figure 16.2), which pose Leonardo's Jesus in outline next to a body builder image of a handsome man with bulging pecs. The two are facing each other; Jesus inclined lovingly toward the man, extending his hand, the man looking up at the Lord. The wording "Be a Somebody with a Body" connects the sexually attractive male physique with Christ's body, not only as a human organism but also as the mystical entity of the Church (referred to as the

**FIGURE 16.2**  Andy Warhol, Detail of *The Last Supper/Be a Somebody with a Body*, 1985/86. Synthetic polymer paint on canvas, 127 × 152 cm (50 × 60 in).

"body of Christ") and as the Eucharistic ritual that Jesus instituted in the Last Supper, when he broke the bread and said to his companions, "Take, eat; this is my body" (Matthew 26:26, New Revised Standard Version). Stoker interprets the work as a juxtaposition between the transient "vitality" of the body builder as opposed to the immortal life of Christ, completely erasing the sexuality of the two men in proximity, just as Dillenberger erases the homosexual valences of "the Big C" (158). In Leonardo's fresco, the hiatus between Jesus and John (the figure on Jesus' immediate right) makes for an unwieldy gap that is disproportionate in an arrangement that is otherwise sheer genius of composition, presumably to allow for the depiction of the landscape through the window behind them. Sensing the incongruity and uninterested in the background, Warhol seeks to fill the space with the Dove logo in *The Last Supper (Dove)* and with the Heinz 57 logo in *The Last Supper (Camel)*. (Rembrandt too, in his drawing, *The Last Supper, after Leonardo da Vinci* (1634–1635), modifies the gap, bringing Jesus and John closer together.) But in *The Last Supper (Christ and St. John)* (1986), Warhol dramatically transfigures the relation between the two by focusing only on Jesus and John in a close-up that frames the outer edges of their faces and their hands on the table. In Leonardo's original, the stark, 90-degree angle of their postures separates the two, depicting the most distance between any two of the figures. But when Warhol eliminates all the other elements, Jesus and John mirror each other, and the visual emphasis is on the point at which their bodies conjoin at their forearms, with their hands almost touching. Rather than disinterest, their downcast eyes, looking away, show the coyness of lovers, the expression of a beautiful erotic tension. That is to say, Warhol's art rejects the presumption that sexual freedom and homosexuality are at odds with Christian piety.

Warhol's art breaks down the opposition between religion and sex just as he breaks down the opposition between the sacred and the profane. It does so in such a way that both systems of value are affirmed and embraced. How can we understand this, given the traditional dichotomy that would pit the sacred against the profane? Recent work in religious studies on "lived religion" provides a perspective that helpfully illuminates what Warhol's art is doing. Much of the study of religion has focused on "official religion," the creeds, texts, rituals, and institutions that those in positions of hierarchical authority recognize, convey, and endorse. The study of lived religion, as a methodological focus, looks to how religion is practiced in the everyday life of ordinary believers. It involves a "questioning of boundaries, a sympathy for the extra-ecclesial, and a recognition of the laity as actors in their own rights" (Hall viii). Robert Orsi gives the example of a present-day Catholic church in the Bronx that has an artificial grotto, built to replicate the landscape in France in which Mary appeared in the 19th century. The New York City water that is piped into the grotto is regarded as sacred and, among other uses, collected to fill radiators "for protection on the road" (4). Orsi notes how offensive this idea is to those who would think of religion and "material needs," as Dillenberger puts it, as oppositional. Holy water in radiators is a "general blurring of categories they want to keep distinct (sacred/profane;

spirit/matter; transcendent/immanent; nature/machine)" (5). Religion, according to many, is not supposed to be "preoccupied with 'material things'" (6). The lived religion approach counters these assumptions and recognizes the way in which religion is very much intertwined with people's daily activities and daily concerns, outside the cathedrals, in their workplaces, supermarkets, kitchens, and bedrooms. It does not see the sacred as categorically set apart from those realms, but rather as thoroughly imbricated within them.[7]

This way of conceiving religion is consonant with what Warhol is doing in his *Last Supper* works. We bathe ourselves and wash our hands. We eat potato chips. We put ketchup on our food. We buy food at markets; we cook it on stoves. We keep our food and ketchup in refrigerators. We ride motorcycles and smoke cigarettes. We have attractions and we have sex, and at our best, we do so freely and passionately. All of these things make up the textures of our lives and are essential aspects of the pursuit of a meaningful life. We pray and attend religious ceremonies. Those too can be essential pursuits of a meaningful life. We need not pit religion and sex against each other, nor religion and consumer goods. What the scholarly methodology of lived religion theorizes, Warhol's art portrays.[8]

## Notes

1  The French pronunciation of these letters is homophonic with "Elle a chaud au cul."
2  Arthur Danto explains that the interpretation along these lines that predominated in Europe gave Warhol intellectual credibility there earlier than in the United States (x–xi).
3  In their own ways, Serrano, Ofili, and Wojnarowicz are all sympathetic to the figure of Christ or Mary, even if they are knowingly offending conservative sensibilities of contemporary Christians.
4  Stoker (136) concurs with this.
5  Dillenberger speaks of Warhol's work in the 1960s as a "mirror of the popular culture of our day," quoting Warhol as advancing the interpretation that "Pop art is a way of liking things" (27).
6  As Miranda Lash says, "[Warhol's] art, perhaps for the first time, knowingly and openly acknowledged the simultaneous roles that *The Last Supper* can play as both a kitsch and devotional object, and it recognized that these roles were not mutually exclusive" (24).
7  Stoker (159) sees Warhol as committed to transcendence in the midst of the immanence of daily life, but for him, it is only insofar as commercial logos stand as referents to transcendent truth, whereas in my view, we should see the commercial logos also as an affirmation of consumer goods and the life pertaining to them.
8  I'm grateful for feedback on drafts of this chapter from Ronald Bernier, Rachel Hostetter Smith, Travis Kroeker, and Sarah Stewart-Kroeker.

## Bibliography

Beck, Jessica. "Andy Warhol: Sixty Last Suppers." *Gagosian Quarterly*, Summer 2017, https://gagosian.com/quarterly/2017/05/01/andy-warhol-sixty-last-suppers/.
Danto, Arthur C. *Andy Warhol*. Yale University Press, 2009.

Diaz, José Carlos, and Miranda Lash, editors. *Andy Warhol: Revelation.* Andy Warhol Museum, 2019.

Dillenberger, Jane Daggett. *The Religious Art of Andy Warhol.* Continuum, 1998.

Durkheim, Émile. *The Elementary Forms of Religious Life*, edited by Mark S. Cladis, translated by Carol Cosman, Oxford University Press, 2008.

Hall, David D. "Introduction." *Lived Religion in America: Toward a History of Practice*, edited by David D. Hall, Princeton University Press, 1997, pp. vii–xiii.

Jameson, Fredric. *Postmodernism, or, The Cultural Logic of Late Capitalism.* Duke University Press, 1991.

Kattenberg, Peter. *Andy Warhol, Priest: "The Last Supper Comes in Small, Medium, and Large."* Brill, 2001.

Lash, Miranda. "Kitsch You Can Believe In: Warhol's Incessant Last Supper." *Andy Warhol: Revelation*, edited by José Carlos Diaz and Miranda Lash, Andy Warhol Museum, 2019.

Newman, Barnett. "The Sublime Is Now." *Barnett Newman: Selected Writings and Interviews*, edited by John P. O'Neill, University of California Press, 1992, pp. 170–73.

Orsi, Robert. "Everyday Miracles: The Study of Lived Religion." *Lived Religion in America: Toward a History of Practice*, edited by David D. Hall, Princeton University Press, 1997, pp. 3–21.

Stoker, Wessel. *Where Heaven and Earth Meet: The Spiritual in the Art of Kandinsky, Rothko, Warhol, and Kiefer.* no. v. 45, Brill, 2012.

Warhol, Andy. *The Philosophy of Andy Warhol: From A to B and Back Again.* Houghton Mifflin Harcourt, 1975.

# 17

## "A KING AESTHETIC?" TIM ROLLINS AND K.O.S. AND THE ETHOS OF THE REV. DR. MARTIN LUTHER KING JR.

*James Romaine*

*I See the Promised Land (after the Rev Dr. Martin Luther King Jr.)*, from a series of paintings begun by Tim Rollins and K.O.S. in 1998, gives material form to a proposition that faith can transform vision and, furthermore, that a rejuvenated vision can be an agent of personal, social, and spiritual renewal (Figure 17.1).[1] Tim Rollins and K.O.S.'s collaborative practice and oeuvre touch on several questions, including, "how can Christianity have potency in contemporary world?" And "can the visual arts be a catalyst for personal, social, and spiritual renewal?"

The collaboration between Tim Rollins and K.O.S. (Kids of Survival) began in 1984 and continued until Rollins's death in December 2017.[2] Initially, K.O.S. was composed of Rollins's students from Intermediate School 52 in the South Bronx neighborhood of New York City.[3] In August 1981, Rollins, then 26 years old, accepted an invitation to be a special-education art educator, working with IS52 students who had been branded by the NYC Department of Education as "at risk." As Rollins began working in the South Bronx, a neighborhood that was renowned for its poverty, crime, and, most dramatically, arson, he had already achieved a degree of success in the New York art world.[4] Having graduated from The School of Visual Arts in 1977, where he studied with the conceptual artist Joseph Kosuth, Rollins co-founded the art collaborative Group Material, which organized a series of critically acclaimed thematic exhibitions around themes such as immigration and the AIDS crisis. Nevertheless, inspired by the ethos of the Rev Dr. Martin Luther King Jr., Rollins wanted a vocation that had a more direct impact on the lives of specific individuals than seemed, at that time, possible in an art-world-oriented pursuit. He would remain at IS52 for seven years, when, perhaps ironically, the art-world success of his collaboration with K.O.S. made maintaining a teaching schedule impossible.

DOI: 10.4324/9781003326809-21

The text visible within the artwork image reads:

> 45
>
> I See the Promised Land
>
> *This was Dr. King's last, and most apocalyptic, sermon. He delivered it, on the eve of his assassination, at [the Bishop Charles] Mason Temple in Memphis, Tennessee, on 3 April 1968. Mason Temple is the headquarters of the Church of God in Christ, the largest African American pentecostal denomination in the United States.*
>
> Thank you very kindly, my friends. As I listened to Ralph Abernathy in his eloquent and generous introduction and then thought about myself, I wondered who he was talking about. It's always good to have your closest friend and associate say something good about you. And Ralph is the best friend that I have in the world.
> I'm delighted to see each of you here tonight in spite of a storm warning. You reveal that you are determined to go on anyhow. Something is happening in Memphis, something is happening in our world.
> As you know, if I were standing at the beginning of time, with the possibility of general and panoramic view of the whole human history up to now, and the Almighty said to me, "Martin Luther King, which age would you like to live in?"—I would take my mental flight by Egypt through, or rather across the Red Sea, through the wilderness on toward the promised land. And in spite of its magnificence, I wouldn't stop there. I would move on by Greece, and take my mind to Mount Olympus. And I would see Plato, Aristotle, Socrates, Euripides and Aristophanes assembled around the Parthenon as they discussed the great and eternal issues of reality.
> But I wouldn't stop there. I would go on, even to the great heyday of the Roman Empire. And I would see developments around there, through various emperors and leaders. But I wouldn't stop there. I would even come up to the day of the Renaissance, and get a quick picture of all that the Renaissance did for the cultural and esthetic life of man. But I wouldn't stop there. I would even go by the way that the man for whom I'm named had his habitat. And I would watch Martin Luther as he tacked his ninety-five theses on the door at the church in Wittenberg.
> But I wouldn't stop there. I would come on up even to 1863, and watch a vacillating president by the name of Abraham Lincoln finally come to the conclusion that he had to sign the Emancipation Proclama-
>
> 279

*Photo: Studio K.O.S.; used with permission*

**FIGURE 17.1**  Tim Rollins and K.O.S., *I See the Promised Land (after the Rev. Dr. Martin Luther King Jr.)*, 2008. Matte acrylic on book pages mounted on canvas, 274.32 × 182.88 cm (108 × 72 in).

From his first day at IS52, Rollins recognized that something unique and exceptional was possible. Inspired by his student's creativity, he told them, "…we are going to make art, but we are also going to make history" (Rollins, interview conducted by the author, June 27, 2006).[5] By 1984, the collaboration between Rollins and his students had outgrown the classroom and they established an after-school program that they called "the Art and Knowledge Workshop." As their collaboration evolved, Rollins and K.O.S. established their own studio, which was supported by the sale of their art. While the membership of K.O.S. changed from year to year, several members of the group remained active in it

for nearly its entire history. These core K.O.S. members are Angel Abreu, Jorge Abreu, Robert Branch, and Rick Savinon.[6] Rollins and K.O.S. also extended the ethos of their project through workshops that they conducted with youth around the world. Works of art by Rollins and K.O.S. are in museums such as the Museum of Modern Art, the National Gallery of Art, the Art Institute of Chicago, and the Tate Modern.

A signature method of Rollins and K.O.S.'s project was that they painted over pages of texts. As the titles of their works suggest, series such as *I See the Promised Land, The Red Badge of Courage (after Stephen Crane)* begun in 1986, *Invisible Man (after Ralph Ellison)* begun in 1998, *Amerika (after Franz Kafka)* begun in 1984, and *The Creation (after Franz Joseph Haydn)* begun in 2002 are collaborations between Rollins/K.O.S. and the text or musical score from which they worked. Rollins and K.O.S. began each new series of works by reading a text (or listening to a musical score), studying the context in which it was created, extracting themes from the text/score that related to their own experiences, exploring motifs that might visualize those themes, studying the history of those motifs, developing new interpretations of those motifs, and, finally, painting their inventions on the pages of the book/score itself.

We can survey this creative process in their painting *The Red Badge of Courage IV (after Stephen Crane)*s (Figure 17.2).[7] Set in the American Civil War, Crane's

*Photo: Lehmann Maupin Gallery; used with permission*

**FIGURE 17.2**   Tim Rollins and K.O.S., *The Red Badge of Courage IV (after Stephen Crane)*, 1986. Oil on book pages mounted on linen, 53.34 × 91.44 cm (21 × 36 in).

novel describes Henry Fleming's discovery of his own identity and sense of purpose. At the start of the novel, Fleming, an eighteen-year-old Private, has romantic imaginations about the heroism of war. However, faced with the reality of battle, he flees. His feeling of shame for this act of desertion is Fleming's first experience of self-awareness; he returns to his regiment and even becomes the flag bearer. In summarizing the conclusion of Fleming's metamorphosis, Crane's final chapter contains this passage describing the protagonist's transformed consciousness of himself and his relationship to his environment,

> Gradually his brain emerged from the clogged clouds, and at last he was enabled to more closely comprehend himself and [his] circumstance… He had dwelt in a land of strange, squalling upheavals and had come forth… for he saw that the world was a world for him.[8]

Fleming had both discovered himself and was able to apply this self-knowledge in collaborative action (i.e. battle).

One of the themes that Rollins and K.O.S. took from Crane's novel was how identity is formed by facing and transforming adversity. In creating their own painting, they translated this theme into the visual motif of the beautiful wound. Each of them could relate to being physically, psychologically, and spiritually wounded. However, every wound could be made into something beautiful, something that expanded one's perception of life rather than diminishing it. Using watercolor on paper, the members of K.O.S. then "competed" to create the most beautiful, colorful, and unusually shaped wounds. The walls and tables of the studio became covered in these studies, from which the group would vote to select the ones that would be incorporated into the final painting.

The work that we see began with the laying of actual pages from a copy of Crane's text in a grid format across a stretched canvas. This grid, which is clearly visible, gives conceptual and compositional structure to the painting. After the book pages have been sealed with a layer of gesso, the wounds were attached. These strange forms were compositionally organized into imagined constellations. Looking at the finished painting one isn't clear if this is a view of the universe seen through a telescope or through a microscope. But it is certain that we are seeing something beyond our natural vision. The painting has made a world that would otherwise be impossible to see present before us.

Rollins and K.O.S.'s painting visualizes a journey, or journeys, of transformation. Like most of the texts that they employed, *The Red Badge of Courage* is a *bildungsroman*. In translating the novel's themes into a work of visual art, Rollins and K.O.S. added another layer of experiences. And the work of art that we encounter in the gallery is a catalyst for a third transformation, our own.

Tim Rollins's own journey began in what he called "the piney woods of Maine" (Rollins, interview conducted by the author, June 8, 2005). He was born on June 10, 1955, in Waterville, Maine, about twenty-two miles southwest of Pittsfield where he lived with his father Carlton Leroy Rollins and mother

Charlotte Imogene Rollins, née Hussey. Growing up in Pittsfield, Rollins has described several formative experiences that would compel him to first become an educator in the South Bronx, what was then the poorest congressional district in the United States, then collaborate with K.O.S. for three decades. From a very young age, Rollins knew that he wanted to be an artist and educator. Although there were no professional artists in the small mill town of Pittsfield, Rollins studied art books in the library.[9] His determination to become an artist and educator motivated Rollins to be the first person in his family to attend college. For Rollins being an "artist" was not really attached to the practice of making pictures or objects, although he was skillful draftsman and painter; rather, being an "artist" meant taking responsibility for shaping his own destiny. In a rural Maine town, where most people in his family never imagined a life or a world beyond Pittsfield, Rollins identified the concept of being an "artist" with living out of a sense of creative and self-defining purpose.[10] Rollins said, "I think that just being an artist and making that decision for myself was my realizing that I could be responsible for the construction of my own situation and life" (Rollins, interview conducted by the author 8 June 2005.)

Another experience that had a shaping impact on Rollins was singing in the choir of the small Baptist church in Pittsfield. Rollins's love for singing was greater than his skill but this fact taught him about the power of the collective group to raise the individual beyond what they might accomplish alone. The hymns of the Baptist church formed Rollins's faith in a God who was active in the present circumstances of life and who empowered the believer to act. "We were 'red letter Christians,'" Rollins said, "that means that the entire Bible is important but what is printed in red, the words spoken by Christ, is what is most important, that's what you read first" (Rollins, interview by the author 8 June 2005).

Two passages of scripture that were especially important to Rollins were Matthew 17:20, "Truly I tell you, if you have faith as small as a mustard seed, you can say to this mountain, 'Move from here to there,' and it will move. Nothing will be impossible for you." And Hebrews 11: 1 and 3,

> Now faith is confidence in what we hope for and assurance about what we do not see... By faith we understand that the universe was formed at God's command, so that what is seen was not made out of what was visible.
>
> *(New International Version)*

This faith that the invisible is present in the visible became the foundational principle of Rollins' art.

Rollins's Baptist faith also contributed to what would be the most significant formative experience of his youth, his encounter with the speeches, sermons, and books of the Rev. Dr. Martin Luther King Jr. Rollins recalled first seeing King on television news in 1963; King spoke with a moral clarity and authority that Rollins had never heard anyone else command. Raised in a home with

an alcoholic and sometimes absent father, Rollins described King as a "father figure." Although Pittsfield was geographically distant from the civil right movement, Rollins felt a spiritual kinship with King.

As King became a continuing catalyst and overarching frame for Rollins' life and work, in several ways, his study of King encouraged him to examine faith's active and reciprocal relationship with contemporary life. King preached that for the gospel of human sin and divine salvation to be real, it needed to manifest in action. He said,

> Any religion that professes to be concerned about the souls of men and is not concerned about the slums that damn them, the economic conditions that strangle them and the social conditions that cripple them is a spiritually moribund religion awaiting burial.
>
> *(King 2005, 200)*

In King, Rollins found an example of faith in action of Christianity applied to contemporary life. "King and Christ get my highest admiration because they crossed the line to put love in action, philosophy in action, art in action" (Rollins, interview conducted by the author, January 5, 2005).

Furthermore, carefully reading King, Rollins developed a personal philosophy of survival, a concept he defines in terms of his creative and spiritual capacity to transform his experiences in Pittsfield and relationships with his parents into purposeful strategies, a methodology that he would employ in his collaboration with K.O.S. Rollins said,

> Growing up in Pittsfield, Maine, I could relate to that sense of having a future scripted for me; I was going to work in a shoe factory like generations of my family had done. At the Art and Knowledge Workshop [in the South Bronx], we had to come together to provide an alternative scenario from the one that was being scripted for us. We had to rewrite the script, to create a situation in which the opportunities that were not given to us could be created by us.
>
> *(Rollins, interview conducted by the author, January 5, 2005)*

Rollins's adaptation of specific principles of King's into a personal philosophy of survival was defined by principles of self-determination, transformation of circumstances, and the transcending of limitations.

Also, King's ethos fundamentally shaped Rollins's conception of the artist as a creative and social person. Rollins noted, "King was an artist. What I learned from King and the civil rights movement was the notion of movement that we don't have to accept identity or society in the way they are handed to us" (Rollins, interview conducted by the author, January 5, 2005).

King not only provided Rollins with a motivation that change is possible, the Civil Rights leader also suggested a means by which growth, positively

directed change, might develop through a process of struggle. King said, "Hegel in modern philosophy, preached a doctrine of growth through struggle. It is both historically and biologically true that there can be no birth and growth without birth and growing pains" (King 1991, 135). King further articulated the application of this principle to his own work in "Stride Toward Freedom," writing,

> Human progress is neither automatic nor inevitable. Even a superficial look at history reveals that no social advance rolls in on the wheels of inevitability. Every step toward the goal of justice requires sacrifice, suffering, and struggle; the tireless exertions and passionate concern of dedicated individuals.
>
> *(King 1991, 472)*

King based this strategy of growth through struggle on a premise that this process drew its momentum from a transformative energy found in "a creative force in this universe that works to bring the disconnected aspects of reality into a harmonious whole" (King 1991, 106–107). King articulated this belief throughout his writings; for example, he described love for others writing, "The universe is so structured that things do not quite work out rightly if men are not diligent in their concern for others" (King 1991, 122). King encapsulated the faith that lay at the heart of the civil rights movement writing, "There is something in the universe that unfolds for justice and so in Montgomery we felt somehow that as we struggled we had cosmic companionship" (King 1991, 14). These pronouncements about the structure and direction of the universe instilled in Rollins a sense that, as an artist, he might find a way to visualize this process and, thereby, participate in King's movement. This became the prism through which Rollins developed a conception of an art that materialized invisible organic and societal growth.

As Rollins developed his own concept of being an "artist," King's example was even more important than any of the pictures that Rollins saw in art books. King's philosophy of growth through struggle became the specific template for Rollins's critical reception and transformation of the artistic strategies, such as Conceptual Art and Arte Povera, that he encountered in art school. Rollin's consciously and carefully translated King's strategy of nonviolent direct action into a philosophy of politically active art.

As he began his collaboration with K.O.S., Rollins felt guided by King. King was a father-figure-like presence in the Rollins/K.O.S. studio.[11] Across the history of their collaboration, Rollins and K.O.S. repeatedly returned to working from texts by King, including *I See the Promised Land*, *Letter from a Birmingham City Jail*, *Suffering and Faith*, *I Have a Dream*, *Where Do We Go From Here*.

The series *I See the Promised Land (after the Rev Dr. Martin Luther King Jr.)* is based on the last sermon by the Rev King. Also known as "I've Been to the Mountaintop," this sermon was delivered on April 3, 1968, at the Mason Temple, Church of God in Christ in Memphis, Tennessee. King, who would be

assassinated the next day, preached, in part, about the idea of a journey, what he called "a mental flight." Rollins expanded on King's point saying,

> the notion of the capacity of the fully developed personality to take a mental flight is realized in a work of art. It is both imaginary and real. I recognize that there are physical limitations to the body but there are no limitations for the spirit. My spirit can travel to the past and be with Shakespeare and travel to the future in works of art that I make.
>
> *(Rollins, interview conducted by the author 5 January 2005)*

King took his audience on a journey through time, beginning in the Egypt of the Exodus and continuing toward the Promised Land. Traveling, imaginatively, through time, King took his listeners to the present day, to a world where "trouble is in the land and [there is] confusion all around." But King didn't leave his audience in discouragement. He said, "I see God working in this period of the 20th century… Something is happening in our world." King closed with what would galvanize Rollins and K.O.S.

> [God] has allowed me to go up to the mountain. And I've looked over. And I've seen the Promised Land. I may not get there with you. But I want you to know tonight that we, as a people, will get to the Promised Land… Mine eyes have seen the glory of the coming of the Lord.
>
> *(King 1991, 286)*

The connection that King articulated between faith, vision, and action, what Rollins would call a "King ethos," inspired and challenged Rollins and K.O.S. to create art that, in turn, inspired and challenged us.

Rollins and K.O.S. adopted the motif of the triangle to visualize the idea of "a mental flight." Reading the work, we travel simultaneously in two directions. Reading the motif as a road, this painting expands infinitely into the distance. Or reading the motif vertically, our eye is drawn toward the apex. However, the apex of this triangle is deliberately beyond the top edge of painting. The motif ascends from the seen to the unseen. Our imagination, elevated by the painting, is such that the appearance of this immaterial apex is made real. We believe that we can see this point, and through this painting, we can see it in our mind. Rollins defined the concept of "prophesy," as a word that calls itself into being. In its ability to entice the viewer to see its own completion, *I See the Promised Land* is a prophetic work of art.

The triangular motif present in *I See the Promised Land* also references another sermon by King, a sermon entitled "The Three Dimensions of a Complete Life." King began his sermon describing John, the Evangelist on the Island of Patmos. King noted that John was incarcerated on an island, "deprived of almost every freedom," but that, in that situation, John "lifted his vision" and saw

"descending out of heaven, a new heaven and a new earth" (King 1998, 121). King, who knew about being incarcerated, called attention to this contradiction between John's earthly experience of confinement and the spiritual freedom that he experienced. According to King, because John looked at his situation from the right perspective of faith, suffering was, in fact, joy. As with his sermon "I've Been to the Mountaintop," King's "The Three Dimensions of a Complete Life" draws a direct connection between faith and a transformed vision, as well as describes how that transformed vision generates renewed life. King's framing of his argument in these terms is instructive because it alerts us to what is his most fundamental presupposition, namely, that it is possible for a person to transform their situation and find a more meaningful freedom by redirecting their vision. King's text encouraged Rollins and K.O.S. to believe that they could directly affect their situation by transforming their vision of it.

According to King, this renewed life has three dimensions: length, breadth, and height. The length of life is a proper self-image and sense of personal purpose; "before you can love other selves adequately, you've got to love your own self properly." The breadth of life is a love for others and to see one's own desires in relationship to others; "a man has not begun to live until he can rise above the narrow confines of his own individual concerns to the broader concerns of all humanity." And the height of life is to have faith to God and believe that good will triumph over evil; to "move beyond humanity and reach up, way up for the God of the universe, whose purpose changeth not" (King 1998, 133).

Rollins had first read "The Three Dimensions of a Complete Life" as a young person living in Pittsfield, and this sermon was formative in his own conception of himself as an artist. Rollins's unique reading of conceptual and process-oriented art through the prism of King's ethos became a catalyst for his development of a method of art making that projected and realized a three-part growth process of self-development, social responsibility, and spiritual connectedness found in "The Three Dimensions of a Complete Life." If King's first principle of a complete life encouraged Rollins to identify art making as his vocation, King's second principle, that personal fulfillment is only found in the service of others, convinced Rollins that he should not be an artist who simply served himself through an art of self-expression but that his artistic talent should be employed as a transformative agent for building creative communities out of situations marked by class and racial differences. And King's third principle convinced Rollins that art had both a purpose and a power to spiritually impact the viewer.

Continuing in his sermon, King described this first dimension of a complete life as only possible when one knows *what* they are meant to do. This is a life-defining purpose that derives from a sense of destiny and vocation in which one finds meaning and pride. King said, "After we've discovered what God has called us to do, after we've discovered our life's work, we should set out to do that work so well that the living, the dead, the unborn couldn't do it any better" (King 1998, 125). He added,

Even if it falls your lot to be a street sweeper, go out and sweep the streets
like Michelangelo painted pictures; sweep the streets like Handel and Bee-
thoven composed music; sweep the streets like Shakespeare wrote poetry;
sweep the streets so well that all the hosts of heaven and earth will have to
pause and say, 'Here lived a great street sweeper who swept his job well'.

*(King 1998, 126)*

Rollins and K.O.S. consciously translated this dimension of a self-realized life
into their artistic project. For example, many of the texts that Rollins and K.O.S.
employed in their art featured a central character who, through the course of the
novel, discovered a transformed sense of personal identity and purpose. In Ralph
Ellison's *Invisible Man*, an unnamed Black man narrates his own experience of
social invisibility. Inspired by the novel's opening line, "I am an invisible man,"

*Photo: Studio K.O.S.; used with permission*

**FIGURE 17.3**  Tim Rollins and K.O.S., *Invisible Man (after Ralph Ellison)*, 2008. Matte
acrylic on book pages mounted on canvas, 91.44 × 91.44 cm (36 × 36 in).

Rollins and K.O.S. turned their own sense of invisibility into a visual declaration of being (Figure 17.3). From the word "VICTIM" in a New York Post headline about a murder victim, they excised the letters "IM" and painted this on to the book pages. Rollins has called attention to the reference to Exodus 3:14 in which God identifies as I AM THAT I AM. Through their art making, Rollins and K.O.S. rejected a "victim" identity and created for themselves a transformed identity. Rollins and K.O.S.'s works *Invisible Man (after Ralph Ellison)* are prophetic in that they accomplish the very thing that they describe.

Rollins and K.O.S.'s art visualizes what King called the "breadth" of life in that the work of art is conceptually, visibly (in the motif), and materially (in the making) the creation of a community; works such as *Amerika (after Franz Kafka) VIII* visualize the process by which a "beloved community" is created (Figure 17.4).[12] Kafka's novel *Amerika* describes the adventures of a young immigrant boy named Karl Rossmann. After numerous adventures, he meets up with a group called "the Nature Theatre of Oklahoma;" their motto is "Everyone is Welcome." Karl joins the group and participates in a collaborative performance in which they play golden horns. Rollins and K.O.S. adopted the motif of the golden horn as a visualization of each one's own artistic voice, their participation in a creative democracy.

A web of interconnected forms, *Amerika (after Franz Kafka) VIII* is a visualization of Rollins and K.O.S.'s conception of "community," which is rooted in what King described as a "Beloved Community." The structural character of King's "Beloved Community" is a mutual relationship in which the collective gives opportunity and amplification for the expression of each individual's voice and the individual finds identity and purpose in the group. Neither the individual nor the group can flourish or find fulfillment without the other. In *Amerika (after Franz Kafka) VIII*, the composition is sustained by the presence of each horn. The removal of even one horn would, in the view of the artists, diminish, or even

*Photo: Museum of Modern Art; used with permission*

**FIGURE 17.4**  Tim Rollins and K.O.S., *Amerika (after Franz Kafka) VIII*, 1986–1987. Watercolor, charcoal, and pencil on book pages mounted on linen, 175.58 × 35.56 cm (69 1/8 × 14 in).

destroy, the unity of the composition. On the other hand, any one of these horns would, for the artists, lose its meaning on its own. *Amerika (after Franz Kafka) VIII* is not an illustration or representation of a "Beloved Community." It *is* a "Beloved Community."

Under the concept or the "height" of life, which is to have faith that, in King's words, "the arc of the moral universe is long, but it bends toward justice," King had described a spiritual impulse to "move beyond humanity and reach up, way up for the God of the universe, whose purpose changeth not" (King 1998, 133). This faith that the history of the universe is unfolding under divine guidance is given visual form in a painting by Rollins and K.O.S. based on a work of music, *The Creation (after Franz Joseph Haydn)*. After listening to the musical score and studying images from the Hubble Space Telescope, Rollins and K.O.S. imagined what the very first moments of the universe might have looked like. Then, they painted over the pages from the score. However, Rollins and K.O.S.'s *The Creation* differs from their previously discussed works in a significant way. In paintings such as *The Red Badge… IV (after Stephen Crane)* or *Amerika (after Franz Kafka) VIII*, the pages are organized in a grid across a single canvas. That means that the entire painting can be viewed from a single point at a single moment. But the painted pages from Haydn's score are hung individually in a long row. This means that the viewer must walk along this row of images in order to see the entirety of the single, multi-panel work. This movement requires that the viewer engages *The Creation* in time rather than at a single moment. Since music is experienced in time, this connects Rollins and K.O.S.'s work back to Haydn's score. But this employment of time also projects the work of art forward. In looking at Rollins and K.O.S.'s *The Creation*, we are activated. We are challenged with the proposition that God's creation is still unfolding and with the question of what we are doing within that divine design.

With *I See the Promised Land* and its beyond-the-edge-of-the-frame apex, Rollins and K.O.S.'s art encourages the viewer to imagine the world that is made complete. We participate in bringing that more-complete world into being by finding our God-designed purpose, applying that purpose within community, and keeping that sense of purpose properly oriented by looking to God. Can a work of art accomplish all of this? According to Rollins, this depends on our faith. "Art is like prayer," he said, "if you don't believe in it, it's not going to do anything for you, but if you believe that this thing you made has some sort of power, then mountains can be moved" (Rollins, interview conducted by the author 5 January 2001).

## Notes

1  In nearly every case, Rollins and K.O.S. have produced multiple works based on the same text or musical score. Unless a specific work is cited, such as *Amerika (after Franz Kafka) VIII*, this chapter addresses all of the paintings based on a particular text as a single body of work.

2 This history of Tim Rollins and K.O.S. is based on interviews with Rollins and K.O.S. members Angel Abreu, Jorge Abreu, Robert Branch, George Garces, and Nelson Ricardo "Rick" Savinon made by the author between 2001 and 2007. Wherever possible, these recollections were corroborated against archival records and by interviews with other persons who witnessed or participated in this history. As with any narrative, Rollins and K.O.S.'s recollections and characterizations of their history and art are shaped by self-perception and aspiration. In this chapter, I treat Rollins and K.O.S.'s self-description, not uncritically, as a kind of work of art in itself. For a more detailed history of Tim Rollins and K.O.S.'s creative partnership and art, see *Tim Rollins and K.O.S.: A History* edited by Ian Berry, MIT Press 2009.

3 Exhibition reviews indicate that Rollins and K.O.S. first exhibited under names such as "Tim Rollins and 15 kids from the South Bronx" and "Twenty Kids from the South Bronx and Tim Rollins." In 1985, K.O.S. adopted the name Kids of Survival, and then just K.O.S. so that they would be recognized as "artists" rather than "students" and because the name "Tim Rollins and K.O.S." was similar to "Afrika Bambaataa and the Soul Sonic Force," "Run-D.M.C.," and "Grandmaster Flash and the Furious Five."

4 For a history of this neighborhood, see *The Bronx* by Evelyn Gonzales, Columbia University Press 2004.

5 Asked to elaborate on what he meant by "making history," Rollins said,

> To dare to make history when you are young, when you are a minority, when you are working, or non-working, class, when you are voiceless in society takes courage. Where we came from, where I came from in Maine and where my kids have come from in the South Bronx, just surviving is 'making history.' So many others, in the same situations, have not survived, physically, psychologically, spiritually, or socially. We were making our own history, something that wasn't given to us. We weren't going to accept history as something given to us.

6 They continue to collaborate under the name Studio K.O.S.

7 Rollins and K.O.S.'s creative process is documented in the 1996 Emmy Award-winning film *Kids of Survival: The Art and Life of Tim Rollins and K.O.S.*

8 Passage from *The Red Badge of Courage* as read by Rick Savinon in *Kids of Survival: The Art and Life of Tim Rollins and K.O.S.*

9 Although Rollins recalls a school trip to an art museum of Boston, his knowledge of art, before moving to New York in 1975, was mostly through illustrations.

10 In an interview, Jasper Johns, who grew up in Allendale, South Carolina, a town much like Pittsfield, said that he became an artist because being an artist was the only thing you couldn't be in Allendale. The implication was that, by becoming an artist, Johns was guaranteeing a break from the constraints he felt as a youth. Rollins had a similar motivation.

11 When I first met Rollins and K.O.S. in 2001, they had a picture of King posted on their studio door. There was no other signage indicating what or who occupied the other side of the door. King's presence was a symbolic passage into the Rollins/K.O.S. studio.

12 "Beloved community" was the term that King used to describe the ultimate goal of redemption and reconciliation that his ethos of nonviolent action might prophetically bring into being.

## Bibliography

Berry, Ian, ed. *Tim Rollins and K.O.S.: A History*. MIT Press, 2009.

Geller, Daniel and Dayna Goldfine, dir. *Kids of Survival: The Art and Life of Tim Rollins and K.O.S.* 1996.

Gonzales, Evelyn. *The Bronx*. Columbia University Press. 2004.

King Jr., Martin Luther. *Testament of Hope: The Essential Writings of Martin Luther King*. Harper Collins, 1991.

——. *A Knock at Midnight: Inspiration from the Great Sermons of Reverend Martin Luther King Jr.*, ed. Clayborne Carson and Peter Holloran. IPM/Warner Books, 1998.

——. *The Papers of Martin Luther King, Jr., Volume V: Threshold of a New Decade*. University of California Press, 2005.

# 18

# FROM THE WOUNDS, GRACE

## John August Swanson and the Theological Aesth/Ethics of Liberation

*Cecilia González-Andrieu*

## The Enigmatic Life

The sketchbooks were everywhere, haphazardly tucked into cabinets, boxes, and drawers. Often, pages were returned to years later, as if the notebook's owner had misplaced it and a new encounter inspired fresh thoughts and images. On this day, the notebooks, which often served as untidy journals, had transformed. The pages, now frozen in time, changed from dialoguing with their owner, to communicating with us. Their purpose would be to give new interlocutors, now and hereafter, a glimpse into the private "inner work" (as he often called it) of one artist's complicated encounters with life. In those pages and in the works of art he left us, John August Swanson reveals an existence lived as a divinely infused enigma, which he sought to explore and communicate.

Tragically, on the day I recall, the possibility of pages receiving new thoughts or drawings had vanished; Swanson had died.[1] Significantly, the last painful months of his life had revealed a quality in his religious sensibilities that made the witness of robust faith given by his art undeniable. From an initial visit to the emergency room on Good Friday of 2021, to a diagnosis of advanced congestive heart failure, to his final days at a Catholic care facility, in the span of a few months, Swanson's spiritual quest had become ever clearer.

The mysterious and enchanted qualities of life that so intrigued him surrounded Swanson those final days. As he was wheeled down in a wheelchair to celebrate the Catholic Mass at Saint John of God,[2] the artist, anonymous in the community of elders, moved past many of his own artworks framing the chapel's entrance. The figures watched silently, and to an observer who knew their secret, it was exceedingly poignant to see them inhabiting the beautiful worlds Swanson had created for them, even as his life faded. Nurses entered the artist's room and called him "Father," intuitively sensing a spiritual teacher. On hearing of his illness, a group from a nearby Lutheran Church created a quilt from bright

DOI: 10.4324/9781003326809-22

orange squares and purple knots representing their prayers. That blanket warmed him those last days. And in a show of unrestrained abundance, daily messages of solidarity arrived from everywhere, in many forms and from many faiths. If an outpouring of love could have kept him alive, this sustained effort from a global community would have ensured him many days, but limited by the fragility of biological life, Swanson's life ebbed.

Although the physical pain was new, there were many other less visible wounds John August Swanson had spent a lifetime carrying, not only for himself but for the world. Could this artist of overflowing starry skies, dreamers, and angels also be someone beset by paralyzing doubt, wounded repeatedly by rejection, and mourning for our broken world? Was this intimacy with heartbreak what flowed into the hopefulness of his works? How might the act of making art take human chaos, and, through a commitment to difficult truths, transform it into a gift of insight-generating goodness for all who encounter it? Finally, is this givenness of art not ultimately a religious act, as it turns wounds into occasions for the liberating outpouring of grace?

On the day he went from being-with-us to being-beyond-us, Swanson's art, and the struggles he chronicled in his private papers, could be glimpsed in this question: *Is God Ultimately for us? And if God is for us, why are we not for each other?* Swanson saw every act of his life incarnated in each brushstroke as work of liberation, all of one-piece, inseparable. In life and art, he invited others to answer these questions, hoping for the "yes" of generous dedication to the common good. Yet, for Swanson "yes" did not rise from certainty but from wrestling all his life with clashing pieces of reality.

## The Artful and the Religious

In modernity, the interwoven nature of the arts and the religious has been undone by categories often theorized as contradictory barriers (Apostolos-Cappadona and Eliade 179–183).

Those who long for certainty and dogmatic boundaries are uncomfortable with the openness and probing queries provoked by the arts. Conversely, those who resist the possibility that the human is not the measure of all things, and that perhaps there's more to reality than we dare to admit, are equally uncomfortable with a material phenomenon that points beyond itself to a transcendent otherness that beckons. Whether in a view of life that is over-spiritualized or over-materialized, the cleft between the artistic and the religious seems to point to the same problem: fear of our smallness, terror of our lack of control over reality, and distress that the fluid dynamism of the real requires much of us that has little to do with our personal comfort or certitude. We want to avoid ultimate questions; the arts and the religious point us to them. In what follows, I look at Swanson and his works as embodying art's exceptional ability to be attentive to the world's suffering and through this disclose the mysterious generosity of creation (*God for us*), thereby moving us to respond with generous compassion (*for each other*).

By paying attention to the aesthetically expressed insights of the wounded, vulnerable, and excluded of the world (here exemplified in Swanson as artist, spiritual seeker, and social justice activist), we glimpse struggles in their ethical fruitfulness. Swanson had profound questions he was working through. His art, engaged through the theological aesthetic approach of an acercamiento or bringing close (González-Andrieu, *Bridge* 90–91), opens up questions, invites us in, and gives us a taste of their possible resolution. Swanson's art, whether explicitly religious (Figs. 2, 3) or not (Fig.1), acts in a religiously redemptive way as it reaches out to the world with a liberative spirit-filled intensity meant to transform us. The theological density of his works, which are disarming in their childlike presentation, demonstrates that attentiveness to the struggles of "the least" is fundamental to the flourishing of all life. If we don't attend to those on the peripheries of power, we will lack the creativity and coherent religious ethics needed to build a better world. This world Swanson glimpsed was one where we live abundantly with and for God and each other.

## a/Art Matters

I use the term a/Art to disrupt language and highlight the ambiguities that examinations of the arts with the religious expose. The convention of referring to Art as only those works "exhibited in galleries in major cities, bought by museums of contemporary art, shown in biennales… and written about in [certain] periodicals" (Elkins 1), is inadequate for engaging the arts in our time. Today, many of us are involved in questions of oppression and the ethical imperative of facilitating agency and liberation for the vulnerable of the world. a/Art's attentiveness to those we ruthlessly wound and exploit, and often arising from those communities, embodies the human response of solidarity and the longing for liberation brought about by crises and societal shifts. In the same way, religious traditions centered on the love of neighbor are compelled by their own belief systems to reflect, denounce, and act in ways that alleviate suffering. As this ethical focus makes evident, the a/Arts and the religious do vital work for the common good, and they do this together.

History witnesses to how when convulsions in societies expose wounds, the arts as religiously insightful, and the religious as artfully imagined, have often appeared simultaneously and profoundly entangled with each other.[3] Consequently, it is unproductive to try to reduce creative expressions to binary categories of value that require that imaginative gifts fit neatly into parameters predicated on disengagement with ultimate human concerns (as in the questionable idea of "art for art's sake"),[4] or that involve elite valuation systems that authorize only some subjects or makers as Art. The tangible work the a/Arts do in a society exposes these boundaries as flawed. Swanson is painfully aware of this, and begins one reflection stating his position,

> The images I make are not for "art's sake," nor are they for pure self expression. I want to speak to you in everyday terms as if you were sitting here

> beside me. I pull from old roots to make a new thing that I hope will catch some of the light of our archetypal beacons.
>
> *(Swanson, "My work" 1)*

Absurdly, many contemporary attitudes claiming to value Art result in alienating it from human concerns and the "old roots" from which it pulls. The result is Art that might be decorative or shocking, commercial, or distant, but seldom relevant. There is an expectation that contemporary Art assert its autonomy by occupying a space outside the human struggle for survival and for answers to ultimate questions. This sidelines artfulness in its pluriform existence and diminishes its ethical influence within a society. If those of us who make and value a/Art believe that creative work matters, we must recover a sense that it exists for and with humanity. a/Art discloses our struggles, not as one of many possible outcomes, but as intrinsic to its very being. As Alejandro García-Rivera summarizes, "The theological dimension of art lies in that, ultimately, art interprets humanity to the human" (18).

## Wounds and Grace

As a theologian, I approach a/Art with appreciation for its inherent potential to move us individually and communally by exposing wounds and inviting grace (González-Andrieu, "Wounded"). I also caution that sundered from ethical concerns, a/Art is reduced to one commodity among many, an artifact of capitalism and nothing more (Moynihan). In contrast when engaged as flowing from the turbulent streams of human life, the a/Arts function as a potent corrective for religious traditions and their societies, urging them to wrestle with what is heartbreaking and initiating the process of communal reflection. The a/Arts so engaged remind us of materiality and finitude, and pull us back into relationship with our world rather than encouraging escape from it. One compelling example (among many) is the heartrending sight of Marc Chagall's unambiguously Jewish Jesus in his *White Crucifixion* (1938). The painting, entangled in the horror of its historical moment with exquisite precision, expresses truths Christianity suppresses at its own peril.

The a/Arts as expressive of ultimate concerns can provoke a religious tradition to see what it must see and do what it must do, restoring it to an effective relationship with society and with itself. Consequently, gifted with creativity, the religious imagination as expressive of ultimate concerns can flow into a society in ways that activate transformation. As theologian Von Ogden Vogt argued from the agonizing shadows of the 20th century's two world wars, what we call ethics is simply "the struggle of human life to have a larger share in the beauty of life" (34).

If what a society values and preserves correlates to what helps it thrive, then the stakes for the survival of the arts and religious traditions are high. Without intentional engagement with the pain and vulnerability of the world, both art and religion could be deservedly thrown into the dustheap of failed experiments. However, united through the crucible of human experience, the aesthetic and the religious can result in awakening and nurturing grace-filled healing and action.

That a/Art is something more expansive and holistic than predominant con-
temporary Western paradigms argue is evident in human history. Much of what
is displayed in museums was never thought of as Art by its communities of ori-
gin. These fruits of human-making took form as creatively expressed acts of
inquiry, disquietude, observation, remembrance, celebration, offering, desire,
and lament, and they did so in myriad forms. As evident from our earliest ances-
tors (García-Rivera 13–19), these works were made for others to encounter and
provide evidence of the complex process of living for their communities. As
Latina/o theology argues, quotidian life is a richly revelatory place (Nanko-
Fernandez 16). The abundance of a/Art produced as communities grapple with
bridging "an unseen reality" with their daily struggles is evidence of how the
material becomes the medium for the immaterial to reveal its presence and lift
us into an awakened and transformed consciousness (Swanson, "My Work" 1).
This wakefulness re-engages us with the material through love and compassion.
Swanson is an example of the tightly woven continuum between aesthetics and
ethics as he connects pain and hope. He never fully resolves either, but his art
gives us a foretaste of the way the resolution may look and feel.

## The Wounds We Carry

John August Swanson was born in Los Angeles, California, on January 11, 1938.
The child of immigrants from vastly different worlds, his parents' story left indel-
ible marks in many of his works. His mother, Magdalena Velasquez, fled north
after the murder of several of the family's men during the Mexican revolution
(Swanson, "Family 1900" 19).[5] Crossing from Ciudad Juarez into El Paso, young
Magdalena eventually reached Los Angeles in 1928 (Swanson, "Family 1900"
24). She attended adult school, worked as a skilled seamstress, and eventually
joined Jewish immigrants to establish the garment workers' union. His mother's
community organizing, which included voter registration drives, and support of
legislative action for issues affecting working-class immigrants, shaped Swanson.
He first learned to make prints to support social justice organizing.

Swanson's father, John "Gus" Swanson (Swanson, "Family 1900" 33)[6],
migrated to the United States from Sweden. Hitchhiking across the country,
he eventually also settled in Los Angeles working as a vegetable seller. The
Swanson-Velasquez marriage was strained; trying to communicate in a language
neither knew well and understand divergent cultural and gender expectations.
The family also had to deal with experiences of discrimination, which welcomed
the white Swede and victimized the brown Mexican. Swanson's recollections
disclose a family disintegrating in slow motion. The future artist was sometimes
sent by his mother to comb the city's jails and "flop houses" searching for his
alcoholic father who died early and alone. For the rest of his life Swanson strug-
gled with these memories, which left him feeling "as an outsider and not quite
fitting in."[7] Yet he nurtured a hope, always elusive, that he might be able to see
and communicate that "Unconditional love = God."[8]

Swanson's context made him keenly aware that class, race, gender, ethnicity, religion, and a host of other markers of difference created barriers and suffering. "In our contemporary Western Society," he writes, "The success of an artist is often based on technical skill, individualism, and commercial success. With these values being the most important, artists can no longer be anchored to God or their community" (Swanson, "My work" 1–2). As an artist, resisting the pull of commodification was difficult and Swanson scrutinized his motivations often. He feared losing himself in the glow of fame, yet he was also afraid to end up like his father, living on the streets and in despair.

## Is God for Us? *The Prisoner* and the Suffering Human

The image of his father haunts many of Swanson's works, heartbreakingly embodying the quest for God's presence. The identities merge. Are we dealing with God's absent fatherhood? Is the man in this work Swanson, his father, or both? Can the religiously infused archetypes of fathers and sons offer anything to a wounded child displaced and searching for home?

There are three categories apparent in Swanson's works that interlace (1) the quest of the suffering human person, (2) with the possibility of divine accompaniment and companionship, and (3) resolving in abundance and planetary flourishing. This suffering human is often presented as the jailed or roaming man. These are often urban images and cityscapes, and framed through windows. Interpreted religiously, they join the stories of Israel as a displaced people to Jesus, as someone who "has nowhere to rest his head" (Matt 8:20) and is imprisoned (Jn 18:1–40, 19:1–16). [9] The biblical sensibility to suffering is there in the background launching the poignancy of new questions.

In *The Prisoner* (1972), the man weeps as he writes his thoughts, mirroring Swanson's journals. Upside down we read "How long must I wait?" The question lingers in the grayness of the man's cell. Yet, the colors visible just beyond link the sun and birds of abundance offered by the natural world, with his longing for liberation. *The Prisoner* suggests that in the suffering is also revealed the possibility of healing if we but look up and engage the beauty of the world. However, the work doesn't resolve this tension. In the last frame, the man dreams, but remains alone (Figure 18.1).

Writing about the *City Walk Suite* (1978), which moves forward the story and presents the man walking the streets observing scenes where others enjoy life, Swanson briefly alludes to his father's story. In a voice that attempts to be as detached as the lonely man, but is heartrending, the artist notes,

> My father was also a personal element to influence this suite…He wandered around alone, moving to various hotels, knew the city, was a tough man. I would hunt him up and have dinner with him. The scenes of looking for him in the downtown area stayed with me.
>
> *(Swanson, "A Suite")*

The father needs a home. The son needs a home. The world offers no comfort.

**FIGURE 18.1**    John August Swanson, *The Prisoner*, 1972. Serigraph, 20.32 × 54.61 cm (8 × 21.5 in). Series of 40 printed.

## Meeting God, *The Ascent,* and the Human Who Dreams *with* God

As Swanson's spirituality merges with his ethical concerns, he begins to connect the wounds of displacement and marginality of the isolated human to a possibility. Can we seek and find God's promised abundance and love? Rather than the human suffering and dreaming alone, the Hebrew and Christian Scriptures reveal that the transcendent realm is responsive and involved. Finding this link, Swanson revisits the story of Jacob's dream (Gen 28:10–20) in multiple works. The sleeping man in *The Prisoner* transforms into the sleeping patriarch Jacob in at least three other works named for the *Dream of Jacob*. It reaches a climax in his final work exploring this theme: *The Ascent* (2014) (Figure 18.2).

Wrestling with the sacred text, the work proposes that the home we long for is found through allowing our imagination to awaken to God's abundance and companionship, in heaven *and* in our world. The divine participates in our flourishing; our dreams are also God's dreams.

The connection between the suffering human, the impulse to dream of a better world, and the possibility of in-breaking grace is revealed by the twin figures of the sleeping prisoner and the slumbering Jacob. In a two-page hand-scribbled letter, which includes a miniature color sketch of the painting in progress, Swanson's merging of life and art in the abundance of incarnated faith becomes explicit. The letter, simply addressed to "Jack," reveals Swanson corresponding regularly with a prisoner at the Pelican Bay Maximum Security Prison.[10] It is this prisoner who receives Swanson's attention and first news of his work on *The Ascent*. The artist writes to this inmate as a fellow artist whose dreams he shares,

> Dear Jack,
>    …I hope you will continue in your drawing. As your options are limited to look and study other artists, try to work from your memories, stories, prayers, using what ever [sic] art materials you can have or find….

**FIGURE 18.2**    John August Swanson, *The Ascent*, 2014. Acrylic on canvas, 83.82 × 62.86 cm (33 × 24.75 in). Candler School of Theology Collection, Atlanta.

I just finished completed painting an acrylic painting—it is called the Ascent. It was in progress for over 6 months—very detailed, my eyes would get very tired…The theme of the Ascent is like a dream of Jacob—with multiple ladders and stairs leading the wandering person's dream to see visions of universes and expanding beauty…It is exciting to look at and see the details as well as the conceptual expression that we have great capacity to keep growing and developing in the short time we are here on earth… I hope this [new] art work… can inspire others with hope and not to loose [sic] heart.

Jack, you are in my prayers—each night I remember you and <sup>also</sup> the others in solitary at Pelican Bay. Thank you for your friendship, John.

*(Swanson, "Ascent" 1–2)*

Swanson likely wept as he wrote this. His experiences of the wounds inflicted by imprisonment, migration, the exploitation of workers, racism, poverty, family disintegration, and the complexity of being caught between worlds were sources from which he drew until the end of his life. As his art opened a vision of what *could be* in its attentiveness to the sacred quality of all reality, his heart was perennially broken. He embodied the link: he had visions of grace because he engaged his heart so intensely. Such depth of empathy was costly. Paradoxically, a man who could make a stranger feel like an old friend[11] nevertheless remained radically alone and wandering in his interior life. This dynamic interaction between wound and vision was burdensome and led him to seek compassionate companions in the human/divine encounters expressed by the stories of biblical faith and in the wisdom of religious traditions. Swanson understood the work of the arts as undertaking what others might have categorized as the realm of religion by enabling people to give the very best of themselves and in so doing, lift the spirits of others (Swanson, "Tales"). His was a constant longing for an existence that offered him – and most importantly the rest of the beloved creation – respite from a world that rejected God's abundant presence and was incapable of emulating God's compassion (Swanson, "Family" 30).

## Being For and With Each Other, *The Procession*, and the Outpouring of Grace

Flowing from the world's brokenness into visions of grace, Swanson's works present a challenge to individualism and commend community. If the human wanders through life alone and alienated, then that same human can be invited to notice that creation and the transcendent realm are loving companions that mutually reveal each other. The recognition of such giftedness has the potential to heal wounds by turning us toward each other in reciprocity. a/Art here reaches its aesth/ethical potential by fostering relationship: to our inner self, to the transcendent companions who love us, and ultimately to our world and each other. Swanson's rich life and works say "Yes, God is for us, look around, feel the deep mystery of kinship bursting out of reality. And yes, because of this, we must be for each other."

The theologically aesthetic through-line is perceptively coherent. The a/Art makes present our wounds, validating them, and rousing us out of a sleep that doesn't dream. Our head cradled resting on a stone; we begin to dream of a universe that dreams with us. We are lifted. We discover. Yet, for the full ethical power of this aesthetic experience to bear fruit it must turn into effective action. The abundance in Swanson's a/Art often surprised even him. Bent over his art table, goggles fitted with magnifiers for his eyes, the artist layered on impossibly small details and

colors. The world is so mysteriously beautiful, if we could just see that, then maybe we will feel so loved that all we can do is love back, abundantly (Jn 10:10).[12]

*The Procession*, 2007, bursts into our world through a subject Swanson had been exploring for decades (Figure 18.3). The first iteration, *The Procession*, a painting completed in 1982, is in the Vatican Museum's Collection of Modern Religious Art. Yet, it is the serigraph from almost three decades later that may be his greatest work. If we imagine reality as atomized and separate, we are alienated and so is everything else. But if we step back and see the unity-in-difference,

**FIGURE 18.3** John August Swanson, *The Procession,* 2007. Serigraph, 91.44 × 60.96 cm (36 × 24 in). Edition of 250.

and exquisite beauty this engenders, then the reciprocity of love is generated. In *The Procession*, the art proposes such unity in technique and subject.

The serigraph has 89 colors; to produce it, Swanson had to draw 89 different screens. Only together would the picture be whole. As the work shimmers jewel-like, the celebrating community spills out of the church toward us. The first group, each with a role in the procession, numbers about a hundred. Behind them, the rest of the community fills the entire church. Each person is unique and yet each person serves the whole (carries a banner, plays music, sings). The gathered comunidad is in turn accompanied by those just beyond the veil of what we can see. A veil Swanson's works invariably make transparent, as heaven and earth are one.

*The Procession* includes the entire community of ancestors and foundational stories of Christianity, particularly those of the Catholic and Hispanic/Latino tradition. There are 20 stories from the Hebrew Scriptures, 14 from the Christian Scriptures, and 18 from saints and angels, including panel 47, which Swanson identifies as "Everyman (You and I)" (The Procession Guide). This figure resembles Swanson, dressed as a monk (a vocation he wanted to follow as a teenager) kneeling before a radiant red heart. The older Swanson is also in the serigraph, dressed in blue; his hair is white and balding. He is the only person giving us their back and contemplating the scene. He gives us a glimpse, perceptible in many of his works but culminating here, of our oneness with all that is: beauty-offered and beauty-extended. Yes, God is for us. Yes, we must be for each other. And yes, we can keep doing this until the whole world joins in.

## Notes

1  September 23, 2021, Los Angeles, California. As his friend, neighbor, and collaborator, I accompanied Swanson throughout his illness. I write both as a close participant in his life and as a scholar of his work.
2  Swanson spent his last days at St. John of God Retirement and Care Center in Los Angeles, California.
3  The link between adversity and creativity is explored in Marie J.C. Forgeard, "Perceiving Benefits After Adversity: The Relationship Between Self-Reported Posttraumatic Growth and Creativity," *Psychology of Aesthetics, Creativity, and the Arts,* 2013, Vol. 7, No. 3, pp. 245–264.
4  "When art is made to serve the interests of other institutions – religion, morality, or politics – it loses its value as *art*." Manjulika Ghosh, "Autonomy of Art and its Value," *Dialogue and Universalism,* 2017, No. 3, p. 53. This approach discloses the limitations of these categories and their incompatibility with the ethical concerns of the human community. The author holds that "Art and life meet at tangents" (53). I hold that art and life are inextricably entangled.
5  The manuscript page numbers do not correspond to the pdf copy. Thus, MS 19, pdf 8. Citations refer to MS numbers.
6  Sven August Svensson.
7  Swanson's personal papers. Basic Sketchbook, identification 2022.02, dated 1989–1997. On loan from the John August Swanson Trust.
8  Swanson's personal papers. Notebook, identification 2022.01, dated 1990. On loan.
9  I use the New American Bible Revised Edition (NABRE, 2019–2022).

10 Pelican Bay State Prison (PBSP), Crescent City, CA. Opened in 1989, is notorious for violence, solitary confinement, and hunger strikes.
11 Swanson could name each person in a group within minutes of first meeting them and remembered their stories at each subsequent meeting. Hundreds of people counted him a close friend, and he cultivated relationships with care. He had a prodigious memory, which masked the trepidation he felt in social settings.
12 "I came so that they might have life and have it more abundantly" (John 10:10).

# Bibliography

Apostolos-Cappadona, Diane, and Mircea Eliade. *Art, Creativity, and the Sacred: An Anthology in Religion and Art*, Continuum, New York, 2001, pp. 179–183.

Chagall, Marc. *White Crucifixion*. 154.6 × 140 cm (60 7/8 × 55 1/16 in.), Art Institute of Chicago, Reference Number 1946.925, 1938.

Elkins, James. *On the Strange Place of Religion in Contemporary Art*, Routledge, New York, 2004.

García-Rivera, Alejandro. *A Wounded Grace: Sketches for a Theology of Art*, The Liturgical Press, Collegeville, 2003.

González-Andrieu, Cecilia. *Bridge to Wonder: Art as a Gospel of Beauty*, Baylor University Press, Waco, 2012.

———. "Wounded Grace and the Disquieting Invitation of the Real." *Proceedings of the Catholic Theological Society of America*, vol. 73, 2 August 2018, pp. 23–37.

Moynihan, Colin. "When a 'Chagall' Is Challenged." *The New York Times*, 7 July 2022, p. 1.

Nanko-Fernandez, Carmen. "Lo Cotidiano as Locus Theologicus." *The Wiley Blackwell Companion to Latino/a Theology*, edited by Orlando Espin, John Wiley & Sons Inc, Hoboken, New Jersey, 2015, pp. 15–33.

Swanson, John August. *The Ascent*, Candler School of Theology at Emory University, Atlanta, 2014.

———. "Ascent Notes," Swanson's Personal Papers, undated. Loyola Marymount University Digital Collection.

———. "City Walk, A Suite of Nine Etchings," Los Angeles, December 1980. Swanson's Personal Papers, Loyola Marymount University Digital Collection.

———. *City Walk Suite*, 1978. Series of nine etchings. Collection of the Bibliothèque Nationale, Paris, France.

———. "Family History," undated. Swanson's Personal Papers, Loyola Marymount University Digital Collection.

———. "Family History-Turbulent Times 1900–1930," undated. Swanson's Personal Papers, Loyola Marymount University Digital Collection.

———. "My Work is My Most Social Act," undated. Swanson's Personal Papers, Loyola Marymount University Digital Collection.

———. "Tales of Hoffmann, (2001)" Video. Loyola Marymount University Digital Collection.

———. *The Prisoner*, 1972. Serigraph. Edition of 40. Multiple private collections.

———. *The Procession*, 1982. Vatican Museum Collection of Modern Religious Art.

———. *The Procession*, 2007. Serigraph. 89 colors. Edition of 250. Multiple private collections.

Vogt, Von Ogden. *Art and Religion*, Beacon Press, Boston, 1948.

# 19

# CITIES OF LIGHT

## Phillip K. Smith III and the Light & Space Movement

*Matthew J. Milliner*

### Beyond the Los Angeles/New York Rivalry

"I guess if you're from California you're allowed to talk about it" (Govan). These were the words of LACMA director Michael Govan. The "it" in question was the matter of serious spirituality, as evidenced by the debut exhibition of Bridge Projects, a Los Angeles art gallery deliberately open to multiple faith traditions (Figure 19.1).[1] Bridge aimed to engage not only vague, unattached spiritual aspirations, but also spirituality tethered to particular historic religious traditions, which is to say, not just the spiritual, but the theological as well (Anderson "Visual Arts," 17).[2] The first exhibition in this Santa Monica Boulevard gallery, the occasion for Govan's address, was a solo show by the Light & Space Movement artist Phillip K. Smith III entitled *10 Columns*. Smith illuminated the cavernous interior of the gallery with portals of color-shifting light that functioned alternatively as mirrors, each tethered to the structural columns of the space. Standing before each light station with the mellifluous live chanting of Norbertine Fathers occasionally breaking through the background, the work seemed more than just another chapter in the Light & Space Movement that has long emanated from Southern California.[3] Instead, Smith's show was ambitious enough to exceed that limited interpretive framework, calling upon not only the regional Light & Space Movement, but on global light and space mysticism as well.

To view Smith's work in this way, however, mandates that serious theological ideas be marshaled to ensure the new openness mentioned by Govan becomes an enduring expansion. In pursuit of this end, this paper will exceed the frame in which Light & Space Movement artists is often placed, namely, the New York/Los Angeles rivalry.[4] It may be that the Light & Space Movement helped Los Angeles to artistically individuate from the artistic epicenter of New York, but I do not aim to rehearse, or dispute, this claim. Instead, I aim to refresh this

DOI: 10.4324/9781003326809-23

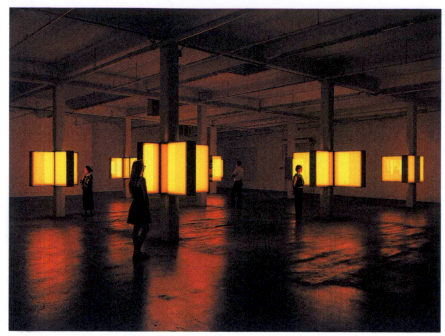

*Photo courtesy of the artist and Bridge Projects, Los Angeles. Photo: Lance Gerber*

**FIGURE 19.1**  Phillip K. Smith III. *10 Columns*, 2019. Aluminum, glass, LED lighting, electronic components, unique color choreography. 7000 sq ft × 10 columns, 106.68 cm high (42 in) × 23 cm (9 in) wide × varying widths, 40.64, 66.04, 91.44 cm (16, 26, 36 in).

somewhat spent North American urban coastal contest by bringing other cities into the conversation – Constantinople, Thessaloniki, and Paris – each of which I will connect to the cityscape of Los Angeles. Drawing on these cities and the rich theologies of light mysticism they generated will help us to see how Smith's work calls to mind not just California sunshine, but uncreated light.[5]

## Constantinople

Although his true identity remains elusive, the man called Pseudo-Dionysius, writing around the year 500, assumed the identity of the disciple converted by St. Paul in the Areopagus (Acts 17:34). Hence, he is also referred to as Dionysius the Areopagite. Dionysius stands as something of a founding father over the Christian mystical tradition, similar to the way that James Turrell stands over the Light & Space Movement today.[6] Dionysius's vastly influential ideas survive in four classic texts, *The Divine Names, Mystical Theology, Celestial Hierarchy*, and *Ecclesiastical Hierarchy*, along with ten letters (Schibille 175). The Areopagite's work has sparked considerable recent interest (Coakley & Stang). As the author

is thought to have originated from Syria, his work has been called "the heart of Asia in Western theology" (Balthasar 148), a judgment shared by artist Bill Viola, who finds considerable inspiration in Pseudo-Dionysius (Viola 249). Dionysius is the mainstay of apophatic or "negative" theology in both the Eastern and Western Christian theological traditions, which entails declaring what God is not, not just what God may be. Dionysius refreshes tired theist/atheist debates with what he calls hypertheism (Balthasar 188), an appeal to a God that is beyond our concepts of God. Similarly, Phillip K. Smith III explains that in his work, "transparency shifts to opacity…. Ingrained in me is a comfort level associated with knowing and not-knowing" (Smith, Phillip K. 33).

At the same time, the God of Dionysius is a God of revelation and disclosure, hence Dionysius's (and Philip K. Smith's) necessary appeal to matter. Dionysius is no mere Platonist, but rather a Christian Platonist bound to the enduring dignity of physical reality. And light – that most diaphanous of "physical" substances – enabled Dionysius to swim between the created and uncreated realms. "[M]aterial lights are images of the outpouring of an immaterial gift of light" (Pseudo-Dionysius 146). These ideas also saturated the greatest church building of Constantinople, and of the first millennia of Christianity, Hagia Sophia. Conveniently enough, the year that construction began on Hagia Sophia (532 AD) is the same year of the earliest surviving evidence of Pseudo-Dionysius's writings (Schibille 174). The Areopagite's theology was reflected, quite literally, in this famous building (Schibille 177). Hagia Sophia is a space where "[t]he main icon is light" (Ahmanson 22), that is, light that leads to the immaterial uncreated light: God.

Jeffrey Kosky rightfully complains about the conceptual poverty of approaches to the Light & Space Movement, where "formal and technical discussions abound" but religion – which artists like Turrell expressly evoke – is left out (173). An appeal to a thinker like Pseudo-Dionysius directly addresses this deficiency. As if to anticipate such an appeal, there has long been an icon of Dionysian theology in California, specifically in Antoine Caron's image from the 1570s at the Getty, purchased in 1985 just as the Light & Space Movement became established. Moreover, the painting's sky-orange haze perfectly matches the atmosphere of the *10 Columns* exhibition. Dionysius is pointing up to an eclipse, the cessation of light, and using that 'not light' as an icon of divinity. This is because, for Dionysius, "the final encounter with God is the form of a 'luminous darkness'" (Schibille 190). The darkened sun in Caron's painting reminds us that Dionysius's God is "at once absolute darkness and absolute light" (Schibille 144). Interestingly, the concept of divine darkness is not found among Platonists but remains a Christian innovation (Schilbille 191). The implications for the discourse of race here should not be missed. And the same notion is appealed to by art critic Dan Cameron when describing Smith's work: "In contrast to typical installations by Turrell or Irwin, Smith employs darkness 'to overwhelm the normal parameters of human perception'" (30) (Figure 19.2).

**FIGURE 19.2** Antoine Caron, *Dionysius the Areopagite Converting the Pagan Philosophers*, 1570s. Oil on canvas. 92.7 × 72.1 cm (36 1/2 × 28 3/8 in.).

## Thessaloniki

Next, we move to the city of Thessaloniki, a scene of later developments in light mysticism that arose from the Dionysian mystical tradition, known as hesychasm, from the Greek word for silence. Thessaloniki is near the Holy Mountain, Mount Athos (Áyion Óros), an ancient and famous enclave of male Orthodox monasticism. These monks experimented in breathing techniques that we might fairly call a Christian form of yoga. They sought an inner light, believed to be viewed in the physical sphere on some occasions. Outrageously, Gregory Palamas asserts "this light is neither an independent reality, nor something alien to the divinity" (77).

This meant that monks who were enjoying these visions of light could see God, or at least God's energies. Gregory illustrated his claim using the classic icon of the Transfiguration, which was deeply significant to the hesychasts. The disciples in the icon's foreground are captured at the moment they witnessed the uncreated light. When this tradition of light mysticism was challenged by an emerging rationalism, it was Gregory Palamas who defended it, and who in turn became the bishop of Thessaloniki, where he lies in repose to this day. When we understand Gregory's imprint on the city, the significance of the Transfiguration mosaic in Thessaloniki's Church of the Holy Apostles, created just before the city's intellectual debate over the nature of light, can be more fully appreciated (Figure 19.3).

*Photograph in the public domain*

**FIGURE 19.3**  *Transfiguration,* Church of the Holy Apostles, Thessaloniki, 1310–14. Approximately 170 × 130 cm (66.93 × 51.18 in). Mosaic.

As one scholar puts it, "Transfiguration is the archetype of the experience of the hesychast," (Louth 90). The hesychast passes over from Christ "without form or beauty" (Isaiah 53:2) to "beauty beyond the sons of men" (Psalm 44:3) (Louth 91). Recalling the theology of Dionysius, for the hesychasts, "[H]oly light was the manifestation of the unity of the material and spiritual" (Andreopoulos 215). The mandorla (i.e. halo) of the Transfiguration has even been described as a mandala (Andreopoulos 235). The strange shapes within this mandorla encode the theology of the hesychasts, referencing the divine darkness of Dionysius as the shapes approach Christ himself (Strezova 94, 96). Perhaps the abstracted angles of triangular light in Light & Space artists such as Olafur Eliasson (*Ephemeral afterimage star*, 2008)[7] and Ann Veronica Janssens (*Yellow Rose*, 2007) can be viewed in a similar way. Not far from the space of Bridge Projects, the Holy Transfiguration Russian Orthodox Cathedral, similar in shape and size to the Church of the Holy Apostles in Thessaloniki, invites us to make hesychastic connections to Smith's *10 Columns* as well.

## Paris

Confusion between Pseudo-Dionysius and the 3rd-century martyred Parisian bishop, known as St. Denis, was responsible for bringing Dionysian light mysticism westward. It is no coincidence then that St. Denis, the Parisian church named after the martyr, is the church from which the light-filled Gothic movement began. In the first half of the 12th century, walls transformed from the standard 25% glass (at Santiago, for example) to a whopping 75% glass at St. Denis (Rudolph 66). "Bright is the noble work," reads the famous doorway inscription at St. Denis, "but, being nobly bright, the work/Should brighten the minds so that they may travel, through the true lights,/To the True Light where Christ is the true door" (Panofsky 23). The 20th-century art historian Erwin Panofsky's claim that St. Denis's connection to Pseudo-Dionysius was certain has admittedly been disputed.[8] Some have suggested Abbot Suger of St. Denis was not inspired by Dionysian light mysticism, but instead by "sensory saturation," and an "aesthetics of excess" (Rudolph 73, 75). Others insist it was the liturgy that served as the true motivation (Speer 69).[9] At the same time, the traditional connection to Pseudo-Dionysius at the church of St. Denis has been defended (Harrington 158–164).[10] In any event, the art historical attempt to disprove this connection has had the ironic result of showing just how available light mysticism of a Dionysian kind was on offer in other Latin sources, from Ambrose of Milan to the everyday church service (Speer 74). At the nearby Parisian Abbey of St. Victor, Hugh of St. Victor wrote a commentary on Pseudo-Dionysius in 1125, which was expanded upon in 1137 (Rudolph 35).[11] All this to say, whatever its source, light mysticism was not emerging from St. Denis alone.[12] It would be similarly misleading to attribute the entire Light & Space Movement to an individual figure like Larry Bell or Robert Irwin.

But art historical disputation should not keep us from making broad connections. When Abbot Suger wrote "the material conjoins with the immaterial, the

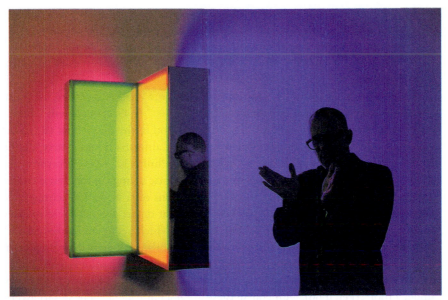

*Photo courtesy of the artist and Bridge Projects, Los Angeles. Photo: Gina Clyne*

**FIGURE 19.4** Phillip K. Smith III alongside his *10 Columns: Small-Small*, 2019. Aluminum, glass, LED lighting, electronic components, unique color choreography, 107 × 91 × 46 cm (42 1/8 × 35 1/8 × 17 3/4 in).

corporeal with the spiritual, the human with the divine" (Panofsky 121), this is not a far cry from "The Material of Immateriality" (Hanor 123) of the Light & Space Movement. The monks of St. Victor wrote movingly of "column symbolism and the related symbolism of church dedication" (Rudolph 36), which connects to the columnar spirituality of the first Bridge Projects exhibition. Richard of St. Victor talked about mirrors as a way of encountering oneself and God beyond the self (Richard 130). Similarly, Phillip K. Smith explains that in his work, "a new self-awareness of one's environment heightens the awareness of what is beyond the reflected self" (Smith, Philip K. 126). Which is to say, if they could have seen the columns and the mirrors in Smith's show, imbued with Dionysius' material mysticism, I expect the Victorines of Paris would have felt right at home.[13] All of 12th-century Paris was swimming in a spirituality of light, columns, and mirrors; and contemporary Los Angeles, enhanced with dozens of neo-Gothic churches and Light & Space artists, swims in such spirituality as well (Figure 19.4).

## Conclusion

My hope is that this chapter has refreshed American insularity by bringing other cities into conversation with the Light & Space Movement beyond the tired trope of Los Angeles's envy of New York. If the museum collections at the Getty conjure Dionysius's Constantinopolitan light mysticism, and the Orthodox or

neo-Gothic churches of Hollywood evoke Thessaloniki and Paris, such connections seem natural enough to me. References to these cities, and the theological currents that pulsed through them, remind us that the Light & Space Movement is less a regional peculiarity than a chapter in the much longer story of global light mysticism.

Even so, we must go beyond the city to make our final connection, for it was the desert where experiential light mysticism began.[14] In fact, in ancient Christianity so many renounced urban centers to seek God in the desert that the desert was itself called a city (Chitty). And it is in the California desert where Phillip K. Smith's aesthetic origins are as well (Smith, Phillip K. 124). "Prayer is the monk's mirror" (Wortley 75), reads one of the cryptic sayings of the desert fathers and mothers, something Smith's mirror installations offer as well, teaching us to "bear the beams of God's love" (Blake). The great desert ascetics were referred to as columns, "pillar[s] of light," (Wortley 111), which yet again evokes Smith's *10 Columns*. *The Los Angeles Times* described Smith's work at Bridge Projects as indoor sunrises (Pagel). Similarly, when Symeon the New Theologian was enjoying a light mysticism experience, he "could not tell whether he was in a house or under a roof" (Petcu 66).[15] Of course these are not equivalents. The desert ascetic or hesychast's mystical encounter with uncreated light should not be confused with the aesthetic experience of a Los Angeles gallerygoer. But on what grounds beyond residual secular prejudice can such connections be entirely ruled out?

## Notes

1 As a matter of full disclosure, I was a founding board member of Bridge Projects Los Angeles. This chapter derives from a talk I presented in conversation with Alexei Lidov, "Light from the Cave: Light in Sacred Space," December 10, 2019. https://www.bridgeprojects.com/programs/light-from-the-cave. Accessed October 27, 2021.

2 For Anderson, the theological is a category that absorbs, without nullifying, more constrictive understandings of the spiritual in art:

> A growing number of scholars are exploring the ways in which the histories of modern and contemporary art operate within a theological horizon. They generally affirm the anthropological, political, and spiritual dimensions of these histories but argue that the nexuses of art and religion are not adequately accounted for without attending to the complex theological contexts and implicit theologics in play throughout those histories.
>
> (Anderson "Visual Arts: Modern Art," 17)

3 The Art of Light and Space, Ambient Art, Environmental Art – these were the different candidates for the movement's name. The first of these designations appears to have triumphed, connected (but not limited) to California. It is far more than regional, enjoying wide influence, even a currency in the wider art world (Feldman 17–18).

4 In the rivalry schema, New York is cast as "material, concrete, retinal, anti-illusion, object-based, and self-referring" (Feldman), whereas Los Angeles is respectively "immaterial, indeterminate, sensorial, optical, ambient, and situational/experimental" (Feldman).

5  Needless to say this mysticism includes traditions beyond Christianity as well. For the purposes of this discussion, I have focused on Christian traditions. For light mysticism pursued from a variety of religious traditions, see Kapstein 2004. To see light mysticism updated in a modern frame with multiple religions in mind, but still departing from a Christian point of reference, see Huston Smith, 265–266.

6  It is usually forgotten that a woman named Damaris was converted in Acts 17 as well; perhaps we can imagine a future Pseudo-Damarian mysticism, evoking the light painting of Mary Corse, who points us to "something beyond the tangible… moving into the realm of the metaphysical" (Conaty 14). But for now at least, Dionysius has gotten most of the historical attention.

7  Olafur Eliasson's "readily acknowledged California [Light & Space] influence" (Feldman 82).

8  "If Pseudo-Dionysian light mysticism has been thought in the past to have been a primary force in the formation of Suger's art program, this is the result of a confusion of the various justifications of Suger in relation to Pseudo-Dionysian mystical theology in general, and of Suger's misleading evocation of it in relation to the traditional meditative function of religious art in particular. Light was never mentioned in relation to Pseudo-Dionysian light mysticism or the stained glass windows: it did not play a principal part in artistic change at St. Denis" (Rudolph 71).

9  Speer's appeal to the liturgy as an alternative explanation to the influence of Dionysius need not be understood as an alternative. Dionysius was informed by the liturgy and the liturgy by Dionysius: "There has hardly been a theology so deeply informed by aesthetic categories as the liturgical theology of the Areopagite" (Balthasar 154). Speer's use of "the stringent criteria of the historical-critical method" (Speer 68) leaves much to be desired. To reduce one's interpretive horizon to merely the historical leaves out additional interpretive domains helpfully elucidated in the same catalog in which Speer's essay appears (Hamburger 11–31). Speer's anxiety that "one's own, as well as the historical horizon can become intertwined" admittedly has its place, but so does Gadamer's felicitous *Horizontverschmelzung* (fusion of horizons).

10  After engaging those who seek to sever the connection point by point, Harrington concludes that

> [v]ery likely we find in Suger both the symbolic theology of Dionysius and the Victorines, as well as a new tendency to create the dematerialized place that the earlier Neoplatonists were content to discover in the landscape and to make that place identical with the sacred place.
>
> (Harrington 164)

11  It is not much of a stretch to say that in a town of under 3,000 people, Suger availed himself of Hugh's expertise (Rudolph 33).

12  "[V]on Simson was very much correct when he noted that although St-Denis was the prototype of the Gothic cathedrals, all of the major elements of Gothic architecture were already in existence by the time Suger began his rebuilding of that church… [it was] not so much the technical components of Gothic that defined its appearance at this moment as it was… the expression of some new religious experience" (Rudolph 74).

13  I expect Richard of St. Victor would also have felt at home in the light mysticism of Impressionism, which emerged in part from the Montmartre neighborhood, and perhaps even in the DADA movement that was retroactively named after Dionysius by its founder: "When I came across the word 'dada' I was called upon twice by Dionysius. D.A. – D. A.… Dionysius the Areopagite is the refutation of Nietzsche in advance" (Ball 210).

14  For the early desert mystic Evagrius of Pontus, formless light imagery is used to describe states of deep prayer, which nevertheless "resembles a sapphire; it is as clear and bright as the very sky." (Evagrius xci).

15 Although he lived in Constantinople, Symeon the New Theologian is often credited as the church father responsible for bringing the spirituality of the desert into the city.

## Bibliography

Ahmanson, Roberta. "Chair's Foreword." In *Bridge Projects: 10 Columns*, edited by Cara Lewis and Linnéa Spransey. Los Angeles: Bridge Projects, 2019.

Anderson, Jonathan A. "Visual Arts: Modern Art." In *Oxford Research Encyclopedias, Religion*. Oxford University Press, 2021, 1–23.

Anderson, Jonathan A., and William A. Dyrness. *Modern Art and the Life of a Culture*. InterVarsity Press, 2016.

Andreopoulos, Andreas. *Metamorphosis: The Transfiguration in Byzantine Theology and Iconography*. St. Vladimir's Seminary Press, 2005.

Ball, Hugo. *Flight out of Time: A Dada Diary*. Edited by John Elderfield, translated by Ann Raimes. University of California Press, 1996.

Balthasar, Hans Urs von. *The Glory of the Lord: A Theological Aesthetics II: Studies in Theological Style: Clerical Styles*. Ignatius Press, 1984.

Blake, William. *Songs of Innocence and of Experience*, ebook: https://www.gutenberg.org/files/1934/1934-h/1934-h.htm. Accessed October 29, 2021.

Cameron, Dan. "Primordial Light." In *Bridge Projects: 10 Columns*, edited by Cara Lewis and Linnéa Spransey. Los Angeles: Bridge Projects, 2019.

Chitty, Derwas. *The Desert a City*. St. Vladimir's Theological Seminary Press, 1977.

Coakley, Sarah and Stang, Charles. *Re-thinking Dionysius the Areopagite*. Wiley-Blackwell, 2009.

Conaty, Kim, ed. *Mary Corse: A Survey in Light*. Whitney Museum of American Art, 2018.

Davies, Hugh. Foreword to *Phenomenal: California Light, Space, Surface*, by Robin Clark. University of California Press, 2011.

Evagrius Ponticus. *The Praktikos & Chapters on Prayer*. Translated by John Eudes Bamberger, OCSO. Cistercian Publication, 1981.

Feldman, Melissa. *Another Minimalism: Art after California Light and Space*. Reaktion Books, 2015.

Florensky, Pavel. *Beyond Vision: Essays on the Perception of Art*. Edited by Nicoletta Misler, translated by Wendy Salmond. Reaktion Books, 2002.

Govan, Michael. "Michael Govan on Dan Flavin." Lecture presented at the Sunset Speaker Series, Bridge Projects, Los Angeles, CA, October 25, 2019.

Hamburger, Jeffrey F. "The Place of Theology in Medieval Art History: Problems, Positions, Possibilities." In *The Mind's Eye: Art and Theological Argument in the Middle Ages*, edited by Jeffrey F. Hamburger, and Anne-Marie Bouché. Princeton University Press, 2006.

Hanor, Stephanie. "The Material of Immateriality." In *Phenomenal: California Light, Space, Surface,* edited by Robin Clark. University of California Press, 2011.

Harrington, L. Michael. *Sacred Place in Early Medieval Neoplatonism*. Palgrave Macmillan, 2004.

Kosky, Jeffrey. *Arts of Wonder: Enchanting Secularity*. University of Chicago Press, 2016.

Louth, Andrew. "Light, Vision, and Religious Experience in Byzantium." In *The Presence of Light: Divine Radiance and Religious Experience*, edited by Matthew T. Kapstein, 85–104. University of Chicago Press, 2004.

Nes, Solrunn. *The Uncreated Light: An Iconographical Study of the Transfiguration in the Eastern Church*. Wm. B. Eerdmans Publishing Company, 2007.

Pagel, David. "Review: This Artist Re-Created Sunrise, Indoors. Walk through the Mind-Blowing Room Yourself." *Los Angeles Times*, October 31, 2019. https://www.latimes.com/entertainment-arts/story/2019-10-31/phillip-k-smith-10-columns-bridge-projects.

Palamas, Gregory. *The Triads*. Translated by John Meyendorff. Paulist Press, 1983.

Pelikan, Jaroslav. "The Odyssey of Dionysian Spirituality." In *Pseudo-Dionysius: The Complete Works*. Translated by Colm Luibheld and Paul Rorem. Paulist Press, 1987.

Petcu, Livi. "The Experience of God's Light in the Texts of Saint Symeon the New Theologian." *Romanian Journal of Artistic Creativity*, Vol. 9, Issue 1, 2021.

Pseudo-Dionysius. *Pseudo-Dionysius: The Complete Works*. Translated by Colm Luibheld and Paul Rorem. Paulist Press, 1987.

Richard of St. Victor. Grover A. Zinn, editor. *The Book of the Patriarchs, The Mystical Ark. Book Three of the Trinity*. Paulist Press, 1979.

Rudolph, Conrad. *Artistic Change at St-Denis*. Princeton University Press, 1990.

Schibille, Nadine. *Hagia Sophia and the Byzantine Aesthetic Experience*. Ashgate Publishing, 2014.

Smith, Huston. *Why Religion Matters*. HarperOne, 2006.

Smith, Phillip K., III. *Five Installations*. Laguna Art Museum and Grand Central Press, 2017.

Speer, Andreas. "Is There a Theology of the Gothic Cathedral? A Re-reading of Abbot Suger's Writings on the Abbey Church of St.-Denis." In *The Mind's Eye: Art and Theological Argument in the Middle Ages*, edited by Jeffrey F. Hamburger and Anne-Marie Bouché. Princeton University Press, 2006.

Strezova, Anita. *Hesychasm and Art*. ANU Press, 2014.

Suger, Abbot. *Abbot Suger: On the Abbey Church of St-Denis and its Art Treasures*. Edited, translated, and annotated by Erwin Panofsky. 2nd ed. by Gerda Panofsky Soergel. Princeton University Press, 1979.

Viola, Bill. *Reasons for Knocking at an Empty House*. Edited by Robert Violette. The MIT Press, 1995.

Wortley, John. *The Anonymous Sayings of the Desert Fathers: A Select Edition and Complete English Translation*. Cambridge University Press, 2013.

# 20

# PERFORMATIVITY AND THE FLESH

## The Economy of the Icon in Lia Chavez's *Light Body*

*Julie M. Hamilton*

Midway through Paolo Sorrentino's visually sumptuous and Felliniesque film *The Great Beauty* (2013), a grand soirée is held at a Roman estate.[1] There, a young artist is forced by her parents to perform and paint before a live audience. The guests are among Italy's most esteemed patrons. Through her tears, she paints for greedy eyes, becoming a marketable commodity exploited by her wealthy parents. The decadent fete is a painful tableau, inviting the gaze of the guests to ogle the uncomfortable spectacle. Critiquing the bacchanal, the protagonist Jep Gambardella perceives the frantic desperation beneath the glittering surfaces of high society – the "blah, blah, blah," as he calls it – and exits the noisy affair. In this scene, Sorrentino shows us performance art's perpetual threat of devolving into spectacle – a beauty that is deeply damaged and objectified – while concurrently illustrating its powerful potential to serve as icon.

This essay considers the performance *Light Body* by the artist Lia Chavez, a practitioner of contemporary performance and embodied art.[2] Chavez employs ascetic disciplines, meditation techniques, and habituated neurological training in hyperconsciousness alongside religious practices culled from Tibetan Buddhism and Christian mysticism. Her ascetic commitments, I suggest, place her in the historical lineage of monastics and saints, whose lives might be read as early forms of performance art.

Actress and activist Isabella Rossellini commissioned Lia Chavez's *Light Body* as the inaugural performance on her farm in Brookhaven, New York.[3] On an unusually warm July evening, she opened her grounds to host the performance, offering the invited guests garden fare and glasses of rosé, of which I am happily obliged. The attendees were adorned in summer finery – maxi-length florals and crisp, white linens. Each spectator was presented with a handsome catalogue featuring art critic Andrea Codrington Lippke's thoughtful essay on *Light Body*, "Foolish Fire, Holy Fools and Thoughtful Paths" superimposed on top of

DOI: 10.4324/9781003326809-24

Chavez's *Ascent* ink-transfer prints.[4] At sunset, Rossellini gathered the guests at a semicircle of blankets in a clearing near the edge of the woods. Directing us to sit facing a dirt path, Rossellini invited us to participate in a guided meditation to clear our minds – a practice that she had learned from filmmaker David Lynch, her former partner. As twilight faded into dusk, Rossellini asked us to open our eyes, which needed to adjust to the darkening horizon. Far off in the distance, I spotted several faint flickers of light, like multicolored fireflies.

As I squinted to better observe the beginning of the performance, I found myself frustrated: I could not see the choreographed dance steps, the exquisite costumes, the vibrant makeup. Enshrouded by the forest, the carefully curated performance was hardly perceptible to my naked eyes. Why go to such lengths to create something intricate that simply could not be seen? Slowly, I began to discern three fluid bands of variegated colors swirling in tandem beyond the trees. Barefoot, I got up from my place on the blanket and walked to the edge of the path, trying to see more of this *Light Body*. Gradually, the soft light moved closer toward me, the sounds of cicadas and crickets wafting through the humid summer air. Three silhouetted figures progressed from right to left, toe-heel, toe-heel, on the unlit path. These three graces moved together in synchronistic unity, as if a single organism, exhibiting the poise of ballerinas. In their lithe arms, LED track lights became effervescent light sculptures, morphing into geometric shapes and genetic helixes.

As I strained to catch sight of the exquisite couture designed by Mary Katrantzou, I began to understand that the limited visibility of the performance was not an oversight.[5] In initially struggling to grasp the vision of light and make sense of what I was seeing, I found myself witnessing a phenomenon yet nonetheless unable to apprehend the thing seen. As my eyes adjusted, however, I began to see each dancer separately: Lia Chavez, Troy Ogilvie, and Djassi daCosta Johnson, each appareled differently.[6] Their heavy breathing increased as they moved toward me – spinning, reeling, twirling, sculpting the night air with kaleidoscopic lassoes, their bands imprinting afterimages of light in the night sky. Finally, the trio of sweaty dancers paused and faced us in a staggered line. Synchronizing their rainbow bands in 360-degree spirals, their motions resembled a thurifer, as if they were swinging incense in around-the-world clockwork circles; a sumptuous *mise-en-scène* (Figure 20.1).

Lia Chavez is always performing. Whether she is meditating in a gallery for eight hours on end, not speaking for forty days, collaborating with neuroscientists in a London laboratory, or meeting me for cocktails at the Mercer Hotel, she knowingly conducts her dancer-like form on the stage of the world and is perfectly herself.[7] Indeed, she seems to inhabit a mythic and fantastical realm – adorned in caftans and headdresses, dramatic eye makeup swathed on her alabaster complexion. Far from pretentious, her effervescence and warmth are disarming, her sincerity and hospitality lush. I am continually surprised by the unforeseen excess of her radiant presence, exuding a beauty that nurtures me.

*Photo documentation by Ira Lippke. © Lia Chavez Studio*

**FIGURE 20.1**  Lia Chavez, *Light Body*, July 23, 2016, performance. Featuring perform-
ers Lia Chavez, Djassi deCosta Johnson, and Troy Ogilvie. A commis-
sion by Isabella Rossellini. Presented at Mama Farm in Brookhaven
Hamlet, NY. Curated by Tali Wertheimer. Produced by Nur El Shami
and Beverly Allan. Costuming by Mary Katrantzou. Beauty by Vir-
ginia Linzee. Styled by Richard Ives.

Even her home adds to this sense of theatrical cohesiveness. The newly reno-
vated house and studio on Long Island functions like a James Turrell light sculp-
ture. A floor-to-ceiling vision in soft white, the minimalist architecture features
glass skylights between the first and second floors that flood her domestic mon-
astery with Zen-style lighting. The structure acts as a kind of sundial, featuring
light more or less prominently at particular stages of the day. That Chavez should
transform her dwelling into an installation comes as no surprise: light is her

primary medium, other than her own body. Her father studied under the astrophysicist and cosmologist Carl Sagan, inculcating her with a love for the celestial heavens and the intersections of science and art. As a result, her knowledge of astronomy and fascination with the cosmos are grounded in serious aesthetic questions about the human body.[8]

Preparation for this commission led Chavez to India to study contemplative walking, the foundation for all other iterations of yoga practice, from the Himalayan yoga and raja-yoga traditions as taught by Swami Rama and Swami Veda Bharati.[9] By reducing yoga to body and breath, this practice unites mindful contemplation and diaphragmatic breathing. Chavez's method incorporates slow walking, toe-to-heel, in equal pace, while simultaneously inhaling one count, exhaling two counts. Mantras, or sacred utterances, are paired with each breath to maintain focus and concentration. Often just a word or sound, these mantras are said in repetition, calming the mind and opening the heart. Together, these religious prayer patterns form the underlying structure of Chavez's *Light Body* performance.

Returning from her training in India, Chavez took a vow of silence for forty days. These ascetic parameters proved difficult when planning and rehearsing without the aid of verbal communication between Chavez and her production team. Nonetheless, it invited them to engage in creative methods using their bodies as primary vehicles for translation and interpretation. Drawing upon the yogic template, Chavez developed her six-part choreographic method specifically for *Light Body*. First, steps 1 and 2 establish the breath and the walk, followed by step 3, which meters and synchronizes inhalation and exhalation; step 4 incorporates the mantra "love" with the breath inhalation and the mantras "light" and "surrender" with the exhalation. These mantra-laden breath cycles continue until the dancer is able to advance to step 5, what Chavez describes as philosophical contemplation, in which the mind asks the self a question or query and is able to encounter mental and physical release. Ultimately, metaphysical contemplation is possible in step 6 if the mind and body simultaneously unite as a "moving mantra," wherein, Chavez says, "exertion becomes cathartic and medicinal." Each of these steps gradually builds on the other and is exponentially self-emptying. The overall goal is transfiguration, or enlightenment – the stage associated with "light bodies."[10]

A light body in Tibetan Buddhism describes the electromagnetic fields or "auras" emitted from the body (otherwise described by scientists as neural networks) (Crow). This rainbow body is a phenomenon ascribed to Buddhist saints and sages in which the body of a holy figure posthumously transforms into rainbows of color, testifying to the saint's transcendence. In Christianity, we might think of the rosary's luminous mysteries, where we encounter the narrative depictions of both the transfiguration and resurrection of Christ. For Chavez, this phenomenological concept of a rainbow body is concretely captured in the prism, a mirror that receives white light and refracts colored light. She has explored iterations of the prism through many mediums prior to *Light Body*,

ranging from photographs in *A Thousand Rainbows* to her meditative nightclub installation *The Octave of Visible Light,* all attempting to represent her light visions through artistic forms.

Over a period of years, Chavez has worked extensively with a team of neuroscientists at Goldsmiths, University of London, as the subject for its research associated with creativity in the brain.[11] By allowing neuroscientists to monitor her neural activity under varying states of meditation, Chavez has not only aided in pinpointing the cranial geography of imagination and artistic creativity but also in underlining the distinctive types of waves the brain transmits during meditation. By assessing Chavez's brain-wave correspondence to her spontaneous mental imageries, a team of researchers has been able to map how imagination is linked to creativity in the brain. Practicing two main types of meditation – stabilizing and analytic (as described above) – Chavez achieves gamma-wave states that generate visions akin to "psychedelic phosphine hallucinations" (Codrington Lippke, "Foolish Fire"). Chavez relates that she witnesses something analogous to the moment of conception – the neurological nexus of artistic creativity. These fractal patterns and "mental meteorologies," as Chavez describes them, echo other forms of conception in the universe: the birth and death of stars, biomorphic phenomena, the growth of organisms, and geometric patterns. From her meditative visions, the research team at Goldsmiths has been able to explore the potential of gamma waves, which scientists are now calling the "dark matter of consciousness" (Crow). So, we might ask, how do these meditative visions precisely situate Lia Chavez within the contemporary world of performance art? Not only is it through her ascetic practices that she is able to encounter her mental pictures, but her ascetic commitments place her in the historical lineage of monastics and saints, who I suggest might be read as early forms of performance art.

In her book *Postmodern Heretics: The Catholic Imagination in Contemporary Art* (2004), art critic Eleanor Heartney discusses performance artists who borrow from specific religious practices, liturgies, prayers, and bodily disciplines in their work. These artists have been overwhelmingly female – think of Carolee Schneemann, Yoko Ono, and Coco Fusco.[12] Each of these women invokes her body as an ephemeral mode of communication, a text and locus of meaning-making, reacting against patriarchal models of museum collecting, which are primarily object-based. Yet, the practices themselves participate in a historical lineage of ascetic disciplines, situated primarily among monastics and saints. By acknowledging performance art's codified evolution out of painting into actions, we might find it fitting to consider an older form of performance that predates the twentieth century, by examining the lives of mystics and holy fools.

Like performance artists, mystics and monastics from the Christian tradition often found themselves in tension with bureaucratic and ecclesial hierarchies, as they employed ascetic and often bizarre practices in efforts to reform the church. With many women occupying these roles, think Hildegard of Bingen, Julian of Norwich, Teresa of Avila, religious women have played significant roles

in challenging authoritative influences among their communities.[13] Mystics, monastics, and martyrs read the dramatic narrative of Christ's life as a play to be reenacted and performed, *imitatio Christi*, often quite literally through flagellation, self-mutilation, and excessive fasting.[14] We now see echoes of these actions in works by performance artists such as Marina Abramović, Hermann Nitsch, and Chris Burden (among others).[15] I draw attention to these artists not to claim any sort of value judgment on their actions but rather to acknowledge that *both* saints and performance artists have participated in strange, ritualistic, and often masochistic actions that test the body's endurance and limitations.

In considering this synthetic connection between contemporary performance art, especially in the context of Chavez and her *Light Body*, and the performativity of saints' lives, I am drawn to Gregory of Nyssa's *Life of Macrina*, in which he provides a hagiographic account of his sister Macrina, a fourth-century monastic. Nyssen, a rhetorically trained bishop, reimagines and articulates the virtuous life of his sister as playing the role of Socrates in Plato's *Symposium*, who is the embodied voice of wisdom. Nyssen emphasizes that Macrina's beauty was unsurpassed – she could have married well and had an economically and socially secure life, yet she turns away suitors, devoting her life to her community, her family, the poor, and, above all, God.

At one point in the account, Macrina discovers a dangerous tumor near her heart, but rather than undergoing a life-threatening surgical procedure, she *performs* the scene from the Gospels in which Christ heals the blind man. Mixing "a mud salve of earth and tears," she applies it to her breast, and then asks her mother to make the sign of the cross over her breast (Carnes 242). She is miraculously healed, and the tumor is replaced with a small scar – a sign or stigma of her flesh witnessing to "wounded love." In depicting these events, Nyssen extols Macrina's faith, arguing that her virtues indicate sainthood.

Nyssen also writes of a dream he has before Macrina's passing: "I seemed to be carrying the relics of martyrs in my hand and a light seemed to come from them, as happens when the sun is reflected on a bright mirror so that the eye is dazzled by the brilliance of the beam" (*Life of Macrina*, 163–91). With this vision, he anticipates her passing, made acutely aware of her life as holy. At sunset before her death, Macrina ends her life with a meditation, offering hymns to God as she witnesses the "beauty of the Bridegroom." As Nyssen observes Macrina's body being prepared for her funeral, he places his mother's veil over her corpse with the help of his sister Vetiana, and observes a unique phenomenon: "In the dark, the body glowed, the divine power adding such grace to her body that as in the vision of my dream, rays seemed to be shining forth from her loveliness" (*Life of Macrina* 186). This description of Macrina's corpse is not unlike our discussion of a light body – in that like the virtuous Buddhist figures, her body posthumously glows. Here, Nyssen portrays the body as a medium for divine beauty, a "mirror" reflecting and radiating light.[16]

Natalie Carnes has noted in her book *Beauty: A Theological Engagement with Gregory of Nyssa* that "[Nyssen's] text never lets the reader leave the beauty of

bodies. It continually returns to them, the final instance of a beautiful body the most compelling, pointing not to possibilities for worldly acclaim, but to divine power and grace. Macrina's body remains bodily but has been transfigured into a sign of divine presence" (66). Macrina's luminosity cannot be concealed but continues to reveal itself to the witnessing community. Carnes reminds us, however, that Macrina's beauty *is* represented in Nyssen's rhetoric. His textual narration celebrates her body as a kind of text, and as a relic and an icon.

Since late antiquity, the icon has served as the primary medium of a visual culture in which religion, art, and politics overlap. Whether they depict Christ, such as *Christ Pantocrator* at St. Catherine's Monastery at Sinai (6th century CE), or Byzantine emperors, like the Justinian and Theodora mosaics at the Basilica of San Vitale in Ravenna (547 CE), icons make figures present to the viewer. Debates in the eighth century over the legitimacy of representing God in matter raged between the iconoclasts and iconodules. Following theological defenses of the icon by both John Damascene (675–749 CE) and his protégé Theodore the Studite (759–826 CE), the church affirmed that icons are analogous to the incarnation and hypostatic union of Christ's divine and human natures. Thus, the icon's modality is a correspondence between the viewer and the viewed, allowing the gaze of the beholder to ascend to the prototype by means of material and relational representation. In essence, an icon makes present and, indeed, *performs* what is unseen.

Christian theologians have described the icon as elastic, such that it may be extended to other artistic forms, including the work of poets such as Gerard Manley Hopkins and Denise Levertov, composers such as J.S. Bach and James MacMillan, and film directors such as Andrei Tarkovsky and Ingmar Bergman.[17] But what about performance art? Theater, certainly, is engaged with aspects of incarnation, especially through mimesis, when an actress inhabits a character and performs that character to the degree that she no longer resembles herself. But *performativity* and *embodied art* get at something different entirely – the person performing is not concerned with verisimilitude but rather, and perhaps more importantly, with depicting dimensions of the self in a nonfictional, often unscripted manner, in the form of her own human flesh.

Paul Griffiths, who draws from the work of phenomenologist Jean-Luc Marion, provides a helpful schema for understanding the correspondence between icons and flesh in his book *Intellectual Appetite: A* Theological Grammar (2009). An icon, Griffiths explains, represents the beauty of the created order and signifies something other than itself, pointing its viewers to something beyond itself. We might find such iconicity in the inexhaustibility of a human face. In this context, the face functions as a kind of mirror, both to the viewer's gaze and to that which it reflects. When the viewer gazes at this face as icon, what she sees is neither static nor arrested, but nourished – she is thereby seduced deeper into its beauty. For Griffiths, things are iconic in so far as they are close to Christ's body. Sometimes, this proximity is intimate, and other times, it is distant (Griffiths 190–92).

Why should Christ's body have a special relationship to the icon? For the Christian, the fleshly body bears the image of God, and through that incarnation, God has made human flesh iconic, regardless of the damage it has incurred. This conviction that human flesh can never cease to be iconic follows from Augustine's Platonic logic: in so far as something exists, it participates in being and thereby participates in God. To not participate in God is to cease to exist, and one cannot irradiate one's iconicity without remainder. That is to say, one cannot be damaged beyond one's ability to be iconic (Griffiths 191).

For Griffiths, as for Marion, the flesh is a lived icon that is saturated and inexhaustible: that is to say, the body is a site of overwhelming givenness, a vehicle in time and space of the unforeseen. The face serves as the endless hermeneutic, the visible in excess. The face is not an abstraction or a concept; it is not beauty or idea. The face is envisaged in me. I know a face because I face it.[18] Consequently, the face, and therefore the flesh, is an icon par excellence.

While Chavez does not necessarily share Macrina's forms of *askesis* (i.e., her vow of poverty and virginity), their performative lives are shaped by shared religious practices. As a bearer of human flesh, the saint Macrina participates maximally in the archetype of the icon. Imagining Macrina's life as a performance, we can reconsider Nyssen's narrative in terms of her bodily practices and rituals. She performs her ascetic commitments to poverty, chastity, and obedience as a monastic way of life. These disciplines afford her a spiritual intimacy and supernatural wisdom that her brother notes as praiseworthy and desirable – in fact, Nyssen describes Macrina as his spiritual mother (Carnes 214). Her life is iconic because, through her body, it bears witness to something beyond itself. Her body is consecrated as a vessel that exhibits holiness and luminosity.

Chavez, too, participates in the modality of the icon, intuiting and perceiving mystical experiences, performing them through artistic mediums in the gallery, the forest, and the monastery. By probing the inner landscapes of her mind, she harnesses creative insights that inspire fresh connections between art and science, stemming from religious consciousness. Deploying this consciousness as an artistic material, she offers her flesh as a conduit or mirror, a prism refracting light.

In the final canto of Dante Alighieri's *Paradiso* (early 14th-century CE), the poet describes the experience of beholding a luminous substance, which appears to be three overlapping circles of differing colors in a singular dimension:

> In the deep and bright essence of that exalted Light, three circles appeared to me; they had three different colors, but all of them were of the same dimension; one circle seemed reflected by the second, as rainbow is by rainbow, and the third seemed fire breathed equally by those two circles (Hollander, 33:114–20).

The longer Dante looks into the light, the more his eyes begin to adjust, seeing more clearly. As his gaze intensifies, the light takes on nuance, difference, multivalence, and *color*. Chavez explained to me that "Dante's *Paradiso* has perhaps been

the greatest influence to my thinking around light mysticism....It has afforded me a classical and poetic foundation for addressing the paradox occurring when the vision of the natural eyes is fused with the vision of the inner eyes."[19] Through her *Light Body*, Chavez offers us the mystery of light – unharnessable, uncommodifiable, uniquely experienced light, a prism refracting a rainbow. Indeed, Ira Lippke's film documentation of the *Light Body* performance captures the three dancers as a trio of intersecting circles, a multicolored Venn diagram, precisely as Dante has described (Figure 20.2).

In a letter Gregory of Nyssa writes to Macrina's brother Peter, he discusses the natural phenomenon of the rainbow as an analogy to the Christian claim that God is triune. The prism, he writes, encounters white light, one indivisible substance, and refracts from it a spectrum of colored light: "there occurs a kind of bending and return of the light upon itself, for the radiance reflects back" (Letter 35 to Peter, 256). *Light Body*, then, not only pictorializes a bodily phenomenon from Tibetan Buddhism but also renders the logic of the icon in the very media it employs – fleshly bodies and colored light. In this way, Chavez not only mirrors the light from her internal visions into her collaborative dance performance, but

*Photo documentation by Ira Lippke. © Lia Chavez Studio*

**FIGURE 20.2**  Lia Chavez, *Light Body*, July 23, 2016, performance. Featuring performers Lia Chavez, Djassi deCosta Johnson, and Troy Ogilvie. A commission by Isabella Rossellini. Presented at Mama Farm in Brookhaven Hamlet, NY. Curated by Tali Wertheimer. Produced by Nur El Shami and Beverly Allan. Costuming by Mary Katrantzou. Beauty by Virginia Linzee. Styled by Richard Ives.

by doing so, she offers us an imaginative play on Dante's beatific vision. Consequentially, her triptych of intersecting rainbows in *Light Body* speaks not only to light's marvelous capacity for refraction but also to the body's iconic performativity in a triune God.

## Notes

1 *La Grande Bellezza* ("*The Great Beauty*"), directed by Paolo Sorrentino (Indigo Film, 2013), DVD.
2 This chapter was adapted from a paper presented at the Association of Scholars of Christianity in the History of Art Symposium, the Union League Club, New York, NY, in February 2017. It was subsequently published under the same title "Performativity and the Flesh: The Economy of the Icon in Lia Chavez's Light Body," in *The Other Journal: Identity*, Volume 27(Wipf and Stock, 2017), pp. 52–61.
3 Lia Chavez, *Light Body*, July 23, 2016, performance. Featuring performers Lia Chavez, Djassi deCosta Johnson, and Troy Ogilvie. A commission by Isabella Rossellini. Presented at Mama Farm in Brookhaven Hamlet, NY. Curated by Tali Wertheimer. Produced by Nur El Shami and Beverly Allan. Costuming by Mary Katrantzou. Beauty by Virginia Linzee. Styled by Richard Ives. Photo documentation by Ira Lippke.
4 Chavez's *Ascent* (2016) ink transfer prints were made in conjunction with the *Light Body* performance. Chavez scribbled, shaded, and stepped onto white paper with black ink, creating minimalist, semi-abstract shapes for the backdrop and cover of the *Light Body* catalogue (my edition is 38/100).
5 Mary Katrantzou is a Greek fashion designer known as "the Queen of Prints" known for her use of patterns and explosive color. Her three differing garments commissioned for this performance echo the rainbow of light used by the dancers.
6 Troy Ogilvie is a New York-based dancer and choreographer, as well as founding collaborator, faculty member, and program manager of the Movement Invention Project. Djassi daCosta Johnson is a native New Yorker based in the US Virgin Islands as an assistant dance professor, choreographer, photographer, filmmaker, and doula.
7 The Mercer is a luxury boutique hotel in the SoHo neighborhood of Manhattan. A Romanesque revival structure from the 19th century, it is known for its chic guests and buzzy atmosphere, as well as Chef Jean-Georges Vongerichten's restaurant, Mercer Kitchen.
8 For more on Lia Chavez's use of bodily know-how, particularly in relation to Maurice Merleau-Ponty's notion of *praktognosia* as the body's primary somatic epistemology in ascetic practices and performance art, see my article "Doing as Knowing: The Performance Art of Marina Abramović and Lia Chavez," *SEEN*, vol. 15, no. 2 (2015): 28–33.
9 Swami Veda Bharati is the founder of the Association of Himalayan Yoga Meditation Societies International. Swami Rama was his mentor and teacher of Himalayan Yoga and Meditation, who emphasized "when you walk it should look like dancing" ("Foolish Fire, Holy Fools and Thoughtful Paths").
10 *Light Body* choreographic method as told to me in personal correspondence with Lia Chavez, February 8, 2017.
11 Lia Chavez received her Masters in Photography at Goldsmiths, University of London in 2005, as well as a Masters of Philosophy in Visual Art in 2010.
12 These three female artists in particular were paramount to the history of feminist performance art. Several prominent pieces include the following: Carolee Schneemann's *Meat Joy* (1964) and *Interior Scroll* (1975); Yoko Ono's *Lighting Piece: Light a Match and Watch Till It Goes Out* (1955), and *Cut Piece* (1964); and Coco Fusco's *The Year of the*

*White Bear and Two Undiscovered Amerindians Visit the West, Performance* (Minneapolis, MN: Walker Art Center, 1992–1994).

13 Hildegard of Bingen (1098–1179 CE) was a German Benedictine Abbess during the High Middle Ages that studied herbology, philosophy, and composed music. Hildegard wrote numerous texts, among them *The Book of Divine Works, Physica,* and *Illuminations.* Julian of Norwich (1343–after 1416 CE) was an English anchoress, known for her texts *Revelations of Divine Love* and *The Showings.* Teresa of Ávila (1515–1582 CE) was a Spanish Discalced Carmelite nun and doctor of the Catholic church, known for her *Interior Castles* and *The Way of Perfection.* All three women identified as mystics and are canonized as saints in the Catholic church. It is significant to note that Hildegard especially has inspired Chavez's artistic practice, as her newest project *Hildegaard Haute Botanical* is a luxury skincare creative house oriented around photosynthesis and light mysticism.

14 For the Middle Ages, participating in Christ's passion was interpreted as various forms of self-inflicted voluntary suffering, fasting, and abstinence. Flagellation was especially popular in the 13th century, encouraged as a form of self-mortification to atone for one's sins. Francis of Assisi (1181 or 1182–1226 CE) inherited Christ's stigmata, five marks resembling the visceral wounds in the hands, feet, and side of Jesus. Saints such as Catherine of Siena (1347–1380 CE) practiced anorexia mirabilis, understood by her contemporaries as "holy fasting," where one abstains from all food other than the consecrated host. These beliefs in a sacred masochism were in hope of suppressing the appetites of lust and other vices to bring one closer to God.

15 Balkan-born Marina Abramović (b. 1946) is considered the godmother of performance art. Drawing upon her Communist upbringing, Orthodox liturgy, and Tibetan Buddhist meditation practices, her works challenge the limitations of the body, particularly in *Rhythm 5* (1974) and *Seven Easy Pieces* (2005). Austrian multimedia artist Hermann Nitsch (1938–2022) was a Viennese Actionist, who combined performance and painting with flesh and blood in his bacchanalian *Orgies Mysteries Theatre* (mid-1950s), a form of mystical ritual, reminiscent of Greek Tragedy and the crucifixion of Jesus. Chris Burden (1946–2015) was pivotal to the 1970s performance art scene in Los Angeles, known for subjecting himself to risky and violent performances, such as *Shoot* (1971) and *Trans-fixed* (1974).

16 Nyssen uses the language of the *mirror* in his symbolic terminology for the body and the soul. See J. Warren Smith, *Passion and Paradise Human and Divine Emotion in the Thought of Gregory of Nyssa* (Crossroad, 2004).

17 English poet Gerard Manley Hopkins (1844–1889 CE); British-American poet Denise Levertov (1923–1997); German composer J.S. Bach (1685–1750 CE); Scottish Composer James MacMillan (b. 1959); Russian filmmaker Andrei Tarkovsky (1932–1986); Swedish filmmaker Ingmar Bergman (1918–2007).

18 See Marion, *The Crossing of the Visible,* translated by James K.A. Smith (Stanford University Press, 2004).

19 As told to me in personal correspondence with Lia Chavez on February 8, 2017.

## Bibliography

Carnes, Natalie. *Beauty: A Theological Engagement with Gregory of Nyssa.* Cascade, 2014.

Chavez, Lia. *The Octave of Visible Light: A Meditation Nightclub,* 2015. Participatory installation and performance. Presented by Art Production Fund at The Cosmopolitan of Las Vegas. Featuring an original multimedia biofeedback meditation technology co-invented by Lia and rehabstudio.

Chavez, Lia, and Andrea Codrington Lippke. *Light Body Catalogue.* Lia Chavez Studio, 2016.

Chavez, Lia, Andrea Codrington Lippke, and Mark Sprinkle. *A Thousand Rainbows.* Damiani, 2013.

Crow, Kelly. "Artist Lia Chavez Lends Her Mind to Science," *Wall Street Journal,* October 18, 2016. https://www.wsj.com/articles/artist-lia-chavez-lends-her-mind-to-science-1476799598.

Dante, *Paradiso,* translated by Robert Hollander and Jean Hollander. Anchor, 2007.

Fineberg, Jonathan David. *Art since 1940: Strategies of Being.* H.N. Abrams, 1995.

Gregory of Nyssa. "Letter 35 to Peter His Own Brother on the Divine Ousia and Hypostasis," in *Gregory of Nyssa: The Letters – Introduction, Translation, and Commentary,* translated by Anna M. Silvas. Brill, 2007.

——. "The Life of Saint Macrina," in *Saint Gregory of Nyssa: Ascetical Works,* translated by Virginia Woods Callahan, *Fathers of the Church,* Vol. 58. Catholic University of America Press, 1967.

Griffiths, Paul J. *Intellectual Appetite: A Theological Grammar.* Catholic University of America Press, 2009.

Heartney, Eleanor. *Postmodern Heretics: The Catholic Imagination in Contemporary Art.* Midmarch Arts, 2004.

*La Grande Bellezza* (*"The Great Beauty"*), directed by Paolo Sorrentino. Indigo Film, 2013.

Smith, J. Warren. *Passion and Paradise Human and Divine Emotion in the Thought of Gregory of Nyssa.* Crossroad, 2004.

# 21

# THEASTER GATES AND THE GOOD USE OF FORGOTTEN THINGS

*Donato Loia*

In a somber, procession-like pace, a choir resonates throughout the Milwaukee Art Museum. "These speakers were made for thumping / hallelujah," sings the choir.[1] Singers' tones are joyful and proud. Their song imbues the museum with an atmosphere of sacrality. With its gigantic wings and cruise ship-like appearance, the Milwaukee Art Museum is a secular temple so grandiose in sculpture that it might upstage the art it exhibits and the events it hosts. It seems that the museum could have been built in Milwaukee, Shenzhen, or Abu Dhabi. Designers of this museum attended to the spectacularized power of the structure's architecture over its human scale. In 2010, that procession-performance introduced audiences to artist Theaster Gates' exhibition *To Speculate Darkly: Theaster Gates and Dave the Potter*. With this exhibition, Gates honors Dave the Potter – or Dave Drake, a slave in antebellum South Carolina who made stoneware pottery adorned with poetic couplets. Gates conceives this exhibition as a celebration of all invisible laborers suffering within unjust social and economic systems. Simultaneously, Gates sheds light on the exclusion of Black potters from the canon of ceramic art history.[2] Although *To Speculate Darkly* participates in public awareness of and education about a Civil War-era Black potter, this chapter does not focus on the relationship between Gates and Dave Drake, whom Gates celebrates in the history of American art. Instead, this chapter concentrates on Gates' opening performance and on the extent to which Gates' religious and cultural upbringings inform his creative motivations. In particular, I reveal the implicit critique of the museum space and art historical traditions expressed by this performance and I consider what it means, today, to talk about religion and spirituality in the context of the utterly reified world of contemporary art.

As part of the exhibition opening, the choir Gates assembled and supervised included a 250-member choral group from neighboring Milwaukee Black churches and Chicago artist communities. Composed in collaboration with

DOI: 10.4324/9781003326809-25

Chicago musician LeRoy Bach, music performed by the choir was inspired by the enigmatic couplets found on Drake's pots (Becker et al. 86). Giving voice and melody to Drake's poetry, the performance recalls songs sung by enslaved Africans in 19th-century America.[3] In particular, the music in Gates' performance builds upon African American sacred music and chants, which were hybridized from Anglo-Protestant traditions and African traditions. As jazz musician and performing arts scholar Richard Harper notes,

> African American congregants were taught the hymns of British psalmists Isaac Watts and Charles Wesley, and while the lyrics remained largely unchanged, the music was transformed through heterophy, call-and-response, and blues inflections into dirges or moans with the purpose of inviting the spirit of God to descend.
>
> *(Kuoni, 258)*[4]

That is, African Americans enriched and transformed communal singing by combining European hymns with African traditions to create songs with incomparable intensity, which forged and sustained a sense of community during the inscrutable trauma of the exploitation and marginalization of Black people in the history of America.

Although Gates' procession-performance in *To Speculate Darkly* refers to Dave Drake's legacy, it also gives insight into Gates' religious and cultural upbringing, which informs his art-making. In an interview with museum director and curator Carolyn Christov-Bakargiev, Gates recalls that he "grew up Black Baptist, which is a very specific thing" (15), and Gates' social concerns were inspired by the family's involvement in the African American church. By age 13, Gates served as a choir director for the New Cedar Grove Missionary Baptist Church. A long tradition of research documents the prominent and pivotal role of religious institutions in the lives of African Americans.[5] Speaking of the centrality of religious life for Black culture, in 1903, W.E.B. Du Bois writes that "The Negro Church of today is the social center of Negro life in the United States, and the most characteristic expression of African character" (117). In a 1933 article that surveyed the religious life of the Black church, authors Benjamin E. Mays and Joseph W. Nicholson registered the church as a place of opportunity in an environment of severe restrictions: "The church was the first community or public organization that the Negro actually owned and completely controlled" (338). However, this sense of autonomy for Black communities is not limited to the early 20th century. Josef Sorett contends that the Black church became the custodians of Black culture, and never did the Black church and secular independent institutions of the Black community become completely detached (217). In Gates' work, religion is continuous with a sense of community, and it never appears as a private belief system. The phenomenon of a community defining itself by singing hymns organizes Gates' procession-like performance, and it positions religious practice as a model for social and communal practices.

But what happens when the artist recontextualizes religious elements, themes, and motifs in a museum context? The response to this question requires elaboration on the meanings of Gates' procession-like performance and its implicit critique of the museum as a secular temple.

In addition to its specific references to African American history and Black culture,[6] Gates' procession-performance in *To Speculate Darkly* also must be understood in the context of art history. During *To Speculate Darkly*'s introductory lecture, Gates mentions the choir's capacity to practice "temple swapping." *Templum* is Latin word for the Greek τέμενος – from τέμνω, "to cut" – because *templum* was each place that was consecrated by augurs and separated from the rest of the earth with a solemn formula (Linderski, 2016). Among many other things, museums have been one of the apparatuses employed to facilitate the modern transformation of religion into a private, speculative realm that is detached from social or practical systems of understanding reality or creating communities.[7] Within the modern museum – that is, within a dispositif participating in a broad, cultural transformation of religion from a sociopolitical paradigm to a private belief system – artworks that initially contained liturgical and devotional missions became devices for aesthetic contemplation.[8] Although scholars, critics, and artists may use religious metaphors to qualify the museum space as a temple, the museum demarcates and separates a secular space from a sacred one. As is evident in Gates' introduction of a choir singing spirituals into the Milwaukee Art Museum, the artist understands the sacredness of the museum as a secular temple just as he understands the church as a sacred temple. Gates' mission to memorialize and preserve spirituals related to African American collective and personal histories in museums implicitly critiques the museum space as a secular temple. The procession-like performance at the Milwaukee Art Museum tries to alienate what alienates – that is, the apparently "neutral" space of the iconic art museum.

Here, we broaden the discussion of the presence of these religious and spiritual motifs in Gates' work outside of *To Speculate Darkly*. Critics and scholars of Gates' work often employ the term "spiritual" with reference to his *oeuvre*. In the *Black Archive*'s exhibition catalogue, Thomas D. Trummer writes that "Gates' practice embodies the material, political, and the spiritual" (23). Similarly, Carin Kuoni writes that Gates "examines urban renewal and social justice through the lens of art, spirituality, alternative economies, and community engagement" (8). In the essay "Redemptive Reification," Bill Brown reflects on Gates' diverse roles as urban developer, installation artist, and entrepreneur and argues that scholars should consider Gates' work a "redemptive project – the effort to redeem built space, the urban fabric, discrete objects and subject/object relations" (36). Brown concludes that Gates' art is necessarily spiritual in nature because "you can't get away with disavowing the spiritual or the congregational dimensions of the term [redemption]" (36). Although many studies refer to a spiritual dimension of Gates' work, its significance is still far from being clear.

In an interview with Carin Kuoni, Gates reflects on the spiritual qualities of his work and system of beliefs: "Part of the makeup of my intellect, part of the

makeup of how I operate in the world, part of my mode of operation," says Gates, "has to do with a very strong understanding of and a very strong sensitivity for *things you cannot see*" (Kuoni 201; emphasis added). These things you cannot see are not 'spirits,' ghosts, or phantasmatic presences. Rather I believe that, for Gates, the 'spiritual' has a pragmatic and almost material nature. A few examples might clarify my position. One might say that when a building is dismissed and abandoned, also dismissed is its 'spiritual' component. When capitalism has transformed the city into a wasteland, erased is also the 'spirit' of a city. When homogenization becomes a crucial feature of globalization, attention to the 'spiritual' feature of communities is the possibility of preserving a cultural heritage that one might not see but that might still be there. Throughout his work, Gates incorporates transformed abandoned buildings, archival holdings, and artifacts.[9] However, as Gates states, "I am not only interested in found objects but also discarded knowledge [and] I am willing to take on the burden of not only the material waste but also the knowledge waste that [is] so disposable" (*12 Ballads* 14). Gates' engagement with fragments and lacunae resembles the work of architectural historians and art historians who reflect on what is missing – what audiences cannot see – from an original work of art, an original building, or a devastated city. In his artistic practice, Gates repeatedly returns to this question: How do we reimagine, re-create, or reinfuse an original object or experience when parts are missing, when they have been obliterated, or when they have gone away? This question permeates the *oeuvre* of Theaster Gates, and it resonates within the procession-like performance at the Milwaukee Art Museum. There, Gates expresses the idea that in the secularized art world, discarded forms of knowledge and religious experiences – that is, *things you cannot see* – represent possible emotional experiences and can create a sense of community.

Moreover, in a 2015 interview, Gates argues that Western art history's denial of "the deep intellectual regime [of] traditional carvers, craftsmen, diviners, and spiritualists" derives from the "racism of modernism" (McDonough 2015), which perpetuates a cultural hierarchy privileging "sophisticated" culture over "naïve" aesthetic expressions. The 19th century's creed of social Darwinism informed not only the ethnographic museum but also the art museum and the discipline of art history with its equal devotion to principles of competition, taxonomy, and hierarchy. In the same interview, Gates also states, "I am fanatical, in that all of the things I do seem to be a working and a re-working toward something that is *beyond* art" (McDonough 2015; emphasis added). This statement about Gates working outside of and "beyond art" suggests that the artist considers "art" a category of objects and standards predicated upon an exclusive canon of modernism. The purpose of this examination is not to pursue Gates' broad critique of the category of art nor a discussion of his entire artistic practice, which study would require a dissertation. However, one must consider that for this artist, the "racism of modernism" determines an intellectual hierarchy based on rational Western philosophical processes that deny the value of the religious and the spiritual, unless artists perform them ironically.

In conclusion and with regard to religious motifs in Gates' work, the artist imbues the neutralizing, generic space of the modern museum with references to his religious upbringing and the importance of religious life in the history of Black culture. By recontextualizing religious experiences and rites in secular aesthetic spaces, the artist recalls the presence and significance of religion for one's personal and collective life. The presence of religious motifs within Gates' works reminds audiences that modernity by no means led to widespread secularization in every society. Instead, religious pluralism, religious–secular coexistence, and secular and religious fundamentalisms continue to shape cultures. Gates' engagement with a spiritual aesthetic interrogates and complicates the secular cosmopolitanism that dominates the world of art. This form of secular cosmopolitanism is predicated upon a narrow understanding of globalization as a decay of religious beliefs through the lens of Western secularization. We know today that the process of Western secularization is limited to a very narrow part of the world – namely, Western Europe. In developing an artistic practice grounded in references to spirituality, Gates continues an ongoing project of provincializing Europe and its disciplinary apparatus, such as the museum and art history. His words and his work state, at least implicitly, that if art wants to become a thoughtful global phenomenon, it must make room for religion and spirituality. Critics must understand Gates' focus on spiritual things – on *things you cannot see* – in the context of a shared mission to open up art history to a multiplicity of art's histories.

My critical responsibility includes supplementing my interpretation of Gates' project with elements of doubt or skepticism. If readers agree that Gates' work critiques the "racism of modernism" and the fallacy of the modern art museum, one could equally ask: Does Gates successfully critique institutions, and does the procession-like performance in *To Speculate Darkly* retain any of the power of an actual religious celebration performed in and for an ecclesiastical setting? I doubt it. This is not a critique of Gates' work per se. I do not tend to believe in the work of a single artist, as incredible and successful that work might be. In a world with economic, intellectual, and social structures in direct opposition to the poetic and to the possibility of pursuing a spiritual path, a *living*, spiritual art has a hard time surviving, and making a difference. Gates reclaims things from carelessness and oblivion, but when these forgotten things – including the possibility of spirituality – are reclaimed, they seem to me to be immediately reintroduced within another circle of oblivion: the circus of the art world with its senseless art fairs, art galleries, art market, and iconic museums. At least since the 1980s, gallerists, collectors, artists, and many critics have pursued the research of an art that is both recognizable and showy, spectacularized, and fully integrated within the cultural industry and within the luxury market. Gates' work is not extraneous to this phenomenon. A more in-depth analysis of the artist's work would demonstrate that Gates' practice testifies that there is no getting outside of capitalism, reification, and logic of the spectacle; there are only modes – more or

less ethical, more or less meaningful – to operate within its structure of power, its advertisement strategies, and its spectacularized modes of existence. From the 1950s to today, the history of art is the progressive history of the success of the art market and of its commodification and spectacularized process. As Andy Warhol understood several decades ago, "business art is the step that comes after art" (92). Already during the mid-1970s, the global financial economy had appropriated the avant-garde for its own purposes. In his entry on "commodity" for the collection of essays *Critical Terms for Art History*, Paul Wood ends by asking: "Is the realm of the commodity now seamless and total, and if so, what are the implications of that?" (267). Perhaps the return of the spiritual is also a symptom of a creative need that tries to respond to this commodification and reification of art. Yet, with regard to Gates' performance in *To Speculate Darkly*, one at times has the impression that we might say what Adorno already noticed a few decades ago: "the religious attitude assumes the air of an externally enforced and ultimately arbitrary community manipulated by individualistic devices behind which there is nothing of the collective power which they pretend" (237). Ultimately, a decisive ambivalence characterizes Gates' work: the need to find something that goes *beyond* art, like spirituality, religion, or a sense of community, on the one hand, and the tacit awareness that we have entered a world of business art that prioritizes spectacle, economic profit, and celebrity culture, on the other hand.

To conclude this examination on a positive note, I want to leave aside these perplexities. I am convinced that there are important reasons today to give room to questions of spirituality and religion in the work of contemporary artists. Many people are seeking because they have been alienated by institutional religion, secular fundamentalism, absent-minded consumption, and obsessive communication. Spirituality is a general concept that applies to almost all the people in the world who seek change in themselves.[10] At the same time, it is important for contemporary art historians to stop looking at religion as an intellectual formation that is always obsolete and dogmatic. One of the values of Gates' engagement with religious themes lies in this attempt to perturb that part of the art world, which still considers, *a priori*, religion and spirituality as forms of antimodern fundamentalism resisting processes of secularization. Gates' engagement with religious beliefs demonstrates the narrow-mindedness of cosmopolitan-secularized elites who value religion as either irrelevant or reactive. Gates' work more clearly refers to or performs religion as an active force that it is not necessarily reactionary. As many have started doing in sociological circles and in religious studies, it is time in art history that we revise our conceptions of a global secular modernity that characterizes the religious *always* as other, fundamentalist, reactionary, or irrelevant. Without abandoning secular rationality or supporting any form of state religion, I feel the need to start a project of translation of religious heritage in the secular public sphere. Perhaps even the multifarious realm of contemporary art can provide occasions of reflections to fulfill such a project.

## Notes

1 For an excerpt from the performance, see Gates, "Performance at the Milwaukee Art Museum."
2 For an excerpt from the opening night lecture in which the artist also discusses the general scope of this exhibition, see Gates, "Opening Night Lecture."
3 Humanist scholar Anthony Pinn argues that song expression enabled enslaved people to maintain memories of a former home and to cope with the dehumanization they experienced from agents of colonial cultures (3). Pinn also recalls that "the songs called into question the nastiness of life and provided a vision of fulfillment expressed with an eye toward the promises of Christian faith" (3).
4 For historical discussions of 18th- and 19th-century African American music, see also Epstein and see Southern.
5 For an overview, see Taylor and Chatters.
6 We should keep in mind the challenges to traditional understanding of cultural specificity and authenticity that also characterize Gates' work. Research on trans-national migrations, trans-cultural correspondences, and trans-spatial resonances qualifies Gates' work, which also draws from and contributes to ideas of Black Atlantic-ism and what Paul Gilroy describes in the *Black Atlantic* as that "desire to transcend both the structures of the nation state and the constraints of ethnicity and national particularity" (19).
7 For the modern transformation of religion into a private, speculative realm, see Walhof and Peterson.
8 As noticed by several museum scholars, the museum's presumed "neutrality" is far from being neutral (Promey xix–xxv). Without renouncing the atmosphere of sanctity, museums expelled the religious and stripped totems, masks, potters, and devotional objects of their purposes, spirits, and connections to religious rituals. Meant to be touched, played, worn, or known through active use, sacred objects are displayed in museums for edification through the eyes alone. Ultimately, what is sacralized and celebrated in museums is human creativity. For an overview, see Duncan, and see also Clifford.
9 As with Gates' exhibition including the potter Dave Drake's ceramics, one finds in Gates' work a taste for the fragment, for what is disappearing, and for the forgotten. In his installation at the 2015 Venice Biennial, *Gone are the Days of Shelter and Martyr*, he reused building materials, a bell, a statue of St. Laurence from the now-demolished St. Laurence Church on Chicago's South Side. Gates' work recalls the ongoing social disinvestment in urban holy spaces, particularly in poor and Black neighborhoods. The installation includes a video showing Gates with The Black Monks of Mississippi, a collective that the artist founded, singing spiritual gospels and interacting with the remnants of the ecclesiastical site. For a more general overview of the artist's work shown at the 2015 Venice Biennial, see Enwezor.
10 For a discussion of the concept of spirituality in modern times, see Taylor.

## Bibliography

Adorno, Theodor W. "Theses upon Art and Religion Today." *The Kenyon Review*, New Series, vol. 18, no. 3/4, 1996, pp. 236–240.
Becker, Carol, Lisa Yun Lee, and Achim Borchardt-Hume. *Theaster Gates*. Phaidon, 2015.
Brown, Bill. "Redemptive Reification." *Theaster Gates: My Labor Is My Protest,* edited by Honey Luard, White Cube Gallery, 2013, pp. 36–40.
Clifford, James. *The Predicament of Culture: Twentieth-Century Ethnography, Literature, and Art.* Harvard University Press, 1988.
Du Bois, W. E. B. *The Souls of Black Folk.* Dover Publications, 1994.

Duncan, Carol. *Civilizing Rituals. Inside Public Art Museums.* Routledge, 1995.

Enwezor, Okwui. *All The World's Future. 56th International Art Exhibition. La Biennale di Venezia.* Marsilio Editori, 2015.

Epstein, Dena. *Sinful Tunes and Spirituals.* University of Illinois Press, 1977.

Gates, Theaster. *12 Ballads for Huguenot House.* Köln: Verlag der Buchhandlung Walther König, 2012.

———. "Opening Night Lecture." *To Speculate Darkly: Theaster Gates and Dave the Potter*, Milwaukee, WI, 16 April 2010. https://www.youtube.com/watch?v=2QWXC36fHNc/. Accessed October 17, 2021.

———. "Performance at the Milwaukee Art Museum." *To Speculate Darkly: Theaster Gates and Dave the Potter,* Milwaukee, WI, 16 April 2010. https://www.youtube.com/watch?v=deCBuX7GYSo. Accessed November 22, 2019.

Gates, Theaster, LeRoy Bach, and Rebecca Zorach. *My Name Is Dave: A Hymnal*, Milwaukee Art Museum: Chipstone Foundation, 2010.

Gilroy. Paul. *The Black Atlantic: Modernity and Double Consciousness.* Verso, 1993.

Kuoni, Carin, and Chelsea Haines, editors. *Entry Points: The Vera List Center Field Guide on Art and Social Justice No. 1.* Duke University Press, 2015.

Linderski, Jerzy. "Templum" in *Oxford Classical Dictionary.* Oxford University Press, 2016.

Mays, Benjamin E., and Joseph W. Nicholson. "The Genius of the Negro Church." *Afro-American Religious History: A Documentary Witness*, edited by Milton Sernett. Duke University, 1985.

McDonough, Tom. "Theaster Gates," *BOMB Magazine*, Winter 2015. https://bombmagazine.org/articles/theaster-gates/. Accessed October 17, 2021.

Peterson, Derek, and Darren Walhof, editors. "Rethinking Religion." *The Invention of Religion*: *Rethinking Belief in Politics and History.* Rutgers University Press, 2002, pp. 1–18.

Pinn, Anthony, editor. *Noise and Spirit: The Religious and Spiritual Sensibilities of Rap Music.* NYU Press, 2003.

Promey, Sally. "Foreword: Museums, Religion, and Notions of Modernity." *Religion in Museums Global and Multidisciplinary Perspectives*, edited by Gretchen Buggeln, Crispin Paine, and S. Brent Plate. Bloomsbury Academic, 2017, pp. xix–xxv.

Sorett, Josef. *Spirit in the Dark: A Religious History of Racial Aesthetics.* Oxford University Press, 2016.

Southern, Eileen. *The Music of Black Americans.* W.W. Norton & Company, 1983.

Taylor, Charles. *A Secular Age.* Harvard University Press, 2007.

Taylor, Robert Joseph, and Linda M. Chatters. "Importance of Religion and Spirituality in the Lives of African Americans, Caribbean Blacks and Non-Hispanic Whites." *The Journal of Negro Education*, vol. 79, no. 3, 2010, pp. 280–294.

Trummer, Thomas, editor. *Theaster Gates: Black Archive.* Kunsthaus Bregenz, 2017.

Warhol, Andy. *The Philosophy of Andy Warhol (From A to B and Back Again).* Harcourt Brace Jovanovich, 1975.

Wood, Paul. "Commodity." *Critical Terms for Art History*, edited by Robert L. Nelson and Richard Shiff. University of Chicago Press, 1996, pp. 382–406.

# 22

# ON PREACHING, PERFORMANCE ART, AND TELEVISION

## Christian Jankowski's *The Holy Artwork*

*Isabelle Loring Wallace*

In 2001, Peter Spencer, a pastor at Harvest Fellowship Church in San Antonio, Texas, agreed to an unlikely collaboration with Christian Jankowski, a celebrated German artist, famous for progressive works in the mediums of performance, installation, and video. What came from their collaboration is multi-faceted and hard to describe – by turns a live performance, an episode of a weekly, evangelical television show, and an acclaimed, contemporary artwork made in the medium of digital video. At the heart of each is a church service and sermon conducted by Spencer at his non-denominational mega-church, a portion of which Jankowski filmed and to which he also contributed, albeit in unexpected ways, as we shall see. Edited footage of the service, in turn, appeared on television three times in the context of Spencer's weekly, cable-access television show, and shortly thereafter, in the spring of 2002, the same edited footage was included in the Whitney Museum's prestigious Biennial, where it was arguably the exhibition's most celebrated and undertheorized entry (Cotter 35). Spencer's sermon, the subsequent television episode, and Jankowski's video all share a single, provocative title: *The Holy Artwork*.[1]

Like many weekly television programs, *The Holy Artwork* opens with a canned montage. It moves from images of the church and its high, roadside sign to action shots of Spencer, cherubic children in church pageants, the "Praise Team" or choir, and intermittent reaction shots of the organization's homogenous congregation. Set to the Christian rock anthem *Ancient of Days*, the montage concludes with a title card on which the titular words "*The Holy Artwork*" appear, written in calligraphic white script. Thereafter, the video then begins in earnest with shaky, first-person footage of a man's khaki pants and shoes, which is quickly followed by a shot of the pastor filmed from the point-of-view of someone in the audience. As the video's spectators quickly devise, that someone is the khaki-wearing Jankowski, whom Spencer introduces and invites to the stage. Filming as he goes, Jankowski approaches Spencer and is warmly greeted at close range, but

DOI: 10.4324/9781003326809-26

after the two men shake hands, the artist drops to the ground, and the point-of-view switches from Jankowski's hand-held video camera to an establishing shot that captures Jankowski's fall. The video then settles squarely on Spencer, who is carefully framed by a high-definition, stationary camera, which reveals, as it zooms out, the image of the immobilized artist at his feet (Figure 22.1). Jankowski remains on the floor like a prop for the duration of the service, ostensibly deaf to its evolution and choreography, and a mere fifteen minutes later, the video concludes as it began: following a final hymn and prayer, the point-of-view shifts back to the artist's inferior camera, and Christian rises and again shakes hands with the pastor before returning to his seat in the audience. The video's final image is familiar. It features Jankowski's shoes as the artist sinks back into his chair just before the screen fades to black once more and, the credits, in the same calligraphic, white script appear – Spencer's name first, followed by the names of several cameramen, an acknowledgment of ArtPace, the organization that originally commissioned Jankowski's video, and finally, the copyright, granted to Jankowski, whose name appears sans serif as the video's final frame.[2]

Needless to say, questions of audience, authorship, and viewpoint are central to this collaborative project and are raised most straightforwardly by the video's distribution to two audiences that are typically understood to be diametrically opposed: religious and provincial, on the one hand, and secular and cosmopolitan, on the other. At the same time, these questions are also built into the form of the video and are evident in its conspicuously shifting point-of-view, which

**FIGURE 22.1** Christian Jankowski, *The Holy Artwork*, 2001, Video, 15:52 min, NTSC, 4:3, color, sound, English with subtitles (German, Italian, Croatian). Reproduced with permission of the artist.

oscillates between the artist's hand-held, seemingly more subjective (or artsy) footage of the service and footage that seems commercial and steady by contrast. Finally, and no less consequently, such matters are central to Spencer's sermon, wherein matters of audience and viewpoint are in turn entangled, both literally and discursively, with the medium of television. For, as I will argue, and as Spencer's homily in its own way insists, there are really three terms in play here – not only religion and art, but also the medium of television and, as I will maintain, the concept of medium more generally.

Following Jankowski's introduction and collapse, Spencer begins his sermon in earnest, calling attention to its reception in three venues (sanctuary, living room, and gallery) that are unexpectedly sutured by Jankowski and Spencer's collaboration. One consequence of this is the conflation of performance and preaching, something Spencer's immediate audience – the individuals watching in real time in the sanctuary – was perhaps well prepared for. Harvest Fellowship Church, although now significantly diminished and no longer operating in the location seen in Jankowski's video, emerged in 1988 under the leadership of Spencer, its founding pastor. In the early 1990s, as the church flourished and grew, Spencer moved his congregation to the structure pictured in Jankowski's video: a former dinner theater called the Fiesta Dinner Playhouse (Levy). Hence, the building we see in Jankowski's video, like preaching itself, is inextricably and foundationally bound to performance – a fact Jankowski's video brings to the surface and explicitly entangles with performance art and video. For while the church's interior is half-heartedly dressed up with decorative columns and fake potted plants, a great many theatrical trappings remain in place and in use – most obviously the fabric backdrop, the exposed rigging, the gel-covered spotlights, and the raised dais on which Spencer and the Praise Team perform. What's more, the charismatic Spencer, who left the church in 2003 after serving for fifteen years as its founding pastor, is clearly at home in this context, his background in art and theater evident in his gestures, carefully calibrated pauses, and choreographed, sharp inhalations (Rice 113). And yet, a church is not a theater and a pastor is not an actor, unless, of course, they are, or were, or might still be. My point is that such facts about Spencer and the repurposed structure he occupies, though perhaps in their own right insignificant, are, in the context of *The Holy Artwork*, indicative of an interesting and interpretable tension, which is arguably exacerbated by the phenomenon of televangelism. This tension, which I claim Jankowski explores, is a tension between acting, which is ineluctably associated with performance, and authenticity, which could be defined precisely in opposition to performance, indeed, to depend upon the fact of its exclusion. Acting requires that an actor's personality be harnessed or repressed such that the illusion of someone else – a specific character – might emerge; in contrast, a person is deemed authentic, when no gap is assumed between who the person is and how the person appears.

Of course, post-structural theory allows us to quibble with so pat a distinction. Most famously, Judith Butler has insisted that identity *is* performance and

is, more precisely, its effect, claiming that authenticity is but a special name given to performances that appear convincing as a consequence of their repetition and refinement over time. Generally, I am persuaded by these arguments, but in this context, I am more immediately concerned with received, non-academic ideas and, therein, the enduring distinction between acting – a rare enclave in which duplicity is celebrated – and authenticity, associated, by contrast, with truth and morality, and thus the church by extension. Admittedly, the church and its clergy are occasionally associated with immorality and deception, and nowhere more spectacularly than in the case of televangelism. To be clear, Spencer, unlike the fallen figures of Jim Bakker and Jimmy Swaggart, has never been accused of any such wrongdoing, but that doesn't mean that he doesn't function as a symbol of this possibility for distant sophisticates in the art world, for whom one televangelist is arguably the same as another. In other words, although Spencer stands, for one audience, as the very emblem of integrity, honesty, and humility – a pastor who leads by example and professes to walk in the way of the Lord – for another audience, his profession and affect immediately raise *the question* of authenticity and the degree to which his sermon and broader persona are only an act.

Interestingly, similar tensions undergird the advent of performance art, which came of age in the 1970s just as televangelism took hold. For, although mid-century American Art was dominated by abstractions that were perceived as unmediated, authentic acts of expression, by the early 60s, a new, more skeptical generation of painters had reframed painting as a language that could be strategically deployed to achieve *the look* of expressivity in the absence of authentic expression. Of course, some artists found the recognition of art-as-language freeing, but others felt that this insight necessitated the wholesale abandonment of painting and the invention of new genres that were perceived to be more immediate and authentic by contrast. Enter here the genre of performance art in which conventional media are eschewed and the body again, for a time, guaranteed – this time without mediation – the authenticity of the artistic gesture, thereby restoring its credibility as a trustworthy purveyor of meaning. In this context, artists were shot in the arm; they rolled around on the floor with chicken carcasses; and all manner of sexual provocations were conducted, one body directly addressed to another. From these early days, performance art has evolved and is often now heavily theatrical, with the artist or his collaborators clearly playing a part, scripted by the artist in advance. But, here, we butt up against an important question: Does the one necessarily preclude the other? In other words, can one perform a role, while at the same time avoiding charges of inauthenticity? With just this question in mind, let's return to *The Holy Artwork* and revisit its opening salvo, and especially, the performances by Spencer and Jankowski.

As noted, *The Holy Artwork* begins with a stunt that involves Jankowski falling to the floor, his camcorder limp in his hand. This theatrical gesture has been linked by scholars to a Spanish Baroque painting by Juan Bautista Maino (1578–1649) that depicts an exhausted painter lying on the floor before his unfinished canvas while an angel endeavors to complete it (Rice 113). Such a conceit,

which is not uncommon in the history of Western art, perpetuates the idea of a miraculous image – that is, an image of inhuman origin endowed with divine power and authority. The artist on the floor in Maino's *Saint Dominic in Soriano ri* (c. 1630) is thus a precursor to Jankowski, who for the duration of *The Holy Artwork* was "only an instrument," as Spencer will say, who "emptied himself" and "yielded to inspiration." Theatrically borne out by the insensate, floor-bound Jankowski, this conception of art, one in which the artist is at once central and effectively evacuated, seemingly sidesteps the performance/authenticity problem and resolves, from a Judeo-Christian point-of-view, the problem of creativity more generally, affirming for the assembled faithful, the belief, reprised by Spencer in his sermon, that while people and artists in particular are creative, there is finally but one Creator, for whom man is an occasional conduit. Or that is the idea at any rate. And, for a preacher its value is self-evident *and transferrable*. For, like Jankowski, many preachers aspire to be "on stage" but, in their own way, inert – dutiful vehicles or *mediums* through which God's message finds cogent and compelling expression.

But this word … "medium." It gives one pause, both because it opens up onto the discourse of art history, wherein the term is ubiquitous, and because, in a religious context, "mediums" are priests' illegitimate cousins, shifty con-artists who make unsanctioned prophecies and indiscriminately channel or perform voices of the dead. That Jankowski is interested in such phenomena is well documented: in 1999, in the context of the Venice Biennale, he collaborated with psychics who regularly appear on live Italian television and explored how mediums seen in this context (i.e. psychics), align with and, in a modern age, rely upon another kind of medium, television, that is no less associated with channels and channeling and the broadcasting of disembodied voices both living and dead. Surely, such connections were on Jankowski's mind in the weeks leading up to the Biennale, during which he called five television-psychics and asked them various questions about his prospects for the exhibition: would he find success; would he realize his vision on time; and would he find collaborators with whom he could realize his project? Recorded by the artist and subsequently presented at the Biennale as *Telemistica* (1999), these conversations would ultimately affirm the predictions of TV psychics who uniformly anticipated his success.

It was less than two years later, during the course of a prestigious residency at ArtPace in San Antonio, that Jankowski would shift his sights from psychics to preachers and embark on another collaboration that again nests one medium inside another and proposes affinities between three things that are also, lest one not get the point, explicitly aligned in Spencer's homily: the medium of television, which delivers a spiritual medium (the pastor), who is in turn used as an artistic medium by Jankowski, despite being himself a passive instrument. But, with so much nesting and channeling and analogizing, one cannot help but wonder: What, finally, is the content or meaning of *The Holy Artwork* and who, finally, is its author? *The Holy Artwork* ends with a concluding prayer, in which Spencer affirms the miraculous nature of Jankowki's work and offers thanks

to God, while also expressing his hope that the worlds of art and religion be enriched by his televisual collaboration with Jankowski:

> Thank you, Lord for creating video ... a medium that we can use to communicate. Thank you for the knowledge and the wisdom and all of the people who collaborated together to make this make this miracle happen. And thank you, Lord for the opportunity to make this Holy Artwork. And for those who caught Christian's vision, because it takes more than the artist – it takes those who believe in the art. Father, we want to say, thank you for letting this artwork reflect even the materials which you have created that can be put together and show the inner possibilities, while pointing beyond them. Father, we want to thank you that there is even purpose in this Holy Artwork. And that purpose was to reach into the hearts of the those watching one dimensionally ... and let them know that there are many dimensions to the body, soul, and spirit, so that it would reach beyond this moment in time. In fact, let this art, this Holy Art, last beyond even our lives. Whether it'll be a century or ten centuries, may this artwork last and continue to teach the message. May it even expand our definition of art. And let this artwork – Father, God we pray – question and challenge the art world and bring it to a level of spiritual dimension. Father, we want this Holy Artwork to make people in the church understand the value of contemporary art, and we pray that this artwork, this Holy Artwork, will be a bridge between art, religion and television. May we end one-dimensional lives and may we experience the dimension of your glory, your power, your spirit, and your will in our lives. We pray these things, by the power of Jesus Christ. Amen.
>
> *(Jankowski unpaginated)*

Following the conclusion of Spencer's prayer, *The Holy Artwork* returns to the shot that established Jankowski's fall. Spencer is then seen to offer Jankowski his hand, extending still further the video's trinitarian logic. For, like his namesake, Christian Jankowski rises – is resurrected, we might say – by the power of God, as channeled through the preacher, his surrogate, in the presence of the holy spirit, which can only be, in this context, the empowering, immaterial force of the airwaves. And yet, strictly speaking, the video's last word and its last image belong to Jankowski through whose camera we again see. For, while the artist credits God with the opportunity to collaborate with Spencer – "Thank you, God, for making this possible!" he proclaims as he leaves the stage – these words are followed, in turn, by the video's credits, which grant, as noted, the copyright to Jankowski in the video's final frame.

So, what, in the end, *is* the video's point-of-view? For the irreligious among us, perhaps encountering the work in an academic context or art exhibition, there is ample evidence to suggest that work is secular and critical of religion, a condescending collaboration designed to capitalize on the novelty of such a

subject within the context of contemporary art. But, for those who are religious, who perhaps watched *The Holy Artwork* in person, or as one in a series of televised sermons delivered by the beloved Spencer, Jankowski's video poses no substantial challenge to a religious world view; indeed, both the video and creativity itself are affirmed as aspects of God's unending creation, which finds expression in any number of available mediums, be they religious, aesthetic, or technological. Indeed, undecidability is built into Jankowski's work and can only be resolved by the willful projection that meaning-making requires. On one level, this is merely a semiotic and hermeneutic point: for as intellectuals have said since Saussure, the signifier is differential and empty and knotted to its meaning only through an act of will. But this act is, above all, an act of faith shared by a broader community, be they savvy Manhattanites visiting the Biennial, a small fraction of the San Antonio faithful, or any other community bound together by convictions that are just as likely to divide them from others. Thus, I can imagine a third audience for whom *The Holy Artwork* is neither an affirmation of an all-encompassing debt to God, nor a smug send-up of fundamentalist piety, but instead a meditation on the polyvalent idea of projection, as that which underwrites and finally makes possible not only the videos that flank Spencer in the sanctuary, but also, on a conceptual level, any system of belief, be it religious, aesthetic, or semiotic. Seen in this light, the televisual medium of video takes on additional meaning in the context of *The Holy Artwork* and assumes a performative dimension of its own, at once a technical means of framing our world view and compelling conviction *and* a theatrical symbol for the very mechanism of projection, which makes of every screen, sermon, and recumbent figure a blank surface made in the image of our beliefs.

## Notes

1  *The Holy Artwork* is one of several works by Jankowski to explore religious themes. See also, *My Life as a Dove*, 1996, *Telemistica*, 1999, and *Casting Jesus*, 2011.
2  *The Holy Artwork* was commissioned as part of a two-month residency at ArtPace, San Antonio.

## Bibliography

Butler, Judith. "Performative Acts and Gender Constitution: An Essay in Phenomenology and Feminist Theory." *Theatre Journal*, Vol. 40, No. 4, December 1988, 519–531.
Cotter, Holland. "Art Review: Spiritual America, from Ecstatic to Transcendent." *The New York Times*, March 8, 2002, 35.
Falckenberg, Harald. "Thank you, God. Thank you for Making this Possible: Christian Jankowski's Contribution to the Pathology of the Culture Industry." *Parkett*, Vol. 81, 2007, 68–81.
Hadden, Jeffrey K. "The Rise and Fall of American Televangelism." *The Annals of the American Academy of Political and Social Science*, Vol. 527, May 1993, 113–130.
Jankowski, Christian. *Christian Jankowski: Everything Fell Together*. Des Moines Art Center, 2005.

Levy, Abe. Contreras, Guillermo, Staff Writers. "Beloved Church Member Also Stole from it." *MYSA*. April 22, 2013. https://www.mysanantonio.com/news/local_news/article/Beloved-church-member-also-stole-from-it-4454917.php.

Pollack, Barbara. "The Elephant in the Room." *ARTnews*, Vol. 103, No. 8, 2004, 118–119.

Princenthal, Nancy. "Whither the Whitney Biennial?" *Art in America*, Vol. 90, No. 6, 2002, 49–53.

Rice, Karen Gonzalez. "Recuperating Religion in Art History: Contemporary Art History, Performance and Christian Jankowski's *The Holy Artwork*." *Performance Matters*, Vol. 3 No. 1, 2017, 112–115.

Rinder, Lawrence, et al. *Whitney Biennial 2002*. Whitney Museum of American Art, 2002, 114–115.

Silva, Eddie. "Stop Making Sense: Christian Jankowski's Lack of Common Sense Has Gotten Him Far." *Riverfront Times*, September 18, 2002. https://www.riverfronttimes.com/stlouis/stop-making-sense/Content?oid=2467753.

# 23

# TOOLS OF THE APOCALYPSE

## Eschatology in Contemporary Jewish and Catholic Art

*Ben Schachter*

Artists have long included motifs related to religious ideas in their work. Eschatological images of judgment and fiery horsemen are easily found in the medieval and renaissance art historical record. Look no further than Albrecht Durer's *The Four Horsemen of the Apocalypse* printed in 1498, or Michelangelo's fresco of the *Last Judgement* adorning the Sistine Chapel in Rome completed in 1541. Durer's image illustrates a passage from the Book of Revelation (6:1–8) describing the events that will take place at a time in the future preceding what is described as the End of Days. Michelangelo's fresco shows angels lifting up a trumpet whose sound will announce the judgment of souls seen elsewhere on the wall. Both examples give form to religious contemplation of what will happen at the end of time. While artistic references to the End of Days played a larger role in religious art of the past, modern artists reflect on these motifs less often. That is not to say that religious iconography has disappeared from contemporary art altogether. In 1974, performance artist Chris Burden lay across the back of a Volkswagen Beetle car and had nails driven through his hands into its roof. His pose and the action recalled the crucifixion. *Trans-fixed* has clear references to Christian iconography.

Even with Burden's visceral restatement of the crucifixion, artists who explore eschatological time are few. David Shrigley and Anshie Kagan explore it effectively. Their work relates to what may happen at the end of time seen from their respective religious perspectives. The artists use contemporary art-making strategies turning a violent, exciting motif into something nearly mundane. David Shrigley and Anshie Kagan make artworks that explore eschatological ideas using found objects that are imagined to perform ordinary tasks at extraordinary times. Their work is a continuation of the use of found objects as explored by Dadaist Marcel Duchamp and Pop artist Andy Warhol. Duchamp is well known for coining the term "readymade" to refer to an ordinary object presented as

DOI: 10.4324/9781003326809-27

an art object. Famously, Duchamp signed a porcelain urinal with the fictitious name, "R. Mutt," and titled it *Fountain* in 1917. Similarly, Warhol recreated ordinary commercial objects in wood and paint. These recreations are virtually indistinguishable from their real counterparts. Art critic and philosopher Arthur Danto examined Warhol's *Brillo Box* from 1964, a sculpture that has the same size and appearance as a box of the cleaning product. Danto explored the question of what the difference between a real-world object and its artistic twin might be. Shrigley and Kagan continue the use of found objects in their work but add theological contemplation to the aesthetic considerations brought to bear on Dada and Pop objects.

This chapter examines the way in which two artists tackle eschatological ideas from differing religious perspectives. David Shrigley, raised in an evangelical Christian household, references the return of Jesus Christ. Anshie Kagan, an Orthodox Jew, explores the arrival of *Moshiach*, or the Messiah. Both artists are influenced by Dada and Pop Art and use found objects. Two works of art show this best: *The Bell* (2007) by Shrigley and *In Case of Moshiach Break Glass* (2013) by Kagan. Most importantly, these works demonstrate the possibility that religious themes can be expressed using contemporary artistic idioms and in fact push those strategies even further.

## Eschatology

Before describing their work, a brief description of the Jewish and Christian description of eschatological time is helpful. Very briefly and at the risk of glossing over important theological principles, here are a few notes. Christian thought believes that Jesus Christ is the Messiah, the Savior of the World, and that when he returns all souls will be judged. That time will be "the hour when all who are in the tombs will hear the Son of Man's voice and come forth, those who have done good, to the resurrection of life, and those who have done evil, to the resurrection of judgment" (John 5:28–29). This moment in time is known as the Last Judgement.

From the Jewish perspective, the Messiah has not yet arrived. When the Messiah comes, a time of world peace will begin. The first mention of this period is found in the Talmud, the Jewish Oral law written down in the 2nd to 5th centuries. It states, "All of the Jewish people, even the sinners and those who are liable to be executed with a court-imposed death penalty, have a share in the World-to-Come…" (Mishnah Sanhedrin 10:1). Of course, this blanket statement is followed by a list of exceptions. Another text states that all people would need to keep the Sabbath, the holy day of rest, for two weeks in a row for the Messiah to arrive (Tractate Shabbat 118b). These Jewish texts suggest that world peace does not arrive because of the Messiah, but rather, world peace is the precondition for his arrival. Regardless, both religious traditions include signs that precede the arrival of the savior. It is these signs that Shrigley and Kagan explore in their work.

## Artists' Backgrounds and Works

Shrigley grew up in a religious household in Great Britain. His father was evangelical Christian. "I remember looking out the living room window," Shrigley said, "watching [my father] burn [my Dungeon and Dragons set] and seeing the little dice melting." Dungeons and Dragons, a role-playing game in which participants act out characters like those found in J.R.R. Tolkien's middle-Earth setting, included magical and demon-like creatures. In reflection, Shigley suggests that his father was acting in accordance with his belief and "Maybe he saved me" (Poyner). Shrigley received a religious education until he was fifteen, which included bible study and Sunday School in Leicester, England (Poyner). Later, he attended the Glasgow School of Art (British Council: Visual Arts). While no longer living within a religious milieu, he became skeptical of religion. "I find the language of religion," Shrigley said, "particularly the language of Christianity, something amusing to subvert, I suppose." But Shrigley does not reject religion or ethical behavior altogether. "I believe in right and wrong," Shrigley said (Poyner). And so while his father may have saved him, Shrigley seems unsure from what he might have been saved.

Shigley's religious attitude is tinged with skepticism, but he does not reject it all together. This attitude shows up in several of his artworks. One work called *God is Idle* 2007 is an acrylic wall painting that stands approximately fifteen feet tall. The work shows its title written in a graffiti-like manner directly on the wall of the gallery. On the face of it, *God is Idle* describes the divine figure as lazy, slothful, and in the face of world affairs perhaps even negligent. Such an attitude might characterize Shrigley's view of a divine being. After all, his professed skepticism regarding the power of religion to save him does not necessarily deny the need for or existence in the divine. But if a higher power does exist, Shrigley might say, "What have you done for me lately?"

But there is more. Shigley might be including a homonym in which "idle" can be read as "idol." Read in this fashion, "God is idol" suggests something different. If the divine being is an idol, then the divinity may be as impotent as a material object. Moreover, to pray to an idol is idolatrous worship and risks the possibility that the image is confused with the divine being. Idolatry is a concern because images are powerful and can draw attention away from the divine toward the physical object, a thing that has no power. Understanding Shrigley's attitude toward religion lets us see this work in a unique way. *God is Idle* proposes a conundrum between a god that does not act against one that might not exist. Shrigley might see no difference between these two answers. Nevertheless, the chance, however slim, of redemption remains and echoes through the humor of Shrigley's work (*Frieze*).

Unlike Shrigley, whose work is informed by skepticism, Kagan's work is inspired by his belief. He is a religious Jew. He received a Jewish day school education, which typically includes training in liturgy, biblical interpretation, and the laws and traditions followed by his community. Later, he attended the

Fashion Institute of Technology in New York City (Sarafraz). Presumably, it was at FIT that Kagan had his formal art and art historical education. Much of his work is directly influenced by Pop Art and a Warhol-like aesthetic uncommon to the art produced by members of his community. Concerning contemporary art, Jewish auctioneer Daniel Kestenbaum comments,

> ...frankly so much of what we see in today's [religiously friendly] galleries is simply boring (stereotypical bearded rabbis and views of the Kosel [Western Wall]) – nothing like the more dynamic aesthetics that we have become accustomed to, reflected in the streets we live in.
>
> *(Sarafraz)*

Kestenbaum is describing his opinion concerning the state of contemporary Jewish Art. In his view, contemporary Jewish Art is dominated by genre paintings showing people performing devotional activities and cityscapes of Jerusalem that include holy sites. Rather, he would like to see Jewish ideas presented in a modern idiom.

Kagan's work fills the void described by Kestenbaum. While Warhol-inspired works of art are commonplace in the art world, Kagan's work stands out among the images popular within some religious communities. Unlike Shrigley whose work engages religious thought intermittently, Kagan's *oeuvre* often intertwines Jewish themes and contemporary art idioms. For instance, drawing on Barbie Doll toy imagery, *Aishes Chayil* mixes Mattel branding and Judaism. "Aishes chayil," alternatively pronounced, "eshet chayil," is the name of a poem written by King Solomon in the Bible and found also in Proverbs 31. The poem is known as "Woman of Valor" and is traditionally recited or sung by some Jewish husbands to their wives on Friday evenings just before the Sabbath arrives. One translation begins, "A woman of value, who can find? For her price is far above rubies/The heart of her husband doth safely trust in her, and he hath no lack of gain" (Proverbs 31). Kagan transforms Barbie into the woman of valor who is faithful, confident, and capable. A religious manifestation of a woman who "has it all" includes the love and devotion of her husband who appreciates his wife in every way.

Shrigley and Kagan are a good pair of artists to compare. Their childhoods share a religious upbringing by parents who valued religion and sought to educate their children within those traditions. Shrigley's self-professed skepticism began when he was a teenager. Kagan continues to observe Jewish law and traditions. Both artists were trained at art academies. Similarly, both artists include religious subject matter in their work. For Shrigley, inclusion of religious ideas occurs on occasion. For Kagan, nearly all of his work includes religious motifs. Two works provide an excellent opportunity to compare these artists' eschatological views. These works are *The Bell* (2007) by Shrigley *and In Case of Moshiach Break Glass* (2013) by Kagan.

## Of Urinals and Brillo Boxes

Both works rely on found art strategies used by the Dadaists and the Pop artists. Marcel Duchamp, one of the first artists to present an object to the viewer as art simply by the authority invested in the "artist," stupefied his viewers. At the time, aesthetic qualities such as beauty or artistic vision were important. Famously, Duchamp presented an inverted urinal, provided it a title, *Fountain* (1917), and signed it with a *nom de plume*. Later, the use of ordinary objects and their representation found renewed interest in the 1960s particularly in Andy Warhol's studio. He famously recreated a box of Brillo cleaning pads. *Brillo Box* (1964) was nearly indistinguishable from the original box in which Brillo pads were shipped.

Found objects in art inspired many reactions including philosophical musings. Arthur Danto, art critic and philosopher, mused over the fact that Warhol's *Brillo Box* seemed identical to its real-world counterpart. He proposed a thought experiment concerning two objects that have the same appearance and are made of the same material. However, the two objects were manufactured by different people – an inventor and an artist. In his thought experiment, the objects each person made were a can opener. The wrought metal object that emerged from the inventor's workshop had utility. The other originating in the artist's studio had only aesthetic value. Danto asked if there is a difference between the two. He suggested that somehow the two objects can be distinguished one from the other even though they appear identical. Only a "philistine" would use the work of art to open a can of soup (Danto 1981, 30). Danto's thought experiment ended in *aporia*, without a clear conclusion as to whether or not the two objects were identical.

Danto's answer was less about the objects themselves and more about how they were treated. "What in the end makes the difference between a Brillo box and a work of art consisting of a Brillo Box is a certain theory of art," Danto wrote. "It is the theory that takes it [the work of art] up into the world of art, and keeps it from collapsing into the real object which it is…" (Danto 1964, 581). Danto's idea was developed by others and came to be known as the Institutional Theory of Art. Danto's idea explained how it can be that two identical objects are treated differently. But other questions emerge.

For example, once an object is elevated into the art world, can it ever be lowered again? Artist Eric Wayne provides a possible answer. He lampoons Duchamp's work by creating a digital photograph depicting *Fountain* installed in a men's restroom (Wayne). To complete the illusion, the caption reads, "'The Urinal' Installation by Eric Küns. Berlin, 2013." The image was included in a PBS documentary on the use of appropriation in the arts and was attributed to the fictional Eric Kuns ("Copying"). Similarly, I included the image and attributed it to "Eric Kuns" in an earlier version of this examination in a paper delivered at the College Art Association Conference (Schachter).

Wayne's lampooning provides an answer to the question, "Can the process by which an object becomes a work of art ever be reversed?" Wayne's photograph

proposes installing *Fountain* in a men's room for use. But how is *Fountain* then received? Does the sculpture "return" to its original state, lose its title and become a bathroom fixture once again? Not exactly. Even if it could be used, the porcelain object is still thought of as an art object, one that is mistreated, but still an art object, nonetheless. I would argue that if Warhol's *Brillo Box* were to be filled with soap pads, the artistic nature of the box would not change.

## The Messiah Is Coming! The Messiah Is Coming!

To explore eschatological time, Shrigley and Kagan assign specific interpretive ideas to objects. In ordinary religious contexts, when an object is given a ceremonial function, it becomes a ritual object. But these works are not in a religious context, they are in an artistic space. David Shrigley's *The Bell* (2007)[1] consists of a small handbell and note written in pen on paper. The paper – actually aluminum – is folded in a simple tent fold and reads, "Not to be rung again until Jesus returns." The instructions are simple, but the wording is very specific. Looking at the words more carefully, each part of the sentence conveys a particular meaning. For example, "Not to be rung again until…" tells us that the bell has a specific purpose. What is that purpose? Well, we are not told directly. Instead, we are instructed when to ring the bell – "Jesus returns." When is that? At the End of Days, the Second coming – notice "until…returns." Taken together, this simple note informs us that the bell, or at least its use, is reserved only for a time in the eschatological future. Reading again, the note might suggest that the bell existed when Jesus Christ was alive for the first time. The word "again" suggests that at some point in the past a similar event or alarm was sounded. The bell has been placed on reserve.

Looking at the entire work, the simple handbell and the sign are very straightforward. It calls to mind where one might encounter a bell to be rung, perhaps at a welcome desk at an inn or small storefront. The sign might read, "Ring for Service." Imagine a person entering the store or lobby looking for some help. Perhaps she leans over the counter attempting to see someone in the back. Perhaps she places her hands on the counter, but when she sees the bell recognition signals on her face and she presses the metal button on the top, confidently or timidly, it doesn't matter. The bell signifies a person waiting for service. But Shrigley's bell is not so simple.

Shrigley's bell maintains the neat silent calm of the call bell, but the event it signals is anything but. The Second Coming is described as a time of rapture, violent noise, and awe. Nothing like the quiet recognition the call bell might inspire. But Shrigley's bell invites us to reconsider what we think will happen at the End of Days. Who will signal redemption? How will it sound? The note recalls the cacophonous sound often depicted in art depicting the event. But might there be another way? The prophet Elijah, while seeking the divine, experienced an earthquake. It was only after that did he hear a "still small voice" (1 Kings 19:12). Maybe Shrigley is on to something.

Anshie Kagan's *In Case of Moshiach Break Glass* is a red metal box with a glass front (Figure 23.1). The title of the work is emblazoned across the glass. Accompanying the box is a metal hammer hanging from a chain. The box, hammer, and chain recreate some fireboxes found in apartment building stairwells and elsewhere. Overall, the case signals emergency. Inside the box is a shofar (trumpet) made from the horn of an animal. The shofar is sounded multiple times throughout the Jewish liturgical year and is mentioned in the Bible numerous times (Montagu). The title is a restatement of a phrase written on fireboxes, "In case of fire break glass." In its usual context, one is supposed to use the metal hammer to smash the glass and reach into the box either to sound an alarm, often by pulling a handle downward, or begin to fight the fire by pulling out a firehose and opening a valve. Kagan has replaced the fire emergency with the urgency with which one might respond to the arrival of the Messiah.

This feeling of immediacy is part of the theological tradition from which Kagan comes. Within some Orthodox communities, one is taught to rush to perform a good deed, a *mitzvah*. This tradition is interpreted from Genesis 18:2 in which Abraham rushes out to meet three strangers and offer them hospitality. His eagerness to welcome the stranger highlights his piety (Avtzon). Looked at in this light, Kagan's box is not only intended to represent a state of preparedness for an emergency but also to express the eagerness with which some people vigilantly await the Messiah. Moreover, part of the *Amidah*, a prayer Jews recite several times a day, alludes to the arrival of the Messiah described as a descendant of King David (Sacks 2009, 124). The shofar as a call to action then becomes the act of the witness who first sees what is happening. While Kagan may not have consciously thought of these connections, the optimistic eagerness with which the arrival of the Messiah is anticipated runs through Orthodox tradition and liturgical Judaism.

The mood in which *The Bell* and *In Case of Moshiach* anticipate eschatological time, the arrival of a Messiah, is the largest difference. Shrigley's work exhibits his skeptical view of religion. If and when eschatological time were to arrive, the artist seems unsure of its benefit. The manner in which the Messiah's arrival is

**FIGURE 23.1**  Anshie Kagan, *In Case Of Moshiach Break Glass*, 2013. Shofar, metal, glass, enamel paint. Courtesy of the artist. www.anshie.com/window.

announced is rather matter of fact. In contrast, Kagan's emergency case anticipates his arrival eagerly. Seen in another way, *The Bell* suggests that salvation comes when called. On the contrary, *In Case of Moshiach Break Glass* demonstrates that he who sounds the alarm is a witness. These interpretations present different aspects of theology. Is salvation guaranteed to come? If so, what role do we play in its arrival?

## Please Touch the Art, But Only When It Is Time

Both the bell and the shofar are found objects. In most cases, a found object is placed off limits from the viewer – elevated into the art world. To ring the bell or blow the horn would be a sacrilegious act against the conventions of contemporary art. However, these objects are not off limits; well, *not entirely*. The well-mannered viewer will not touch the objects on display. But at the same time, Shrigley and Kagan have provided instructions that the objects can, nay *must*, be used at a certain time. In this way, these artists have finessed the relationship between the artwork and the viewer in a novel way. When they are used, these objects cease being only aesthetic things. But they do not return to a state of the ordinary either. These objects are a kind of ritual-object-in-waiting. But even that description seems to lack some aesthetic element because such a thing could sit in a cabinet inside a church. Rather, the bell and the shofar are out of bounds or, as Danto would say, elevated to art until they are needed. Shrigley and Kagan leverage theological thinking about eschatological time and keep these objects just out of reach.

## Note

1 David Shrigley, *The Bell*, 2007. Brass bell and aluminum sign; bell: 31 × 17 × 17cm (12 × 6 3/4 × 6 3/4in); sign: 7 × 10 × 9cm (2 3/4 × 4 × 3 1/2in). Collection of the artist. See Stephen Friedman Gallery for an image of the work: https://www. stephenfriedman.com/artists/54-david-shrigley/works/4717/.

## Bibliography

Avtzon, Levi. "Why Is Inviting Guests such a Mitzvah?" *Chabad.org* https://www. chabad.org/parshah/article_cdo/aid/4165732/jewish/WHy-is-inviting-guests-such-a-mitzvah.htm. Accessed March 15, 2022.

Danto Arthur. "The Artworld." *The Journal of Philosophy*. Vol. 61, No. 19. American Philosophical Association Eastern Division Sixty-First Annual Meeting. (October 15, 1964): 571–584.

——. *Transfiguration of the Commonplace*. Harvard University Press, 1981.

"David Shrigley (1968–)." British Council: Visual Arts. http://visualarts.britishcouncil.org/ collection/artists/Shrigley-david-1968?_ga=2.120404232.1632376978.1627403031-730769480.1627403031. Accessed March 15, 2022.

"Jesus Doesn't Want Me for a Sunbeam." *Frieze*. September 11, 1995. http://www.frieze.com/article/jesus/doesnt-want-me-sunbeam. Accessed March 15, 2022.

Montagu, Jeremy. "The History and Ritual Uses of the Shofar." In *Qol Tamid, The Shofar in Ritual, History, and Culture*, edited by Jonathan L. Friedman and Joel Gereboff. Claremont Press, 2017, 11–31.

Proverbs 31. Mechon-mamre.org. https://michon-mamre.org/p/pt/pt2831.htm. Accessed March 15, 2022.

Poyner, Rick. "The Evil Genius of David Shrigley." *Design Observer.* January 31, 2012. https://designobserver.com/feature/the-evil-genius-of-david-shrigley/32418/. Accessed March 15, 2022.

Sarafraz, Bath. "In Case of Moshiach Break Glass." *San Diego Jewish World.* November 15, 2015. https://www.sdjewishworld.com/2015/11/15/in-case-of-moshiach-break-glass/. Accessed March 15, 2022.

Sacks, Jonathan, translation. *The Koren Shalem Siddur.* Introduction and commentary by Rabbi Lord Jonathan Sacks. Jerusalem: Koren Publishers, 2009.

Schachter, Ben. "Bell, Book, and Shofar: Contemporary Art and Eschatology." College Art Association, New York, February 12, 2020. Conference Presentation

"The Case for Copying." *The Art Assignment.* Season 3, Episode 36. PBS Digital Studios. Video 10:16. https://www.pbs.org/video/the-case-for-copying-sospmh/. Accessed March 15, 2022.

Wayne, Eric. "Confession: I am a Renowned Conceptual Artist." *Art and Crit by Eric Wayne.* February 26, 2019. https://artofericwayne.com/2019/02/26/confession-i-am-a-renowned-conceptual-artist/. Accessed March 15, 2022.

# 24

# BACK TO THE GARDEN

## Utopia and Paradise in the work of Jim Shaw, Liza Lou, Shirin Neshat, and Shoja Azari

*Eleanor Heartney*

In her brilliant book, *Reinventing Eden*, science historian Carolyn Merchant, connects the story of Genesis, the progress narrative of the scientific revolution, the colonizing impulses of 17th-century Europe, and contemporary warnings of ecological doom. She outlines the ways that religion, science, literature, poetry, and art are permeated by the cultural memories of a lost Paradise and by longings for a future world in which its vanished harmony and peace will be restored. As a result, she maintains, "The Recovery of Eden story is the mainstream narrative of Western Culture" (2).

Merchant outlines the costs that have accompanied the effort to master nature, tame its wildness, and recreate an Edenic garden on earth. She shows how the Recovery Narrative has encouraged humanity to reshape the natural world to its needs and to recreate human society in a more perfect mode. She also reveals how this dream exposes human hubris. Utopian narratives have sustained thinkers as diverse as Thomas Moore, Jonathan Edwards, William Blake, and H. G. Wells. The metaphor of "the shining city on the hill" has been a driving force behind a foreign policy devoted to reshaping the world in the form of American democracy. Dominionism – rooted in Genesis 1:26 in which God gives mankind dominion over all the creatures of sea, air, and earth – has helped justify scientific conceptions of nature as man's tool. But the serpents in such Utopian gardens have included the subjugation of women, the colonization of indigenous lands, the obliteration of their inhabitants, and the destruction of the delicate balance between the human and non-human worlds. Modern history is in many ways the story of efforts to re-engineer human society and take control of nature in ways that have produced such unhappy consequences as the nightmares of totalitarianism, eugenics, and sectarian strife.

DOI: 10.4324/9781003326809-28

The flip side of the Utopian dream of recovered Eden is the Paradise narrative. Instead of recreating heaven on earth, seekers of Paradise look for Eden in the next world and are willing to sacrifice comfort and tranquility here in order to attain it. Paradise has emerged as a flashpoint in some of our most intractable contemporary conflicts. One finds it invoked, for instance, in the so-called clash of civilizations that has fueled so much unrest in the Middle East as radical Islamic militants motivate their troops with the promises of future bliss and various American leaders have celebrated war as a prelude to the Second Coming. Meanwhile, a secularized version of Paradise seems to lie behind the dreams of techno-visionaries like Elon Musk and Jeff Bezos who dream of the colonization of space as an alternative to life on an irretrievably damaged earth.

Narratives of Utopia and Paradise both pair the promise of regeneration with an unwillingness to accept our place in an imperfect world. Because they look to a past or future golden age marked by a restoration of a lost state of "natural" political and social relationships, they make it difficult to engage with the world in the here and now. Such nostalgia distorts our sense of current possibilities. Merchant ends her book calling for a new narrative that takes us beyond the human-centric fantasies of Utopia and Paradise.

But shaking our addiction to the Edenic Recovery narrative is not easy. It requires uprooting long established habits of thought. One way to approach the problem is to turn to art. A number of contemporary artists take a critical eye to the seductions of Eden as found in various religious belief systems. They reveal the complexities of religious belief and practice and suggest how the politics of Paradise and Utopia can take belief in unexpected and often unfortunate directions.

Jim Shaw is a multifaceted artist who has immersed himself in an exploration of what Harold Bloom described as "The American Religion" (Bloom). By this, Bloom was referring to those uniquely American faiths that flourish outside the mainstream, among them The Church of Jesus Christ of Latter-day Saints, Christian Science, the Seventh-day Adventist Church, and the Jehovah's Witnesses. Shaw has amassed an enormous collection of ephemera relating to fringe religions, crackpot science, conspiracy theories, not so secret societies, and paranormal research. These in turn have inspired his own work (Figure 24.1).

One of his most epic works, *My Mirage* (1986–1991), is a lightly autobiographical narrative that tells the story of Billy, a young Midwesterner whose search for meaning leads him through the turbulent currents of the 1960s as he careens between various lifestyles and belief systems. He throws himself into sex, drugs, rock and roll, and finally, evangelical Christianity. This work is realized through a set of poster-sized collages that constitute "chapters" of the story. Each is composed of mashups of text and imagery incorporating drawn, photocopied, silkscreened, and collaged material from myriad sources. Each chapter uses elements appropriate to the phase of Billy's life so that, for instance, early collages are heavy on comic book imagery, while during Billy's hippie era, the images draw on psychedelic posters and rock album covers.

**FIGURE 24.1**   Jim Shaw, *The Whole: A Study in Oist Integrated Movement,* 2009 (film still). Video, 16:40 minutes, courtesy of the artist and private collector.

*My Mirage* is the story of the coming of age of an American Everyman. It shares the spirit of Puritan morality tales like John Bunyan's 1678 allegory *The Pilgrim's Progress,* and like that work presents a journey through the temptations and hazards of life as its hero works his way toward ultimate redemption. However, Shaw is more equivocal than Bunyan about the final stage of his hero's life as Billy reinvents himself as a televangelist hawking a patently dubious version of Evangelical Christianity.

Eventually, Shaw carried his homage to the American Religion to its logical conclusion with the creation of his own religion, which he dubbed Oism. Oism contains echoes of Scientology, Christian Science, and the American Utopian tradition as embodied in communal experiments like New Jerusalem, the Shakers, and the Amana Colony. Shaw presents Oism as a goddess-centered religion founded in upstate New York in the mid-1800s by a prophet named Annie O'Wooten. A feminist allegory, Shaw's religion centers on a virgin who gave birth to herself at the dawn of history. According to the mythology of the religion, she brought writing and agriculture to society, but was eventually toppled by the "I" – a stand-in for patriarchy/ ego. Oism is an ongoing project expressed in music, video, installation, performance, comic books, drawings, photographs, and paintings.

As in all his work, Shaw's approach to Oism is a mix of irony and fascination. Its satirical aspects are balanced by his interest in the mixed meanings of American identity. He reports that one source of his religion is an actual 19th-century American woman who reinvented herself as the "Public Universal

Friend." This genderless preacher promoted a feminist and anti-slavery philosophy and formed a short-lived Utopian community in the town of Jerusalem near Penn Yan, New York. After the death of its founder, the community dwindled and eventually disappeared. Shaw incorporated the progressive ideals of that social experiment into Oism while remaining cognizant of the ultimate failure of its aims (Taft).

While Shaw has invented a Utopian religion, Liza Lou has lived within one. She is celebrated for sculptures and installations of objects covered with tens of thousands of tiny glittering glass beads. What is less well known is the fact that she spent her early years immersed in a fire and brimstone-dominated Christian sect. This experience has shaped her work in ways that are both obvious and subtle. Her earliest installations, created in the late 1990s when she was just out of art school, included fully beaded recreations of a full-scale suburban kitchen and a suburban back yard. However, the upbeat ambience of those works soon began to give way to darker subjects. By the early 2000s, she was creating works like *Trailer* (2002), a full size, fully beaded airstream trailer whose interior held hints of a grisly crime scene, and *Relief*, also from 2002, which presents a beaded young girl laid out in a coffin in a pose that is reminiscent of Millais' painting of the drowned Ophelia. Such works hinted at class, religious, and economic divides starkly at odds with popular visions of the American Dream.

Lou brought these undercurrents out into the open two years later in a confessional work titled *Born Again* (Figure 24.2). This live performance, later recast as a fifty-minute black and white video, is a fictional narrative based on Lou's evangelical upbringing and its heady, frightening mix of guilt and ecstasy. In the

**FIGURE 24.2** Liza Lou, *Born Again*, 2004 (film still). 54-minute film. Written and performed by Liza Lou. Directed by Mick Haggerty, courtesy of the artist and Lehmann Maupin, New York, Hong Kong, Seoul, and London.

video version of *Born Again* (Lou), the camera is fixed on a frontal view of Lou sitting at a table. She tells her story in first person in the voice of the young girl who serves as narrator. Sometimes, she breaks into song; sometimes, she assumes the voices of other characters in the story; and throughout, she is extremely animated. She leans conspiratorially toward the camera as she offers a particularly intimate moment of the story. Sometimes, she pulls back and looks heavenward for inspiration, at one point climbing on the table that separates her from the viewer.

The story is both compelling and chilling. Our heroine recounts the tale of her childhood. She begins with her bohemian parents' marriage and brief submersion in New York City's downtown cultural scene. She chronicles their sudden and somewhat shocking conversion to evangelical Christianity and their move to rural Minnesota to work with the church. We learn about a childhood immersed in poverty, prayer, ecstatic dancing and singing, night terrors, the specter of Satan, and the violent unwinding of her parents' marriage. Among the striking set pieces are the story of the fire her parents set in their loft to burn their godless books, music, and art (including several paintings given them by their neighbor Roy Lichtenstein); her father's brutal treatment of their dog, Ezekiel, who eventually goes mad and is given away to a church camp; his equally brutal punishment (and hinted at sexual abuse) of his daughter; and raging parental battles. The last of these is followed by the disappearance of Lou's father and her mother's rejection by the church community as a fallen woman. There are also moments of pleasure and bliss, as when the narrator and her sister sing and dance together or feel the hand of God.

*Born Again* is a powerful evocation of both the horror and the attraction of this particular form of Pentecostal Christianity. Lou's account is filled with Gospel songs and visual descriptions that offer glimpses of otherworldly beauty. However, this beauty seems inextricably linked to the psychic and physical violence of renunciation and purification. The narrator speaks of her belief that prayers are jewels in her crown, and she describes her post-baptismal experience of the water in which she was immersed as a "lake of diamonds." One can't help feeling a link between this kind of imagery and the glittering splendor of her chosen art medium. Suddenly, *Kitchen* and *Back Yard* seem less homages to the female craft tradition than acts of worship directed at casting a glow of spiritual radiance over the banality of the everyday world.

In more recent work, Lou has moved beyond this focus on her evangelical background. From 2005 to 2014, she lived in Durban, South Africa, where she assembled a collective of native beaders, working with them to create works that deal in a more conceptual way with issues of power and justice. More recently, she maintains a nomadic existence based in the Mojave Desert in southern California while continuing to create beaded abstraction works based on the beauty of the Western landscape. The longing for beauty and transcendence that underlie *Born Again* remains a touchstone for Lou's current work. Ultimately, one senses Lou has found her Eden, not through religion, but through art.

The equivocal seductions of Eden reappear in a pair of works by two well-known Iranian artists. Shirin Neshat and Shoja Azari draw on Islamic conceptions of Eden to explore the politics of Paradise. Old Testament descriptions of the Garden of Eden merge with the *Book of Revelation's* promise of the New Jerusalem to form the Q'uran's vision of Jannah, the well-tended garden that is the ultimate reward of the faithful. Jannah shares many characteristics with the Christian and Jewish heavens. It is described as a blissful place composed of "gardens beneath which rivers flow." These include

> rivers of water, the taste, and smell of which are never changed. Rivers of milk the taste of which will remain unchanged. Rivers of wine that will be delicious to those who drink from it and rivers of clear, pure honey.
>
> *(47:15)*

Jannah differs from other versions of Paradise in one important respect: this is a realm-filled, not just with spiritual delights, but also with every kind of sensual pleasure, including wine, food, sex, and luxurious robes, bracelets, and perfumes. One of its most attractive features, at least for male inhabitants, is the "houri," beautiful, idealized maidens who await their pleasure in the garden. The erotic

**FIGURE 24.3**   Shoja Azari, *The King of Black*, 2013 (film still). HD color video with sound, TRT 24 minutes, ©Shoja Azari, courtesy of the artist and Leila Heller Gallery, New York.

aspects of Jannah have assumed political significance in recent years as radical Islamic sects recruit martyrs with promises of access to these voluptuous virgins in the afterlife.

Azari has drawn on this narrative in his mesmerizing video, *The King of Black* (2013) (Figure 24.3). This work offers a retelling of a story by the 12th century Persian poet Nizami Ganjavi. The video is based on the first episode of Nizami's larger epic, *Haft Paykar (Seven Beauties)*. That work is designed as a series of parables that describe the schooling of a ruler in virtues such as faith, passion, serenity, fairness, and devotion to God. The opening story counsels patience and the control of desire, but as reimagined by Azari, *The King of Black* also presents a lesson in cultural dissonance.

The film is a story of Paradise gained and lost. A king questing for knowledge travels outside his kingdom and finds himself in a bleak world filled with black-garbed mourners. While seeking an explanation for their sorrow, he meets a mysterious man with a wheel. This figure transports him to a paradisiacal world populated by beautiful women luxuriating in a magical landscape full of abundant fruit and wine. The most beautiful woman is the queen of this land. She enjoins him to enjoy all the pleasures of this place, excepting her own sexual favors. Initially, the king sates himself but finds himself longing for the forbidden fruit. After several attempts to seduce the queen, he takes her by force, upon which he is suddenly and mercilessly returned to the land of sorrows from which he began his journey. Titles tell us that he spends the rest of his life there garbed in black and mourning his lost Paradise.

Azari uses contemporary green screen technology to create an effect that harks back to early cinema. Sumptuously costumed actors move before and around flat backdrops that consist of digitally recreated details of 16th century Persian miniature paintings. Such exquisite paintings were traditionally kept in private albums or books. Azari adapts their aesthetic with particular attention to their heightened colors, flattened spaces, decorative borders, and stylized architecture. The artifice of these painted sets contrasts with the realism of the filmed characters, heightening the narrative's sense of otherworldliness. Filmed crows fly across skies dotted with schematically drawn curlicue clouds. Voluptuous maidens sink into landscapes strewn with real fruit and delicately painted images of flowers and trees. Artifice is further heightened by text inserts that interrupt the narrative like intertitles from a silent film. Through such self-conscious Orientalism, Azari plays with Western fantasies about the mysterious East.

The narrative undermines the assumption of male privilege that is so much a part of the Islamic concept of Paradise, with its willing virgins and unending sex. This Paradise is presided over by a queen who asserts her independence and, when crossed, expels the offending monarch from Paradise. The hell to which he returns suggests the wasteland created by the current Middle East conflict. Machismo, violence, and power combine to destroy any hope of earthly Utopia. Thus, by deliberately engaging with the tropes of Orientalism and patriarchy, the

film ultimately exposes the cultural biases embedded in this and, by extension, any vision of Paradise.

Shirin Neshat's *Women Without Men*, created in collaboration with Azari, also explores the garden as a representation of Jannah (Figure 24.4). This work is inspired by a controversial 1998 novel by the Iranian novelist and political refugee Shahrnush Parsipur. Both the novel and Neshat's interpretation combine magic realism with historical recreations of pivotal events.

Neshat's *Women Without Men* takes two forms, comprising both a series of discrete video installations and a full-length feature film that uses some of the footage from the installations. Both these formats, like the book on which they are based, follow a group of Iranian women from different classes during the US-assisted *coup d'etat* that replaced Iran's first democratically elected government with the Shah. Today, many Iranian activists see this as the fatal step that set Iran on the path to the Iranian Revolution. The individual video installations present each woman's story separately, while the film weaves them together into a narrative that blends realism and fantasy in order to create a feminist parable.

While each woman has her own dilemmas and desires, the driving force of the narrative is their escape to an orchard in the countryside. This garden, presided over by a mysterious male gardener whom Neshat describes as a stand-in for Christ, becomes both a place of refuge and a metaphor for Paradise. In the novel and the film, the women create a Utopian community that nurtures them until one of them gets bored and chooses to open the orchard to outsiders. There are some distinct differences between the novel and film. Neshat places greater emphasis on the political context of the story. She turns one of the women, Munis, into a political activist and makes her the narrator of the film. Neshat also initiates the expulsion from Paradise with a party that devolves into a raid by

**FIGURE 24.4**  Shirin Neshat, *Mahdokht Series*, 2004, C-print, photo: Larry Barns, ©Shirin Neshat, courtesy of the artist and Gladstone Gallery, New York and Brussels.

supporters of the *coup d'etat*. Fantasy and fact mingle in the film. The narrative is punctuated by faithful recreations of documentary footage of the protests that preceded the coup. Meanwhile, there are magical sequences, as when Zarin, the prostitute, observes the literal erasure of her clients' faces or Munis, dead from suicide, rises from the earth of the garden to begin a new life.

While the film is grounded in the Islamic vision of Jannah, its allegory of Paradise is rooted in the personal and secular freedoms that have been curtailed by the theocratic state. Paradise is lost here through the excesses of ideology, foreshadowing Iran's subsequent slide into religious autocracy.

Azari and Neshat are partners who sometimes collaborate. They also work separately to produce works that reveal very distinctive artistic personalities. They share a history that has influenced their vision of Paradise. Both were displaced from their native country following the 1978 Iranian Revolution. From their vantage as exiles in the United States, they have taken activist stances, speaking out strongly against the Iranian government's draconian policies surrounding cultural expression and free speech. In their artistic work, they infuse poetic narratives with echoes of Islamic literature, art, and music. Given the artists' difficult relationship to the theocratic state, it is not surprising that both their films emphasize the themes of failed Utopia and the expulsion from Paradise.

Each of the artists discussed here exhibits an awareness of both the emotional resonance and the dangers of the Recovery Narrative. Shaw's seekers find only temporary satisfaction in the Utopian promises of the American Religion's narrative of spiritual rebirth. Liza Lou ultimately finds Eden in art rather than religion. Azari and Neshat, each in different ways, explore the politics of Paradise and conclude that the search for perfection is antithetical to the realities of human life and society.

Eden remains a seductive dream in an era beset by fears of global warming, nuclear holocaust, global famine, and worldwide pandemics. The promise of a new Eden, now or in an eventual future, is a promise of hope. But, as the artists discussed above suggest, it is an ambiguous promise. Longings for Paradise and Utopia can blind us to visions of nature and history that emphasize mutuality over perfection and recalibration over recovery. As Merchant maintains, Edenic thinking is deeply embedded in the Western psyche. But as she also suggests, there are alternatives. Instead of mastery of nature, there is *tikkun olam*, the Jewish concept of "repairing the earth." In place of Dominionism, there is the call for stewardship represented by Pope Francis' encyclical *Laudato Si'*. In place of the mechanistic view of natural law presented by Western science, there is the Gaia theory of James Lovelock and Lynn Margulis that suggests that the earth is, in essence, a living thing. Like the Recovery Narrative, such ideas are based on religion. But unlike it, they open new pathways to sustainable models for human culture and society.

## Bibliography

Bloom, Harold. *The American Religion: The Emergence of the Post-Christian Nation*. Touchstone, 1992.

Lou, Liza. *Born Again*, http://www.lizalou.com/index?title=Born-Again.

Merchant, Carolyn. *Reinventing Eden: The Fate of Nature in Western Culture*. Routledge, 2004.

Taft, Catherine. "Profession: Dilettante." Interview with Jim Shaw, *Metropolis M*, December 9, 2013, https://www.metropolism.com/en/features/23314_profession_dilettante.

# 25

# DEEP WATERS

## Art and the Revival of Religion in Contemporary China

*Patricia Eichenbaum Karetzky*

With the advent of the Communist party's leadership of China in 1949 came the suppression of religious practice. However, after 30 years of rule, in 1980, the government gradually relaxed these constraints. This was a watershed moment in China's history when, finally open to the west, interaction with foreign countries resumed. At this time, the economic practices of Chinese socialist communism evolved into an aggressive form of capitalism, promulgated in the leader Deng Xiaoping's endorsement, "To Be rich is glorious" (Salisbury). In addition, the cult of Mao eroded with his death in 1976 and further declined in 1980 with the televised trial of the Gang of Four, who signified the ills committed during the Cultural Revolution (Zheng). The decline in the belief in Mao left a void in everyday life that many sought to fill with religious devotion. Moreover, despite the rapid economic transition to prosperity, people still had a longing for spiritual fulfillment. Two recent studies have tracked the resurgence of religious activity. In his insightful book, *Age of Ambition: Chasing Fortune, Truth and Faith in the New China* (2014), Evan Osnos observed dramatic changes in Chinese society during the eight years he lived in China as a journalist. Osnos' study was broad – political and social, the result of extensive and repeated interviews with people from all stages and arenas of life.[1] In his chapters on religious developments, he notes the desire to fill the spiritual void of the western capitalist model with Christianity. But in the many years since his research, the Chinese government has become less tolerant of such activities, while increasing its support of Daoism and Confucianism. The scholar of China's religious movements, Ian Johnson, recently traveled extensively throughout China's rural villages and urban enclaves, witnessing mainly the survival of ancient Daoist and Buddhist practices, which, along with popular beliefs, were burgeoning. In his research, he observed the appeal of local charismatic spiritual leaders and the revival of broad participation in temple holiday events, organizing his study around the

DOI: 10.4324/9781003326809-29

annual calendar (19). In sum, after the 1980s, Chinese people were able to participate in a wide variety of religious activities. They gradually began to visit the hastily renovated Buddhist and Daoist temples, read the multitude of freshly reprinted scriptures, make pilgrimages to famous holy places, form Christian prayer groups, and explore Confucian moral teachings.

Art blossomed too. After nearly two decades of being shut, universities and art colleges reopened, offering a curriculum based on western techniques, with no propagandist dictates as to subject matter. Commercial art markets, east and west, slowly emerged. Trained in the academy, most artists not only achieved expertise in western oil painting but also worked in newer more innovative western media – performance art, installation, and digital photography among them. Somewhat later, an interest evolved in national art or *guohua,* a style of art from pre-communist China, comprising brush and ink paintings mainly of flowers, birds, and landscapes. So, too, there were paintings of western religious themes, as well as from the Daoist and Buddhist traditions. A view of some of these works will demonstrate the presence and meanings of spiritual expression in contemporary Chinese art. Each artist responds to various stimuli and makes art according to a personal source of inspiration. First to consider are those influenced by the most ancient of the religions, Daoism.

## Daoist Art

Perhaps the impact of Daoist art is easiest to appreciate, for despite the Communist restrictions of its temples and scriptures, most Chinese beliefs concerning personal health and the spiritual world are couched in Daoist terms and permeate the culture. Daoism is not a monolithic religion. Briefly explained, the oldest expression of Daoism derives from ancient philosophical writings, the earliest of which is the *Daodejing* (*Classic of the Way of Virtue*) attributed to Laozi in the 6th-century BCE (Kaltenmark). This compendium of poetic sayings concerns the means to achieve a utopian government, self-perfection, and a mystical understanding of the mysteries of the universe. By the 2nd-century CE, two religious communes adopted these writings and worshipped Laozi, their putative author, as an omnipotent god (Kohn). This was the beginning of the institutional form of the religion. However, Daoism also concerns methods to achieve longevity – breathing, physical exercise, diet, and meditation, and there also are compilations of alchemical recipes for the concoction of elixirs aimed at extending life, like those recipes recorded in a manual written by Ge Hong (d. 343) (Company; Ware). In its broadest sense, alchemy may be simply described as the transmutation of things. Chinese alchemy includes both the mystical, introspective alchemy (*nei tan*) and the preparation of elixirs (*wai tan*) to escape death. As a 2nd- to 1st-century BCE, Han dynasty text describes,

> Summon spirits and you will be able to change cinnabar powder into yellow gold. With this yellow gold you may make vessels to eat and drink out of. You will then increase your span of life. Having increased your span

of life, you will be able to see the *hsien* [immortals] of Peng-lai that is in the midst of the sea. Then you may perform the sacrifices of Feng and Shan and escape death.

*(Waley)*

The Daoist Canon has many alchemical treatises that are accompanied by charts and illustrations that delineate the internal human organs and flow of *Qi*, the breath of life. Throughout Chinese history, artists focused on nature, especially gardens and landscapes, as a manifestation of the Dao. Daoist traditions, rich in temple ritual performances with elaborate dress and accoutrements and personal escapes in nature, evolved over thousands of years.

Looking to the alchemical school of Daoist belief is contemporary artist Chen Zhen (1955–2000) (Guggenheim Online Collection)[2] whose parents were both doctors and surely educated him in Chinese medicine, especially as at the age of twenty-five he contracted an incurable illness, hemolytic anemia ("Chen Zhen," Gallery Continua 2021). Chen employed Daoist themes in many of his works in a deeply personal way. For *Daily Incantations* (1996), he arranged 101 wooden chamber pots that he collected in Shanghai, which reminded him of his childhood there; he remembered seeing them being washed in the streets. He also recorded the sounds he associated with them from his youth – the sound of pots being washed and children saying quotes from Mao*'s Red Book*; recordings of them accompanied the installation (Chen Zhen, *Artist's Statements* and Goodman). In addition, at the center of arrangements of the pots, he heaped up electronic junk – computer parts, wires, audio components – resulting in a jolting apposition; he explained "The mixture of the sound of the chamber pot washing and political preaching creates a kind of religious atmosphere which makes one experience the pleasure of transcendence from the mundane noises" (Chen Zhen, *Artist's Statements*). In the last year of his life, Chen was prolific, and these pieces reflect his consideration of the impact of Daoist *neidian,* or inner alchemical meditation on the internal viscera to purify the body and extend life. *Crystal Landscape of Inner Body* comprises eleven crystal sculptures of the major organs: heart, lung, spleen, liver, kidney, gallbladder, stomach, small intestines, large intestines, bladder, the three visceral cavities, and spinal column, all exhibited on clinical beds. For Zhen, "When one's body becomes a kind of laboratory, a source of imagination and experiment, the process of life transforms itself into art" (*The Allure of Matter).* Another example is an oversize sculpture now in the Tate, London, *Cocon du Vide* (2000). Described as a biomorphic sculpture, resembling a large, curved chrysalis resting on an ornately carved Chinese lacquered chair (tate.org.uk/art/artworks), it is also an enormous sculptural replication of the Daoist immortal's double gourd drug jar, a frequent image in Chinese art.

Cai Guoqiang (b. 1957) is world famous for his complicated firework performances linked to historical events, often war atrocities and natural disasters. (Cai and You).[3] In China, he is renowned for his 2008 Olympic firework display marking the opening and closing ceremonies. His vision includes alien worlds, like his *Drawing for Oxford Comet: Project for Extraterrestrials No. 17* in 1993 or

*Searching for Extraterrestrials* of 1997. Daoists discovered fireworks as a result of their alchemical experimentations in the search for the elixir of immortality; it soon became a popular visual display and a relatively ineffective weapon, until the west realized its full destructive potential. Other presentations more concretely allude to Daoist ritual, like the 1994 work, the *Elixir of Immortality*, for which Cai dressed up as a Daoist priest in white robes and a long false beard. Behind a silk scrim, he and others struck a Daoist gong, danced in ritual fashion, and offered tea and medicinal herbs (caiguoqiang.com/projects/projects-1994/setagaya-art-museum). Cai's *Cultural melting bath, a project for the 20th century*, is rich in Daoist symbolism; it employs eighteen Taihu rocks, a hot tub with hydrotherapy jets, bathwater infused with herbs, and pine tree fronds. It was on view at the Queens Museum in 1997 (*Cai Guo-Qiang: Cultural Melting Bath* 1997). In China, spirituality finds expression in rocks, gardens, and landscape painting. Taihu rocks were especially prized in ancient China, for with their extraordinary shapes and convoluted interior holes, they were a manifestation of *Qi,* or the mystic energy of the universe, and pine trees, which never lose their leaves, signify longevity. More recently, aroused by his love for his rapidly declining 100-year-old beloved grandmother, Cai constructed the *Sky Ladder*, an almost impossible feat that took nearly twenty years to complete. Performed in several iterations around the globe, it comprised a 1650-foot-tall ladder of fireworks supported by balloons to link the earth to the sky. He explained, "As the massive sculpture ignites, it creates a fiery vision that miraculously ascends to the heavens.... This is where I want to make a ladder to connect the Earth to the universe" (Manvicosky). Here is a reference to the goal of Daoist practitioners to never die but ascend to heaven, an accomplishment of Daoist adepts recorded in the medieval era (Needham and Ho).

Other artists influenced by Daoism include the famous, contemporary, literati artist Xu Bing (b. 1955) who, in his *Travelling to the Wonderland* of 2013 at the Victoria and Albert Museum, London, UK, recreated the utopian Daoist paradise described by the 5th-century poet Tao Yuanming (Chiang; Karetzky 2014).[4] Around the pool of water in the garden at the rear of the museum, he installed large rocks imported from different mountains in China, smoke machines, and small sculptural narrative details, as well as an explanation of the poem. Xu presented his signature work, *Book from the Sky* (Tsao and Ames)*,* using his own pseudo-Chinese printed script, in the guise of a spiritually received Daoist scripture. Also to be considered are his colossal pair of *Phoenix* sculptures, the immortal bird of Chinese mythology, composed of urban debris collected from construction sites; internally illuminated, weighing twelve tons, the birds measure 90 and 100 feet long respectively (xubing.com; https://massmoca.org/event/xu-bing-phoenix). Wenda Gu (b. 1955), another literati artist, also engaged in many projects that clearly draw upon Daoist traditions. He too gave several performances for which he was dressed as a Daoist priest, and with a huge calligraphic brush wrote super large Chinese script as part of a marriage ceremony to a blond woman.[5] Notable among his other works are efforts to stabilize traditional Chinese cultural industries in danger of disappearing and to examine biological art by creating works such as the *Alchemy of Ink,*[6] an installation consisting

of bottles of ink he had prepared from human hair, which he calls "Genetic ink pigment" exquisitely displayed in glass flacons (Figure 25.1). "Genetic ink sticks," also fabricated of human hair, were set in rich wood boxes commonly used for Chinese medicine. Here, his art alchemy transforms one substance, hair, into another, ink; this is the very definition of art which is the transmutation of materials. Gu also produced *Tea Alchemy,* manufacturing thousands of sheets of paper prepared from tea; the fragrance was intoxicating[7] (Clark). In sum, these artists, to name a few, instinctively draw upon ancient Daoist ideas in their contemporary creations.

**FIGURE 25.1**  Wenda Gu, *Ink Alchemy,* 1999–2001. Mixed media. Image courtesy of the artist.

## Buddhist Art

Buddhism, which originated in India around the 6th-century BCE and came to China around the 2nd-century CE, is based on the teachings of the founder Shakyamuni, who achieved enlightenment (or the state of Buddhahood) after sitting in meditation under a tree. Buddhist teachings, as encapsulated in the Four Truths, maintain the following: all life experiences suffering; the cause of suffering is attachment; the end to suffering is non-attachment; and non-attachment is achieved by following the Eightfold Path, a moral and meditative code of behavior. With the invasion of nomadic peoples who ruled North India in the first centuries of the millennium, the teachings morphed into a religion. Because of contact with foreign cultures, principally Rome and Persia, Buddhism came to espouse new doctrines of paradise and an expansive pantheon of deities. Most important is the Bodhisattva of Compassion, Guanyin (Chinese), who will, under any number of circumstances, save the faithful from destruction. For contemporary Chinese, the Buddhist theocracy of Tibet, acquisitioned by the Chinese in 1951, was a Buddhist heartland, and many contemporary artists traveled there after 1980, when such visits became possible. Among them, the artists Gao Bo (b. 1964) (Karetzky 2011, gaoboarts.com);[8] and Gao Lei (b. 1965) (www.art.newcity.com and aaa-a.org/events/from-gaza-to-beijing-gao-lei)[9] took magnificent photographs of awesome mountaintops and impassable snowscapes, as well as of resident monks. Their works are spiritually vibrant. The artist Yang Jinsong (b. 1961) (yangjinsong.com, Karetzky 2008) became attracted to Buddhism when his father died; he began by copying the scripture describing the Buddha's death (*Mahaparinirvana sutra*) as a form of meditation and subsequently traveled to Buddhist cave sites in North China where he copied the decoratively carved interior walls.[10] Most recently, he has painted large icons of Guanyin, the Bodhisattva of Compassion, seated in his island home in the South Seas.

Wang Qingsong (b.1966), on the contrary, photographed himself as the multi-armed manifestation of Guanyin, but in the details of these works, he addresses the clash between the mystical values of religious belief and the selfish values of consumer society.[11] *In Requesting Buddha Series No.1,* 1999 (180 × 110cm), like an icon he sits on a base, but it is decorated with the *Coca-cola* logo, and each of his multiple hands holds a consumer product – Marlboro cigarettes, beer, the Chinese flag, money, and more (Karetzky 2013). In his accompanying text, he explains,

> As the quintessence of Chinese traditional culture, Buddhism has accompanied Chinese civilization for thousands of years. It brings comfort and fortune to the people, inspires their soul and enlightens a responsibility for having good relations with the others. This Buddha used to set its goal to save the suffering through self-devotion. However, in the current commercial society, the respectable Buddha has also been changed. It reaches out its hands insatiably for money and material goods towards every troubled person.
>
> *(wangqingsong.com)*

In a 2019 re-representation of the work, Wang, now middle aged, again depicted himself as the multi-armed Guanyin holding different objects, raw meat, a plastic skeleton, money, a cell phone, the UN flag, a statue of Confucius, a camera, and a bottle of red wine. But now, among the debris before his feet is a statue of Mao

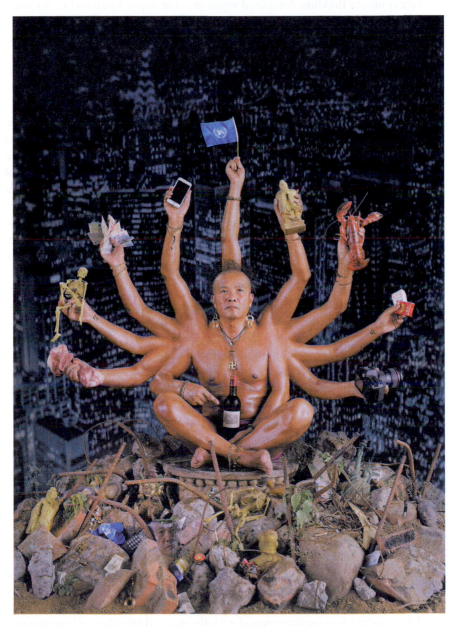

**FIGURE 25.2**  Wang Qingsong, *Bequeathing Buddha*, 2019. C-print, 180 × 130 cm (70.8 × 51.2 in). Courtesy of the artist.

facing backward, the statue of liberty, a Buddhist icon, and more. So many ideals and hopes discarded in the wake of "progress" (Figure 25.2).

An early pioneer in performance body art in the '80s, Zhang Huan (b.1966), converted to Tibetan Buddhism in 2005 (instagram.com/zhanghuanofficial/).[12] Now, he creates unique Buddhist devotional works in a contemporary idiom like the oversize Buddhist icon fabricated of incense ash for which he used twenty tons of incense ash gathered from Buddhist temples in Shanghai. "We treat the ash as a precious gift from the temples... we make a donation [to them in exchange] and invite the blessings that come with the ash to our studio" (artasiapacific.com/ZhangHuanSydneyBuddha). Accompanying the 5.3-meter ash sculpture was the aluminum mold from which it was cast, and when the mold was removed, the ash sculpture started to dissolve, a startling testimony to its impermanence in the face of its metal twin. Zhang began employing ash as an artistic medium following a visit to the Longhua Temple in Shanghai: "The temple floor was covered with ash which leaked from the giant incense burner....These ash remains speak to the fulfillment of millions of hopes, dreams and blessings" (Zhang Huan 2008, 11–12). Not restricted to Buddhist iconographical traditions, in 2007 Zhang cast an oversize (859.8 × 1280.2 × 1198 cm) steel and copper Buddha with three legs and headless torso; two of the feet rest on small piles, the third on a head, which is a self-portrait of the artist (stormking. org/exhibitions/zhanghuan). These provocative works are a multivalent meditation on the ego, impermanence, and spiritual values. Zhang also found inspiration in the fragments of icons destroyed during the Cultural Revolution that he saw in Tibet – an arm, a hand, a head, or a leg. These he fashioned into monumental metal sculptures like *Three Heads Six Arms* 2011 (Figure 25.3). As Zhang said,

> I collected a lot of fragments of Buddhist sculptures in Tibet [beginning in 2005]. When I saw these fragments in Lhasa [the center of religious life in Tibet], a mysterious power impressed me. They're embedded with historical and religious traces, just like the limbs of a human being
>
> *(stormking.org/exhibitions)*

The young artist Lu Yang (b. 1984) found inspiration in her grandmother's Buddhist beliefs and the severe asthmatic attacks that took her to the hospital throughout her youth. In a unique way, she draws upon the style of Japanese Manga and anime to construct cartoon-like creations of the unconventional in her internet videos, 3D-animated films, video game-like installations, holograms, neon, VR, and even software manipulation (Feola). These ideas are nowhere more evident than in her video *Delusional Mandala* (2015), in which her own avatar investigates the neurological symptoms of dying. Using a 3D printer, she generated a clone of herself that dances energetically, either naked or clothed, but without gender markings, and eventually disintegrates. Visual patterns explode and form Tibetan-like mandala designs. Interspersed with the medical episodes are long passages of dancing to house music. Lu described her beliefs,

> I really agree with a lot of points in some religions, especially Buddhism and its ideas about reincarnation and suffering. In Buddhism they say there

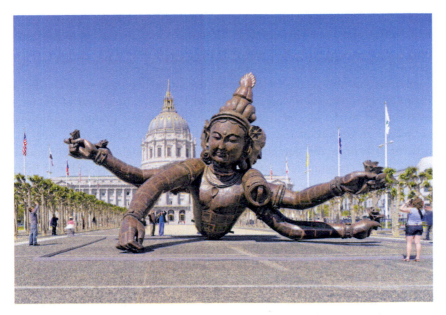

**FIGURE 25.3**   Zhang Huan, *Three Heads Six Arms,* 2011. Steel and Copper, 800 × 1800 × 1000 cm (315 × 708.7 × 393.7 in). 1881 Heritage Grand Piazza, Hong Kong, Edouard Malingue Gallery in Cooperation with The Pace Gallery. Courtesy of the artist.

are eight different kinds of suffering, whether you're happy or you're mad or whatever emotion you have, it's all painful. Because you can tell, a lot of things are because of the chemical elements in your brain. Sometimes you like to eat sweets, sometimes you really don't want to eat sweets, it's just because the brain wants to. I think the brain is the control center of your whole body, and there's another consciousness on top of your brain….But I'm more [likely to] believe people have a consciousness on top of the brain, and that's what gets reincarnated.

*(Feola)*

In a Vimeo, she examines Tibetan Buddhism's description of end of days – a group of wrathful deities destroy all evil beings; however, she maintains, terrifying as these deities are, they are expressions of the Buddha's infinite mercy. Coming from vastly different experiences and inspirations, these artists each draw upon the rich tradition of Buddhist art and thought to create extraordinary comments on its mystical teachings and the state of current society.

## Christian Art in Contemporary China

After 1980, Christianity, too, developed rapidly, with an estimated hundred million followers of various denominations (Wenger 2004), and contemporary Chinese Christianity, as opposed to Eurocentric Christianity, is distinct: adherents revere Jesus and the bible, they have a direct connection with their beliefs and,

by and large, eschew the institutions of western Christianity, which they find materialistic and somewhat corrupt. Although communal worship takes place, mostly among Catholics, it is not essential to practice; theirs is not a congregational religion, as it is in the west. Christianity spread not only in isolated rural areas but also in the cities among urban intellectuals, professionals, and Boss Christians (businesspeople) (Chen and Huang). The appeal of the faith is often linked to the idea of freedom which it embodies (Yang). Traditionally, art played an important role in the dissemination of Christianity with magnificent cathedrals and gorgeous altar paintings throughout the world and in China. Some contemporary artists like He Qi (b. n.d.) draw colorful Biblical narratives.[13] Others, like Miao Xiaochun (b. 1964), found inspiration in masterpieces of western Christian art like Michelangelo's *Last Judgement* (https://www.miaoxiaochun.com/Texts.asp?language=en&id=7), and Hieronymus Bosch's, *The Garden of Earthly Delights,* which he transformed into three-dimensional digital videos. Yue Minjun (b.1962) also based a series of paintings on famous Christian themes like the *Deposition of Christ, The Baptism of Christ,* and *Christ in Thorns,* to mention a few, which he renders in his signature style with falsely grinning, pink-skinned self-portraits. The interpretations of these works vary and stimulate much discussion (Jones).[14] The contemporary spectrum of styles is as varied as the types of Christianity practiced in China, and for the most part, the works often do not resemble western iconography.[15] Since worship takes place outside of formal religious institutions in China, art creation is a form of personal meditation and devotion (Kreissl). Some artists are trained in the art academy; others make more naïve works of art to express their faith. The Gao Brothers (Zhen b. 1956 and Qiang Gao b. 1962), avant-garde artists and ardent Christians, created a life-sized bronze sculpture of Mao shooting Christ with a rifle; another is an enormous sculpture of a red crucifix[16] (Wang 2009, Karetzky 2017). Li Qiang (b. 1966) found villagers with bibles bearing phonetic transcriptions of the Lord's Prayer given to them by western proselytizers. He exchanged the worn-out books with new bibles and presented the old ones along with the recorded sound of the villagers reciting their prayers in his installation *The Sound Disappeared Project,* 2004 (Karetzky 2017). Gao Ge, (b. 1964),[17] a professor, makes ink sketches like *The Good Fruit* (2008), illustrating Biblical citations such as "Even so every good tree bringeth forth good fruit; but a corrupt tree bringeth forth evil fruit" (Matthew 7:17) (Karetzky 2017).

Daozi (b. 1957),[18] a renowned poet and art critic, turned to ink painting as a form of prayer. His paintings have a clear Christian content and modern symbolic visual vocabulary. He calls his works, *Saintism,* and uniquely, he is determined to employ traditional Chinese-style ink painting. Spontaneously, Daozi executes his ink lines that cannot be altered. With bold and varied calligraphic lines, which have great emotional intensity, he freely draws angels, Christ, Mary, halos, candles, fish, birds, and abbreviated Biblical narratives. He signs his works with a Chinese chop engraved with Christian images. Daozi's bamboo paintings reveal his intent to build a bridge between Chinese traditional culture and Christian meaning. Bamboo is an ancient Chinese theme beloved by literati artists, for its

flexible segmental structure enables it to survive extreme storms, making it an apt metaphor for the gentleman who endures trauma yet retains his inner character. Daozi's bamboo paintings capture its segmental structure with burgeoning growth at the nodes (Figure 25.4). Skillful manipulation of variable tones of

**FIGURE 25.4** Daozi, *Saintism*, 2010. Ink on rice paper, 152.4 × 96.5 cm (60 × 38 in). Courtesy of the artist.

saturated ink on a heavily loaded wide brush renders the stalk; and a smaller brush and darker ink mark the accents, but there are no leafy branches; the close view resembles the crucifix. It is as if nature herself felt the painful event.

Daozi now has turned to calligraphy, adopting the ecstatic untrammeled cursive script of the Tang Buddhist monk Huaizu, eulogized by the famous 8th-century poet Li Bo,

> ... Like a whirlwind and driving rain, it amazes us with its sighing sounds,
> Like falling flowers and flying snow-how vast and boundless![19]
>
> *(Little 377)*

Daozi's work from 2020 renders a passage from Matthew 5:4: "Blessed are they that mourn: for they shall be comforted" (Figure 25.5). The majestic strength and freedom of the brushwork, the varied sizes of the characters, and erratic spatial relationships have effectively destroyed the strict vertical arrangement of the legible clerical script and convey his rapturous spiritual state of mind.

The photographer Cao Yuanming (b. 1974),[20] the gatekeeper of a small church, recorded the humble stools on which his congregation sat, their mats, and the decorative papercut Christian images posted on the doors, and in modernist manner, he arranged them into a geometrical grid. He also shot a series of portraits of rural pastors holding portrayals of their home churches and executed an earthwork of a large cross cut into a field grass (https://www.westmont.edu/yuanming-cao). He explains,

> I spent four years researching in various provinces, such as Anhui, Henan, Shandong, etc. Since the Cold War, religion has been the key to conflicts.... There are nearly a hundred million Christians in China now. Churches in the countryside present the primary space where Christian culture and Chinese local culture meet and blend together. My artworks are mainly discussing Chinese peasants' imagination towards foreign religion. They have never been to the West, nor have they seen the Western churches. They have built the churches based on their fantasy and fully intake the religion as a part of their life.
>
> *(Personal Communication 2021)*

Now Cao makes traditional oil paintings and videos of performance pieces. In Cao's *My Story Cannot Be Read*, he writes his personal story with chalk perched on the narrow median of a highway, while walking backward.[21] In this way, he says he can privately tell his stories (Personal Communication 2021). He expresses the need for secrecy, of stories that cannot be told, of danger and impermanence – chalk on concrete. Cao also memorialized the performance in a set of eight nearly abstract oil paintings. Another performance, *Love Poems on the Square*, takes place in a section of People's Park, Shanghai, where relatives

**FIGURE 25.5**   Daozi, *Matthew 5:4 Blessed are they that mourn: for they shall be comforted.* (King James Version), 2020. Ink on paper, 45.9 × 69 cm (18 × 27 in). Courtesy of the artist.

come to find marital prospects for their family members, often with placards detailing their good attributes. Standing on a low plastic stool, Cao recites T.S. Eliot's (d.1965) *Wasteland,* a mournful commentary on the dissolution of civilization and love, much to the consternation of the onlookers. In Chinese cultural tradition, poetry, the most highly regarded of the arts, has the power to move people, yet these people are not responsive to it: for the most part, they are more concerned about his intrusion on their loveless match-making mission.[22]

In summation, the dramatic transition from an isolated premodern Communist China to one which allows capitalist enterprise and the participation in religion, with restrictions, has produced a new artistic environment. A convergence of events led to a modern global existence led by foreign exchange with the west, the death of Mao, economic prosperity, and the reopening of universities and colleges that were shuttered during the Cultural Revolution. In this cosmopolitan atmosphere, artists explore a multitude of styles and media enjoying freedom from the early Communist era dictums to create propaganda art. The artists presented here are relatively few compared to the practitioners in China today, but they attest to the endurability and impact of the religious traditions for those who seek a balance against a rapidly burgeoning consumerist society. They turn to the ancient teachings and art of Daoism and Buddhism for solace, to understand the difficulties of life, and to examine what is important. Several employ Christian themes; some are professional artists trained in western curricula, and many are recent converts. Viewed as a group, we can see their art as a response to a spiritual hunger amid a fast-paced and rapidly changing world.

## Notes

1  See Part III Faith: 277ff.
2  Chen Zhen, who earned a BFA from the Shanghai School of Arts and Crafts (1973) and a MFA from the Shanghai Drama Institute (1978), moved to Paris in 1986, where he studied at the École nationale supérieure des beaux-arts. He worked primarily as a sculptor and installation artist.
3  Cai Guo-Qiang studied stage design at the Shanghai Drama Institute from 1981 to 1985 and attended the Institute for Contemporary Art: The National and International Studio Program at P.S.1 Contemporary Art Center, Long Island.
4  Xu Bing spent two years in the countryside during the Cultural Revolution and enrolled in 1977 at the Central Academy of Fine Arts in Beijing; internationally acclaimed, in 2008 Xu Bing was appointed vice president of the Central Academy of Fine Arts.
5  Wenda Gu is a graduate of the Shanghai School of Arts and the China Academy of Art. http://wendagu.com/going-pop/performances/wenda-gus-wedding-life/wedding-life_1.html, Wenda Gu's *Wedding Life #1,* a special art performance for Asian Art Museum of San Francisco, February 8, 1999; artist: Wenda Gu (groom, Chinese), collaborator: Frances Kaplan (bride, Australian-American), minister: Cameron Corwin (six years old, Filipino and Caucasian).
6  http://wendagu.com/home.html, an installation with three boxes of liquid ink, three boxes of ink sticks made of powdered Chinese hair, sixteenth-inch TV monitor period of creation: 1999–2001, Shanghai.
7  http://wendagu.com/installation/tea_alchemy/tea_alchemy03.html, this project was created at Hong Ye rice paper factory, Jing County, Anhui Province, China, in

2000–2002. It was commissioned by the International Chado Cultural Foundation in Tokyo and the Itoen Company in New York. The project comprised 30,000 sheets of tea (rice) paper made out of 4000 pounds of green tea metal tea powder spreader and one hundred pounds of green tea powder, Chinese classic accordion painting book made of green tea paper, and a video document "tea alchemy-making tea paper."

8  Gao Bo graduated from the Academy of Arts & Design, Tsinghua University, in 1987. In 1990, he lived in France and worked with Agence VU and Galerie VU.

9  Born in 1965, Gao Lei invented a Bulk Commodity Container, and technology and invention eventually led him to discover photography as an art form, which he studied at the Speos Photographic Institute in France.

10  Yang Jingsong earned a master's degree at Sichuan Fine Arts Institute oil painting department, where he taught for decades.

11  Wang Qingsong studied at the Sichuan Academy of Art.

12  Zhang Huan received a BA from Henan University in Kai Feng in 1988 and an MA from the Central Academy of Fine Arts in Beijing in 1993.

13  He Qi Studied at Nanjing Normal University, Nanjing Art Institute in China and Hamburg Art Institute in Germany. Now, he is currently an Artist-in-Residence at Fuller Theological Seminary (CA) and a Distinguished Visiting Professor at the Art Institute of RUC (Renmin University of China, Beijing). https://www.heqiart.com/.

14  Yue Minjun worked in the oil industry until the events of the 1989 Tiananmen Square uprising encouraged him to join an artists' colony outside of Beijing.

15  Miao Xiaochun graduated from CAFA, Beijing, China, in 1989 and from Kunsthochschule Kassel, Germany, in 1999.

16  Gao Zhen graduated from Shandong Academy of Fine Arts and Gao Qiang from Qufu Normal University; they have worked together since 1985.

17  Gao Ge teaches at the Academy of Fine Arts, Shandong University of Technology.

18  Daozi, the pen name of Professor Wang Min from the Academy of Art & Design in Tsinghua University, was deputy editor-in-chief of *Chang An*, an art journal.

19  When he gets up and faces a wall, he doesn't stop his hand,
There's one line of characters big as dippers.
In total, amazement-like hearing spirits and ghosts alarmed,
From time to time, all we see is dragons and snakes running.
On the left coiled up, on the right converging, like frightening lightning,…

20  Converted to Christianity, Cao Yuanming was educated as painter and photographer in an art university and currently teaches at Shanghai University.

21  Tang Ningrong and Yuan Zihan filmed the performance on December 31, 2017, on the Huyi Highway (Jiading Section of Shanghai) on a hazy day, with strong winds and low temperatures.

22  Cao Yuanming said,

> On weekends and holidays, this place is like a bazaar. The elderly men and women from Shanghai and the surrounding Jiangsu and Zhejiang regions gathered here to make blind dates for their older children. There are at least tens of thousands of booths, plus tens of thousands of domestic and foreign tourists every day.… In the blind date advertisements, self-introduction and requirements for the other party are mainly house, car, deposit, household registration, education, height, occupation, income, etc., except for love.

(Personal Communication 2021)

## Bibliography

Andrews, Julia F. "Traditional Painting in New China: Guohua and the Anti-Rightist Campaign," *The Journal of Asian Studies*, Vol. 49, No. 3 (August 1990), 555–577.

Bays, Daniel H., 2003. "Chinese Protestant Christianity Today Source," *The China Quarterly*, No. 174, Religion in China Today (June 2003), 488–504.

"Cai Guoqiang." *Art Boom*, https://www.designboom.com/art/cai-guo-qiang-hanging-out-in-the-museum/2010. Accessed September 27, 2021.

——. https://www. caiguoqiang.com.

——. *Sky Ladder*, 2015. https://www.youtube.com/watch?v=JmW2avkGduQ. Accessed September 27, 2021.

Cai Guo-Qiang and You Jindong, "Painting with Gunpowder," *Leonardo,* Vol. 21, No. 3 (1988), 251–254.

Campany, Robert Ford, "Two Religious Thinkers of the Early Eastern Jin: Gan Bao and Ge Hong in Multiple Contexts," *Asia Major*, Vol. 18, No. 1 (2005), 175–224.

Cao Yuanming. https://www.westmont.edu/yuanming-cao.

"Chen Zhen," 2015. Gallery Continua 2021. https://www.galleriacontinua.com/artists/chen-zhen-83/biography. Accessed September 27, 2021.

——, 2000. "Invocation of Washing Fire." https://www.youtube.com/watch?v=fqyCJdd3Z0M. Accessed September 27, 2021.

Chen Zhen, *The Allure of Matter*, Wu Hung et al. Chicago: Smart Museum, 2020. https://theallureofmatter.org/artists/chen-zhen/. Accessed September 27, 2021.

Chen Zhen, 2000. https://www.tate.org.uk/art/artworks/chen-cocon-du-vide-t12941. Accessed September 27, 2021.

*Chen Zhen: A Tribute*, Jeffrey Uslip and Rachael Zur, editors. New York: MOMA, 2002. https://www.moma.org/calendar/exhibitions/4780. Accessed September 27, 2021.

*Chen Zhen*, New York: P.S. 1 Contemporary Art Center, 2003.

Chen Cunfu and Huang Tianhai, "The Emergence of a New Type of Christians in China Today," *Review of Religious Research*, Vol. 46, No. 2 (December 2004), 183–200.

Chiang, Sing-chen Lydia. "Visions of Happiness: Daoist Utopias and Grotto Paradises in Early and Medieval Chinese Tales," *Utopian Studies*, Vol. 20, No. 1 (2009), 97–120.

Clark, Amanda C.R. "Contemporary Chinese Artists' Books: New Artistic Voices in a Time of Transition," *Art Documentation: Journal of the Art Libraries Society of North America*, Vol. 34, No. 1 (2015), 15–28.

Danial. 2021. "Daozi Interview: When Chinese Ink Painting Meets Western Bible" published on *wechat*

Davis, Tenney L. and Yün-ts'ung, Chao, "A Fifteenth Century Chinese Encyclopedia of Alchemy," *Proceedings of the American Academy of Arts and Sciences*, Vol. 73, No. 13 (1940 July), 391–399.

Feola, Josh. "Mindful Indulgence: Lu Yang's Art as Spiritual Entertainment," November 2017. https://radiichina.com/lu-yang-interview/ http://luyang.asia. Accessed September 27, 2021.

Friedman, Thomas L, "The Cultural Revolution: China's New Gang of Four," *New York Times*, March 21, 1998, A15.

Gao Bo. *Déclaration Laotiste,* 2020. https://www.citedesartsparis.net/en/fringe-event-gao-bo-declaration-laotiste. Accessed September 27, 2021.

"Gao Bo." http://www.gaboarts.com. Accessed September 27, 2021.

"Gao Lei," 2010. https://art.newcity.com/2010/05/04/review-gao-leiwalsh-gallery/. Accessed September 27, 2021.

"Gao Lei." *Asian Art Archive*, 2010. https://www.aaa-a.org/events/from-gaza-to-beijing-gao-lei/. Accessed September 27, 2021.

Goldman, Merle. 1986. "Religion in Post-Mao China," *Annals of the American Academy of Political and Social Science*, Vol. 483, Religion and the State: The Struggle for Legitimacy and Power (January 1986), 146–156.

Goodman, Jonathan, "Chen Zhen at PS1 Review," *Yishu Journal of Chinese Contemporary Art*, Vol. 2, No. 3 (2003), 105–106. http://yishu-online.com/wp-content/uploads/mm-products_issues/uploads/yishu_06.pdf. Accessed September 27, 2021.

Gu, Wenda. http://wendagu.com/going-pop/performances/wenda-gus-wedding-life/wedding-life_1.html. Accessed September 27, 2021.

Guggenheim Online Collection. https://www.guggenheim.org/artwork/artist/chen-zhen. Accessed September 27, 2021.

He, Qi. www.heqiart.com/. Accessed September 27, 2021.

Johnson, Ian. *The Souls of China: The Return of Religion After Mao.* Pantheon, 2017.

Jones, Victoria Emily. "Yue Minjun and the Maniacally Grinning Christ," *The Jesus Question* June 15, 2011. https://thejesusquestion.org/2011/06/15/yue-minjun-and-the-maniacally-grinning-christ/. Accessed September 27, 2021.

Kaltenmark, Max. *Lao Tzu and Taoism.* Translated by Roger Greaves. Stanford, 1969.

Karetzky, Patricia Eichenbaum. "New Works, New Directions in the Art of Yang Jinsong," *Yishu Journal of Chinese Contemporary Art,* Vol. 7, No. 1 (2008), 37–40.

——. "Bomu: Don't Fence Me In," *Yishu Journal of Chinese Contemporary Art,* Vol. 10, No. 4 (2011), 93–109.

——. "Wang Qingsong's Use of Buddhist Imagery (There Must Be a Buddha in a Place Like This)," *Yishu Journal of Chinese Contemporary Art,* Vol. 12, No. 1 (2013), 42–54.

——. "Xu Bing's Magical Mystery Tour," *Yishu Journal of Chinese Contemporary Art,* Vol. 13, No. 1 (2014), 76–92.

——. "Amazing Grace: Contemporary Chinese Christian Art," *Yishu Journal of Chinese Contemporary Art,* Vol. 16, No. 1 (2017), 90–107.

——. *Chinese Religious Art.* Lexington Books, 2013.

Kohn, Livia, *God of The Dao: Lord Lao in History and Myth.* Michigan Monographs in Chinese Studies, 2000.

Kreissl, Barbara. 2001. Several Colleges Offered Training in Christian Style Chinese Art, see "Christian Art in China," *Artway.* https://www.artway.eu/content.php?id=515&lang=en&action=show. Accessed September 27, 2021.

Laurie. Chen. "Vatican's Chinese Christian Artworks Go on Display at Beijing's Palace Museum," *South China Morning Post,* May 28, 2019. https://www.scmp.com/news/china/society/article/3012170/vaticans-chinese-christian-artworks-go-display-beijings-palace. Accessed September 27, 2021.

Lawton, Mary S. "A Unique Style in China: Chinese Christian Painting in Beijing," *Monumenta Serica,* 43 (1995), 469–489. See also the exhibition of such paintings in the collection of the Vatican displayed in Beijing.

Little, Stephen. "Chinese Calligraphy," *The Bulletin of the Cleveland Museum of Art,* Vol. 74, No. 9 (November 1987), 372–403.

Manvicosky, "Artist Creates First Burning Ladder to the Sky, the Reason He Did it Is So Touching." *Opera News,* 2015. https://ng.opera.news/ng/en/entertainment/9c5febd2a230e0314ded885b2c0aa2e2. Accessed September 27, 2021.

Needham, Joseph, and Ping-Yü, Ho, "Theories of Categories in Early Mediaeval Chinese Alchemy," *Journal of the Warburg and Courtauld Institutes,* Vol. 22, No. 3/4 (July–December 1959), 173–210.

Osnos, Evan. *Age of Ambition Chasing Fortune, Truth and Faith in the New China.* Farrar: Straus and Giroux, 2014.

Salisbury, Harrison E. "The Last Emperor: How Deng Xiaoping Assumed 'The Mandate of Heaven' to Fashion a New China After Ming, Marx and Mao," *Los Angeles Times,* January 26, 1992. https://www.latimes.com/archives/la-xpm-1992-01-26-tm-1113-story.html. Accessed September 27, 2021.

Tsao Hsingyuan and Ames, Roger T. *Xu Bing and Contemporary Chinese Art: Cultural and Philosophical Reflections.* SUNY series in Chinese Philosophy and Culture, 2011.

Waley, Arthur. "Notes on Chinese Alchemy ("Supplementary to Johnson's A Study of Chinese Alchemy"). *Bulletin of the School of Oriental Studies,* Vol. 6, No. 1 (1930), 1–24.

Wang, Jimmy, "In China, a Headless Mao Is a Game of Cat and Mouse," *New York Times*, October 5, 2009. http://www.nytimes.com/2009/10/06/arts/design/06gao.html?_r=0/.

Ware, James. *Alchemy, Medicine & Religion in the China of AD 3.20 The Nei P'ien of Ko Hung.* Dover Publications, 1981.

Wenda Gu, *Art From Middle Kingdom To Biological Millennium.* Edited by Mark H.C. Bessire. MIT Press, 2003.

Xi, Lian. "A Messianic Deliverance for Post-Dynastic China, The Launch of the True Jesus Church in the Early Twentieth Century," *Modern China,* Vol. 34, No. 4 (October 2008), 407–441.

Xu Bing. https://xubing.com.

Yang, Fengyang, "Christianity's Growth in China and Its Contributions to Freedoms," *Conscience, Reformation, and Religious Freedom Across the Centuries.* October 31, 2017 https://berkleycenter.georgetown.edu/responses/christianity-s-growth-in-china-and-its-contributions-to-freedoms.

Yang Jinsong. https://www.yangjinsong.com.

*Zhang Huan,* Harry Blain and Graham Southern, editors. Haunch of Venison, 2008.

Zhang Huan, Storm King Center, n.d. https://stormking.org/exhibitions/zhanghuan/works/3leggedbuddha.html. Accessed September 27, 2021.

"Zhang Huan" 2015. http://artasiapacific.com/Blog/ZhangHuanSydneyBuddha. Accessed September 27, 2021.

Zheng, Haiping,"The Gang of Four Trial," 2010. https://web.archive.org/web/20171230122458/http://law2.umkc.edu/faculty/projects/ftrials/gangoffour/Gangof4.html. Accessed September 27, 2021.

# 26

# SALVATION IN THE FALLEN WORLD

## On Meng Yan's Recent Monumental Works

*Changping Zha*

If we assume that the secular city that is opposed to the sacred is located at the intersection of heaven and hell, then the worldly city that is opposed to the atheistic lies in the middle ground between them. This middle ground is depicted as the purgatory of the human world in artist Meng Yan's recent monumental oil paintings *The Last Supper* (2008–2016) and *The Divine Comedy* (2006–2016). This human purgatory is a place where money, power, and lust trample human hearts in turn. It is also the true picture of Chinese society, culture, and civilization today where a transformation is taking place from a pre-modern to a modern society, from power politics to capital-based economics, and from a pre-Christian era to a Christian one (Zha 22–34). In addition to these shifts, the paintings also reflect the urbanization and "entertainmentization"[1] that characterize the post-modern age.

Meng's painting, *The Last Supper* (Figure 26.1), takes a vertical form to present the relationship between human and God.[2] The painting can be divided into four sections: at the top are Jesus and the twelve disciples. They are in the air above a chaotic, war-torn city, each with different hand gestures and facial expressions and with halos that signify their salvation. Jesus is positioned at the center with his hands stretched out toward the falling and ripped earth below and ink marks dripping down his face indicating his infinite suffering. Immediately below, the second section presents a modernized industrial city with such architectural icons as the Oriental Pearl Tower of Shanghai, seemingly built upon a vast ocean. The third section is at the eye level of the viewer. Here, we see industrial furnaces, silver coins representing Chinese Yuan, and American dollars on the left and an ongoing war with soldiers, tanks, planes, and homing missiles on the right, all of which appear to be floating over the ocean. The road in the center of the image has collapsed, crumbling into a giant chasm. In the left side of the lowest section, we see the image of Jesus flying through the air, calling

DOI: 10.4324/9781003326809-30

out to all those falling into the widening abyss, simultaneously appearing as if he is about to cast himself down into that abyss to save those souls that are rapidly receding down the path of the lost. Meanwhile, the soldiers on the right, with gas masks over their mouths, relentlessly persist in their acts of massacre. This kind of image, structured vertically, presents a vision of hope for salvation from collapse and the abyss through the divine love of Jesus as a love that overcomes all the hatred in the world.

Such is the "last supper" of humankind today in Meng Yan's mind. It is different from Leonardo Da Vinci's famous work in Santa Maria delle Grazie in Milan (1495–1498).[3] Here, the quiet dining room of a monastery is replaced by a swirling misty sky; the clean white dining table by a city dwarfing the sea; and the skeptical and terrified expressions of the disciples by painful and hopeless looks, although their loyalty and care for Jesus as a rabbi are implied by the same gestures and their leaning bodies. Further, Judas' uncomfortable look is replaced by his dead sleep, although he leans back just as he does in the original painting. Jesus is still in the center of the picture, but his calm and thoughtful action of bread-breaking is replaced by a compassionate look with tears in his eyes.

Meng's work is also different from what the Bible records. According to the Gospel of John, Chapter 13, Jesus appeared worried and told his disciples, "One of you will betray me." The disciples looked at one another and Peter motioned to the "disciple whom Jesus loved," John, to ask him of whom Jesus was speaking. But in his painting, Meng Yan has made Jesus the focus, as if all of the disciples are asking this of Jesus and waiting for *his* reply. The Gospel of John states that Judas received a piece of bread from Jesus and immediately left. But in Meng's work, Judas looks like an oriental beauty sleeping restfully. According to John, Jesus washed the disciples' feet before the last supper to show his *agape* love for them – for those who belonged to him – and then gave his new commandment: "You love one another, just as I have loved you, you also should love one another. By this everyone will know that you are my disciples, if you have love for one another" (John 13:34–35, NRSV). For John, the last supper is a love feast during

**FIGURE 26.1** Meng Yan. *The Last Supper*, 2008–2016. Oil on canvas, 1150 × 400 cm (452.75 × 157.5 in).

which God illustrated his unconditional and sacrificial love for everyone, *including* Judas the traitor. Just as Jesus foretold Judas's betrayal, he also predicted Peter's denial. Both of these incidents confirm the indifference of human beings even toward God's Son. Despite this, Jesus said: "I am the way, and the truth, and the life. No one comes to the Father except through me" (John 14:6, NRSV). The crucifixion of Jesus, who was betrayed, denied, and abandoned by his disciples, revealed God's *agape* love for this world, and established an example for human love. This, indeed, may be the ultimate significance of Meng Yan's painting, *The Last Supper*.

According to artist and theologian Clover Xuesong Zhou,

> Chinese Christian contemporary artists exhibit a number of sundry conceptions of the relationship between art and faith. Art can be a medium for worship or for evangelizing. It can be a tool for generating cultural dialogue. It can be a means of pursuing truth, or it can be an exercise in visual hermeneutics. Most Chinese Christian artists present a blend of these aspects.
>
> (788)

However, as one who is not an adherent of the Christian faith, Meng Yan simply regards art to be a tool for representing his cultural ideas about human life in the world.

Meng's painting *The Divine Comedy* (Figure 26.2) is also a piece of conceptual art that can be divided vertically into upper, middle, and lower portions: a "heaven" where many saints are present in the upper part of the canvas, a "purgatory" where different forms of life rotate under the cross in the middle, and a "hell" that is filled with throngs of people in circles in the lowest part. The prototype of the structure of the painting is the circulation system of the universe in Meng's imagination. The painting focuses on the age of capital-based economy, which is represented by gold ingots, silver coins, and Chinese Yuan, and the circular building of the United Nations made of stacks of US dollars. Rising from the center is a crystal-like miniature of the global system, signifying the destiny of the entire cosmos. Above are teary representatives from all nations and countries indicated by their national flags who are being dragged into a whirlpool by the forces of this age. Some ascend into "heaven" to become saints because of the light of the cross that shined upon them. The saving light in the center is a symbol for *agape* love, hope, and truth. To the left are images of Jesus, the Virgin Mary, Muhammad, Gandhi, Audrey Hepburn,[4] Che Guevara, Moses, Plato, Joan of Arc, Voltaire, Dante, and the like; to the right are Buddha, the Goddess of Mercy (Guanyin), Laozi, Confucius, Mozi,[5] Lei Feng,[6] Lu Xun,[7] Wang Fengyi,[8] and representatives from all walks of life. In the eyes of the artist, they are ordinary people just like you and me. All of these "saints" appear to have experienced hardships and suffering and have halos around their heads, bathed in the light radiating from the cross above them. The left and right sides

**FIGURE 26.2** Meng Yan. *The Divine Comedy*, 2006–2016. Oil on canvas, 900 × 920 cm (354.3 × 362.2 in).

of the painting depict the emergence of the age of power politics, which is symbolized by the space shuttle, aircraft carriers, and rising rockets. This purgatory of the human world is in fact a place where money, power, and lust intertwine and take turns ruling human hearts. It is also the battlefield between the age of a capital-based economy, the age of power politics, and the age of psychic or spiritual culture. In this place power reigns, money piles up, dollars fly about, lust spreads and corrupts, ambitions inflate on the fringes of the city, and crises are brewing in nuclear power stations. Due to their lack of self-control, the majority of people fall into the surging ring of the mouth of "hell" to an underground world where ghosts fight one another amidst mountains of skulls and skeletons. This is the way Meng Yan represents the sins of the world and the fate of fallen souls. He has sympathy not just for "good" people but also for the "bad." In Meng's view, both are wretched or sick, and need to be saved into an ontological truth, goodness, and beauty – which "correspond respectively to being as true, good, and beautiful," as Jonathan King affirms in his book *The Beauty of the Lord: Theology as Aesthetics* (20). But for Meng, they have neither transcendental

nor divine properties because Meng believes in Buddhist karma rather than the transcendent, triune God of Christianity. Nevertheless, in Dante's *Divine Comedy*, Christian theology, as scholar Etienne Gilson explains,

> constitutes *its very substance* [my emphasis], since it provides its subject matter, determines its structure, directs its unfolding, and takes it, through episode after episode, up to the mystical experience which is its term. The sacred poem is even wider in scope than a straight religious and theological work would have been.
>
> *(176)*

Moreover, in the Gospel of Mark, Jesus said, "Those who are well have no need of a physician, but those who are sick; I have come to call not the righteous but sinners" (2:17, NRSV). In contrast, Meng Yan says,

> Hell, earth and heaven are not eternal things. They are a living circulation system. Only love can resolve the contradictions of the world. Evil and violence can only bring destruction. 'Love' is the key and remedy for all problems. I believe in karma. Evil is rewarded with evil, and good with good. Those who are impudent, ignorant, bad and evil will fall into hell to suffer or live in hell on earth with tribulation.
>
> *(qtd. in Zha 388)*

Because Meng Yan understands heaven, earth, and hell as an endless circulation system, he regards Jesus as merely another member of the company of saints or prophets in history, no different from Muhammad, Moses, Plato, Gandhi, Laozi, or Confucius. But if this is the case, how should one understand Jesus' own declaration that *he* is "the way, the truth and the life," God's Son whose death and resurrection make possible the salvation of those who believe in him, the revelation of God's love and righteousness?[9] Moreover, how could the saving light shine forever if there were no Jesus Christ on the cross? How can love never fail? For Meng Yan, the theory of a universal circulation system reconciles the concepts of heaven, earth, and hell and their relationships to one another. In essence, he believes in the Buddhist ethics of karma, a closed system of cause and effect. The "hell" in his *Divine Comedy* has nothing to do with the "Hades" (from the Greek), where the rich man arrived after death in the Gospel of Luke, Chapter 16. Nor does the "heaven" in his art have anything to do with the New Jerusalem as described in the book of Revelation:

> See, the home of God is among mortals. He will dwell with them as their God; they will be his peoples, and God himself will be with them; he will wipe every tear from their eyes. Death will be no more; mourning and crying and pain will be no more, for the first things have passed away.
>
> *(Revelation 21: 3–4, NRSV)*

No wonder all those saints in heaven, with the exception of Dante and Lu Xun, are weeping, their tears soaking into earth and the depths of hell through the spilt ink in his work.

Meng Yan's painting *The Divine Comedy* is the lament of the artist faced with the cultural and civilizational transformation of contemporary Chinese society. His perceptions, however, are limited by belief in karma and reincarnation from his Chinese heritage, hindering a breakthrough in his thinking that would also advance his art. As Etienne Gilson writes in *The Arts of the Beautiful,*

> Art creates beauty. The beautiful is a transcendental of being, and to approach being as such is always to reach the threshold of the sacred. In this sense, all pure art, and all the pure arts as such, are related to the religious sphere in the same way as are the other great human activities, such as science, philosophy and ethics.
>
> *(182)*

But Meng Yan's *The Divine Comedy* resides in a humanistic religious sphere, which is absent of any transcendental elements, even though he strives to provide some inspiration for salvation to the floundering people in the world, by creating, in the artist's own words, "a painting that is big yet not empty, complicated yet not messy, subtle but not slippery, and capable of cleansing hearts, touching souls, answering questions, and clarifying problems" (qtd. in Zha 389).

The majority of Meng Yan's other works also reflect the theme of human existence in an oppositional relationship to God. These include images of the city dominating the sea, war, and skeletons, which became the base of his renditions in *The Last Supper* and *The Divine Comedy*. His painting *The Crisis* demonstrated a superior command of the dripping technique he employs. In *Ambition*, both heroes and human skeletons fight for gold, silver, and American dollars, and the entire city sinks into the sea of death because of war. In *Lust*, the last work in this trilogy, angels flying in the sky directed by Lady Liberty shoot arrows at the pleasure-seekers in the city and the self-consoling skeletons in hell. A giant skeleton in the center of the painting remains fixed on this world, hoping to claim everything as its own even though it is already dead. In *Memory* and the *"Alive"* series (2007–2008), Meng Yan developed a scribble technique and further matured his unique skill of dripping or flowing paints in his *"Lonely"* series (2008) to convey obsessive and frenzied sexual desire (*Meng Yan: Desires*). The distinctness and power of this technique is aptly described in the catalog for the 2008 exhibition *Desires*, Meng Yan's first solo exhibit outside of China at the Gossip Gallery in Bangkok:

> ...there is an urgency and fury to Meng Yan's method, and a wildly contrasting, sometimes electrified color palette that manages to be both of our contemporary moment and still offer something as yet unseen....Meng Yan brilliantly contributes to the discourse; while all the time hints of form,

signs of life, figures in the act of becoming and unbecoming flit across the retina.

*(Easton 34)*

It was only after producing many experimental portraits of individuals including Einstein, Churchill, Andy Warhol, Dali, and Giacometti (*Meng Yan Solo Exhibition*) that Meng Yan finally completed *The Last Supper* and *The Divine Comedy*, two monumental works of art that should be viewed as landmarks in the history of contemporary Chinese art that issue a clarion call regarding the detrimental and dehumanizing effects of the forces that are transforming not only China but modern societies everywhere.

## Notes

1  The term "entertainmentization" was introduced by Michael Wolf, *The Entertainment Economy: How Mega-Media Forces Are Transforming Our Lives* (Times Books, 1999) to describe how media and entertainment have moved beyond "culture" to shape contemporary life and drive the global economy.

2  Wang Wangwang's "Search for God" series (2008), Daozi's "Saintism Ink-water," Qian Zhusheng's woodcuts, Duofu's images composed of cross-shaped brushstrokes (the "Genesis" and "the 12th Lunar Month" series, 2013), The Gao Brothers' installation "Crisis – A Big Cross" (1994–1996), the blood red imagery of Wang Lu's work, Zhu Jiuyang's wave themed pictures, all of these works appeal to represent the relationships between human and God in contemporary Chinese art, they call for the divineness of the contemporary to arise, they call forth a spiritual outlook characterized by an eternal hope (Zha "A History of Ideas" Vol. 1, 35–37); see also Zha Changping, "The Dimension of Human-God Relation in the Thought-picture of Chinese Contemporary Art," *Yearbook of Chinese Theology*, ed. Paulos Z. Huang (Leiden: Brill, 2015), 51–68.

3  For information on the reception history of Da Vinci's *The Last Supper* in China, see Luo Le's dissertation in Sichuan University in 2018: "Research on *The Last Supper*: Image of Postmodernism from the Perspective of in-between," unpublished.

4  Audrey Hepburn (1929–1993), born Audrey Kathleen Ruston, was a British actress and humanitarian.

5  Mozi, original name Mo Di, (b. 470?, died 391? BCE, in China), Chinese philosopher whose fundamental teaching of undifferentiated love (*jianai*), which challenged Confucianism and gave the basis to a socio-religious movement known as Mohism.

6  Lei Feng (1940–1962) was a soldier in the People's Liberation Army who was the object of several major propaganda campaigns in China. The most famous of them promoted the slogan in 1963, "Follow the examples of Comrade Lei Feng." Lei has been depicted as a model citizen, with some personal characters such as selflessness, modesty, and devotion to Mao Zedong. After Mao's death, state media kept on promoting Lei Feng as a model of service.

7  Zhou Shuren (1881–1936), pen name Lu Xun (or Lu Sun), was a Chinese writer, essayist, poet, and literary critic. He was a leading figure of modern Chinese literature.

8  Wang Fengyi (1864–1937), a Confucian educator from northern China, transposed ancient wisdom into a practical 5-element based emotional healing system.

9  Based on the relationship between theological beauty and the beauty of the world, or on the relationship between God and human in Christ, Jonathan King explains that "the objective beauty of the person of Christ, the beauty of the work of Christ (redemption accomplished), and the beauty of Christ's work ongoing through the

Holy Spirit (redemption applied) are the preeminent aspects of God's 'beautiful self-showing' according to the redemptive-eschatological fulfillment of his original creational purposes" (324).

## Bibliography

Easton, Craig. "Confronting Meng Yan." *Meng Yan Solo Exhibition*. Jiashan: Jiashan Museum, 2021.

Gilson, Etienne. *The Arts of the Beautiful*. Dalkey Archive Press, 2000.

King, Jonathan. *The Beauty of the Lord: Theology as Aesthetics*. Lexham Press, 2018.

Meng Yan. *Meng Yan Desires*. Bangkok: Gossip Gallery, 2008.

——. *Meng Yan Happiness*. Lugano: Fafa Fine Art Gallery, 2016.

——. *Meng Yan Solo Exhibition*. Jiashan: Jiashan Museum, 2021.

Zha Changping. *Zhongguo xianfeng yishu sixiangshi diyi juan: shijie guanxi meixue* 中国先锋艺术思想史第一卷世界关系美学 (*A History of Ideas in Pioneering Contemporary Chinese Art,* Volume 1: World Relational Aesthetics). Shanghai Joint Publishing Co., 2017.

Zhou Clover Xuesong. "Chinese Contemporary Christian Arts and the Bible." *The Oxford Handbook of the Bible in China*, edited by K.K. Yeo. Oxford University Press, 2021.

# 27

## CHRYSANNE STATHACOS, CHARWEI TSAI

## The Mandala

*Haema Sivanesan*

Picture a magnificent tree in a public garden, festooned with brightly colored ribbons and marked in the cardinal and intercardinal directions by painted wooden benches and various formal elements inviting visitor participation. *Refuge, A Wish Garden* (2002–2011) (Figure 27.1). by Canadian artist Chrysanne Stathacos was exhibited in various cities in Germany, Canada, and the United States. The artist describes the installation as "an interactive public artwork acting as a garden for meditation, protection, and wishing actions" (Stathacos, n.d). Visitors to the garden were invited to tie a ribbon to the wishing tree and find a moment of refuge under its branches. The artist's intention was not only to create an artwork as a site of public interaction, but "to bring spirituality into the public sphere" (Stathacos, 2020), into sometimes unexpected secular spaces and into social life. The interactive artwork describes a field of spiritual activity: as a mandala-like ritual circle intended to focus and transcend the mundane mind. The artist recounts that she was inspired by the wishing trees that she saw in temples in India. According to Indian mythology, wishing trees or *kalpataru* are celestial trees with broad trunks and leafy branches, bearing fragrant fruit and flowers, and sheltering a myriad of creatures. These wishing trees have the awesome power to grant the wishes of whomever propitiates them. In his anthology on Vedanta philosophy, Christopher Isherwood described the wishing tree as a metaphor for the heart, suggesting that the wish-fulfilling capacity of the celestial tree is embodied within each person (Isherwood, 1986). Accordingly, Stathacos' wish garden is an invitation for anyone who engages with the work to manifest this potential.

*Refuge, A Wish Garden* and Stathacos' subsequent installation *Wish Machine* (1997–2021) were intended as sites for the manifestation of "a certain energy and intention; a focusing of the mind and heart; of compassion" (Stathacos, 2020).

DOI: 10.4324/9781003326809-31

**FIGURE 27.1** Chrysanne Stathacos, *Refuge, A Wish Garden* (Abington Art Center, Philadelphia, USA), 2006. Interactive public artwork: cloth, benches, flowers, sand, rakes; dimensions variable. Courtesy of the artist.

These wish devices proposed to harness a relationship between everyday life and our capacity to transcend it. They anticipated a more recent and ongoing body of work titled *The Rose (Mirror) Mandalas* (1999–ongoing), concerned with the creation of circular, mandala-like spatial fields. Created as temporal works that change over time, these installations address concepts of beauty, decay, transformation, and impermanence. The rose and mirror suggest femininity, referring to Stathacos' interest in Buddhism as a religion that recognizes and embraces female empowerment. Indeed, Stathacos' teacher, Jetsunma Tenzin Palmo, once famously declared, "I have made a vow to attain Enlightenment in the female form – no matter how many lifetimes it takes" (Mackenzie, 5), aligning with Stathacos' interest in the potential of a feminist approach to divinity. Further, Tenzin Palmo describes *The Rose (Mirror) Mandalas* as symbolizing "the gradual unfolding of our innate spiritual potential" (Stathacos, n.d), and indeed, this body of work that has engaged the artist for more than two decades parallels the artist's development as a Buddhist practitioner.

An early installation, *Rose Mirror Mandala* (2003), was made for the exhibition *The Invisible Thread: Buddhist Spirit in Contemporary Art* (Snug Harbor Cultural Center, Staten Island, New York, 2003). Since then, variations of the work have been created and exhibited around the world, including on the occasion of His

Holiness the 14th Dalai Lama's visit to the University of Buffalo for the conference *Law, Buddhism and Social Change* (2006). Stathacos describes these mandalas as the merging of "different actions [or symbols]," as both experience and dynamic form (Stathacos, 2020). Her most recent and most elaborate mandala titled *The Three Dakini Mirrors (of the Body, Speech and Mind)* (2021), (Figure 27.2) commissioned by the 13th Gwangju Biennale, South Korea, invokes the dakini figures of Tibetan Buddhism, the manifestation of female Awakening. In a Zoom conversation with the artist to discuss this work, Tenzin Palmo described this installation as a manifestation of interconnectedness and integrity,

> [the mandala] has to be perfect, it has to be in tune with everything around it and that is a lesson for our life; that every single action should be done with integrity and mindfulness and care (Stathacos and Tenzing Palmo).

As an exhibition experience, *The Rose (Mirror) Mandalas* demarcate a liminal space between the sacred and secular into which the viewer is invited to move around and pass through, as a space of temporary refuge, meditation, or prayer, made possible in otherwise secular public spaces Like previous works, these installations act as prompts to the possibility and availability of spiritual consciousness in everyday life. While Stathacos' artworks are informed by her commitment to

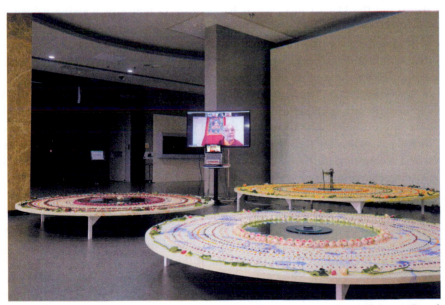

*Photo: 13th Gwangju Biennale*

**FIGURE 27.2** Chrysanne Stathacos, *The Three Dakini Mirrors (of the Body, Speech and Mind)*, 2021. Installation: mirrors, rose petals, Bodhi leaves; 76.2 × 76.2 cm (30 × 30 in), variable arrangement. Courtesy of the artist and Gwangju National Museum.

Buddhism, her installations are personal expressions and dedications. They do not conform to the rigorous prescriptions required of iconographic images created for consecration or intended to serve a ritual purpose. Nor are they didactic in the way of artworks commissioned by temples or monasteries to serve a pedagogical purpose. Nor are they suppliant in the way of images commissioned for the purpose of merit-making. Instead, these artworks are personal explorations and offerings of universal compassion and hope. They reflect on Buddhism as a modern and globalizing religion that is developing by way of an ongoing and dynamic East-West cultural exchange.

Since the mid-20th century, artists' study of and engagement with Buddhism has contributed to the development of key ideas in modern and contemporary art. In the United States, artists as diverse as Mark Tobey, John Cage, Allan Kaprow, alongside feminist practitioners including Suzanne Lacy, Linda Montano, Pauline Oliveros, Marina Abramovic among numerous others, describe an expanded artistic milieu engaged with Buddhism as a source and influence for the production of contemporary art (Sivanesan). Stathacos' work, for example, can be contextualized alongside the work of her peers, the Toronto-based collective General Idea, members of which traveled to India with the Dutch Fluxus artist Louwrien Wijers at the height of the AIDS crisis in 1982 to meet with His Holiness the 14th Dalai Lama. In the year prior, Wijers had famously orchestrated a meeting between the German conceptualist Joseph Beuys and the Dalai Lama. Wijers has written of how this meeting helped to further shape Beuys' idea of social sculpture, which proposed that society could be regarded as a work of art (Wijers). The implications of the larger history of the encounter between 20th-century art and Buddhism are to rethink the terms of the development of modern art to consider how Buddhism contributed to these developments. Correspondingly, this encounter also requires us to rethink the historicization and orientalization of the category of 'Buddhist art' as an area-specific, geographically bound field of practice and cultural expression, and therefore to consider the relationship between Buddhism and art more expansively, accounting for Buddhism as a dynamic, living, globalizing religion with ongoing contemporary relevance and cultural impact.

While Stathacos travels regularly from North America to India to study with her teacher, the Taipei-based artist Charwei Tsai travels from Taiwan to the United States to study with hers – the 7th Dzogchen Ponlop Rinpoche, one of the heart sons of the 16th Karmapa (the head of the Karma Kagyu School of Tibetan Buddhism). Ponlop Rinpoche is the abbot of the Dzogchen Monastery in Kham, Eastern Tibet (China), and is also a lay teacher based in Seattle. Tsai's inclination toward Buddhism was first revealed through her well-known ephemeral installation works where she wrote the Heart Sutra – the most commonly recited Buddhist sutra in East Asia – in Chinese calligraphy on ephemeral surfaces such as a large slab of tofu, on trees, on flowers, on shells, and other natural objects. Tsai later expanded the idea into a series of separate but related performance works titled *Earth Mantra* (Figure 27.3), *Sea Mantra,* and *Sky Mantra*

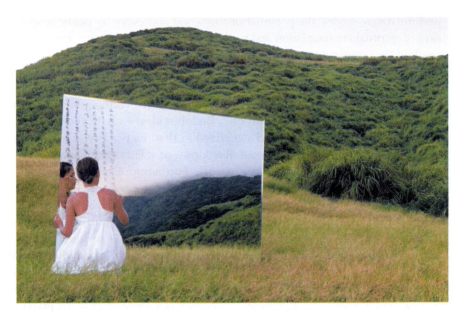

**FIGURE 27.3**   Charwei Tsai, *Earth Mantra,* 2009. Performance document: photograph, 67 × 120 cm (26.4 × 47.2 in). Courtesy of the artist.

(2008–2009). In each of these performances, the artist sat in various landscapes with a large, propped mirror or glass upon which she inscribed the sutra in black ink. The mirror framed and reflected the transient, ever-changing conditions of the surrounding landscape as she worked, causing the environment to appear as though an illusion and evoking the Buddhist concept of samsara, the endless cycle of change. The serialized and repetitive process of creating these performance works over a more than decade-long period of practice, described a means by which the artist drew on her art practice to explore and grasp the often abstract and esoteric concepts at the heart of Buddhism.

In Buddhism, the concept of Awakening (*budh*), the ultimate goal of Buddhist practice, is precisely the comprehension of unending change, which encourages the development of a capacity for awareness without focusing on any one specific object or end. Awakening enables the Buddhist practitioner to comprehend the drama of life as Emptiness (*shunyata*). Accordingly, meditation is a practice of mental release or flow in order to suspend or arrest one's enmeshment in the cycle of change. Tsai's Heart Sutra performances give visuality to this practice of flow – of losing oneself in an immersive practice that eventually discloses a kind of state of grace. For Tsai, these performances, which resulted in the production of images (captured as video and photo-documents), were also intrinsically a meditation where each performance presented an opportunity to further contemplate and deepen her understanding of this essential sutra.

While Stathacos and Tsai are separated by a generation and often working in different cultural milieus, their respective practices demarcate, and

performatively model, the potential of the world and everyday public spaces as sites of spiritual contemplation and possible Awakening. Their artworks are the result of the co-mingling of spiritual and creative practices. They are concerned with the realization of spiritual concepts as both process and image. Their work demonstrates the intersection, not only of art and life, but also of art and religion by way of an approach to practice. For both artists, art-making provides a context wherein religious ideas – in this case, Buddhist ideas – can be independently examined, performed, tested, and actualized so that the practice of art and the practice of Buddhism are intertwined. Religion – or at least spiritual inquiry and investigation – is central to their artistic work. Furthermore, both of these artists have arrived at a commitment to Buddhist practice by way of an intellectual engagement with Buddhist thought and philosophy as mediated by their practice of art. For these two artists, alongside numerous contemporary artists around the world engaged with Buddhism, art-making is not simply the pursuit of creative self-expression, but a practice of contemplative, experiential, and philosophical inquiry, directed toward the goal of self- and social transformation or actualization. In other words, for these artists, Buddhism is not simply a source of artistic inspiration but should be, I propose, considered as a *methodology* of art practice, where Buddhism contributes a framework of thinking and a system of methods that may be directed toward the creation of works of art (Sivanesan).

In her most recent work, Tsai has shifted away from iterations of the Heart Sutra to investigations into the idea of the mandala by exploring the historic dissemination of tantric Buddhism to remote parts of Asia. Tantric Buddhism is an esoteric form of Buddhism that is commonly associated with the Vajrayana Buddhism of Tibet. But between the 4th and 8th centuries, tantric Buddhism flourished at the Nalanda monastery in Bihar, India. From Nalanda, these teachings were widely dispersed to regions as far flung as Java, Indonesia, to the South, Mongolia to the North, and Mount Koya near Osaka, Japan, to the East. At each of these centers and over millennia, tantric Buddhism developed in unique and culturally inflected ways, taking on new ritual forms and visual expressions.

Traveling to each of these sites in a kind of personal pilgrimage between 2017 and 2020, Tsai met with local artists, and set about identifying collaborators to develop ideas and artworks for an exhibition titled *The Womb & The Diamond* (Live Forever Foundation, Tai Chung City, Taiwan, 2021). This exhibition explored visual concepts of the mandala as they are currently expressed at these dispersed sites. Collaborating with an accomplished ikat dyer and weaver, Nency Dwi Ratna in Sumba, Indonesia, and the skilled Mongolian feltmaker, Davagjantsan Khorolsuren, Tsai developed artworks that drew on regional expressions of the mandala as a ritual circle. The slow, craft-based approach to the making of these artworks reflected on cycles of life, cycles of time, and the promise of rebirth or renewal. The centerpiece of the exhibition was an architectural scale sculptural installation titled *The Womb & The Diamond* (2021) (Figure 27.4). Drawing on the gridded form of the Diamond and Womb Realm mandalas of Shingon Buddhism, this installation consisted of a mirrored platform upon which were

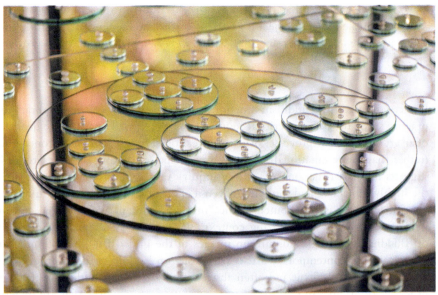

*Photo: Anpis Wang*

**FIGURE 27.4** Charwei Tsai, *The Womb & The Diamond*, 2021. Mirror, blown glass and diamond; 300 × 600 cm (118.1 × 236.2 in). Courtesy of the artist and Live Forever Foundation, Taichung, Taiwan.

arranged a series of hand-blown glass vessels and a single diamond. Each glass vessel was made by capturing the recitation-breath of a series of single-syllable mantras (bija mantra) so that the mantras were sealed in the glass (Tsai, Sherpa, Sivanesan).

Tsai's interpretation of the mandala is abstract, shimmering, and immersive, an installation of reflected light and fractured, prismatic images of the surrounding architecture and environment. In a related video, the celebrated lama Dzongsar Khyentse Rinpoche explains the concept of the mandala as an image of order that reveals itself through meditation practice as the principle of chaos. Mandala practice directs the practitioner's focus to "go beyond" both order and chaos to comprehend the non-dual principle that is the foundation of Buddhism (Tsai and Khyentse Rinpoche). For Tsai, however, the process of making the artwork is contiguous with her development as a student of Buddhism, using the process of art-making to investigate this concept of the mandala. For this exhibition, Tsai used the opportunity of art-making to learn directly from a senior teacher, engaging Khyentse Rinpoche on video to explain the concept of the mandala, and further enlisting him to assist with the process of the making of the artwork by having him bless the work and blow the glass centerpiece. Tsai explains,

> So, I asked [Khyentse Rinpoche for] his blessings and for his participation in realising this work. The mantra that he chose was the 'Dependent

Arising Mantra' that is commonly recited during the consecration of a new project. This project is again about the interdependence of form and emptiness. It also became a reflection on how our material world is driven by immaterial forces.

*(Guest)*

Understanding how Buddhism functions as a methodology of contemporary art practice shifts the focus of critical inquiry from the formal and stylistic qualities of an art object to the processes of artistic creation. The experimental, conceptual (rather than representational), and often participatory nature of these artworks suggests how art functions as a site of inquiry into Buddhist thought. In turn, the highly subjective and sometimes even iconoclastic nature of artists' inquiries into Buddhism has contributed to the "making different" of its visual culture in the contemporary globalizing context. Whereas, for example, the category of 'Buddhist art' might conjure up images of the gilded Buddhas of an Asian historical past, contemporary artists who draw on Buddhism as a methodology grapple with the difficult and often abstract philosophies of Buddhism through processes of art-making, resulting in the creation of artworks that are experimental and speculative, and which function as a record of an artist's individual spiritual inquiry and development.

This phenomena of Buddhism as a methodology of art practice results from the emergence of a new form of Buddhism – what Buddhist studies scholars describe as modern Buddhism – produced at the interface of East-West encounters in the late 19th–early 20th centuries, under conditions of colonialism and attendant social and political modernization (Lopez, 2002; McMahon, 2008). Stathacos and Tsai's respective approaches to art-making disclose some of the characteristics of modern Buddhism: the impact of esoteric knowledge systems on their work as lay practitioners; the impact of de-traditionalization, secularization, and globalization; and an engagement with modern social issues such as feminism, the refugee crisis, or climate change. Accordingly, considering Buddhism as a methodology of art practice encompasses a range of intellectual, meditational, experiential, and interpersonal methods, directed, not only toward the generation of creative outcomes, but also toward the deepening of an artist's understanding of Buddhist concepts and teachings. Moreover, the work of these artists suggests an important shift in terms of how Buddhism is being transmitted in contemporary times, where students of Buddhism arrive at a commitment to practice by way of an intellectual engagement with Buddhist thought and philosophy, often by way of an individual practice formed outside of the conventions of an established religious or monastic community, that is, as lay practitioners. This is in contrast to how Buddhism has traditionally been transmitted in Asia – where lay practitioners inherit the religious and cultural practices of Buddhism from their families and cultural communities and are socialized into it by way of long-standing religious and cultural institutions. What the work of these artists

reveals, then, is a private spirituality made public as works of art – not intended to be didactic or proselytizing in any way, but simply as expressions of artists' preoccupations with the search for meaning and a higher social purpose in the creation of art.

While the prejudices – and in the context of the influence of Buddhism, the Eurocentrism – of certain academic writers might have excluded religion from discussions about modern and contemporary art, that does not mean that religion does not have a deep impact on artists' approaches to the creation of work, and that Buddhism did not contribute to developments in the visual arts in significant ways. What it does reveal, however, is a bias in contemporary art criticism and its discourses, suggesting the need for new methodologies and frameworks that account for the ongoing entwinement of artistic and spiritual practice in order to better understand an artist's purpose in making art. The success and visibility of these two artists, and the circulation of their work in the context of major exhibitions and collections, suggests that the potential of spiritual expression in contemporary art is to offer instances of hope, wonder, delight, forms of meaningful connection, and refuge. What more could be asked of an artist at this moment in time?

## Bibliography

Guest, Luise. "Emptiness and Form, Form and Emptiness: Interview with Charwei Tsai." cobosocial.com. February 4, 2021. https://www.cobosocial.com/dossiers/interview-with-charwei-tsai-2021/.

Isherwood, Christopher. *The Wishing Tree*. Harper Collins, 1986.

Lopez, Donald. *A Modern Buddhist Bible: Essential Readings from East and West*. Beacon Press, 2002.

Mackenzie, Vicki. *Cave in the Snow*. Bloomsbury Publishing, 1998.

McMahon, David L. *The Making of Buddhist Modernism*. Oxford University Press, 2008.

Sivanesan, Haema. *In the Present Moment: Buddhism, Contemporary Art & Social Practice*. Figure 1 Publishing, 2022.

Stathacos, Chrysanne. *Refuge, A Wish Garden*. chrysannestathacos.com. No date. https://chrysannestathacos.com/refuge-a-wish-garden

——. *The Rose Mandalas*. chrysannestathacos.com. No date. https://chrysannestathacos.com/the-roses

——. Telephone interview by Haema Sivanesan. August 5, 2020.

Stathacos, Chrysanne and Jetsunma Tenzing Palmo. *Chrysanne Stathacos in Conversation with Jetsunma Tenzin Palmo* 크리산네 스타타코스 퍼포먼스, 제쭌마 텐진 팔모 대담. vimeo.com. April 17, 2021. https://vimeo.com/538138651.

Tsai, Charwei. Telephone interview by Haema Sivanesan. June 15, 2021.

Tsai, Charwei and Dzongsar Khyentse Rinpoche. *Dzongsar Khyentse Rinpoche on Mandala*. vimeo.com. February 2021. https://vimeo.com/509116200.

Tsai, Charwei and Ang Tshering Sherpa moderated by Haema Sivanesan. *Museums in Motion 3 – Envisioning Emptiness: Contemporary Art and Buddhist Practice*. youtube.com. July 17, 2021. https://www.youtube.com/watch?v=kTO9rupfM7U.

Wijers, Louwrien. *Joseph Beuys Talks to Louwrien Wijers*. Kantoor voor Cultuur Extracten, 1980.

# 28

# PERFORMING MEMORY AND MOURNING

## Diane Victor's Martyred Women

*Karen von Veh*

South Africa is a country beset by violence and social ills, resulting in a sense of personal insecurity felt most consistently by women and children who are the most vulnerable members of society.[1] Their lack of personal safety has often been compared with that encountered in countries undergoing armed conflict or social unrest. In August 2021, Ian Cameron, ambassador for the #SafeCitizen campaign, stated that "South Africa's gender-based violence statistics (GBV) are equal to a country at war. It is important to note that 2695 women are murdered every year in South Africa – that's 1 woman every 3 hours" (quoted in Keipo). The most recent Human Rights Watch report on South Africa includes the following statistics on femicides:

> In June 2020, following protests against the murder of Tshegofatso Pule, a 28 year old woman whose body was found dumped in Soweto, Johannesburg, President Ramaphosa acknowledged that South Africa had among the highest levels of intimate partner violence in the world. As much as 51 percent of South African women have experienced violence at the hands of someone with whom they were in an intimate relationship. He described violence against girls and women as South Africa's "second pandemic," after the coronavirus, and called on residents to end the culture of silence around gender-based violence.
>
> *(Human Rights Watch)*

Diane Victor's[2] installation discussed here, *The Fourteen Stations* (2018) (referring to the Fourteen Stations of the Cross), is a work about femicides, which, like the titular association with Christ's journey to his crucifixion, memorializes the unjust death of innocent martyrs.

DOI: 10.4324/9781003326809-32

Victor's art is a form of therapy for her, a way of working through the daily onslaught of distressing realities presented in news reports. Much of her imagery relating to social ills has been framed by critical responses to figures of authority, those she deems culpable in the demise of social order. Religious icons have not been overlooked in this blanket critique.[3] Her uncomfortably transgressive interventions into imagery that is traditionally held sacred aid her purpose in disturbing and upsetting viewers.[4] Victor has exploited emotive beliefs uncompromisingly in the harshness of her interpretations, aiming to transmit her fury at the shortcomings of society in the hope that viewers will be jolted from their complacency and moved to effect redress.

*The Fourteen Stations* discussed here is, however, a departure for Victor in terms of the restrained simplicity of her approach and the almost magical transformation of a bleakly brutalist architectural vestibule into an emotive space, where a journey taken through contemplation on lost lives carries the gravitas of religious ceremony. Lisa Saltzman (35), in an article titled "Gerard Richter's *Stations of the Cross*: On Martyrdom and Memory in Postwar German Art,"[5] speaks of the notion of staging rituals of remembrance by creating "commemorative or *memorial* paintings, a pictorial practice that produces the possibility of performing the work, if not of mourning, of remembrance." I argue that Victor achieves this memorial aesthetic through empathetic investment in her subjects, and thereby demonstrates what I would call a "performance of mourning" in her installation. She creates a participatory experience akin to a religious meditative procession, evoking the emotional response to loss and suffering that might be associated with the effect and purpose of engaging with traditional (religious) representations of Stations of the Cross. In this chapter, I unpack her methods and the aesthetic decisions that create this result.

*The Fourteen Stations* was created in October 2018 as an installation for the Aardklop National Arts Festival, which was held in Potchefstroom, South Africa. The festival committee allotted Victor a stairwell in the Sanlam Auditorium on the campus of the North-West University in Potchefstroom to display her work. The challenging nature of the space was part of the inspiration for Victor and certainly added to the atmospheric nature of her installation. It is a dark and narrow stairwell containing four ramps placed along the edges of an irregular triangulated space that does not easily lend itself to displaying works of art. Victor (2018) was, however, intrigued by the liminal nature of a ramp, which indicated a journey rather than a destination. Moreover, the odd shape of the atrium produced an irregular journey upward with twists and turns that Victor metaphorically associated with Christ's torturous journey and final ascent to his crucifixion, memorialized in the Stations of the Cross. The notion of creating a processional memorial for the death of innocent victims of femicide was thus devised, and the title at the bottom of the stairs referred to this association quite clearly: *The Fourteen Stations: points to meditate on loss and grief (an investigation of femicide in South Africa)* (Figure 28.1).

**FIGURE 28.1**   Diane Victor, *The Fourteen Stations,* 2018. Installation View in the Sanlam Auditorium stairwell, Northwest University, Potchefstroom, South Africa.

With reference to the title, the icons along the ramp are 14 portraits of women who died at the hands of an intimate partner, drawn in smoke on glass and projected onto the stone wall. The physical conditions of an upward journey and the process of contemplation at each portrait echo the typical meditative journey employed in church-based Stations of the Cross. This is reinforced conceptually by the overwhelming knowledge that we are confronting the very worst aspects of human nature, whether we think of the tormentors of Christ or the tormentors of the 14 female victims depicted by Victor. The original Stations of the Cross is a journey that takes us from Christ's condemnation (in the first station) through many winding ways, where He is whipped, mocked, taunted, crucified, and ultimately killed and buried (Milgate 57–69). Apart from occasional small acts of kindness along the way, this is not a memorial of redemption or hope, as the stations end with entombment, not resurrection. According to James Burklo, "To walk these stations and contemplate them actively is to retrace the steps that lead to destruction of ourselves and others." The practicing Christian may understand the larger message of gratitude, penitence, and salvation implied in their knowledge of Christ's resurrection, but the fact that this is not an integral aspect of the Stations of the Cross makes the end, in death, more poignant in Victor's iteration with its *lack* of salvation afforded to her memorialized women.

Victor's method of drawing with smoke from a candle enhances both the meaning and the effect of the images. Her working procedure involves suspending a glass panel above her head, and by holding a lit candle beneath the glass,

she quite literally draws onto the surface with smoke from the candle. Details are then gently and carefully scratched into the carbon stains on the glass with a fine paintbrush. More carbon is added if areas need building up, and more details are scratched away, so the image is created in both an additive and subtractive manner until the likeness is achieved. The end result is extremely fragile, and the merest touch can destroy an image, evoking the fragility of those whose lives are being memorialized. The images are so easily damaged that they cannot be placed where the public might touch them. Victor's ingenious solution to the limitations of a dark space without adequate lighting for artworks, and the delicacy of the works themselves, led to the drawings being suspended over the central stairwell high above the heads of the public, with lights shining through each image, so the portrait was projected onto the concrete wall. Due to the height of the original images, many visitors were unaware of the existence of the original glass-based drawing and only saw the shadowy face, which was projected onto the wall like a hazy apparition. Victor (2018) explains that many people would go up to the wall and touch it or ask how the portrait was "drawn" onto the wall (Figure 28.2).

The wall itself has an irregular concrete structure with leaks and stains, arbitrary divisions, and perforations reminiscent of bullet holes, but this harsh aesthetic provided an appropriate backdrop for images of the dead. Our knowledge of their demise is what informs the poignancy of these images and encourages viewers to meditate on a life cut short, potential unfulfilled, and the tragedy of

*Photograph: Diane Victor; courtesy of the artist*

**FIGURE 28.2** Diane Victor, *The Fourteen Stations*, 2018. Unnamed victim of femicide. Smoke drawing on glass and shadow projection.

living in an imperfect world. Victor's installation is in some ways reminiscent of the effect and meaning created by Barnett Newman in his series on the Stations of the Cross painted in 1958–1966.[6] Titled *The Stations of the Cross: Lema Sabachthani* (why have you forsaken me?), Newman, like Victor, was responding to existential tragedy. In his case, it was the aftermath of World War II and the Jewish Holocaust, whereas Victor was recording the ongoing "genocide" of South African women.

Like Victor, Newman was not religious; like Victor, he was employing a religious framework of ritual and mourning to express the agony of the human condition (Hellstein 2014). The simplicity of Newman's abstraction is, according to Mark Godfrey (56), "a serious attempt to rethink painting in the aftermath of the Holocaust." Newman's black and white minimal, pared down canvases in his *Stations of the Cross*, has large unpainted areas intersected occasionally by a black line or two. This restraint encourages the viewer to consider the lack of humanity or perhaps the apparent absence of a merciful God (referred to in "why have you forsaken me?") with which Newman was grappling. Abstraction in this case is arguably more intensely emotional for a viewer, knowing the genesis of the works, who must rely on his/her imagination in the absence of illustrative scenes of the gory details of war. Godfrey (70) describes the original installation of these works at the Guggenheim Museum as "a place where memory was activated, a place of starkness, a place of loss,"[7] words that could just as easily be applied to Victor's installation.

Both Newman and Victor approach what is a processional form of art normally replete with details of Christ's journey, to express in minimal terms their deep sense of grief and mourning. This reductive mode of creation is an unusual development for Victor who, in previous works, has typically filled her imagery with relevant supplementary details, enriching the narrative and adding visual layers of meaning to her works. For example, a triptych in the form of gothic church windows, made prior to the *Fourteen Stations*, titled *No Country for Old Women* (2013) (Figure 28.3), addresses similar subject matter (the murder and abuse of women and children) and in a similar medium (smoke drawings on glass), but each figure in her glass coffin-shaped panel is accompanied by a plethora of details that graphically record the story of her trauma. In the panel on the far left, we see the old woman after whom the artwork is named, holding the garden shovel used to dig her grave by the robbers who had killed her, while her spirit is shown departing above her body as a gray mass of smoke. Further panels depict women with faces that are beaten or bruised, a vulnerable child shadowed by her abuser, women left literally "holding the baby" without acknowledgment or state support, entrails spilling in baroque profusion across the body of a young woman who was raped and disemboweled, and the stoning of a witch (among other details).[8]

In *The Fourteen Stations*, these narrative details have been removed. We do not know who these women are, nor how they died. Victor (Interview 2018) researched the tragic details of each woman and randomly selected published images from hundreds of newspaper reports, yet chose not to refer to any details

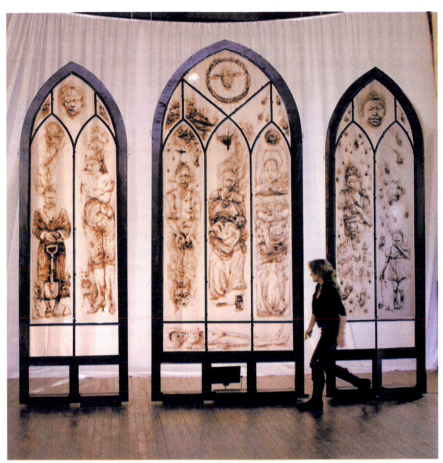

**FIGURE 28.3**  Diane Victor, *No Country for Old Women,* 2013. Smoke drawings on glass, approx. 4 × 4 m (13.12 × 13.12 ft).

of their stories or include names with her portraits.[9] Their anonymity allows them to represent the many who were not memorialized in this way, but anonymity also evokes their lack of worth in a society where their lives are not valued or protected. Victor (Interview 2022) also notes that for her, part of the importance of drawing with smoke is the uncontrollable nature of the medium. It is impossible to produce accurate likenesses of people. At best, it can form a shadowy ghost of an identity, an approximation. The erratic movement of smoke, affected by the slightest breath of air, means that it inherently transcends the act of creation. Instead of control exerted by the artist, Victor finds herself working intuitively, almost like a collaboration with the smoke. It is this rescinding of control to some extent, which enhances the meaning in *The Fourteen Stations.* They are simply presented – no bruises, no damage, no anxiety in their faces, no expectation of tragedy. These anonymous women thus symbolize anyone who has been, or

might be, killed by their lovers, husbands, or boyfriends. Like Newman, Victor's decision to omit detail and information ensures that nothing distracts from the presence/absence of what is presented as the viewer must focus on a simple representation, signifying that they once lived, in order to contemplate their loss.

Even details that might be relevant to the processional importance of each stop in the traditional Stations of the Cross have been removed. There is no significance to the position of each martyr on the ascent. Perhaps the only aspect of Christ's journey that might be echoed here is the hazy image of each victim, which could be associated with the legendary *acheiropoieton*, the image of Christ, miraculously transferred to the veil of Veronica when she wiped the sweat from His face at the sixth station. In effect, each of these women has acquired the status of icons in both religious and semiotic terms and at the same time function as semiotic indexes of their lost lives.[10] Like church icons that give substance to the unseen, Victor's portraits have an elusive quality that evokes the "real" presence of a real person. A viewer's position between the two iterations of each woman adds meaning to the connection between icon and index, resulting in a symbolic understanding of the fragility of life. Memory is accumulative in this procession, where viewers stop at each image to contemplate the pain and trauma that affected the life of each person represented. Their act of turning away and advancing to the next image constitutes the performative nature of this memorial, mentioned earlier. The viewer must actively, physically, mentally, and emotionally engage with each of these women in isolation to encompass their collective tragedies by the time they reach the summit.

Once the visitors ascended to the top of the ramp, they were able to look over the side down into the central floor area of the vestibule. The floor is an approximately 11 x 5 meter triangular area onto which an enormous drawing of a sleeping woman, entwined with a skeleton representing death, could just be made out, etched into an ashy substrate. This is a fifteenth image, the culmination of the upward journey, and is unlike the previous portraits as it includes details that ensure the viewer cannot mistake the content of this installation. Interestingly, Newman also made a 15th painting, titled *Be II*, which functions as a culmination of his series. *Be II* differs from his first 14 stations as it is the only canvas to include color (a thin red stripe) as if to signal a change or a new beginning, a fragment of hope perhaps. The intensity of this small line of red in a room that is only black and white cannot be underestimated. One could perhaps liken it to the surge of energy that supposedly accompanied Christ's resurrection, although Newman was aiming for a metaphysical rather than a religious interpretation (Katzin 47).

The sleeping woman, however, is the antithesis of a resurrection image (Figure 28.4). Victor felt that while the meditational journey progressed upward, the downward spiral of the ramp metaphorically evoked the descent of sinners into Dante's circles of hell, a journey reserved for the perpetrators of the femicides she was commemorating. In Dante's Inferno, the lowest level of hell (the ninth level) consists of a frozen lake reserved for what he identified as the most despicable

**FIGURE 28.4**   Diane Victor, *The Fourteen Stations,* 2018. Sleeping woman with Death. Drawing made in fly ash, 11 × 5 m (36.1 × 16.4 ft), detail.

in his hierarchy of evil, those guilty of the sin of betrayal or treachery, to which clearly the perpetrators of femicide belong. Dante considered the betrayal of trust so reprehensible that the Devil himself is condemned to this level for his sin of treachery against God (Alighieri).

The woman's facial expression is ironically peaceful, as she embraces her *bête noire*, obviously unaware of her partner's latent hostility and her impending demise. Her position as a culmination image is, in fact, a depressing rendition of imminent death and the lack of earthly salvation available for these memorialized women. It is also a warning to viewers of a fate that probably awaits many more. To emphasize impending evil Victor has etched this drawing into a toxic medium made of fly ash,[11] which consists of the ashy remains taken from coal-burning power stations. Fly ash causes silicosis, a deadly lung disease suffered by coal miners, so it is associated with the misery and deaths of many exploited workers. The material thus required very careful handling, and masks had to be worn during the installation.[12] In the current crisis of global warming, it is also a pertinent reminder of the devastating effect that burning coal has had on the planet. Fly ash in this installation provides a metaphor for mindless destruction and the uncaring nature of humanity in general. The sleeping woman made of ashy dust, together with the smoky portraits above her, also remind us of the words spoken at funerals – "ashes to ashes and dust to dust." As with many of her works, Victor has chosen to create images in the very materials of which we are made and to which we all return.

Victor sat on the first floor level of the ramp and used a four–meter–long stick to draw the sleeping figures in the ashy floor. Details were created by adjusting the textures of the ash itself, which can be coarse or smooth depending on the number of times it has been burned in processing. She was able to source five or six different versions of the ash for this installation, creating a variegated texture for her drawing. In addition, elements were also added by attaching in turn a rake, a feather duster, and a toilet brush to the long stick to create the wavy lines of the sleeping woman's hair on the pillow, and the details of her clothing. Victor finished the process by using stockings to sieve the ash, to eliminate some of the larger lumps, and then by sprinkling this fine ashy powder strategically over the drawing to soften the final image. This vignette of "sleeping with death" is a culmination of the contemplative procession upwards. Appropriately Victor's vision ends with a warning to women of their fragility and vulnerability where even a most beloved partner may become their nemesis. In this way, her installation provided a voice for the voiceless martyrs by reminding live participants that they partake in a world where life is not held sacred.

Like the Fourteen Stations of the Cross, this is a journey memorializing instances of ignominy and violence, leading to death and burial. The resurrection is not part of this processional memorial even in its original manifestation – in church traditions, the purpose of the Stations of the Cross is to memorialize Christ's suffering and martyrdom and to affect the devotee emotionally through their contemplation of the accumulation of physical torments and difficulties that He suffered. Yet without the narrative content, can the same effect be ascribed to Victor's works? In a discussion of Barnett Newman's abstract version of the Stations of the Cross, Jeffrey Katzin (8) explains, "As the paintings are not explicit in their message, nothing explicit can be taken from them. This, however, only prevents meaning from being specific; it does not prevent it from being powerful." I suggest that emotional power was particularly manifest on the opening night of Victor's installation when there were many visitors. During the opening, several members of the North-West University choir were present, and while looking at the ghostly portraits, they were moved to spontaneously burst into song. There is a wonderful resonance in this space due to the height and the dimensions of the stairwell, and many of the guests were affected by the combination of beautifully haunting music and emotive imagery. Victor (2018) was inspired to find a female singer from the local choir whom she later asked to sing an African dirge in the venue. A recording of this music now accompanies a video that was made of the work. The video and photographs are all that remain, as the installation was deconstructed and removed at the end of the festival, proving to be as transient as the women it commemorates.[13]

As mentioned at the start of this essay, this case study is a departure from Victor's approach in many of her earlier works. While it is still a critique of the state's inability to protect women, it is decidedly not affected though the transgressive use of religious icons. In addition, I suggest that she approximates a form of spiritual expression, not in terms of religious imagery but in relation

to the spiritual purpose of religious iconography, which is that of contemplation, of seeing beyond the image itself to a "truth." Anton Houtepen (66) points out that icons can be approached in a hermeneutic rather than an aesthetic fashion by concentrating on their "deictic" function – they demand action and participation from the viewer. Houtepen (66–67) explains:

> It is not our 'aesthetic gaze' that liturgy and icons want to evoke, nor artistic emotional pleasure or personal satisfaction, but a real 'change of heart', conversion or *metanoia*…It is a permanent performative, transforming and transfiguring symbol and that is precisely what its 'deictic' function means.

Victor's work may not be presenting any sort of religious iconography, and her iconic portraits are not imbued with spiritual potency. Her installation is, however, asking us to meditate on the imagery, to see the tragic truth beyond the simple iconic image of a face, to see the person, and to understand the life that was represented by that face – and most certainly, it is a call to action. It calls us to acknowledge the state of the society in which we live and to interrogate the value of our participation and engagement with that society. Much like the purpose of religion, Victor's memorial work is asking us to consider whether our presence in the world has made it a better place for others or not.

## Acknowledgments

My research for this article was made possible by generous financial support from the National Research Foundation (NRF) of South Africa. Please note, however, that any opinions, findings, conclusions, or recommendations expressed here are my own, and the NRF accepts no liability in this regard.

## Notes

1 South Africa's continued social problems are largely a result of historic imbalances of power that were written into law under the system of "separate development," or apartheid. From 1948 until the early 1990s, the Nationalist Government, run by a white (mostly Afrikaans) minority, was in power and the black majority were denied basic human rights, including quality education, good health care, decent housing, equality, and the right to vote. During the apartheid era, violent protests and criminal acts were understood by the black community to be a form of resistance that would render the townships ungovernable and thereby promote political change. The struggle for equality thus legitimized crime and violence as a liberation strategy. Instead of the new democratic ANC government ameliorating this situation, however, it has rather enabled the enrichment of a small elite, through corruption and maladministration, leaving the masses (who voted them into power) disenfranchised and increasingly angry. There is, therefore, an ongoing struggle for equality now identified in economic terms, with blatant displays of unequal distribution of wealth in the "new" South Africa. The Centre for the Study of Violence and Reconciliation (CSVR) has found that "South Africa's high rate of violent crime is just as related to economic and social marginalization as it was during the 1980s" (Hunt).

2 Diane Victor was born in 1964. She received her BA Fine Arts Degree from the University of the Witwatersrand. She won the SASOL New Signatures Award in 1987 and became the youngest recipient of the prestigious Volkskas Atelier Award in 1988, which granted her a ten-month stay at the Cité Internationale des Arts in Paris. Since 1990, Victor has been a part-time lecturer, teaching drawing and print-making, at various South African institutions including the University of Pretoria, Tshwane University of Technology, Open Window Academy, the University of the Witwatersrand, Rhodes University, and the University of Johannesburg. She has had numerous solo and group exhibitions in South Africa and internationally and has taken part in several residencies, including those in Poland, Vienna, the USA, and China. Victor is represented in many public and private collections in South Africa and abroad including The Victoria and Albert Museum, London, and the Museum of Modern Art, New York. She has been the festival artist at ABSA KKNK, Innibos, and Aardklop festivals. Victor is represented by Goodman Gallery and is associated with David Krut printmaking in South Africa (ART.co.za.).

3 For examples of Victor's transgressive use of religious imagery, see *Little Deposition Picture* (2002) discussed and illustrated in von Veh (Contemporary Iconoclasm in SA...). *The Eight Marys* (2004), and *Minder, Mater, Martyr* (2004), both discussed and illustrated in von Veh (Diane Victor, Tracey Rose...). *The Problem with Being a God These Days* (1987), *The Adoration of St. Eugene* (1988), *Stained Gods* (2004), and *The Good Preacher, The Good Doctor and the Honest Politician* (2005) are discussed in von Veh (The Intersection of Christianity and Politics...).

4 This form of iconoclasm is effective because church imagery has a long history and is both well-known and widely revered, even by non-believers. The continued strength of religious associations and the "truths" that they represent are identified in vehement public responses to works that are deemed transgressive.

5 In Saltzman's article, the memorial and processional nature of Gerhard Richter's work *October 18th 1977* (1988), otherwise known as the Baader-Meinhof Cycle, is compared with the *Stations of the Cross: Lema Sabachthani* (1958–1966) by Barnett Newman.

6 Barnett Newman's *Stations of the Cross: Lema Sabachthani* were first exhibited together in 1966 at the Guggenheim Museum in New York, and are now hung in the National Gallery in Washington, DC (Katzin 11).

7 It is interesting to note other overlaps in Victor and Newman's work – the Guggenheim Gallery, where Newman's *Stations of the Cross* was first shown is also architecturally based on a ramp system (although it is wider than Victor's venue at the festival, and well-lit and designed specifically for displaying art).

8 A detailed analysis of this work can be found in von Veh, "Feminism as Activism in Contemporary South African Art."

9 In an interview in 2018, Victor notes that she mostly looked online in news websites for media photographs of women who had been killed by an intimate partner. Such publicity images would not create a privacy or copyright issue and Victor explains that there were literally hundreds to choose from.

10 In semiotic terms, according to the theorist Charles Sanders Pierce (1839–1914) images can be divided into symbolic, indexical, or iconic categories depending on their relationship to their object. Pierce explains that an iconic image is one where an image has "specific properties in common with its object"; in other words, one can look at it and recognize its origin, as in a portrait where it is clear that this likeness was taken from someone who once existed (Huening [Sa]). An indexical image is something that doesn't necessarily resemble the object or concept being represented but resembles something that implies the existence of the object or concept.

11 The original floor was covered with orange and white tiles, an aesthetic typical of the building's construction date in the 1970s and visible in the ramps. Victor felt that the tiles were too garish for her subject matter. She intervened by covering the floor with

wood which she polished to a dark brown color, creating a smooth substrate for her ashy drawing medium.

12 Victor furthermore explains that they also had to vacuum the fly ash up and dispose of it very carefully once the exhibition was over.

13 The transience of this work, particularly relating to the removal of the fly-ash drawing, might remind one of spiritual works such as the Buddhist sand Mandalas which after months of creation are removed to express their belief in the transience of physical life. However, the Buddhist mandalas are believed to effect purification and healing so the sand, once swept up, is distributed through water (a river, for example) to carry this healing power back into the earth (BBC). The careful collection and disposal of fly ash in order not to pollute the earth is perhaps more similar to the Navajo practice of creating "dry paintings" (sand paintings), which form part of a ritual for harvests and physical healing. In the healing ceremonies, the afflicted person must sit on the painting while the spirits are called (through chanting) to absorb the illness. Immediately afterward, the painting is considered to have absorbed the toxicity of the illness and must be disposed of and destroyed (Navajo Sandpaintings), rather like the treatment of the toxic fly ash.

## Bibliography

Alighieri, D. and Cary, H. F. (trans). *Project Gutenberg's The Vision of Hell, Complete, by Dante Alighieri: The Inferno*, 2014. https://www.gutenberg.org/files/8789/8789-h/8789-h.htm#link1, January 3, 2022.

*ART.co.za*. Diane Victor. Artist's CV. http://www.art.co.za/dianevictor/, June 24, 2017.

*BBC*. Religions: Sacred Mandala. 2009. https://www.bbc.co.uk/religion/religions/buddhism/customs/mandala.shtml, March 17, 2022.

Burklo, J. "Stations of the Cross." *Progressive Christianity.Org*, 2016. https://progressive-christianity.org/resources/stations-of-the-cross/. November 16, 2021.

Godfrey, M. *Abstraction and the Holocaust*. Yale University Press. 2007.

Hellstein, V. "Barnett Newman, The Stations of the Cross: Lema Sabachtani." In *Conversations: An Online Journal for the Center for the Study of Material and Visual Cultures of Religion*, 2014. https://mavcor.yale.edu/conversations/object-narratives/barnett-newman-stations-cross-lema-sabachtani, October 29, 2021.

Houtepen, A. "The Dialectics of the Icon: A Reference to God?" In W. Van Asselt, P. van Geest, D. Muller, and T. Salemink (Eds.), *Iconoclasm and Iconoclash: Struggle for Religious Identity*. Second Conference of Church Historians, Utrecht, University of Tilburg, Brill, 2007, 49–73.

Huening, D. "Symbol/index/icon". *The Chicago School of Media Theory*. https://lucian.uchicago.edu/blogs/mediatheory/keywords/symbolindexicon/, November 16, 2021.

*Human Rights Watch*. Human Rights Watch, World Report 2021, South Africa. https://www.hrw.org/world-report/2021/country-chapters/south-africa, August 25, 2021.

Hunt, S. "Turning the Tide of Violence in South Africa." In *The International Development Research Centre*, 2003. http://www.idrc.ca/en/ev-45629-201-1-DO_TOPIC.html, November 5, 2010.

Katzin, J. "Perception, Expectation and Meaning in Barnett Newman's *Stations of the Cross* Series." BA Hons in Art History Essay, Wesleyan University, Middletown, Connecticut, 2010.

Keipo, K. "Gender-Based Violence: 'Time to call out our brothers, friends'." *Health-E News*, August 19, 2021. https://health-e.org.za/2021/08/19/gender-based-violence-time-to-call-out-our-brothers-friends/, November 17, 2021.

Milgate, R. "Fourteen Stations of the Cross" Doctor of Philosophy Thesis. University of Wollongong, 1988, October 29, 2021. https://ro.uow.edu.au/theses/1752, October 29, 2021.

Navajo Sandpaintings. 2019. https://navajopeople.org/navajo-sand-painting.htm. March 16, 2022.

Saltzman, L. 2005. "Gerhard Richter's Stations of the Cross: On Martyrdom and Memory in Postwar German Art." *Oxford Art Journal*, Vol. 28, no. 1, 2005, 25–44.

Victor, D. Interview between Diane Victor and Karen von Veh, Johannesburg, November 8, 2018.

——. Telephone interview between Diane Victor and Karen von Veh, March 3, 2022.

von Veh, K. "Diane Victor, Tracey Rose, and the Gender Politics of Christian Imagery." *African Arts*, Vol. 45, no. 4, Winter 2012, 22–33.

——. "The Intersection of Christianity and Politics in South African art: A Comparative Analysis of Selected Images since 1960, with Emphasis on the Post-Apartheid Era." *De Arte*, Vol. 85, 2012, 5–25.

——. "Contemporary Iconoclasm in SA: Transgressive Images of Madonna and Christ in Response to Social Politics." *IKON 9: Journal of Iconographic Studies*, Vol. 9, June 2016, 355–362.

——. "Feminism as Activism in Contemporary South African Art." In M. Buszek and H. Robinson (Eds.), *A Companion to Feminist Art*. Wiley Blackwell, 2019, 69–90.

# 29

# WEAVING LAND AND WATER

## On the Poetics of Diasporic and Indigenous Resistance

*Yohana Agra Junker*

For decades and across geopolitical divides in the Americas, contemporary visual artists have transported their audiences to what Tiffany Lethabo King so brilliantly names as the shoals – offshore formations that allow Black and Indigenous peoples to meet one another away from the extractive gaze. "The shoal," she writes, "is a place for contact, encounter, as well as emergent formations" (2). As dynamic, ever-moving assemblages, the artworks presented in this chapter not only interrupt the flow of violence – asking the audience to pause before proceeding – but also develop what Ailton Krenak names as a poetics of existence that maintain dreams and subjectivities alive (16). Growing up in the outskirts of São Paulo, Brazil, during the last years of my country's dictatorship regime meant that communities would often be left to deal with the aftermath of forceful floods that devastated entire neighborhoods. Early in my childhood, I sensed that below the mud, the debris, and the cracks on the asphalt, there were stories, memories, and sunken perspectives that pressed up against the earth's shell waiting to be released. A combination of governmental negligence and extractive practices in the state submerged thousands of rivers and watercourses. No matter where you stand in São Paulo, you are never more than 200 meters away from a spring that has been buried under the asphalt.[1] The interdisciplinary project *Rios Des.cobertos* (Rivers Un.covered) maps out these suppressed rivers through video and photo documentation, installations, and community programming making visible these submerged waterways. Such artistic and decolonial initiatives have been fundamental in revealing and interrupting the flow of environmental and colonial violence. The following sections will, thus, focus on such poetics of resistance through the works of Cecilia Vicuña, Nicholas Galanin, and Joelington Rios.

DOI: 10.4324/9781003326809-33

## Cecilia Vicuña: Weaving of Waters, Remembering Worlds

Cecilia Vicuña is an artist who creates poetic shoals that interlace peoples, histo-ries, memories, place names, ancestral ways of knowing, and a becoming-with the land and water. Born in Santiago de Chile in 1948, she was raised in a region known as the Maipo Valley. In 1973, she was forced into exile, following the death of Salvador Allende and the ensuing *coup d'état* installed by Augusto Pino-chet. Throughout her career, she has engaged with themes of exile, extinction, dissolution, ancestral presence, memory, the precarity and limits of life, heritage, loss, ritual in the face of ruin, rememberings, and so much more. The connec-tion between her art and the ocean runs deep. Vicuña describes her art practice as emerging "at the meeting point of two waters, the Aconcagua River and the Pacific Ocean" (Vicuña 6). She recalls having a profound experience with these two bodies of water in 1966, which transformed her relationship with both the river and the ocean: she sensed the ocean as a living entity, becoming aware of its awareness (Vicuña 111).

As a conjurer of worlds that are not-yet, Vicuña has been "weaving waters" and "unravelling words" through a poetics of resistance and remembrance for more than forty years.[2] Having lived through her country's political revolution, she knew from an early age that any political struggle would necessitate the type of total transformation, "a complete change of being, or a way of the senses, a revolution of the body, a revolution of the way we loved each other, the way we composed our poetry, our music" (Vicuña 114). In her poem *Entering*, Vicuña explains that part of her artistic practice emerges as a way of encountering and integrating ancient ways of knowing that seeks to sense the land, sky, and the sea, while responding to these encounters with gestures, artworks, offerings, acts of communion, and *precis* – prayer (Vicuña 128). Whether she is assembling objects found at the shores (what she calls *basuritas del fin del mundo*, debris at the end of the world), or placing extensive unspun red wool across landscapes, stag-ing poetic encounters among human, more-than-human bodies, the ocean, and the earth, the artist ongoingly forewarns her audience of the rapid rate at which waterways, ancestral traditions, and territories are vanishing.

In her film *Kon Kón* (2010), Vicuña returns to Chile's central valley to inter-weave twelve films into one narrative that delineates the relationships among land, water, Indigenous rituals, songs, and ways of knowing. Her performances involve placing extensive red threads under, across, and over water, rocks, and sand while her sonic compositions call back the ancient spirits of the land. As artistic vessels, the films recollect the multiple and conflicting overlays of the ter-ritory's ancient and modern histories, rituals, spiritualities, songs, and cultures. Throughout the film, the audience learns that Con Cón, for example, "was an ancient ritual site, perhaps associated to the oracle of Con (Qon or Kon), the mother of life and the sea," as well as a site for an oil refinery built in 1954 and more than 6,000 years of human activity (Vicuña 103). Today, the area is deeply endangered due to the extractive practices of industrial fishing companies that

periodically vacuum that portion of the ocean's floor. "The resultant impending death of its layered ecologies," Macarena Gómez-Barris clarifies, "is multiply equated with the colonial evacuation of indigenous memory" (139). Vicuña describes her performances at these Chilean shoals as ritual responses and learning experiences that allow participants to access erased histories and memories of the land, which has been "erased by European conquest and colonization, and yet, available for those who seek the source of sound and language in the land" (27). Her artistic gestures are attempts at recovering and uncovering such knowledge. On such complexity of place, Gómez-Barris expounds:

> The colonial irony here is that Aconcagua simultaneously refers to the Aconcagua indigenous people, the River, and the Con cón oil refinery that is owned by the transnational Chilean oil company, Aconcagua. The fact that the Aconcagua oil company has made efforts to extract petroleum deposits from the pristine natural preserves of the Minnesota Headwaters in the United States is one web of relationality that we might weave by working from Vicuña's regional perspective. What is the hemispheric condition and memory of colonial capitalism? How does our own consumption and petroleum dependence implicate and connect us back to the buried histories of the Aconcagua?
>
> *(143)*

Taken together, Vicuña's artworks alter her viewer's capacity to see and sense the world. The found objects employed in her ephemeral installations or as she names them "the precarious" are not mere objects – they are witnesses to relationships and histories that have been forgotten, obliterated, or lost (Vicuña 28). Like the rivers of my own childhood, these waters and perspectives have been buried under the weight of ecocidal corporate desires. Vicuña's artistic gestures index, interrupt, and disarticulate such neocolonial and extractivist violence. And, in doing so, she affirms that there is power in the poetic to undrown submerged worlds.

## Nicholas Galanin: A Decolonial Poetics for Indigenous Sovereignty

Nicholas Galanin, of Lingít and Unangax̂ heritage, is a multidisciplinary artist also committed to uncovering submerged perspectives in his art practice. Born in Sitka, Alaska, in 1979, his body of work fosters Indigenous sovereignty and calls for social and environmental justice. Collaborator and fellow artist Merritt Johnson describes Galanin's art as dialogical work seeking truth and trust. Writing about his piece *Welcome,* which features a polar bear's fur as a rug inscribed with the word "welcome," he observes:

> This 'welcome' reflects use of land for extraction of wealth with wasteful, harmful practices. It is a reflection on the history of invasion by corporate

colonial interests that attempted to destroy the people and cultures indige-
nous to the Western Hemisphere, as they steadily threatened the lives and
depleted the populations indigenous to this land.

(Galanin 16)

Like Vicuña's, Galanin's artistic production is incisive in denouncing the com-
pounding effects of neocolonial violence, taking seriously the interconnectedness
of life, land, and culture. In many ways, his work follows what Patrisia Gonzales
names as the undivided unit of *bodyspiritplacetime*, a sacred geography that sees
life as based "on a web of various ecologies or unities of experience," which are
spun expansively and continuously from the Indigenous principles of related-
ness, mutuality, respect, reciprocity, and circularity (Gonzales xix). In Gonzales'
understanding, *bodyspiritplacetime* is an epistemology that cannot be divided or
compartmentalized in Western categories of place, space, time, spirit, self, and
other. For several Indigenous peoples, the cosmological of the land is one in
which all its elements are at once alive, interactive, inspirited, and undivided.

Though multi-vocal and incredibly diverse when it comes to geopolitical,
cultural, spiritual, and social coordinates, Indigenous visualities share particular
worldviews and cosmologies that hold common beliefs about the world as bound
to places and ancestral knowledge. As Indigenous scholar Leroy Little Bear artic-
ulates, there are enough convergences among Amerindian philosophies, episte-
mologies, and protocols to allow researchers to speak amply about Indigenous
concepts without defaulting to a pan-Indigenous approach.[3] Margaret Kovach
refers to the tradition of uncovering such colonial traces in Indigenous land and
bodies, as a practice shared by several Indigenous peoples. These practices are
typically holistic in nature, experiential, tribal-centered, collaborative, and con-
siderate of colonial relationships (Kovach 47).

Galanin's art has been fundamental in efforts of centering Indigenous knowl-
edge, culture, tradition, and technologies. He expands:

> Culture is rooted in connection to land; like land, culture cannot be con-
> tained. I am inspired by generations of Lingít & Unangax̂ creative produc-
> tion and knowledge connected to the land to which I belong. From this
> perspective, I engage across cultures with contemporary conditions. My
> process of creation is a constant pursuit of freedom and vision for the pres-
> ent and future. Using Indigenous and non-Indigenous technologies and
> materials, I resist romanticization, categorization, and limitation. I use my
> work to explore adaptation, resilience, survival, active cultural amnesia,
> dream, memory, cultural resurgence, and connection to and disconnection
> from the land.

(Galanin 20)

Galanin's sculpture *What Have We Become, Vol. 5* (2009) is one example of the
power contained in his poetics of resistance (Figure 29.1).

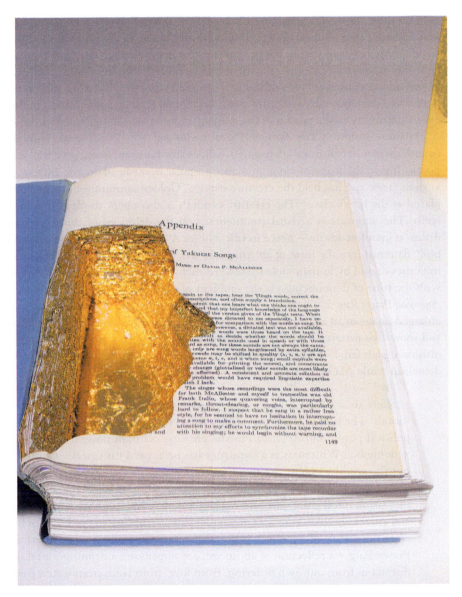

**FIGURE 29.1**  Nicholas Galanin, *What Have We Become? Gold*, 2018. Carved book, 29.8 × 48.3 × 6.3 cm (11 ¾ × 19 × 2 ½ in). Courtesy of the artist.

The sculpture features the carving of his self-portrait out of the pages of an ethnographic study written by the anthropologist Frederica de Laguna on his Lingít community during the 1970s. By carving out his three-dimensional face from the pages of Laguna's book, *Under Mount St. Elias: The History and Culture of the Yakutat Tlingit*, he inserts his body into the publication, marking his contemporary presence within the circuit of extractive research within Indigenous

communities. These practices have often written Indigenous life into a vanished past without being implicated in their flourishing. Not only does Galanin reclaim freedom, agency, and vision, but he also resists romanticization and limiting categorizations, putting an end to the particular facsimile's use. In so doing, Galanin at once renders obsolete *Under Mount St. Elias* as an ethnographic work and brings it alive as a contemporary sculpture. Such decolonial retaliation maintains Indigenous continuity in the pursuit of freedom against ongoing settler colonial abuse.

Galanin's sculpture *The American Dream is Alie and Well*, 2012, speaks directly to such themes. It features a US flag, .50-caliber ammunition, foam, gold leaf, and plastic. It is in the shape of a rug, presenting a polar bear's head on one extremity as though the rug has held the creature captive. Golden ammunition is carefully placed as the bear's claws. The creature's mouth is also open, displaying golden teeth. The sculpture is a visual commentary on the delusions of the American dream as manifest destiny – hence its title *Alie* (or A-Lie) *and Well*. The polar bear's body flattened into the form of an American flag is a critique on the compounding crises caused by human violence toward each other and the earth. In keeping with the tone of denouncing via the emblem of tapestry, Galanin's *White Noise, American Prayer Rug*, 2017, also sends an equally resounding message. It features an enlarged image of an analog television set with pixelated, black and white, dotted and snow-like patterns, typical of the static displayed when the television transmission signals fail. Is this a commentary that tackles white supremacy and climate denialism while Alaskan ice caps melt? *White Noise*, Galanin explains,

> ...refers to a steady droning tone used to mask or obliterate unwanted sounds. The title of this work applies this term to the sources of American political power and American media creating constant noise in support of xenophobia. Whiteness as a construct has been used historically throughout the world to obliterate the voices and rights of generations of people and cultures, regardless of complexion. This white noise is the source of increasing intolerance and hate in the United States, as politicians, media, and citizens invoke America's genocidal past attempting to mask and obliterate the reality of America's past and its presence....This is the American Prayer Rug – a reflection of an image, accompanying a droning sound, to distract us from our own suffering, from love, from land, from water, from connection. There is no space for prayer.
>
> *(Galanin 112)*

Julia Bryan-Wilson has asked what it would mean to imagine textile work as dangerous political tools (1). By pushing, pulling, lacing, embellishing, stitching, fraying, undoing, and puncturing this sculpture, Galanin weaves into the rug multivalent threads. Often rendered as a politically impotent tool – and therefore relegated to the confines of gendered domesticity – handiwork has fomented political triumphs and dissent across the Americas, as the Chilean *arpilleristas* under the Pinochet dictatorship can help testify.[4] Using textile as art-making, Galanin achieves what Bryan-Wilson terms "textile politics." *White Noise* thus

**FIGURE 29.2**   Nicholas Galanin, *Wé tl'átk áwé át sa.áx̱ – Listen to the land*, 2020. Single-channel video w/audio, 4 min 53 sec. Courtesy of the artist.

declares aesthetic sovereignty by tearing the colonial seams that have kept Indigenous works securely bound to the category of "folk art" and "craft."

In 2020, Galanin produced a film entitled *Wé tl'átk áwé át sa.áx̱, Listen to the Land*, as part of Meshell Ndegeocello's *Chapter and Verse: The Gospel of James Baldwin*, a 21st-century ritual toolkit for art and justice. Released in the fall of that year during the peak of the COVID-19 global pandemic and the uprisings against anti-Black racism and violence, the toolkit was intended to be a "gift during turbulent times" (Figure 29.2).[5] Inspired by Baldwin's *The Fire Next Time,* it featured music, film, visual media, theater, poetry, sculptures, performances, and meditations from various artists. Galanin's film expanded the toolkit's offering by weaving Black and Indigenous solidarities and by providing a perspective from someone deeply rooted in his territory.[6] In keeping with themes of his body of work, the film denounces and discontinues cycles of brutality imposed by the USA within the ancestral lands of Alaska. In one of the first scenes, the artist sets out on a journey into the forest carrying his toddler son on his back. The narrative text that accompanies the frame affirms the power in the circularity that animates their relations: "from the land love is born and returned." Galanin explains that the opening scene is a reference to our connection and care to place, and how this relationship to land is so vital to the health of our communities and ourselves. "This is shown through continuum and demonstrated through good ways to exist with the land as sentient. We can only truly care for ourselves when the land is cared for," he affirms.[7] His (then) one-year-old son is a constant companion in the visual narrative, and his presence represents generational responsibility, the importance of a fatherhood rooted in love. "Often," Galanin reflects, "the Eurocentric ideas perpetuated in films with wilderness are narratives of a solo man finding himself in wilderness, or other gendered roles that uphold patriarchy, which are so distant from our own Indigenous relationships to our homes

and communities."[8] Galanin's emphasis on relationality is precisely what Leanne Betasamosake Simpson describes as the Michi Saagiig Nishnaabe epistemology: one that generates a learning *with* and *from* the land, in the context of love, supported by elders and community, curiosity, and embodied intelligence (Simpson 7). Such Indigenous way of being, knowing, and passing on of knowledge, Simpson sustains, creates generations of self-determining, interdependent, and creative individuals capable of maintaining relationships with each other, the land, and the sacred while holding on to values such as "reciprocity, humility, honesty, and respect with all elements of creation" (Simpson 10). This is evidenced in the film as it was shot in the artist's ancestral land where the interweaving between land and water, and humans and ecosystems has been carried out for over 15,000 years.

## Joelington Rios: A Poetics of Resistance and Confluence

In *Pedagogies of Crossing*, M. Jacqui Alexander exposes the movements that have agitated the Atlantic Ocean – embodied trauma, grief, losses, and sacred technologies of resistance that have traveled through these crossings. "Water," she writes, "overflows with memory. Emotional Memory. Bodily Memory. Sacred Memory. Crossings are never undertaken all at once, and never once and for all" (Alexander 318). Afro-Brazilian artists have been determined in exposing the ongoing effects of such colonial movements. Committed to building diasporic visual traditions that corrode colonial dominance and mitigate the grotesque results of the transatlantic human kidnapping, trafficking, and enslavement, their work not only denounces such violence but also proposes a fierce praxis of survival and self-determination. In some ways, they perform what Abdias Nascimento has described as *aquilombamento* – that is, the forging of a place where Afro-Brazilians and their ways of knowing are protected. He writes, "Quilombo is the fraternal living together, in freedom, solidarity, intimacy, and existential communion" (Nascimento, 205). Quilombos are part of a centuries-old movement for Black survival that, through a poetics of resistance, has been committed to building communities of solidarity and continuity. They exist to this day in Brazil and maintain similarities to Lethabo King's metaphor of the shoals, as they foster encounters among land, histories, memories, water, people, and territories that give rise to emergent formations and the reshaping of worlds.

Joelington Rios is a member of such a community. Born in 1997 in Maranhão, Brazil, he was raised in the Quilombo Jamary dos Pretos. Though relatively young, his life has followed the confluences of many territories, histories, peoples, and the dislocation between the states of Maranhão and Rio de Janeiro. As a multidisciplinary artist, his work has been devoted to tracing the crossings through land and water. Rios explains:

> My work investigates this character of in-betweenness, of living in different worlds. I come from the traditional Afro-Indigenous territory of the Quilombo, but I also spend time in Rio de Janeiro. My work occupies this interstitial place. I am always coming and going and am very interested in such ideas of dis-location and dis-placement.[9]

Rios' visual research, indeed, weaves land and water to reveal how his embodied encounters with territory, communities, memories, and ontologies give rise to formations that at once bear the marks of colonial violence, as well as Afro-Brazilian survival and continuity. His photomontage *What Sustains Rio* juxtaposes portraits of Black subjects – who typically travel long distances to work in the

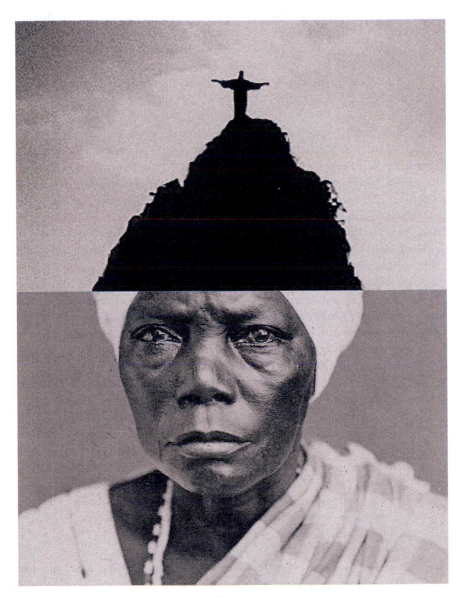

**FIGURE 29.3**   Joelington Rios, *O que sustenta o Rio-Maria. A presença dos negros mantidos como escravos, dentro do processo de sustentação. Pocesso de perpetuação,* 2019. Photomontage, 35 × 35 cm (13.78 × 13.78 in) with frame. Courtesy of the artist.

city – with Rio de Janeiro's most celebrated tourist attractions. The Sugar Loaf, Ipanema Beach, and Christ the Redeemer are literally sustained by the bodies, perspectives, workforce, and heads of those who have been denied the right to leisure in the city (Figure 29.3).

Rios reflects:

> There is an aggressive dislocation where people travel across long distances to reach their workplaces. As I traveled from my home in the favelas of Rio to reach my workplace downtown, I began to note how we – the Black population of Rio – carry out this 'sustaining process.' It became very clear to me how Black people from the favelas literally carry the city on their heads.[10]

*What Sustains Rio* reenacts such aggressive dislocation while signaling the brutal conditions to which the Black Brazilian population has been subjected to for centuries. According to Luiz Antonio Simas and Luiz Rufino, colonization in Brazil is a "permanent trauma, an open wound, an ongoing bleeding" (Rufino, Simas 17). They argue that acts of transgressive re-montage – precisely what Rios achieves through the photo series – confer dignity and reparation to colonized subjects. "The body," they expand, "is the first place of colonial attack," and only creative routes of escape, dislocation, and confrontation are capable of dismantling what they name as the colonial *carrego*, or residue (Rufino, Simas 18). For Simas and Rufino, colonial *carrego* is understood as the somber violence that still haunts, circulates, and weighs down colonized bodies in material and immaterial dimensions (20). *What Sustains Rio* performs such transgressive re-montage through a creative maneuver that exposes the brutality and contrasts of structural violence while sabotaging ongoing colonial dominance.

Through his art, Rios also creates poetic spaces for Black bodies to participate, occupy, and reclaim the city while building communities for Black epistemic survival, world-making, and solidarity. For the artist,

> Black bodies are expansive. We have resisted and continue to reinvent ourselves to remain alive. Even in the face of inhumaneness and violence, we get stronger, we smile, we organize collectively. We are – and each day become – vaster. With the support of our ancestors and our territories, we sprawl outwards, backwards, and forward like rivers. And like rivers, we return to our nascent. As we surrender to the flow we become as giant and as fluid as bodies of water.

Joelington Rios' awareness of the vibrancy, dynamism, and life force present in the world is very much in continuity with the cosmovision shared by Afro-Brazilian religious traditions and Comunidades Tradicionais de Terreiro (Traditional Communities of Terreiro). The vital force of Axé, which dynamizes energies and generates transformation, is precisely the power that allows

for the preservation, renewal, and expansion of life. Nei Lopes affirms that axé is "responsible for mobilizing and maintaining all that happens in the universe, both visible and invisible. Every being in the universe is imparted with this vital force" (Lopes 68). For Helena Theodoro, axé in the context of Afro-Brazilian religious traditions imbues everything with "the force of life, a dynamic power that dwells within the divine, but also within sacred places, consecrated objects, the natural world, animals, plants, certain minerals" (Theodoro 28). Within this cosmology, Exú is the orixá who governs and safeguards the axé, residing in the

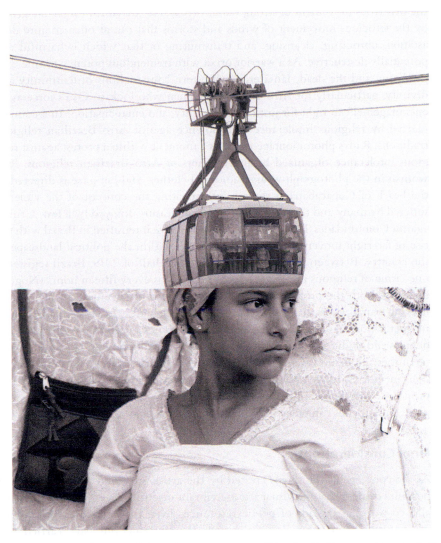

**FIGURE 29.4**  Joelington Rios, *O que sustenta o Rio, Iansã. Processo de sustentação e espiritualidade*. 2018. Photomontage, 11 × 13 cm (4.33 × 5.12 in). Courtesy of the artist.

interstices, ruling over movements, crossings, pathways, intersections, messages, and creative acts. As a trickster, Lopes expounds, "Exu lives and operates between worlds, between night and day, good and evil, light and darkness. He is the messenger to whom individuals respond, reverence, and respect" (Lopes 146).

Rios artworks are charged with elements of Afro-Brazilian religious traditions, as the photomontage *What Sustains Rio – Iansã* demonstrates (Figure 29.4). Here, he specifically references the orixá Iansã (also named as Oyá), known in Candomblé as the deity who controls the winds and the rays. Theodoro clarifies: "O-ya means 'she has shredded' in Yoruba, which gives us the idea of the disastrous movement of strong winds" (103). Her dynamism is characterized by the ferocious movement of winds and storms that can at once conjure devastation, uprooting, cleansing, and transmuting of that which is harmful and potentially destructive. As a warrior orixá with tremendous potency to rule over the living and the dead, Iansã erodes Western constructions of femininity and divinity, particularly for Afro-Brazilian women who look to Oyá's force as an encouragement to fight for justice, sovereignty, and emancipation. In a country marred by religious intolerance and violence against Afro-Brazilian religious traditions, Rios's photomontage registers a moment within a protest against religious intolerance organized by practitioners of Afro-Brazilian religions. The woman in the photograph wears traditional clothes, and her gaze is directed to the beach of Copacabana as though interrogating the contrast of the violence suffered by many and the right to leisure and pleasure enjoyed by a few. Crimes against Comunidades Tradicionais de Terreiro have intensified in Brazil with the rise of far-right movements and their presence within the political landscape of the country. Between January 2015 and the first half of 2019, Brazil registered one crime of religious intolerance against Terreiros every fifteen hours (Nogueira, 580). Both the protest and Rios' artwork perform a refusal to such domineering brutality and claim spatial presence to celebrate Afro-Brazilian religions in liberty. Joelington Rios' art contests hegemonies by giving visibility to the peoples and traditions of the diaspora. By interweaving bodies, land, water, and territories, he demonstrates how his people maintain intimacy with the earth, their memories, roots, bodies, and ancestral cosmovisions. Rios' artistic practice proposes a visual agitation along with a testimony: Black-Indigenous life, religions, and poetics can efficiently disintegrate colonial attacks.

## Final Considerations

As we converge at the shoals created by the artists surveyed in this chapter, it becomes evident that the visual arts are vibrant meeting places for co-witnessing and co-weaving threads of poetic resistance. Even in the face of impossibility, negation, and colonial derealization, their productions have carried vast and complex cosmologics that orient us toward liberation, reverence, and living life through communal and reciprocal acts of sacredness. By deeply witnessing, regarding, and learning from the work of decolonial, Indigenous, and

Afro-Brazilian contemporary artists, we begin to unsettle the hegemonic place Eurocentric art, religion, and culture have occupied. We also stimulate a derailing of universalizing narratives. Settler colonial ways of understanding and relating to land, the earth, and its elements have not instilled a reorientation or a profound sense of reverence and indebtedness for the earth as a living entity that communicates, interacts, transmits knowledge, and sustains earth-beings through "situated cosmologic" (Gonzales xix).

Artworks such as the ones examined in this chapter not only build and transmit knowledge communally but clean up spaces to confront the damage carried out by colonializing tropes and environmental degradation while also weaving possibilities for intimate, communal kinship, and the creation of new imaginaries that "[distort] a linear sense of time and [visualize] a sensual relation to place," as Gómez-Barris puts it (*The Extractive Zone* 83). Their aesthetics provide imaginative and commanding tools for contesting, interrupting, and discontinuing the colonial project in the Americas.[11] Some of these artistic productions work interdisciplinarily to orient viewers toward a participatory praxis of care for our common home, increasing our awareness of human and more-than-human entanglements. Cecilia Vicuña, Nicholas Galanin, and Joelington Rios invite their audiences to move, re-emerge, and drift offshore to expand our "capacity to relate deeply and respectfully across differences," while maintaining a "receptivity to the unknown" (Pérez xx). As one of the most provocative formations for indicating new ways of imagining and expanding our subjectivities and ways of being and relating to what is sacred, their artworks allow for a re-worldling that recuperates submerged ontologies so fundamental for our collective survival. Though working from different shores across the Americas, their artworks rescue sunken perspectives and propose a poetic confluence capable of inundating and destabilizing the colonial project while orienting us toward the sacrality of life.

## Notes

1  This is based on my own experience growing up in Brazil. See also Jason King, "São Paulo – Rios (Un/dis)covered." *Hidden Hydrology,* January 3, 2018. www.hiddenhydrology.org/sao-paulo-rios-un-discovered/#:~:text=The%20platform%20 provides%20an%20awesome,Discover!%E2%80%9D.

2  In 1992, Vicuña published collection of poems through Graywolf Press entitled *Unravelling Words and Weaving Water,* which inspired the title of the present chapter.

3  As cited in Kovach, *Indigenous Methodologies,* 37, 56.

4  See Jacqueline Adams, *Art Against Dictatorship: Making and Exporting Arpilleras under Pinochet* (University of Texas Press, 2013).

5  See "Meshell Ndegeocello Chapter & Verse: The Gospel of James Baldwin." *Museum of Contemporary Art Chicago.* https://mcachicago.org/Calendar/2020/09/Meshell-Ndegedocello-CHAPTER-AND-VERSE-THE-GOSPEL-OF-JAMES-BALD-WIN.

6  Nicholas Galanin, "Wé tl'átk áwé át sa.áx̱ – Listen to the Land." *Youtube,* Fall 2020. https://www.youtube.com/watch?v=CYp6_rrSM_Q.

7  Personal correspondence with author, October 23, 2020.

8  Ibid.
9  Personal correspondence with author, September 10, 2020.
10  See Eduardo Vanini, "Artista maranhense descortina a realidade carioca em fotos." *O Globo*, January 14, 2022. https://oglobo.globo.com/ela/gente/artista-maranhense-descortina-realidade-carioca-em-fotos-1-25353115.
11  For a brilliant study that uncovers submerged perspectives in the Americas via the aesthetic, see Macarena Gómez-Barris, *The Extractive Zone: Social Ecologies and Decolonial Perspectives* (Durham, NC: Duke University Press, 2017).

## Bibliography

Alexander, M. Jacqui. *Pedagogies of Crossing: Meditations on Feminism, Sexual Politics, Memory, and the Sacred.* Duke University Press, 2005.
Bryan-Wilson, Julia. *Fray: Art + Textile Politics.* University of Chicago Press, 2017.
Galanin, Nicholas and Merritt Johnson. *Nicholas Galanin: Let Them Enter Dancing and Showing their Faces.* Minor Matters Books, 2018.
Gómez-Barris, Macarena. *The Extractive Zone: Social Ecologies and Decolonial Perspectives.* Duke University Press, 2017.
Gómez-Barris, Macarena. "I Felt the Sea Sense Me: Ecologies and Dystopias in Cecília Vicuña's Kon Kón," in Cecilia Vicuña Artist's book: *About to Happen.* Siglio Press, 2017.
Gonzales, Patrisia. *Red Medicine: Traditional Indigenous Rites of Birthing and Healing.* University of Arizona Press, 2010.
King, Tiffany Lethabo. *The Black Shoals: Offshore Formations of Black and Native Studies.* Duke University Press, 2019.
Kovach, Margaret. *Indigenous Methodologies: Characteristics, Conversations, and Contexts.* Toronto University Press, 2009.
Krenak, Ailton. *Ideias pra Adiar o fim do Mundo.* Companhia das Letras, 2019.
Lopes, Nei. *Ifá Lucumí: O Resgate da Tradição.* Pallas Editora, 2021.
Nascimento, Abdias do. "Quilombismo: um Conceito Emergente do Processo Histórico-cultural da População Afro-brasileira," in *Afrocentricidade: Uma Abordagem Epistemológica Inovadora,* edited by E. L. Nascimento. Selo Negro, 2009.
Nogueira, Sidnei. *Intolerância Religiosa.* Editora Pólen, 2020.
Pérez, Laura E. *Eros and Ideologies: Writings on Art, Spirituality, and the Decolonial.* Duke University Press, 2019.
Rufino, Luiz, and Luiz Antonio Simas. *Flecha no Tempo.* Mórula, 2019.
Simpson, Leanne Betasamosake. "Land as Pedagogy: Nishnaabeg Intelligence and Rebellious Transformation." *Decolonization: Indigeneity, Education & Society,* Vol. 3, No. 3, 2014: 1–15.
Theodoro, Helena. *Iansã: A Raina dos Ventos e das Tempestades.* Pallas Editora, 2019.
Vicuña, Cecília. *Cecília Vicuña: About to Happen.* Siglio Press, 2017.

# 30

## AL BURAQ

## Explorations of Liminality in Contemporary Islamic Art

*Sascha Crasnow*

In Islamic mythology, the prophet Muhammad journeys from Mecca to Jerusalem to the heavens, hell, and back again in a single night. *Al Buraq*, a human-headed flying steed, was originally described as having carried Muhammad on the journey from Mecca to Jerusalem (*isra'*) only, until later descriptions combined this event with the ascension to the heavens (*mi'raj*) with *al Buraq* sometimes described as carrying Muhammad throughout (Gruber). The inclusion of *al Buraq* functioned to ground the events described as corporeal, rather than only a vision or dream (Gruber). During this journey, Muhammad met a number of the other prophets of the Abrahamic religions, including Adam, Moses, Jesus, and John the Baptist (Schrieke, et al.). Again, the inclusion of *al Buraq* here is significant. *Al Buraq* was the steed of prophets: for example, 8th-century biographer of the prophet, Ibn Ishaq, describes Abraham riding on *al Buraq* to Mecca to visit Hagar and Ishmael (Firestone 117). As such, the inclusion of *al Buraq* in the story of Muhammad's celestial ascension, combined with his interactions with the other prophets during his visit to the heavens, served to establish Muhammad's place within their lineage.

*Al Buraq* is a liminal creature: it is neither fully human nor fully animal; grammatically, *al Buraq* is both masculine and feminine; and additionally, *al Buraq* is able to move between the earthly and spiritual worlds. It is this fluidity and in-betweenness, alongside the creature's significance within Islamic religious mythology, that makes *al Buraq* a potent site for exploration of liminality in art among artists from the so-called Islamic world and its diaspora, from articulations of identity to ambiguities of fact and fiction. In this chapter, I will look at the use of the figure of *al Buraq* in a variety of contemporary artistic practices, and in particular how contemporary SWANA (South West Asian and North

DOI: 10.4324/9781003326809-34

African) artists utilize the creature's liminal state as a way to articulate other liminal experiences.

In a previous essay, I analyzed two contemporary queer SWANA artists' use of hybrid mythological figures in works about their intersectional identities (Crasnow 212–224). One artist who I discuss in that text is Durham-based artist Saba Taj who utilizes the liminal nature of *al Buraq* to articulate what I call their[1] "intersectional liminality" – the liminal nature of both their queer non-binary identity and their Southern U.S. American, Pakistani-Kashmiri Muslim identity. Their kinetic sculptural installation *Interstellar Uber//Negotiations with God* depicts *al Buraq* and is comprised of materials that speak to all these varying aspects of Saba Taj's identity. Their Muslim identity is articulated through the use of the figure of *al Buraq* itself, and the evil eye is a symbol, which also connects to their South Asian identity. Their American identity is indicated in the blue jeans adorning one of *al Buraq*'s pairs of legs, and a queer femme identity is signaled through the inclusion of the glittered roller skates, stiletto heels, sparkling gold, beads, and other bedazzled elements.

These components, among others detailed further in the article, mark the varying ways in which Saba Taj is liminal. They are made to feel liminal within their American identity, which centers white Christianity as normative, because of their Pakistani and Kashmiri Muslim identities. Their queer femme identity keeps them in a position of liminality with regard to their Muslim identity – one that often privileges binary gender identification and roles. Their diasporic identity prevents them from feeling completely included in the experiences and identities of those family members who were born in or live in South Asia. However, in the figure of *al Buraq*, this intersectional liminality is not one of limitations, but rather one of possibility. As a creature that is neither male nor female, and which moves with ease between spaces both terrestrial and celestial, the figure of *al Buraq* is one which embodies the potential of the in-between. The space in-between is a celebration of the confluence of these varying aspects of identity rather than a complaint or distress about the state of liminality.

Another artist whose work has incorporated the figure of *al Buraq* to explore their own intersectional identities is Yasmine Kasem. Kasem first began utilizing the figure of *al Buraq* in her work as a means to navigate her uncertainty in Muslim spaces and communities as a queer Muslim. For her, the figure of *al Buraq* became a productive means to explore the liminal and hybrid aspects of her identity. For Kasem, the figure of *al Buraq* is a positive one – a creature who came to the prophet at a time of distress in his life and carried him through it. Additionally, she admired the character of the creature, evident in the story of it bucking off the prophet the first time he attempted to mount it, after which it felt such remorse that it sweat until it was soaked (Kasem, 2021). In her current project named after that story, *Sweat Until I am Soaked* (2022) (Figure 30.1), Kasem fabricates the figure of *al Buraq* as a symbol of positive change and liminal hybrid identity. Kasem constructs the multiple sculptural *Buraqs* that make up the work out of cotton with dyed cotton piping to add color. Aesthetically, they are modeled on Malaysian sculptures of the creature (Kasem 2022). After completing the

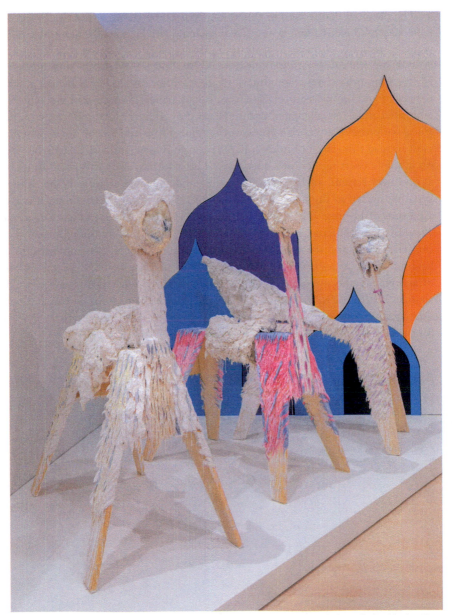

**FIGURE 30.1**   Yasmine K. Kasem, *Sweat Until I am Soaked* (detail), 2022. Wood saw-
horses, salt, cotton, and dyed cotton piping, 101.6 × 53.34 cm (40 × 21
in per sculpture). Courtesy of the artist.

sculpture, she then uses salt to harden, crystallize, and preserve them. Over time, the salt changes the shape and condition of the sculpture. While the salt acts as a means of preservation, it also reveals the mutability of our very nature – the fact that we, our identities, are not static but ever changing.

The personal connection to this is emphasized by the fact that the *Buraq*s all have Kasem's face. Kasem notes that in placing her face on the sculptures, she wants to embody *al Buraq*: "I want to be this amalgamous being that defies any type of specific categorization but is loved by God and is also in turn accepted by its community – my community" (Kasem 2022). Because of *al Buraq*'s gender neutrality and liminal nature, Kasem reads it as a queer figure – and one which is embraced and even celebrated within Islam. For Kasem, placing her face on her *Buraq* sculptures is a way of coming out as a queer Muslim. As she notes, whether viewers read this into it or not, for her the figure is queer, and by placing her face on it, she is asserting her own queerness. The materials themselves also function as queer for Kasem, as they are undefinable and always changing. While Kasem situating herself in the queerness of *al Buraq* is steeped in vulnerability, it is also a gesture of healing. The salt functions in this way – Epsom salt is a material agent used in medicine, salt is a necessity for the human body (though too much can harm you), and the salt forms on the sculptures like a scab, another sign of healing. Kasem's gesture with the sculptures is not one of fear, but rather one of acceptance and opening up to the possibilities of what future unknowable changes may arise. In the figure of *al Buraq*, against claims both within and outside Muslim community that state there is none, Kasem finds a potential space for the non-normative, the queer, to have a place.

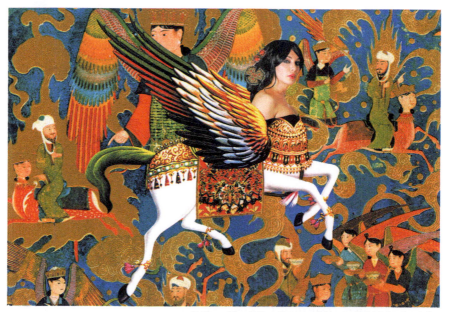

*© Chaza Charafeddine, Courtesy of the artist & Saleh Barakat Gallery*

**FIGURE 30.2** Chaza Charafeddine, *Sans Titre VI*. Background: details from different plates of the Miraj Nameh depicting the paradise, 2010. Photomontage, giclée print on fine art paper, 35 × 50 cm (13.8 × 19.7 in).

Other artists have also explored the potential for the figure of *al Buraq* in articulating liminal gender identities broadly, rather than as an examination of their own identifications. One such artist is Chaza Charafeddine. Charafeddine's interest in *al Buraq* came about as she was researching Islamic art history and in particular gendered representations throughout Islamic art. She was struck by the research of Asfaneh Najmabadi, in her book *Women with Mustaches and Men without Beards*, where Najmabadi looks at changing notions of male and female beauty in Iran during the Qajar dynasty (from the 17th–20th centuries), from one of more ambiguity between men and women's beauty, to one more resembling European perceptions (Charafeddine; Najmabadi). Charafeddine also noted that these more ambiguously gendered figures were articulated in Mughal artists' works (whose aesthetics were adopted from the Persian miniatures) in the 16th–17th centuries, including depictions of *al Buraq*. She saw this in contrast to the popular imagery of *al Buraq* in the 20th century, specifically the 1940s, when a distinctly feminine human face was portrayed. Charafeddine was interested in not only exploring this shift, but also subverting it in her composite images that make up the *Divine Comedy* series, a reference to Dante's epic, which some scholars believe may have been influenced by Muhammad's Night Journey.[2]

To create each of her images, Charafeddine selected a background from 16th- to 18th-century Persian and Turkish miniatures, as well as Mughal Islamic art. For instance, in *Sans Titre VI* (Figure 30.2), Charafeddine used details from different plates of the Miraj Nameh depicting the paradise that were produced in the 15th century at the illumination workshops of Herat. She then chose a depiction of the body of *al Buraq* from a selection of popular portrayals from Iran, India, Pakistan, and Egypt used in the 1940s. She lastly added a portrait of a feminine figure, akin to those depicted in those 1940s popular images; however, the subjects themselves embody the liminality that *al Buraq* represents. For the faces of the *Buraqs*, Charafeddine photographed individuals who represent articulations of gender that do not adhere to a strict binary, much like the creature of *al Buraq* itself. According to Charafeddine, the models describe themselves as: "men who liked to play women from time to time, transvestites, cross-dressers, transsexuals, and transgender individuals" (Charafeddine). These individuals' embodied articulations of gender are thereby liminal – not adhering to the binary – centering *al Buraq* as a symbol of this in-betweenness.

Further emphasizing this liminality is the combination of sources from three different time periods: the background images sourced from artistic images centuries earlier, in *Sans Titre IV*, a 16th-century Persian miniature illustration, *The Adulterous Couple* from the Baharistan of Jami, the bodies of the Buraqs coming from the mid-20th century, and the portraits as contemporary, coming from the 21st century. In this sense, these works transgress the boundaries of time, perhaps making a claim to the ever-presence of varied articulations of gender.

However, artists have not just used the figure of *al Buraq* to articulate liminalities associated with gender, religious identification, and ethnicity. Much like Yasmine Kasem, Arshia Fatima Haq plays with the mutability of materials in her

**FIGURE 30.3** Arshia Fatima Haq, *The Ascension*. Originally shown as part of a four-channel installation *Solution*, with contributions from Cassils, Arshia Fatima Haq, Rafa Esparza, and Keijaun Thomas. Performance and concept by Arshia Fatima Haq. Film by Cassils, 2018.

work involving *al Buraq*. However, rather than using it to comment on the unfixed nature of gender, she utilizes the liminal figure of *al Buraq* to articulate her own tensions in identifying as both a Muslim and an artist. Her work, *The Ascension* (Figure 30.3), is a performance that was originally conducted in 2018, which was

documented on video, the form in which the work is now exhibited (Haq, "The Ascension").[3] In the work, Haq stands before an ice sculpture of *al Buraq*. She then proceeds to attempt to cover the figure in gold leaf, gilding it – an impossible task due to the melting of the ice, which both dilutes the gold leaf and defies adhesion. As the artist notes, growing up in a family where iconography was not permitted made her choice to become an artist rooted in conflict – both between her and her family and community, and within herself (Haq, "The Ascension"). The liminal figure of *al Buraq*, neither entirely human nor entirely animal, but rather embodying both, serves as an articulation of Haq's own embodiment of her Muslim and artist identities – two aspects of her whole that, in the context in which she was raised, were presented as incompatible and irreconcilable. Indicative of this, Haq's family knows nothing about her artistic practice.

In spite of this, it was actually her early interactions with Sufi Islam that sparked an interest in artistic forms. Growing up, her father's family lived across from the biggest Sufi shrine in Hyderabad. Haq witnessed another form of Islam from the one she experienced in her own family at that shrine – one rooted in music, bodily practice and ritual (Haq, interview). The figure of *al Buraq* in particular was visible in iconography around shrines and even sold at the shrines as take-home paraphernalia – something that now is often met with claims of paganism (Haq, interview). As her family moved toward a much more "orthodox" engagement with Islam, particularly after moving to the States, what she saw at the shrine stuck with Haq (Haq, interview).

For Haq, it is the mutable nature of *al Buraq* that is most appealing to her about the creature. It is a creature that was once prominent in visual culture, then receded, and now is reappearing among contemporary artists (Haq, interview). Additionally, depictions of *al Buraq*'s human visage changed with the beauty standards of the time. For Haq, *al Buraq* is a symbol that is generative and rich as a site of what is possible, as well as one that embodies the inherent failure in representation. She notes that her practice has moved toward a greater interest in the ephemeral – a subconscious homage to what she internalized growing up about the impossibility of and restrictions on representational imagery.

In *Ascension*, Haq attempts to preserve the elusive figure of *al Buraq*. In attempting to gild the ice sculpture, the work makes reference to religious narratives of idolatry such as the golden calf at Mount Sinai, a story that appears in all three Abrahamic traditions. As the ice melts, taking the gold with it, the impossibility of preserving this representation, or perhaps even of representation at all, is made clear. In spite of this, there is an alchemy that happens in the process that creates something new – a merging of gold and ice. In performing this action, Haq perhaps produces a form of art that attempts to reconcile the lessons about restrictions on representation that she has internalized and her own identity as an artist.

Lastly, there are other artists who have engaged with the liminality of *al Buraq* outside the scope of embodied identity. Mohammad Said Baalbaki has used the in-betweenness of *al Buraq* as a jumping-off point for exploring liminalities and ambiguities between fact and fiction, particularly those histories constructed by

**FIGURE 30.4**   Said Baalbaki, Reconstruction of a Pegasus skeleton from the installation *Al Burak I*, 2007–2009. Ceramic and brass on wood, 50 × 48 × 72 cm (19.7 × 18.9 × 28.3 in).

museum institutions. In his three-part project *Al Burak*, Baalbaki creates a fictional museum dedicated to a re-telling of the history of the Middle East. The first part tells the story of a German archeologist who discovered the skeleton of a winged creature during a dig in Jerusalem in 1914. After consulting with a number of other scientists and scholars in adjacent fields, it is suggested that this skeleton might be that of the mythical creature, *al Buraq*. The installation includes an archive of correspondence and photographs related to the dig and the scholarly discussions that led to this conclusion, as well as a replica skeleton of the *Buraq* – the "original" skeleton having been lost following the subsequent World Wars and bombing of Berlin (Figure 30.4).

Baalbaki's story of *al Buraq* opens at the moment right before the historical events whose legacy would result in much of the continued strife in the region known as the Middle East. This includes the First World War and subsequent division of the region between the British and French in the Sykes–Picot Agreement – the start to a regional European colonial exploitation and rule that would continue into the second half of the 20th century for many countries. As part of this, there was an incredible loss of Middle Eastern heritage through colonial pillaging for "preservation," only to have these objects be destroyed during the bombing campaigns of WWII.

In displaying these objects in the style of a traditional archeological or natural history museum, in vitrines with accompanying explanatory text, Baalbaki

uses this familiar context to lend an air of authenticity to the narrative that he tells, while also problematizing the notion that the narratives that are told and contextualization of the objects shown in other museum contexts are inherently "the whole truth." The work plays on visual references and historical knowledge that a viewer may "know" as truth, such as the colonial history of the Middle East and the presumed factual nature of museum displays, and by inserting the fantastical "evidence" of the existence of *al Buraq* asks viewers to question the entire enterprise of history as objective and museum institutions as truth-tellers. Baalbaki's project thereby problematizes the notion of a black-and-white division between fact and fiction and reveals the liminal nature of the (hi)stories that are told – the blurred lines between arti*fact* and arti*fice*. The liminal figure of *al Buraq* emphasizes this further.

The work also serves to blur the boundaries between science and myth. This is perhaps drawn out most directly in the skeletal drawings attributed to two of the German scientists. While the rest of the installation does include illustrative images of *al Buraq*, the skeletal drawings reduce the nature of the fantastical down to the anatomical – the scientific. These drawings recall medical journals, the anatomical illustrations of Michelangelo and Leonardo's *Vitruvian Man* – linking the typically perceived as "objective" science to the "subjective" creativity of art and the possibility of what might be embodied by myth. It also highlights the supremacy that hegemonic Euro-American societal expectations put on evidence sourced through scientific artifact rather than giving due to the possibility of mythological storytelling as historical artifact in and of itself.

A detail in the story of the discovery of *al Buraq*'s bones gestures toward another element of liminality. In Baalbaki's story, the German archeologist discovers the bones buried in a suitcase. The suitcase, a common motif in Baalbaki's work, references immigration and the migrant diasporic experience, including Baalbaki's own as a Lebanese-born artist now living in Berlin. The suitcase references travel, or a journey, much like Muhammad's on *al Buraq*. The immigrant experience is similarly liminal to Muhammad's journey in that the immigrant is always both where they came from and where they now reside – an experience described by Edward Said as "contrapuntal" and by Homi Bhabha as "hybridity" (Said 186; Bhabha ix). The immigrant experience thereby collapses time and space and exists in a temporal and geographical in-between.

The works discussed in this chapter are just a selection of examples of contemporary SWANA artists utilizing the figure of *al Buraq* in their works. Notably, all instrumentalize the liminality of *al Buraq* as an in-between creature whose journey transgresses earthly planes as a mode for exploring other aspects of liminality – be those identity categories or the blurry space between fact and fiction. It is fitting that it is a mythological figure that is at the root of these articulations, as they are all asking viewers to rethink what is, and what might be possible.

## Notes

1 Saba Taj uses they/them/their pronouns.
2 See Miguel Asin Palacios, *Islam and The Divine Comedy*, trans. Harold Sutherland (Routledge, 2012); Jan M. Ziolkowski, ed. *Dante and Islam* (Fordham University Press, 2014); Bisquees Dar, "Influence of Islam on Dante's Divine Comedy," *International Journal of English and Literature* 3:2 (June 2013): 165–168; Mariwan N. Hasan and Shamal Abu-Baker Hussein, "Dante's 'The Divine Comedy', Eliot's 'The Love Song of J. Alfred Prufrock' and Muhammed's Isra and Miraj: A Comparative Study," *International Review of Social Sciences* 4:11 (November 2016), 483–486.
3 According to Haq's website, "The piece was created under the name Fanaa and conceptualized in response to the artist Cassils' seminal work 'Tiresias,' who invited three artists to create works in ice exploring themes of ephemerality, devotion, and perseverance. Originally shown as part of a four-channel work 'Solution' alongside works by Cassils, Rafa Esparzo, and Keijaun Thomas."

## Bibliography

Bhabha, Homi. "Foreword." *Debating Cultural Hybridity: Multicultural Identities and the Polictics of Anti-Racism*, edited by Pnina Wernber and Tariq Modood. Zed Books Ltd, 2015, ix-xiii.

Charafeddine, Chaza. "Divine Comedy, 2010." *Chaza Charafeddine.* https://chazacha rafeddine.com/work/9/divine-comedy-2010.

Crasnow, Sascha. "The Diversity of the Middle: Mythology in Intersectional Trans Representation." *Journal of Visual Culture*, vol. 19, no. 2, 2020, 212–224.

*Dante and Islam*, edited by Jan M. Ziolkowski, Fordham University Press, 2014.

Dar, Bisquees. "Influence of Islam on Dante's Divine Comedy." *International Journal of English and Literature*, vol. 3, no. 2, 2013, 165–168.

Firestone, Reuven. *Journeys in Holy Lands: The Evolution of the Abraham-Ishmael Legends in Islamic Exegesis.* Albany: SUNY Press, 1990.

Gruber, Christiane. "al-Burāq." *Encyclopaedia of Islam.* 3rd ed., edited by Kate Fleet, Gudrun Krämer, Denis Matringe, John Nawas, Everett Rowson. Brill, 2012. http://dx.doi.org.proxy.lib.umich.edu/10.1163/1573-3912_ei3_COM_24366.

Haq, Arshia Fatima. "The Ascension." *Arshia Fatima Haq.* https://arshiahaq.com/The-Ascension.

———. Personal interview. 5 April 2022.

Hasan, Mariwan N. and Shamal Abu-Baker Hussein. "Dante's 'The Divine Comedy,' Eliot's 'The Love Song of J. Alfred Prufrock' and Muhammed's Isra and Miraj: A Comparative Study." *International Review of Social Sciences*, vol. 4, no. 11, 2016, 483–486.

Kasem, Yasmine. Personal correspondence. March 12, 2021.

———. Personal interview. April 4, 2022.

Najmabadi, Asfaneh. *Women with Mustaches and Men without Beards.* Berkeley: University of California Press, 2005.

Palacios, Miguel Asin. *Islam and the Divine Comedy.* Translated by Harold Sutherland. Routledge, 2012.

Said, Edward. "Reflections on Exile." *Reflections on Exile and Other Essays.* Harvard University Press, 2002, 173–186.

Schrieke, B., J. Horovitz, J.E. Bencheikh, J. Knappert, and B.W. Robinson. "Miʿrādj." *Encyclopaedia of Islam*, 2nd ed., edited by P. Bearman, Th. Bianquis, C.E. Bosworth, E. van Donzel, W.P. Heinrichs. Brill, 2012. http://dx.doi.org.proxy.lib.umich.edu/10.1163/1573-3912_islam_COM_0746.

# AFTERWORD

## A Colloquy with Diane Apostolos-Cappadona, James Elkins, Ben Quash, and S. Brent Rodriguez-Plate

To close this collection of scholarship and criticism at the intersections of "religion" and contemporary art, we, the editors, invited four prominent scholars – working from different disciplinary frameworks, and who have made significant contributions to the field themselves – to participate in a conversation. We asked them to take stock of the current state of art practice and scholarly/critical discourse in this expansive field of inquiry. We provided them with drafts of our contributors' chapters and posed several initial questions, inviting them to respond to each other's comments. Their reflections included looking back to trace some of the critical developments that paved the way for the wide-ranging and diverse work being produced today. Finally, we asked them to cast an eye forward to consider the future trajectories of scholarship and other engagements at the nexus of art and religion. We are grateful for their willingness to participate in this project and for their deeply informed and thoughtful responses that resulted in the rich and insightful colloquy found below. Our roundtable scholars and their institutional affiliations (as well as the abbreviations used to identify them in the conversation) are as follows:

### Diane Apostolos-Cappadona (DA-C)

Professor Emerita of Religious Art and Cultural History
Catholic Studies Program
Georgetown University

### James Elkins (JE)

E. C. Chadbourne Chair of Art History, Theory, and Criticism
School of the Art Institute of Chicago

**Ben Quash (BQ)**
Professor of Christianity and the Arts
Director of the Centre for the Arts and the Sacred
King's College London

**S. Brent Rodriguez-Plate (SBRP)**
Professor, Department of Religious Studies and Cinema and Media Studies
Hamilton College; Executive Director, APRIL; Editor, CrossCurrents

## QUESTION 1

*In 2004, as the final statement in his book* On the Strange Place of Religion in Contemporary Art, *James Elkins wrote that it was "impossible to talk sensibly about religion and at the same time address art in an informed and intelligent manner: but it is also irresponsible not to keep trying." The landscape of art production and art-critical and historical discourse has developed considerably since then; this volume of essays offers just one example of the wide-ranging work currently being done in this arena. How would you characterize the current state of "religion" (broadly framed) as it surfaces in contemporary art, and in art's criticism and scholarship, and how (and, perhaps more significantly, why) has this changed over the last several decades?*

SBRP: In 2002, Jim Elkins sent me a draft of what would become his book, *On the Strange Place of Religion in Contemporary Art*. He's always been a great collaborator and truly interested in other people's ideas. My responses to him took two main trajectories. One was about the relation between the terms "religion" and "spirituality," and I think that still needs some playing out, two decades later. The second was about the relation of what I loosely would call "content and context," which I'll discuss later.

One of the constant themes that emerges in these conversations is whether we are talking about "religion," or something more nebulous like "spirituality." "Religion" is the term used in the First Amendment of the United States Bill of Rights, as well as the term used by the United Nations, the US Citizenship and Immigration Services, and more. "Spirituality" may have more street-cred these days, but it has very little legal or political standing, and so I think it is important to "talk sensibly" about some of the political dimensions of these differences.

In relation to the arts, I think the dialogue about "religion and the arts" is that it continues to get boiled down to a discussion of spirituality, which tends to harken back to the individual artists' own "interior feelings" in ways that have not changed much since Kandinsky's writings 100 years ago. The use of the term "spirituality" often reifies the mythology of the individual artist creating in *his* [sic] own studio, waiting for inspiration. Elkins' book used his students as examples, and I appreciated that aspect of it and can appreciate the kind of individuality and interiority that may be part and

parcel of the university experience, a time of rapid personal growth and reflection. Thus, "spirituality" may be an important moniker at times, but I also try to get my own students to understand how connected they remain to their socially constructed worlds of gender, sexuality, race, language, bodily abilities, and religion, no matter how much of a spiritual individual they hope to be.

There's nothing wrong with that, but I do think it is important to be clear about these differences as we move forward. The use of a term like religion should force us outside, into the public realm, and start our questions in that regard.

BQ: To "broadly frame" something called "religion" is already to align oneself with a certain legacy of *Wissenschaft* and its concomitant methodologies.

I have recently been re-reading the theologian Hans Frei's account of the philosophical questions at stake in the foundation of the University of Berlin in 1809, and specifically the question of whether theology should have a place in a "modern" university. It could almost as well be entitled "On the Strange Place of Theology in the Modern University." A readiness to be subject to the highest court of *Wissenschaft* was assumed on all sides to be the essential "price of admission" to a place in the university. *Wissenschaft* is summarized by Frei as "inquiry into the universal, rational principles that allow us to organize any and all specific fields of inquiry into internally and mutually coherent, intelligible totalities." "The philosophical faculty became, in effect, the cement and the most important faculty in the university [and] Christian theology was in principle [...] in the position of having to demonstrate that it was truly *wissenschaftlich* and had a right to citizenship in this university."[1]

Shortly after I was appointed to my present position at King's College London in 2007, I received a long, handwritten letter from a recently retired Professor of Theology in my Department, who had been one of the doyens of a "liberalizing" theological agenda, warning me passionately that the advancement as normative of the distinctive, historically formulated doctrinal claims of Christianity in a contemporary university endangered the subject's very future. It would, he wrote, seem to those in other departments indistinguishable from "shamanism." Here too, I think, the animating anxiety was that theology would find itself condemned at the bar of *Wissenschaft*.

But a self-limitation to description marks an intellectual retreat; it restricts what counts as worthy of attention in the study of religion by genericizing what religion is, and it restricts it further by disallowing the voices of those who inhabit particular traditions to converse, argue, and give utterance to their desires in their own voices and in a rigorous, self-critical, and mutually challenging way. Scholars of religion can also use "description" as a way to avoid displaying their own norms as comprehensively and honestly as possible when engaging with the norms of those who inhabit religious traditions. The search for alternative terms to "religion" ("the sacred," "the

transcendent," "the spiritual," "the ultimate," and so on) usually just repli-
cates the problem.

DA-C: As the senior (age-wise) member of this quartet, I want to comment
briefly on the history of the study of religion and art from which this present
volume springs, and which provides a context for what I suspect will be the
group responses to the issues posed here. This is not to say that we all – we
who are involved in this conversation, the editors and contributors to this
volume, and our readers – are mired within only one cultural perspective,
but it helps us to note that as we describe either historically or contempo-
raneously the terms "religion" and "art" and their roles, we recognize how
fluid and flexible these terms have become, even unto their most recent
reformulations into spirituality, material culture, popular culture, and per-
haps most significantly for this volume, visual culture. This latter category
name has come to replace art history in a parallel fashion to the evolution of
religious studies from the history of religions and theology.

Since the mid-to-late 19th century, when art history and the history of
religion were initiated as academic fields within established European uni-
versities and museums, introduced first in Germany and then throughout
mainland Europe, there was a growing interest in those world religions and
philosophies that lay beyond the borders of Christianity, Judaism, and even
Islam. Commensurately the social, political, and economic universes that
undergird "the West" were reshaped and have continued to be reshaped in
response to the concerns and needs of our collectives. However, we need to
have an eye on the past to understand where we are or might be going in
the next decade(s).

JE: Since 2010 or so, there has been a large number of events, exhibitions, con-
ferences, books, and essays on religion and contemporary art. I'll just start by
saying that from my point of view – teaching in a large art school, looking at
the art world from the perspective of practice, and not at all from the vantage
of scholarship – the principal phenomenon that correlates with the increased
dialogue between religion and art is the demise of certain postmodernism
associated with political change, institutional critique, and postminimalism,
and the rise of a welter of theories and concerns that are more personal,
including gender and affect theory. I say "correlates" because I wouldn't
want to draw a cause-and-effect relation between the new openness about
faith and religion and the new acceptance of art that performs gender and
aims at affect.

BQ: Contemporary art may not feel itself bound by any distinctively academic
history of *Wissenschaftlichkeit* (even if Art History, Visual Studies, et al., are
the inheritors of *Wissenschaft*'s strictures, and in some cases find themselves
tempted to stay in the safe havens of the "descriptive"). So there is every rea-
son to be optimistic about its power to push into more risky and potentially
constructive territory. But to do so, it needs to avoid being satisfied with
"private values," which are a close cousin of positivism's fragmenting effects

in the academy. The problem of positivism seems to me to be closely connected with the problem of privatization. In both cases, there is inarticulacy about in-betweenness; an inability to give an account of shared realities and shareable meanings.

JE: I'm glad you mention that because it's been on my mind looking through the essays in this book. Most of the contributors here are interested in publicly shareable concepts (doctrines, religious practices, doxa, from reliquaries to eschatology), and those may indeed be material out of which bridges need to be built. But in my experience – in recent years I've been focused on undergraduate art students more than grads and academics – young artists who have faith on their minds aren't usually interested in publicly communicable meanings. Part of my job in orienting these young artists is to demonstrate how ideas and feelings they think are private actually connect to history (how a red background in a manga drawing is sublime, and why Burke's opinion about such a thing might be relevant), but I am aware, at the same time, that the stakes in that game are higher for me than for them.

DA-C: I would like to interject two points here, and I suspect this comment will be applicable throughout the ensuing conversation: first, that each of us and our work, whether written texts, research interests, or lectures, is clearly influenced by our daily milieu or what used to be identified as the quotidian existential. So Jim's description of the differences in his reading of some of the contributions in this collection and his own commitment to his current students highlight this. Secondly, at least for me, I have seen several cultural shifts in both the audiences for our work among colleagues, students, and the larger public which have affected the shape of our own vocabulary and category structures especially away from the concept, if not the rule, that one's faith tradition did not need to be publicly identified either in the classroom or publications. As the social etiquette of such an understanding of personal privacy has shifted dramatically to complete transparency by the 1980s, one moved into the recognition that Paul Tillich's reflection that the theologian doesn't have to be a believer, morphed to study or teach theology into clear and public advocacy of one's religious affiliation (read faith) and one's right to teach, research, and publish either within or outside of that boundary, as evidenced for example in the then ground-breaking work of David Tracy as a scholar of religion and theology and not as a Catholic priest. Hence the expanding fluidity of the terms "religion" and "spirituality" have moved beyond the initial discussions by artists such as Kandinsky in the early 20th century and the Abstract Expressionists following World War II and the Korean War. Those we would today identify as "contemporary artists," including all of those mentioned by my conversation partners here, have been culturally socialized into this newer sense of religiosity, if you will, and the relationship between art and religion, as Jim has noted being present in the texts in this volume, is distinct from what he gleans from his current students.

BQ: I think there are signs that many contemporary artists (take as examples Andrea Büttner, Theaster Gates, Alicja Kwade, Danh Vo, Kehinde Wiley), and some contemporary art theorists and critics (T.J. Clark; Whitney Davis) are actually interested in questions of normativity. If so, I see ample reason for the exploration of religious traditions of thought and practice in art and art criticism, and growing evidence for it too – both in "third person" and in "first person" modes. In the context of such developments, the commitments and traditions of religious people need neither be invisible nor strange. What needs to be made stranger than it is at present is the notion of "religion" as a distinct and definable domain of human activity, positioned and analyzed by supposedly objective tools of academic inquiry (whether historical or other), rather than an aspect of how human beings engage in the making of meaning and the creation of conditions for flourishing. By extension, the boundary between apparently religious norms and the norms of allegedly objective scholars, or avowedly dogma-free artists who "only want to ask questions," should be acknowledged to be far more complex than it presently is.

If we altered our search terms a little, asking not so much after art "about religion" as art about what some of our most world-forming religious traditions seem themselves to be "about" – art about what is essential to, or of especial interest to, Christianity, Judaism, Jainism, Zoroastrianism, Islam, etc. – then we might find a lot to observe and to talk about. Art about humility, generosity, sin, hope, history, for example. And maybe art about what those valuable hermeneuticists, Habermas, Gadamer, and Ricoeur, have been so interested in: the possibility of communication itself. In which case, might there be certain ways in which, whenever art decides it wants to be about art, it also finds itself being about something of intense metaphysical (and perhaps theological) import? Modern academic positivisms leave this important realm of inquiry largely untouched, unexplored, and unaddressed, even though the material they study begs a set of questions about it at every turn. We evade any sustained investigation into the nature of the "in-betweenness" that makes communication between different human subjects possible (in any one historical epoch, as well as across historical epochs). Yet such in-betweenness is, arguably, the condition of there being art at all. It is the medium in which art works. This medium needs a philosophical treatment, which may result in something more like a theory of art's communicative possibilities than historical-positivist methods can produce in their own terms.

If there is a shift toward a more explicit interest by artists in such questions, why might this be happening? Perhaps there is a perceived need to reestablish the terms for the pursuit of connected, productive, meaningful life together. Public truth, common good, shared delight.

DA-C: The rapidity of the cultural and societal shifts that brought about the sexual revolution, Civil Rights movement, and Feminism in the 1960s and 1970s has morphed into the contemporary concerns for racial justice, ethnic

identity, multiple redefinitions of sexuality, and concerns for the environ-ment among other causes, have implications for ecclesial and academic insti-tutions, and are significant motivators for artists, critics, and museums. The floodgates have opened the narrowest definitions of religion and of art, and while we have all benefited, we have also been questioned and critiqued by those fearful of change, so they cling to their fundamentalist definitions and categories, and sadly their financial support. The future may only be possible if the economics of the art world – for artists, critics, and academics – can provide support for "the new" as well as for "the traditional."

## QUESTION 2

*As we survey the important work that has been done in this field in recent decades, muse-ums, galleries, and other exhibition and cultural sites have arguably been more open to engaging the intersections of contemporary art and religion. Why do you think this has been the case?*

DA-C:  We all need to recognize that most major museum exhibitions do not emerge overnight but require a two- to five-year (sometimes longer) plan-ning period for successful execution of loans and writing of a catalog. To be fair, many of those exhibitions that incorporated contemporary art and reli-gion in the earliest decade of the 21st century were initiated and developed in the late 20th century and in anticipation of the Millennium, i.e., in terms of religion, the life of Christ was a major topic. Additionally, although many major museums, like the Metropolitan, the Hermitage, or the Art Institute of Chicago, have curators who propose exhibition/symposium topics, there is always the issue of funding and the reality of what might be accessible loans. Clearly, one of the simplest (in terms of organization only) topics for an exhibition is a retrospective or single-artist presentation.

Museums like the Met are also always in search of audiences who will buy tickets, visit the gift shops, perhaps become members, and since the millennium have also sought to increase their audience among younger and younger individuals. Many younger individuals are not inclined to attend exhibitions of classical (read traditional) art or themes related to tra-ditional religion. They have – as the Costume Institute at the Metropoli-tan Museum (unfortunate, in my opinion) blockbuster exhibition *Heavenly Bodies: Fashion and the Catholic Imagination* (2018) which had an excellent theme but overplayed its hand – successfully brought in new and younger audiences, but at what cost in terms of exhibition presentation and rationale. So, for me, this raises the serious question "what is the purpose of museum exhibitions?" – to pander to new audiences or to present controversy, like the Met's presentation *Chroma* (2022), which garners headlines and thereby hopefully new members, or to continue within a traditional pattern of con-noisseurship illuminated by expanding the conversation through new modes

of presentation, such as online access, companion media such as televised documentaries, recognition of the current questions raised by scholars, artists, and critics, and consideration of currently intriguing motifs/themes. So, I would propose that younger audiences will be more and more attracted to mixed exhibitions such as popular and material culture objects displayed next to traditional works of high art, or to provocative displays of Outsider art, Folk art, and contemporary photography.

BQ: There is no doubt at all that there are more exhibitions at this intersection, even if they're only happening in certain places. Pre-eminent examples are the National Gallery in London's *Seeing Salvation* exhibition in 2000, whose vast success emboldened it to program a series of major exhibitions that explicitly invited the public to explore works of visual art in a way that prompted questions about their original religious contexts of commissioning, manufacture, display, and devotional use, as well as how they might still provoke existential questions in present viewers. These have included *Devotion by Design: Italian Altarpieces before 1500* (2011), in which one room presented altarpieces in a manner that deliberately recreated distinctive elements of a church interior; *The Sacred Made Real: Spanish Painting and Sculpture 1600–1700* (2009–2010) which did likewise, while inviting visitors to imagine what might motivate religious reactions to vividly polychrome and often gruesome depictions of bodily suffering; and, most recently, *Sin: The Art of Transgression* (2020), which is now on tour around the UK.

Elsewhere, exhibitions with comparable intent to permit (indeed, foster) questions about sacred traditions and questions of faith, and the visual arts' connection to them, have included *The Problem of God* at K21 Kunstsammlung Nordrhein-Westfalen, Düsseldorf (2015–2016), *Divine Beauty: From Van Gogh to Chagall and Fontana* at Palazzo Strozzi, Florence (in exactly the same period), and the fascinating *Fragments of a Crucifixion* at Chicago's MCA in 2019, curated by Chanon Kenji Praepipatmongkol. The brief but rich outputs of Bridge Projects in Los Angeles are also a mark of what is now imaginable in this territory.[2]

I think the reason for this change is that museums with historic collections have begun to see the acknowledgment, explanation, and exploration of the devotional histories of their works, and (just as important) the ability of those works to "speak religiously" in the present as well as in the past, as part of their curatorial responsibility; something entailed by their custodianship of these works. Museums have a duty of care both to the works and to those audiences who cherish the works on religious grounds.

Internationally, there have been very substantial numbers of curators enthusiastically involved alongside theologians in the Visual Commentary on Scripture (VCS).[3] This is a project which I direct at King's College London whose ambition is to respond to (more specifically, to offer curatorial "interpretation" of) the entire canon of Christian Scripture in an ever-growing set of online exhibitions. The VCS model moves beyond the

consideration of how to tell "the story of art," to ask questions with the help of art about the kinds of things the Bible speaks about. This, too, seems to be a mark of a new openness and collaborative spirit.

DA-C: Can I interject here again my earlier comment about the shift away from the privacy of one's religion to the wider discussion, if not inclusion, of one's religious values into public discourse? It seems to be that has worked hand-in-glove with the evolution of the types of exhibitions Ben is highlighting as well as the promise of projects such as the VCS and its inclusion of museum professionals as well as art historians, biblical scholars, and theologians. Expanding the borders within which or outside of which one can discuss religion, religious values, religiosity, faith, or spirituality has significantly paralleled the redefinitions, if you will, of Christian art to religious art to spiritual art. This seems to be not simply something that occurred within the academy or within museums but in the larger public spheres including religious communities and museumgoers.

SBRP: Going along with my previous response, spirituality has become an acceptable term to use in polite conversation in recent years, which has also allowed people to discuss art in these terms more readily. And I think it is generally spirituality (or sometimes another nebulous term like "transcendence") that is used freely. It's somewhat non-committal, has no political substance, but expresses an "inner sense" of things. I think much of the openness within the art world has simply been because spirituality has become a topic more discussed outside of art circles.

Beyond that, I'd like to believe that the art world has matured over the last century of its professionalization. There has been a strong move since the late 1970s or so, toward socially engaged art (several of the essays in this volume speak to that), and I think the "art for art's sake" approach has run its course. It still exists, but I guess I am optimistic that the end of modernism opened things up for new possibilities, including attention to religion/ spirituality.

It's important also to note the ways funding projects, especially through the Luce and Lilly foundations, have changed the shape of religion in museums; from endowing curators at Smithsonian museums to generating a series of exhibitions on religious-oriented themes and projects. Lilly Endowment created a "Religion and Cultural Institutions" initiative that has provided funds to museums across the United States "that foster deeper understanding of religious traditions, topics and themes."[4] Meanwhile, the Templeton Foundation has funded projects on the arts in theological education.

Significantly, especially for the Lilly grants, this has pushed "religion and art" exhibitions beyond Christianity. Others here have mentioned some of the Western and Christian-themed exhibitions in recent years, but to my mind what has been far more important are exhibitions in Europe and North America displaying the arts from across Asia, the Middle East, and Africa, that reflect the religious dimensions of cultures. A recent $13.5 million grant

to the Smithsonian will result in exhibitions and community-based projects that will highlight, variously, Zen Buddhism, Sufi arts, Krishna, and "Global Religions of Africa" at the National Museum of African Art.

## QUESTION 3

*Professional scholarly associations for the study of art, such as the College Art Association (CAA) and its affiliated groups, long resisted efforts to address modern and contemporary art's engagement with the sacred, while academic associations of religion and theology (such as the American Academy of Religion, Duke Initiatives in Theology and the Arts, the Institute for Theology, Imagination, and the Arts, among others) have more readily embraced such interdisciplinary scholarship. Why has this been the case? What still needs to be done to address this neglect or oversight?*

SBRP:  In grad school, I did a lot of interdisciplinary work, and as I completed my PhD I was regularly attending CAA and AAR. After a couple of years I quit going to CAA as I found my work was not really understood; other scholars just kept asking me what period and what region I was working on. There was little conceptual awareness that there are larger possibilities in relating art and religion. My experiences at CAA suggested that it had a conservative approach to scholarship, that the scholar was to dig deep into some small area of expertise and spend their lives in that little burrow.

While not perfect, I have continued to find the academic study of religion a capacious place to query so many labyrinthine rabbit holes in life. No one seems to mind if you stir in cultural anthropology with cognitive science and art history and then think about it all in the terms of religious studies. It's a large field with many holes to dig.

Why is this? Obviously, scholars of religion are a bit less embarrassed by the term religion, though I will admit that when I started working in areas of "religion and the arts" and "religion and film" in the 1990s, people looked askew at some of our work, like the arts were just an "expression" of the real work of theology or text translation. In that context, "art" was often the term of embarrassment. Nonetheless, there were already established places that the work could be done. Since then, through the work of Diane Apostolos-Cappadona and others, the AAR, and religious studies more broadly, has developed numerous programs relating religion and the arts.

DA-C: I am not sure I agree with the overall characterization of professional scholarly associations for the study of art as long resistant to address modern and contemporary art. Of all the disciplinary borders I have crossed, the most territorial and possessive of its identity was Art History, and yet some of the finest and most creative work relating religion and art has been done by art historians, as for example, Robert Rosenblum in his *Modern Painting and the Northern Romantic Tradition: Friedrich to Rothko* (1975); Leo Steinberg in his many publications on Leonardo, Michelangelo, Picasso, and his then

controversial *The Sexuality of Christ in Renaissance Art and in Modern Oblivion* (1983, rev. 1996), and two of the exhibitions curated by Maurice Tuchman, *The Spiritual in Art: Abstract Painting 1890-1985* (1986), and *Parallel Visions: Modern Artists and Outsider Art* (1992). However, it should be noted that within the territories of their own disciplines both Rosenblum and Steinberg were highly criticized for the interdisciplinary tenor of these books. In point of fact, when I invited Rosenblum to contribute to *Art, Creativity, and the Sacred* in 1982, he declined, first thanking me for my positive comments about his 1973 tome and the invitation, but basically indicated he found the criticism from his colleagues so intense that he never ventured into the realm of religion again.

I remember one panel I organized sometime in the late 1980s for the AAR/SBL on the theme of "Theology and Contemporary Art." All the theologians I invited, including John Cobb, Langdon Gilkey, and David Tracy, immediately and affirmatively responded as did those scholars in religion and art including Doug Adams and John Dillenberger. The AAR, however, was concerned there would be no audience and hesitated to offer a large room for this session. I was delighted as I believed then as I do now better to have a room too small than a room too big! Well, we filled all the chairs (over 50) plus the aisles and had attendees flowing out the door and sitting on the floors of the hallways. I confess, sometimes it's just luck but sometimes you must take the risk to try "the new."

As far as the AAR and academic institutions of religion and theology are concerned, most of those programs identified in your question had funders, either individual patrons or foundations, who saw encouraging the programming of religion and the arts as a new direction, especially in the 1970s and 1980s. Interdisciplinary scholarship in religious institutions has a long history, including its foundational programs in literature, music, and performance, all of which can be related directly to liturgy, preaching, and community conversations.

Recently, of course, Art History departments have evolved into Visual Culture programs incorporating the widest possible swath of "the visual," from the traditional fine arts and art history courses to include film, television, digital communications, and other forms of new media, along with the growing conversations with gender and sexuality studies, ethnicity, race, and all those "culture" topics from pop/popular culture, material culture, etc. The boundaries of their previously walled spheres have opened although not perhaps to the forms of religion and contemporary art that are discussed in this present volume, but more headway can be made if the funding can be found, and the jobs made available to the graduating students and practicing artists.

JE: I agree, the disciplinary walls are still up when it comes to most of the examples discussed in this book. The obstacle is visual culture studies itself, which is infused with an ironic, postmodern attitude to cultural products that

represent consensus positions such as those of major religions. Visual culture studies are immune to the kinds of sincerity that matter in the studies in this volume. The only essay in this book that crosses that boundary is Isabelle Loring Wallace's essay on Christian Jankowski, and *The Holy Artwork* has been a special case ever since it appeared in 2001. Art history (which I see as regaining the ascendant position in most departments) is more capacious, and a good first step here might be to group Jankowski's experiment with others close to it in time if distant in subject matter, like Andrea Fraser or Coco Fusco.

SBRP: Meanwhile, several of us (and I'd single out the work of David Morgan here most especially) began to show how the arts were constitutive of religion itself. The use of terms like "visual culture" and "material culture" began to help assert the place of artistic work at the heart of histories of religion. I think this intellectual shift has allowed a more prominent place for the arts within the academic study of religion.

Furthermore, the CAA, and related avenues of art criticism, have been reluctant to approach religion in part because of a general cultural illiteracy about what "religion" actually might mean. Maybe it's the fault of us scholars of religion ourselves, and the little burrows *we* dig, that we haven't been able to broadcast the message that religion has little to do with "belief in God." All of us, whether we "believe" or not, participate in powerful stories and behaviors, adhere to symbolic actions, create community, and otherwise live out our lives in religious and religious-like manners. Art not only reflects this but also helps create these communal, symbolic, structures of life. A realization of the structural kinship between the human realms of religion and of art shifts our modes of analysis.

BQ: I find that so interesting, Brent, having just been reading T.J. Clark's 2018 book *Heaven on Earth*. Clark assumes that what he calls "the question of belief and unbelief"[5] is the central concern of religious people (or of Christians at least), and this seems to predispose him against any idea of a genuine or deep "structural kinship" (to use your words) between art and religion. Instead, religion is something the artists he admires have to surmount in order to achieve a greater "subtlety" (Clark 15). I am much more inclined to your view. A focus on doctrinal orthodoxy and/or inner conviction about certain propositions or states of affairs (if that is what Clark means by "belief") represents a highly intellectualized model of what religious commitments and solidarities are; it misses what gives them their traction and allows people to put them to work in their lives.

But of course I *am* a theologian, and so I'm nevertheless quite interested in the religious words and concepts at which Clark – and maybe a good many scholars of material religion – look askance! So I had better answer this question with my theologian's hat on.

Theology's attractions to an engagement with Art History (and the arts) are multiple, but include (1) a missional imperative, (2) the discernment of

metaphysical common ground (based on the conviction that every metaphor implies a metaphysic), (3) a desire to capitalize on the popularity of art (and make theology more attractive), but – perhaps most reputably – (4) a conviction that theology's subject matter is not just God, but all things in relation to God. (In this sense, *theology's* interest in art – as too, arguably, in science, politics, etc. – is importantly distinct from the interest of *scholars of religion* in art – as "material religion," for example.)

But what about attitudes from the other "side"?

The Centre for Arts & the Sacred at King's (ASK),[6] which is another of the centers you rightly identify in your question, encountered a very positive response to our proposal to have a whole day of papers on religion and art at the annual meeting of the UK's Association for Art History at its 2018 conference. It ended up being a key part of the program. Since 2010, we have also run a termly Sacred Traditions & the Arts graduate seminar in conjunction with the Courtauld Institute of Art.[7] So there is a receptivity here that is encouraging. Nevertheless, it is true that many of these initiatives originate more with the theologians and scholars of religion than with art historians.

A collaborator of mine at the Courtauld Institute of Art once admitted that aesthetic enjoyment was what drew him to his discipline in the first place, but that now – in practicing his discipline as a trained art historian – he feels he must exclude it rigorously. He suppresses his particular delights, kicking over their traces, for to do otherwise would result in what he called "the imposition of affect." And if affect is not admissible in rigorous Art History, how much less welcome is faith? The accusation of writing anything that might sound pious, even about works made for profoundly devotional purposes, is the accusation that many art historians fear above all, as though it would represent a blurring of their critical judgment; a "failure of objectivity" of the most embarrassing kind.

JE: Ben, can I inject a note of optimism? When you mention the art historian who suppresses his aesthetic pleasure, his affect, in favor of "objectivity," I recognize my old self, freshly minted with a doctorate after a strict education by a German-trained architectural historian. (I wore charcoal silk pants and ties to my first job in the art school.) After the *Re-Enchantment* event in Chicago, we did another, which is now also a book, called *Beyond the Aesthetic and the Anti-Aesthetic*. We – in that case nearly 30 international scholars, convened for a week – came to the general conclusion that what might come "after" the aesthetic values of modernism and the political values of postmodernism is an opening to affect. In particular we meant affect theory, but since then the gates have opened, and art historians are increasingly engaged with feelings, both their own and others'. I'm happy to report I only know a few art historians who suppress their aesthetic pleasure (although they may still find it difficult to articulate in their published writing); quite a few interested in minor aesthetic qualities, affect, feeling, mood, and emotion; and not a single one who would want to claim their work is objective.

DA-C: My turn to interject here but not necessarily, like Jim, a note of optimism but more of a reflection on the borders between these disciplines both inside and outside of the academy and the museum world. I was once asked, ironically, almost verbatim by an art history colleague and later that same semester by a religious studies colleague, the same provocative question. Cognizant that my answer could not begin either with the word "both" or "sometimes the latter, sometimes the former" – each queried: "Which could you live in – a world without art or a world without religion?" My greatest mentor in the relationship between religion and art was the Japanese-American sculptor Isamu Noguchi, who began many conversations (and essays) with the phrase "When art stops being Art with a capital letter..." He would turn to me and say that is the place where your work helps to reclaim the space between religion and art.

## QUESTION 4

*What do you see in the future for work at the intersections of "religion" and contemporary art? Are there new and perhaps promising or fruitful directions you see in art production, representation, and critical engagement?*

SBRP: I come back here to the second main response that I made to Jim's draft, noted above, about "content and context." I maintained, and still maintain, that to talk about art, one must talk about both. By "content," I mean simply what is inside the frame of art. By "context," I mean simply what is outside the frame of the artwork. Content refers to the composition, style, medium, length of time (in the case of performative and installation pieces, for example), artist's intentions, etc. – all the things that art historians and critics usually talk about. Context refers to where the work is seen, heard, felt, and otherwise interacted with, who is doing the seeing, and how the reaction takes place – all the things that a scholar of anthropology or religious studies might talk about. Another way to put this is to think about the artwork and the work of art. In the former, "work" is a noun, in the latter it is a verb.

While content (the artwork) and context (the work of art) have many slippages between them, one of the things those of us working between religion and the arts keep coming back to is the religiousness of content while ignoring the context. We write essays and books analyzing artworks, but often ignore the work of art. We spend too much time on the production of art and do not spend enough time with the reception. Yet, to understand the religiousness of art, the artwork is often much less important than the work of art, the affects and responses that art invokes.

By context, I'm not really talking about some vague historical setting, but hoping we begin to home in on human bodies, bodies that engage the world through the senses. Which is of course an uncovering of the term "aesthetics" for its Greek roots, that which pertains to sense perception. A primary

aesthetic question for understanding the religion–art relation could become: What happens to bodies, and what do they do when they encounter a work of art? Followed by a question like: how is this corporal engagement religious? Even if the artwork is not necessarily religious? How are people behaving religiously when confronted with the work of art?

DA-C:  What I would like to see here is a recognition among artists, curators, and educators about the fluidity of words/terms "religion" and "[contemporary] art." I think we need to move beyond the traditional categories of iconography to thematic topics such as "Iconoclasm" and "Blasphemy" to begin conscious discussions of the interrelationship between religion and contemporary art. Further, I think we need to recognize, as others in this conversation have noted, the significance of reception and response, especially from our audience whether students, colleagues, artists, or museum goers. Art is a form of effective AND affective communication not simply between the artist and her audience but also between and within each individual viewer. With an eye to history and the other to the future, I think it would behoove artists, curators, and educators to open up the stereotypical categories of religious art and consider the reality of the role art plays in individual journeys, as for example in the work of Picasso and Viola.

JE:  My modest proposal would be something like this: convene a conference without papers. Let people introduce themselves to one another. Let the atheist or agnostic or entirely non-religious scholar of art history from Harvard or Princeton talk to the committed artist and believer from Biola or Lipscomb (or other faith-based academic institutions). There wouldn't be a set topic or any guidelines. It might be a little like those Tino Sehgal performances, where people knew they were talking to someone who'd been briefed, but they didn't know what was scripted and what wasn't.

It's thanks to Jonathan Anderson that I settled on my own entirely heuristic solution. He hosted several events at Biola in Los Angeles that made me realize that conversation, as much as content, has been the culprit. The conversations I had with people of faith at Biola University, Lipscomb University, Westmont College, and elsewhere have been consistently eye-opening.

My insight, if it can even be called that, is so simple that it almost doesn't bear explaining. I noticed that when I talked to my professional colleagues at art history conferences, the conversations nearly always opened with each person rehearsing their current research. When I talked to people at institutions like Biola, it was likely that the first thing they'd want to know is whether I am a religious person. I've been asked so many times – always in those settings – that I have a set speech. It's brief and honest, and it recounts how I converted to a Conservative temple when I was at the university, but how I'm no longer observant. The idea is this: a person of faith may want first of all to know whether the person to whom they're talking has the experience of faith, knows what belief is, knows what commitment is, has

experienced a life of observance. After that, they'll know what other kinds of conversation are possible.

I think what's necessary to make a genuine difference is to *change the ways we talk,* and only then try changing the kinds of art we want to talk about.

BQ: Jim, when I hear you describe the way that an interlocutor at a Christian university or college will typically want to know what your religious commitments are before going on to talk to you about art (whereas professional colleagues in the art-historical guild may carefully avoid inquiring), I recognize an experience I often have in the US but rarely in Europe. I find myself wondering whether there is a "confessional" quality to US religious discourse, which may be traceable to its roots in a certain sort of Protestant Christianity. Maybe also it has something to do with the secularity of the US Constitution: a religious identity is a *declared* identity. In my British context, and particularly in my denomination (the Church of England), talking about one's religion, and asking other people about theirs, is sometimes considered a lapse of good manners! But maybe this diffidence can serve some comparable purposes to those you look for in your imagined "conference without papers," in which people acknowledge who they are and why they care when they describe what they study. The British version might avoid immediately pigeonholing people as either religious or not but would assume that quite a lot of "religion" was in the room, even if implicitly. The fascination would be to see the ways it surfaced. I would anticipate a large number of complex identities (the "my parents were devout;"; the "I like to attend but it's mainly for the music;" the "no longer observant" [but, as in your case, closely observing!]).

I have hope in these sorts of conversations, because I have had them – or have seen others have them – with many contemporary artists, and they are sometimes rich and critically productive. I mentioned some of these artists already (Büttner, Gates, Wiley, Vo, Kwade). And their bodies of work ask after many of the things that religious traditions ask after, even if they do not often suggest the same answers. Teresa Margolles, Rebecca Salter, Anselm Kiefer, Antony Gormley, Cornelia Parker, Kris Martin, and Doris Salcedo are also intriguing figures in this regard.

In the work of many of these artists (and the list could be extended without too much effort), one finds not just an engagement with (even an embrace of) religious "material," but of modes of religious experience and thinking: meditative practices, contemplative disciplines. They are often just below the surface and emerge into view if you probe a little. As Matthew Milliner has put it to me in conversation: "this is where many artists are finding most interest right now; it's what they feel they haven't been able to talk about for a long time."[8]

Finally, the increase of "transhistorical" exhibitions with a connecting thematic focus is extremely exciting and likely to offer fertile ground for conversation with multiple disciplines (including theology) and audiences

(including religious communities). The 2022 exhibition "Reframed: The Woman in the Window,"[9] curated by Jennifer Sliwka, and garnering 5-star reviews in London, is a case in point. Gathering works spanning three millennia, it is not principally a show about how artists influenced one another, or about how their techniques and materials evolved. It is about the human condition: the continuities and changes, revolutions and recurrences, triumphs and tragedies that we can be helped to see when we consider works that show women at, or in, windows (or, occasionally, when women artists depict the views from their own windows). It is an exhibition that interrogates the present as much as the past; which is non-didactic but deeply moral; existentially involving and provocative of questions about what sort of world we think we inhabit and how to live in it well.

## QUESTION 5

*Each of you has brought up observations that are critical for fruitful scholarship or criticism at the intersections of religion and contemporary art: the importance of context and affect of the work on the audience or recipient of the work; the way that so many contemporary artists are taking up the issues that religious traditions have typically addressed, the so-called "big questions," which create a common currency between the two arenas; the need to expand or create new categories and language to more effectively discuss art that moves into this territory; and the willingness to open ourselves to real dialogue across differences with the expectation it might lead to new understandings, and even genuine relationship. This volume brings together the work of a diverse group of scholars and critics, including both well-established and emerging new voices, to reflect something of the extent and depth of interest in the arena of "religion" and contemporary art: theoretical and interpretive frameworks, common artistic strategies one sees being used by artists, and a substantial number of case studies that examine the work of particular artists and some important themes that evince "a curious accord" between "religion" and contemporary art. What do you think is some of the most interesting and significant art and scholarship or criticism in this arena being produced today and, perhaps more importantly, what makes it so? And, finally, what might it forecast for what we can anticipate going forward?*

JE: First, I need to say I am deeply grateful to Dan Siedell and Jonathan Anderson for their very thoughtful responses to my work. Dan's essay corrects a narrowness in my sense of the concept of faith, showing that separating art and faith requires an unrealistic desire for "clarity and cleanliness." He talks candidly about how he went in search of a theology that could be as "vulnerable, fragile, unjustifiable, and unexplainable" as the modernist art practices he also values. Dan's journey has been an exemplary one, and I hope that he continues to write about it so it can provide a model in form, if not in specific content, for other people trying to negotiate the "strange" or "curious" regions "between" forms of art and faith. I met John Caputo, one of Dan's models here, at a wonderful small conference in Belfast, where

there was more modesty, more vulnerability and uncertainty, than in any other academic or faith-based gathering I've ever attended.

Jonathan Anderson has been an almost supernaturally thoughtful interlocutor for a decade and a half now, and I entirely take on board the correctives in his essay. He's right that my book was always about how people talk about the art, rather than how artists intend it or what it might be in and of itself, and his four categories of renewed or enlarged conversation on art – anthropological, political, spiritual, and theological – are promising. The first, the anthropological, could also have been called "sociological," or even just labeled "social art history." (Some of the scholars he mentions, like Margaret Olin, Isabelle Malz, and Sally Promey, identify as art historians and might be bemused by the label "anthropological.") His second category, "political," might also include social art history, especially when it's a question of someone like Tim Clark seeing religious themes in current art "as loci for political questions of suffering, tragedy, spectacle, and hope." Disciplines become especially hard to discern in this second heading when Jonathan turns to Donald Preziosi and Claire Farago, whose position is something more like philosophical cultural critique, and whose conceptual analyses of "religion" and "art" are as undercutting or abstracting as, say, Bruno Latour's operations on the word "nature." All this is just to say that disciplines, or interpretive communities, are as interesting to disentangle as the terms under discussion in this book.

A tremendous amount has changed in the years since *On the Strange Place of Religion in Contemporary Art*, but some of the problems of discourse are still very much with us. (Jeffrey L. Kosky's essay on Robert Storr's reaction on Y.Z. Kami's *Endless Prayers* is a case in point.) There is still an identifiable group of artists that tend to be studied by scholars interested in religion and contemporary art. Kiefer has long been an example, and so has Bill Viola, who figures in several essays in this volume. Andy Warhol has been an example since Jane Dillenberger's studies (in this volume see Stephen Bush's contribution), and so has Betye Saar (see Cynthia Hahn's essay), Cai Guoqiang, and Wolfgang Laib. Some relatively unfamiliar artists who are now attracting attention share traits with those more established names. The Shanghai artist Meng Yan, studied in Changping Zha's essay, works in the tradition of Anselm Kiefer as well as Chinese inkbrush painting. I have often wondered if a sufficiently capacious sense of "religious art" could help expand this canon to include most or all of contemporary art production, soaked as it is in a deeply religious culture.

One way to do that is signaled by essays in this volume that build bridges between particular concepts in religion and art. In this vein there's Kathryn Barush's essay on pilgrimage, using Chiara Ambrosio's project *As Far As The Eye Can Travel* as an example (and essays on the fourteen stations by Karen von Veh and Aaron Rosen); Elissa Yukiko Weichbrodt's essay on lament, empathy, and reciprocity; Cynthia Hahn's essay on materiality, using the

example of reliquaries; Karen Gonzalez Rice's revisiting of Thomas McEvilley's work on performance art and shamanism; Rachel Hostetter Smith's inquiry into the similarity between some artists' actions and Catholic ritual; Katie Kresser's essay describing how portraiture, in the Western tradition, can be said to descend from icon painting; Ben Schachter's essay on eschatology in Jewish and Christian artists' work; Eleanor Heartney's essay on concepts of paradise; and Wayne L. Roosa's essay on the parallels between the avant-garde and the "sacred discontent" of the prophets. These alone would have made this a great book, a kind of *Dictionary of Concepts for Art with Religion.*

Yet another thing that's changed since my book, and also since *Re-enchantment,* is the specificity of information about particular traditions that is permitted, or expected, in art writing. In the *Strange Place of Religion* book, I noted a couple of examples where mandalas were permitted in art exhibitions and mentioned in essays simply because the scholars and their public didn't know enough about their content to perceive them as anything other than exotic, private, or formal. Haema Sivanesan's study shows that mandalas do not need to be taken as empty signifiers of "unknown" religions but can be brought into a fuller conversation on the meanings of the works. The same welcome infusion of exact meanings can be found in the essays by Jorge Sebastián Lozano, Sascha Crasnow, and Yohana Agra Junker, who explores indigenous meanings in the work of three artists from Chile, Alaska, and Brazil.

But most of all, from my perspective, it's great to see scholarship exploring new kinds of conversations. I'm especially glad to see Lieke Wijnia's essay on the concept of translation as a way to talk across secular and religious differences because it shows a willingness to consider what she describes as "the intertwinement of the secular and religious" as amenable to linguistic theories. Donato Loia's essay on Theaster Gates does similar work of adjusting conversations by suggesting Gates's work "performs religion as an active force that it is not necessarily reactionary." Loia asks that "we revise our conceptions of a global secular modernity that characterizes the religious always as other, fundamentalist, reactionary, or irrelevant." These are both ways to rethink the kinds of conversations we have, and not just the subjects of the conversations, and I still think that's the most fruitful, collegial, and ecumenical way forward.

BQ: I can only affirm Jim's endorsements of Jonathan Anderson's and Dan Siedell's contributions. They embody virtues which I think are the key to any good academic conversation; to any quest for public truth and common good. Jim has named a great many of them already: vulnerability, sincerity, collegiality, capaciousness. That the emerging dialogue between theology and the arts is so widely marked by these virtues is enormously promising. They need to be prized and nurtured for the sake of the future of the conversation.

There is evidence in some places of a new self-awareness on the part of art-historical discourse that it needs to examine its norms (indeed, its normativity) – to pick up and continue a theme from Question 1. Michael Squire has done important work here, arguing that Art History's methodological origins are deeply influenced by theology, even though it has persistently denied its religious conditionings. Squire writes:

> If, as Ernst Gombrich famously wrote, Hegel is in one sense the "father of art history" it is also true (as Michael Ann Holly puts it) that "there remains something of the Hegelian epistemology in the work of every art historian" One aspect of this heritage lies in the art-historical quest to make objects speak of the broader cultural contexts in which they are situated—whether social, economic, cultural, intellectual and theological. Another part lies in the drive to track changes in both artistic form and cultural framework, and thereby to construct a narrative of development...[10]

Perhaps one of Hegel's better legacies for those who hope for a fuller dialogue between theology and art is his claim that what art is interested in, what religion is interested in, and what philosophy is interested in all in the end overlap. As Squire summarizes it: "what is important [for Hegel] about 'art' [*Kunst*] is its function of making known, through material form, the workings of 'spirit' [*Geist*]; 'art has no other mission but to bring before sensuous contemplation the truth as it is in the spirit, reconciled in its totality with objectivity and the sphere of sense" (Kottman and Squire 30). Hegel recognizes that art is a form of revelation; it makes something known that would not otherwise be known and makes it known *through form*.

An approach to Art History (and Visual Studies/art theory/art criticism too) which is ready to relearn from Hegel the value of the question "what community does my scholarship serve?" will also need to articulate how, as intellectual activity, it is both self-involving, and existentially relevant to others. What is its aim? What common hermeneutical context for study does it embody or imply? Perhaps an ideal of humane culture; perhaps a stripping away of the idols of modernity (these are compatible). Perhaps something else entirely. But, if this challenge is risen to, the door is open to better interdisciplinarity with Theology and Religious Studies (and other disciplines in the Humanities and Social Sciences, too). Art can be made something "to think with," or "to meet in," in the service of some question that needs an answer, or some problem that needs repair.

I reiterate the value of Michael Squire's genealogy of the theological DNA of modern Art History and propose that it would be a great idea to have a conference that asked about the prejudices that might lurk in our methods, and (when necessary) how to liberate ourselves from them, as far as we can. Tom Crow's *No Idols* is of great service here:[11] I felt that book to be a liberation in its call for the "interdiction" on theology in art-historical discourse to be lifted.

The work of charities like Art+Christianity and Bridge Projects, and initiatives like Aaron Rosen's *Stations* project and new Parsonage Gallery, are going to be vital in brokering trust on the ground between art practitioners and people of faith. So is the work of curators bold enough to explore the "emic" dimensions of religious traditions, which may often turn out not to be backwaters of "insider-speak" but conduits of the deep reasonings that any sustainable civilization depends on for its future. St. Augustine of Hippo said that a functioning society needs common objects of love; the logic of global capitalism has tried to replace this with proliferating "altars" of individual devotion. But *shared* altars (which is to say, shared acknowledgment of the sources of the presuppositions that inform our everyday judgments, when those judgments serve our collective long-term flourishing) may be due a come-back. I can imagine many contemporary artists wanting to make "altarpieces" for such "altars."

And I think it would be wonderful to see a good many of those represented in this volume (and others too) devoting some concentrated and collective attention to the *norms*, the *sources*, and the *methods* that have been/could be most productive for developing the conversation between theology and contemporary visual art (indeed, the visual arts in general: past, present, and future). The essays in this volume display the shared wisdom and best practice of those who have been working at this frontier, and push toward a better articulation of these things. This needs to continue to be refined, to be shared with others, and commended to our institutions. There will be no shortage of students who find this material fascinating. What's needed is that scholars, teachers, and academic houses are given the confidence and the resources to commit to it.

And an additional aim should be for theologians to produce something that contemporary artists will find valuable ("serviceable theological resources," as Matthew Milliner put it in a conversation we had in summer 2022).

SBRP: I'm currently inspired in two directions. First, I am thrilled to see how visual and material culture (including, but not limited to what we call "art") has been a vital force in the scholarship on religious histories. Just as religion/spirituality is now less embarrassing to the art world, the arts are less embarrassing to the religion world. The works of artists through the ages have become a source of evidence for historical scholars in ways that sometimes complement, and sometimes supplement, earlier scholarly attention to verbal texts. This includes contemporary art and related issues.

Here too, the work I find most interesting is that which has left behind the older paradigm of image analysis and has turned to the broader religio-cultural issues of what the work of art might do to, within, and among human bodies and human communities. This is not about idealized, intellectualized audiences, but actual people and actual bodies. A recent work from art historian Yuhang Li, *Becoming Guanyin: Artistic Devotion of Buddhist Women in*

*Late Imperial China* (Columbia UP, 2020) is a great historical example. From another perspective, research that investigates museum audiences and their responses to exhibitions and artworks has gained some traction (see several of the essays *Religion in Museums*, Buggeln, Paine, Plate, eds. Bloomsbury, 2017). Neither of these books is about "contemporary" art, but both demonstrate the kind of intersections that occur between religion, the arts, and the world beyond that dyad. We need more historicizing and corporealizing (if you'll allow me such a term) of contemporary art and religion. I tried to do some of that with my 2006 book *Blasphemy: Art that Offends* (Black Dog Press): to think about how images affect people, and the responses they may have to them.

Related, I'm interested in the ways art can be transformational, the ways it can capture something in the public's eye and impact the ways we see *after* we leave the presence of the artwork. I recently became Executive Director of a smallish non-profit called the Association for Public Religion and Intellectual Life.[12] We run summer colloquia and a journal called *CrossCurrents*. We've long been interested in the arts, particularly as they intersect with interreligious work and social justice issues. This position has allowed me to interact with many people working across the world thinking about how art might be transformative, and how religious/spiritual and social life can be improved through attention to the arts. Relevant social identity issues of race, ethnicity, linguistic abilities, sexuality, gender, and dis/abilities intersect with religious realms in many ways.

So, what do these intersections tell us about how public life might be changed? How do religion and art intersect with race? Sexuality? Does public art, in whatever form, remember histories? Or does public art have the potential to rewrite history? How might curators, critics, and scholars influence the public understanding of religion? In beginning to answer these questions, it becomes clear that a move beyond the hermetic scholarly analysis of images is absolutely necessary at this point in history.

DA-C: Looking into the future requires both a fantastic crystal ball and a sense of where we have come from. Given my past experiences as both editor and author of books and essays in this field of religion and art, I want to comment first on where we have come from and what may be the potential strengths of this present volume. My initial forays into what was then an interdisciplinary form of study resulted in *Art, Creativity, and the Sacred* (1984, updated in 1994). Just as with *Religion and Contemporary Art: A Curious Accord*, back then I wanted to offer not simply a gamut of scholarly essays but also reflections from practicing artists. By 2014, I was asked to edit *Religion: Material Religion* (2016) which was Volume 5 of the 10-volume *Macmillan Interdisciplinary Handbooks,* which were being designed for upper division high school students and lower division undergraduates.

Within that 30-year span, religion and art had morphed into religion and material culture, religion and visual culture, religion and film, and so forth.

A wide umbrella that covered a broad array of materials and methodologies, and which I tried to cover by modeling my volume on the five senses – as Brent has alluded to the Greek root for our word aesthetic – I wanted to interject that etymologically that Greek word promotes the concept of coming to know through the senses (plural). Again, I strove to respond not only to the expanding borders of academic investigations, but also to the realities of everyday encounters, so I divided that volume into two sections using the active verbs "sensing" and "experiencing" as the key titular words. While I included contributors who were artists and/or scholar-practitioners, I wanted to highlight the growing attention to the role of museum exhibitions for both students and scholars, especially in light of the growing interest in the display of sacred objects which had been removed from their original religious milieux; and I went one step further by inviting a contribution from a leading critic/reviewer of art exhibitions who specialized in religious-themed exhibitions.

Now the borders of the field(s) are expanding once again, as witnessed by the many contributions to this present volume whose authors engage from academic and artistic perspectives, but also from voices raised from sensitivities to gender, race, ethnicity, and multiple religious discernments. We are clearly moving beyond those older boundaries characterized as interdisciplinary to the widest possible frames of multidisciplinarity which allows us to consider newer and perhaps wider questions beyond the frame of object, content, and audience receptivity to the longer-lasting effects of artworks beyond the limitations of an exhibition/display encounter, into long term experiences even unto transformations in our individual journeys and those of our students, colleagues, and the larger public. However, we also need to recognize that, even when one is seeking to reflect upon, produce, or understand "the new" or cutting edge, we should retain respect and thereby an openness to both the past and the modes of other disciplines which may not yet have caught up with us...or where we are going. I can only hope that the next 50 years or so can prove to be as productive, heuristic, and engaging as I have known throughout my past 50 years.

## Notes

1  Hans W. Frei, *Types of Christian Theology* (Yale University Press, 1992), p. 98.
2  https://www.bridgeprojects.com.
3  https://www.TheVCS.org.
4  https://lillyendowment.org/our-work/religion/public-understanding-of-religion/religion-and-cultural-institutions-grantee-list/.
5  T.J. Clark, *Heaven on Earth: Painting and the Life to Come* (London: Thames & Hudson, 2018), pp. 8, 15.
6  https://www.kcl.ac.uk/research/ask.
7  https://www.kcl.ac.uk/events/series/past-sacred-traditions-seminars-events.
8  Conversation in January 2021 in the context of the *Theology, Modernity and the Visual Arts* project (https://www.kcl.ac.uk/events/series/theology-modernity-and-the-visual-arts-tmva-1).

9 https://www.dulwichpicturegallery.org.uk/whats-on/exhibitions/2022/may/reframed-the-woman-in-the-window/.

10 Paul A. Kottman and Michael Squire (eds.), *The Art of Hegel's Aesthetics: Hegelian Philosophy and the Perspectives of Art History* (Leiden: Wilhelm Fink, 2018), p. 44.

11 Thomas Crow, *No Idols: The Missing Theology of Modern Art* (Sydney: Power Publications, 2017), p. 134.

12 https://www.aprilonline.org.

# CONTRIBUTORS

## Biographical Notes

**Jonathan A. Anderson** is Postdoctoral Associate of Theology and the Visual Arts at Duke University. He is the author (with William Dyrness) of *Modern Art and the Life of a Culture: The Religious Impulses of Modernism* (2016) and several articles, including "Modern Art" (2021) in *The Oxford Research Encyclopedia of Religion*.

**Diane Apostolos-Cappadona** is Professor Emerita of Religious Art and Cultural History, Catholic Studies Program, Georgetown University, Washington, DC. Her publications/books include *Mary Magdalene: A Visual History* (2023) and *A Guide to Christian Art* (2020). Her main research interests include iconology of women in religious art and Christian iconography.

**Kathryn R. Barush,** D.Phil. (Oxon) is Thomas E. Bertelsen Jr. Chair and Associate Professor of Art History and Religion at the Graduate Theological Union, Berkeley, and Santa Clara University. She is the author of *Imaging Pilgrimage: Art as Embodied Experience* (Bloomsbury, 2021) and the founder and director of the Berkeley Art and Interreligious Pilgrimage Project.

**Ronald R. Bernier** is Professor of Humanities at Wentworth Institute of Technology in Boston, MA. His books include *The Unspeakable Art of Bill Viola* (2014), *Beyond Belief* (2010), and *Monument, Moment, and Memory: Monet's Cathedral in Fin-de-Siècle France* (2007). His research interests are modern and contemporary art and religious studies.

**Stephen S. Bush** is Professor of Religious Studies at Brown University. He has published *Visions of Religion: Experience, Meaning, and Power* (2014) and *William*

*James on Democratic Individuality* (2017). He is currently working on a project on religion, politics, art, and aesthetics.

**Sascha Crasnow** (she/her) is Lecturer of Islamic Arts in the Residential College at the University of Michigan. She writes on global contemporary art practices, with a particular focus on SWANA (South West Asia and North Africa), race, sociopolitics, gender, and sexuality.

**James Elkins** is Professor of Art History, Theory, and Criticism at the School of the Art Institute Chicago. He is the author of *The Strange Place of Religion in Contemporary Art* (2004) and a co-editor of *Re-enchantment* (2009).

**Cecilia González-Andrieu** is Professor of Theology at Loyola Marymount University, Los Angeles. She works on political theology, theological aesthetics, and Latino/a theologies. She is the author of *Bridge to Wonder: Art as a Gospel of Beauty* (2012) and a co-editor of *Teaching Global Theologies: Power and Praxis* (2015), and many other publications.

**Karen Gonzalez Rice** is Associate Professor of Art History at Connecticut College. Her book *Long Suffering: American Endurance Art as Prophetic Witness* (2016) explores the intersection of twentieth-century American avant-garde performance art with traditions of prophetic religious discourse in the United States.

**Cynthia Hahn** is Professor of Art History at Hunter College and the Graduate Center CUNY. Her recent books concern reliquaries including *Strange Beauty* (2012), *Saints and Sacred Matter* (ed. with Holger Klein, 2015), *The Reliquary Effect* (2017), and *Passion Relics and the Medieval Imagination* (2020).

**Julie M. Hamilton** is the Manager of the Foundation for Spirituality and the Arts. Her publications include "'What is This Love that Loves Us?': Terrence Malick's *To the Wonder* as a Phenomenology of Love" in *Religions Journal* (2016). Her research engages phenomenology, critical theory, and religion in contemporary art and film.

**Eleanor Heartney** is Contributing Editor to *Art in America* and *Artpress*. She is the author of numerous books about contemporary art including *Critical Condition: American Culture at the Crossroads* (1997)*Art and Today* (2008), *Postmodernism* (2007), *Postmodern Heretics: The Catholic Imagination in Contemporary Art* (2004), and *Doomsday Dreams: the Apocalyptic Imagination in Contemporary Art* (2019).

**Yohana Agra Junker** is Assistant Professor of art, religion, and culture at Claremont School of Theology. Her research probes the salient intersections of art,

religions, and decoloniality across the Américas, with special attention to contemporary Amerindian and diasporic art practices. Dr. Junker's publications include "Interreligious Pedagogies: Indigenous and Afro-Atlantic Religious Traditions and the Visual Arts" (2022) and "Unsettling the Gaze: Bathsheba between Verse and Image" (Society for Biblical Literature, 2021).

**Patricia Eichenbaum Karetzky** holds the Oskar Munsterberg Chair of Asian Art at Bard College, New York, and serves as Adjunct Professor at Lehman College, CUNY. She has written many books and articles on contemporary and medieval Chinese art and was editor of the *Journal of Chinese Religions*.

**Jeffrey L. Kosky** is Professor of Religion at Washington & Lee University. His book *Arts of Wonder: Enchanting Secularity* received the 2013 Award for Excellence in Constructive-Reflective Studies from the American Academy of Religion and was named on the New Museum's list of "Favorite titles from the past year." He is also the author of *Levinas and the Philosophy of Religion* (2001).

**Katie Kresser** is Professor of Art History at Seattle Pacific University. She is the author of award-winning essays and two books, *The Art and Thought of John La Farge* (2013) and *Bezalel's Body: The Death of God and the Birth of Art* (2019), which received an Award of Merit from *Christianity Today*.

**Donato Loia** is a PhD Candidate in Modern and Contemporary Art at the University of Texas at Austin and the 2022–2023 Andrew W. Mellon Fellow at the Blanton Museum of Art. His work has appeared in *Religion and the Arts*, *Visual Studies*, and *Critical Inquiry*, among other places.

**Matthew J. Milliner** is Professor of Art History at Wheaton College. He is a recipient of a Commonwealth Fellowship at the University of Virginia, and his books include *Mother of the Lamb: The Story of a Global Icon* (2022).

**Ben Quash** was appointed at King's College London as its first Professor of Christianity and the Arts in 2007. He is Director of the Centre for Arts & the Sacred at King's (ASK), and General Editor of the *Visual Commentary on Scripture* (TheVCS. org). He runs an MA in Christianity and the Arts in association with the National Gallery, London. His publications include *Abiding: The Archbishop of Canterbury's Lent Book 2013* (2012) and *Found Theology: History, Imagination and the Holy Spirit* (2014).

**S. Brent Rodriguez-Plate** is Professor of Religious Studies at Hamilton College and Editor of the journal *CrossCurrents* and has published more than 15 books. Recent books include *A History of Religion in 5½ Objects* (2014) and *Religion and Film* (2004). Their esssays have been published in *Newsweek*, *Slate*, *The Los Angeles Review of Books*, *The Christian Century*, *The Islamic Monthly*, the *Huffington Post*, and elsewhere.

**James Romaine** is Professor of Art History at Lander University with a PhD from the Graduate Center of the City University of New York. His publications include *Beholding Christ and Christianity in African American Art* (2017). He is a co-founder of ASCHA. His videos can be found at Seeing Art History.

**Wayne L. Roosa** is Professor of Art History Emeritus, Bethel University, St. Paul, Minnesota. An Andrew Mellon Research Fellow at the Metropolitan Museum, he is a co-founder of NYCAMS, NYC, and the recipient of an NEH grant for work on Stuart Davis at Harvard. His publications include catalog essays on Davis in the United States, Europe, and Japan; and essays for MoBIA, *Image,* and *Arts.*

**Aaron Rosen** is Professor of Religion & Visual Culture and Director of the Henry Luce III Center for the Arts and Religion at Wesley Theological Seminary, Washington, DC and a Visiting Professor at King's College London. He is the author of many books, including *Art and Religion in the 21st Century* (2015). He founded and directs The Parsonage, a contemporary art gallery on the Maine coast that explores issues of spirituality and ecology.

**Ben Schachter** is Professor of Digital Art at Saint Vincent College in Latrobe, PA. He is the recipient of the Emma Lazarus Art Award. His publications include *Image, Action, and Idea in Contemporary Jewish Art* (2017) and a graphic novella *Akhnai Pizza* (2020). His creative practice integrates Jewish texts with graphic novels.

**Jorge Sebastián Lozano** is Assistant Professor in the Department of Art History of Universitat de València in Spain. His research mostly covers three areas: contemporary art and visual culture, Digital Art History, and female representation in Spanish early-modern art. In 2020, he collaborated on the Sofonisba Anguissola exhibition in Museo del Prado.

**Daniel A. Siedell** is a Senior Fellow, Modern Art History, at The King's College in New York City. His books include *Weldon Kees and the Arts at Midcentury* (2004); *God in the Gallery* (2008); and *Who's Afraid of Modern Art?* (2015). He has also collaborated with many artists on numerous exhibition and publishing projects over the course of his career.

**Haema Sivanesan** is an independent curator, researcher, and art writer. She is a recipient of a Robert H N Ho Family Foundation (Hong Kong) exhibition development grant, and an Andy Warhol Foundation for the Visual Arts (New York) curatorial research award for the project *In the Present Moment: Buddhism, Contemporary Art, and Social Practice* (2022). Her research focuses on Asian and Asian diasporic transnational and transcultural art histories.

**Rachel Hostetter Smith** is Gilkison Distinguished Professor of Art History at Taylor University. She publishes widely on aspects of religion and the arts, including two edited volumes of *Religion and the Arts* and several exhibition catalogues and has developed numerous international, intercultural art projects and traveling exhibitions, most recently *Matter + Spirit: A Chinese/American Exhibition*.

**Linda Stratford** is Professor of Art History and History at Asbury University. She is a recipient of the Millstone Prize for her work on the reception of American art in France following the Liberation. Other publications include *ReVisioning: Critical Methods of Seeing Christianity in the History of Art* (2014).

**Karen von Veh** is Professor Emeritus at the University of Johannesburg, South Africa. Recent publications include "St. Sebastian Reimagined: Diane Victor's Gendered Subversion of the Sebastian-Apollo Icon" in *IKON 14* (2021), and an edited book, *Paul Emmanuel* (2020). Main research interests are gender studies, transgressive religious iconography, and postcolonial art.

**Isabelle Loring Wallace** is Associate Professor of Contemporary Art at the University of Georgia in Athens, USA. She is the author of *Jasper Johns* (2014) and is a contributor to and co-editor of three anthologies: *Contemporary Art and Classical Myth* (2011); *Contemporary Art About Architecture: A Strange Utility* (2013); and *Ventriloquism, Performance and Contemporary Art* (2023).

**Elissa Yukiko Weichbrodt** is Associate Professor of Art and Art History at Covenant College in Lookout Mountain, Georgia. Her first book is *Redeeming Vision: A Christian Guide to Looking At and Learning From Art* (2023). She is a contributing editor for *Current*, writing about the intersections of art history, culture, and faith.

**Lieke Wijnia** is Head of Curators and Library at Museum Catharijneconvent in Utrecht. She is the recipient of the Teylers Theological Society golden medal (2017). Recent publications include *Resonating Sacralities: Dynamics between Religion and the Arts in Postsecular Netherlands* (2022) and *Mary Magdalene: Chief Witness, Sinner, Feminist* (2021).

**Changping Zha** is Professor of New Testament studies, contemporary Chinese art, and philosophy at the Institute of Daoism and Religious Culture's Center for Christianity Studies of Sichuan University in Chengdu, China, and the author of many books including *A History of Ideas in Pioneering Contemporary Chinese Art* (2 vols, 2017).

# CREDITS

## Cover Image

Wolfgang Laib, *Passageway,* 2013. 7 brass ships and rice. 46 × 352.1 × 259.1 cm (18 × 128 × 108 in). © 2022 Wolfgang Laib, Courtesy Sperone Westwater, New York.

## PART I: Wijnia

Figure 3.1 Jacques Frenken, *Blue Madonna*, 1965. Gypsum, wood, paint. 151 × 74 × 39 cm (59.45 × 29.13 × 15.35 in). Museum Catharijneconvent, Utrecht. RMCC b119. Used with permission.

Figure 3.2 Helen Verhoeven, *Descent from the Cross*, 2017. Acrylic on canvas. 280.5 × 165 × 5 cm (110.43 × 64.96 × 1.97 in). Centraal Museum, Utrecht, acquired with support by the Mondriaan Fonds. Inv. 34862. © Centraal Museum Utrecht / Ernst Moritz. Courtesy of the artist.

Figure 3.3 Giorgio Andreotta Calò, *Anastasis*, 2018. Light Installation. Installation View. Oude Kerk, Amsterdam. Photo by Gert Jan van Rooij. Courtesy artist and Oude Kerk.

## PART I: Kosky

Figure 4.1 Y.Z. Kami, *Untitled*, 2009–2012. Oil on linen, 284.5 × 190.5 cm (112 × 75 in) unframed. © Y.Z. Kami. Photo: Rob Mc Keever. Courtesy Gagosian.

Figure 4.2 Y.Z. Kami, *Untitled (Hands) I*, 2013. Oil on linen, 274.3 × 182.9 cm (108 × 72 in) unframed. © Y.Z. Kami. Photo: Rob Mc Keever. Courtesy Gagosian.

Figure 4.3 Y.Z. Kami, *White Dome IV,* 2013. Acrylic on linen, 137.2 × 149.9 cm (54 × 59 in) unframed. © Y.Z. Kami. Photo: Rob Mc Keever. Courtesy Gagosian.

## PART I: Rosen

Originally published as: Aaron Rosen, "Curating an Interfaith Pilgrimage: Visual Strategies for Interreligious Studies," in *The Georgetown Companion to Interreligious Studies*, Lucinda Mosher, Editor, pp. 88–98. Copyright 2022 by Georgetown University Press. Reprinted with permission. www.press.georgetown.edu.

Figure 7.1 Güler Ates, *Sea of Colour,* 2016. Salvation Army International Headquarters, London, UK. Photo by Güler Ates. Courtesy of the Artist © Güler Ates.

Figure 7.2 Güler Ates, *Sea of Colour,* 2016. Performance on February 2, 2016. Millennium Bridge, London, UK. Photo by Cilin Deng. Courtesy of the Artist © Güler Ates.

## PART II: Kresser

Figure 8.1 Christ *Pantrocrator* icon, 6th c. Encaustic on wood, 84 × 45.7 cm (33 × 18 in). Monastery of St. Catherine on Mt. Sinai. Public domain; photo courtesy of Wikimedia Commons.

Figure 8.2 Albrecht Durer, *Self-portrait,* 1500. Oil on panel, 66 × 50.8 cm (approx. 26 × 20 in). Alte Pinakothek, Munich, Germany. Public domain; photo courtesy of Wikimedia Commons.

Figure 8.3 Bruce Herman, *Ben,* 2014. Oil and alkyd with silver leaf on wood 76.2 × 76.2 cm (30 × 30 in). Photo courtesy of the artist.

Figure 8.4 Barbara Earl Thomas, *The Geography of Innocence,* 2020. Installation view. Permission Seattle Art Museum. Photo: Spike Mafford.

## PART II: Hahn

Figure 9.1 *Arm Reliquary,* French, 13th c. with 15th c. additions. Silver, silver-gilt, glass, and rock crystal cabochons over wood core, 51.6 × 15.8 × 7.4 cm (20 5/16 × 6 1/4 × 2 15/16 in). Metropolitan Museum of Art Collection, 17.190.353. Gift of J. Pierpont Morgan, 1917. Photo: Metropolitan Museum of Art, Creative Commons Zero (CC0) license.

Figure 9.2 Nari Ward, *We the People (Black version),* 2015 Shoelaces 96 × 324 inches (243.8 × 823 cm) In collaboration with The Fabric Workshop and Museum, Philadelphia Installation view, *The Freedom Principle: Experiments in Art and Music, 1965 to Now,* MCA Chicago, July 11—November 22, 2015. Photo: Nathan Keay, MCA Chicago, courtesy of the artist.

Figure 9.3 Nari Ward, *Sugar Hill Smiles*, 2014, performance, cans, and video, for *No Longer Empty: If You Build It*, exhibition June 25–August 10, 2014 in Broadway Housing Communities' Sugar Hill Building, NYC Video still, courtesy of the artist. Full video available on Vimeo: https://vimeo.com/104024881.

## PART II: Barush

Figure 10.1 Chiara Ambrosio, *As Far As The Eye Can Travel*, No. 20, Palermo Dialogues (August 2017). Hand-held printed paper zine, 6 × 8.5 cm (2.36 × 3.35 in). Photo: Chiara Ambrosio.

Figure 10.2 Chiara Ambrosio, *As Far As The Eye Can Travel*, No. 26, Napoli 18 (August 2016). Printed paper zine, 4 × 8.5 cm (2.16 × 3.65 cm). Photo by the author. Used with permission of the artist.

Figure 10.3 Chiara Ambrosio, *As Far As The Eye Can Travel*, No. 8: Napoli 16 (August 2016), hand-held, printed paper zine, 4 × 8.5 cm (1.57 × 3.35 in). Photo: Chiara Ambrosio. Used with permission of the artist.

Figure 10.4 Chiara Ambrosio, *As Far As The Eye Can Travel*, No. 3, Justo Botanica (December 2014). Handheld printed paper zine, 5 × 7 cm (1.97 × 2.76 in). Photo by the author. Used with permission of the artist.

## PART II: Smith

Figure 11.1 Teresa Margolles, *Limpieza (Cleaning)*, 2009. Performance: exhibition floors were cleaned with a mixture of water and blood from people murdered in Mexico. The action took place at least once daily for the duration of the 2009 Venice Biennale. Performance view: *What Else Could We Talk About?*, curated by Cuauhtémoc Medina, 53rd Biennale di Venezia, 53rd Biennale de Venezia, Italy, June–November 2009. Courtesy of the artist and James Cohan, New York. © Teresa Margolles.

Figure 11.2 Installation view. Wolfgang Laib, *Crossing the River with Pollen Mountain*. Hazelnut pollen and rice. Bündner Kunstmuseum Chur, 2022. Curated by Damian Jurt. © 2022 Wolfgang Laib. Permission of the artist. Photo © Bündner Kunstmuseum Chur, Thomas Strub.

Wolfgang Laib, *Pollen Mountain*, 2022. Hazelnut pollen, Height: ca. 12 cm (4.72 in). Courtesy of the artist and Galerie Buchmann, Lugano.

Wolfgang Laib, *Crossing the River*, 2022. Indian basmati rice, 29.3 × 30.9 m (96.13 × 101.38 ft). Courtesy of the artist.

Figure 11.3 Installation view. Wolfgang Laib, *Crossing the River with Early Carolingian Eucharist Casket*, eighth century. Gold-plated copper sheet on wood casket, 1 carnelian, 1 glass flux, 2 crystals, 16.5 × 20 × 6.5 cm (6.5 × 7.87 × 2.56 in), Chur Cathedral Treasure Museum (Inv. No. VS.IV.2) and rice. Bündner Kunstmuseum Chur. Curated by Damian Jurt. © 2022 Wolfgang Laib. Permission of the artist. Photo © Bündner Kunstmuseum Chur, Thomas Strub.

*Early Carolingian Eucharist Casket*, eighth century. Gold-plated copper sheet on wood casket, 1 carnelian, 1 glass flux, 2 crystals, 16.5 × 20 × 6.5 cm (6.5 × 7.87 × 2.56 in), Chur Cathedral Treasure Museum (Inv. No. VS.IV.2). Property of the Cathedral Foundation of the Diocese of Chur. Used with permission.

Wolfgang Laib, *Crossing the River*, 2022. Indian basmati rice, 29.3 × 30.9 m (96.13 × 101.38 ft). Courtesy of the artist.

Figure 11.4 Damien Hirst, *The Kingdom of the Father,* 2007. Butterflies and household gloss on three canvas panels, 294.31 × 482.6 cm (115 7/8 × 190 in). The Broad Art Foundation. Image used with permission. © Damien Hirst and Science Ltd. All rights reserved / DACS, London / ARS, NY 2022.

## PART II: Roosa

An earlier version of this chapter was published as: Wayne Roosa, "The Avant-Garde and Sacred Discontent: When Contemporary Performance Artists Meet Jewish Prophets," *Image*, A Journal of the Arts and Religion, Issue #83 (December 2014), pp. 23–32. Revised and reprinted with permission.

Figure 12.1 Ann Hamilton, *Malediction,* 1992. Performance, Louver Gallery, New York. Courtesy of Ann Hamilton Studio. Photo: D. James Dee.

Figure 12.2 Zhang Huan. *12m²* (*Twelve Meters Squared*), 1994. Performance. Beijing, China. © Zhang Huan Studio, courtesy Pace Gallery.

## PART II: Sebastián

Figure 14.1 Ellsworth Kelly, *Austin*, 2015. Artist-designed building with installation of colored glass windows, marble panels, and redwood totem, 18.3 × 22.25 × 8 m (60 × 73 × 26 ft 4 in). Blanton Museum of Art, The University of Texas at Austin, photograph by Kate Russell ©Ellsworth Kelly Foundation, Courtesy Matthew Marks Gallery. Blanton Museum of Art, The University of Texas at Austin, Gift of the artist and Jack Shear, with funding generously provided by Jeanne and Michael Klein, Judy and Charles Tate, the Scurlock Foundation, Suzanne Deal Booth and David G. Booth, and the Longhorn Network. Additional funding provided by The Brown Foundation, Inc. of Houston, Leslie and Jack S. Blanton, Jr., Elizabeth and Peter Wareing, Sally and Tom Dunning, the Lowe Foundation, The Eugene McDermott Foundation, Stedman West Foundation, and the Walton Family Foundation, with further support provided by Sarah and Ernest Butler, Buena Vista Foundation, The Ronald and Jo Carole Lauder Foundation, Emily Rauh Pulitzer, Janet and Wilson Allen, Judy and David Beck, Kelli and Eddy S. Blanton, Charles Butt, Mrs. Donald G. Fisher, Amanda and Glenn Fuhrman, Glenstone/Emily and Mitch Rales, Stephanie and David Goodman, Agnes Gund, Stacy and Joel Hock, Lora Reynolds and Quincy Lee, Helen and Chuck Schwab, Ellen and Steve Susman, and other donors,© Ellsworth Kelly Foundation, Courtesy of Matthew Marks Gallery.

Figure 14.2 Davide Maria Coltro, *CRUX – per crucem ad lucem*, 2013–2022. Installation of 11 media panels with digital icons transmitted remotely. Hardware and software designed by the artist. Courtesy of Pietro Gagliardi collection, Turin, and the artist.

Figure 14.3 David López Ribes, *Dwellings (Couch)*, 2006. Video installation. Photograph courtesy of the artist.

Figure 14.4 Javier Viver and Eduardo Delgado Orusco, ephemeral Eucharistic chapel in Madrid, 2012. Photograph courtesy of Javier Viver.

## PART II: Bernier

Figure 15.1 Bill Viola, *Man of Sorrows*, 2001. Color video on freestanding LCD flat panel, 49.2 × 38.1 × 15.2 cm (19 3/8 × 15 × 6 in). Performer: John Fleck. 16:00 minutes. Edition of five with one artist's proof. Photo: Kira Perov © Bill Viola Studio.

Figure 15.2 Bill Viola, *Dolorosa*, 2000. Color video diptych on two freestanding hinged LCD flat panels, 40.6 × 62.2 × 14.6 cm (16 × 24 ½ × 5 ¾ in). Performers: Natasha Basley, Shishir Kurup. 11:00 minutes. Edition of five with one artist's proof. Photo: Kira Perov © Bill Viola Studio.

Figure 15.3 Bill Viola, *Unspoken (Silver and Gold)* (2001). Black-and-white video projected diptych on one gold and one silver-leaf panel mounted on wall, 62.3 × 193 × 5.7 cm (24.53 × 75.98 × 2.24 in); 35:40 minutes. Performers: John Malpede, Weba Garretson. Photo: Kira Perov © Bill Viola Studio.

Figure 15.4 Bill Viola, *Observance*, 2002. Color high-definition video on flat panel display mounted vertically on wall, 120.7 × 72.4 × 10.2 cm (47.52 × 28.5 × 4.01 in). 10:14 minutes. Performers: Alan Abelew, Sheryl Arenson, Frank Bruynbroek, Carol Cetrone, Cathy Chang, Ernie Charles, Alan Clark, JD Cullum, Michael Irby, Tanya Little, Susan Matus, Kate Noonan, Paul O'Connor, Valerie Spencer, Louis Stark, Richard Stobie, Michael Eric Strickland, Ellis Williams. Photo: Kira Perov © Bill Viola Studio.

## PART III: Bush

Figure 16.1 Andy Warhol, *The Last Supper (with Blue GE & 59¢/Pink Dove)*, 1986. Synthetic polymer paint and silkscreen ink on canvas, 305 × 676 cm (120 × 266 in). Image and artwork © The Andy Warhol Foundation for the Visual Arts, Inc./Licensed by ARS.

Figure 16.2 Andy Warhol, Detail of *The Last Supper/Be a Somebody* with a Body, 1985/86. Synthetic polymer paint on canvas, 127 × 152 cm (50 × 60 in). Image and Artwork © The Andy Warhol Foundation for the Visual Arts, Inc./Licensed by ARS.

## PART III: Romaine

Figure 17.1 Tim Rollins and K.O.S., *I See the Promised Land (after the Rev. Dr. Martin Luther King Jr.)*, 2008. Matte acrylic on book pages mounted on canvas, 274.32 × 182.88 cm (108 × 72 in). Photo: Studio K.O.S.; used with permission.

Figure 17.2 Tim Rollins and K.O.S., *The Red Badge of Courage IV (after Stephen Crane)*, 1986. Oil on book pages mounted on linen, 53.34 × 91.44 cm (21 × 36 in). Photo: Lehmann Maupin Gallery; used with permission.

Figure 17.3 Tim Rollins and K.O.S., *Invisible Man (after Ralph Ellison)*, 2008. Matte acrylic on book pages mounted on canvas, 91.44 × 91.44 cm (36 × 36 in). Photo: Studio K.O.S.; used with permission.

Figure 17.4 Tim Rollins and K.O.S., *Amerika (after Franz Kafka) VIII*, 1986–1987. Watercolor, charcoal, and pencil on book pages mounted on linen, 175.58 × 35.56 cm (69 1/8 × 14 in). Photo: Museum of Modern Art; used with permission.

## PART III: González-Andrieu

Figure 18.1 John August Swanson, *The Prisoner*, 1972. Serigraph, 20.32 × 54.61 cm (8 × 21.5 in). Series of 40 printed. © The John August Swanson Trust. All rights reserved.

Figure 18.2 John August Swanson, *The Ascent*, 2014. Acrylic on canvas, 83.82 × 62.86 cm (33 × 24.75 in). Candler School of Theology Collection, Atlanta. © The John August Swanson Trust. All rights reserved.

Figure 18.3 John August Swanson, *The Procession*, 2007. Serigraph, 91.44 × 60.96 cm (36 × 24 in). Edition of 250. © The John August Swanson Trust. All rights reserved.

## PART III: Milliner

Figure 19.1 Phillip K. Smith III, *10 Columns*, 2019. Aluminum, glass, LED lighting, electronic components, unique color choreography. 7000 sq ft × 10 columns, 106.68 cm high (42 in) × 23cm (9 in) wide × varying widths, 40.64, 66.04, 91.44 cm (16, 26, 36 in). Photo courtesy of the artist and Bridge Projects, Los Angeles. Photo: Lance Gerber.

Figure 19.2 Antoine Caron, *Dionysius the Areopagite Converting the Pagan Philosophers*, 1570s. Oil on canvas. 92.7 × 72.1 cm (36 1/2 × 28 3/8 in). Image courtesy of the Getty's Open Content Program.

Figure 19.3 *Transfiguration*, Church of the Holy Apostles, Thessaloniki, 1310–14. Mosaic, approximately 170 × 130 cm (66.93 × 51.18 in). Photograph in the public domain.

Figure 19.4 Phillip K. Smith III alongside his *10 Columns: Small-Small*, 2019. Aluminum, glass, LED lighting, electronic components, unique color choreography, 107 × 91 × 46 cm (42 1/8 × 35 1/8 × 17 3/4 in). Photo courtesy of the artist and Bridge Projects, Los Angeles. Photo: Gina Clyne.

## PART III: Hamilton

An earlier version of this chapter was published as: Julie M. Hamilton, "Performativity and the Flesh: The Economy of the Icon in Lia Chavez's Light Body," *The Other Journal: Identity* (Volume 27), Wipf and Stock, 2017, pp. 52–61. Revised and reprinted with permission from *The Other Journal.*

Figure 20.1 Lia Chavez, *Light Body*, July 23, 2016, performance. Featuring performers Lia Chavez, Djassi deCosta Johnson, and Troy Ogilvie. A commission by Isabella Rossellini. Presented at Mama Farm in Brookhaven Hamlet, NY. Curated by Tali Wertheimer. Produced by Nur El Shami and Beverly Allan. Costuming by Mary Katrantzou. Beauty by Virginia Linzee. Styled by Richard Ives. Photo documentation by Ira Lippke. © Lia Chavez Studio.

Figure 20.2 Lia Chavez, *Light Body*, July 23, 2016, performance. Featuring performers Lia Chavez, Djassi deCosta Johnson, and Troy Ogilvie. A commission by Isabella Rossellini. Presented at Mama Farm in Brookhaven Hamlet, NY. Curated by Tali Wertheimer. Produced by Nur El Shami and Beverly Allan. Costuming by Mary Katrantzou. Beauty by Virginia Linzee. Styled by Richard Ives. Photo documentation by Ira Lippke. © Lia Chavez Studio.

## PART III: Wallace

Figure 22.1 Christian Jankowski, *The Holy Artwork*, 2001, Video, 15:52 min, NTSC, 4:3, color, sound, English with subtitles (German, Italian, Croatian). Reproduced with permission of the artist.

## PART III: Schachter

Figure 23.1 Anshie Kagan, *In Case Of Moshiach Break Glass*, 2013. Shofar, metal, glass, enamel paint. Courtesy of the artist. www.anshie.com/window.

## PART III: Heartney

Figure 24.1 Jim Shaw, *The Whole: A Study in Oist Integrated Movement*, 2009 (film still). Video, 16:40 minutes, courtesy of the artist and private collector.

Figure 24.2 Liza Lou, *Born Again*, 2004 (film still). 54-minute film. Written and performed by Liza Lou. Directed by Mick Haggerty, courtesy the artist and Lehmann Maupin, New York, Hong Kong, Seoul, and London.

Figure 24.3 Shoja Azari, *The King of Black*, 2013 (film still). HD color video with sound, TRT 24 minutes, ©Shoja Azari, courtesy of the artist and Leila Heller Gallery, New York.

Figure 24.4 Shirin Neshat, *Mahdokht Series*, 2004, C-print, photo: Larry Barns, ©Shirin Neshat, courtesy of the artist and Gladstone Gallery, New York and Brussels.

## PART III: Karetzky

Figure 25.21 Wenda Gu, *Ink Alchemy*, 1999–2001. Mixed media. Image courtesy of the artist.

Figure 25.22 Wang Qingsong, *Bequeathing Buddha*, 2019. C-print, 180 × 130 cm (70.8 × 51.2 in). Courtesy of the artist.

Figure 25.3 Zhang Huan, *Three Heads Six Arms,* 2011. Steel and Copper, 800 × 1800 × 1000 cm (315 × 708.7 × 393.7 in). 1881 Heritage Grand Piazza, Hong Kong, Edouard Malingue Gallery in Cooperation with The Pace Gallery. Courtesy of the artist.

Figure 25.4 Daozi, *Saintism*, 2010. Ink on rice paper, 152.4 × 96.5 cm (60 × 38 in). Courtesy of the artist.

Figure 25.5 Daozi, *Matthew 5:4 Blessed are they that mourn: for they shall be comforted.* (King James Version), 2020. Ink on paper, 45.9 × 69 cm (18 × 27 in). Courtesy of the artist.

## PART III: Zha

Figure 26.1 Meng Yan. *The Last Supper*, 2008–2016. Oil on canvas, 1150 × 400 cm (452.75 × 157.5 in). ©Meng Yan, courtesy of the artist, Shanghai. All rights reserved.

Figure 26.2 Meng Yan. *The Divine Comedy*, 2006–2016. Oil on canvas, 900 × 920 cm (354.3 × 362.2 in). ©Meng Yan, courtesy of the artist, Shanghai. All rights reserved.

## PART III: Sivanesan

Figure 27.1 Chrysanne Stathacos, *Refuge, A Wish Garden* (Abington Art Center, Philadelphia, USA), 2006. Interactive public artwork: cloth, benches, flowers, sand, rakes; dimensions variable. Courtesy of the artist. Photo: Amy Lipton.

Figure 27.2 Chrysanne Stathacos, *The Three Dakini Mirrors (of the Body, Speech and Mind)*, 2021. Installation: mirrors, rose petals, Bodhi leaves; 76.2 × 76.2 cm (30 × 30 in), variable arrangement. Courtesy of the artist and Gwangju National Museum. Photo: 13th Gwangju Biennale.

Figure 27.3 Charwei Tsai, *Earth Mantra*, 2009. Performance document: photograph, 67 × 120 cm (26.4 × 47.2 in). Courtesy of the artist.

Figure 27.4 Charwei Tsai, The Womb & The Diamond, 2021. Mirror, blown glass and diamond; 300 × 600 cm (118.1 × 236.2 in). Courtesy of the artist and Live Forever Foundation, Taichung, Taiwan. Photo: Anpis Wang.

## PART III: von Veh

Figure 28.1 Diane Victor, *The Fourteen Stations,* 2018. Installation view in the Sanlam Auditorium stairwell, Northwest University, Potchefstroom, South Africa. Photograph: Diane Victor; courtesy of the artist.

Figure 28.2 Diane Victor, *The Fourteen Stations,* 2018. Unnamed victim of femicide. Smoke drawing on glass and shadow projection. Photograph: Diane Victor; courtesy of the artist.

Figure 28.3 Diane Victor, *No Country for Old Women,* 2013. Smoke drawings on glass, approx. 4 × 4 m (13.12 × 13.12 ft). © Diane Victor; courtesy of the artist.

Figure 28.4 Diane Victor, *The Fourteen Stations*, 2018. Sleeping woman with Death. Drawing made in fly ash, 11 × 5 m (36.1 × 16.4 ft), detail. Photograph: Diane Victor; courtesy of the artist.

## PART III: Junker

Figure 29.1 Nicholas Galanin, *What Have We Become? Gold,* 2018. Carved book, 29.8 × 48.3 × 6.3 cm (11 ¾ × 19 × 2 ½ in). Courtesy of the artist.

Figure 29.2 Nicholas Galanin, *Wé tl'átk áwé át sa.áx – Listen to the land,* 2020. Single-channel video w/ audio, 4 min 53 sec. Courtesy of the artist.

Figure 29.3 Joelington Rios, *O que sustenta o Rio-Maria. A presença dos negros mantidos como escravos, dentro do processo de sustentação. Pocesso de perpetuação,* 2019. Photomontage, 35 × 35 cm (13.78 × 13.78 in) with frame. Courtesy of the artist.

Figure 29.4 Joelington Rios, *O que sustenta o Rio, Iansã. Processo de sustentação e espiritualidade.* 2018. Photomontage, 11 × 13 cm (4.33 × 5.12 in). Courtesy of the artist.

## PART III: Crasnow

Figure 30.1 Yasmine K. Kasem, *Sweat Until I am Soaked* (detail), 2022. Wood sawhorses, salt, cotton, and dyed cotton piping, 101.6 × 53.34 cm (40 × 21 in per sculpture). Courtesy of the artist. Photo courtesy of John Michael Kohler Arts Center.

Figure 30.2 Chaza Charafeddine, *Sans Titre VI*. Background: details from different plates of the Miraj Nameh depicting the paradise, 2010. Photomontage, giclée print on fine art paper, 35 × 50 cm (13.8 × 19.7 in) © Chaza Charafeddine, Courtesy of the artist & Saleh Barakat Gallery.

Figure 30.3 Arshia Fatima Haq, *The Ascension*. Originally shown as part of a four-channel installation *Solution*, with contributions from Cassils, Arshia Fatima Haq, Rafa Esparza, and Keijaun Thomas. Performance and concept by Arshia Fatima Haq. Film by Cassils, 2018.

Figure 30.4 Said Baalbaki, Reconstruction of a Pegasus skeleton from the installation *Al Burak I*, 2007–9. Ceramic and brass on wood, 50 × 48 × 72 cm (19.7 × 18.9 × 28.3 in). © Wekbundarchiv, Museum der Dinge, Berlin. Photo: Armin Hermann.

# INDEX

Note: *Italic* page numbers refer to figures and page numbers followed by "n" denote endnotes.